Danish Studies in Classical Archaeology

ACTA HYPERBOREA

16

Approaches to Ancient Etruria
Mette Moltesen & Annette Rathje (eds.)

Managing editor: Bodil Bundgaard Rasmussen
Layout and typesetting: Erling Lynder
Image editing: Janus Bahs Jacquet and Erling Lynder
Cover: Thora Fisker and Janus Bahs Jacquet
Revision of English texts: Nicola Gray
Set with Garamond
Printed in Denmark by Tarm Bogtryk a|s

ISBN 978 87 635 4697 3
DOI https://doi.org/10.55069/llw75521

Danish Studies in Classical Archaeology. Acta Hyperborea 16
ISSN 0904 2067

Collegium Hyperboreum
Niels Bargfeldt, Kristine Bøggild Johannsen, Mette Moltesen, Jane Hjarl Petersen,
Birte Poulsen, Annette Rathje, Eva Rystedt & Knut Ødegård
c/o The Saxo Institute,
Section of Classical Archaeology, University of Copenhagen
Karen Blixens Plads 8, DK–2300 Copenhagen S

Cover illustration: Tomba dell'Orco II, Tarquinia (360–330 BC). The back wall:
The three-headed Geryoneus, Persephone and Hades. Facsimile 1897, Ny Carlsberg
Glyptotek H.I.N. 126 (adapted photo). Photo: Ny Carlsberg Glyptotek.

This book has been published with financial support from
The Carlsberg Foundation

Published and distributed by
Museum Tusculanum Press
Rådhusvej 19
DK–2920 Charlottenlund
www.mtp.dk

Danish Studies in Classical Archaeology
ACTA HYPERBOREA
16

Approaches to
Ancient Etruria

Edited by
Mette Moltesen & Annette Rathje

Museum Tusculanum Press

2022

CONTENTS

INTRODUCTION

METTE MOLTESEN, BODIL BUNDGAARD RASMUSSEN & ANNETTE RATHJE

The study of the Etruscans, their material culture, their lifestyle, religion, language and civilization in general, as well as the natural resources of their territories and their role in international connections, has accelerated in recent decades. Many important discoveries have come to light by accident, through excavations or even when tidying up old excavation sites. Other surprises come from museum storerooms and archives and give fresh insights into old finds. New methods are being applied and new questions asked. It is no wonder, then, that a number of handbooks on the Etruscans have been published in recent years, many monographs and innumerable articles, and other publications that pay homage to prominent scholars, both contemporary and in previous times.[1]

More than ever, we need to look at the Etruscan and pre-Roman material from Italy in the wider Mediterranean and European context of the first millennium BC. For the *Acta Hyperborea* series we have primarily chosen interdisciplinary and interregional subjects, and the Etruscan civilization, covering central Italy and beyond, in itself invites an interdisciplinary approach. Despite this, participants at the inter-Nordic seminar "Ancient Etruria", which was held at the University of Copenhagen on 15th–16th November 2018 and whose talks form the basis of this book, were primarily classical archaeologists with Etruscan expertise, leaving ancient history, linguistics and prehistoric (as seen from the Nordic angle) archaeology aside. Some of the contributors, moreover, come from outside the Nordic countries.

By the end of the Etruscan civilization the language was lost, and no copying of their literature took place to form a manuscript tradition of the kind that has saved so much Greek and Latin literature. Archaeology is fundamental to our knowledge of the Classical World, and even more so in the case of the pre-Roman peoples of Italy, and particularly the Etruscans, whose literacy is of an early age and which has left a very rich epigraphical record on durable materials.[2] This rich and ever-growing epigraphical material has not only led to linguistic studies, but is also useful in studies

of religion looking at dedications to the gods, as is done by Helle Salskov Roberts, or in mapping social relations, as in Marjatta Nielsen's contribution.

Landscape surveys have proved valuable when looking at long-term developments in settlement patterns and land use. Most of the larger Etruscan cities were in fact inhabited from the late Bronze Age onwards, and a particularly early case is treated here by Lars Karlsson. Urban settlements were not only situated on hilltops, but thick layers of mud have also concealed stone structures in river valleys (Gonfiente and Pontecagnano) and estuaries (Pisa). City walls, gates and fortifications, which would have been part of an urban setting, have been visible throughout the ages. Vast engineering enterprises for water management (*cuniculi*, wells) and for cutting roads through rocks have long been known, and remind us that the Etruscans were renowned for their engineering skills.

Sanctuaries and temples were built and rebuilt, leaving behind stone foundations and large amounts of terracotta fragments from different building phases. At Tarquinia, the excavations carried out by the University of Milan have brought to light evidence of the formation of the religious tradition of *disciplina etrusca*. In the present volume, matters related to religion are treated by Annette Rathje, J. Rasmus Brandt and Helle Salskov Roberts. In the last twenty years, the excavations at Campo della Fiera, below the slopes of Orvieto, have offered a convincing candidate for the identification of the federal sanctuary *Fanum Voltumnae* and a meeting point for the Etruscans.[3]

Ingrid Edlund-Berry's contribution on the architectural profiles used on temple podia, in tomb architecture and elsewhere derive from her work on the re-editing of Lucy Shoe Merritt's book on the Etrusco-Italic and Roman Republican mouldings. Etruscan art and imagery from all periods are an intriguing and many-faceted area of research. Etruscan images are treated in the contributions by by Annette Rathje, Liv Carøe and Sofie Ahlén, Laura Nazim, and Ingela Wiman, while the problem of Etruscan portraiture in late tomb contexts is presented in a case study by Sofie Heiberg Plovdrup.

Tombs, burial customs, funerary art and grave goods have always played a major role in Etruscan studies, and they do so in this volume, too: Annette Rathje, Nora Petersen, J. Rasmus Brandt, Matilde Marzullo, Laura Nazim, Sofie Heiberg Plovdrup and Marjatta Nielsen all deal with

various aspects of burial archaeology and iconography. In past centuries tombs have been subjected to merciless treasure-hunting, and the most precious objects have been given new life as art objects in museums and collections. Yet new discoveries, especially in the Chiusine territory and even at Tarquinia, have proved how we can delve into to the minds of ancient people when examining intact tombs, where the deceased have been staged within their social and ancestral setting. In Bologna, dense depositions of mud have preserved tombs that contained astonishing wooden furniture. Closer to the Adriatic Sea, at Verucchio, mud has entered tombs, corroding iron objects but preserving all the rest such as textiles, very refined amber jewellery, and wooden furniture with exquisite carvings.

Etruscan studies in Denmark

Bronze vessels of Etruscan origin, recycled as cinerary urns, have been found in Danish and Swedish soil, and common features of material culture and imagery reveal knowledge of Etruscan and Italic material among our colleagues in prehistoric archaeology. Interest in the Etruscans has older roots in the Nordic countries than one might expect. From the Renaissance onwards, one reason for the interest was that the Etruscan script was seemingly reminiscent of the Runic alphabet. Whether from books or from travels, many students, scholars and artists were acquainted with the "Hetrurians" as one of the pre-Roman peoples of Italy. Some, like the Danish theologian and bishop of Zealand, Frederik Münter (1761–1830), even acquired inscribed Etruscan objects for his 'Museum Münterianum'.[4]

Bertel Thorvaldsen and his Collection of Antiquities

The Danish sculptor Bertel Thorvaldsen (1770–1844) arrived in Rome in 1797 and remained there for most of his life. He was much involved in the renewed interest in the Etruscans and their culture in the early 19th century. He was a member of the *Instituto di Corrispondenza Archeologica* from its inception in 1828, with the special task of judging the quality of the illustrations for the Institute's publications. At the frequent meetings, new finds were reported to an international audience, who were all believers in the free mobility of antiquities and were eager to form their own collections, as Thorvaldsen was himself, or to make acquisitions for museums.[5] In the present volume, the contribution by Kristine Bøggild Johannsen deals with Thorvaldsen's role in the early 19th-century rediscovery of the

Etruscans. The demand for genuine Etruscan objects being higher than the supply led to the fabrication of fakes, including engravings on mirrors, treated here by Bjarne Purup.

The Etruscan Antiquities in the National Museum of Denmark
The Etruscan antiquities in the Collection of Classical and Near Eastern Antiquities (*Antiksamlingen*) in the National Museum came to Denmark little by little – over more than two centuries through the efforts of various people dedicated to Antiquity and collecting.

In the 18th century, "Hetrurian" antiquities were only found in two private collections, one belonging to the influential minister Ove Høegh-Guldberg (1731–1808)[6] and the other to the above-mentioned Frederik Münter.[7] Münter was especially interested in inscriptions and acquired several Etruscan urns. The inscriptions and one of the urns were embedded in the wall of the gatehouse to his residence (still *in situ*) following the Renaissance habit he had observed in Rome.[8] Høegh-Guldberg's collection, including some "Hetrurian" pots and a few bronzes, was acquired for the Royal Kunstkammer upon his death,[9] while Münter's was put up for auction when he died, though luckily a major part of it was acquired for the Kunstkammer. When the Kunstkammer was dissolved in the early 1820s, the antiquities were transferred to the Royal Art Museum. In 1851 this collection was merged with a collection that had belonged to the late King Christian VIII,[10] and both collections were moved to the future National Museum in the centre of Copenhagen under the name *Cabinet of Antiquities*.[11]

In the latter half of the 19th century and the early parts of the 20th, many acquisitions were made for the new Cabinet, of all types of objects, of all kinds of material and from all periods. Etruscan figurines, pots, pans, utensils, weapons, several *candelabra* and *thymiateria*, and not least a well-preserved *cista* were added to the bronzes. A small group of three mirrors acquired in 1837 ended up comprising 23 complete or fragmentary mirrors by 1890/1891.[12] In total the Etruscan bronzes in *Antiksamlingen* number around 3,000 objects.[13] By far the majority were acquired in the second half of the 19th century.

A large number of *impasto bruno*, *bucchero* with incised or cut-out decoration, as well as examples of both *bucchero pesante* and *bucchero sottile* were incorporated into the *Cabinet*. Likewise, Etruscan black-figure

vases, red-figure, and black gloss vases[14] were acquired, as were gold and amber jewellery and amber figurines.[15] A major addition to the pottery was made in 1894 by keeper Chr. Blinkenberg (1863–1948), in the form of five Etruscan/Faliscan tomb groups comprising about 110 objects, allegedly from the territory of Narce.[16]

In some instances, a keeper would travel in the company of Carl Jacobsen (1842–1914), the brewer and founder of the Ny Carlsberg Glyptotek who acquired objects that he donated to the *Cabinet*. Similarly, in 1883 Norwegian archaeologist Ingvald Undset (1853–1893) bought an entire tomb complex from Chiusi and passed it on to the museum.[17]

The "Helbig Museum" in the Ny Carlsberg Glyptotek in Copenhagen

In a letter of 24th May 1887, addressed to Ludvig Müller, the director of the Cabinet of Antiquities, German archaeologist Wolfgang Helbig offered the National Museum an Etruscan sarcophagus, though the museum could not afford it. Müller forwarded the letter to Carl Jacobsen, who purchased the Vulcian sarcophagus (H.I.N. 57), and thus a direct connection to Helbig was established.[18] This sarcophagus was the first Etruscan object acquired by Jacobsen.

Carl Jacobsen's wife, Ottilia, gave her husband Jules Martha's up-to-date volume *L'art étrusque* as a Christmas present in 1888.[19] To his surprise, Jacobsen was able to read in the first chapters of the volume ample and appreciative references to the work of Wolfgang Helbig regarding the discussions on the origin and early phases of the Etruscan civilization, whether in northern Italy or in Etruria proper.[20] Helbig's interest in these matters went back to the international archaeological congress in Bologna in 1871, the first congress to be held after the unification of Italy, where the programme was centred on the Etruscans and their role in long-distance contacts in Europe and the Mediterranean. A Danish delegation to the congress was headed by eminent archaeologist, J. J. A. Worsaae (1821–1885). Also present, from Sweden, was Oscar Montelius (1843–1921), who would become an authority in interregional chronology for decades to come. Ingvald Undset (1853–1893), the Norwegian scholar mentioned above, was too young at the time and did not participate. Inspired by Martha's book, Carl Jacobsen decided to form an Etruscan Cabinet within the Ny Carlsberg Glyptotek, which at the time was situated beside his villa in Valby, then on the periphery of Copenhagen.

On October 5th 1891, Jacobsen wrote to Helbig that he had named his Etruscan collection *The Helbig Museum in the Ny Carlsberg Glyptotek* in his honour. Helbig acted as Jacobsen's agent in Rome from 1887 until 1914. It had been a part of Helbig's duties as the secretary of the German Archaeological Institute in Rome to inspect and report on the new finds in Etruria and Latium for the Institute's publications, *Annali* and *Bullettino*. From 1887 to 1899, Helbig served as an honorary inspector of the Tarquinia area, where he often went to inspect new finds. This made him an expert in the chamber tombs found in the area, many of which were decorated with wall paintings, and several of which he published himself. When the Helbig Museum was created, it only contained a limited number of objects, but the first separate catalogue for the collection, published in 1911, contained no less than 319 pieces, besides a large number of facsimiles and watercolours of Etruscan tomb paintings from Tarquinia.[21]

Frederik Poulsen (1876–1950) graduated in Greek and German and later studied classical archaeology. Poulsen was employed by the Ny Carlsberg Glyptotek in 1910 to give guided tours in the museum, particularly to make Etruscan culture accessible to the Danish public. He was made curator in 1911, and was director of the Museum from 1926–1943. He published several influential and highly respected publications on Etruscan art and archaeology.[22]

'The World of the Etruscans'

In 1982, the three museums with Etruscan collections in Copenhagen – the The National Museum of Denmark, the Ny Carlsberg Glyptotek and Thorvaldsens Museum – joined forces for the exhibition *The World of the Etruscans – Life and Death,* in which the objects were staged in contexts, illustrating economic bases, international connections, and the function of the objects in their urban setting, in daily life, in sanctuaries and in tombs. This pioneering approach inspired numerous later exhibitions, for example in Florence and other Tuscan museums in 1985, in Berlin in 1988, in Paris in 1992, and the most recent overall presentation of the Etruscans in Bologna in 2019–2020. In 2003, the three Copenhagen museums lent material to Helsinki, as did the Archaeological Museum of Florence and other European museums.[23] Among others, the tombs of the small family necropolis of Casale Marittimo were shown, to give concrete evidence of the development from the Villanova culture to the Orientalizing and fur-

ther to the Archaic periods. Likewise, the cultural horizons of the Hellenistic period were illustrated by reassembling the tomb of the Purni family from Città della Pieve in the Chiusine territory.

The Antikmuseet at the University of Aarhus is currently showing a semi-permanent exhibition entitled *Etruskerne, Rejsen til Dødsriget* (The Etruscans, the Journey to the Hereafter), displaying objects from the university collection and on loan from the National Museum of Denmark, as well as facsimiles of tomb paintings from the Ny Carlsberg Glyptotek. Inspired by the exhibition, a series of public lectures were subsequently published in *Tæt på Etruskerne* (Close to the Etruscans) in 2018.[24]

Etruscan studies at Danish Universities
Today, with the outstanding Etruscan collections in Nordic museums, notably in the Ny Carlsberg Glyptotek, Etruscan culture is taught at university level. It is worth noting that the institutes of Classical, Near Eastern and Prehistoric archaeology were accommodated at the Danish National Museum until 1977, which meant easy access to the collections. Poul Jørgen Riis (1910–2008) was employed at the National Museum early in his career and became professor of Classical and Near-Eastern Archaeology, first in Aarhus and later in Copenhagen. He made a name for himself with his study of Etruscan antefixes and the dating of Etruscan sculpture in *Tyrrhenika: An Archaeological Study of the Etruscan Sculpture in the Archaic and Classical periods* (1941), later followed by *Etruscan Types of Heads* (1981) and as late as 1997 he published *A Study of Vulcian Bronzes.*[25]

The study of Etruscan bronzes was continued in the next generation by Flemming Johansen (1934–2018), director of the Ny Carlsberg Glyptotek from 1978 to 1998, with his *Reliefs en bronze d'Etrurie* (1971) that treated the relief-decorated bronze bands for the decoration of furniture and chariots. Johansen lectured for many years on Etruscan art. Ingrid Strøm (1929–) taught classical archaeology at the University of Odense (now the University of Southern Denmark) and later at the University of Copenhagen, and has written extensively on the Orientalizing period in Etruria.[26] Ingrid Strøm excavated at Monte Becco, a minor Etruscan site (ca. 700–300 BC) near Lake Mezzano, east of Lake Bolsena in the province of Viterbo in 1971–72 and 1976–77, and at Pontecagnano in 1986–87 and 1989–90. A team of Danish students were also involved in the publication of the tombs from Pontecagnano. Ingrid Strøm's successor at the University of

Copenhagen, Annette Rathje (1942–), has taught special courses in Etruscan Archaeology from 1986–2013. Since then, these courses have been taken over by Nora Petersen and Liv Carøe.

Etruscology is an international discipline and has always been part of the curriculum for students of Classical Archaeology at the University of Copenhagen. Thus, students can find interest in the subject and choose it for their bachelor or master's theses, and some have written their doctoral dissertations on Etruscan topics. Many students have participated in excavations in Etruria, for example at Murlo, Tarquinia, Pyrgi, Veii, Acqua Rossa and Pontecagnano. According to a long-standing practice, there has always been a fine collaboration between the universities and the museums, and young students become involved in museum work and act as guides in the collections.

The present volume might be classified as a collection of fragments of material and immaterial memory, placing art and material culture in their context.[27] We believe that close examination of the visible gives insight into the questions of social and cultural identities, and that broader questions lead to new interpretations and hypotheses. We study the real and the imagined, in two and three dimensions, whereby we endeavour to identify the people behind them. For an archaeology of the senses, see Cecilie Brøns's contribution to this volume.

When looking at the illustrations, it is striking that several of the contributions use representations of the facsimiles of the Etruscan tomb paintings in the Ny Carlsberg Glyptotek, and the preliminary sketches for them. It is important to stress that no matter how many new three-dimensional representations and advanced photographs of the tomb paintings are published, the copies that Carl Jacobsen sponsored in the years 1895–1913 are still the most thoroughly prepared and some of the very few to be represented in a 1:1 scale on canvas, thereby rendering the impression of texture one encounters confronting the originals. These old copies have had a revival, since the year 2017 brought a renewed interest in the Etruscan tomb paintings. After nearly thirty years of silence on the subject, an exhibition in the Museo della Grafica in Rome showed the handsome watercolours of the painted walls made by Wolfgang Helbig's son-in-law, Alessandro Morani (1859–1941). These watercolours, belonging to the Swedish Institute in Rome, and never published in their entirety before, were the sketches for the facsimiles in the Ny Carlsberg Glyptotek.[28]

A few of Morani's sketches had been shown in an exhibition of the facsimiles at the Glyptotek in 1991,[29] and a selection was shown in Stockholm at the Italian Cultural Institute in 2019 and likewise in January 2020 in Copenhagen. In December 2017, the Ecole française de Rome held a conference that was titled simply *Fac-simile*.[30] Moreover, Matilde Marzullo has published several volumes on tomb architecture, the actual as well as the painted architecture,[31] and contributes here with a text based on a lecture that she gave in Copenhagen in 2019.

In 2021, a generous grant from the Ny Carlsberg Foundation financed a project to conserve the damaged paintings in the *Tomba dei Vasi Dipinti* at Tarquinia, a Danish contribution to the preservation of this outstanding UNESCO site.

For various reasons our publication has been delayed, and the period of closures and isolation caused by the COVID 19 pandemic caused particular challenges. We are grateful for the patience of the authors and peer reviewers, and our special thanks goes to Museum Tusculanum Press.

Finally, we would like to express our gratitude to the Carlsberg Foundation for funding the publication.

NOTES

1 Bartoloni 2012; Turfa 2013; Bell & Carpino 2016; Naso 2017; Stoddart 2020; Potts & Smith 2021; for exhibitions: *Etruschi* 2019; *Gli Etruschi* 2020.

2 Whitehouse 2020.

3 Stopponi 2020a and 2020b.

4 Latest e.g. Fischer-Hansen 2010; Nielsen 2010; Petersen 2012.

5 We refer to *Networking in Archaeology since 1829,* Giornata di studio/Studientag, Deutsches Archäologisches Institut, Rome, 6th December 2019.

6 Ove Høegh-Guldberg had studied theology and history at the University of Copenhagen. In 1764 Frederik V (1723–1766, reigned from 1746) employed him as a teacher to his son (Christian (VII), the Prince hereditary. Being a strong supporter of the absolute monarchy Høegh-Guldberg became a prominent member of the 'ruling class'. Besides politics, his great interests were Antiquity and collecting.

7 Frederik Münter studied theology at the University of Copenhagen and the University in Göttingen. As a member of the Committee of Antiquities, established by Royal decree in 1807, Münter became one of the founding fathers of the National Museum.

8 Fischer-Hansen 2017; Petersen 2012.

9 Hermansen 1951; Haslund Hansen, Nørskov & Thomasen 2009.

10 Christian VIII (1786–1848, reigned from 1839). In 1820 he bought a large collection of antiquities in Naples and brought it to Copenhagen; Breitenstein 1951; Bundgaard Rasmussen 2000; Lund 2000 and 2015.

11 Hermansen 1951, 48–50.

12 Salskov Roberts 1981, 7–111.

13 I thank H. Salskov Roberts for kindly sharing this information with me. For part of the collection see Salskov Roberts 2021.

14 Breitenstein 1951; Beazley 1947/1976, 322; *CVA* Copenhague Musée National, fasc. 5, pl. 193–225.

15 Bundgaard Rasmussen 1991.

16 Salskov Roberts 1974.

17 Undset 1997.

18 Moltesen 2012.

19 Officially the book was printed in Paris in 1889, but it must have been available already for the Christmas market the previous year.

20 Helbig 1879 and 1884.

21 M. Moltesen & Marjatta Nielsen, *Etruria and Central Italy 430–30 BC*, Ny Carlsberg Glyptotek, Copenhagen 1996; J. Christiansen & Nancy Winter, *Catalogue Etruria* I; *Architectural Terracottas and Painted Wall Plaques, Pinakes c. 625–200 BC*, Ny Carlsberg Glyptotek, Copenhagen 2010; J. Christiansen & Nora Petersen, *Catalogue Etruria* II, Ny Carlsberg Glyptotek, Copenhagen 2017.

22 *Der Orient und die Frühgriechische Kunst*, Leipzig 1912; *Etruscan Wall Paintings*, Oxford 1922 (in Danish 1920, in German 1927); and *Aus einer alten Etruskerstadt*, Copenhagen 1927, on a collection of objects acquired at Orvieto.

23 M. Nielsen, J. Kaimio, E. Jarva, *Etruskit*, Helsinki 2003.

24 The authors are Anna Sofie Schjødt Ahlén, Cecilie Brøns, Marjatta Nielsen, Vinnie Nørskov, Nora Petersen and Annette Rathje.

25 P. J. Riis left a legacy in organizing his vast archives of Etruscan bronzes into a data base.

26 Noteworthy: *Problems Concerning the Origin and Early Development of the Etruscan Orientalizing Style*, Odense 1971.

27 Hamilakis 2021, 246.

28 S. Renzetti & A.Capodiferro 2017; the watercolours are now in the database of the Swedish Institute of Classical Studies in Rome, www.isvroma.org.

29 M. Moltesen & C. Weber-Lehmann 1991, 1992.

30 The proceedings of this conference, *Fac-simile* 2019.

31 Marzullo 2016, which contains the descriptions of 500 painted Etruscan tombs; Marzullo 2017.

BIBLIOGRAPHY

G. Bartoloni (ed.) 2012
Introduzione all'Etruscologia. Milano 2012.

J. D. Beazley 1947/1976
Etruscan Vase Painting. Oxford-New York 1947/1976.

S. Bell & A. A. Carpino (eds.) 2016
A Companion to the Etruscans. New York 2016.

N. Breitenstein 1951
Christian VIII's Vasecabinet, in: *Antik-Cabinettet 1851, udgivet I Hundredaaret af Nationalmuseet*, København 1951, 57–176.

B. Bundgaard Rasmussen 1991
Baltic amber in Italy, in: *Nationalmuseets Arbejdsmark* 1991, 49–60 (with English summary), København 1991.

B. Bundgaard Rasmussen 2000
A Danish Prince in Naples, in: B. Bundgaard Rasmussen *et al.* (eds.), *Christian VIII and the National Museum*, Copenhagen 2000, 11–43.

CVA Copenhague, Musée National, fasc. 5.
Text by Chr. Blinkenberg and K. Friis Johansen, Paris-Copenhague (no year).

Etruschi 2019
Etruschi Viaggio nelle terre dei Rasna (Exhibition Catalogue, Bologna). Milano 2019.

Gli Etruschi 2020
V. Nizzo (ed.) *Gli Etruschi e il Mann*, (Exhibition Catalogue, Napoli). Milano 2020.

Fac-simile 2019
Fac-simile: Le collezioni di documentazione grafica sulla pittura etrusca. Consistenza dei fondi, contesti di produzione e impiego (L. Cuniglio, N. Lubtchansky & S. Sarti, eds.), *MEFRA* 131-2, 2019.

T. Fischer-Hansen 2010
Frederik Münter og hans rejse til Italien – med særligt henblik på erfaringer fra Sicilien, in: *Oldsagskommissionens tidlige år, forudsætninger og internationale forbindelser (Nationalmuseets*

200 års jubilæums symposium 2007), Aarbøger for
Nordisk Oldkyndighed og Historie / Annual of
the Royal Society of Northern Antiquaries 2007,
(with English summary), København 2010,
91–106.

T. Fischer-Hansen 2017
Biskop Frederik Münter og hans *Museum
Münterianum*, in: *Klassiske Studier 4, 2017/
Aigis. Elektronisk tidsskrift for klassiske stud-
ier i Norden, Year 4*, København 2017 (with
English summary) https://aigis.igl.ku.dk/
aigis/KAF40/Tobias%20F-H.pdf.

Y. Hamilakis 2021
A Response to the Archaeology of J. C. Barrett,
in: *Far from Equilibrium: An Archaeology of
Energy, Life and Humanity*, Oxbow Books, 2021.

A. Haslund Hansen, V. Nørskov &
H. Thomasen 2009
Artist and Antiquary: Wiedewelt's Catalogue
of Egyptian and Roman Antiquities, 1786,
Acta Hyperborea 11, 241–257, Copenhagen 2009.

W. Helbig 1879
Die Italiker in der Poebene. Leipzig 1879.

W. Helbig 1884
La provenienza degli Etruschi, *Annali
dell'Instituto di Corrispondenza Archeologica* 1884,
108–188.

V. Hermansen 1951
Fra Kunstkammer til Antik-Cabinet, in:
*Antik-Cabinettet 1851, udgivet i hundredåret
af Nationalmuseet*, København 1951, 9–56.

J. Lund 2000
Royal connoisseur and consular collector:
the part played by C. T. Falbe in collecting
antiquities from Tunesia, Greece and Paris for
Christian VIII, in: B. Bundgaard Rasmussen
et al. (eds.), *Christian VIII and the National
Museum*, Copenhagen 2000, 11–43.

J. Lund 2015
The Unacknowledged Consul: Carl Christian
Holck as Collector of Antiquities from Tunesia,
in: B. Bundgaard Rasmussen (ed.), *The Past in the
Present*, Copenhagen 2015, 63–82.

M. Marzullo 2016
*Grotte cornetane: materiali e apparato critico per
lo studio delle tombe dipinte di Tarquinia I–II*,
Tarchna Supplemento 6, Milano 2016.

M. Marzullo 2017
*Spazi sepolti e dimensioni dipinte nelle tombe
etrusche di Tarquinia*, Tarchna Supplemento 7,
Milano 2017.

M. Moltesen 2012
*Perfect Partners. The Collaboration between Carl
Jacobsen and his Agent in Rome Wolfgang Helbig
in the Formation of the Ny Carlsberg Glyptotek
1887–1914*. Copenhagen 2012.

M. Moltesen & C. Weber-Lehmann 1991
*Catalogue of the Copies of Etruscan Tomb Paintings
in the Ny Carlsberg Glyptotek*. Copenhagen 1991.

M. Moltesen & C. Weber-Lehmann 1992
*Etruskische Grabmalerei. Faksimiles und Acquarel-
le. Dokumentation aus der Ny Carlsberg Glyptotek
und dem Schwedischen Institut in Rom*. Sonder-
nummer, Antike Welt. Zeitschrift für Archäolo-
gie und Kulturgeschichte 23, 1992.

A. Naso (ed.) 2017
Etruscology. Boston-Berlin 2017.

M. Nielsen 2010
Frederik Münter og brødrene Vivenzio i Nola
– vaser, kontekster og lag, in: *Oldsagskommis-
sionens tidlige år, forudsætninger og internationale
forbindelser (Nationalmuseets 200 års jubilæums
symposium 2007)*, Aarbøger for Nordisk Oldkyn-
dighed og Historie / Annual of the Royal Society
of Northern Antiquaries 2007, København 2010,
107–148, with English summary.

N. M. Petersen 2012
Biskop Frederik Münter og hans museum,
Nationalmuseets Arbejdsmark, 2012, 18–29,
(with English summary), København 2012,
18–29.

C. R. Potts & Chr. J. Smith 2021
The Etruscans: setting New Agendas, Journal
of Archaeological Research
https://doi.org/10.1007/s10814-0 21–09169-x

S. Renzetti & A. Capodiferro (eds.) 2017
*L'Etruria di Alessandro Morani. Reproduzioni di
pitture etrusche dalle collezioni dell'Istituto Svedese
di Studi Classici a Roma*, Firenze 2017.

H. Salskov Roberts 1974
Five Tomb Groups in the Danish National Muse-
um from Narce, Capena and Poggio Sommavilla,
Acta Archaeologica 5, Copenhagen 1974, 49–106.

H. Salskov Roberts 1981
Corpus Speculorum Etruscorum, Denmark,
I, *The Danish National Museum and The Ny
Carlsberg Glyptotek.* Copenhagen 1981.

H. Salskov Roberts 2021
*Catalogue of the Sardinian, Etruscan and
Italic Bronze Statuettes in the Danish
National Museum. Gösta Enbom Mono-
graphs* Vol. 7. Copenhagen-Aarhus 2021.

S. Stoddart 2020
*Power and Place in Etruria the Spatial Dynamics
of a Mediterranean Civilization, 1200–500 BC.*
Cambridge 2020.

S. Stopponi 2020a
*Il luogo celeste. Il santuario federale degli etruschi a
Orvieto.* Spoleto 2020.

S. Stopponi 2020b
Campo della Fiera di Orvieto tra preromano e
romano: il *Fanum Voltumnae,* in: M. C. Biella
(ed.), *Displacements. Continuità e discontinuità
urbana nell'Italia centrale tirrenica,* Roma 2020.

J. M. Turfa (ed.) 2013
The Etruscan World. London-New York 2013.

Undset 1997
L. Berczelly & J. R. Brandt (eds.), *Ingvald Undset
– man and scholar* (conf. Rome 1997); *Aspects of
European Iron Age,* AAAHP series altera in 8°, 9,
Rome 1997.

R. Whitehouse (ed.) 2020
*Etruscan Literacy and its Social Context – Accordia
Specialist Studies on Italy* 18. London 2020.

SAN GIOVENALE
A TERRAMARE FOUNDATION

This article was inspired by Andrea Cardarelli's ideas around the Terra-mare culture.[1] The discussion is here taken further to suggest that the Ter-ramare movement is Etruscan, that Protovillanovan San Giovenale was a Terramare foundation and thus part of a Pelasgian "diaspora", as described by Dionysios of Halikarnassos.

The Swedish excavations at the two Etruscan sites of San Giovenale and Luni sul Mignone produced a sensational type of pottery, which was very early identified as Protovillanovan.[2] The Swedish archaeologists considered this facies to be part of the Iron Age, as it was discovered immediately under the Archaic levels. During my work with the mate-rial from Area F East at San Giovenale, I have been able to distinguish a more comprehensive stratigraphy of the archaeological levels at San Giovenale (Area F). The stratigraphic layers can be described in the fol-lowing way:[3]

(1) On top one finds a thin, mixed layer of top soil containing Hellenistic and later pottery;

(2) Below is the significant Archaic level with ashlar-built square houses with terracotta roofs and developed bucchero (ca. 625–550/30 BC);

(3) Below is the Orientalizing period with buccheroid impasto, some very fine bucchero *sottile* pieces, spiral amphorae, and a square house built with wattle-and-daub walls and a mud roof. This is the period of the Capanna tomb in Cerveteri (ca. 675–625 BC).

(4) Below is a level of roundish huts built with a stone socle. Connected with these is pottery of the type called Brown Impasto in the San Giovenale publications. It should belong in the second half of the 8th century BC. There is really no Villanovan pottery from San Giovenale, even though a few pieces could be interpreted in this way.[4]

(5) Below, and mixed with all later strata, is a very large amount of Protovillanovan pottery. The many discovered huts are here built into channels cut in the tufa bedrock.[5]

The large amount of Protovillanovan pottery from San Giovenale surprised the excavators.[6] Since this type of pottery was not so well known at the time, the Swedish archaeologists were slow in publishing the material. Fortunately, the excavations were well conducted and all pottery was saved in many hundreds of boxes at the Swedish Institute in Rome (nowadays in storage rooms in Blera). Since this time, Italian archaeologists have been working on Protovillanovan material from other sites and have concluded that this facies belongs to the Bronze Age. During my work with the Area F East, I was able to C14-date two preserved charcoal fragments taken from the large hearth discovered in Oval Hut I.[7] At this level, the excavator Arne Furumark collected pieces "from vessels standing along the inner wall of the hut".[8] Furumark believed that this hut had been deserted abruptly or violently destroyed.[9] The C14 dates were 1510–1110 BC and 1500–1310 BC, both with 95.4% confidence. Thus pottery of the Protovillanovan culture belongs to the Bronze Age, also at San Giovenale, and more specifically it seems to be the Recent Bronze Age (*bronzo recente*), dated ca. 1350/1300–1150 BC. A small Mycenaean sherd was also found.[10]

Another surprising fact was that remains (i.e. cut channels and post holes) from Protovillanovan huts were discovered all over the plateau of the so-called Acropolis. This suggests that the Protovillanovan settlement at San Giovenale must have been very substantial and extensive. However, a limited part of San Giovenale was settled earlier, with a concentration around the 13th century AD castle.[11] It thus seems a possibility that the extensive Protovillanovan settlement at San Giovenale was very much like a colony, a foundation *ex nuovo*.

Dionysios of Halikarnassos

If the Protovillanovan settlement at San Giovenale is a new foundation, from where did the settlers come? In a 2009 article, Andrea Cardarelli connected the north Italian Terramare culture with a people called the Pelasgians, known from ancient sources to be a pre-Greek people in Greece and western Anatolia. According to Cardarelli, the Terramare culture in Italy arose in the Middle Bronze Age 1 (ca. 1650–1550 B),[12] and disappeared

rather abruptly in the 12th century, at about the passage from the Recent Bronze Age to the Final Bronze Age. Cardarelli connects this abrupt end of the Terramare culture with the incredible story told by Dionysios of Halikarnassos of the crisis that befell the Pelasgians two generations before the Trojan War (thus about 1250 BC). The ancient historian, who wrote at the time of Augustus, came from Karia in Anatolia, as did his predecessor Herodotos of Halikarnassos, so both of them originated from an area not so remote from a suggested Pelasgian 'homeland'. Dionysios says that the Pelasgians came to Italy from Thessaly (1.89.1–2). They were expelled from Thessaly by the Greeks and landed at the mouth of the River Po. Even though Dionysios himself did not support the interpretation that the Pelasgians were Etruscans, both the historians Myrsilos of Methymna (ca. 250 BC) and Hellanikos from Mytilene (5th c. BC), believed that the Pelasgians were Tyrrhenians (Dion. 1.28.3 and 1.25.5),[13] the term Greek authors used for the Etruscans. In a long passage copied carefully in the work of Dionysios of Halikarnassos, Myrsilos of Methymna described what happened to the Pelasgians after they had migrated from Greece to Italy:

The Pelasgians, after conquering a large and fertile region, taking over many towns and building others, made great and rapid progress, becoming populous, rich and in every way prosperous. Nevertheless, they did not long enjoy their prosperity, but at the moment when they seemed to all the world to be in the most flourishing condition they were visited by divine wrath (1.23.1).

The first cause of desolation of their cities seemed to be a drought which laid waste their land, when neither fruit remained on the trees till it was ripe, but dropped while still green, nor did such of the seed corn as sent up shoots and flowered stand for the usual period till the ear was ripe, nor did sufficient grass grow for cattle; and of the waters some were no longer fit to drink, others shrank during the summer, and others were totally dried up (1.23.2).

The rest of the people, also, particularly those in the prime of life, were afflicted with many unusual diseases and uncommon deaths (1.23.3).

For the Pelasgians in a time of general scarcity in the land had vowed to offer to Jupiter, Apollo and the Cabeiri tithes of all their future increase (1.23.5).

The time when the calamities of the Pelasgians began was about the second generation before the Trojan War; and they continued to occur even after the war, till the nation was reduced to very inconsiderable numbers. For, with the exception of Croton, the important city in Umbria, and any others that they had founded in the land of the Aborigines, all the rest of the Pelasgian cities were destroyed (1.26.1).

These passages from Dionysios of Halikarnassos are very interesting and informative. One wonders if the natural disasters described by him were also the ones that caused the downfall of the Mycenaean civilization and Troy. What is the evidence for the suggestion that the 'Italian' Etruscan-speaking people were related to the Pelasgians, known from Greece? In an article from 2001, the Italian scholar G. M. Facchetti has suggested that the language on the Linear A tablets, known from Crete and the Aegean area, is proto-Etruscan.[14] We know that the Etruscan language was spoken on Lemnos down into the Classical period, and place names on Crete have parallels in Etruria, for example Croton (Cortona)–Gortyn.[15] Here I would like to add the place name Larissa or Larisa, which can be found both in Thessaly and in Aeolis in Anatolia, areas where, according to ancient sources, Etruscan-speaking people lived.[16] I suggest that this place name must come from Laris/Larth, which is possibly the most common male name in Etruscan society. This cannot be a coincidence. In this context, it is interesting that Dionysios writes that the Pelasgians sacrificed to the Kabeiroi.[17] The Kabeiroi were worshiped at Samothrace, where pre-Greek graffiti have been discovered. Is this language also Etruscan? One myth says that the Kabeiroi were twins who helped their father Hephaistos in his metalworking shop on Lemnos, where there was also a Kabeiroi sanctuary and where perhaps the Etruscan language was spoken. The connection with metalworking in this cult is interesting as the excavations of Terramare settlements produce a large amount of metal artefacts[18] – not to mention the skill of the later Etruscans in metalworking.[19] Finally, Helmut Rix has been able to prove that inscriptions in the southern Alpine region are written in an Etruscan language, confirming Pliny's statement that the Rhaetians were Etruscans.[20] Interestingly, modern DNA analyses have indicated that Etruscan DNA is closely related to that of modern-day Turks.[21]

Terramare – San Giovenale

An important part of the Terramare culture is the practice of cremation in biconical jars of various sizes. Although, as has been pointed out, some Terramare cemeteries include inhumation graves, the majority contain cinerary urns.[22] This cultural practice is a break from an earlier Bronze Age inhumation tradition. Around San Giovenale, surprisingly, and in spite of a very extensive archaeological inventory research, only seven tombs of a pozzo type were discovered, four of them in the Porzarago necropolis.[23] Tomb 1 contained three biconical jars, of which one had a lid in the shape of a bowl and one was decorated with four parallel zigzag lines and dimples (**Fig. 1**).[24] Interestingly, Tomb 1 also contained a stone lid of the tomb cut in tufa, which was placed on a cut shelf in the grave pit (**Fig. 2**).[25] These tombs must belong to the Protovillanovan settlement on the Acropolis, because of the shape of the cinerary urn and its zigzag decoration.

Fig. 1 Protovillanova cinerary biconical jars from San Giovenale Porzarago necropolis. (After *San Giovenale* 1:5, pl. IV).

23

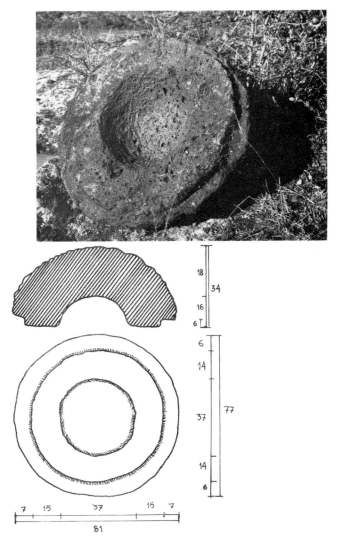

Fig. 2 Tufa lid of a
Protovillanovan tomb
from San Giovenale
Porzarago necropolis.
(After *San Giovenale*
1:5, pl. III).

The Protovillanovan pottery

The most characteristic feature of San Giovenale pottery is the very rich, so-called primitive impasto ware. However, the pottery is not primitive; rather, it is made from a very good and fairly compact clay with some inclusions of black mica and white specks. The firing technique produced a pottery

that varied in both colour and hardness. The colour goes from a brick-red through olive green to brown or black, sometimes with yellowish-brown patches. The surface is always very well burnished.[26]

The Protovillanovan pottery also has very characteristic shapes. The largest shape is the biconical jar. The second largest shape is the "oval-cylindrical jar", which regularly has a band running around the neck, often with impressions to resemble a cordon but also just smooth. The most common shape is the carinated cup or bowl. The carination is very much the hallmark of Protovillanovan pottery. The projecting *carina* develops from a very sharp angle in the earliest phase to a more rounded profile, probably in order to make room for more decorative fluting.[27] These bowls can have a high handle with a zoomorphic apex.

In his 2009 article, Cardarelli gathered examples of pottery shapes from the Terramare culture found at sites in northern Tuscany (**Fig. 3**: Fossa Nera di Porcari, Lucca). As can be seen from his examples, the cups have a sharp *carina* decorated with short parallel lines, or longer flutes often placed obliquely. Cardarelli writes: "Various types of bowl with distinct necks, often decorated with wide, vertical or oblique grooves on the shoulders or body, are recurrent in this phase; they have raised, vertical handles, either flat or round in section, and are often decorated with horizontal or oblique grooves or ribs."[28] The cups are extremely similar to examples from San Giovenale (**Fig. 4**) and even Luni sul Mignone.[29] I argue here that the archaeological evidence suggests a connection between the Terramare culture and the sites with Protovillanovan pottery in central Italy. Already Luigi Pigorini argued for a similar connection in 1895 (although his reference is to the Villanovan phase): "...the inhabitants of the Terramare and the lake-dwellings in the East and the Veneto are just as Italic as those to whom the tombs of the Villanovan type belong. Between one and the other the only difference is that the former lived in the Bronze Age and the latter in the early Iron Age. The Italic peoples of the Villanova period did not therefore descend from nowhere to occupy the lands of the Terramare dwellers, but are themselves 'Terramareans' in a phase of civilization less ancient and more advanced."[30]

Carderelli linked the success of the Terramare culture to the spreading of the Pelasgians, as described by Dionysios of Halikarnassos. It is my belief that this scenario could well describe the historic development of the Pelasgians/Etruscans in Italy and the coming of the later Etruscan

culture (we know them as Etruscans only with the invention of the script). The Terramare culture, with its characteristic biconical urns and decorated carinated cups, seems to have established itself on sites that often were not

Fig. 3 Cups from the Recent Bronze Age site of Fossa Nera di Porcari, Lucca, Tuscany. (After Cardarelli 2009, 495, fig. 15).

occupied by the Apennine Bronze Age culture. Even though fragments from the Apennine Bronze Age were discovered below and west of the castle at San Giovenale,[31] most of the plateau must have been uninhabited.

Fig. 4 Protovillanova cups from San Giovenale, Area F East. (After *San Giovenale* IV:1, pl. 4).

According to P. G. Gierow, the Apennine settlement was destroyed in a fire.[32] Did the arrival of the Terramare people cause a destruction of the probably very small, pre-existing settlement?

The Terramare settlement at San Giovenale spread out over the entire plateau, but it seems to have been abandoned and possibly violently destroyed. The destruction could well have happened around/shortly after the Trojan War, as suggested by Dionysios. It is important to observe that there is no Villanovan development at San Giovenale, nor at Luni. Instead, the Villanovan culture developed at new sites,[33] for example Tarquinia, Cerveteri, and the nearby San Giuliano site.[34] Interestingly, from these Villanovan sites very little has been reported concerning Protovillanovan levels.

San Giovenale was uninhabited between about the 12th century down to about the second half of the 8th century. One of the reasons why the early Swedish archaeologists believed that the Protovillanova pottery was Iron Age was that the soil layers were so thin, and the Archaic level seemed to rest directly on top of the Protovillanovan hut face. Could the extreme weather conditions around the Trojan War, so vividly described by Dionysios, have been responsible for the thin soil layer between the Bronze Age and the Archaic periods?

To conclude, recent research and ideas have shed new light on the early history of the Etruscans. The suggestion by Facchetti that Linear A was written in an early Etruscan language, and the inscriptions reported from Lemnos and the Rhaetian region indicate that the Etruscans inhabited an area stretching from western Asia Minor to the south Alpine region. It is likely that the pre-Indoeuropean Etruscans lived in this area before the coming of the Greeks, as is indicated in Greek sources about the Pelasgians. Most ancient authors agree that the Pelasgians were the same people as the later Tyrrhenians. In the long passage by Myrsilos quoted in the work of Dionysios of Halikarnassos, the Pelasgians are described as being thrown out by the Greeks and settling in northeastern Italy. Although Dionysios does not accept the connection between the Pelasgians and the Etruscans, his source, Myrsilos of Methymna, does indeed say that they are the same people. Cardarelli's application of this story to the development of the Terramare culture seems very convincing. The Terramare developed in northeastern Italy from the Middle Bronze Age (ca. 1650 BC) and disappears around the break between the Recent and Final Bronze Ages (around 1150

BC). The pottery produced by the Terramare culture is very similar to that of the Protovillanovans, as is their cremation burials in biconical jars. The suggestion put forward here is that the Terramare develops into the Protovillanovan culture and as such is an Etruscan culture. The spreading of the Pelasgian people and the creation of many new settlements in central Italy (among the aborigines, as Dionysios writes) is the background to the foundation of Protovillanovan San Giovenale. C14 dates from San Giovenale in the 13th century BC indicate that the settlement at San Giovenale goes back to this period. The end of San Giovenale probably came in the 12th century BC, possibly through a violent destruction or sudden abandonment, as Furumark suggested when he excavated the pots standing *in situ* in the Protovillanovan hut in Area F East in S Giovenale.

NOTES

1 See Cardarelli 2009; for a further discussion on the Terramare 'diaspora', see Bettelli, Cardarelli & Damiani 2018.

2 See the conference volume *San Giovenale. Materiali e problemi*. For Luni, *see Luni sul Mignone* II:1 and II:2. The term Protovillanova was created as an initial phase of the Villanova culture, on the model of Protogeometric compared to the Geometric period in Greece. The name Villanova was coined in 1853 when a large necropolis outside of Bologna was discovered. It contained biconical jars with burnt bones, indicating a new cremation culture older than the then known Archaic Etruscan culture. The Protovillanovan culture is characterized by similar but simpler biconical cinerary urns with similar but less intricate incised lines.

3 See San Giovenale IV:1, 140.

4 See *San Giovenale* IV:1, 125. These fragments were decorated with thin impressed cord lines, common in the Villanova period but they can appear in the Protovillanovan repertoire also. The interpretation of these few fragments as Villanovan is thus very uncertain.

5 For the huts, see Karlsson 2017.

6 From only Area F East, I processed 8,465 Protovillanova sherds – 31% of all the pottery found at the site!

7 See *San Giovenale* IV:1, 141, fig. 265.

8 *San Giovenale* IV:1, 140.

9 This is also argued by Bengt Malcus who excavated the best-preserved Protovillanovan huts in Area D. He writes: "Le capanne sono state deteriorate o distrutte dal fuoco o da altri agenti;" Malcus 1984, 38; also Malcus 1979.

10 Malcus 1984, 45. In trench 3, "purtroppo in un contesto mal definito". The fragment was dated by Arne Furumark to LH IIIB2–LH IIIC1 (a–b).

11 This was probably the site of the earliest settlement as it has the best naturally protected location at San Giovenale, as is also evidenced by the large medieval castle on the spot; Gierow 1982. A few Middle Neolithic and Apennine Bronze Age fragments were reported by Gierow from the plateau, but most of the early evidence comes from under the castle.

12 Cardarelli 2009, 456.

13 Dionysios also says that Thukydides writes the following about the Thracian *Acta* and the cities situated on it (1.25.4): "There is also a Chalcidian element among them, but the largest element is Pelasgian, belonging to the Tyrrhenians, who once inhabited Lemnos and Athens."

14 Facchetti 2001.

15 Facchetti 2001, 22, n. 114. Croton in Umbria was also mentioned as Pelasgian by Diony-

sios of Halikarnassos. For the Lemnos stele, see Agostiniani 1986; moreover, other graffiti in Etruscan have been found on Lemnos.

16 The connections between Larisa in Aeolis and the Etruscans were obviously strong down into the Archaic period. The Swedish (and later German) excavations at Larisa revealed architectural terracottas with scenes of symposia strongly reminiscent of the Acquarossa terracottas. For a connection between Anatolia and Etruria, due to refugee artists, see Winter 2017. The connection can also be seen in the earliest prototype of an Aeolic (Ionic) capital that was found in Larisa, and a similar type in the 6th-century *Tomba dei capitelli* in Cerveteri; see *Larisa am Hermos* II, 66–67 and pl. 27 (Fries VII), and Ciasca 1962. Both Aeolian Larisa and Lemnos are called Pelasgian by Strabo 5.2.4. Another eastward-pointing fact is the curious name of the city Tarquinia/*Tarchna*, probably related in some way to the name of Jupiter in west Anatolian languages: *Trqqnt* in Lycian and Karian and *Tarhunt* in Luwian. The Etruscan name of Jupiter was Tin/Tinia.

17 The Kabeiroi were believed to have originated from Mount Kabeiros in Phrygia.

18 Cardarelli 2009, 452 writes: "The abundance of bronze objects, moulds for casting and frequent traces of metalwork processes suggest the likely presence, in most villages, of a resident skilled smith."

19 The Archaic structures on the Borgo (Work Area Ac) at San Giovenale were certainly part of a metalworking quarter (*San Giovenale* V:1, 94f.). Quite possibly the Protovillanovan settlement at San Giovenale (as I suggest, founded by a Terramare group of people) was also in search of metal.

20 Rix 1998; Pliny, *NH* 3.24.

21 Perkins 2017, 111. Here one should understand 'inhabitants in Anatolia', since the genetic pool in Anatolia preserves large pre-Turkic groups of people.

22 Cardarelli 2009, 453.

23 Gierow 1987, 27.

24 *San Giovenale* I:5, 20–21 and plate IV:3. Tomb 2 contained only "a sherd of the ossuary and two small vases, while the third tomb was empty".

25 *San Giovenale* I:5, pl. III.

26 *San Giovenale* IV:1, 119–120.

27 *San Giovenale* IV:1, 122.

28 Cardarelli 2009, 487–489.

29 *Luni* II:1, figs. 22–26, 29–33; *Luni* II:2, pls. 64:11–14, 65:22–23, 71:162–182.

30 Translation in Cardarelli 2009, 502, after Pigorini 1895.

31 See Malcus 1984, 45.

32 Gierow 1982, 19; also Nylander 1986, 37.

33 Noticed by Francesco di Gennaro in 1983: "il passaggio dall'aspetto protovillaviano a quello villanoviano corrisponda in genere, pur se non mancano eccezioni, ad un cambiamento delle sedi abitate", in *San Giovenale. Materiali e problemi*, 98.

34 Bonghi Jovino 2001 (Tarquinia); Brocato 1997 (San Giuliano).

BIBLIOGRAPHY

Dionysius of Halicarnassus, *The Roman Antiquities*, E. Cary and E. Spelman (trans.), Loeb Classical Library, Cambridge MA, 1948.

L. Agostiniani 1986
'Sull'etrusco della stele di Lemnos e su alcuni aspetti del consonantismo etrusco', *Archivio Glottologico Italiano* 71, 1986, 15–46.

M. Bettelli, A. Cardarelli & I. Damiani 2018
'Le ultime terramare e la Penisola: circolazione di modelli o diaspora?', *Preistoria e protostoria dell'Emilia Romagna*, II, Firenze 2018, 187–198.

M. Bonghi Jovino 2001
Tarquinia. I luoghi della città etrusca. Roma 2001.

P. Brocato 1997
San Giuliano. Recerche su un centro etrusco dell'Etruria meridionale interna, Diss. Università di Roma 'La Sapienza'.

A. Cardarelli 2009
'The collapse of the Terramare culture and growth of new economic and social systems during the Late Bronze Age in Italy', *Scienze dell'Antichità. Stora archeologia anthropologia* 15, 2009, 449–520.

A. Ciasca 1962
Il capitello detto eolico in Etruria. Firenze 1962.

G. M. Facchetti 2001
'Qualche osservazione sulla lingua minoica',
Kadmos 40, 2001, 1–38.

P. G. Gierow 1982
'Le fasi preistoriche: Dal neolitico al bronzo
recente', in: *San Giovenale. Materiali e problemi*,
17–36.

P. G. Gierow 1987
'San Giovenale', in: *Architettura etrusca nel
Viterbese. Ricerche svedesi a San Giovenale e
Acquarossa 1956–1986*, Roma 1987, 27–30.

L. Karlsson 2017
'Hut architecture, 10th cent.–730 BCE, in:
A. Naso (ed.), *Etruscology*, Boston-Berlin 2017,
723–738.

Larisa am Hermos II, L. Kjellberg, *Larisa am
Hermos* II. *Die architektonischen Terrakotten*,
Stockholm 1940.

Luni sul Mignone II:1, T. Wieselgren, *Luni sul
Mignone. The Iron Age settlement on the Acropolis*
(ActaRom-4:o, 27:2:1), Stockholm 1969.

Luni sul Mignone II:2, P. Hellström, *Luni sul
Mignone. The zone of the large Iron Age building*
(ActaRom-4:o, 27:2:2). Stockholm 1975.

B. Malcus 1979
'Un frammento miceneo di San Giovenale', *Dial-
Arch*, n.s. 1, 1979, 74–77.

B. Malcus 1984
Area D (ovest), in *San Giovenale. Materiali e
problemi*, 37–60.

C. Nylander 1987
'San Giovenale', in: *Architettura etrusca nel Viter-
bese. Ricerche svedesi a San Giovenale e Acquarossa
1956–1986*, Roma 1987, 37–40.

P. Perkins 2017
'DNA and Etruscan identity', in: A. Naso (ed.),
Etruscology, Boston-Berlin 2017, 109–118.

L. Pigorini 1895
'Gli Italici nella valle del Po', *Bull. Paletn. It.* 21,
1895, 39–48.

H. Rix 1998
Rätisch und Etruskisch. Innsbruck 1998.

G. Säflund 1939
*Le Terremare delle provincie di Modena, Reggio
Emilia, Parma, Piacenza* (ActaRom-4:o, 7),
Stockholm 1939.

San Giovenale. Materiali e problemi, S. Forsberg
& B.E. Thomasson (eds.) (ActaRom-4:o, 41),
Stockholm 1984.

San Giovenale I:5. E. Berggren & K. Berggren,
San Giovenale I:5. *The necropoleis of Porzarago,
Grotte Tufarina and Montevangone* (ActaRom-4:o,
26:1:5), Stockholm 1972.

San Giovenale IV:1. L. Karlsson, *San Giovenale*
IV:1. *Area F East: Huts and Houses on the Acropolis*
(ActaRom-4:o, 26:4:1), Stockholm 2006.

San Giovenale V:1. C. Nylander, B. Blomé, L.
Karlsson, A. Bizzaro, and G., S. and A. Tilia, *San
Giovenale* V:1. *The Borgo: Excavating an Etruscan
Quarter. Architecture and stratigraphy* (ActaRom-
4:o, 26:5:1), Stockholm 2013.

N. A. Winter 2017
'Traders and Refugees: Contributions to Etruscan
Architecture', *Etruscan Studies* 20, 2017, 123–151

WITH A SENSE OF PLACE AND TIME
THE USE OF MOULDINGS IN ETRUSCO-ITALIC AND REPUBLICAN ROMAN ARCHITECTURE

INGRID EDLUND-BERRY

Introduction

> Le modanature sono come l'alfabeto dell'architettura. (Mouldings are like the alphabet of architecture.) (Vignola 1770, ch. 2)

Within the vast field of architectural history, the study of mouldings may appear to be somewhat esoteric. Even a cursory glance, however, at buildings and monuments from different time periods and different parts of the world allows us to see how old traditions of curved architectural mouldings have reached across space and time to form new creations where traditional stone mouldings can appear in unexpected places and are sometimes even executed in modern building materials such as cement or polystyrene.[1]

By tradition, the profiles of architectural mouldings[2] have been recorded in line drawings (**Fig. 1**), and depending on the audience, the terminology of mouldings includes a Greek or Latin-based vocabulary, or one adapted to modern languages, whether Italian, English, French, or German. Depending on the measuring techniques used, these drawings focus on illustrating the profile view of the moulding shown in thin lines, sometimes including a rendering of the actual block of stone or other material. The size and proportions may relate to a scale, drawn in centimeters or inches, or may be referred to in the text or accompanying captions.

Terminology of mouldings (Italian: Modanature or
Sagoma; French: Moulure; German: Profilleiste).[3]

Already Vitruvius' vocabulary for mouldings illustrates the difficulty of assigning consistent terms. He seems to use "cymatium" ("small wave") (*DeArch*. 3.5.10) as a general term for a rounded moulding,[4] but refers also to an upper and lower "torus" ("bolster") as part of an Attic-Ionic (*DeArch*. 3.5.2) or Etruscan-like (*DeArch*. 4.7.3) column base,[5] whereas the curved

elements of a podium include a "lysis" ("ogee") and a "spira" ("twist") (*DeArch.* 3.4.5).[6] Through the centuries, different terms have been developed in the architectural nomenclature, and of these some have been particularly applicable to Etrusco-Italic and Roman architecture, including the torus, the cyma reversa, the cyma recta, and the hawksbeak.[7]

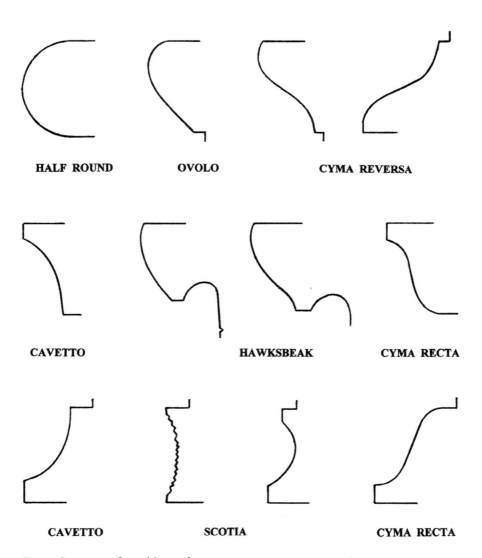

Fig. 1 Overview of mouldings (from ERRM 2000, xiii, Figure B).

While the shapes of mouldings can be comfortably identified in Greek and Western Greek buildings and monuments, the language of Etrusco-Italic and Republican Roman mouldings is quite different, both in terms of proportions and placement. On the whole, Greek mouldings are small and used as crowning mouldings, whereas non-Greek ("Etruscan") mouldings are large and appear both in a crowning and base location. This distinction becomes particularly important in evaluating monuments and buildings in areas that were historically Greek, but which with time became part of an Etruscan or Roman political and cultural sphere in mainland Italy or in Sicily.[8]

As outlined in the introduction by Shoe Meritt to ERRM 2000, her terminology for mouldings used in ancient Italy follows the usage from Greek architecture, with the important exception of the term "Etruscan Round". It describes a moulding that "might vary in proportion from a full half round to a quarter round or a quarter oval, but it was a round developed for whatever the necessity."[9] And, indeed, many of the monuments and buildings found in central Italy prominently display this round feature, so different from anything in the Greek world (**Fig. 2**). At the same time, however, this kind of moulding was "Etruscan" only in the sense that it was neither Greek nor Western Greek, but in terms of distribution it appeared in locations that were demographically not only Etruscan but also Roman, Latin, Umbrian or Samnite. And this unintended split between Etruscan and non-Etruscan has become particularly pronounced in the areas on either side of the Tiber where monuments from Veii in Etruria would be regarded as full-fledged Etruscan, whereas those from Rome or Lavinium or Ardea in Latium could be considered creations by Latin speakers. Thus, monuments and mouldings have entered the political sphere of identifying cities and communities by their linguistic or cultural affiliation, and to speak of an "Etruscan Round" moulding could appear to be misleading and contrary to historical facts and interpretations.

This issue has been particularly relevant in discussions of the form and chronology of temple podia with mouldings in central Italy where the earliest examples come from sites in Rome and Latium rather than from Etruria,[10] and I have in previous publications tried to balance between the architectural terms "Tuscan" and "Etruscan Round" or "Etrusco-Italic" and the historical evidence for the different populations of central Italy.[11] As so often, the insightful remarks by Nancy Winter may serve as a guideline

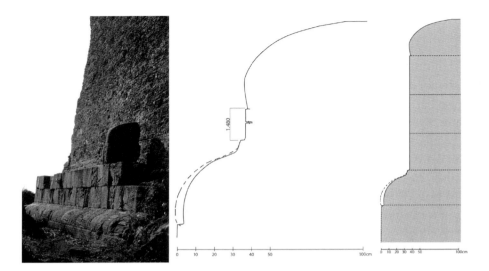

Fig. 2 Temple at Cosa. Left: Photo (Lucy Shoe Meritt collection); Center: profile drawing (from ERRM 1965, XXV,1); Right: profile drawing (rendered by Beth Chichester and Ingrid Edlund-Berry).

for the following discussion, in that she has documented that architectural terracottas with round mouldings from the First Phase (640/630–510 B.C.) are first found in Etruria, and that therefore the term "Etruscan Round" as an architectural term may rightly be applied to mouldings regardless of the locations where they appear.[12]

A study of mouldings

As a student, my first introduction to the study of mouldings was at the theater of Marcellus in Rome. Looking up at the monument from ground level I was trying to identify the different types of architectural details and soon realized that my ability to differentiate one from the other was sadly lacking. Many years later I would spend time with Lucy Shoe Meritt, at the University of Texas at Austin, helping her prepare a revised edition of ERRM 1965. Even with failing eye sight, she was able to identify any number of recently published mouldings and could immediately place each one in its proper architectural context. Our goal was to update the contents of ERRM 1965 and to highlight the important differences between Greek and

Western Greek mouldings, documented in PGM 1936 and PWGM 1952, and Etruscan and Republican Roman mouldings.[13] In addition to a new introduction, the main change in the presentation consisted of a separate set of plates where most of the drawings were reproduced at a 1:1 scale, an important feature in Shoe Meritt's approach to the study and interpretation of mouldings.[14]

This revised version was published in 2000, and it was the author's wish that I continue her work. As I began to gather new information and to share my discoveries in lectures and papers,[15] I soon realized that my generation of students of ancient architecture lacked the experience of our mentors and senior colleagues who had been given the opportunity to travel and study first-hand all or most of the monuments they wrote about while we often have to resort to photographs and verbal descriptions. Lacking this autopsy, I also recognized that the line drawings in ERRM 1965 and 2000 may be difficult to interpret without additional knowledge of the physical appearance and location of the actual monuments, especially since crowning and base mouldings that occur on the same monument are discussed separately. Likewise, the description of each moulding requires a fair knowledge of other examples, especially for providing a historical, stylistic and chronological analysis. As the result of many years of thinking about mouldings and how to incorporate them into a meaningful study of ancient architecture and culture, I have decided to forego the optimum assembly of material for a corpus of mouldings,[16] and have instead opted to give an overview of the study of mouldings with temple podia as a case study to illustrate the main points that I hope may be applicable to a broader study of other material.[17]

History of scholarship

> At San Giovanni di Bieda, on the road between Vetralla and Viterbo, are several sepulchres in the rock, with mouldings of genuine Etruscan architecture.[18]

Sir William Gell was not the only early traveler to be intrigued by the mouldings sculpted on the façades of Etruscan tombs. His statement is quoted by Elizabeth Hamilton Gray who also includes a drawing from Gell illustrating mouldings from tombs at Castel d'Asso.[19] Both authors, however, attracted the scorn of George Dennis who pointed out that Gell's

information about San Giovanni di Bieda was incorrect, and that his draw-ings from Castel d'Asso were not only wrong but were copied from Inghi-rami's 1825 publication of *Monumenti Etruschi*.[20]

Whether or not Sir William Gell had actually mistaken San Giovanni di Bieda for the nearby town Bieda (Blera) or the majestic Etruscan cemeter-ies at Castel d'Asso and Norchia, he and others seem to have been particu-larly fascinated by these rock-cut tombs. Both the sites and the sequence of mouldings that adorned the façades have been presented in early studies and succeeded by extensive monographs.[21]

In addition to the somewhat surprising excitement over mouldings found in Etruscan monumental tombs expressed by these 19th-century travelers, the general topic of mouldings has mostly been reserved for dis-cussions of the so-called Vitruvian Orders (or Types) of Renaissance and later architecture and handbooks of architecture serving as guides to mod-ern architects.[22] Isolated studies of Etrusco-Italic or Roman mouldings occur as part of publications of individual buildings or monuments such as the Fortuna temple at Praeneste, the temples at Tivoli, and Cori,[23] and the rock-cut tombs in central Etruria at Bieda (Blera), Castel d'Asso, Norchia, and other sites[24] but it was not until Lucy Shoe Meritt undertook a system-atic study of full-scale drawings[25] of a variety of mouldings in central Italy that their unique features and use in relation to Greek and Western Greek mouldings became evident. Whereas, in the Greek world, it was possible to follow a development of different styles, in Italy the size and proportions were related to the building or monument where they appeared, and, most importantly, the types of mouldings used did not follow a clear chrono-logical sequence. Instead, individual mouldings or combined sets could be linked geographically or culturally to specific areas or time periods.[26]

Lucy Shoe Meritt's approach to the study of mouldings

It is to the credit of one scholar, Lucy T. Shoe Meritt, to have developed a unified system of documenting Greek, Western Greek, and Etruscan and Republican Roman mouldings in publications ranging from 1936 to 2000. By manually recording the shape of the mouldings with a large car-penter's contour gauge ("Maco"; It. "profilografo a pettine"), her goal was to document the exact profile or form of mouldings in a 1:1 scale (**Fig. 3**). The features were then transposed from the contour gauge by tracing the curves with a pencil onto paper, which were subsequently completed in ink

Fig. 3 Maco template (contour gauge) (from ERRM 2000, xii, Figure A,a).

and reproduced in her first two publications of *Profiles of Greek Mouldings* (PGM) and *Profiles of Western Greek Mouldings* (PWGM) in 1936 and 1952 on large plates that accompanied the text and discussion. The third volume on *Etruscan and Republican Roman Mouldings* was published in 1965 (ERRM), but at that time the cost of publication necessitated that some of the illustrations be shrunk to a much smaller scale (1:2 to 1:8), and printed together with the text.[27]

In addition to the full-scale drawings, Shoe Meritt kept handwritten notes of each monument or building which contained a sketch of the moulding with measurements, bibliographical information, and often the date when the drawing was made. These notes, although unpublished, and the limited number of black-and-white photographs in ERRM 1965 have proven to be particularly useful as documentation of some blocks with mouldings, recorded by Shoe Meritt, but now missing.[28]

When Shoe Meritt first ventured into Etruscan territory as a diversion from her study of Western Greek mouldings in the 1930s, it was the size of the monumental tumulus tombs at Caere with rounded mouldings, to become known as "Etruscan Round,"[29] that immediately made her realize that she was in a cultural environment that was very different from the Greek world. Although she was, of course, aware of the use of mouldings in other cultures, including Egypt,[30] and recognized that traveling craftsmen could be inspired to develop new and different architectural styles, she attributed the creation of the Etruscan Round to local initiatives, different in each community. While she was intrigued by the seeming similarities between the Etruscan Round and mouldings found in ancient Lydia and Syria, differences in scale and arrangement of smaller and larger rounds on any given monument would, in her opinion, make the presence in Etruria of architects and craftsmen of non-Etruscan origin less than likely.[31]

In addition to the remarkable size of the mouldings from the tumulus tombs at Caere, Shoe Meritt noted that they, based on the find context rather than the actual form, represent the earliest known examples from Etruria (late 8th-early 7th c. B.C.), and therefore have their given place in the first chapter of ERRM 1965.[32] As can be expected, however, tomb architecture from other Etruscan sites developed its own traditions through the centuries and is illustrated in the examples that include rock-cut tombs at Bieda (Blera), stone grave markers ("cippi") at Chiusi, Vulci, Ferentum, Orvieto, Saturnia, Volterra, Tuscania,[33] and Marzabotto, and sarcophagi at Tarquinia (Partunu family tomb) and Rome (Scipio sarcophagus).[34] Interiors of tomb chambers are discussed in a section on frieze and wall crowns (with examples from Orvieto and Sovana).

Of the many rock-cut tombs in the Etruscan landscape, Shoe Meritt included only a small sample from Bieda (Blera). These are characterized by a tall quarter Etruscan Round, known in the publications by Koch (1915) and Rosi (1925 and 1927) as a "campana" (English "bell") or "Glocke", combined with smaller rounds and a beak ("hawksbeak").[35] That the pattern of mouldings used in the rock-cut tombs from this area of Southern Etruria is very uniform and expresses a regional affinity rather than a chronological one, has recently been confirmed by Laura Ambrosini in her study of the tombs from Norchia.[36]

If then the presence of mouldings in tomb architecture can be linked to the type of monument (tumulus, rock-cut tomb, cippus, etc.) and the

Map of sites mentioned in the text and tables (created by Ingrid Edlund-Berry and Jessica Trelogan).

location, the following chapters in ERRM 1965 are arranged by type of moulding (Etruscan Round, Cyma Reversa, Cyma Recta, and Republican Orders[37]) and architectural features (podia, altars, column bases, etc.). As already noted by Shoe Meritt from her study of the tomb mouldings, no two mouldings are exactly alike, and while the chronology can be inferred from the find context, the individual moulding itself is usually not datable in other than very general terms within a range from the seventh century B.C. to the first century B.C.[38]

A new overview of the Etruscan Round, Cyma Reversa,
and Cyma Recta and Mixed forms of mouldings

With the increasing number of excavations and discoveries of new mouldings and with today's changing publication practices, it has become only too clear that it is no longer realistic for an individual archaeologist to be able to prepare and publish drawings in the format created by Shoe Meritt. In addition to the question of painstakingly recording the profiles of mouldings correctly, there are also issues of interpretation that are relevant for our understanding of the historical context of mouldings, and their role in place and time within the cultures of the ancient Mediterranean. In the following, I have opted to focus primarily on temple architecture, especially podia,[39] as an example of how new discoveries and interpretations can be merged with previously known examples to highlight their history and importance for our understanding of the culture of Etruscans and Romans and their immediate neighbors.[40] It is my hope that the careful documentation by Shoe Meritt will inspire others to continue the study of other types of monuments and objects and to add new methodologies as appropriate.[41]

Since the publication of ERRM 1965 and ERRM 2000 many new examples of architectural mouldings have been identified and published. By using the examples available to me of mouldings found primarily in temple podia, I believe that it is now possible to provide an overview of the location of the Etruscan Round, Cyma Reversa, and Cyma Recta mouldings in Central Italy and surrounding areas to highlight the historical or cultural context in the different regions.[42] The sites discussed are shown on the map included [See Map],[43] and the individual monuments and buildings are presented in tables 1–4 arranged by type of mouldings, including combinations of crowning and base mouldings .[44]

As can be expected, much interest has been devoted to clarifying the role of the city of Rome in the use of mouldings in temple and other architecture in comparison with her neighbors in Etruria and Latium. Although there are many temples preserved, we cannot, however, take the presence (or absence) of certain types of mouldings as an immediate indication that Rome was an innovating force through the centuries.

Undoubtedly, the Capitoline temple is the most famous early temple in Rome, and it is variously considered a true Etruscan creation or an example of Rome's international contacts for the creation of monumental buildings.[45] It is therefore perhaps disappointing to note that what is preserved of the tall podium today does not preserve any mouldings, although evidence from later coins may suggest that they may have existed.[46]

The earliest preserved mouldings on temples in Rome and Latium belong to the Archaic temple at Sant'Omobono. In the early phase (580 B.C.), the podium shows a crowning round placed on top of the vertical podium, whereas the second phase (530 B.C.) is shown with a double round. This sequence has been interpreted as evidence for two distinct podia, but recent studies of the documentation of the early excavations suggest that the second phase did not include a true podium moulding around the building, but rather that it was instead added outside the supporting blocks much like the mouldings at the temples at Vulci (**Fig. 4**) and at Tarquinia.[47] It must therefore remain in doubt whether this one temple should be categorically viewed as a pioneer in terms of the types of mouldings, and considered truly Latin rather than Etruscan.

The temple of Castor (484 B.C.) in the Roman Forum is conspicuous for its tall podium, and a block with a rounded base moulding has been attributed to the first phase of the building.[48] It preserves a vertical fascia, crowned by a tall and narrow Etruscan round, somewhat similar to the mouldings on the tumulus tombs at Caere. The combination of the fascia and round moulding could suggest a variation of a double Etruscan round, where the lower component is vertical rather than rounded.

Outside Rome, the earliest example of a single small Etruscan round comes from Satricum (550–540 B.C.) whereas the Casarinaccio temple at Ardea (500–480 B.C.) preserves a double round.[49] The newly discovered temple B at Ardea, Castrum Inui (500 B.C.), has double round mouldings which may have been added at a later date to the original temple.[50]

While the temples in Latium just mentioned fall within the Archaic/late

Fig. 4 Tempio grande at Vulci (Photo: Ingrid Edlund-Berry).

Archaic period, examples from Etruria are few, and later (fifth to fourth c. B.C.). The earliest, a fragment of a small round moulding, belongs to temple A at Pyrgi (460 B.C.), followed by the monumental temple, Tempio grande, at Vulci (5th-4th c. B.C.) with a single round (**Fig. 4**), and at the Ara della Regina temple at Tarquinia (4th c. B.C.), with a double round.

An isolated block from the Belvedere temple (5th c. B.C.) at Orvieto (an Etruscan city in Antiquity, today part of Umbria) has been variously interpreted as an altar or part of a podium. Its pronounced curved Etruscan round has been compared to the characteristic shape of altars from Orvieto.[51]

The type of double Etruscan round mouldings found on a group of monumental temples or podium blocks from sites as varied as Fregellae, Praeneste, and Sora (**Fig. 5**) in Latium, Villa San Silvestro in Sabina (today Umbria), and Isernia in Samnium (today Molise) shows a wide-spread distribution of this type of moulding from the 4th c. B.C. and later. While the shape of the mouldings is distinctly similar, they are not identical and suggest local workmanship. As will be discussed later, the creation of these

Fig. 5 Temple podium at Sora (Photo: Ingrid Edlund-Berry).

temples has been associated with Roman presence in central Italy, and the mouldings, although not common in Rome proper, have been regarded as evidence of Romanization.[52]

Even further afield from Rome is the monumental temple B1 at Cumae in Campania (**Fig. 6**), later known as the Capitolium, where a double round moulding from its 3rd c. B.C. phase shows similarities in form with the Ara della Regina temple in Tarquinia.[53] Whether this Etruscan round moulding should be regarded as an example of a pan-Etrusco-Italic usage or specifically as evidence of Romanization may depend on our view of architecture and politics.[54]

Regardless of the origin of the Etruscan round, its continuity in temple architecture in the 2nd/1st c. B.C. is documented in the so-called Capitolium at Cosa (150 B.C.) in Etruria with a crowning and base moulding (**Fig. 2**), and the hour-glass-shaped double round on the 'pedestal' of the temple at Fiesole (1st c. B.C.).

Although the Etruscan round continued to be used on temple podia as well as on altars and other monuments through the Roman Republic, a new

Fig. 6 Temple podium at Cumae (Photo: Ingrid Edlund-Berry).

development seems to have taken place when a cyma reversa appears as a variant to the round. Shoe Meritt ascribes its origin to Greek architecture,[55] but regardless of the stylistic influence, there are many local variations in the form as it appears in temple podia in Rome and elsewhere.[56]

Temple C (Feronia?) at Largo Argentina in Rome from the early third c. B.C. is considered the earliest preserved example in Rome of a tall podium with a cyma reversa crowning moulding but no base moulding (**Fig. 7**).[57] In the Forum Boarium, the Rectangular temple or "Temple of Portunus" preserves blocks from a podium crown of the first period of this temple with a cyma reversa moulding, but there is no evidence for a base moulding.

As noted by Shoe Meritt, the close resemblance in form between the two temples in Rome and the temple of Juno Sospita in Lanuvium suggests that the early use of cyma reversa was not limited to Rome.[58] Other early (late 4th/3rd c. B.C.) examples[59] are found at the sanctuary of Diana at Nemi,[60]

Fig. 7 Temple C, podium, at Largo Argentina, Rome (Photo: Ingrid Edlund-Berry).

also in Latium, and at the temple of Diana Tifatina in Capua in Campania, followed by the temple at Collemancio in Umbria and temples A-D in Teano in Campania. The so-called temple of Peace at Paestum may have been built soon after the foundation of a Latin colony in 273 B.C., but later dates have also been suggested.[61]

The introduction and distribution of the cyma reversa suggest that its use was not confined to any one area of central Italy, and with time it became widespread in the 2nd c. B.C. with the noticeable exception of Etruria (Volterra, Temple A).[62] In addition to examples from Rome, Temple A at Largo Argentina and the Temple of Pietas at the Forum Holitorium, temples are found at Ardea, Castrum Inui, at Formiae, Gabii, Fregellae, Terracina, and Fabrateria Nova in Latium, Rieti in Sabina (today Lazio), but also at Potentia in Picenum (today Marche),[63] and Herdonia in Apulia (today Puglia).

While some of these sites have a long local history (Ardea, Gabii), others

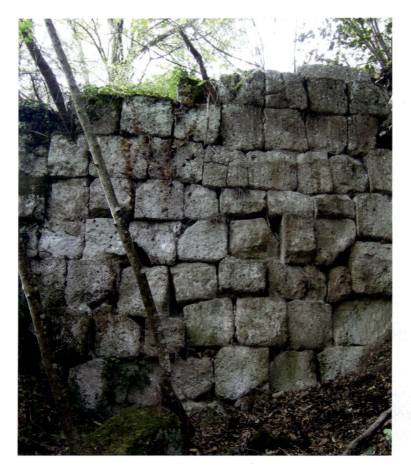

Fig. 8 Re-used blocks in wall at San Giovenale (Photo: Ingrid Edlund-Berry).

had at some point become Roman or Latin colonies (for example, Fregel-lae, Potentia, Terracina) but it is an open question as to the extent to which the political affiliation influenced the architectural history of any community. Particularly remarkable is the building activity in the modern regions of Abruzzo and Molise, where small communities erected one or more temples in the 2nd c. B.C., including Basciano and Colle S. Giorgio in the territory of the Praetutii, Schiavi d'Abruzzo (**Fig. 9**) in Samnium, Vittorito in the territory of the Paeligni, Iuvanum in the territory of the Carricini,[64] and Penne in the territory of the Vestini.

Fig. 9 Temple podium at Schiavi d'Abruzzo (Photo: Chris Williams and Ingrid Edlund-Berry).

Although the tradition of cyma reversa mouldings gradually seems to be replaced by the complex cyma recta, many prominent temples were still built in the last century of the Roman Republic, ranging from Ostia, Terracina, Tivoli, and Cori in Latium to S. Giovanni in Galdo in Samnium.[65]

While the cyma reversa mouldings often are quite restrained and serve to accentuate the transition from a horizontal foundation to a vertical podium, the cyma recta mouldings tend to form part of more complex mouldings, of which the cyma recta is only one element. A cavetto is often added to create additional height to the moulding sequence,[66] and the form

Fig. 10 Temple of Jupiter at Pompeii (Photo: Courtesy of Valentino Gasparini).

could be modified by stucco to create new effects, as suggested for the temple of Jupiter at Pompeii (**Fig. 10**).[67]

Temples dated to the 2nd c. B.C. with cyma recta mouldings come from Cori in Latium, Gubbio Nogna in Umbria,[68] Fontecchio and Navelli in the territory of the Vestini, Capua and Pompeii in Campania, Canosa in Apulia, and Tricario in Lucania (today Basilicata), followed by 1st c. B.C. temples at Ostia and Minturnae in Latium, Isernia in Samnium, and Grumentum in Lucania, suggesting that the architectural traditions were by now fairly uniform throughout the peninsula, including Rome.

In Rome, examples of more or less complex cyma recta mouldings are found in temples from the 1st c. B.C., including those from Largo Argentina, the temple of Portunus, the so-called temple of Bellona, the temple of Veiovis and temples A and B at the Forum Holitorium.

Examples of a continuing tradition into the 1st c. A.D. come from Gubbio Guastuglia in Umbria,[69] Saepinum in Samnium (today Molise),[70] and Grumentum in Lucania.[71]

Since in many cases only a crowning or base moulding is preserved, the evidence for mixed mouldings is limited and each represents a different

approach or tradition of accentuating the podium in examples dating from the 3rd/2nd c. B.C. to the 1st c. A.D from regions as varied as Samnium (modern Molise) and Etruria (modern Toscana). A crowning cyma reversa matched with a base Etruscan round were previously known from temple A at Pietrabbondante in Samnium (early 2nd c. B.C.) and from Quadri (2nd c. B.C.) in the territory of the Carricini (now in Abruzzo), but has recently been suggested also for temple C at Populonia (3rd/2nd c. B.C.) in Etruria (**Fig. 11**).[72] The crowning Etruscan round from Vastogirardi (2nd c. B.C.) in Samnium may be incomplete in that it is lacking a vertical fascia above the moulding, and the base shows a cyma reversa moulding.

Temple B at Pietrabbondante in Samnium (late 2nd/early 1st c. B.C.) has a cyma reversa base moulding, but a crowning moulding which elegantly combines Greek and non-Greek features, ranging from a cavetto at the top, followed by an ovolo and a half round, all Greek forms but rendered in non-Greek, or rather Etrusco-Italic, proportions forming a version of the complex cyma recta. The fact that the form also matches the base moulding of the Fondo Patturelli at Capua[73] suggests that local styles could be mixed with more widespread ones such as the Etruscan round on temple A at Pietrabbondante.

The temple at Castel di Ieri (2nd c. B.C.)[74] in the territory of the Paeligni (now in Abruzzo), the Round temple at Tivoli (1st c. B.C.) in Latium

Fig. 11 Temple C at Populonia (Photo: Courtesy of Cynthia Mascione).

Fig. 12 Round temple at Tivoli (Photo: Ingrid Edlund-Berry).

(**Fig. 12**), and the Twin temples at Carsulae in Umbria (1st c. A.D.) share the base cyma reversa moulding but the crowning cyma recta mouldings at Carsulae and Castel di Ieri are very simple compared to the elaborate complex moulding at Tivoli.

Geographic distribution of mouldings

The distribution of mouldings discussed here is, of course, determined by the number of buildings that have been discovered and published. Studied together with mouldings on other monuments, the temple podia may be included in regional styles, easily identified, as for example at Vulci or Orvieto.[75] In some temples the podium is very well preserved, whereas in others the evidence for a podium consists of only a singular moulded block. Throughout central Italy, the number of podia is ultimately determined by the state of preservation, and excavation history, and new discoveries are likely to be made.

While allowing for the incomplete preservation of temples adorned with mouldings, and the often uncertain chronology,[76] distinct patterns of the geographic distribution can be recognized. In Etruria, the Etruscan round is displayed in monumental temples, whereas the cyma reversa

is rare and the cyma recta lacking. Latium, including Rome, provides a continuous stream of Etruscan round that ends with the temples at Fregellae, Praeneste, and Sora that are linked through the mouldings to the temples at Isernia in Samnium and Villa San Silvestro in Sabina (now in Umbria). Examples of the cyma reversa appear in all of Latium throughout the Roman Republic and especially in Rome they occur parallel with the cyma recta.

Samnium presents an interesting sequence of temples with cyma reversa and with cyma recta mouldings, with a sole example of an Etruscan round at Isernia, while Campania includes an Etruscan round at Cumae, as well as cyma reversa and cyma recta mouldings. In Sabina and Umbria we find an example of the Etruscan round at Villa San Silvestro, a cyma reversa at Collemancio, and cyma recta mouldings at Gubbio.

Examples of mixed mouldings appear primarily in Abruzzo and Molise, with isolated examples also in Etruria and in Umbria, and the areas of Marche, Apulia, and Lucania (now in Basilicata) illustrate the presence of cyma reversa and cyma recta mouldings also far away from central Italy.

What the geographic distribution of mouldings suggests to me is that there is no one city or region from which the impetus came to create and distribute new types or variations. Rather, similarities in form may be explained either through traveling craftsmen or local artisans who became aware of possible models that suited the size of the planned temple and the available building material. Whether or not we should ascribe a political or religious significance to the form of moulding is a complex question,[77] but I believe that especially for temples it is important to consider the location and surrounding environment to understand the architectural features, including the mouldings.

Chronology of mouldings

For all the moulding profiles included in ERRM 1965, Shoe Meritt had studied the available archaeological context and provided the date provided by the excavators to the extent possible. When variable dates existed, she outlined the controversy and opted for the ones that seemed to apply best to the particular moulding. In this study I have opted to follow Shoe Meritt's chronology unless there is new evidence for a revised date. Since I am in full agreement with Shoe Meritt that the profile by itself cannot be

53

used as a dating tool in the architecture of central Italy without a valid dat-
able context, I have refrained from discussions of complex chronological
issues concerning the dating of individual temples.

From the selection of mouldings discussed in this article, it is at least
possible to draw some general conclusions about chronology. The earliest
examples of the Etruscan round mouldings in central Italy are found in
the tumulus tombs at Caere, on the temples at Sant'Omobono in Rome,
Satricum, and Pyrgi and in the architectural terracottas from a number of
sites. The form varied from the small quarter or half round, to the large
bulging single or double rounds found at Ardea, Vulci, and later at Ara
della Regina at Tarquinia. The overall dates for the Etruscan round range
from the late 7th century B.C. to the end of Roman Republic, as seen in
the hour-glass altars in Rome, at Fiesole, and other sites (for which see
Table 1).

Although the Etruscan round could take on features of an elongated
curved round, as seen in the "campana" or "bell" form on rock-cut tombs,
and in the second phase of the temple at Sant'Omobono in Rome, the
most distinctive example of the cyma reversa as it appears in central Italy
is from temple C at Largo Argentina in Rome, dated to the early 3rd c.
B.C.[78] Regardless of whether we consider the Roman cyma reversa as a
variant of the Etruscan round or as modification of the Greek form, it
quickly gained popularity, and we find examples of podia with a crown-
ing and base cyma reversa at a number of sites throughout Italy (for which
see Table 2).

In buildings dated to the 2nd century B.C. we find examples of different
forms of the cyma reversa, but also a new development which consisted of
a cyma recta with the addition of other features such as a small round or
a cavetto. Shoe Meritt labels the composite of forms as a complex podi-
um crown or base, and notes that no two such mouldings are alike. She
introduces the podium mouldings of the so-called Capitolium (temple of
Jupiter) at Pompeii (**Fig. 10**) as the earliest example of the cyma recta, to
be dated to the mid-second century B.C., and other variations appear in
Rome and other sites (for which see Table 3).

Although the title of ERRM 1965 specifically limited the scope of the
study to the end of the Roman Republic, a few examples of mouldings
from the first century A.D. are included here.[79] There is definitely a desid-
eratum for a future study of Roman imperial mouldings, especially as

they seem to have inherited features from the past, including the Etruscan round, that were incorporated in the ever more elaborate forms of the cyma recta.[80]

Mouldings and Roman history

As each city or area of central Italy developed its own architectural traditions, and temples were built to reflect local styles, perhaps with features inspired from elsewhere, it is tempting to try to link such innovation with historical events. The city for which we have the best historical record is, of course, Rome, and it is not surprising that the creation of Roman and Latin colonies has been used to suggest dates for city planning and construction of temples and public buildings modeled on Rome herself. Following the accounts in the ancient historians, we therefore tend to associate a newly erected temple in any one colony with a Roman Capitolium to be dated shortly after the foundation of a colony.[81]

While this methodology would seem to make historical sense, the archaeological evidence has, however, shown this reasoning to create interesting chronological discrepancies. Thus, the temples at Cosa and Paestum, both Latin colonies founded in 273 B.C., were built long after the foundation of the colony, and, what is of interest to us, they display very different mouldings, Etruscan round crowning and base mouldings for Cosa (**Fig. 2**),[82] and cyma reversa crowning and base mouldings for Paestum.[83]

Another group of temples includes two examples discussed by Shoe Meritt, one from Isernia in Samnium (now in Molise) and the other from Villa San Silvestro in Cascia in Sabina (now in Umbria) to which can be added temples from Sora (**Fig. 5**), Fregellae, and perhaps Praeneste, all in Latium.[84] What these temples have in common is a podium or podium blocks with a distinct double round, and the historical connection with Rome in that Fregellae was established as a Latin colony in 328 B.C., Sora in 303 B.C. and Isernia in 263 B.C. Praeneste became an ally of Rome after 338 B.C. and the area of Cascia in Sabina entered into contact with Rome after 290 B.C.[85]

Because of the historical connection with Rome, the temples at these sites would seem to be good examples of Capitolia erected soon after the colonies had been founded or other ties with Rome had been established.[86] Recent studies have, however, shown that Capitolia were not automatically

part even of Romanized settlements,[87] and especially for the temple at Sora it has been argued that there is no archaeological context that would suggest a date in the early 3rd c. B.C.[88]

Since the Etruscan round is not a typical Roman moulding, and, as we have seen, cannot be used as a general criterion for dating, it would seem prudent to date the temples based on related archaeological evidence. For Fregellae, the case remains open since the temple is under study,[89] and for Praeneste, it is a question of when a monumental temple would have been built, and by whom.[90]

While historical analysis of communities with monumental temples may link these to Rome, whether or not as Capitolia, there is, as far as I can tell, no immediate connection between the type of moulding and the political significance of any one temple. The temple of Jupiter at Pompeii (**Fig. 10**) is, however, a good example of how the focus of a temple may change due to historical events, but such a change did not affect the type of mouldings used.[91]

Future study of mouldings

ERRM 1965 and ERRM 2000 have continued to be the standard reference guides in recent publications. At the same time, it is also clear that our field would gain from a systematic study of all types of mouldings presented through drawings, images, and a descriptive text, preferably available as an on-line publication. As seen in the documentation presented in this study, the bibliography of isolated moulded blocks as well as temple foundations is immense, and it has not been possible to fully evaluate the examples I have gathered. Unlike Shoe Meritt who had first-hand knowledge of the monuments discussed in her books, I have many times had to rely on publications where mouldings are not always described in great detail, or illustrated with good drawings.

In the Mouldings Workshop held at the Swedish Institute in May 2018 and in follow-up discussions among the participants we agreed on the importance of sharing our research with other scholars, and that traditional methods of recording mouldings with a contour gauge combined with new technology ultimately provide the most reliable results. While drawings on paper remain useful, digitized versions will no doubt become more common and accessible to future students.

Recording of drawings

While many publications of ancient architecture include drawings of mouldings, there is unfortunately no consensus on how they should be executed. The format chosen by Shoe Meritt has the advantage that all the drawings were prepared by the same person and with great care. The profiles all face the same direction, and the original drawings were all recorded at a 1:1 scale. The drawback is that they do not provide any architectural context such as the texture of the stone or the number and shape of the blocks on which the mouldings appear. Also, since crowning and base mouldings are drawn separately, it is not possible to visualize the complete building or monument on paper unless a photograph is included, in addition to the descriptive text.

In examining the mouldings in central Italy and surrounding areas, I have learned to appreciate the publications that include good drawings as well as photographs and text. Although, in my opinion, all three features are essential, some types of information are easier to access than others. In cases where the mouldings on the same building or monument have been drawn at different times, it is apparent that different draftsmen and different techniques provide renderings that are close but not identical, and there are also cases where a photograph will indicate that the drawing may not do full justice to the actual monument.

In recent years, many temples or other monuments are shown in 3D-reconstructions which provide a useful impression of the scale and overall appearance. Due to the scale of such reconstructions, architectural details such as the mouldings may sometimes appear very stylized and should be used with caution unless they can be supplemented with detailed documentation based on the actual building blocks.

Conclusions

As much as mouldings stand out as details in ancient architecture, they deserve to be studied in the context of the material used, the skill of the artisan or architect as well as the type of monument or building, the geographical location, and the type of community where they occur. The comments presented here are intended as a guide for future study of mouldings. My hope is that future archaeologists and architects will develop a system of recording and publishing drawings and illustrations of mouldings that are easy to read and that may follow a consistent format. Although we can

no longer hope for large books with Full Scale Drawings, indications of scale and individual measurements remain important. Photographs and autopsy at sites and museums should also allow us to record the materials used, and alert us to differences of techniques as well as of style. As for the terminology, the traditional terms (cyma reversa, cyma recta, etc.) will most likely continue to serve their purpose, and for the rendering of "torus" (It. "toro") in Anglophone contexts the term "Etruscan round" is convenient, as long as we realize the potential culture clash between mouldings that are truly "Etruscan" in a geographical and cultural sense as opposed to their "Latin" or other counterparts that reflect regional variations. And, finally, the day may come when we can comfortably interpret the visual language of mouldings as a tool by which the presence (or absence) of mouldings, the individual forms and variables in size and proportions can be related to local traditions and workshops, ranging from the concentration of Etruscan rounds in Etruria and Latium (but less in Rome) to the distribution of cyma reversa and cyma recta throughout central Italy, with the exception of Etruria. Regardless of the individual forms, the long-lasting use of the Etruscan round makes this moulding grounded in the architecture of central Italy and creates a common tradition, shared by many, and incorporated into distinct local expressions of architectural monumentality.

NOTES

Many thanks go to Annette Rathje (University of Copenhagen) and the Collegium Hyperboreum for organizing the seminar on Ancient Etruria in Copenhagen on November 15–16, 2018. The paper I presented there, "Tid och plats: etruskiska profiler ('modanature' eller 'mouldings') i Centralitaliens arkitektur", has served as a springboard for this article, dedicated to the memory of Erika Simon (1927–2019) and Donatella Gentili (1956–2019).

Many colleagues and friends have provided guidance and encouragement through the years. Lucy Shoe Meritt inspired me from early on to continue her pioneering work, and heartfelt thanks go to John Berry, Astrid Capoferro, Beth Chichester, Penelope J.E. Davies, Mary B. Hollinshead, Margaret M. Miles, Carlo Rescigno, Ingrid D. Rowland, Tesse D. Stek, Alessandra Tanzilli, Jessica Trelogan, Jean M.Turfa, Chris Williams, Ingela Wiman, Shiela Winchester, Nancy A. Winter, and to the participants in the Workshop on the Study and Interpretation of Architectural Mouldings in Ancient Italy that Laura Ambrosini and I organized at the Swedish Institute in Rome in May 2018 at the invitation of the Director, Kristian Göransson. The invited speakers introduced a variety of topics, all relevant for our understanding of the importance of architectural mouldings: Laura Ambrosini (Norchia and Castel d'Asso), Donatella Gentili (Tuscania), Monica Ceci, Jens Pflug, and Stephan Zink (Largo Argentina), Francesca Diosono and Alberto La Notte (Nemi), Teresa Cinquantaquattro and Marilena Sica (Saepinum), Letizia Ceccarelli (Ardea), Claudia Carlucci (Architectural terracottas), and Ilaria Menale (Ceri). My research on mouldings has been funded by grants from the Fondazione Famiglia Rausing which have allowed me time at the library of the Swedish Institute in Rome and travels in Italy.

I have not been able to include references to a recent publication by Dimosthenis Kosmopoulos, *Architectura templare italica in epoca ellenistica, Roma* 2021.

1 Walker 1926 [repr. 2007]; Edlund-Berry 2006.

2 The spelling "moulding" reflects Lucy Shoe Meritt's definition of such a feature as being part of the cut blocks in stone (or rendering in terracotta or other material), different from features applied externally to a building. As an architectural term, this distinction sometimes stands in conflict to publication stylesheets (see Edlund-Berry 2008, 441 *).

3 See PGM 1936; Ginouvès and Martin 1985, 152–164, pls. 47–49; ARCATA 2008; Hellmann 2002. The many webpages that discuss and illustrate different types of mouldings range from 19th and 20th century texts to advertisements for mouldings (mostly of wood) used in modern building construction, see, for example, http://www.newoodmoulding.com/MouldingHistory/Moulding.htm (accessed 14 February 2019) and https://www.homedepot.com/b/Building-Materials-Moulding-Millwork-Moulding/N-5yc1vZar1 (accessed 14 February 2019).

4 Marquand 1906; Rowland and Howe 1999, xvi n. 3, 202.

5 Rowland and Howe 1999, 202, fig. 47; 229, fig. 73. I have followed Rowland's and Howe's translation of "Tuscanicus" as indicating something that is "Tuscan-like" rather than strictly "Tuscan" (as a term used for the so-called Tuscan order) or "Etruscan", see Edlund-Berry 2013.

6 Rowland and Howe 1999, 200, fig. 45.

7 Smeaton 1883; Stevens Curl and Wilson 2015. The Italian equivalents for "torus" are "toro", "cuscino", or "echino" (Stopponi 2011, 21, n. 17). Cyma ["wave"] recta and cyma reversa (Italian "gola diritta" and "gola rovescia") indicate curved mouldings, described by Alberti 1485, 7.7) as "gulula" ("little throat") and "undula" ("little wave") but later authors (for example, Pompei 1735, 74) preferred the term "gola" (or "cyma") (Marquand 1906, 286). The term "becco di civetta" ("hawksbeak") is defined by Vignola 1770, 21 as a "Scozia Rivoltata" ('turned-over concave moulding'). For a useful list of the international terminology of mouldings, see Winter 1990, 7–10.

8 For example, at Capua, Cumae, and Paestum, for which see below, Tables 1–3.

9 ERRM 2000, xv.

10 See, for example, Potts 2015, 38–50.

11 Edlund-Berry 2008; 2013; "Cultural Frontiers" submitted. For a summary of the issue of terminology, see also Hopkins 2016, 185, n. 35.

12 Winter 2012 and 2017, 140 n. 45 (a new attribution of the raking sima at Sant'Omobono to the second phase, based on evidence from Velletri. I thank Nancy Winter for this additional information). A recent dissertation by Stephen Smith 2015 focuses on specific forms of rounded mouldings, referred to as "rounded wave moulding" and "double-rounded moulding", which he links to religious traditions in Latium rather than to Etruria.

13 In the following I will use the term "Etrusco-Italic" rather than "Republican Roman" to emphasize the geographical distribution of mouldings in Etruria and Central Italy and to highlight the architectural and artistic continuity that existed independent of historical or political events. In some cases, however, a distinct connection between the use of mouldings and Roman history has been proposed (see below).

14 ERRM 2000 includes the text from ERRM 1965 with references to monuments and drawings. The drawings in both editions are derived from the original drawings, with the difference in scale, reduced in ERRM 1965, and for the most part in a 1:1 scale in ERRM 2000. Shoe Meritt was inspired in her effort to produce full-scale drawings (F.S.D.) by F.H. Bacon's publications from Assos, see ERRM 2000, xi, and Edlund-Berry 2005. For a recent discussion of Shoe's contributions to the study of ancient architecture, see Fino 2021.

15 See the bibliography at the end of text. To avoid duplication of references I will primarily cite the publications which provide photos and drawings of the mouldings discussed.

16 It should, of course, be noted that while the examples of mouldings discussed and illustrated in ERRM are abundant, the volume was never intended as a complete corpus, and the apparent imbalance between the categories and locations was further exaggerated by the loss of the original manuscript (ERRM 1965, 5).

Likewise, the revised edition, ERRM 2000, did not intend to provide other than a selection of examples, which led to the exclusion of individual mouldings (see R.T. Scott, *JFieldA* 29:1/2, 2002–2004, 247–248). As needed, I have, however, attempted to add new or revised information on mouldings discussed in ERRM 1965 and 2000. For example, my reference to the so-called Capitolium at Minturnae in Edlund-Berry 2017, 763 should be amended to refer to ERRM 1965,

185, where the entry for Temple A includes a note on the podium base of the Capitolium for which there is an unpublished drawing in Shoe Meritt's archives. See also, Mesolella 2012, 120–135. While the original drawings rarely need to be replaced, new discoveries and research have modified or corrected some of the interpretations in ERRM 1965 and ERRM 2000. See, for example, Cozza 1975 for the altars at Lavinium.

17 Colleagues who are using PGM and PWGM in their research assure me that Shoe Meritt's publications are still invaluable, with the obvious proviso that more material has surfaced, and more recent studies of style and chronology may modify some of her conclusions (see Hellmann 2002, 197–198). I thank Mary B. Hollinshead for bridging the gap between Greece and Italy and for providing valuable insights into the study of Greek mouldings. For a recent overview of Greek mouldings, see Barletta 2016, 40. That scholars of today would treasure a digitized version of all of Shoe Meritt's work is a truism that one day may yield results. Currently, only ERRM 1965 is available on JSTOR: www.jstor.org/stable/4238656.

18 Hamilton Gray 1843, 396.

19 Hamilton Gray 1843, 397.

20 Inghirami 1825, pls. 34–42; Gell 1834, 209; Dennis 1907, 284 and 311.

21 Orioli 1833; Koch *et al.* 1915; Rosi 1925, 1927; Colonna Di Paolo and Colonna 1970, 1978; Steingräber 2014; Ambrosini 2016, 2018 (see, for example, Tav. 142–143 for some particularly well- preserved details of mouldings). An interesting example of a recently discovered partially rock-cut shrine with Etruscan round mouldings is the sanctuary at Macchia delle Valli (Vetralla), for which see Scapaticci 2014. A model of the structure is now on display at the Museo Nazionale Etrusco Rocca Albornoz in Viterbo.

22 Rowland and Howe 1999, 15; Walker 2007.

23 Delbrueck 1907 and 1912.

24 Above, n. 21. As can be expected, drawings of mouldings are also included in more recent monographs, especially of temples in Rome (see, for example, Adam 1994 and Coarelli 1981).

25 Above, n. 14.

26 ERRM 2000, xii-xviii.

27 Above, n. 14. The Lucy Shoe Meritt archive of text, notes, drawings, and photographs is now distributed in three libraries: Bryn Mawr College Library: Special collections, Lucy T. Shoe Meritt papers 1888–2003;

American Academy in Rome: Drawings of Western Greek Mouldings; The University of Texas at Austin: Lucy Shoe Meritt Collection. Most of the material relevant for this article is to be found at the University of Texas at Austin. For a selection of reviews of PGM, PWGM, and ERRM, see R. Stillwell, *AJA* 42:3, 1938, 430–432; H. Plommer, *ClR* 5:1, 1955, 118–119; K.M. Phillips, Jr., *AJA* 70:3,1966, 300–301; D. Ridgway, *ClR* 54:1, 2004, 251–252.

28 See, for example, the podium crown from the Rectangular temple (Portunus) in the Forum Boarium (Rome), ERRM, 1965,148, XLVI,1, fig. 31 and the podium crown from Lanuvium, 148, XLVI,2, fig. 32. A missing column base from Paestum is recorded in ERRM 1952, 182, XXXI,13, fig. 20.

29 See above, Terminology of mouldings.

30 ERRM 2000, xvi-xvii.

31 For comparisons between Etruscan mouldings and possible Eastern parallels, see Colonna 1986, 1007 and tav. VI; Naso 1996, 2007, 2015, and 2016. I assume that Shoe Meritt did not include the moulding from the Tumulo del Colonnello at Caere in her discussion of these early mouldings because it was not available to her on her visit in 1937. Mengarelli 1940 includes a drawing on pl. XV, fig. 79, but according to Marini the tomb was not excavated until 1947 or later (Marini 2009–2010, 15). For the question of local workmanship, see Edlund-Berry 2002. See also Ambrosini 2018, 164 and 192, and 2019; Rizzo 2018.

32 ERRM 1965, 39–40. It should be noted that throughout ERRM 1965 and 2000, the dates given for any mouldings reflect the find context established by the excavators. In ERRM 1965, the profile drawings from Caere (Pls. I-III) had to be printed at a 1:4 scale, and even so some sections had to be cut and indicated only as partial measurements in the complete drawing (see, for example, the temple at Cosa, **Fig. 2**). Naso 2007, 143, notes that the mouldings at Caere represent the "first stone moldings in the history of Italian architecture."

33 Donatella Gentili, paper presented at the Mouldings Workshop in May 2018.

34 Edlund-Berry 2014.

35 ERRM 1965, 32.

36 Ambrosini 2016, 2018 (see, for example, Tav. 142–143 for some particularly well-preserved details of mouldings), and paper presented at the Mouldings Workshop in May 2018.

37 The chapter in ERRM 1965 on Terracottas

provides a sample of architectural terracottas, a subject that now has developed its own identity through the international conferences *Deliciae Fictiles* I-V and in-depth studies such as Winter 2009. Architectural terracottas and mouldings were also discussed by Claudia Carlucci at the Mouldings Workshop in May 2018.

38 The Etruscan Round has the widest range, from Orientalizing/Archaic (7th/6th c. B.C.) to late Republican (1st c. B.C.), while the Cyma Reversa first appears in the late 4th/ early 3rd c. B.C., followed by the Cyma Recta. In her description of each moulding, Shoe Meritt refers to the main applicable publications known to her, but in some cases differences in dating occur, and more recent studies are available. See below, Chronology of mouldings.

39 See Potts 2015, 38–40, for different terminologies for defining a 'podium'. I am here using the term to refer to the foundation of a temple, regardless of height or relation to the superstructure.

40 For drawings published in ERRM 1965 and 2000, I refer to these publications. For other examples discussed in the text, I refer to drawings, when available, in other publications, supplemented by text and photographs. Since I have not had the opportunity to study all the monuments discussed in person, I am grateful to the many colleagues who have provided valuable information on their research.

41 Since the publications by Castagnoli 1959 and Cozza 1975, much research has focused on the form and use of altars in central Italy, for which see most recently Moser 2019. At the Mouldings Workshop in May 2018 Ilaria Menale introduced material with mouldings from Quartaccio di Ceri, for which see Menale 2019.

42 In addition to the city of Rome, the main regions are Latium (modern Lazio) and Etruria (modern Toscana and Lazio north of Rome) and Campania, with examples also from Apulia/Puglia, Lucania/Basilicata, Picenum/Marche, Samnium, Umbria, and modern Abruzzo and Molise. I thank Laura Ambrosini for her valuable help in coordinating between the ancient and modern names of regions and areas. The examples included for each region are defined by their location as well as by their suggested chronology, see below, Tables 1–4.

43 I am most grateful to Jessica Trelogan for providing the map of the relevant sites in the different regions of central Italy.

44 I thank Nancy Winter for suggesting this format of presenting the information. Each table includes the region, city, name of temple or monument, the generally accepted date (based on ERRM 1965 or more recent publications), bibliographical references to ERRM 1965 and 2000, and comments on the types of mouldings. Within each region, the examples are listed more or less in chronological order, allowing for the considerable discrepancy between the dates suggested in different publications. In some cases I have not had access to a documentation of the exact form of the moulding but have included those items with a question mark, and I hope that continued research will allow for a more precise identification.

45 Hopkins 2016, 97–122.

46 Castagnoli 1984, 8–9 and fig. 3. For a 3D rendering of the temple resting on a podium with round mouldings, see Hopkins 2016, fig. 87.

47 Brocato and Terrenato 2017, 100–104, figs. 3–5.

48 I thank Birte Poulsen for sharing her knowledge of this block and the related stratigraphy with me.

49 The rich and complicated variety of sanctuaries at Ardea was presented by Letizia Ceccarelli at the Mouldings Workshop in May 2018.

50 See bibliographical references in Table 1. Blocks re-used in the temple of Sol Indiges at Lavinium may represent rounded (?) mouldings of the early fifth c. B.C. according to the information kindly provided by Alessandro Jaia.

51 ERRM 1965, 99.

52 See below, Mouldings and Roman history.

53 Rescigno 2009, 469–476, fig. 29.

54 See below, Mouldings and Roman history.

55 ERRM 1965, 32, 143; ERRM 2000, xvii.

56 Depending on the size and proportions, there are many rounds that also include a curved feature which easily could be merged with the more traditional cyma reversa, including the so-called "campana" or "bell" moulding found in rock-cut tomb façades and the lower round of the temple at Sant' Omobono, second phase (see Table 1). Likewise, several mouldings could be expanded with a small round or cavetto, and ultimately the cyma recta was created by combining several distinct forms, classified by Shoe Meritt as Complex podium crowns and Complex podium bases (ERRM 1965, 173–187; ERRM 2000, xxv).

57 I am grateful to Monica Ceci for helpful

guidance at Largo Argentina and for presenting new information at the Mouldings Workshop in May 2018. For a recent publication, see Zink, Pflug, and Ceci 2020.

58 ERRM 1965, 148.

59 Blocks with cyma reversa mouldings from San Giovenale in Southern Etruria have been dated by the excavators to the 5th/4th c. B.C. (Blomé 1984) but this date is most uncertain since they were re-used in a much later (Medieval?) wall (**Fig. 8**). I thank Johnny Bengtsson for discussing the phases of the wall with me (correspondence, 17 June 2019).

60 Francesca Diosono highlighted the recent explorations at Nemi at the Mouldings Workshop in May 2018.

61 See, for example, Torelli 1999, 64–68 (date of temple: early 2nd c. B.C.).

62 Bonamici 2003.

63 I thank Edvige Percossi for her generosity in providing information and drawings of the temple podium.

64 I am grateful to Sandra Lapenna for clarifying the appearance of the preserved mouldings.

65 For an interesting comparison with the temple at S. Giovanni in Galdo found at Pollentia on Mallorca, see Vallori Márquez *et al.* 2016.

66 Palombi 2008, 17, n. 12 includes a reference to the temple at Tricarico (see Table 3, n. 18). I thank Domenico Palombi for valuable information about the temples at Cori.

67 ERRM 1965, 175.

68 I wish to thank Lucio Fiorini for sharing information and images of the temple.

69 Basciu 2013. I am most grateful to Giuseppe Basciu for providing bibliographical information and for sharing images of the podium block.

70 Teresa Cinquantaquattro and Marilena Sica presented information about this temple at the Mouldings Workshop in May 2018. See also Cinquantaquattro and Sica 2019.

71 I thank Ugo Fusco for information about this temple.

72 This is a particularly intriguing reconstruction since cyma reversa mouldings are rare in Etruria. Penelope Davies first alerted me to the Etruscan round on this temple. I am most grateful to Cynthia Mascione for shar-

ing her research with me both in correspondence and at the site.

73 See Koch 1907; PWGM 1952, 130, XXII, 11 and the bibliography for Table 4, note 4.

74 Campanelli 2007.

75 ERRM 1965, 54–59; 60–68.

76 See below, Chronology of mouldings.

77 See below, Mouldings and Roman history.

78 For an example from the Tomba del Peccato at Falerii Novi, see Ambrosini 2017, fig. 24. I am grateful to Laura Ambrosini for providing this reference.

79 At times the material used suggests that earlier mouldings in tufa may have been replaced by travertine. See, for example, the cyma reversa crowning mouldings from Lucus Feroniae, which Shoe Meritt considers a Sullan or Augustan restoration (ERRM 1965, 148, XLV,2,3). An earlier date, 2nd c. B.C., is suggested by Stanco 2016, 81.

80 ERRM 2000, xxv, n. 92. For an interesting example of time lag in the use of cyma reversa mouldings, see Vallori Márquez *et al.* 2016.

81 Bispham 2006; Edlund-Berry 2008; Quinn and Wilson 2013; Edlund-Berry 2017, 762–763. For a general discussion, see most recently, Stek and Burgers 2015.

82 Edlund-Berry 2008, 444–445; Quinn and Wilson 2013, 123–128.

83 Edlund-Berry 2017, 761.

84 See Table 1.

85 Edlund-Berry 2017, 762–764.

86 See, for example, Coarelli and Diosono 2009, 60; for Isernia, Stek *et al.* 2015, 236 (I thank Francesca Diosono for providing this reference).

87 Bispham 2006; Quinn and Wilson 2013.

88 See, Tanzilli 2015, 24–69. I thank Alessandra Tanzilli for stimulating discussions about the chronology of the mouldings at Sora and other sites.

89 Diosono 2019.

90 Zevi 1989, 42–46. For a useful discussion of the podium at Praeneste, see also Diosono 2019, 25 and fig. 5B. Diosono 2019, 25 n. 45 also refers to a dissertation by E. Iannucci, La Sapienza-Università di Roma 2004/2005 [non vidi].

91 Gasparini 2014. I thank Valentino Gasparini for providing useful information about the temple and its mouldings.

APPENDIX

Table 1 The Etruscan Round in central Italy and surrounding areas

Region	City	Temple	Date	ERRM 1965/ERRM 2000	Comments
Latium (now in Lazio)	Rome	S. Omobono I[1]	580 B.C.	ERRM 1965, 84, nn. 2–3. ERRM 2000, xxiii, n. 32	Crowning Single round
Latium (now in Lazio)	Satricum	Temple of Mater Matuta[2]	550–540 B.C.	ERRM 1965, 86–88, XXIII, 3	Small fragmentary round
Latium (now in Lazio)	Rome	S. Omobono II	530 B.C.		Double round
Latium (now in Lazio)	Ardea, Castrum Inui	Temple B[3]	500 B.C.		Double round mouldings may have been later addition
Latium (now in Lazio)	Ardea	Casarinaccio temple[4]	500–480 B.C.	ERRM 1965, 84–86, XXIII,1–2, figs. 12–13 (photos)	Double round
Latium (now in Lazio)	Lavinium	Temple of Sol Indiges[5]	early 5th c. B.C.		Re-used blocks with ?round mouldings
Latium (now in Lazio)	Rome	Temple of Castor in the Roman Forum[6]	484 B.C.		Base round
Latium (now in Lazio)	Fregellae	Temple[7]	4th c. B.C.		Double round
Latium (now in Lazio)	Praeneste	Podium blocks[8]	4th-3rd c. B.C.		Double round
Latium (now in Lazio)	Sora	Temple[9]	3rd/1st c. B.C.?		Double round

1 LTUR, s.v. Fortuna e Mater Matuta, Aedes; Edlund-Berry 2008, 442, fig. 1 (drawing); Edlund-Berry 2016, 266–267, fig. 2 (photo and drawing). In the early phase (ca. 580 BC), the podium shows a crowning round placed on top of the vertical body, whereas the second phase (530 BC) is shown with a double round. This sequence has been interpreted as evidence for two distinct podia: Colonna 1991, 51–59, fig. 2; Winter 2009, 149–150, Roof 3–6, Plan 11.2, 580 B.C. and 316–318, Roof 5–4, Plan 12.2.

2 Edlund-Berry 2008, 442, fig. 2 (drawing).

3 Di Mario 2016, 222–232; Di Mario and Ronchi 2018, 80–92, including fig. 36 (photo) rather than fig. 35 (drawing). The preserved form of the double round moulding is worn, and may suggest that the moulding was originally accentuated by stucco

(Di Mario and Ronchi 2018, 89) and may have been added at a later date. Ceccarelli and Marroni 2011, 45–49.

4 Ceccarelli and Marroni 2011, 31–36 (date of temple: late Archaic); Edlund-Berry 2016, 267 and fig. 3 (drawing).

5 I thank Alessandro Jaia for providing information on this temple. See also, Jaia 2011.

6 LTUR, s.v. Castor, Aedes, Templum (date of temple: 484 B.C.); Nielsen and Poulsen 1992, 82, fig. 60a.

7 Diosono 2019, 19–28, fig. 3.

8 Fasolo and Gullini 1953, 27–29, fig. 39 (photo); Zevi 1989, 42–46; Pittaccio 2001, 50, 169–171; Ceccarelli and Marroni 2011, 394–396.

9 Tanzilli 2015, 3–48 and fig. 42 (drawing); Edlund-Berry 2016, 270, fig. 7.

Table 1 (continued)

Region	City	Temple	Date	ERRM 1965/ERRM 2000	Comments
Etruria (now in Lazio)	Pyrgi	Temple A[10]	Ca. 460 B.C.		Small fragmentary round
Etruria (now in Umbria)	Orvieto	podium block?[11]	5th c. B.C.	ERRM 1965, 99, XXVII,4	or altar?
Etruria (now in Lazio)	Vulci	Tempio Grande[12]	5th-4th c. B.C.		Single round
Etruria (now in Lazio)	Tarquinia	Ara della Regina phase III[13]	4th c. B.C.	ERRM 1965, 89–90, XXV, 2–3 and fig. 16 (photo)	Double round
Etruria (now in Toscana)	Cosa	"Capitolium"[14]	150 B.C.	ERRM 1965, 88, XXV,1, fig. 14 (photo)	Crowning and base moulding
Etruria (now in Toscana)	Fiesole	Temple[15]	1st c. B.C.	ERRM 1965, 92, XXV,6, fig. 20 (photo)	Hour-glass-shaped double round on 'pedestal' of temple
Sabina (now in Umbria)	Villa San Silvestro	Temple[16]	3rd c. B.C.	ERRM 1965, 90–92, XXV.5, fig. 18 (photo)	Double round
Samnium (now in Molise)	Isernia	Temple[17]	3rd c. B.C.	ERRM 1965, 22, 92, LXXVI,1, fig. 19 (photo)	Double round
Campania (now in Campania)	Cumae	"Capitolium"[18]	3rd c. B.C.		Double round

10 Edlund-Berry 2008, 442 and fig. 3 (drawing).
11 Stopponi 2002, 239, fig. 7 (photo); Edlund-Berry 2016, 271, fig. 12 (photo).
12 Edlund-Berry 2016, 269–270 and fig. 6 (photo).
13 Edlund-Berry 2016, 268–269, fig. 5 (photo and drawings). The earlier phases of the temple (I and II) do not have any mouldings preserved, see Bonghi Jovino 2012.
14 Edlund-Berry 2016, 270, fig. 10 (photo and drawing).

15 Cagianelli 1995–1996, 12, and fig. 1 (photo).
16 Coarelli and Diosono 2009; Diosono 2016a; Edlund-Berry 2016, 270, fig. 9 (photo).
17 Pasqualini 1966, 82–83, figs. 7–8 (photo and drawing); Marasco and De Rose 2001, 91–95 with drawing; Edlund-Berry 2016, 270 and fig. 8 (photo).
18 Petacco and Rescigno 2007, 51–76; Rescigno 2009, 469–476, including fig. 29 (drawing); Edlund-Berry 2017, 763.

Table 2 The Cyma Reversa in central Italy and surrounding areas

Region	City	Temple	Date	ERRM 1965/ERRM 2000	Comments
Etruria (now in Lazio)	San Giovenale	blocks re-used in later wall[1]	5th/4th c. B.C.?	Blomé 1984; ERRM 2000, xxiv	? Base moulding
Etruria (now in Toscana)	Volterra	Temple A[2]	2nd c. B.C.		Base moulding
Campania (now in Campania)	Capua	Temple of Diana Tifatina[3]	4th-3rd c. B.C.		Base moulding
Campania (now in Campania)	Teano	Temples A-D[4]	3rd-2nd c. B.C.		Crowning and base moulding
Campania (now in Campania)	Paestum	Temple of Peace[5]	"soon after 273 B.C." or 80 B.C (if copy of earlier podium)	ERRM 1965, 153–155, XLVIII, 3 and 158, L.4	Crowning and base moulding
Latium (now in Lazio)	Nemi	Temple[6]	late 4th/early 3rd c. B.C. [no date in ERRM 1965]	ERRM 1965, 160, LI,2, fig. 36 (photo)	Base moulding
Latium (now in Lazio)	Rome	Largo Argentina, Temple C (Feronia?)[7]	early 3rd c. B.C.	ERRM 1965, 146, XLV,1, fig. 30 (photo)	Crowning moulding
Latium (now in Lazio)	Rome	Forum Boarium, blocks from Rectangular temple (Portunus), first phase[8]	3rd c. B.C.	ERRM 1965, 148, XLVI,1, fig. 31 (photo)	Crowning moulding

1 Since the blocks have been re-used, it is difficult to suggest their date, but they are likely to be later than the 5th/4th century B.C. date in the original publication.

2 Bonamici 2003, 75, fig. 23 (photo).

3 De Franciscis 1956, 16–17, fig. C; Melillo Faenza 2012, 197–200; Quilici Gigli 2012, 35; 2014, 164, fig. 5 (photo); Giuliano 2012, 210–211, figs. 3 (photo), 7 (drawing). The moulding of this first phase of the temple consists of a 'toro' and a 'scotia' which combined form an unusual form of cyma reversa.

4 Johannowsky 1963, 136–140, fig. 8 (drawing).

5 Edlund-Berry 2017, 761 and fig. 2 (photo); Campanile and Cangiano 2019.

6 Ghini and Diosono 2012a, 269–276; 2012b, 128–129; Diosono et al., 2019.

7 LTUR, s.v. Feronia, Aedes; De Stefano 2012, 542–543 (late 4th-early 3rd c. B.C.); Davies 2017, 54 and fig. 2.16 (date: 3rd c. B.C.).

8 LTUR, s.v. Portunus, Aedes; Diosono 2016b, 84–85 and fig. 3 (drawing from notes by Colini). There has been some question of whether the blocks actually belonged to temple (Diosono 2016b, 84, n. 25).

Table 2 (continued)

Region	City	Temple	Date	ERRM 1965/ERRM 2000	Comments
Latium (now in Lazio)	Lanuvium	Temple[9]	3rd c. B.C.	ERRM 1965, 148, XLVI,2, fig. 32 (photo)	Crowning moulding
Latium (now in Lazio)	Rome	Forum Holitorium, Temple of Pietas[10]	2nd c. B.C.		Base moulding
Latium (now in Lazio)	Ardea, Castrum Inui	Temple A[11]	2nd c. B.C.		Crowning and base moulding
Latium (now in Lazio)	Formiae	Temple[12]	2nd c. B.C.		Crowning and base moulding
Latium (now in Lazio)	Fregellae	Temple of Asclepius[13]	2nd c. B.C.	ERRM 2000, xxv	Base moulding
Sabina (now in Lazio)	Rieti	Temple[14]	2nd c. B.C.		Base moulding
Latium (now in Lazio)	Terracina	so-called Temple of Jupiter Anxur[15]	2nd c. B.C.	ERRM 1965, 164, LIV,9	Base moulding with a cavetto
Latium (now in Lazio)	Fabrateria Nova	Temples A and B[16]	2nd c. B.C.		Base moulding with a cavetto
Latium (now in Lazio)	Gabii	Temple[17]	mid-2nd c. B.C.	ERRM 1965, 153, XLIX,1 and 160–161, LI,3	Crowning and base moulding
Latium (now in Lazio)	Rome	Largo Argentina, Temple A (Iuturna) (2nd phase)[18]	150–100 B.C.	ERRM 1965, 152, XLVII.5 and 159, pl. LI,1	Crowning and base moulding

9 Ceccarelli and Marroni 2011, 213–214 (date of temple: late 4th c. B.C.). The photo in ERRM 1965, fig. 32, taken in 1937, is probably the last known image of the podium block which most likely went missing during WWII.

10 LTUR, s.v. Pietas, Aedes in Foro Holitorio/in Foro Flaminio; Rossetto 1994–1996, 199–200, figs. 4–5 (photo and drawing); Vitti 2010. Date of temple: 2nd c. B.C. Davies 2017, 90 and fig. 3.10 (vowed in 191 B.C.).

11 Di Mario 2007, 65–77, fig. 29 (drawing); 2009, 337–340, fig. 16 (drawing); Di Mario and Ronchi 2018, 66–79, including figs. 30–31 (photos) rather than fig. 32 (drawing). Ceccarelli and Marroni 2011, 49–50.

12 Guaitoli 1974, 132–133, fig. 4 (drawing).

13 Verzár-Bass 1986, 45–46, pls. XX.2 (drawing) and XXIV.5–6 (photos); Lippolis 2009, 150 and fig. 9.

14 Reggiani 1987, 370–371, fig. 7 (drawing).

15 Franz 2016, 15–22 and fig. 4 (photo).

16 Fröhlich and Nicosia 2016, 71 and figs. 13 and 14 (photos).

17 Shoe Meritt suggests a Sullan date. Ceccarelli and Marroni 2011, 181–184 (date of temple: 150–125 B.C.).

18 LTUR, s.v. Iuturna, Templum; De Stefano 2012, 543–545 (date: mid-2nd c. B.C.); Davies 2017, 53, fig. 2.13 (photo), 154.

Table 2 (continued)

Region	City	Temple	Date	ERRM 1965/ERRM 2000	Comments
Latium (now in Lazio)	Tivoli	Rectangular temple[19]	100 B.C.	ERRM 1965, 151, XLVIII,2 and 162, LI,10	Crowning and base moulding
Latium (now in Lazio)	Cori	Temple of Hercules[20]	ca. 100 B.C.	ERRM 1965, 152, XLVII,3	Crowning moulding
Latium (now in Lazio)	Ostia	Tetrastyle temple[21]	100 B.C.	ERRM 1965, 162, LI,8	Base moulding
Latium (now in Lazio)	Ostia	Four temples (II,VIII,2)[22]	100–70 B.C.	ERRM 1965, 152, XLVII,4 and 162, LI,5	Crowning and base moulding
Latium (now in Lazio)	Ostia	Reg. I Temple (Tempio dell'Ara rotunda)[23]	80–60 B.C.	ERRM 1965, 149, XLVI,4	Crowning moulding
Latium (now in Lazio)	Ostia	Decumanus temple (Tempietto repubblicano, II,IX,4)[24]	80–50 B.C.	ERRM 1965, 153, XLVIII,4 and 160, L,12	Crowning and base moulding
Latium (now in Lazio)	Terracina	So-called Capitolium[25]	43 B.C.-early Augustan	ERRM 1965, 155, XLIX,2 and 164, LI,12	Crowning and base moulding
Latium (now in Lazio)	Ostia	Porticus temple (Tempio di Giove)[26]	late 1st c. B.C.	ERRM 1965, 153, XLVIII,5 and 160, L,13	Crowning and base moulding
Latium (now in Lazio)	Terracina	Temple[27]	Augustan?	ERRM 1965, 151, XLVIII,6	Crowning moulding

19 Ceccarelli and Marroni 2011, 533–535 (date of temple: mid-2nd c. B.C.)
20 Ceccarelli and Marroni 2011, 131–132 (date of temple: 100–80 B.C.); Brandizzi Vittucci 1968, 77–96; Palombi 2003, 221–222 (date: mid- 2nd c. B.C.).
21 Ceccarelli and Marroni 2011, 312–314 (date: end of 2nd c. B.C.); Moser 2019, 32–34.
22 Ceccarelli and Marroni 2011, 324–332 (date of temple: 100–50 B.C.); Pensabene 2007, 87–113; Zevi 2012, 541–547 (date of temple: 65–55 B.C.).
23 Ceccarelli and Marroni 2011, 320–323 (date of temple: second half of 2nd c. B.C.); Pensabene 2007, 53–64; Moser 2019, 28–32.
24 Ceccarelli and Marroni 2011, 332–335 (date of

temple: 100 B.C.); Pensabene 2007, 118–122 (date of temple: 70–50 B.C.).
25 Ceccarelli and Marroni 2011, 486–487 (date of temple: mid-1st c. B.C.); Mesolella 2012, 293–299 and fig. 158 (drawing); Valenti 2016, 49–53. For the Tempio Maggiore, built into the Cathedral, see Ceccarelli and Marroni 2011, 484–485 (Augustan); Mesolella 2012, 300–326; Cassieri 2016, 35–48.
26 Ceccarelli and Marroni 2011, 309 (date of temple: late 1st c. B.C.); Pensabene 2007, 123–128; Zevi 2012, 547–554.
27 Shoe Meritt suggests in an unpublished note that this block is part of the so-called Capitolium.

Table 2 (continued)

Region	City	Temple	Date	ERRM 1965/ERRM 2000	Comments
Umbria (now in Umbria)	Collemancio (Urvinum Hortense)	Temple[28]	3rd c. B.C.		Base moulding
Area of the Praetutii (now in Abruzzo)	Basciano	Temple[29]	2nd c. B.C.		Crowning and base moulding
Area of the Praetutii (now in Abruzzo)	Colle S. Giorgio	Temple[30]	2nd c. B.C.		Base moulding
Samnium (now in Abruzzo)	Schiavi d'Abruzzo	Tempio grande[31]	2nd c. B.C.	ERRM 2000, xxiv	Crowning and base moulding
Samnium (now in Molise)	S. Giovanni in Galdo	Temple[32]	ca. 100 B.C.	ERRM 2000, xxiv	Crowning and base moulding
Area of the Paeligni (now in Abruzzo)	Vittorito	Temple[33]	2nd c. B.C.	ERRM 2000, xxiv	Crowning and base moulding
Area of the Carricini (now in Abruzzo)	Iuvanum	Temple[34]	2nd c. B.C.		Base moulding
Area of the Vestini (now in Abruzzo)	Penne	podium block[35]	2nd c. B.C.		Base moulding
Apulia (now in Puglia)	Herdonia	Temple B[36]	2nd c. B.C.		Crowning and base moulding
Picenum (now in Marche)	Potentia	Temple[37]	2nd/1st c. B.C.		Crowning and base moulding

28 Stopponi 2002, 238–239 (date of temple: 250–200 B.C.); Edlund-Berry 2016, 271, fig. 13 (photo).
29 Messineo 1986; Stek 2009, 148–150, figs. 7.10–11 (drawings); Edlund-Berry 2016, 274 n. 38.
30 Iaculli 1993, 33–35, fig. 18 (photo); Liberatore 2019.
31 La Regina 1976, 230, pl. XI (drawing); Coarelli and La Regina 1984, 269–273 (with drawing); Lapenna 1997b, 81–82; 2001, 43–47, photo, 46.
32 La Regina 1976, 237–241, pls. XII-XIII (drawings); Coarelli and La Regina 1984, 295–298 (with drawings); Stek 2009, 42–44, figs. 3.2 and

3.3 (drawings); Edlund-Berry 2016, 276, fig. 15 (photo and drawing).
33 Van Wonterghem 1976, 148, figs. 4–5 (photos); 1984, 196–200, figs. 253–254 (photo and drawing). (Note also the rounded block from another podium or an altar, fig. 257).
34 Lapenna 1997a, 64–66; 2006, 59–65.
35 La Regina 1968, 419, Tav. XXI, fig. 40 (photo).
36 Van Wonterghem, 1979, 44–50, fig. 14 (drawing); Mertens and Volpe 1999.
37 Percossi 2001, 81–83.

Table 3 The Cyma Recta in central Italy and surrounding areas

Region	City	Temple	Date	ERRM 1965/ERRM 2000	Comments
Latium (now in Lazio)	Cori	Temple at S. Oliva[1]	3rd/2nd c. B.C.		Crowning moulding
Latium (now in Lazio)	Rome	Largo Argentina, Temple D (Lares Permarini or Nymphs)[2]	[mid-1st c. B.C.] or early 2nd c. B.C.	ERRM 1965, 180, pl. LVII,1 and 185, LVIII,7	Crowning and base moulding
Latium (now in Lazio)	Ostia	Temple of Hercules[3]	100–80 B.C.	ERRM 1965, 178, LVI,2 and 183, LVIII,6	Crowning and base moulding
Latium (now in Lazio)	Rome	Forum Boarium, Rectangu-lar temple (Portunus)[4]	[50 B.C.] or early 1st c. B.C.	ERRM 1965, 180, LVI,4 and 184, LVIII,11, fig. 40 (photo)	Crowning and base moulding
Latium (now in Lazio)	Rome	Forum Holitorium, Temple B (Juno Sospita)[5]	[Augustan restoration of] 90 B.C.	ERRM 1965, 177, LV,4 and 184, LVIII,10	Crowning and base moulding
Latium (now in Lazio)	Rome	Forum Holitorium, Temple A (Janus)[6]	90 B.C.	ERRM 1965, 175–176, LV, and 184, LVIII,9, fig. 38 (photo)	Crowning and base moulding
Latium (now in Lazio)	Rome	Temple of Veiovis[7]	78 B.C.	ERRM 1965, 178, LVI,3 and 183–184, LVIII, 8	Crowning and base moulding

1 See, Palombi 2008, 16–17, fig. 6 (photo and drawing); Ceccarelli and Marroni 2011, 134. Date of temple: early 3rd-late 2nd c. B.C. (Palombi). For the Tempio dei Dioscuri at Cori, see Palombi 2003, 225–228, and correspondence. Ceccarelli and Marroni 2011, 132–134 (date 100 B.C.).

2 LTUR, s.v. Lares Permarini, Aedes; De Stefano 2012, 543 (date: early 2nd c. B.C.); Davies 2017, 87–88, fig. 3.7 (photo), 224 (date: 2nd c. B.C.; restoration mid-1st c. B.C.).

3 Ceccarelli and Marroni 2011, 314–319 (date of temple: late 2nd-early 1st c. B.C.); Pensabene 2007, 64–72; Moser 2019, 34–37.

4 LTUR, s.v. Portunus Aedes; Adam 1994 (date: 75 B.C.); Diosono 2016b; Davies 2017, 190 and fig. 2.2 (photo) (date of restoration: between 80 and 70 B.C.).

5 LTUR, s.v. Iuno Sospita (in Foro Holitorio), Aedes; Davies 2017, 154–155 and fig. 2.15 (date of restoration 1st c. B.C. uncertain).

6 LTUR, s.v. Ianus, Aedes (apud Forum Holitorium, ad Theatrum Marcelli); Davies 2017, 154–155 and figs. 2.7, 2.15 (date of restoration 1st c. B.C. uncertain).

7 LTUR, s.v. Veiovis, Aedes (in Capitolio); Davies 2017, 92–93 and fig. 3.14, 194 and fig. 5.9 (date: restored ca. 78 B.C.).

Table 3 (continued)

Region	City	Temple	Date	ERRM 1965/ERRM 2000	Comments
Latium (now in Lazio)	Rome	Largo Argentina, Temple A (3rd phase)[8]	Sullan	ERRM 1965, 175, LV,2 and 182, LVIII,2	Crowning and base moulding
Latium (now in Lazio)	Rome	Largo Argentina, Temple B (Fortuna Huiusce Diei) (1st phase)[9]	Sullan	ERRM 1965, 178, LVI,1 and 182–183, LVIII,3	Crowning and base moulding
Latium (now in Lazio)	Rome	Largo Argentina, Temple B (2nd phase)[10]	[late Republic or Augustan] mid-1st c. B.C.	ERRM 1965, 181, LVII,2 and 184, LVIII,12	Crowning and base moulding
Latium (now in Lazio)	Rome	So-called Temple of Bellona, via delle Botte- ghe Oscure[11]	? 50 B.C.	ERRM 1965, 177–178, LV,6 and 183, LVIII, 4, fig. 39 (photo)	Crowning and base moulding
Latium (now in Lazio)	Minturnae	Temples A and B[12]	A: 1st c. A.D. B: 1st c. B.C.	ERRM 1965, 185, LVIII,13–14	Base moulding
Umbria (now in Umbria)	Gubbio Nogna	Temple[13]	2nd c. B.C.		Crowning and base moulding
Umbria (now in Umbria)	Gubbio Guastuglia	podium fragment[14]	1st c. A.D.?		Cyma recta (?) base moulding
Area of the Vestini (now in Abruzzo)	Fontecchio	Temple[15]	2nd c. B.C.		Crowning and base moulding

8 LTUR, s.v. Iuturna, Templum; De Stefano 2012, 543 (date: 111–101 B.C.); Davies 2017, 157–160, fig. 4.7 (date: 100 B.C.).

9 LTUR, s.v. Fortuna Huiusce Diei, Aedes; Caprioli 2011; De Stefano 2012, 544 (date: after 111 B.C.); Davies 2017, 156, 173, fig. 4.3 (photo) (date: vowed in 101 B.C.).

10 LTUR, s.v. Fortuna Huiusce Diei, Aedes; De Stefano 2012, 545 (date: 101–55 B.C. and later remodeling).

11 LTUR, s.v. Nymphae, Aedes; Davies 2017, 83, fig. 3.6 (photo) (date: vowed after 167 B.C.)

12 Mesolella 2012, 120–135 (Capitolium), 135–146 (temple A), 152–160 (temple B). The cyma recta base of the Capitolium is described but not drawn in ERRM 1965, 185 and the statement in Edlund-Berry 2017, 763 should be corrected.

13 Fiorini 2011, 42.

14 Basciu 2013.

15 La Regina 1968, 387–392 with drawing, 391; Coarelli and La Regina 1984, 30–32 with drawing, 32.

Table 3 (continued)

Region	City	Temple	Date	ERRM 1965/ERRM 2000	Comments
Area of the Vestini (now in Abruzzo)	Navelli	Temple[16]	2nd c. B.C.		Crowning moulding
Apulia (now in Puglia)	Canosa	Temple[17]	2nd c. B.C.		Crowning and base moulding
Lucania (now in Basilicata)	Tricarico	Temple[18]	2nd c. B.C.		Cyma recta/ cavetto base
Lucania (now in Basilicata)	Grumentum	Etrusco-Italic temple[19]	[mid-1st c. B.C.] end of 2nd c. A.D.		Cyma recta ? crowning and base moulding?
Lucania (now in Basilicata)	Grumentum	Temple D[20]	1st c. A.D.		Cyma recta/ cavetto base
Campania (now in Camania)	Pompeii	Temple of Jupiter[21]	150–120 B.C.- Tiberian	ERRM 1965, 175, LV,1 and 182, LVIII, 1	Crowning and base moulding
Campania (now in Campania)	Capua	Temple of Diana Tifatina[22]	late 2nd c. B.C.		Base moulding
Samnium (now in Molise)	Isernia	Temple[23]	1st c. B.C.?		(?) Cyma recta crowning and base moulding
Samnium (now in Molise)	Saepinum	Temple[24]	Augustan		Base moulding

16 La Regina 1968, 402–406 with drawing, 405; Coarelli and La Regina 1984, 31–34.
17 Dally 2000, 73–75, Beilage 9.1–2 (drawing).
18 De Cazanove 2001, 194, fig. 17 (drawing).
19 Giardino 1981, 39–40, Tavv. XXIV-XXVI (photos). According to Giardino, the mouldings are similar to examples from Largo Argentina in Rome, Tivoli, and Ostia, but the datable context of the temple indicates a date of the 2nd c. A.D.

20 Fusco 2013, 243, figs. 31–32 (photo and drawing).
21 Gasparini 2014, 47, 64, fig. 16 (drawing); Lippolis 2017.
22 Quilici Gigli 2012, 2014, fig. 5 (photo); Giuliano 2012, figs. 7 (drawing), 8 (photo).
23 Terzani 1991, 2001; Ciliberto et al. 2012.
24 Cinquantaquattro and Sica 2019.

Table 4 Mixed mouldings in central Italy and surrounding areas

Region	City	Temple	Date	ERRM 1965/ERRM 2000	Comments
Etruria (now in Toscana)	Populonia	Temple C[1]	3rd-2nd c. B.C.		Crowning cyma reversa and base Etruscan round
Samnium (now in Molise)	Pietrab-bondante	Temple A[2]	early 2nd c. B.C.	ERRM 1965, 151, XLVI.3 and XXIV.4, 94, fig. 21 (photo)	Crowning cyma reversa and base Etruscan round
Samnium (now in Molise)	Vastogirardi	Temple[3]	2nd c. B.C.	ERRM 2000, xxiii, n. 42	Crowning Etruscan round and base cyma reversa
Samnium (now in Molise)	Pietrab-bondante	Temple B[4]	late 2nd/early 1st c. B.C.	ERRM 2000, xxiv	Crowning cyma recta with cavetto and ovolo and base cyma reversa
Area of the Carricini (now in Abruzzo)	Quadri	Temple[5]	2nd c. B.C.	ERRM 2000, xxiii, n. 41	Crowning cyma reversa and base Etruscan round
Area of the Paeligni (now in Abruzzo)	Castel di Ieri	Temple[6]	2nd c. B.C.	ERRM 2000, xxiv, n. 58	Crowning cyma recta and base cyma reversa
Latium (now in Lazio)	Tivoli	Round temple[7]	Sullan	ERRM 1965, 177, LV,5 and 164, LI,11, fig. 37 (photo)	Complex crowning cyma recta and base cyma reversa
Umbria (now in Umbria)	Carsulae	Twin temples[8]	1st c. A.D.		Crowning cyma recta and base cyma reversa moulding

1 See Mascione 2021, 136–137, fig. 9.2.
2 Strazzulla 1973, 12–16, Tav. 2 (photo); La Regina 1976, 225, drawing of mouldings, fig. V; Coarelli and La Regina 1984, 239–242 with drawing, 239; ERRM 2000, xxiii; Edlund-Berry 2016, 273 and fig. 14 (photo and drawing).
3 Morel 1976, 255–262; Coarelli and La Regina 1984, 257–259 with drawing, 259.
4 Strazzulla 1973, 23–28, fig. 2 (drawing); La Regina 1976, 225–237 with drawing of crowning mould-ing, 225, fig. VI; Coarelli and La Regina 1984,

247–252 with drawing of podium mouldings, 249; Edlund-Berry 2017, 760. For general comments, see also Wolf 2015.
5 La Regina 1976, 230; Coarelli and La Regina 1984, 316–317 with drawing, 316; Lapenna 1997c, 68–69.
6 Campanelli 2007; Torrieri 2007, 67–96, podium drawings, 74–75.
7 Ceccarelli and Marroni 2011, 536–537 (date of temple: late 2nd c. B.C.)
8 Edlund-Berry 2016, 265, fig. 1 (photo).

BIBLIOGRAPHY

J. P. Adam 1994
Le temple de Portunus au Forum Boarium.
Rome 1994.

L. B. Alberti 1485
De re aedificatoria. Firenze 1485.

L. Ambrosini 2016
Norchia II. Roma 2016.

L. Ambrosini 2017
La Tomba del Peccato di Falerii Novi.
Riflessioni in margine a documenti inediti,
MEFRA 129/1, 2017, 293–313 (on line http://
mefra.revues.org/4237 [accessed 17 June 2019]).

L. Ambrosini 2018
Norchia III. Rome 2018.

L. Ambrosini 2019
Norchia. La topografia del settore monumentale
della necropoli (Pile B), in: *XXIX Convegno di
Studi Etruschi ed Italici, L'Etruria delle necropoli
rupestri (Tuscania e Viterbo 26–28 ottobre 2017),*
Roma 2019, 163–182.

ARCATA 2008
https://www.andromeda.roma.it/wp-content/
uploads/2015/11/elementi-modanature1.pdf
(accessed 12 February 2019).

B. Barletta 2016
Monumentality and Foreign Influence in Early
Greek Temples, in: M. Miles (ed.), *A Companion
to Greek Architecture*, Chichester, West Sussex,
2016, 31–45.

G. Basciu 2013
Gubbio, Guastuglia: scavi condotti dall'Univer-
sità di Perugia, *Bollettino per i beni culturali
dell'Umbria* 6:2, 2013, 163–168.

E. Bispham 2006
Coloniam deducere: How Roman was Roman
Colonization During the Middle Republic?, in:
G. Bradley and J.-P. Wilson (eds.), *Greek and
Roman Colonization: Origins, Ideologies and
Interactions*, Swansea, 73–160.

B. Blomé 1984
Le mura etrusche, in: S. Forsberg and
B. Thomasson (eds.), *San Giovenale. Materiali
e problemi*, Stockholm 1984, 81, pls. II-III.

M. Bonamici 2003
Il santuario e le sue fasi strutturali, in:
M. Bonamici *et al.* (eds.), *Volterra. L'acropoli
e il suo santuario*, Pisa 2003, 35–95.

M. Bonghi Jovino 2012
Alle origini del processo di strutturazione del
tempio etrusco. La presenza del podio, *StEtr* 75,
2012, 3–8.

P. Brandizzi Vittucci 1968
Forma Italiae I:5 *Cora*. Roma 1968.

P. Brocato and N. Terrenato 2017
The Archaic Temple of S. Omobono:
New Discoveries and Old Problems, in:
P.S. Lulof and Ch.J. Smith (eds.), *The Age of
Tarquinius Superbus: Central Italy in the late
6th Century BC*, Leuven 2017, 97–106.

C. Cagianelli 1995–1996 [1997]
Il tempio etrusco di Fiesole: due secoli di
indagini, *Annuario dell'Accademia etrusca di
Cortona* 27, 1995–1996 [1997], 11–57.

A. Campanelli (ed.) 2007
Il tempio di Castel di Ieri. Sulmona 2007.

I. Campanile and I. Cangiano 2019
Le terrecotte architettoniche del tempio della
Pace: il prodotto di una fabbrica templare pesta-
na, in: P.S. Lulof and C. Rescigno (eds.), *Deliciae
Fictiles* V, Oxford-Philadelphia, 2019, 273–277.

F. Caprioli 2011
Forma architettonica, linguaggio decorativo
e committenza della prima fase del tempio B
di Largo Argentina, in: E. La Rocca and
A. d'Alessio (eds.), *Tradizione e innovazione.
L'elaborazione del linguaggio ellenistico
nell'architettura romana e italica di età
tardo-repubblicana*, Roma 2011, 89–107.

N. Cassieri 2016
Terracina. Spazi e forme di culto nei contesti
urbani, in: M. Valenti (ed.), *L'architettura del
sacro in età romana*, Roma 2016, 35–48.

F. Castagnoli 1959
Sulla tipologia degli altari di Lavinio, *BullComm*
77, 1959–1960, 145–172.

73

F. Castagnoli 1984
Il tempio romano: questioni di terminologia e di tipologia, *PBSR* 52, 1984, 3–20.

L. Ceccarelli and E. Marroni 2011
Repertorio dei santuari del Lazio. Roma 2011.

F. Ciliberto, C. Molle, and C. Ricci 2012
L'ambiente sotto la cattedrale di Isernia. Decorazioni e scritture, in: *Sylloge Epigraphica Barcinonensis* 10, 2012, 351–169.

T. Cinquantaquattro and M. M. Sica 2019
Saepinum: architettura sacra, decorazione archi-tettonica e forme di ritualità, in: P. S. Lulof and C. Rescigno (eds.), *Deliciae Fictiles* V, Oxford-Philadelphia 2019, 319–328.

F. Coarelli 1981
L'area sacra di Largo Argentina. Topografia e storia, in: F. Coarelli *et al.*, *L'area sacra di Largo Argentina* 1, Roma 1981, 11–51.

F. Coarelli and F. Diosono 2009
Il tempio principale: architettura, fasi edilizie, committenza, in: F. Coarelli and F. Diosono, *I Templi e il Forum di Villa S. Silvestro*, Roma 2009, 59–69.

F. Coarelli and A. La Regina 1984
Guide archeologiche Laterza: Abruzzo Molise. Roma-Bari 1984.

G. Colonna 1986
Urbanistica e architettura etrusca, in: G. Colonna, *Italia ante Romanum Imperium*, vol. II:1, Pisa and Rome 2005, 995–1145. (from G. Pugliese Carratelli (ed.), *Rasenna*, Milano 1986, 369–530.)

G. Colonna 1991
Le due fasi del tempio arcaico di S. Omobono, in: M. Gnade (ed.), *Stips Votiva. Papers presented to C. M. Stibbe*, Amsterdam 1991, 51–59. [also in G. Colonna, *Italia ante Romanum imperium*, vol. II:2, Pisa-Roma 2005, 1271–1280.]

E. Colonna Di Paolo and G. Colonna 1970
Castel d'Asso. Roma 1970.

E. Colonna Di Paolo and G. Colonna 1978
Norchia. Roma 1978.

L. Cozza 1975
Le tredici are. Struttura e architettura, in: F. Castagnoli *et al.* (eds.), *Lavinium* II *Le tredici are*, Roma 1975, 89–174.

O. Dally 2000
Canosa, Località San Leucio. Heidelberg 2000.

P. J. E. Davies 2017
Architecture and Politics in Republican Rome. Cambridge 2017.

O. De Cazanove 2001
Cività di Tricarico, in: E. Lo Cascio and A. Storchi Marino (eds.), *Modalità insediative e strutture agrarie nell'Italia meridionale in età romana,* Bari 2001, 169–202.

A. de Franciscis 1956
Templum Dianae Tifatinae, *Archivio Storico di Terra di Lavoro* 1, 1956, 1–60 [301–358].

F. De Stefano 2012
Appendice. L'area sacra di Largo Argentina, in: A. Carandini (ed.), *Atlante di Roma antica*, Milano 2012, 542–548.

R. Delbrueck 1907 and 1912
Hellenistische Bauten in Latium I-II. Strassburg 1907 and 1912.

G. Dennis 1907
The Cities and Cemeteries of Etruria, vol. I. London 1907.

F. Di Mario 2007
Ardea, la terra dei Rutuli, tra mito e archeologia: alle radici della romanità. Nuovi dati dai recenti scavi archeologici. Roma 2007.

F. Di Mario 2009
Ardea, l'area archeologica in località Le Salzare—Fosso dell'Incastro, in: G. Ghini (ed.), *Lazio e Sabina* 5, Roma 2009, 331–346.

F. Di Mario 2016
Ardea, Il santuario di Fosso dell'Incastro, in: A. Ancillotti, A. Calderini, and R. Massarelli (eds.), *Forme e strutture della religione nell'Italia mediana antica. Forms and Structures of Religion in Ancient Central Italy, III Convegno Internazion-ale dell'Istituto di Ricerche e Documentazione sugli Antichi Umbri, Perugia-Gubbio 21–25 September 2011*, Roma 2016, 217–243.

F. Di Mario and D. Ronchi 2018
Lo scavo: descrizione delle scoperte e delle fasi del santuario, in: M. Torelli and E. Marroni, *Castrum Inui. Il santuario di Inuus alla foce del Fosso dell'Incastro*, Roma 2018, 63–139.

F. Diosono 2016a
Il posto degli dei: santuari extraurbani e colonizzazione nel III secolo a.C. Il caso di Villa San Silvestro di Cascia, in: A. Ancillotti, A. Calderini, and R. Massarelli (eds.), *Forme e strutture della religione nell'Italia mediana antica. Forms and Structures of Religion in Ancient Central Italy, III Convegno Internazionale dell'Istituto di Ricerche e Documentazione sugli Antichi Umbri, Perugia-Gubbio 21–25 September 2011*, Roma 2016, 245–263.

F. Diosono 2016b
La porta e il porto. Il culto di *Portunus* nella Roma arcaica e repubblicana, in: V. Gasparini (ed.), *Vestigia*, Stuttgart 2016, 81–98.

F. Diosono 2019
Il tempio del Foro: ricostruzione architettonica e ipotesi per una lettura del monumento nel quadro della colonizzazione medio-repubblicana, in: G. Battaglini, F. Coarelli and F. Diosono (a cura di), *Fregellae. Il tempio del foro e il tempio suburbano sulla via Latina* (Monumenti dell'Accademia dei Lincei), Roma 2019, 19–28.

F. Diosono *et al.*, 2019
F. Diosono, P. Braconi, G. D'Angelo, G. Ghini, A. La Notte and Le prime fasi edilizie del Tempio di Diana a Nemi, in: F. M. Cifarelli, S. Gatti, D. Palombi (a cura di), *Oltre Roma Medio-Repubblicana: il Lazio tra i Galli e Zama* (Atti del Convegno Roma 7–9 giugno 2017), Roma 2019, 383–390.

I. Edlund-Berry 2002
Etruscan Architectural Traditions: Local Creativity or Outside Influence, *EtrSt* 9, 2002, 37–43.

I. Edlund-Berry 2005
Architectural Theory and Practice: Vitruvian Principles and 'Full-scale Detail' Architectural Drawings, *MemAmAc* 50, 2005, 1–13.

I. Edlund-Berry 2006
The Etruscan Heritage in Postmodern Architecture, in: C. C. Mattusch, A. A. Donohue, and A. Brauer (eds.), *Proceedings of the XVIth International Congress of Classical Archaeology. Boston August 23–26, 2003. Common Ground: Archeology, Art, Science, and Humanities*, Oxford 2006,, 147–150.

I. Edlund-Berry 2008
The Language of Etrusco-Italic Architecture: New Perspectives on Tuscan Temples, *AJA* 112, 2008, 441–447.

I. Edlund-Berry 2013
The Architectural Heritage of Etruria, in: J.M. Turfa (ed.), *The Etruscan World*, London and New York 2013, 695–707.

I. Edlund-Berry 2014
Etruscan mouldings and Tarquinian sarcophagi, *Mediterranea* 11, 2014, 27–39.

I. Edlund-Berry 2016
Etruscan round and cyma reversa mouldings: the religious context of architectural mouldings in central Italy, in: A. Ancillotti, A. Calderini, and R. Massarelli (eds.), *Forme e strutture della religione nell'Italia mediana antica. Forms and Structures of Religion in Ancient Central Italy, III Convegno Internazionale dell'Istituto di Ricerche e Documentazione sugli Antichi Umbri, Perugia-Gubbio 21–25 September 2011*, Roma 2016, 265–278.

I. Edlund-Berry 2017
Greek, Western Greek, Etruscan, and Roman architectural mouldings: a question of cultural and regional identity, in: L. Cicala and B. Ferrara (eds.), *'Kithon Lydios' Studi di storia e archeologia con Giovanna Greco*, Napoli 2017, 759–767.

I. Edlund-Berry, "Cultural Frontiers", presented at *Ancient Architecture in Central Italy and Modern Perceptions of Cultural Frontiers*, at the international conference "Frontiers of the European Iron Age with a regional focus on Central Italy" at Magdalene College, Cambridge University, 20–22 September 2013. Submitted for publication.

ERRM 1965: see L. T. Shoe 1965

ERRM 2000: see L. T. Shoe Meritt and I. Edlund-Berry 2000

F. Fasolo and G. Gullini 1953
Il santuario della Fortuna Primigenia a Palestrina. Roma 1953.

A. Fino 2021
Decorazione architettonica in Sicilia dall'età arcaica alla romanizzazione. Una revisione dell'opera di Lucy T. Shoe. Roma 2021.

L. Fiorini 2011
Un Nuovo santuario extraurbano a Gubbio. Il tempio in loc. Caipicchi (Nogna), *Ostraka* 20:1-2, 2011, 39–47.

S. Franz 2016
Il tempio maggiore di Monte S. Angelo, a Terracina. La ricostruzione dell'architettura in base al nuovo rilievo, in: M. Valenti (ed.), *L'architettura del sacro in età romana*, Roma 2016, 15–22.

T. Fröhlich and A. Nicosia 2016
L'area dei templi repubblicani di Fabrateria Nova, in: M. Valenti (ed.), *L'architettura del sacro in età romana*, Roma 2016, 63–78.

U. Fusco 2013
Il Foro di Grumentum. Il Tempio D e le strutture adiacenti, *RM* 118, 2012, 223–269.

V. Gasparini 2014
Il culto di Giove a Pompei, *Vestigia* 6, 2014, 9–93.

Sir William Gell 1834
The Topography of Rome and Its Vicinity, vol. 1. Rome 1834.

G. Ghini and F. Diosono 2012a
Il Tempio di Diana a Nemi: una rilettura alla luce dei recenti scavi, in: G. Ghini and Z. Mari (eds.), *Lazio e Sabina* 8, Roma 2012, 269–276.

G. Ghini and F. Diosono 2012b
Il santuario di Diana a Nemi: recenti acquisizioni dai nuovi scavi, in: M. Torelli (ed.), *Ostraka* 2012 (volume speciale), 119–137.

L. Giardino 1981
Il tempietto di tipo italico, in: *Grumentum: la ricerca archeologica in un centro antico*, Galatina 1981, 39–42.

R. Ginouvès and R. Martin 1985
Dictionnaire méthodique de l'architecture grecque et romaine. Tome I. Matériaux, techniques de construction, techniques et forms du décor. Roma-Paris 1985.

M.G. Giuliano 2012
Illustrazione dei nuovi rilievi dei resti del tempio di Diana Tifatina, in: S. Quilici Gigli (ed.), *Carta archeologica e ricerche in Campania*, fascicolo 6, *Ricerche intorno al santuario di Diana Tifatina*, Roma 2012, 205–211.

M. Guaitoli 1974
Un tempio di età repubblicana a Formia, in: *Ricognizione archeologica e documentazione cartografica* (Quaderni dell'Istituto di Topografia Antica della Università di Roma VI), Roma 1974, 131–141.

Mrs. E. C. Hamilton Gray 1843
Tour to the Sepulchres of Etruria in 1839. London 1843 (3rd ed.).

M.-C. Hellmann 2002
L'architecture grecque, vol. 1. Paris 2002.

J. N. Hopkins 2016
The Genesis of Roman Architecture. New Haven and London 2016.

G. Iaculli 1993
Il tempio italico di Colle S. Giorgio (Castiglione Messer Raimondo). Penne 1993.

F. Inghirami 1825
Monumenti Etruschi o di Etrusco Nome, vol. 4. Fiesole 1825.

A. Jaia 2011
La decorazione plastica tardo arcaica del santuario di Sol Indiges, in: P. S. Lulof and C. Rescigno (eds.), *Deliciae Fictiles* IV, Oxford 2011, 188–193.

W. Johannowsky 1963
Relazione preliminare sugli scavi di Teano, *BdA* 48, 1963, 131–165.

H. Koch 1907
Hellenistische Architekturstücke in Capua, *RM* 22, 1907, 361–428.

H. Koch, E. von Merklin, and C. Weickert 1915
Bieda, *RM* 30, 1915, 161–310.

A. La Regina 1968
Ricerche sugli insediamenti vestini, *MemLinc* s. 8, 13, 1968, 363–446.

A. La Regina 1976
Il Sannio, in: P. Zanker (ed.), *Hellenismus in Mittelitalien*, I, Göttingen 1976, 219–254.

S. Lapenna 1997a
Iuvanum, in: A. Campanelli (ed.), *I luoghi degli dei. Sacro e natura nell'abruzzo italico*, Pescara 1997, 64–66.

S. Lapenna 1997b
Il santuario italico di Schiavi d'Abruzzo, in: A. Campanelli (ed.), *I luoghi degli dei. Sacro e natura nell'abruzzo italico*, Pescara 1997, 81–82.

S. Lapenna 1997c
Il tempio italico di Quadri, in: A. Campanelli (ed.), *I luoghi degli dei. Sacro e natura nell'abruzzo italico*, Pescara 1997, 68–69.

S. Lapenna (ed.) 2001
Schiavi d'Abruzzo. Sulmona 2001.

S. Lapenna 2006
L'acropoli iuvanense: il complesso templi-teatro,
in: S. Lapenna (ed.), *Iuvanum. L'area archeologica*,
Sulmona 2006, 59–65.

D. Liberatore 2019
Le terrecotte architettoniche di Colle San
Giorgio (TE): nuovi dati sul frontone, in:
P. S. Lulof and C. Rescigno (eds.), *Deliciae
Fictiles* V, Oxford-Philadelphia 2019, 329–342.

E. Lippolis 2009
L'Asklepieion di Fregellae: architettura, esigenze
rituali e forme di recezione del culto ellenistico
in ambito centro-italico, in: E. De Miro,
G. Sfameni Gasparro, and V. Calì (eds.),
Il culto di Asclepio nell'area mediterranea. Atti
del Convegno internazionale, Agrigento 20–22
novembre 2005, Roma 2009, 145–157.

E. Lippolis 2017
Il Capitolium, in E. Lippolis and M. Osanna
(eds.), *I pompeiani e i loro dei. Culti rituali e
funzioni sociali a Pompei*, Scienze dell'Antichità
22.3, 2016 (2017), 111–148.

LTUR
Lexicon Topographicum Urbis Romae I-VI, E. M.
Steinby (ed.), Roma 1993–2000.

G. Marasco and A. S. De Rose 2001
Il tempio della colonia latina di Isernia, III sec.
A.C., in: D. Catalano, N. Paone, and C. Terzani
(eds.), *Isernia*, Isernia 2001, 91–95.

E. Marini 2009–2010
A Study of the Architectonic Development of the
Great Funerary *Tumuli* in the Etruscan Necropo-
leis of Cerveteri, *EtrSt* 13, 2009–2010, 3–28.

A. Marquand 1906
On the Terms Cyma Recta and Cyma Reversa,
AJA 10, 1906, 282–288.

C. Mascione 2021
Etruscan-Roman Populonia: Recent Research
on the Sacred Area of the Acropolis, in:
A. Sebastiani and C. Megale, *Archaeological
Landscapes of Roman Etruria*, Turnhout 2021,
133–148.

L. Melillo Faenza 2012
Riflessioni e approfondimenti sullo scavo del
1993 del tempio di Diana Tifatina, in: S. Quilici

Gigli (ed.), *Carta archeologica e ricerche in Cam-
pania, 6 Ricerche intorno al santuario di Diana
Tifatina*, Roma 2012, 193–204.

I. Menale 2019
I. Menale, Lo scavo in località Quartaccio di Ceri
rivisitato, in: G.M. Della Fina (ed.) *AnnFaina* 26,
2019, 485–498.

R. Mengarelli 1940
L'evoluzione delle forme architettoniche nelle
tombe etrusche di Caere, in: *Atti del III Convegno
nazionale di storia dell'architettura*, Roma 1940,
1–17, pls. I-XV.

J. Mertens and G. Volpe 1999
Herdonia. Un itinerario storico-archeologico. Bari
1999.

G. Mesolella 2012
*La decorazione architettonica di Minturnae
Formiae Tarracina. L'età augustea e giulio-claudia*.
Roma 2012.

G. Messineo 1986
Il vicus di S. Rustico, in: L. Franchi Dell'Orto
(ed.), *La valle del medio e basso Vomano* II, Roma
1986, 136–166.

J. -P. Morel 1976
Le sanctuaire de Vastogirardi (Molise) et les
influences hellénistiques en Italie centrale, in:
P. Zanker (ed.), *Hellenismus in Mittelitalien*, I,
Göttingen 1976, 255–262.

C. Moser 2019
The Altars of Republican Rome and Latium.
Cambridge 2019.

A. Naso 1996
Osservazioni sull'origine dei tumuli monumenta-
li nell'Italia centrale, *OpRom* 20, 1996, 69–85.

A. Naso 2007
Etruscan Style of Dying: Funerary Architecture,
Tomb Groups, and Social Range at Caere and its
Hinterland during the Seventh-Sixth Centuries
B.C., in: N. Laneri (ed.), *Performing Death. Social
Analyses of Funerary Traditions in the Ancient Near
East and Mediterranean*, Chicago 2007, 141–162.

A. Naso 2015
Tumuli nei paesaggi funerari del Mediterraneo
e dell'Europa centrale, in: G.M. Della Fina (ed.),
*La delimitazione dello Spazio Funerario in Italia
dalla Protostoria all'Età Arcaica. Recinti, Circoli,
Tumuli*, *AnnFaina* 22, 2015, 29–59.

77

A. Naso 2016
Tumuli in the Western Mediterranean, 800–500
BC. A Review before the Istanbul Conference, in:
O. Henry and U. Kelp (eds.), *Tumulus as Sema.
Space, Politics, Culture and Religion in the First
Millennium BC*, Berlin-Boston 2016, 9–32.

I. Nielsen and B. Poulsen 1992
The Temple of Castor and Pollux. Rome 1992.

F. Orioli 1833
De' sepolcri etruschi di Norchia e Castellaccio
nel territorio di Viterbo, *AdI* 1833, 18–56.

D. Palombi 2003
Cora: bilancio storico e archeologico, *ArchClass*
54, 2003, 197–252.

D. Palombi 2008
Il tempio a divinità ignota sotto la chiesa di
S. Oliva, in: D. Palombi and P. F. Pistilli (eds.),
Il complesso monumentale di S. Oliva a Cori,
Tolentino (MC) 2008, 13–33.

A. Pasqualini 1966
Isernia, in: *Studi di urbanistica antica*, Roma
1966, 79–83.

P. Pensabene 2007
*Ostiensium marmorum decus et decor: studi archi-
tettonici, decorativi e archeometrici*. Roma 2007.

E. Percossi (ed.) 2001
Potentia. Quando poi scese il silenzio…, Milano
2001.

L. Petacco and C. Rescigno 2007
I saggi sul Capitolium e il settore occidentale
della piazza forense, in: *Cuma. Il foro. Scavi
dell'Università di Napoli Federico II, 2000–2001*,
Quaderni del Centro Studi Magna Grecia 5,
Studi Cumani 1, Pozzuoli 2007, 51–91.

PGM 1936: see L.T. Shoe 1936

S. Pittaccio 2001
*Il foro intramuraneo a Praeneste. Origini e
trasformazioni*. Roma 2001.

A. Pompei 1735
*Li cinque ordini dell'architettura civile di Michel
Sanmicheli*. Verona 1735.

Ch. R. Potts 2015
*Religious Architecture in Latium and Etruria c.
900–500 BC*. Oxford 2015.

PWGM 1952: see L.T. Shoe 1952

S. Quilici Gigli 2012
Il santuario di Diana Tifatina e il contesto topo-
grafico, in: S. Quilici Gigli (ed.), *Carta archeolo-
gica e ricerche in Campania, 6 Ricerche intorno al
santuario di Diana Tifatina*, Roma 2012, 9–190.

S. Quilici Gigli 2014
Il santuario di Diana Tifatina: squarci di imma-
gini nel Museo Provinciale Campano, *BStorArt* 9,
2014, 161–174.

J. C. Quinn and A. Wilson 2013
Capitolia, *JRS* 103, 2013, 117–173.

A. M. Reggiani 1987
Reate: avvio di un'indagine topografica, *Archeolo-
gia laziale* 8, 1987, 365–372.

C. Rescigno 2009
Osservazioni sulle architetture templari di Cuma
preromana, in: *Cuma*, Atti del XLVIII Convegno
di Studi sulla Magna Grecia, Taranto 27 settem-
bre – 1 ottobre 2008, Taranto 2009, 445–479.

M. A. Rizzo 2018
L'inizio dell'architettura monumentale a
Cerveteri: la tomba 1 del tumulo del Colonnello,
in: A. Naso and M. Botto (eds.), *Caere orientaliz-
zante. Nuove ricerche su città e necropoli* (Studia
Caeretana I), Roma 2018, 133–170.

G. Rosi 1925
Sepulchral Architecture as Illustrated by the
Rock Façades of Central Etruria: Part I, *JRS* 15,
1925, 1–59.

G. Rosi 1927
Sepulchral Architecture as Illustrated by the
Rock Façades of Central Etruria: Part II, *JRS* 17,
1927, 59–96.

P. C. Rossetto 1994–1996
Ritrovamenti nel Campo Marzio meridionale,
BullComm 96–97, 1994–1996, 197–200.

I. D. Rowland and T. N. Howe 1999
Vitruvius Ten Books on Architecture. Cambridge
1999.

M. G. Scapaticci 2014
Nuovi interventi nel santuario rupestre di
Macchia delle Valli, in: S. Steingräber (ed.),
L'Etruria meridionale rupestre, Roma 2014,
130–149.

L. T. Shoe 1936 (PGM)
Profiles of Greek Mouldings. Cambridge, Mass. 1936.

L. T. Shoe 1952 (PWGM)
Profiles of Western Greek Mouldings. Rome 1952.

L. T. Shoe 1965 (ERRM)
Etruscan and Republican Roman Mouldings. Rome 1965. (www.jstor.org/stable/4238656).

L. T. Shoe Meritt and I. Edlund-Berry 2000 (ERRM 2000)
Etruscan and Republican Roman Mouldings. A reissue of the Memoirs of the American Academy in Rome 28 (1965). Philadelphia 2000.

A. C. Smeaton 1883
The Builder's Pocket Companion; containing the elements of Building, Surveying, and Architcture. Philadelphia 1883.

S. Smith 2015
Sacred by Design: Expressing Latin Identity through Architectural Mouldings. (Diss. Royal Holloway, University of London 2015).

E. A. Stanco 2016
L'impianto urbanistico, in: A. Russo Tagliente, G. Ghini, and L. Caretta (eds.), *Lucus Feroniae il santuario, la città, il territorio,* Roma 2016, 77–82.

S. Steingräber (ed.) 2014
L'Etruria meridionale rupestre. Roma 2014.

T. D. Stek 2009
Cult places and cultural change in Republican Italy. Amsterdam 2009.

T. D. Stek and G.-J. L. M. Burgers (eds.) 2015
The Impact of Rome on Cult Places and Religious Practices in ancient Italy. London 2015.

T. D. Stek *et al.* 2015
An early Roman colonial landscape in the Apennine mountains: landscape archaeological research in the territory of *Aesernia* (Central-Southern Italy), *Analysis Archaeologica. An International Journal of Western Mediterranean Archaeology* 1, 2015, 229–291.

J. Stevens Curl and S. Wilson 2015
The Oxford Dictionary of Architecture. Oxford 2015 (3rd edition).

S. Stopponi 2002
Da Orvieto a Perugia: alcuni itinerari culturali,

in: G. M. Della Fina (ed.), *Perugia Etrusca, AnnFaina* 9, 2002, 229–257.

S. Stopponi 2011
Campo della Fiera at Orvieto: new discoveries, in: N. T. de Grummond and I. Edlund-Berry (eds.), *The Archaeology of Sanctuaries and Ritual in Etruria, JRA,* Portsmouth, Rhode Island, 2011, 16–44.

M. J. Strazzulla 1973
Il santuario sannitico di Pietrabbondante, Roma 1973.

A. Tanzilli (ed.) 2015
Sora. Chiesa Cattedrale Santa Maria Assunta. Roma 2015.

C. Terzani 1991
Aesernia, in: S. Capini and A. Di Niro, *Samnium. Archeologia del Molise,* Roma 1991, 225–228.

C. Terzani 2001
L'area sacra, in: D. Catalano, N. Paone, and C. Terzani (eds.), *Isernia,* Isernia 2001, 85–90.

M. Torelli 1999
Paestum Romana. Roma 1999.

V. Torrieri 2007
Tipologia, tecnica costruttiva e architettura, in: A. Campanelli (ed.), *Il tempio di Castel di Ieri,* Sulmona 2007, 67–96.

M. Valenti 2016
Il "Capitolium" e il tempio maggiore di Terracina, due esempi di podi templari a sostruzione cava. Caratteristiche tecnico-formali, funzione e terminologia, in: M. Valenti (ed.), *L'architettura del sacro in età romana,* Roma 2016, 49–59.

B. Vallori Márquez, M. Á. Cau Ontiveros, and M. Orfila Pons 2016
The small temples in the *forum* of *Pollentia* (Mallorca, Balearic islands), *MEFRA* 128:1, 2016, mis en ligne le 21 mars 2016, consulté le 07 mai 2019. URL : http://journals.openedition.org/mefra/3428 ; DOI : 10.4000/mefra.3428

F. Van Wonterghem 1976
Archäologische Zeugnisse spätrepublikanischer Zeit aus dem Gebiet der Peligner, in: P. Zanker (ed.), *Hellenismus in Mitteilitalien,* I, Göttingen 1976, 143–155.

F. Van Wonterghem 1979
Un tempio di età repubblicana sul foro di Herdonia ('tempio B'), *Ordona* 6, 1979, 41–81.

F. Van Wonterghem 1984
Forma Italiae IV:I *Superaequuum, Corfinium, Sulmo.* Firenze 1984.

M. Verzár-Bass 1986
Elementi lapidei del tempio e della *porticus*, in: F. Coarelli (ed.), *Fregellae 2: il santuario di Esculapio*, Roma 1986, 45–50.

J. Barozzi da Vignola 1770
Il Vignola illustrato, G. Spampani and C. Antonini (eds.), Roma 1770.

M. Vitti 2010
Note di topografia sull'area del Teatro di Marcello, *MEFRA* 122:2, 2010, 549–584.

C. H. Walker 2007
Theory of Mouldings. New York and London 2007 [reprint from 1926].

N. A. Winter 1990
Proceedings of the International Conference on Archaic Greek Architectural Terracottas, December 2–4, 1988, *Hesperia* 59:1, 1990, 1–323.

N. A. Winter 2009
Symbols of Wealth and Power. Architectural Terracotta Decoration in Etruria and Central Italy, 640–510 BC. Ann Arbor (MI) 2009.

N. A. Winter 2012
Monumentalization of the Etruscan Round Moulding in sixth-century BCE Central Italy, in: M. L. Thomas and G. E. Meyers (eds.), *Monumentality in Etruscan and Early Roman Architecture. Ideology and Innovation,* Austin, TX 2012, 61–81.

N. A. Winter 2017
Traders and Refugees: Contributions to Etruscan Architecture, *EtrSt* 20, 2017, 123–151.

M. Wolf 2015
Hellenistische Sakralbauten in Kampanien. Ein Vorbericht, *RM* 121, 2015, 83–114.

F. Zevi 1989
Note di archeologia prenestina: il santuario della Fortuna e il tempio di Giove sotto la cattedrale di S. Agapito, in: *Urbanistica ed architettura dell'antica Praeneste: Atti del convegno di studi archeologici, Palestrina 16/17.4.1988*, Palestrina 1989, 33–46.

F. Zevi 2012
Culti ed edifici templari di Ostia, in: *Sacra Nominis Latini*, M. Torelli (ed.), *Ostraka* 2012 (volume speciale), 537–563.

S. Zink, J. Pflug, and M. Ceci 2020
How a Temple Survives. Resilience and Architectural Design at Temple A of Largo Argentina in Rome, *RM* 121, 2020, 387–427.

IMAGES, IMAGERY AND PERCEPTION IN EARLY ETRUSCAN SOCIETIES

ANNETTE RATHJE

Images were invented before writing; images facilitate memory as they can be stored whereas spoken words cannot, and one of the reasons for writing was the growing need for storage.[1] Among mammals, humankind is the only image-maker. Thus, images constitute an anthropological phenomenon, present many thousands of years before writing. In his article about *homo pictor*, Hans Jonas states that "the artifacts of animals have a direct physical use in the promotion of vital ends, such as nutrition, reproduction and hibernation".[2] Think of the paradise birds: the males compete to build the nests, and the females choose the finest nest and not the finest male. We have learnt that in the beginning was the Word (John 1:1), but we could, rather, also say: in the beginning was the image. An object or an image can function as a materialized metaphor with no need of words, and we have nonverbal narratives. Images may depict and objects may refer to visual narratives.[3]

What is an image? Together with the semiotic philosopher Charles S. Peirce, I suggest an image to be a figurative *representamen*: an image is a figurative representation, which in some respect or capacity means something to someone.[4] Representation is defined as a substitution *for* reality, and as an imitation *of* reality.[5] Thus, images are iconographic documents. By studying the human use of objects in various contexts, we might be able to reach imaginary contexts, whether ritualized or not. Images are powerful. In the preface to her study on Etruscan religion, Nancy de Grummond eloquently stated that we must forego studying Etruscan myth as a reflexion of Greek mythology: "There is a tendency to turn away from and ignore the representations that cannot be explained easily", and she urges us to "start with the images themselves."[6] I took up that challenge when treating a group of vessels in which an image has been integrated with the function of the object: out-turned human figures in the round used for

handles or handle-tops, underlining "eye contact" when pouring. Refer-
ring to the power of their bodies, I have suggested their use for specific rites
in connection with the *rites de passage* from being a living person to being
dead in the otherworld.[7]

When dealing with the culture of images in Antiquity, the Greek-Roman
culture is often emphasized at the expense of others.[8] However, images are
relevant to all cultures, although they are not always what they seem to be.
Modern humans are used to seeing all sorts of visual representations; pic-
tures surround us in an extreme complexity, with or without any context.
It could be argued that we are overfed with images and therefore are not
receptive to them any more – or at least to a lesser extent.

This article is not meant to be a theoretical contribution on imagery, or
to follow an ongoing transdisciplinary debate.[9] I take it from the "bot-
tom up" by discussing material culture empirically, dealing with images on
objects, objects as images and *simulacra* from funerary, that is sacred, con-
texts. In Peircian terms, I focus on a certain kind of representation in some
specific "respect or capacity". When studying ancient societies, we must
bear in mind that their images contained a contextual meaning when they
were produced, as well as a meaning in the minds of the viewers. Images
are constructions and they were meant to express and arouse emotions. To
understand images, you must comprehend the mentality of the period in
question so as to be able to decode consciously-chosen metaphors and mes-
sages. We must trace the imaginary and its reality, the image producing
processes, internal and external, mental and factual, as they are embedded
in a historical-cultural course. As archaeologists, we must highlight the
archaeological potential of many forms of visual representation, and ana-
lyze the use of images and their meanings in past societies in order to come
closer to the reality of the imaginary.

Premises

This contribution is a work in progress,[10] an attempt to realize how much
we can squeeze from the evidence of images from a specific cultural context
– that of *the early Etruscans.* Most of what we have come to know about
the Etruscans has been obtained through painstaking archaeological stud-
ies. These people tell us very little about themselves. We have no literature,
no historical record and no philosophy from their hand; all we have is the
selective evidence from other peoples, *in casu* the Greeks and the Romans.

When dealing with these statements we always have to ask which specific Etruscans, in time and space, are intended, described and analyzed? And by whom? And why? Nevertheless, we do not classify the Etruscans as being illiterate. When is a society literate? The Etruscan societies could be defined as both illiterate and literate, depending on time and context, and there is much evidence that has been lost.[11] The meaning of images is intelligible only with great difficulty when explanatory texts are missing, as is the case with the early Etruscan society, and a specific visual representation can have several meanings. Henry David Thoreau allegedly put it thus: "The question is not what you look at, but what you see."[12] The brain creates what you see of the reality (the seen reality); the experience of sight is a complicated process in which the brain combines information from the eyes with experiences stored in networks between billions of nerve cells.

Images on objects

The first examples of figurative images from the early Etruscans are found on Villanovan bronze and ceramic objects. Bronze scabbards and razors show representations of deer hunting with schematical figures. The different hands of artisans can be recognized, although the animals cannot always be easily defined (**Figs. 1–2**).[13]

A bronze sword with its scabbard was found in a warrior's tomb at Tarquinia. It was engraved with a series of panels in a geometric decoration (**Figs. 1a– 2a**).[14] We see a man pointing a spear at a short-legged animal. Hugh Hencken suggests it represents a wild boar; I would suggest, rather, a fox. Then follows a panel with a dear and a hound. The next panel shows two more deer, while the last panel contains an ornament formed as a very naturalistic leaf. I prefer to see a boar in the bristly furred animal on another scabbard that is being pierced from the front by a man and attacked in its behind by a dog (**Figs. 1b–2b**).[15] The same kind of animal is seen on the lid of an urn from Pontecagnano near Salerno,[16] unless the animal is a hybrid. Another scabbard, also from Pontecagnano (**Figs. 1d–2d**), shows three panels representing animals of the forest, a stag with two hounds, followed by two pairs of deer.[17] If the hunter is absent, is this representation an abbreviation for a hunting scene? Quite another scene is represented on yet another scabbard from Pontecagnano (**Figs. 1c–2c**): a man holds his spear in his right hand in a horizontal position, with the spearhead pointing away from the stag at his side.[18] His left arm is bent and ends

Fig. 1 and 2 Hunting and forest
scenes on scabbards and razors.
(Drawings by Thora Fisker, adapted
from Bianco Peroni 1970; 1979 and
Gastaldi 1998).
a Bianco Peroni 1970, 85 no.209;
b Bianco Peroni 1970, 88–89 no.228;
c Gastaldi 1998, 43 fig.29;
d Bianco Peroni 1970, 84 no.206;
e Bianco Peroni 1979, 70 no.363;
f Bianco Peroni 1979, 127 no.746

at the mouth of the animal. Behind the stag, a
dog is seen with an upturned tail. It looks as
if the man is caressing the stag, thus remind-
ing us of the representation on the painting in
the pediment of the back wall in the Tomb of
the Painted Lions at Cerveteri (Fig. 3).[19] Here,
a man is seen between two standing lions, with
his arms around their necks – not like the well-

known Near Eastern scheme of the "master of the animals",[20] but caressing them, rather, as equals.

On a bronze razor from Bologna, we discern a man (?)[21] (without his head and with a strange bough-like right arm) who is armed with a bow and who seems to have lassoed a stag (**Figs. 1f–2f**). On the other side of this object is represented an axe with a bent shaft. Images of axes like this have been found on razors from Bologna, Terni, Fermo, Tarquinia and Veii, while hunting scenes are mostly known from Tarquinia and Bologna.[22] An

Fig. 3 Tomba dei
Leoni Dipinti, Cerveteri.
Watercolour by
M. Baroso (1910–1913).
(After Steingräber 1985,
pl. 187).

example from Vetulonia (**Figs. 1e–2e**) shows (from the right) a man aiming at a stag with his bow; in front of the stag a hind is looking back while another hind and a young deer are heading forwards.[23] These razors, as functional objects, are seen as belonging to the *rites de passage* from puberty to adulthood.[24]

The hunter is met again on the impasto helmet/urn lid from Pontecagnano, in which the man is seen with legs wide apart between a stag and a boar (?) and raising his spear.[25] Representations of deer are also found connected to women, as stags appear on bronze belts found in high status female tombs at Veii, such as Tomb I 17, Quattro Fontanili.[26] Thus, the meaning of these animals can be connected to aristocratic life, although we have no evidence of huntresses.

In the case of the swords, we might understand that the rare examples with this kind of decoration evoke the warrior as a hunter. To my knowledge, there are no representations of fights on Etruscan scabbards, and evidently no hunt is shown where the hunter uses a sword. On the scabbards, he always uses a lance; on the razors, he is equipped with a bow and a lasso, the animals are woodland creatures, and one may ask if the leaf seen on the scabbard (**Figs. 1a–2a**) represents an abbreviation for a tree or trees or forest. Bows have not been found in the graves. Yet, battle scenes are found on jewellery, as seen on the gold fibula from Vulci in Munich.[27]

What kind of narrative are we dealing with? Probably the idea of a "Beyond". The beings described can be human, hybrids, and/or divine, and they can be seen to be travelling to the "Other Side". An eventual narrative is represented through the help of symbols and abbreviations.[28] The hunt can refer to an "aristocratic" life style: hunting has always been a good exercise for warriors. However, the difficulty of identifying the beings shown could point to transition, and the idea of eternal hunts in the beyond cannot be excluded.

Objects as images

Let us look at the context of the Tarquinian tomb that contained the scabbard (**Figs. 1a–2a**). Two strikingly rich cremation burials, Poggio dell'Impiccato I (cist) and II (pit), are part of a small group distinguished from other tombs at the site by their position on the hill (they were probably family), and by the type of burials as the urns have been laid down and thus the urn/body is represented as if being inhumated, intended as a kind of pseudo-inhumation.[29] Filippo Delpino has dedicated a thorough study to this phenomenon, reconstructing the placing of the different objects in the tombs from the notes of the excavator.[30] The urn/body of the deceased (**Fig. 4**) was dressed with clothes traced with fibulae and ornaments made of gold sheet; probably the sword was placed around the belly of the urn, as the bronze rings and hooks seem to have belonged to a belt. The handle of the sword was at the right side of the urn. A necklace was around the neck of the urn, which was covered with a lavishly decorated crested bronze helmet. To the right of the body was a fine handled bronze cup, to the left a large shell of *Charonia nofifera,* used for making sounds, and a ritual vessel, a bronze pyxis with a chain for suspension.[31] On the other side of the sword was the lance-head and tip of bronze, and at the feet impasto vessels for a commensality or "banquet", and a double ritual vessel. The ceramics found were not distinguished from those from other tombs.[32]

An intertwined relationship between conception and representation is seen. The urn represents the deceased, the helmet the head of the warrior and perhaps the shell was meant to be used for blowing war signals. The ritual vessels and "banquet" equipment, together with the weapons, represent the eminent role and rank of the deceased. This is the *mise en scène* of an eminent warrior.

The Poggio dell'Impiccato Tomb II (**Fig. 5**) gives us a different image.

The urn was dressed, as witnessed by the ornaments of gold sheet, and it was then placed between two highly decorated hemispherical bowls, of which the topmost one seems to represent a cap helmet. The decoration on the front represents eyes, nose and a mouth, thus forming a mask. Delpino

Fig. 4 Poggio dell'Impicato I, Tarquinii. (After Delpino 2008, fig.5).

argues that the two bowls had been made expressly for the tomb, as they belong together. At the urn's right is the lance-head and tip, at the left two impasto drinking cups. All the other objects, among which was a razor, were found inside the urn. The metaphor of the deceased has no need of

Fig. 5 Poggio dell'impicato II, Tarquinii. (After Delpino 2008, fig.7).

symbols of role and rank, there is no need of sword, neither of "banquet"-equipment, the urn=body has taken the space. The self-representation shows an aristocrat who had not won but probably inherited his power. Delpino connected these tombs with extraordinary inhumations placed inside the habitations, recalling the unifying values and persons of these societies.[33] I would add that these urns are personal identifiers, as well as indication of membership of a group.

I will now turn to the last part of the Iron Age, a period that bears witness to a veritable revolution in the actual spectrum of images. The contexts treated are still funerary and belonged to the highest echelons. Many of these tombs however, do not render, or did not render even when excavated, the total *mise en scène*.

In the early Iron Age, few animals were represented, apart from the very rare hunting scenes mentioned above. The repertoire included birds, fish and horses, while a "new wave" of the late Iron Age, the so-called Orientalizing period (750–575 BCE) brings representations of fantastic and real animals, among which exotic felines are very common. The Etruscans made a clear distinction between the sizes and the fur of the various species. Probably fur, as well as live animals, were imported, together with exotic objects of precious metals, bronze, ivory, shells and textiles, which all characterize – or, rather, have become icons of – the circulation of goods in the Mediterranean in this period.

In an attempt to contextualize the images,[34] I have argued that the painted representations of felines in the tombs of this period represent escorts to the other world.[35] Big cats are definitely the most popular motif. Out of eleven painted tombs, three also have representations of human figures, although they are rather schematic.

The fact that objects can be understood as images makes it possible to expand the concept to the space of the tomb as such. The Tomb of the Painted Lions at Cerveteri (**Fig. 3**) shows parts of lions painted on the walls of the two lateral chambers as well as those of the "sala a pilastri".[36] In the right side-chamber, lions are seen moving towards the rear wall – that is, towards an image in the pediment that, at first sight, shows the familiar master of the beasts. However, here the man with legs wide apart and the standing or walking animals of the same size seem to be his equals, as it looks as if he is caressing them; no violence is shown, as in the well-known representations from the Near East. This representation could be interpret-

ed as a metaphor for triumph over death. Does the man belong to another sphere? Is he buried in the tomb?

The Tomb of the Painted Animals, also at Cerveteri, represents a hunter with a bow, while the lions are preying upon a deer and a ram.[37] Both this tomb and the Campana Tomb in Veii[38] are painted in two panels, the paintings thus appearing like a tapestry.[39] I shall leave aside the paintings in the Tomb of the Painted Animals as they, too, are blurred. As for the Campana Tomb (**Fig. 6**), I have chosen to believe that the drawing is genuine, as the single motives are known from elsewhere,[40] being well aware that Delpino has argued that the colours were manipulated after the excavation.[41]

In the Campana Tomb the paintings covered the back wall of the first chamber, on either side of the opening to the inner chamber. This is the only tomb to have *phytomorphic* filling ornaments. These plant motifs clearly refer to the Near Eastern Tree of Life; in this case, however, they have been fragmented, filling the space between the humans and the animals, real or not. To the left, a small man is riding towards the opening; behind him a seated feline is looking back. Below this a lion is walking towards the opening, with its tongue hanging out. Beneath, a seated dog is turning its head against the lion; behind the dog, a small feline is seated with an upraised paw. To the right, another small man is riding towards the opening; a large person leads, carrying an axe over his left shoulder, a *lictor*, and behind him walks another large man who appears to be holding the horse. Behind the horseman, a hunting leopard is seen on the horse, and on the ground a dog is moving forward and turning its head back. On the lower panel, a winged sphinx is moving towards the opening; below, a smaller deer; and behind the sphinx is a sitting feline with forelegs raised looking out of the picture. All others are seen in profile. Felines and sphinx frame the two riders in a heraldic scheme, and the principle figures are all moving towards the opening or axis of the back chamber. Stephan Steingräber has rightly characterized this picture as an abstract and metaphoric figuration, "un linguaggio fantastico".[42] I see this image as the owner of the tomb, followed by a lictor on his way to "the other side"; the hunting leopard and the dogs refer to hunting, as we have seen in the examples from the early Iron Age mentioned above.[43]

The cult of the dead and the belief in another world is continued from the earlier Iron age. Feline escorts, which are powerful but never aggres-

Fig. 6 Tomba Campana, Veii. Copy made in 1897, Ny Carlsberg Glyptotek Copenhagen, Inv. No. 1604. (Museum photo).

sive, might be compared to the figures of Vanth and Charu in later times.[44] Surely they represent the liminal space between the world of the living and the world of the dead. It is a great pity that we do not have the grave goods from these tombs as this would have helped us to reconstruct the burials in their entirety.

An image of the "in-between" comes from Tolle at Chianciano Terme in the territory of Chiusi, on an impasto situla from a chamber tomb of the 7th century BC.[45] This vessel is decorated with reliefs on its sides

and on the lid (**Fig. 7**). The sides are covered with two rows of winged creatures with lion's bodies; in the lower row, indefinable beings are seen, while the beings of the upper row have moulded, out-turned griffin heads. Moulded griffin heads are placed at the tails, so that these heads form a "wreath" around the vessel. Between the two rows, a figure resembling a human being with a very short tail climbs upwards on all fours, and he, like the creatures in the upper row, has an out-turned griffin head. On the lid, zoomorphic beings (griffins and centaurs?) are sitting, alternating

Fig. 7 Impasto situla-shaped vase from Tolle, tomba 704, Museo Civico Archeologico Chianciano Terme. (Photo courtesy of G. Paolucci).

with seated human beings with griffin heads – all have out-turned heads. They form a ring around a moulded water bird.

Giulio Paolucci has interpreted this image as the figuration of a *rite de passage,* a transition from human existence to being in the other world. By being transformed into a hybrid animal, one is able to overcome this final transition.[46] The waterfowl shows the way, an interpretation that is, to my mind, not improbable.[47]

It is interesting to compare this vessel with the moulded decoration on a cinerary urn from Montescudaio, in the territory of Volterra[48] (**Fig. 8**). On this impasto vessel, a bearded man is sitting on the handle looking out-wards. His arms are outspread while his hands are placed on his knees. He wears a hat (indistinguishable, since the vessel is broken). On the lid, a man,

94

Fig. 8 Cinerary urn from Montescudaio, territory of Volterra, Museo Archeologico Nazionale Firenze, Inv. No. 82930. Su concessione del Museo Archeologico Nazionale di Firenze (Direzione regionale Musei della Toscana).

seemingly the same person, is seated at a well-supplied table. He raises his right arm in a gesture, as if for a toast or a fill-up. A smaller woman stands at his side on a footstool, raising a fan with her right hand and holding up her left arm, too; since it is broken at the shoulder, we are missing her gesture/movement. Is she holding a jug, being about to serve, or has she just served him? At her left is a large, footed, mixing vessel for wine. Another large vessel seems to have broken off.[49] These figures in the round represent one of the first banquet scenes in Etruria. We understand the man as the deceased, buried in the urn, so he has already passed the transitional, liminal zone and is now seated at the eternal meal on the other side. These two vessels, analyzed above, are rare examples of moulded renderings of the passage to the otherworld.

Another group shall also be included here. Etruscan tombs are interpreted as the dwellings of the dead with doors, windows, furniture like thrones, stools and beds; this is especially well known from Cerveteri and its territory. The tombs in the territory of Chiusi have left some special images of the dead, the so-called canopic urns, anthropomorphic cinerary urns, that bring to mind the burials from Tarquinia discussed at the beginning. For years, canopic urns of impasto were known mostly out of context and were valued as extraordinary museum pieces.[50] New evidence from regular excavations of intact tombs has given us a valuable insight into a new corpus of these urns produced between 680/670– 580/570, firstly in single burials (mostly *a ziro*), and from 630/620 BC in family chamber tombs.[51] The evolution of this kind of urn has been connected to figurative experiments in the area of Vulci.[52] From the same Chiusine area, we have bronze urns with wooden heads covered with masks of gold foil and inlaid eyes of bone and amber, and evidently dressed and placed in the tombs seated at a banquet, as in the scene of the Montescudaio urn mentioned above. A fine example is from the undisturbed tomb Tumulo dei Morelli from Chianciano Terme, from about 600 BC.[53] Characteristic for both types, the impasto and the bronze and poly-material urns, is the anthropomorphic rendering, and the fact that the urns were dressed. The heads of the canopic urns may be simply hemispheric;[54] they may wear masks,[55] have inlaid eyes,[56] and faces rendered more or less naturally, either with or without hair, like the two urns from the tomb of Macchiapiana at Sarteano (**Fig. 9**). The female urn is placed on a throne of stone; she is wearing earrings and her baldness suggests that she wore a wig. Both urns from this tomb had moveable forearms placed in the band-handles on the shoulder of the vessel. The hands are held closed downwards as if holding perhaps a shaft in front of the body. In the museum the figure has been restored with an axe, showing the power of this woman.[57] Many urns have arms; the urn from the *a ziro* burial Tomb 729 from Tolle (**Fig. 10**) has a hemispherical lid. However, the relief-like arms from the shoulder of the vessel, with fingers indicated, leave no doubt as to the human nature of it.[58] The position of the hands varies from urn to urn. For the most part they are placed forward, on the "stomach". One may notice the upturned, oversized thumbs on the urn from Tolle, Tomb 401 (**Fig. 11**), which surely had a meaning.[59] Giulio Paolucci convincingly argues that these anthropomorphic urns are indicators of social prestige.[60] The urns are representations of the dead;

Fig. 9 Tomba Macchiapiana in the Museo Archeologico di Sarteano. (Museum photo).

Fig. 10 Cinerary urn from Tolle, Tomba 729. (Photo courtesy of G. Paolucci).

Fig. 11 Burial from Tolle, Tomba 401, in the Museo Civico Archeologico Chianciano Terme. (Museum photo via Flickr).

they give the final image of persons forever young (at least the more naturalistic ones), placed in the tomb with food (as eggs and the bones of fowl were present) and with banquet equipment and weapons. The whole set-up of the tomb is an image, an installation, which would be remembered by the surviving relatives at the funeral, and would, not to forget, make a great impression on the supernatural beings from the otherworld. A new detailed contextual understanding should be possible when the results of the ongoing analysis of the grave goods are published.[61]

Simulacra

The last group to be mentioned is that of the anthropomorphic *simulacra* – images of the dead, assembled of various parts made of different materials such as wood, textile, ivory, bone and metal. Recently, such a natural-sized figure was found in the Osteria Necropolis at Vulci, Tomb 1 (the so-called

Fig. 12 Assemblage from Tomba del Carro, Vulci in Museo Nazionale Etrusco di Villa Giulia. (© Museo Nazionale Etrusco di Villa Giulia. Photo Mauro Benedetti).

Tomb of the Silver Hands).[62] It represents a woman lavishly dressed and covered by a veil, ornamented with miniature buttons of gilded bronze and, furthermore, ornamented with necklaces of different forms and materials. Such figures have mainly been found in the area of Vulci, a site with many new spectacular finds.[63] At Vulci, the tombs with *simulacra* lie close to each other in the necropolis, indicating a deliberate choice of burial space and the self-representation of a specific elite group. Similar representations have also been found at Marsiliana d'Albegna. They are never found in sanctuaries, as we know them from Greece.[64] A fine example is the Tomb of the Chariot, on display in the Villa Giulia Museum, Rome (**Fig. 12**).[65] The single chamber tomb contained the burial of an eminent man. Two *simulacra* were found, one standing in a bronze chariot, a symbol of status in the 7th century BC, the other standing behind. The chariot was of reduced size, thus being merely symbolic.[66] The figures had spheric heads, with no

indication of a face and probably wore wigs. Bust and hands are all made of embossed bronze, and they were dressed. The bones from a cremation were found in a bronze cauldron, representing a type of a heroic burial well known from Greece. However, in this tomb, three or four persons were buried together,[67] with some lavish banqueting equipment of bronze and ceramic, including remnants of food: meat, fruits and nuts. Anna Maria Sgubini Moretti sees the two figures as a *parabates* and a charioteer. However, I am not convinced by this interpretation. When seen together with the evidence from the Chiusine area, we may understand these figures as embodying the deceased, although they are not ash containers – and are found in inhumation burials as well. They are representations of distinguished people of both sexes from the *stratum* of landowners, in control of production and commerce, as can be seen from the objects buried with them that refer to the banquet, implying the eating of meat as indicated by spits, an axe and a knife.

The message is ambiguous: the Etruscan tomb is both a house/home and a liminal space. A tomb is more than a burial place: it is also a place of cult practices and a ritual site. The banqueting seemingly takes place in the tomb, connected to funerary rituals, yet it also refers to meals in the world of the living as well as to the otherworld and the eternal banquets.

However, we must look at the entire situation, collecting the fragments of an image, a *mise en scène*, an installation that would have once contained much more organic material which has now perished. We can only imagine the procession of people bringing the deceased and the grave goods to the tomb for the construction of the installation there.[68] The last image of the personified dead in these urns, and the *simulacra* immortalized in the tomb at the same time, were travellers to the otherworld; they were becoming ancestors. They are not to be classified as temporary pictures.[69] These figures have been understood as deified, when placed on thrones like the man in the Tumulo dei Morelli at Chianciano Terme. A few have been identified with gods, like the more naturalistic, half-bronze statue that was part of a poly-material statue from the Isis Tomb from Vulci, now in the British Museum.[70]

This contribution has considered different categories of evidence for belief in the afterlife of some early Etruscans by studying images meant for funerary purposes and contributing to an ideological understanding.

Images, in my wider definition, were used for ritual practice and religious ideologies; they conveyed ideas and discourses, through the use of powerful symbols. The tombs analyzed have shown patterns of symbolic communication[71] in Etruria, which is defined as a vast territory with different cultural areas that must be distinguished from each other. The tendency to valuate texts written by others, and in later periods, more than the images themselves, has distorted our understanding of these pre-Roman peoples. I hope to have shown a roadmap by this case study, although I am well aware that I have more questions than answers and that there are no single explanations when exploring ambiguous images, messages and identity-construction.

NOTES

Earlier versions of this contribution have been given as papers at the Accordia Research Institute, London, at the University of Groningen, The Netherlands, and at the University of Copenhagen.

1 Whitehouse 2020, 184–185.
2 Jonas 1962, 203.
3 Wagner Durand 2019, 1, 5.
4 Peirce 1897, CP 2.228.
5 Ginzburg 1998, 82.
6 de Grummond 2006, xxii.
7 Rathje 2013a, 118.
8 Hölscher 2018; *Homo Pictor* 2020.
9 See e.g. Renfrew and Morley 2007.
10 This contribution is not an art-historical paper, neither is it a contribution to the ongoing debate about cultural hybridity; nor is it a discussion about the value of Etruscan visual expression when compared to, for instance, Greek visual culture.
11 *Etruscan Literacy* 2020.
12 Journal 5 August 1851. Oxford essential quotations.
13 For a list of animals represented in the Iron Age, see Drago Troccoli 2013a, 16: bovine, birds, horses, dogs, sheep, deer, turtles, reptiles and monkeys; and Drago Troccoli 2013b, 139 reference 31.
14 Hencken 1968, 115– 123, for the scabbard 117–118, and fig. 106; Iaia 1999, pp. 54–55; Iaia compares to a scabbard from Tomb Arcatelle 37, Tarquinia, fig. 14, p. 56. I deliberately leave out the non-figurative decoration.

15 Bianco Peroni 1970, 88–89 no. 228 without context.
16 Drago Troccoli 2013b, 142, fig. 17.
17 Pontecagnano 494, Bianco Peroni 1970, 84 no. 206.
18 Pontecagnano T. 5121, Gastaldi 1998, 43 fig. 29.
19 Steingräber 1985, 261, no. 6; Naso 1990, 479–481.
20 Rathje 2013b, 157.
21 Drago Troccoli 2013b, 136 argues that this kind of representation may represent a being from the other world.
22 Bianco Peroni 1979, no. 746.
23 Bianco Peroni 1979, no. 363; Iaia 2013, 80, fig. 5c.
24 Iaia 1999, 117; Iaia 2013, 80–81.
25 Cf. reference 7.
26 Drago Troccoli 2013a, 19 and fig. 17; she does not identify the bristly animal: ..lascia aperta… l'interpretazione della "bestia" dal corpo triangolare irsuto con fauci spalancate e zanne."
27 München Antikensamlung 2331; Pacciarelli 2002, 315– 322; Sannibale 2008, 349.
28 Drago Troccoli 2013b, 137–139.
29 Delpino 2005, 344 tomba a cassa di nenfro (I) fossa con pareti vestite di tufo (II) are very rare "strutture particolari" the oblong form imitating inhumation tombs. Pseudo inhumations are also found at the necropolis of Villa Bruschi-Falgari Tombs 21,44, 58, cf. Barbaro *et al.* 2012; Vulci Tomb LXXXIII

(Necropoli di Cuccumella), Casi-Petiti 2014, 25.

30 Delpino 2005, 345 ref. 22.

31 Delpino 2005, 346.

32 Delpino 2005, Table III, shows items that could not be placed in the reconstruction; a razor, however, was found inside the urn.

33 Delpino 2008, 606, 608: "con il ricorso ad un uso sempre più marcatamente ideologico e propagandistico dei rituali funerari: funzionale a questi fini potrebbe essere stata la messa in scena, per così dire, di pseudo-inumazioni, con il richiamo a valori, miti e persone ("sacro", "sacrificio", "fondatori") sentiti dalla comunità come unificanti."

34 Following Watanabe 2015.

35 Rathje 2013b, an overview of the tombs are listed on fig. 2: Veii (2), Cerveteri (5) Tarquinia (1), Chiusi (1), Sant' Andrea/ Magliano (1), San Giuliano (1). Fig 3 shows direction movements of the felines in ten tombs.

36 Rizzo 1989, 117–119; Naso 1990.

37 Rizzo 1989, 113–116; the drawings are too bad to be used in this context, so I defer from any description; Naso 1990, 478.

38 Rizzo 1989, 109–111; Naso 1990.

39 See Delpino 2012 about the actual excavation; the most credible colours are those on the facsimilie of the Ny Carlsberg Glyptotek, Moltesen & Weber-Lehmann 1991, 138 no. 122; see also Capoferro & Renzetti 2017, 314–317 nrs. 160–166.

40 Rathje 2013, 159.

41 Delpino 2012, 102.

42 Steingräber 2006, 59.

43 Naso 1990, 464–465: corteo funebre verso l'aldilà, and calling the man before the horse "demone".

44 Later, in the archaic period, the style of tomb paintings changed: the big felines did not disappear, but they changed place from the walls to the pediments. Their magic was still there and they were necessary in easing the passage for the dead.

45 Paolucci 2013; Etruschi 2019, 291, nr. 219.

46 Paolucci 2013, 37–38.

47 Drago Troccoli 2013b, 157 about transfiguration; Carapellucci & Drago Troccoli 2015, 97–98 about the water birds.

48 Nicosia 1969, 369–401; Maggiani & Paolucci 2005, 4.

49 Nicosia 1969, 389.

50 Paolucci 2015, 1–20; this volume is an update of R. D. Gempeler, Die Etruskische Canopen. Herstellung, Typologie, Entwicklungsgeschichte, Einsiedln 1974, cf. Appendices 381–390.

51 Paolucci 2015. About family tombs, cf. Paolucci 2015, 379; a fine example of a family tomb is Tolle T. 116: Paolucci 2015, 61–68, including the burials of a father, mother and son. The tombs are splendidly presented in the museums of Chianciano Terme and Sarteano.

52 Paolucci 2010, 109; Carosi and Regoli 2019, 76, fig. 5.

53 Paolucci and Rastrelli 2006, 17–22: on the wooden head and the gold foil; cf. also Paolucci 2015, 364 about golden masks from Tolle and elsewhere at Chiusi and Vulci; Maggiani 2020, 188–189.

54 In T. 585, the urn is an olla covered by a bowl placed bottom down with moulded eyes, nose and ears, and incised hair; Paolucci 2015, 220–222.

55 Paolucci 2019, 288 nr. 216 =Paolucci 2015, T. 462 p. 173–176, tav. CXXVI c, fig. 154, cfr. Tav. CCLXXXVII; Tomb 401, 135–138.

56 Paolucci 2019, 292, nr. 220= Paolucci 2015, T. 203, 83–84; T. 513, 192–194.

57 Paolucci 2015, 365.

58 Paolucci 2015, Type I (675–650), fig. 271, tav. CCXLVIII.

59 In his typology of urns, Paolucci analyzes heads and masks: 358–366, and movable arms: 355–357. As for the enlarged upturned thumbs, they are seen in T. 401, T. 582, fig. 189 and T. 659 fig. 219, cf. T. 503, fig 165: here, the left hand is held in front of the body with the thumb up, as we find it in T. 62 fig. 39. For the significance of hands see Rathje 2017, 173.

60 Paolucci 2015, 378.

61 We are looking forward to reading the results of the work of Mattia Bischeri, PhD fellow at La Sapienza, University of Rome.

62 Russo 2014; Carosi 2016.

63 Vulci: Tomba del Carro di Bronzo, Tomba C from Mandrione di Cavalupo, Tomba della Sfinge, Tomba dell' Iside; Marsiliana d'Albegna: Circolo della Fibula (T. 41), Circolo degli Avori (T.67); Morandi 2013 gives a thorough analysis without the Tomb of the Silver Hands; Carosi and Regoli 2019.

64 Russo 2014, 29.

65 Sgubini Moretti 2000.

66 Emiliozzi 2014, 33, also mentioning fragmentary finds of chariots not recognized earlier, like those from Tomba degli Animali Dipinti and Tomba dei Leoni Dipinti at Cerveteri.

67 Sadly, we are missing a proper publication.

68 A new trend is sensory archaeology, Skeates and Day 2020.

69 Rüpke 2006, 270.
70 Maggiani & Paolucci 2006, 17 ref. 17;
 Morandi 2013, 25–26; for the figure in the

Isis tomb, see Bubenheimer-Erhart 2012,
114–116.
71 Nebelsick 2016.

BIBLIOGRAPHY.

B. Barbaro, D. De Angelis, F. Trucco 2012
La Necropoli di Villa Bruschi-Falgari di Tar-
quinia, in: A. Mandolesi & M. Sannibale (eds.),
Etruschi. L'ideale eroico e il vino lucente, Milano
2012, 196–200.

V. Bianco Peroni 1970
Le spade nell'Italia continentale, P.B.F. IV, 1,
München 1970.

V. Bianco Peroni 1979
I rasoi nell'Italia continentale, P.B.F. VIII, 2,
München 1979.

F. Bubenheimer-Erhart 2012
*Das Isisgrab von Vulci. Eine Fundgruppe der
Orientalisierenden Periode Etruriens*. Wien 2012.

A. Capoferri & S. Renzetti (eds.) 2017
*L'Etruria di Allesandro Morani. Riproduzioni di
pitture etrusche dalle collezioni dell'Istituto Svedese
di Studi Classici a Roma*. Firenze 2017.

A. Carapellucci & L. Drago Troccoli 2015
Riflessioni sul bestiario avernale. Le credenze
sull'aldilà a Veio nel periodo orientalizzante, in:
M. C. Biella & E. Giovanelli (eds.), *Nuovi studi
sul bestiario fantastico di età orientalizzante nella
penisola italiana*, Aristonothos Quaderni 5, 2015,
85–114.

S. Carosi 2016
Archeologia e altre discipline a Vulci: La Tomba
delle Mani d'argento della Necropoli dell'Osteria,
Tesori, 2016, 27–31.

S. Carosi & C. Regoli 2015, Esaltare l'individuo,
frammentare gli individui. Alcune attestazioni
rituali dall'Area C della Necropoli dell'Osteria di
Vulci, in: *Archeologia e Antropologia della Morte.
III Incontro di Studi di Archeologia e Antropologia
a Confronto*, Roma 2015, 213- 217.

S. Carosi & C. Regoli 2019
Ritualità funeraria a Vulci alla luce dei nuovi
scavi, in: M.Arizza (ed.), *Società e pratiche funera-
rie a Veio. Dalle origini alla conquista romana*,
(Conferenza Roma 2018), Roma 2019, 69- 87.

C. Casi & P. Petitti 2014
Il corpo ritrovato. Rituale funerario e antropo-
morfizzazione tra Bronzo finale e prima Età del
ferro a Vulci, in: *Principi immortali* 2014, 23–25.

N. de Grummond 2006
Etruscan Myth, Sacred History, and Legend.
Philadelphia PA 2006.

F. Delpino 2005
Dinamiche sociali e innovazioni rituali a
Tarquinia villanoviana: Le tombe I e II del sepol-
creto di Poggio dell'Impiccato, in: *Dinamiche
di sviluppo delle città nell'Etruria meridionale
Veio, Tarquinia, Vulci. Atti del XXIII convegno di
studi etruschi ed italici* (2001), Pisa-Roma 2005,
343–354.

F. Delpino 2008
La morte ritualizzata. Modalità di sepoltura
nell'Etruria protostorica, in: X. Dupré Raventòs,
S. Ribichini, St. Verger (eds.), *Saturnia Tellus.
Definizioni dello spazio consacrato in ambiente
etrusco, fenicio-punico, iberico e celtico* (Atti Con-
vegno Roma 2004), Roma 2008, 599–608.

F. Delpino 2012
La Tomba Campana e la sua "scoperta", in: I. van
Kampen (ed.), *Il nuovo museo dell'Agro Veientano
a Palazzo Chigi di Formello*, Roma 2012, 97- 102.

L. Drago Troccoli 2013a
Ricerche sul tema del bestiario fantastico di età
orientalizzante. I precedenti della prima età del
ferro, continuità o discontinuità, in: M. C. Biella
et al. (eds.), *Il bestiario fantastico di età orientaliz-
zante nella penisola italiana*, Aristonothos Scritti
per il Mediterraneo antico Quaderni 1, 2013,
15–33.

L. Drago Troccoli 2013 b
Raffigurazioni "mostruose" nel repertorio icono-
grafico dell'Italia mediotirrenica nella I età del
ferro in: I. Baglioni (ed.), *Monstra – Costruzione
e Percezione delle Entità Ibride e Mostruose nel
Mediterraneo Antico*, vol. 2, Roma 2013, 129- 164.

A. Emiliozzi 2014
Carri d'élite a Vulci, in: *Principi immortali* 2014,
33–35.

Etruscan Literacy 2020
R. Whitehouse (ed.), Etruscan Literacy in
its Social context, *Accordia Specialist Studies
on Italy* 18, London 2020.

Etruschi 2012
A. Mandolesi and M. Sannibale (eds.), *Etruschi.
L'ideale eroico e il vino lucente* (Exhibition Asti),
Milano 2012.

Etruschi 2019
L. Bentini, M. Marchesi, L. Minarini,
G. Sassatelli (eds.), *Etruschi. Viaggio nelle
terre dei Rasna* (Exibition Bologna 2019/2020),
Milano 2019.

P. Gastaldi, *Pontecagnano II.4. La Necropoli del
Pagliarone*, Napoli 1998.

C. Ginzburg 1998
Occhiacci di legno. Nove riflessioni sulla distanza,
Milano 1998.

A. Haug 2017
Bilder und Geschichte im 8. und 7. Jh. v. Chr.
Ein Diskursanalytischer Ansatz, *JdI* 132, 2017,
1–39.

H. Hencken 1968
Tarquinia, Villanovans and Early Etruscans,
Cambridge Ma.1968.

T. Hölscher 2018
*Die Geschöpfe des Daidalos. Vom sozialen Leben
der Griechischen Bildwerke*, Heidelberg 2018.

Homo Pictor 2020
Bracker, Jacobus (ed.), *Homo pictor: Image Studies
and Archaeology in Dialogue*, (Freiburger Studien
zur Archäologie und visuellen Kultur, Vol. 2)
Heidelberg, 2020.

C. Iaia 1999
*Simbolismo funerario e ideologia alle origini di
una civiltà urbana. Forme rituali nelle sepolture
"villanoviane" a Tarquinia e Vulci, e nel loro
entroterra*, Firenze 1999.

C. Iaia 2013
Warrior identity and the materialization of power
in early Iron Age Etruria, *Accordia research papers*
(2009–2012) 2013, 71- 95.

H. Jonas 1962
Homo Pictor and the differentia of Man, *Social
Research* 29 1962, 201–220.

A. Maggiani 2020,
La costruzione dell'immagine del princeps. I
cinerari iconici di Chiusi, in: AnnFaina XXVII,
2020, 179–211.

A. Maggiani and G. Paolucci 2005
Due vasi cinerari dall'Etruria settentrionale.
Alle origini del motivo del 'recumbente' nell'
iconografia funeraria, *Prospettiva* 117–118, 2005,
2–20.

M. Moltesen & C. Weber Lehmann 1991
*Catalogue of the Copies of Etruscan Tomb Paintings
in the Ny Carlsberg Glyptotek*. Copenhagen 1991.

L. Morandi 2013
La necropoli orientalizzante della Banditella a
Marsiliana d'Albegna Considerazioni sulle com-
binazioni di corredo e su alcuni aspetti rituali,
BABesch 88, 2013, 13- 38.

A. Naso 1990,
All'origine della pittura etrusca: decorazioni
parietali e architettura funeraria in Etruria
meridionale nel VII sec. a.C, *JRGZMainz* 37,2,
1990 (1995), 439–499.

L. D. Nebelsick 2016
*Drinking against Death. Studies on the materiality
and iconography of ritual sacrifice & transcendence
in later prehistoric Europe*, Warszawa 2016.

Nicosia 1969
Il cinerario di Montescudaio, *StEtr* XXXVII,
1969, 369–401.

M. Pacciarelli 2002
*Raffigurazioni di miti e riti su manufatti metallici
di Bisanzio e Vulci tra il 750 e il 650*, in A. Caran-
dini, *Archeologia del Mito: Emozione e ragione fra
primitivi e moderni*, Torino 2002, 301–332.

G. Paolucci 2010
I canopi di Tolle tra restituzione del corpo e
memoria del defunto, *Scienze dell'antichità* 16
2010, 109–118.

G. Paolucci 2013
Il viaggio ultraterreno e il bestiario orientaliz-
zante: La tomba 704 di Tolle, *StEtr*, LXXVI
(2010–2013), 33–43.

G. Paolucci 2015
*Canopi etruschi. Tombe con ossuari antropomorfi
dalla necropoli di Tolle (Chianciano Terme)*.
(Monumenti Etruschi 13), Roma 2015.

G. Paolucci and A. Rastrelli 2006
La Tomba"Principesca" di Chianciano Terme, Pisa 2006

Ch. S. Peirce 1897
= Collected Papers of Charles Sanders Peirce
(8 vols.). Charles Hartshorne, Paul Weiss, and
Arthur Burks (eds.). Cambridge, MA 1931 /1965

Principi immortali 2014
Principi immortali. Fasti dell'aristocrazia etrusca a Vulci (Exhibition Roma), Roma 2014.

A. Rathje 2013a
The Ambigous Sex or Embodied Divinity.
A note on a Unusual Vesssel in the Ny Carlsberg
Glyptotek, in: H. Thomasen, A. Rathje og
K. Bøggild Johannsen (eds.), *Vessels and Variety*
(*Acta Hyperborea 13*), 2013, 108–122.

A. Rathje 2013b
Pitture tombali. La realtà costruita, *Mediterranea*
X, 2013, 153–166.

A. Rathje 2017
Pissidi orientalizzanti da Ficana. Una nota,
Aristonothos 13.1, 2017, 167–181.

C. Renfrew and I. Morley (eds.) 2007
Image and imaginations: A Global Prehistory of Figurative Representation, Cambridge, 2007.

M. A. Rizzo, 1989
Catalogo: Veio, Cerveteri, in *Pittura Etrusca al museo di Villa Giulia,* Roma 1989, 103–116.

A. Russo 2014
Dall'umano al divino: *eidola* e *simulacra* tra
Mediterraneo orientale ed Etruria, in: *Principi immortali*, Roma 2014, 27–31.

J. Rüpke 2006
Triumphator and ancestor rituals between symbolic anthropology and magic, *Numen* 53, 2006,
251–289.

M. Sannibale 2008
Gli ori della Tomba Regolini-Galassi: tra tecno-
logia e simbolo. Nuove proposte di letteratura nel
quadro del fenomeno orientalizzante in Etruria,
MEFRA 120,2, 2008, 337–367.

Sgubini Moretti 2000
Tomba del carro di bronzo, Vulci, in: M. Torelli
(ed.), *Gli Etruschi* (Exhibition Venezia 2000),
Milano 2000, 568–570.

R. Skeates and J. Day (eds.) 2020
The Routledge Handbook of Sensory Archaeology,
London and New York 2020.

S. Steingräber (ed.) 1985
*Etruscan Painting. Catalogue raisonné of Etruscan
Wall paintings*, New York 1985.

Tesori 2016
B. Davidde Petriaggi & S. Carosi, *Tesori per
l'Aldilà. La Tomba degli Ori di Vulci dal sequestro
al restauro.* Roma 2016.

Wagner-Durand 2019
Image – Narrative – Context. Visual Narration
in Cultures and Societies of the Old World, in:
E. Wagner-Durand, A. Heinemann & B. Fath
(eds.), *Freiburger Studien zur Archäologie & Visu-
ellen Kultur* Vol. 1, 2019, 1–17.

C. E. Watanabe 2015
The symbolic role of animals in Babylon:
A contextual approach to the lion, the bull
and the mušḫuššu, *Iraq* 77.1, 2015, 215–224.

J. Weidig 2015
Un banchetto funebre intorno alla sepoltura? Il
rito della frammentazione del vasellame ceramico
nelle tombe arcaiche dell'Italia centrale: il caso
di Bazzano presso l'Aquila, in: A. Esposito (ed.),
*Autour du "banquet". Modèles de consommation
et usages sociaux*, Dijon 2015, 115–131.

Whitehouse 2020,
Personal Names in Early Etruscan Inscriptions.
An anthropological perspective, in: *Etruscan
Literacy* 2020, 181–193.

THE LIFE AND DEATH OF THESATHEI

A REINTERPRETATION OF THE TRAGLIATELLA OINOCHOE

LIV CARØE & SOFIE AHLÉN

Since its discovery, the iconography of the Tragliatella oinochoe[1] has captured the attention of the viewer. The oinochoe is adorned with two friezes depicted on the neck and body, respectively (**Fig. 1a and Fig. 1b**), which have been examined by a number of scholars, with the maze-like structure on the belly, especially, causing much discussion. A number of interpretations have been proposed and many of them are based on the understanding of the "maze".[2] Individual motifs of the friezes have often been examined, but rarely, if ever, explained in their full length. We would like to propose a reinterpretation of the friezes that reads both friezes together as a continuous story. Furthermore, we would also like to examine the iconography in the light of Etruscan beliefs and culture instead of that of the Homeric poems and Greek myth as is often done. Another focus of attention is the maze-like structure, and here we propose a new interpretation.

Context

The oinochoe was part of the grave goods found in a chamber tomb on the Tragliatella necropolis, near Caere, during excavations in the winter of 1877–79. In total, 19 tombs were excavated, but unfortunately the context of the oinochoe has not been fully documented. However, it was registered that the grave goods of the 19 graves comprised vessels of impasto and bucchero, furniture, glass cups, necklaces, and that some of the vases had incised inscriptions.[3]

Description

The oinochoe (630–600 BC) is made in the Etrusco-Corinthian style and belongs to the Group of Polychrome Vases.[4] The jug is 24 cm high and is decorated with two figured friezes incised on the neck and belly, respec-

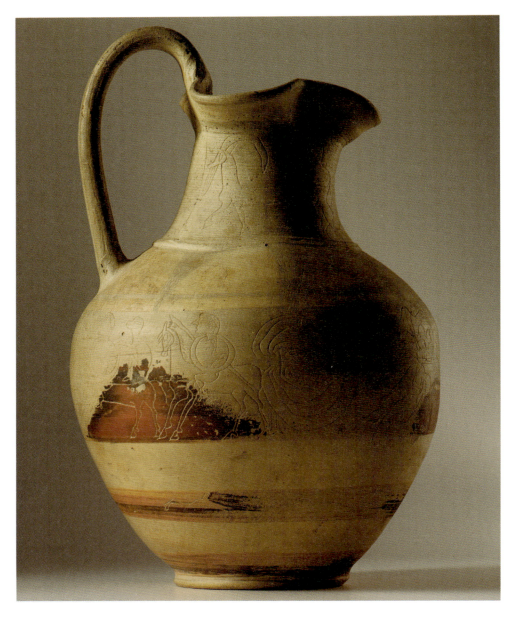

Fig. 1a Oinochoe di Tragliatella, 630–600BC. Group of the Polychrome Vases. Museo Capitolino inv. MOB 358 (Courtesy of Musei Capitolini).

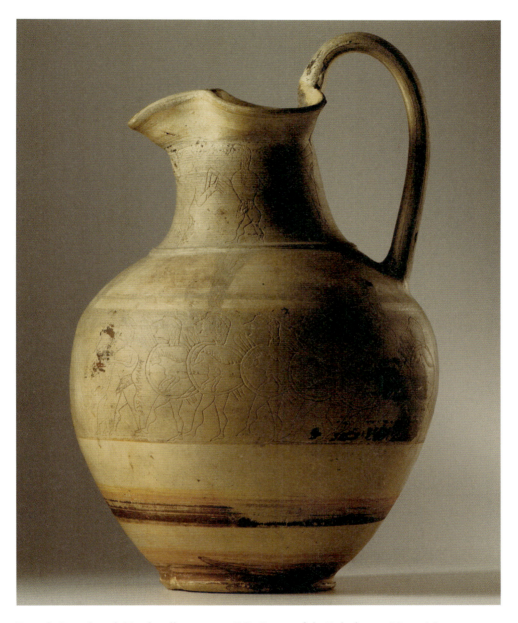

Fig. 1b Oinochoe di Tragliatella, 630–600BC. Group of the Polychrome Vases. Museo Capitolino inv. MOB 358 (Courtesy of Musei Capitolini).

tively (**Fig. 1a and 1b**). The two friezes are separated by an incised frieze of bucrania which runs along the shoulder of the jug. On the lower part of the vase is a depiction of a hare chasing a dog and along the handle is a snake. Some remains of the polychromy, primarily reddish-brown, are still visible. In the following, we read the friezes from right to left, as suggested by Jocelyn Penny Small.[5]

Upper frieze: (read right to left, from the position of the handle) a vertical ship and then a couple facing each other. The woman wears a long dress decorated with lozenges and her long, loose hair is falling over her shoulder, her stomach seems to bulge out; the man wears a loincloth and probably a band around his head. The man has his right hand on the woman's wrist, and is pointing towards the vertical ship behind him with his left. Then come two heraldic birds with compact bodies and relatively short necks and beaks (a couple?),[6] followed by a nude man holding a goat on a lead, moving towards the left and turning his back towards the birds and the couple. Finally, ending the frieze is another goat depicted in a vertical position. The vertical ship and goat thus flank the handle and direct the viewer's eyes towards the incised snake on the handle (**Fig. 2**). The snake seems to be swallowing a bird with a long beak, similar to the bird on one of the riders shield in the lower frieze (**Fig. 2**).

Lower frieze: (read right to left, from below the handle) the frieze depicts a procession of seven young men carrying shields with the emblem of a boar while holding three javelins in the right hand (one man only carries two); they are moving towards the left with the same foot lifted as if keeping pace. In front of the group stands a couple facing each other with a small girl between them. The woman is dressed like the woman above; however, it seems like she might be wearing a veil, or part of her garment covers her hair, due to the rendering of crosses in her hair. Behind the man's back runs in a vertical line the letters *miammarce*, meaning "I am Ammarce" and thus naming the man *Ammarce*. In his raised left hand, he offers an egg (most likely) to the woman, while his right hand rests on the shoulder of the little girl. As with the male figure, the sentence *mi Velelia* is inscribed in three horizontal lines in front of the little girl, and the position of the inscription between the tall woman and the small figure might underscore the familial connection between them. Likewise, a female name is inscribed behind the neck of the tall woman in a horizontal line: *mi Thesathei*. The labelling of the

three figures with Etruscan names may suggest that the group represents a family and that the depiction should be read as such rather than as a mythical scene, as has been suggested recently.[7] The woman offers a large round object to the man with her left hand. The frieze continues with a woman, also clad in a long dress and probably wearing a veil like the other woman in the frieze. She is facing left, with her right hand stretched out, perhaps holding a fan, and thus turning her back on the couple and the rest of the figures; she approaches two oval-shaped, throne-like objects. A vertical incised line separates the woman from the next motif, which represents two nude couples having intercourse, the one pair above the other divided by a horizontal line. Next to them is an almost circular maze-like structure, with the word *Truia* inscribed in the outermost of its seven "rings". The frieze ends showing two horsemen lead by a nude man holding a staff with both hands. Both horsemen carry round shields with bird emblems; the hindmost one carries a spear, the horseman in front has a monkey sitting on the horseback behind him and touching his shoulder/shield with its arm.

Earlier interpretations

Before an examination of the scenes on the neck and body of the jug, some of the earlier interpretations should be mentioned (**Fig. 3**). As already said, very often the scenes are read in the light of the Greek myths and the Homeric poems and for many scholars the identification of the circular maze-like structure is central for their interpretations. In classical time, the labyrinth was connected with the myth of Theseus and the Minotaur, but pictorial representations of this myth are very few and late.[8] In an Etruscan context, the story of Ariadne and Theseus is depicted on the François Vase (ca. 570 BC), which shows Ariadne handing over a ball of thread to Theseus. On the belly frieze of the Tragliatella oinochoe the woman named *Thesathei* likewise offers the man a round object, but the man already holds a round object himself. The identification of these objects is unclear. Small suggests that rather than being a ball of thread they may be either eggs or fruit, exchanged as parting gifts.[9] It has been suggested that the couple and the ship in the neck frieze refer to the escape of Ariadne and Theseus from Crete,[10] and the procession of armed men and the maze in the belly frieze may represent a dance danced by Theseus's companions on Delos in commemoration of the escape from Minos's labyrinth.[11]

Fig. 2 Drawing of the Tragliatella Oinochoe, upper and lower frieze (© Thora Fisker).

The inscription in the maze-like structure, *Truia*, has led to two different interpretations: *Truia* refers either to the *Troiae lusus,* a kind of horse game or initiation ceremony, described by Virgil in Aeneid V (545–603), or it refers to the city of Troy. The Roman game, *Troiae lusus* was introduced by Sulla,[12] but Small suggests that the depiction on the oinochoe testifies to historical events, namely the grand games that were held in Etruria during the reign of Tarquinius Priscus.[13] In the other interpretation, the maze structure is interpreted as the wall of the city and the two riders as Trojans departing to fight the Greeks.[14] The family group in the belly frieze has also been explained as a reference to the Homeric poems. A misreading of the name adjacent to the small female as "Helena" led to the earlier interpretation of the scene as the judgment of Paris.[15] Others see a family scene where the husband *Ammarce* is either returning from or leaving for war.[16] Another non-mythological interpretation proposes that the friezes show different episodes in the life of an aristocrat.[17] The ship and goat are seen as references to *Ammarce* being a wealthy sea trader dealing in livestock, and the two riders are *Ammarce*'s sons who are performing a kind of initiation ceremony, like the *Troiae lusus.* The double *symplegma* is explained as a record of *Ammarce* having been married twice. The rest of the frieze shows different elements of the life of the aristocracy, for example the exchange of gifts between the couple, the aristocrat's armed followers and the hare hunt below the main frieze also refer to the role of hunting as a traditional aristocratic pursuit.[18] Others underscore the ceremonial themes of the motifs,[19] and one scholar suggests that the scenes in the lower frieze represent the succession of a king. In this interpretation the stools are seen as thrones and the armed men refer to a ceremonial procession and the transfer of royal power.[20]

Our interpretation

THE UPPER FRIEZE

The ship motif: The motif of the ship, in combination with the couple and the procession of armed men in the frieze below, may be compared to the depiction on the Pania pyxis (dat. 630 BC) (**Fig. 4**). Here the lower frieze showing a warrior in a wagon followed by armed men and mourning women, is interpreted as a representation of the journey to the afterlife.[21] The ship in the upper frieze of the pyxis can also be interpreted as a reference to the journey to the Underworld. This interpretation of the scene

	Vertical ship	The couple (man & woman)	Nude man with goat on a lead	Procession of warriors
Deecke 1881				
Giglioli 1929				Military dance – the naked man being a referee or trainer
Christofani 1978		Thesathei & Ammarce		The armed followers of the aristocrats
Small 1986		Couple about to embark on the ship	Goatherd – the second goat belonging to his flock	Funeral games/ javelin contest held in honour of Thesathei
Säflund 1993		"Hieros Gamos"		
Menichetti 1992/1994		Theseus & Ariadne "Hieros Gamos"	Myth of Ariadne & Aphrodite	Initiation rites of young men – reflecting the ritual Crane dance (Geranos) associated with Theseus
Martinez-Pinna 1994				
Haynes 2000	Ammarce as a sea trader		Ammarce as a merchant dealing in livestock	The armed followers of the aristocrats
Krämer 2015	The journey to the Underworld		Ritual / sacrifice	
Rasmussen 2016	Paris and Helen about to elope by sea	Reference to Paris's rural background	Etruscan couple meeting in their youth/ Paris and Helen	Birdseye view of the city of Troy – the monkey on the horseback an ill-omen
Sarullo 2018			Myth of Ariadne & Aphrodite. The transformation & sacrifice of the goat.	Salii dances (sacred dance) reflecting Geranos

Fig. 3 Table showing earlier interpretations of the Tragliatelle oinochoe. (L. Carøe & S. Ahlén).

114

The three named persons	Woman by two "throne-like" objects	Symplegma	Mazelike structure and the two riders
The Judgement of Paris			The city walls of Troy
Family group/ parents with a child	"Due Idoli" and a woman		Troiae Lusus
Family group/ warrior departing or leaving for war			
Family group/gift exchange before departure to the Underworld	Relative of Thesathei in front of her grave	Sexual intercourse during funeral games	Funeral games – reflecting games held during the reign of Tarquinius Priscus
		Ritual sexual intercourse	
Theseus, Ariadne, Nurse	Thrones and a goddess (represent- ing the transfer of royal power)		Troiae lusus (representing the succession of royal power)
	Thrones representing the ancestor cult		
Married couple exchange		Record of Ammarce being married twice	Initiation rites performed by the sons of Ammarce
Thesathei as the deceased			
Family group/eggs symbolizing the vase in a funeral context	The daughter by the family grave	Paris & Helen – the seduction at Sparta and their life in Troy	Warriors defending Troy
Theseus, Ariadne, Nurse	Thrones represent- ing the transfer of royal power	Duplicity – reflects the myth of Ariadne & Aphrodite (two thrones, two horsemen)	Troiae lusus (representing the succession of royal power)

Fig. 4 The Pania pyxis, 630 BC, Museo Archeologico Firenze Inv. 73646. In the upper register a ship, in the lower register a scene with a warrior in a wagon followed by armed men and mourning women. Su concessione del Museo Archaeologico Nazionale di Firenze. (Direzione regionale Musei della Toscana).

is underscored by the iconography of the sarcophagi and tomb paintings from the archaic period and onwards, which clearly shows the journey to the realm of the dead as a recurrent theme. An example is the depictions on a sarcophagus showing the dead riding on a hippocamp (3rd century BC),[22] and the same motif is seen on the wall paintings in the *Tomba dei Tori* (530BC).[23] In the *Tomba della Nave* (450–425 BC), a ship is seen on the right wall next to some cliffs, like the one from the painting in the *Tomba dei Tori*.[24] Giovanni Colonna suggests that the cliffs are the mythological cliffs *Plotai* or *Planktai* at the border of the world of the living. The ship, rather than being a sign of the status and occupation of the deceased as a rich trader is a reference to his journey to the realm of the dead.[25] It is likely that the ship on the Tragliatella oinochoe may be interpreted in the same way, especially as the snake on the handle and the bucrania denote an eschatological meaning and suggest a funeral purpose for the oinochoe.

The couple: It is a tradition in Etruscan iconography to depict a husband and wife together. The intimate relation between husband and wife is depicted in an early representation on a biconic crater (675–650 BC), showing a woman caressing her husband's cheek (**Fig. 5**).[26] Another way of showing the married couple is 'the hand on wrist' motif, like the one on the Tragliatella oinochoe. This motif is also seen, for example, on the relief slab (*lastrone a scala*) (600–550 BC) from the Monterozzi necropolis in Tarquinia.[27] On the oinochoe, the motif has previously been read in connection with the intercourse scene in the lower frieze and has been interpreted as a scene of wooing.[28] Here the bulge on the woman's stomach may suggest that she is pregnant, and there is a marital relation between the couple.

The bird couple: The birds next to the couple can be perceived as a parallel theme.[29] The image of two birds underscores the intimacy and affection between husband and wife, as also seen in the hand on wrist motif. A pair of birds as a symbol of a married couple is also seen in Etruscan tomb paintings. It is depicted in the banquet scenes showing the married couple lying on a kline with the birds sitting in pairs below, as in the *Tomba delle Bighe* for example.[30] Birds are a very popular motif in Etruscan iconography and are shown in various media, from the Iron Age to the end of the Etruscan era. They often occur in funerary contexts as they may also symbolize the transformation from life to death.[31]

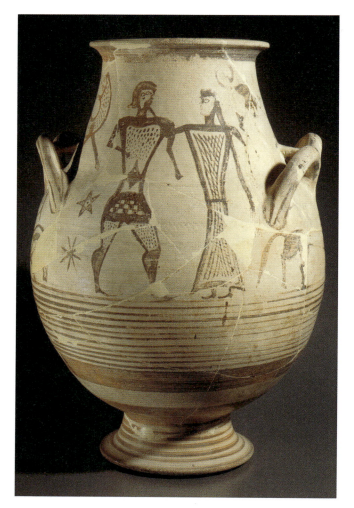

Fig. 5 Biconic krater, attributed to the Painter of the Heptacord, Museo Archeologico Cerveteri. (Ritzau Scanpix).

Nude man and goat: The nude man holding a goat on a lead and the vertical goat could be perceived as part of the same group. A very similar motif is shown on a brazier dating from 610–570 BC. Here, a nude man is following a grazing animal/deer and beside him are two birds (**Fig. 6**). A nude man in company with one or more animals probably refers to fertility. Nude men in motion occurring alone in the company of different kinds of animals (deer, horses, birds, goats and/or *Mischwesen*) are a common motif on various types of Etruscan ceramics (impasto, bucchero, Etrusco-Corin-

Fig. 6 Brazier, impasto, 610–570 BC. J. Paul Getty Museum, Malibu. (After Krämer 2015, CA13, fig.13a & b).

thian) from the Orientalizing Period.[32] On the Tragliatella vase, however, the goat can also, according to Robinson Peter Krämer, be seen as a symbol of ritual sacrifices in connection with the journey to the underworld as represented by the ship.[33] The same motif of goat and ship is shown on a white-on-red amphora (600–575BC) in the British Museum, but on this the goat is embarking the ship (**Fig. 7**).[34] On the Tragliatella oinochoe, the vertical ship and goat are depicted heraldically, separated by the handle with the incised snake on it. This might imply that goat and ship should be interpreted together. On the lower frieze, beneath the scene with the nude man and the goat, a *symplegma* scene is depicted. The same juxtaposition of motifs is seen on a bronze situla from Sanzeno dated to the 4th century BC. Although there is a timespan between the two of three hundred years, the similarities are obvious. Seen together, the sexual intercourse stresses the theme of fertility incorporated in the plowing scene, thus underscoring the importance of fertility and birth. We suggest that the gesture of the man with the goat on a lead on the Tragliatella vase could represent plowing, although the plow itself is not depicted. Thus, in this case the goat might carry more meanings; it could be perceived as a symbol of fertility belong-

Fig. 7 White on red amphora, 600–575 BC, British Museum, inv. 1850,0227.49. (After *CVA*, Br. Mus., fasc. 7, p. 9, Fig. 3, pl. 9,3).

ing to the plowing group, and also as a sacrificial animal connected to the rituals concerning the journey to the beyond. Objects referring to fertility are common themes in the iconography of the graves, symbolizing rebirth.

THE LOWER FRIEZE

The procession of young armed men: The procession of armed men has been interpreted as the armed followers of an aristocrat who are leaving or returning from war. However, the fact that the men are probably naked

may suggest that rather than being warriors, who are usually depicted in full armour and with greaves, the men here are taking part in some kind of ritual. Some tomb paintings show scenes of athletic games,[35] and they are seen as representations of real games being held at the funeral.[36] In the wall paintings, not only different kinds of athletics are represented, but also horse races, jugglers and acrobats as well as armed men, interpreted as dancers taking part in a weapon (arms) dance.[37] It has been suggested that the funeral games did not comprise only sports competitions, but also included theatrical performances and ritual dances with the purpose of ensuring the life after death of the deceased.[38] In connection to the other scene on the oinochoe, the procession of armed men may be perceived either as part of a funeral ritual or some kind of initiation rite.[39]

The couple with a child: Greetings between family members, often a husband and wife, was a popular motif on ash urns from the late 3rd century to the Augustan age. Sometimes the motif is rendered as a handshake, *dextrarum iunctio*. In the funeral iconography, this representation is perceived either as a farewell between a dead family member and the mourning relatives before the travel of the deceased to the underworld, or as the reunion of the family members in the afterworld. For the Etruscans, the motif may have carried both meanings.[40] Married couples are also represented in different media in the archaic period. In several banquet scenes in the wall paintings, we see couples, a man and a woman, lying together on a kline, and two terracotta sarcophagi found in the chamber tombs in the Banditaccia necropolis of Cerveteri have a married couple as lid figures shown reclining on a bed or a kline. Like the man on the oinochoe (*Ammarce*), the men on the two sarcophagi may originally have held a small round object in their right hand. This gesture can be compared with banquet scenes in wall paintings where the object can clearly be identified as an egg. Small models of eggs made in stone or terracotta have been found in tombs, and the egg is normally perceived as a symbol of continuation of life and rebirth.[41] On the oinochoe, *Ammarce* has placed his hand on the shoulder of the girl, which underlines the family connection. We perceive the scene as a farewell scene, and the close relation between *Ammarce* and *Velelia* implies that they are the living, mourning relatives. *Thesathei* and *Ammarce* are exchanging a parting gift at the time of her death. *Thesathei* is then the deceased and the object she holds in her hand can probably be identified as a pomegranate symbolizing death and rebirth.[42]

The Cult of Ancestors: The woman standing in front of two empty thrones, with her back to the rest of the scenes probably holds an object in her outstretched right hand (**Fig. 2**).[43] Two empty thrones are also found in the left side chamber of the *Tomba delle Cinque Sedie* in the Banditaccia necropolis at Caere.[44] In the same room human figures made of terracotta, all with a right hand stretched out, occupied five chairs. It is believed that the figures represent the ancestors and the unoccupied thrones were intended for the deceased couple.[45] The throne might combine two beliefs associated with the ancestral cult.[46] Over time, the thrones lose their connection to the banquet, but the thrones remain in the tomb, thus representing the deceased.[47] Because *Thesathei* is standing in front of two empty thrones and her gesture is the same as the figures in the tomb mentioned above, we propose that the woman represents *Thesathei* as deceased and about to take her place/seat among her ancestors.

Two couples having intercourse: The motif of sexual intercourse occurs in two different media: on bronze items and in wall paintings in the tombs. A mirror from Castelvetro (5th century BC), in the Modena Galleria Nazionale Estense, shows a couple lying on a bed adorned with swan necks. The rest of the frieze on the mirror, which surrounds a tondo with a swan, shows more similarities to the imagery of the Tragliatella oinochoe in showing a procession of men and horses, a couple engaging in a conversation and a woman sitting on a throne adorned again with swan necks.[48] Behind the throne stands a man and he faces towards the intercourse scene like an observer, and together with the procession it gives a ritual meaning to the intercourse act. It might be interpreted as a wedding ceremony or a sacred fertility ritual. On a situla from Montebelluna (6th–5th century BC), in the Museo di Storia Naturale e Archelogia di Montebelluna, is an intercourse scene shown together with a libation, here interpreted as a ritual.[49] On the oinochoe, however, there are two scenes of intercourses, and a parallel, although later, can be seen on the wall paintings in *Tomba delle Bighe*.[50] On the oinochoe the scenes of intercourses are depicted almost next to the horsemen and the armed naked men, which we will propose later are part of funeral games or initiation rites. On the wall painting, we see two male couples copulating under the stand, where spectators are watching the games.[51] However, there is a clear difference between the scenes, as the two intercourses between man and woman on the oinochoe refer to fertility and (re)birth,

while the two copulating homosexual couples apparently carry another meaning. A closer look at the frieze on the oinochoe reveals that the two intercourse scenes differ dramatically from each other; the upper clearly shows the intimacy and affection between the couple, the two lying close together nose to nose; while the lower scene is characterized by aggression and the man seems to be transformed into an animal like figure. The two scenes show a clear duality and suggest that the scenes carry a symbolic meaning: The upper scene refers to the realm of living, while the lower refers to the continuation of life after death.

Two horsemen with maze and monkey: The maze-like structure has attracted much attention. Many of the interpretations are, as mentioned above, based on the story of the Minotaur and the maze. According to John L. Heller, however, depictions of mazes will most likely be square, as is the case with the labyrinth of Knossos.[52] Few maze-like figures have the same form as the one on the oinochoe, and the most striking example is from Val Camonica (**Fig. 8**). In his article Heller associates the maze from Val Camonica as well as the one on the oinochoe with the labyrinth in Crete.[53] We would like, however, to propose another interpretation. In our opinion, the maze most likely depicts a female reproductive organ, due to its similarity/resemblance to an anatomical votive (now in Villa Giulia in Rome) dedicated by an inscription to Uni. The votive shows circles inside each other, similar to the depiction of the maze-like structure on the vase. Furthermore, the classification of the votive by the museum as a uterus underscores the meaning of procreation (**Fig. 9**). Rather than a uterus, we suggest that the votive depicts a placenta, simply because it looks like an actual placenta, which supports the idea of fertility and birth even further. Another maze-like figure to be considered is located in a cave in Sicily. Referred to as the Polyphemus Cave by local authorities, it was discovered in 1986 near Trapani by Giovanni Vultaggio (**Fig. 10**). It contains a niche to the far left, with the painting on the ceiling of a figure similar to the maze on the oinochoe (**Fig. 2**). The maze has been interpreted as a vulvic symbol, a symbol of female procreation – an interpretation that the red colour underscores.[54] The niche is too low for a person to be standing upright, so in order to observe the painting in the ceiling one has to lie down on one's back. It supports the idea suggested by Marguerite Rigoglioso that the niche under the painting was used by couples for sacred sexual rituals, and even intercourse.[55] The same theme may be repressented on the

123

oinochoe; the two couples have intercourse in close relation to the maze. The inscription in the maze, *truia*, seems far more puzzling and is difficult to interpret. It has been suggested that the word *truia* derives either from *amputruare* or *deamptruare*, meaning dancing, moving or turning around.[56] Thus, on the one hand, the inscription could support the idea of games, or the *Troiae Lusus* suggested by various scholars; on the other hand, if the maze resembles a female reproductive organ, the meaning of the word "turning around" or "moving" would also make sense, underscoring the movement of the fetus and the birth of the child. However, if the words are Latin the question arises of whether Latin usage can be applied to early

Fig. 8
Cave painting, Naquane, Val Camonica, 1800–1000 BC. (www.labyrinthos. net).

Fig. 9 Anatomical votive, Villa Giulia, C. A. Collection, Geneve, inv. 100958 (Photo, Liv Carøe, su concessione del Museo Nazionale Etrusco di Villa Giulia). Rome.

Etruscan language.[57] Latin could have adopted and adapted the *tru*-words from Etruscan, as seen in other cases suggested by Small.[58]

The two apparently naked horsemen, only covered by shields with birds on them, may symbolize the journey to the underworld (which the birds might underscore) and could also refer to aristocratic values.[59] Naked men on horses in the company of mythical creatures and birds are a motif seen on ceramics and ivory from the Orientalizing Period (**Fig. 11**).[60] The same motif is also depicted in the Campana tomb at Veii (600 BC). The monkey sitting on the horse could allude to a funeral sphere, as proposed by Mauro Menichetti.[61] Horsemen with monkeys is a motif influenced by the Phoenicians, and small figurines resembling these have been discovered in Phoenician graves in Sardinia.[62] In the Bocchoris tomb from Tarquinia, which has been interpreted as being Phoenician, three bronze fibulae were found. Each fibula is shaped like a horse carrying a monkey on its back.[63] An almost similar fibula was discovered in Este (now in the Museum Villa Benvenuti). The bronze fibula consists of three horses, of which the two outermost horsemen are covered by shields decorated with concentric cir-

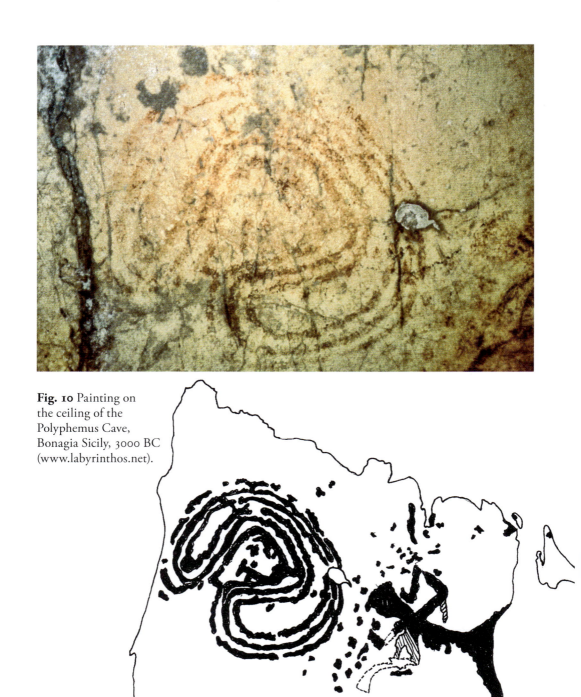

Fig. 10 Painting on the ceiling of the Polyphemus Cave, Bonagia Sicily, 3000 BC (www.labyrinthos.net).

cles, while the horse in the middle is ridden by a duck, and on the back of all three horses sits a monkey.[64] The monkey on the horse depicted on the Tragliatella oinochoe might in this case also refer to a funeral sphere, and the riders may refer to funeral games.

Other motifs

On the shoulder the bucrania have an arrowlike shape pointing at specific scenes and persons in the lower frieze and might indicate a connection between them. The bucrania motif seems to be rare in Etruria in the 7th century BC and the scene on the oinochoe might be a forerunner for the

Fig. 11 Bucchero pyxis, orientalizing motif of a naked man on horseback in a procession together with mythical creatures. (After Krämer, 2015, VU02, fig. 25).

later Roman use. On the handle the snake is connected to the underworld and often appears in funeral iconography.

The hare-hunting motif refers to an activity practiced in Etruria, and hare/dog hunting scenes reflect the values of the aristocracy.[65] In the *Tomba del Cacciatore*, the walls are decorated as the inside of a hunting tent. On the upper part of its wall the tent has a frieze with animals hunting animals, which emphasizes the theme of the hunt even further. It has been suggested that in funeral contexts the hunt symbolizes the virtue of the dead, underscoring the danger in hunting ferocious animals such as wild boars, and referring to death as a dangerous journey to the underworld.[66]

Juxtaposition of the friezes

When the two friezes, the upper and the lower, are juxtaposed it provides a remarkable connection between some of the scenes and underscores our understanding and interpretation of the friezes. It means that the wooing motif is placed above the family group on the lower frieze (**Fig. 2**). Furthermore, the women are placed directly above each other, thus supporting the theory that all the women depicted represent the same woman in various stages of her life. The placement of the inscription: *Thesathei* between the two women's heads underscores this hypothesis. The plowing scene is placed just above the "maze", underscoring fertility and reproduction and supporting the interpretation of the maze as a female reproductive organ (placenta) (**Fig. 9**). Juxtaposing the two birds with the lower frieze, they are positioned just above the woman by the two thrones (**Fig. 2**). Seeing the birds as a symbol of transformation from life to death echoes the cult of the ancestors as represented by the thrones, and indicates the hope of reunion in the afterlife of husband and wife and earlier deceased family members. In general, the decoration of the oinochoe is characterized by duality; two goats, two birds, two thrones, two intercourses, two horsemen and so on. The oinochoe itself represents two narratives; on the one side we have the life of *Thesathei* and *Ammarce* in the realm of the living on the other the symbolic meaning of life and death characterized by the nudeness of the figures. The figures of *Thesathei* and the nude man positioned below the snake mark the separation of the two sides.

Life and death of Thesathei?

The scenes of the two friezes of the oinochoe can be read as the life and death

of the protagonist, *Thesathei*. The scenes in the upper frieze, the "wooing scene" paralleled by the "love birds", refer to her marriage, and the plowing scene to fertility and the continuations of life, underscoring the importance of the family and the continuation of *gens*. The ship motif indicates the journey beyond, while the scenes in the lower frieze refer to the departing of *Thesathei* and her family. Both horsemen and the procession refer to the funeral games held in the honour of the deceased to secure rebirth and the continuation of life in the hereafter. Life and rebirth are expressed even more strongly in the depiction of the placenta and the intercourse scenes. As many of the scenes allude to the transition from life to death, we conclude that the oinochoe was made for the tomb, as also implied by the snake motif. Even though the oinochoe was made for a funeral purpose, its scenes also refer to the circle of life and thus new beginnings.

NOTES

1 Museo Capitolino inv. 358 Mob.
2 The Tragliatella oinochoe's discovery was announced by W. Helbig in 1881. The same year W. Deecke published an article on its inscriptions. The first full publication was made by Giulio Q. Giglioli in 1929; see also *Etruschi 2020*, cat.no. 34, 93–94.
3 NSc 1878, 162.
4 Szilagyi 1992, 86–87.
5 Small 1987, 66 proposes a reading from right to left, given the movement of the figures in the same direction.
6 The depiction of the birds differs from the birds depicted in the Villanovan period, see Christiansen & Petersen 2017, 458–460. The species of the birds, from our point of view, is difficult to establish.
7 Bonfante 2020, 145–150.
8 Small 1987, 69–70.
9 Small 1987, 89.
10 Small 1987, 88.
11 Haynes 2000, 98.
12 Small 1987, 79.
13 Small 1987, 96 underlines that, traditionally, Tarquinius Priscus is said to have brought the *Roman ludi* to the Romans.
14 Small 1987, 68.
15 Small 1987, 87–88; Deecke 1881, 161–168; Rasmussen 2016, 39.
16 Small 1987, 89–91; Giglioli 1929, 119; Cristofani 1978, 56.

17 Rasmussen 2016, 38 suggests that the motifs reflect real life situations, proposing that the woman standing alone could be the daughter mourning her parents at the family tomb.
18 Haynes 2000, 98–99.
19 Cherici 2010, 223; Menichetti 1992, 8–9.
20 Menichetti 1992, 8–9; Menichetti 1994, 62.
21 Torelli 1997, 134.
22 BK 1916, Pl. 33,1
23 Steingräber 1985, no. 120, 350–351.
24 Steingräber 1985, no. 91, 328.
25 Colonna 2003, 68–71, 76–77.
26 Cristofani 1979, 28.
27 Haynes 2000, 148; the scene on the relief has been interpreted as the union of a divine couple.
28 Säflund 1993, 48; the wooing stance is known from Greek art as *cheir epi karpoi*.
29 Säflund 1993, 48.
30 Steingräber 1985, no. 47, 289–291. See also the Tomba della Caccia e Pesca: backchamber, rearwall the left corner of the pediment, no. 50, 293.
31 Brocato 2008, 72–75; Bonaudo 2007, 162
32 Krämer 2015, 188.
33 Krämer 2015, 193.
34 Krämer 2015, 193.
35 Steingräber 1985: Tomba degli Auguri, no. 42, 283; Tomba delle Olimpiadi, no. 92, 328–329; Tomba del Maestro delle Olimpiadi, no. 83, 319; Tomba delle Bighe no.

47, 289–291;Tomba del Letto Funebre no.
82, 319–320; Tomba Francesca Giustiniani,
no. 65, 305; Tomba del Guerriero, no.73,
313; Tomba del Poggio Gaiella, no. 23, 272;
Tomba di Montollo no.17, 269; Tomba
della Scimmia, no. 25, 273–275; Tomba del
Colle Casuccini no. 15, 266–268; Tomba del
Poggio al Moro no. 22, 271–272.
36 Torelli 1999, 147; Jannot 2005, 49–52.
37 Lawler 1964, 31, 42, 106–208.
38 Jannot 2005, 50.
39 Sarullo 2018, 91–92, proposes that the men
either symbolize sacred dancers or an initia-
tion rite for young boys becoming warriors.
40 Davies 1985, 632.
41 Pieraccini 2014, 271–279.
42 Jannot 2009, 81–82.
43 It is not all reconstructions that clarify
whether she holds an object in her hand
or not. Giglioli 1929, 121 suggests that
she clearly holds an object, either a fan
or a mirror
44 Martinez-Pinna 1994, 87.
45 Damgaard Andersen 1993, 49; Camporeale
2009, 226.
46 Damgaard Andersen 1993, 32.
47 Damgaard Andersen 1993, 32.
48 Bonfante 1978, 236–237; Zaghetto 2018,
247–248, fig. 8.
49 https://archeologiavocidalpassato.com/tag/

mostra-storie-di-antichi-veneti-la-situla-
figurata-di-montebelluna/
50 Steingräber 1985, no. 47, 289–291.
51 Small 1987, 67; Martinez–Pinna 1994, 82.
52 Heller 1961, 57–62.
53 Heller 1961, 58.
54 Rigoglioso 2017, 4.
55 Rigoglioso 2017, 5.
56 Giglioli 1929, 124; Small 1987, 76–77;
Sarullo 2018, 98–99.
57 Small 1987, 77; see also Berndt 2015,
106–110.
58 Small 1987, 77.
59 Krämer 2013, 193.
60 For other examples, see Krämer 2013, fig. 6b
CA05 and fig.18 CH02, 212, 215.
61 Menichetti 1994, 61. However, Rasmussen
2016, 39 offers another interpretation. He
sees the "maze" as the city of Troy as seen
from the perspective of a bird, and the
monkey as a monster symbolizing an ill-
omen, foretelling the fall of Troy.
62 McDermott 1938, 29, 31, 131–140. For more
about monkeys in the Etruscan context, see
also Bonacelli 1932, Drago 2012, 16 nota 10.
63 McDermott 1938, 200 (catalogue nos.
237–239).
64 McDermott 1938, 201 (catalogue no. 243).
65 Camporeale 1984, 57.
66 Steingräber 1985, no. 51, 295, pl. 52–53;
Torelli 1999,153.

BIBLIOGRAPHY

S. Berndt 2015
Cutting the Gordion Knot, *Opuscola* 8, 2015,
77–122.

BK 1916
E. Brunn & G. Körte 1916 *I Rilievi delle Urne
Etrusche*, vol. 3. Berlin 1916.

R. Bonaudo 2006/2007
Dalla Ceramica a Figure nere alla Tomba del
Triclinio: Un Immaginario Visuale delle Rap-
presentazioni degli Uccelli su alcuni Monumenti
Figurati Etruschi, *Aion* Nuovo Serie N. 13–14,
157–172.

B. Bonacelli 1932
La scimmia in Etruria, *StEtr* VI, 1932, 341–382.

L. Bonfante 1978
The Arnoaldi Mirror, the Treviso Discs, and
Etruscan Mirrors in North Italy, *AJA* 82, 1978,
235–240.

L. Bonfante 2020
Writing against the Image, in: R. D. Whitehouse
(ed.), *Etruscan Literacy in its Social Context,
Accordia Specialist Studies on Italy* 18, London
2020, 145–150.

P. Brocato 2008
Osservazioni sulla Tomba delle Anatre a Veio e
sulla più antica ideologia religiosa etrusca, *Ocnus*
16, 2008, 69–105.

G. Camporeale 1984
La caccia in Etruria. Rome 1984.

G. Camporeale 2009
The Deified Deceased in Etruscan Culture, in:
S. Bell & H. Nagy (eds.), *New Perspectives on
Etruria and Early Rome*. Madison 2009, 220–250.

A. Cherici 2010
Otium erat quodam die Romae in Foro.
Dirigazioni su milizia, paesaggi danze e cavalieri

nella Roma piu antica, in: G. M. Della Fina (ed.), *La Grande Roma dei Tarquini*, AnnFaina XVII, 2010, 367–489.

J. Christiansen & Nora Petersen 2017
Etruria II. Ny Carlsberg Glyptotek. Copenhagen 2017.

M. Cristofani 1978
L'arte degli etruschi. Rome 1978.

M. Cristofani 1979
The Etruscans: A new Investigation. London 1979.

G. Colonna 2003
Osservazioni sulla Tomba Tarquiniese della Nave, in: A. Minetti (ed.), *Pittura Etrusca: Problemi e Prospettive*, (atti del convegno, Sarteano, Teatro comunale degli Arrischianti, 26 ottobre 2001, Chiusi, Teatro comunale Mascagni, 27 ottobre 2001), Siena 2003, 63–78.

H. Damgaard Andersen 1993
The Etruscan Ancestor Cult – Its Origin and Development and the Importance of Anthropomorphization, *AnalRom* 21, 1993, 7–66.

G. Davies 1985
The Handshake Motif in Classical Funerary Art, *AJA* 89, 1985, 627–640.

W. Deecke 1881
Le iscrizioni etrusche del vaso di Tragliatella, *AdI* 53, 1881, 161–168.

L. Drago 2012
Ricerche sul tema del bestiario fantastico di età orientalizzante. I precedenti della prima età del Ferro: continuità o discontinuità? In: M. C. Biella *et al.* (eds.), *Il Bestiario fantastico di età orientalizzante nella penisola Italiana Aristonothos, Scritti per il Mediterraneo antico Quaderni* 1, 2012 [2013], 15– 33.

Etruschi 2020
Etruschi. Viaggio nelle terre dei Rasna (Exhibition cataloque. Bologna), Bologna 2020.

G. Q. Giglioli 1929
L'Oinochoe di Tragliatella, *StEtr* III, 1929, 111–160.

S. Haynes 2000
Etruscan Civilization: A Cultural History. London 2000.

W. Helbig 1881
Adunanza dell'instituto (Marzo 4), *BdI* 1881, 65–67.

J. L. Heller 1961
A Labyrinth from Pylos?, *AJA* 65, 1961, 57–62.

J-R. Jannot 2005
Religion in Ancient Etruria, Madison 2005.

J-R. Jannot 2009
The Lotus, Poppy and other Plants in Etruscan Funerary Contexts, in: J. Swaddling & P. Perkins (eds.), *Etruscan by Definition: Papers in Honour of Sybille Haynes*. London 2009, 81–86.

R. P. Krämer 2015
Non di Questo Mondo? Riflessioni sul significato dei fregi animalistici etruschi con figure antropomorfe nel VII e VI sec. A.C., in: M. Biella & E. Giovanelli (eds.), *Nuovi studi sul bestiario fantastico di Età orientalizzante nella Penisola Italiana, Aristonothos, Scritti per il Mediterraneo antico Quaderni* 5, 2015 [2016], 187–220.

L. B. Lawler 1964
The Dance in Ancient Greece. London 1964.

W. C. McDermott 1938
The Ape in Antiquity. Baltimore 1938.

J. Martinez-Pinna 1994
L'Oenochoé de Tragliatella: Considerations sur la Société Étrusque Archaïque, *StEtr* LX, 79–92.

M. Menichetti 1992
L'oinochóe di Tragliatella: mito e rito tra Grecia ed Etruria, *Ostraka* 1, 1992, 7–30.

M. Menichetti 1994
Archaeologia del Potere. Re, immagini e miti a Roma e in Etruria in età arcaica. Milan 1994.

L. C. Pieraccini 2014
The Ever Elusive Etruscan Egg, *Etruscan Studies* 17, 2014, 267–292.

T. Rasmussen 2016
Interpretations of the Chigi vase, *Babesh* 91, 2016, 29–41.

M. Rigoglioso 2017
The Polyphemus Cave, in: *Labyrinthos Archive*, 2017, 1–8 (originally published in *Caerdroia* 29, 1998, 14–22).

G. Sarullo 2018
Danze Rituali nella Roma Arcaica tra Processioni
Saliari e Lusus Troiae, *Aristonothos* 14, 2018,
87–131.

J. Small 1987
The Tragliatella Oniochoe, *MDAI* 93, 1987,
63–96.

S. Steingräber 1985
*Etruscan Paintings: Catalogue Raisonné of Etruscan
Wall Paintings.* New York 1985.

J. Szilagyi 1992
Ceramica etrusco-corinzia figurata Vol.1: 630–580
a. C.. Florence 1992.

G. Säflund 1993
Etruscan Imagery: Symbol and Meaning. Jonsered
1993.

M. Torelli 1997
*Il rango, il rito e l`imagine. Alle origini della
rappresentazione storica romana.* Milan 1997.

M. Torelli 1999
Funera Tusca: Reality and Representation in
Archaic Tarquinian Painting, in: B. Bergmann &
C. Kondoleou (eds.), *The Art of Ancient Spectacle.*
New Haven-London 1999, 147–161.

L. Zaghetto 2018
Il Methodo narrativo nell' Arte delle situle,
Arimnestos 1, 2018, 239–250.

THE UNDERWORLD IN THE LATE ORIENTALIZING PERIOD

A UNIQUE REPRESENTATION ON A BRONZE PLATE FROM TOMB XI AT COLLE DEL FORNO

NORA MARGHERITA PETERSEN

Religion, ancestor cults and the afterlife were important aspects of everyday life in Etruria and central Italy in the Orientalizing period (ca. 750–575 BC). The Roman historian Livy writes that Etruria was "a nation devoted beyond all others to religious rites".[1] Nevertheless, as no literary sources have survived from the Orientalizing period, we have no written description of how people imagined either the afterlife or the underworld.

However, the archaeological records do provide an intricate perception of the afterlife and the underworld. For example, the rich princely tombs of the Orientalizing period in both Etruria and Latium contain a large amount of grave goods (e.g. food and drink, banquet equipment, weapons, writing tablets, textiles, jewellery, chariots and status symbols), which archaeologists deduce were placed in the tomb in the belief that the deceased would consume or use them in the afterlife. Representations of the Etruscan underworld are also known from later tomb paintings, such as the Tomba Golini I (350–300 BC) at Orvieto and Tomba dell'Orco II (325–300 BC) in Tarquinia.[2] Yet, the ideas of the afterlife and the underworld in the Orientalizing period have remained unclear, because the archaeological material does not supply any evidence of a specific afterlife or underworld context. We have had no inscriptions referring to the underworld, and no representations so far of recognizable underworld figures such as Aita (the Greek god Hades), or Cerberus, (Kerberos to the Greeks), the dog guarding the entrance to the underworld).

Certain objects from the Orientalizing period do, however, put forward an idea of the afterlife. For example, the modelled figures on the Monte Scudaio urn from Volterra (ca. 650 BC): on the lid, a man, almost certainly the deceased, is seated on a throne at a table. A. Rathje rightly suggests that the plastic decoration appears to be an afterlife eternal banquet.[3] Another

example on the Bisenzio urn (ca. 725–700 BC) provides us with the imagery of a chained wolf-like monster surrounded by dancing warriors, which J. Elliott interprets as warriors attempting to control the beast to assure their own survival in the afterlife.[4] On both urns, however, the room or space within which the figures are placed remains questionable or unclear to a modern audience.

A bronze plate dated to ca. 600 BC found in a princely tomb, Tomb XI at Colle del Forno, may depict the first presentation of an underworld scene from the Orientalizing period (**Fig. 1**). Paola Santoro studied the bronze plate in 2006 and compared the motifs to Greek and Near Eastern parallels.[5] In 2016, I myself studied the plate and drew the motifs (**Fig. 2**). In a serendipitous moment, I noticed details that no one seems to have as yet analyzed or even described.[6] To me, the most surprising discovery was the dog in the lower frieze – a dog with three heads, like Cerberus (**Fig. 3**). Using the discovery in the motifs, this article will examine a new and maybe unique depiction of the Etrusco-Italic vision of the underworld in the Orientalizing period: Firstly, I introduce Tomb XI and the Orientalizing period. Secondly, I examine the chariot scene on the upper frieze, two of a few unattached bronze fragments, and the motifs on the lower frieze. Thirdly, I analyze the different parts of the composition in the lower frieze, providing much deserved attention to its unique and complex composition.[7] But before we turn our attention to the bronze plate, a few words need to be said about its context.

Tomb XI at Colle del Forno and the Orientalizing Period

Tomb XI is a chamber tomb in the necropolis of Colle del Forno near Eretum, a Sabine town about 30 km northeast of Rome. Eretum was situated near the river Tiber, which served as an important trade and communication route linking the Sabines to the Etruscans, the Faliscans, and the city of Rome. Around 1970 Tomb XI was ravaged, and archaeologists do not therefore know where most of the grave goods were originally placed. However, Santoro, who excavated the tomb after it was violated, suggests that the bronze plate served as a decorative plaque on a wooden box, perhaps an urn.[8] Santoro's suggestion may be correct as we have other examples of urns from the Orientalizing period in the shape of rectangular boxes with decorated metal plaques.[9] Yet, the evidence remains inconclusive so far.

Fig. 1 Bronze plate from Tomb XI at Colle del Forno. (Photo: Thomas Ryming).

In the Orientalizing period, Greek and Phoenician tradesmen transported, traded and exchanged foreign and exotic goods from the Eastern Mediterranean with the local communities of central Italy. Through contact with these tradesmen, the people from central Italy became familiar with new motifs and objects, and with the elite customs from the Eastern Mediterranean. The lifestyle of the central Italian elite changed as they began to use fans, sceptres and thrones, to wear purple garments and hold large banquets, thus imitating the royal lifestyle of their foreign contacts.[10] Furthermore, the construction of the great princely tombs began in this period. Alongside the new objects, images and the new customs, Greek and Phoenician myths also reached the central Italian communities and began blending in with local beliefs and myths.[11] Tomb XI clearly reflects the contact with the Greeks and the Phoenicians. It contained elite objects such as bronze vessels and chariots, one decorated with Near Eastern creatures (**Fig. 4**), and the bronze plate has, among others, a depiction of the Greek mythological figure Cerberus.

The Bronze Plate Motifs

The bronze plate consists of several fragments that originally formed a rectangular plate of roughly 16 × 27 cm. It is divided into two horizontal friezes separated by a meander-like pattern, and the motifs are made in repoussé and with engraved details. Along the edges, which are slightly bent in some places, are small holes for nails to attach the plate to a wooden surface.[12] The five small fragments belonging to the same object (a box?) are not used in the reconstruction of the bronze plate.

UPPER FRIEZE (**Figs. 1 & 2**)

The upper frieze is very fragmented, but originally it depicted two chariots. The two-wheeled chariot at the far right is the best preserved. This chariot (a *triga*) is drawn by three horses moving to the right. The front horse is depicted in full, while the other horses are presented in profile behind it; manes, horse bits, teeth and harnesses are reproduced in detail. A person, dressed in a long tunic decorated with diamond-shaped patterns, is shown standing in the chariot, pulling the reins of the horses. Only one hand and the lower body of this person is preserved. To the left are fragments of a second chariot; a horseback, hind legs and four reins are preserved.[13]

In the Near Orient, chariots were used by Phoenicians and Assyrians and they are shown in both Phoenician and Assyrian art.[14] The elite in Etruria and the neighbouring regions adopted the use of the chariots, and the motif became popular in the Orientalizing and the Archaic periods, with chariots depicted on ceramics, architectural terracotta plaques and bronze plates.[15] Furthermore, several princely tombs contained real chariots.[16] Chariots had several purposes; they transported warriors to and from the battlefield, and they were used for hunting and for ceremonial processions.[17] Chariots also underline the high status and wealth of a family, something that would be of significant importance during an elite event such as a princely funeral.[18]

Fig. 2 Drawing of bronze plate from Tomb XI at Colle del Forno. (Drawing: Nora Margherita Petersen).

Fig. 3 Detail of the bronze plate showing the three-headed dog Cerberus.
(Drawing: Nora Petersen; photo: Thomas Ryming).

Fig. 4 Bronze plates deriving from a chariot from Tomb XI. Ny Carlsberg Glyptotek, (Photo: Ole Haupt).

The upper frieze of the plate shows a ceremonial procession, perhaps related to the funerary rituals.[19]

THE BRONZE FRAGMENTS

The bronze fragments belonged to the same box, and recognizable motifs, although fragmented, are discernable in two cases: 1) a veiled female head (**Fig. 5**); and 2) a dotted hoof, and the tip of a tail (**Fig. 6**). Behind the female head are the muzzle, bits and harnesses of a horse. The woman may have been standing either in the chariot behind the driver on the upper frieze (as seen on the Hydria Polledrara from the Isis tomb in Vulci (ca. 580 BC), and on a terracotta revetment plaque from Acquarossa (560–550 BC), or she may have been standing on the ground between the chariot and the horses.[20] The veil over her head is decorated with diamond patterns. The dotted hoof is similar to the deer hoof on the lower frieze, while the tip of the tail resembles those of the horses on the upper frieze. However, neither fragment fits into the composition of the bronze plate, indicating that they both belong to one of the other sides of the box.

Fig. 5 Bronze plate fragment showing a veiled female head. (Photo: Nora Petersen).

Fig. 6 Bronze plate fragment with a dotted hoof and the tip of a tail. (Photo: Nora Petersen).

LOWER FRIEZE (**Figs. 1, 2 & 3**)

The lower frieze is more complex than the upper, and I have chosen to divide the motifs into two scenes;

- Right scene: *Mischwesen*, three-headed dog, deer and animal rump.
- Left scene: *Mischwesen*, two she-wolves with suckling cubs carrying prey.

Right scene

The scene on the right depicts a *Mischwesen* with a feline or lion (?) head, and a human body in the *Knielauf* position.[21] The figure or person (?) wears boots, a diamond patterned loincloth, and a short-sleeved top. He thrusts a lance with his right hand into the midsection of the deer in front of him. The hunted deer has a short tail, dot rosettes on the body, and the position of the antlers shows that the animal is turning its (missing) head backwards. Depicted underneath the deer is a three-headed dog moving towards the right. Two of the heads are very fragmented, but it is clear that all three heads wear collars around their necks, collars which are connected to one leash held in the right hand of

the *Mischwesen* with the lance. Furthermore, an animal rump to the far right presents a *Tierkampf*, with a lion (?) attacking a deer. The flame pattern on the animal rump is depicted on other lions from the Orientalizing period, while the lion tail could either be hidden under the body or be represented by the thin vertical line descending from the rump.[22]

Left scene
At the far left is another *Mischwesen* with bent legs, the body facing left and the head turned to the right. Its human body wears a dotted short tunic, probably illustrating an animal skin or fur. Its head reveals a snout and pointed teeth, demonstrating an animal head, probably from a wolf or a lion.[23]

What appears to be a sword (?) held in the *Mischwesen's* hidden right hand or in its belt is pointed at the she-wolf to the left. Behind the sword is what could be a spear (?) or maybe the right arm (?). The left hand of the figure grabs the forepaws of the she-wolf, as if the *Mischwesen* wants to lead the animal somewhere. If so, the wolf does not take notice of the gesture, being fully occupied by the double task of feeding her cubs and managing the body of a prey in cooperation with the second she-wolf.[24] The full head of their prey is not visible, but its long horns indicate that the animal is either an ibex or a cow.[25] An ear of the animal may be represented in a small section of short lines.

The two she-wolves have long bodies, necks and snouts; their ears are triangular, and their tails appear voluminous and furry. Both animals have teats filled with milk and cubs suckling from them. The she-wolf on the left has two cubs feeding in apparent calm alongside each other, while the single cub feeding off the wolf to the right lifts its forelegs in motion, as if trying to keep up with the movements of its mother.

Unlike the chariot scene, the lower frieze reproduces dynamic moments where contradictory movements dominate. In addition, the three-headed dog and the two she-wolves with suckling cubs are unique motifs in the Late Orientalizing period (end of the 7th century BC – beginning of the 6th century BC). This interesting and novel composition raises the following questions: who are the different figures on the bronze plate? What context or location is represented? And why are these scenes depicted on a bronze plate from a princely tomb in Eretum?

Four-legged Creatures on the Lower Frieze

THE THREE-HEADED DOG (CERBERUS)

Ancient representations of three-headed dogs are interpreted as Cerberus, the guard dog of Hades known from Greek mythology. Cerberus was said to fawn over those who entered Hades and to be ferocious to those who tried to leave.[26] This fearsome dog is mentioned for the first time in literary sources by Homer. However, Homer does not use the name Cerberus; he mentions it as the dog from Hades in connection with the labours of Heracles.[27] The first to mention the guard-dog by the name Cerberus is the Greek poet Hesiod; Hesiod lived in the 7th century BC, and according to him Cerberus had fifty heads. Cerberus is described in different ways in literary sources – for example, as one-hundred-headed, or having a triple-tongued head surrounded by snakes – but later authors in Antiquity generally agree on the three heads.[28] The representations of Cerberus in the archaeological records also vary. In Greece he was presented with either one, two or three heads, and sometimes with snakes attached to the body, while Etruscan representations show him with either two or three heads, and also occasionally with snakes. The earliest Greek, multi-headed dog version is found in two small terracotta statuettes from Olympia, one with two and one with three heads, dated to the 7th century BC. They are, however, isolated examples and therefore cannot be identified with certainty as Cerberus.[29] The first clearly identifiable image of a Greek Cerberus appears on a Corinthian kotyle from the first quarter of the 6th century BC.[30]

The earliest representation of Cerberus in central Italy may be found on two fibulae described as fibulae *"a cavallino"*; the figures here have two heads, one body and two tails.[31] The fibulae were found in a female tomb in Casale Marittimo (Tomb L, ca. 650 BC). The funerary context and the two heads recall images of the guard dog of the underworld. Furthermore, the two fibulae derive from the same period in which, according to tradition, the Greek aristocratic merchant Demaratus of Corinth introduced Greek culture to central Italy.[32] However, there is no inscription – or, for example, a Heracles figure – to confirm their identity. The earliest image of Cerberus with a collar and a leash, held by a Heracles-looking figure, from central Italy, therefore derives from this exceptional bronze plate found in Tomb XI at Colle del Forno.

Compared to the Greek representations, the Cerberus on the bronze plate is smaller. However, this tendency to show Cerberus as less mon-

strous and resembling a normal dog has also been seen in southern Italian and on Etruscan representations, as in the Tomba dei Rilievi (4th century BC) from Cerveteri.[33]

The Cerberus figure on the bronze plate places the context of the lower frieze in the underworld, not only because of Cerberus's role as the guard dog of Hades, but also because of its association with the other figures present, such as the *Mischwesen*, the wolves and the wounded deer.

DEER AND LION (HUNT, BLOOD AND *Tierkampf)*

The wounded deer in the lower frieze is just one of many bleeding and dying animals depicted in central Italian tombs reflecting the offering of an animal. In funerary contexts, the blood was thought to represent the anger of the dead and meant to protect the souls against the dangers of the transitions to the afterlife.[34] The little we know about afterlife in central Italy derives from the Etruscan *Libri Acheruntici* (or the books about death, the grave and the afterlife), which tell us that human souls could be transformed into gods through certain animal sacrifices. The blood sacrifice was meant to present dead souls with immortality.[35] In Homer's Odyssey, the dead are reanimated when they drink blood. Homer mentions that dead souls talk to Odysseus as the blood of a sacrificed sheep flows into a pit.[36] I suggest that the deer hunt on the bronze plate may refer to a similar sacrifice. However, a hunt in an elite tomb could also refer to the elite activity of hunting wild animals. The lion attacking the deer from behind further enhances the important aspects and contrasts of life and death; animal combats are symbols of a violent death that can suddenly overwhelm the living. Furthermore, *Tierkampf* scenes are a common motif in the pediment of the rear wall of Tarquinian painted tombs – they can in that position also be viewed as an expression of protection of the soul on its death journey.[37]

WOLVES OR LIONS

The two nursing animals in the lower frieze have earlier been described as lions.[38] In Antiquity, lions were usually depicted with round ears, a short neck and round snout, like, for example, the lions on a gold plaque from the Bernardini tomb.[39] However, not all lions from the Orientalizing period bear these characteristics. Brown, for example, emphasizes certain long-eared, long-faced and flat-snouted lions that do not bear the typical lion features, and Krauskopf highlights an experimental phase where lion

depictions do not yet follow a fixed schedule.[40] The craftsmen of central Italy had never seen a real lion, and their lion depictions were therefore imitations of lion motifs that reached central Italy on ceramics, textiles, ivory objects, jewellery, and the like, from the Eastern Mediterranean. Some animal representations show elements from both wolves and lions, and Krauskopf refers to these as *leoni-lupi*.[41] However, the similarities between the representations of wolves and lions in burials are not surprising, as both animals are associated with funerals and death cults, and share symbolism.[42] According to Nijboer, the wolves were for Europe what the lions were for the Near East.[43]

In this context, the artist responsible for the motif on the bronze plate most probably wanted to reproduce wolves; the features of the two animals could hardly be clearer. They have long snouts, long necks and bodies, the ears are triangular, and the tails are full and furry – strongly reminiscent of real she-wolfs. The local Sabine people would have been familiar with wolves as part of the natural habitat of forests. They were thought to be threatening animals and to pose a real danger to the people of central Italy. This association with danger may explain the connection with death and the cult thereof, and it further explains why the Etruscan word *lupu* means "to die".[44] From the 4th century BC it becomes clear that the wolf is connected to the underworld; figures with wolf caps and wolf heads are, for example, seen on wall paintings and on urns.[45]

A wolf-like bronze figurine from Cortona (3rd century BC) carries the inscription Calu, which was probably the old Etruscan name for the ruler of the underworld, Aita.[46] Calu is associated with wolves, and he is known from inscriptions because the dead "went to Calu".[47] The tail of the bronze figurine is furry, and like the two she-wolves on the bronze plate it has emphasized fur down the back, long triangular ears and an elongated snout.[48]

The voluminous furry tails, especially, determine the identities of the wolves on the bronze plate. Lion tails are normally represented as long and thin, curved, and in the majority of cases with a tuft at the end. The full and furry wolf tails are rarely depicted in the Orientalizing period. However, the same type of tail is seen on dogs – as, for example, in a hunting scene on an Egyptianizing bowl from the Regolini Galassi tomb. In this scene both lions and dogs are represented, which makes the difference between the lion and dog tail very clear.[49] On the bronze plate, the wolf

tails also differ from that of the fragmented lion on the far right; the tails thus mark the identity of the animal.

Although wolves are rarely represented in central Italian iconography, an early example of a wolf-like animal is seen on the aforementioned bronze urn from Bisenzio from the end of the 8th century BC. In the centre of the urn's lid, a beast is chained and sits upright with his front paws thrust forward. It has been interpreted as a wolf or a wolf-like monster, and it has been suggested that the warriors who dance around it are trying to control the animal in order to guarantee their continuance in life after death.[50]

Wolves also have an important local signification, as they can be linked to Sabine myths. Some Sabines were said to have emigrated to Hirpinia led by a wolf, and the cult of the Hirpi Soranus (the wolves of Soranus, a cult imported from the Sabine area to the Faliscan area) had elements in common with the early Roman Lupercalia cult. [51]

SUCKLING CUBS AND NURSING ANIMALS

The motif of the she-wolves with the suckling cubs is unique for central Italy. The nursing animal motif derives from the Near Orient, where most often cows or deer nurse their calves whilst turning their heads to lick their offspring clean. The motif is a symbol of fertility and is used abundantly in, for example, Assyria.[52] The Phoenician tradesmen spread the images of the suckling and nursing animals to the Western Mediterranean. Thus, a suckling animal decorates the Cypro-Phoenician bowls found in the Regolini Galassi tomb at Cerveteri, and at Praeneste.[53] Moreover, these Egyptian and Assyrian motifs became popular on locally produced ceramics such as bucchero, white-on-red ceramics, and on Etrusco-Corinthian products.[54]

A scene similar to that of the suckling one on the bronze plate is seen on a hydria (6th century BC) from Cerveteri where a lioness (?) is pictured being disturbed by hunters while nursing her cubs. The two cubs are not shown actually suckling but are situated at a short distance from the teats of the mother, and it has been suggested that the two cubs are hunting dogs.[55] Santoro suggested the same for the single cub on the bronze plate; this seems unlikely, however, because its mouth actually meets with the teat.[56] Another nursing lioness (or wolf?) appears on a stele from Bologna (5th century BC) where the animal is shown nursing a human child.[57] The stele motif recalls the Roman she-wolf and the suckling twins, Romulus and Remus. The nursing scene on the bronze plate can thereby also be

associated with the Roman foundation myth. Rome and Eretum are geo-graphically close to one another; the she-wolves are nursing either two cubs or babies, and the period in which the city of Rome is developing into a large urban city, where the she-wolf myth may have played an important role, is chronologically the same as the date of the bronze plate (ca. 600 BC). The she-wolf was associated with fertility, and especially in connection with Romulus and Remus, whom she protected, but also in connection with the Lupercalia festival that honoured the she-wolf.[58] The Lupercalia was an ancient Roman purification and fertility festival, and the name relates to the Latin word *Lupus*, wolf.[59]

Nevertheless, in elite tombs the fertility aspect played an important role in securing the continuity of the family. The two wolves on the bronze plate from Colle del Forno are feeding their cubs while eating their prey. In this way, milk and blood, growth and decay, life and death are represented in one composition that underlines the circle of life, which includes fertility, (re) birth and the securing of strong future generations.

Who are the Mischwesen on the Bronze Plate?

Mischwesen are known from Etruria and Latium vetus from the Oriental-izing period, and they were probably inspired by an oriental model. In the Assyrian palace reliefs, *Mischwesen*, *genii* and demons are depicted with lion heads, some appearing in processions, while other hybrid creatures have fish or bird heads.[60] Another example of a *Mischwesen* derives from Nimrud, where an Egyptian lion-headed god from the Neo-Assyrian peri-od (911–612 BC) is shown on an ivory plaque in the Phoenician style.[61] An Etruscan pendant with the presentation of a lion-headed figure is found in the Montefortini tumulus in Comeana (second half of the 7th cen-tury BC).[62] The function of these creatures in Assyria was to protect the palace and the king.[63] However, the Etrusco-Italic *Mischwesen* with their different animal heads (e.g. lions and bulls) are not assumed to be specific mythological creatures as the oriental types are. Instead, they are thought to symbolize the transition from the living world to the underworld.[64] The presence of the *Mischwesen* on the bronze plate sets the scene on the lower frieze in a sphere that is not a part of everyday life, a sphere that refers to an otherworldly context.[65]

Yet, the left *Mischwesen* on the lower frieze may have been inspired by Greek mythology. Greek myths are presented in all phases of central Ital-

ian figural art, and Heraclean myths are seen in the archaeological records beginning from the 7th century BC.[66] It is therefore likely that the Heraclean myth with Cerberus also reached the coast of central Italy in the Orientalizing period. In Greek depictions, Heracles holds Cerberus's leash;[67] so, could the figure in the right scene be an early version of the Greek hero? In Greek presentations, Heracles is known for his attributes, the club and the lion skin, whereas the figure on the bronze plate has a feline head and a lance. The frontal feline head could have an apotropaic function, however; perhaps it is an early attempt to depict a lion skin, and as the head is fragmented perhaps a human face could have been depicted in the missing spot. The lance on the bronze plate may refer to a local myth. In the Sabine area, Heracles was associated with a local god by the name of Semo Sancus (Roman sources call him Semo Sancus Dius Fidius).[68] Semo Sancus was the ancestor of the Sabine race, and Roman sources refer that he was the deified king or the legendary founder of the Sabine city, Cures. In Sabine, "cures" meant lance.[69] Roman sources further refer that Semo Sancus defeated a tricephalic monster called Cacus.[70] The lion-headed figure on the bronze plate appears to combine elements of the local Sabine god with influences from Greek mythology. Nevertheless, the lance may also have had personal significance to one of the deceased of Tomb XI, in which four lances were actually found.

Maybe the *Mischwesen* to the far left can also be identified more closely. The lion or wolf-headed figure is placed in connection with the two she-wolves and their cubs. In the Etruscan world a certain type of demon named *Demone-lupo* was closely associated with wolves, the underworld, and the transition thereto.[71] The death demons were beings who led the deceased to the underworld and who could have different wolf-like characteristics. In later periods, the Etruscan god of the underworld, Aita, wears the characteristic cap made from the skin of a wolf on wall paintings in Tomba Golini I (350–300 BC) at Orvieto, and in Tomba dell'Orco II (325–300 BC) in Tarquinia. In both tombs, Aita is represented as being in the underworld.[72] But not only Aita wears wolf skin. On an urn from Perugia a figure emerging from a well is wearing a wolf-skin hat, and on a similar urn, also from Perugia, the whole head of the emerging figure is shaped like a wolf mask.[73] According to Jannot, the emerging figures are communicating with the "world below".[74] Furthermore, a wolf mask (6th–5th century BC) in the Harvard Art Museums has been identified as probably originating from

Etruria.[75] When wearing an animal mask, the wearer assumes the animal's attributes and shamanistic powers.[76] The figure with the wolf mask (or wolf head) on the bronze plate may represent an early Aita or a demon-wolf (*demone lupo*), considered a predecessor for the "Hellenized" demons which according to Krauskopf are found in the 6th century BC and generally combined a human body with heads of wolves or predatory birds.[77]

A very interesting detail is that the two *Mischwesen*, the Heracles-figure and the demon-wolf, are dressed differently. The figure associated with Heracles and Semo Sancus, wears a diamond patterned loincloth and high boots. The diamond pattern is often seen in connection with the elite – for example, in the Tomba delle Cinque Sedie, and in the upper frieze of the bronze plate. In contrast to this, the figure associated with the demon-wolf wears a cloth of animal skin or fur. These small details essentially differentiate the elite dress from the primitive; thus, civilization from nature, or hero from demon.

Conclusion

The bronze plate from Colle del Forno presents the earliest insight into a central Italian conception of the underworld. The unique motifs reflect a handover of Near Eastern and Greek customs, images and myths, which show that not only the lifestyle and the material culture changed, but also that the religion and the beliefs of the local people merged with the newly presented foreign ideas in the Late Orientalizing period. In the lower frieze, a local Italic underworld, with a demon-wolf and two nursing she-wolves, meets the exotic and foreign underworld that combines an animal combat, a Cerberus, and a Greek Heracles with local features. In contrast to this, the upper chariot frieze may represent the world of the living, such as elite participants arriving at a princely funeral.

The foreign themes signalized the status of the family, as they manifested their openness towards new customs and contacts with foreign individuals and ideas, and showed that the family had the capacity to integrate new customs and ideas with local beliefs. Therefore, it is not unthinkable that one of the deceased in Tomb XI came from abroad and married a local person.

We may furthermore imagine that the grave goods were displayed and presented to the participants at the princely funeral before they were brought to the tomb. A large funeral event may have been the perfect occa-

sion to show members of high society and the participants of the funeral the new elite customs and beliefs. The bronze plate may have served as a hopeful "brochure" on how life after death would present itself, or as a religious guide to the underworld. After all, the continuity of the underworld creatures, the wolves and the wolf-skin cap, Cerberus and the *Mischwesen*, are identifiable in later wall paintings, bronze figurines and ceramics, etc., which did, then, successfully convey the underworld tradition that began in the late Orientalizing period to future generations.

NOTES

1 Livy 5,1.
2 Marzullo 2016, 261–270; Steingräber 2006, 211–213; Krauskopf 2006, 69–70; De Grummond 2006, 229–231.
3 See Rathjes contribution in this edition of *ActaHyp*; Krauskopf 2006, 78.
4 Elliott 1995, 20, fig. 7.
5 Santoro 2006, 267–273.
6 The majority of the objects from Tomb XI ended up in Copenhagen at the Ny Carlsberg Glyptotek in the early 1970s. However, the whole tomb was returned to Italy in December 2016. The objects that the tomb robbers left in the grave were subsequently excavated by Paola Santoro and exhibited at the museum of Fara Sabina. It was while the bronze plate was still at the Ny Carlsberg Glyptotek that I became interested in its unique motifs (former Inv.no. H.I.N. 527 at the Ny Carlsberg Glyptotek); Santoro 2006, 272, note 1; Benelli & Santoro 2011, 108. Betori & Licordari 2021.
7 The scope of this article is not to analyze all the representations in detail, but to present the images on the bronze plate in order to gain a greater understanding of the representations.
8 Santoro 2006, 271–272; Cremated bones have been found in the grave, although they may not belong to the deceased. Benelli & Santoro 2009, 61.
9 See e.g. Raffanelli 2009, 95–97, for the urn in Tomba del Duce, and Adami *et al.* 2013, fig. 10, for a reconstruction of the urn from Tomb 5 at Monte Michele Veii.
10 Delpino 2000, 223–225; Petersen 2015, 301–302.
11 Simon 2013, 495–510.
12 Santoro 2006, 267.
13 Santoro 2006, 267.
14 Atac 2010, 173, fig. 6.10; 151, fig. 5.6; Santoro 2006, 269; Littauer & Crouwel 1997, 5–8; Curtis & Reade 1995, 161–163.
15 Santoro 2006, 269, fig. 2–3; Emiliozzi 2013, 778.
16 Emiliozzi 2013, 779; Colonna 1997, 15, 17; Santoro & Emiliozzi 1997, 291–300. Tomb XI contained a *currus* and a *calasse*. In some cases, horses are also sacrificed and placed in the graves, as seen in Tomb 36 (ca. 500 BC) from Colle del Forno; Benelli & Santoro 2009, 62; Benelli & Santoro 2011, 108.
17 Emiliozzi 2013, 779.
18 Bartoloni 2000, 225–226; Emiliozzi 2013, 779; Colonna 1997, 17.
19 For a chariot in procession in an Etruscan tomb, see Tomba dei Demoni Azzurri from 450–430 BC. Marzullo 2016, 117–122.
20 Winter 2009, 265–267, fig. 4.15; Colonna 1997, 19, fig. 5.
21 Santoro identifies the head as a lion head. Santoro 2006, 268.
22 Santoro 2006, 269; for a lion with flame pattern on the animal's rump, see De Puma 1996, pl. 302.2 & 303.2.
23 According to Santoro (2006, 269), Szilagyi identifies the animal head with that of a bull (*testa taurina*). However, on a closer look this cannot be the case; the snout and the pointed tooth definitely belong to a wolf or a lion.
24 See Santoro 2006, 269–270 for more examples of dead animals on backs. In the collection of the Ny Carlsberg Glyptotek, animals are depicted on two amphoras with animal prey on their backs. Christiansen & Petersen 2017, 423–426, no. 181–182.

25 Santoro (2006, 267–268) refers to the animal as a ram or a boar; however, some of these diverse interpretations may be explained by the fact that Santoro studied the plate only through photographic evidence.

26 Woodford & Spier 1992, 24.

27 Heracles fetching Cerberus up from the underworld. Homer *Il.* 8, 366–369; Homer mentions the dog again in *Od.* 11, 623–626.

28 Hes. *Theog.* 306–312; Pind. (*Dith.* 2 frg. 249a Snell/Maehler); Hor. *C.* 3, 11, 17–20; Woodford & Spier 1992, 24–25 & *Enciclopedia dell'Arte Antica* II, 505 for more references concerning Cerberus.

29 Woodford & Spier 1992, 25–28, no. 20 & 40.

30 Woodford & Spier 1992, 25, no. 1.

31 Esposito 2001, 64, fig. 59; Colombi 2008, 12. A fibula reminding of the fibulae from Casale Marittimo, but made of gold and decorated with small gold granulation, is today in the Museum of Fine Arts in Boston. However, it might be either 6th century BC or modern. Densmore Curtis 1914, 17–25. https://collections.mfa.org/objects/249849

32 Gras 2000, 20.

33 Woodford & Spier 1992, 31; Steingräber 2006, 254.

34 Krauskopf 2006, 76; Elliot suggests that the bloodletting may on some occasions have been a rite that effected the fate of the honoured person. Elliott 1995, 31. see Brandt in this volume.

35 Krauskopf 2006, 66; De Grummond 2006, 209. Other examples of blood sacrifice represented in tombs are seen in the François Tomb, and in the Tomba degli Auguri. De Grummond 2006, 209–210 & Krauskopf 2006, 76.

36 De Grummond 2006, 209; Hom. Od. 11.35.

37 Krauskopf 2006, 76.

38 Santoro 2006, 267–268; for more about the lion's appearance and typology see Camporeale 1965.

39 Krauskopf 2015, 16. Gold plaque from the Bernardini tomb; Sannibale 2015, 319, no. 189.

40 Brown 1960, 25; Krauskopf 2015, 16.

41 Krauskopf 2015, 21, 23; Krauskopf 2013, 524.

42 Krauskopf 2015, 17.

43 In *Crustumerium* 2016, 95.

44 *Crustumerium* 2016, 95; Krauskopf 2015, 21; Elliott 1995, 24; Holleman 1985, 609.

45 This will be treated below.

46 Krauskopf 2006, 80, note 30; De Grummond 2006, 57.

47 De Grummond 2006, 57.

48 De Grummond 2006, 55–56, fig. IV.4. Another small bronze figurine that might represent a wolf is the so-called *lupetto bellino*, which originates from the Sabine area (*Valle Fuino*). However, according to Stalinski the *lupetto bellino* might be identified as a small deer. A similar Etruscan or Italic wolf-looking figurine (3rd century BC) is in the Boston Museum of Fine Arts. Stalinski 2001, 180–181, 295, fig. 171. http://www.mfa.org/collections/object/begging-dog-152857

49 Sannibale 2015, 322–323, no. 193.

50 Elliott 1995, 20; De Grummond 2006, 2–3. Another wolf motif, also from the Orientalizing period, was found in 2012 at Crustumerium. In Tomb 59 (ca. 650 BC), a bone amulet with a wolf depiction was found near the head of an elderly woman; the wolf has pointed ears, gazing eyes, a long pointed snout and a large, half open mouth. *Crustumerium* 2016, 94–95, 99–100, fig. 6.25.

51 De Cazanove 2007, 46; Bakkum 2016, 29.

52 Fontan 2015, 154, 51C; Caubet *et al.* 2007, 211, fig. 5.

53 De Puma 2016, 202–203; Sannibale 2012, 315, fig. 16; *La Mediterranée des phéniciens* 2007, 344–345, no. 174. Another example is the golden ring (ca. 600 BC) with the motif of a nursing cow that was found at Sant'Angelo Muxaro in Siciliy. Interestingly, a similar ring discovered in a tomb also at Sant'Angelo Muxaro was decorated with a wolf. See Booms & Higgs 2016, 46–47, fig. 26, fig. 27.

54 Bonamici 1974, 73–74, tav. LII–LIII; Belelli Marchesini 2006, 229, no. II.226; Szylágyi 1992, 39, tav. III); Santoro 2006, 271.

55 Brown 1960, 74–75, pl. XXVI c; CVA Louvre IX pl.4 (France 612) 1–3.

56 Santoro 2006, 268.

57 Presicce 2000,19, fig. 2.

58 Elliott 1995, 23.

59 Holleman 1985, 609; Elliot 1995, 24.

60 Atac 2010, 160–162; Curtis & Reade 1995, 58–59, no. 9.

61 Aruz 2015, 124, fig. 3.9.

62 Bettini & Nicosia 2000, 250, 258, no. 299 & 315; Giovanelli 2013, 190–191, fig. 4; 491. For more on the different combinations of human body and animal heads in central Italy, see Perego 2013.

63 Santoro 2006, 231, 270.

64 Perego 2013, 490, 492–493. The oriental-inspired figures have probably preserved some of the attributes they had in the Near East, where they are often depicted in con-

nection with public functions and ceremonies. Santoro 2006, 272.

65 Perego 2013, 492.

66 Bettini & Nicosia 2000, 250, 258, no. 299 & 315. The adventures of the Argonauts and of Odysseus are among the earliest myths. A fragmentary ivory plaque found in the Montefortini tumulus probably shows the Hydria from Lerna, and from 630 BC representations of Medea and Daidalos were made on a bucchero jug from Cerveteri. Simon 2013.

67 For a Greek depiction of Heracles holding the leash of Cerberus, see Woodford & Spier 1992, 24–27, no. 22.

68 Briquel 1996, 38–39; Stalinski 2001, 228–250. According to Stalinski, Semo Sancus was a sort of official guarantor of earthly peace and safety of both men and animals during the 6th century BC and he therefore became a symbol of stability and prosperity. Stalinski 2001, 245.

69 Sabini 2009, 23; Woodward 2006, 196–197, 202; Stalinski 2001, 236.

70 Woodward 2013, 231–232; Woodward 2006, 196–197; Alvino 2009, 4445.

71 Rissanen 2012, 126–127; Elliott 1995, 24.

72 Krauskopf 2015, 23; Jannot 2005, 66–67; Elliott 1995 20–21. On later urns from Chiusi, Aita is also represented; see Agelidis 2013, 47, fig. 4.8. For more information on heads with skin caps, see Elliott 1995, 20–22.

73 Perego 2012, 490, 494–495, fig. 6; Elliott 1995, 17–20, figs. 5 & 6.

74 Jannot 2005, 70.

75 Elliott 1995, 17, fig. 1; Haynes 1965, 22, no. 65a. For technical observations and conservation treatment, see: https://www.harvardartmuseums.org/collections/object/304243?position=343. A bronze figurine with a sharp line between the wolf's head and the human body might also be wearing a mask; Perego 2012, 491–95; Franken 2013, 97. 495.

76 Perego 2012, 495; Elliot 1995, 20 & 27. And the Egyptian priests used wolf masks in connection with the Anubis cult; Elliott 1995, 30, figs. 16–18.

77 Krauskopf 2006, 73–74.

BIBLIOGRAPHY

A. Adami *et al.* 2013
The Etruscan grave n.5 of Monte Michele, in Veii: from the digital documentation to the virtual reconstruction and communication, in: *Digital Heritage International Congress vol. II (DigitalHeritage)*, 661–668.

S. Agelidis 2013
Death and the Afterlife, *Etruscans in Berlin*. Regensburg 2013, 41–58.

G. Alvino 2009
I Sabini e le evidenze archeologiche, in: M. C. Bettini & A. Nicosio (eds.), *I Sabini popolo d'Italia. Dalla storia al mito*, Roma 2009, 41–78.

J. Aruz 2015
Art and Networks of Interaction Across the Mediterranean, in: J. Aruz, S. B. Graff & Y. Rakic (eds.), *Assyria to Iberia at the dawn of the Classical Age* (Exhibition New York), New York 2015, 112–124.

M. A. Atac 2010
"Time and Eternity" in the Northwest Palace of Ashurnasirpal II at Nimrud, in: A. Cohen & S. E. Kangas (eds.), *Assyrian Reliefs from the Palace of Ashurnasirpal II*, Hanover & London 2010, 159–180.

G. C. L. M. Bakkum 2016
Iunonicolae Falisci: Faliscan Cult and Local Identity, in: A. Ancillotti, A. Calderini & R. Massarellin (eds.), *Forme e strutture della religione nell'Italia mediana antica*, Roma 2016, 27–34.

G. Bartoloni 2000
La guerra e la caccia, in: G. Bartoloni, F. Delpino, C. Morigi Govi & G. Sassatelli (eds.), *Principi etruschi tra Mediterraneo ed Europa*, Venice 2000, 225–229.

B. Belelli Marchesini 2006
Olla con quattro piattelli, in: M. A. Tomei (ed.), *Roma. Memorie dal sottosuolo, Ritrovamenti Archeologici 1980/2006* (Exhibition Roma), Milano 2006, 229.

E. Benelli & P. Santoro 2009
Colle del Forno (Montelibretti, Roma). Nuovi dati dalle ultime campagne di scavo, *Lazio e Sabina, Scoperte Scavi e Ricerche* 5. Roma 2009 59–62.

E. Benelli & P. Santoro 2011
1970–2010: quaranta anni di scavi a Colle del

Forno (Montelibrettti, Roma), *Lazio e Sabina* 7. Roma 2011, 107–109.

A. Betori & F. Licordari 2021
Strada Facendo Il lungo Viaggio del "carro di Eretum" (Exhibition Rieti), Rieti 2021.

M. C. Bettini & F. Nicosia 2000
Gli avori di Comeana (Firenze), tumulo di Montefortini, tomba a tholos in: G. Bartoloni, F. Delpino, C. Morigi Govi & G. Sassatelli (eds.), *Principi etruschi tra Mediterraneo ed Europa*, Venice 2000, 246–270.

M. Bonamici 1974
I buccheri con figurazioni graffite. Florence 1974.

D. Booms & P. Higgs 2016
Sicily: Culture and Conquest (Exhibition London). London 2016.

D. Briquel 1996
La tradizione letteraria sull'origine dei Sabini: qualche osservazione, in: G. Maetzke & L. T. Perne (eds.), *Identità e civiltà dei sabini, Atti del convegno di studi etruschi ed italici Rieti – Magliano Sabina*, Firenze 1996, 29–40.

W. L. Brown 1960
The Etruscan Lion. Oxford 1960.

G. Camporeale 1965
Considerazioni sui leoni etruschi di epoca orientalizzante, *RM* 72 1965, 1–13.

A. Caubet *et al.* 2007
L'Âge del l'ivoire, in: E. Fontan & H. Le Meaux (eds.), *La Méditerranée des phéniciennes de Tyr à Cartage*, Paris 2007, 205–215.

J. Christiansen & N. Petersen 2017
Etruria 2, Ny Carlsberg Glyptotek, Copenhagen 2017.

C. Colombi 2008
Die zwei Frauengräber der orientaliserenden Nekropole von Casale Marittimo, *Bulletin de l'Association Suisse d'Archéologie Classique*, 2008, 9–15.

G. Colonna 1997
L'italia antica: Italia centrale, in: A. Emiliozzi (ed.), *Carri da Guerra, Principi Etruschi* (Exhibition Viterbo), Roma 1997, 15–24.

Crustumerium 2016
Crustumerium. Death and Afterlife at the Gates

of Rome. Ny Carlsberg Glyptotek (Exhibition Copenhagen). Copenhagen 2016.

J. E. Curtis & J. E. Reade (eds.) 1995
Art and Empire: Treasures from Assyria in the British Museum. New York 1995.

O. De Cazanove 2007
Pre-Roman Italy, Before and After the Romans, in: J. Rüpke (ed.), *A Companion to Roman Religion*, Oxford 2007, 43–57.

N. T. De Grummond 2006
Etruscan Myth, Sacred History, and Legend. Philadelphia 2006.

F. Delpino 2000
Il principe: Stile di vita e manifestazioni del potere. Regalità e potere, in: G. Bartoloni, F. Delpino, C. Morigi Govi & G. Sassatelli (eds.), *Principi Etruschi tra Mediterraneo ed Europa*, Venice 2000, 223–225.

C. Densmore Curtis 1914
An Early Graeco-Etruscan Fibula, *JRS* 4.1, 1914, 17–25.

R. D. De Puma 1996
Etruscan Impasto and Bucchero, Corpus Vasorum Antiquorum, The J. Paul Getty Museum, fasc. 6, 1996.

R. D. De Puma 2016
Gold and Ivory, in: N. T. De Grummond & L. Pieraccini (eds.), *Caere*, Austin 2016, 195–208.

J. Elliott 1995
The Etruscan Wolfman in Myth and Ritual, *EtrSt*, 1995 vol. 2, 17–33.

A. Emiliozzi 2013
Princely Chariots and Carts, in: J. M. Turfa (ed.), *The Etruscan World*, New York 2013, 778–797.

A. M. Esposito 2001
Principi guerrieri: la necropoli etrusca di Cassale Marittimo (Exhibition London). Milan 2001.

E. Fontan 2015
Ivories of Arslan Tash, in: J. Aruz, S. B. Graff & Y. Rakic (eds.), *Assyria to Iberia at the dawn of the Classical Age* (Exhibition New York), New York 2015, 152–156.

N. Franken 2013
Bronze Metalwork, in: V. Kästner (ed.), *Etruscans in Berlin*. Regensburg 2013, 89–97.

E. Giovanelli 2013
Esseri fantastici alle origini della glittica
preromana: spunti preliminari su alcuni intagli,
in: M. C. Biella, E. Giovanelli & L. G. Perego
(eds.), *Il bestiario fantastico di età orientalizzante
nella penisola italiana, Aristhonothos* Quaderni n.
1, Trento 2013, 189–206.

M. Gras 2000
Il Mediterraneo in età Orientalizzante:
merci, approdi, circolazione, in: G. Bartoloni,
F. Delpino, C. Morigi Govi & G. Sassatelli (eds.),
Principi etruschi tra Mediterraneo ed Europa,
Venice 2000, 15–26.

S. Haynes 1965
Zwei archaisch-etruskische Bildwerke aus dem
Isis Grab von Vulci, *AntP* 4, 1965, 13–24

A. W. J. Holleman 1985
Lupus, Lupercalia, lupa, *Latomus* 44.3, 1985,
609–614.

J.-R. Jannot 2005
Religion in Ancient Etruria. London 2005.

I. Krauskopf 2006
The Grave and Beyond in Etruscan Religion, in:
N. T. de Grummond & E. Simon (eds.), *The
Religion of the Etruscans*, Austin 2006, 66–89.

I. Krauskopf 2013
Gods and Demons in the Etruscan Pantheon, in:
J. M. Turfa (ed.), *The Etruscan World*, New York
2013, 513–538.

I. Krauskopf 2015
Leoni, lupi e leoni-lupi nell'arte orientalizzante
etrusca, *StEtr* 2015, 15–23.

La Méditerranée des phéniciens 2007
La Méditerranée des phéniciens de Tyr à Cartage
E. Fontan & H. Le Meaux (eds.). Paris 2007.

M. A. Littauer & J. H. Crouwel 1997
Antefatti nell'Oriente mediterraneo: Vicino
Oriente, Egitto e Cipro, in: A. Emiliozzi (ed.),
Carri da Guerra, Principi Etruschi (Exhibition
Viterbo), Roma 1997, 5–10.

M. Marzullo 2016
*Grotte corneteane. Materiali e apparato critico per
lo studio delle tombe dipinte di Tarquinia* I–II,
Tarchna suppl. 6. Milano 2016.

L. G. Perego 2012
A proposito di *Mischwesen* cinomorfi: commistio-

ni animali-uomo tra "lettura del reale" e rito, in:
M. C. Biella, E. Giovanelli & L. G. Perego (eds.),
*Il bestiario fantastico di età orientalizzante nella
penisola italiana, Aristhonothos* Quaderni n. 1,
Trento 2012 [2013], 498–503.

N. M. Petersen 2015
The Fan, a Central Italian Elite Utensil, *ActaHyp*
14, 2015, 301–328.

C. P. Presicce 2000
La lupa capotolina. Roma 2000.

S. Raffanelli 2009
La Tomba del Duce, in: M. Celuzza (ed.),
*Signiori di Maremma. Elites Etrusche fra Populo-
nia e il Vulcente*, Firenze 2009, 95–97.

M. Rissanen 2012
The Hirpi Sopani and the Wolf Cult in Central
Italy, *Arctos* 46, 2012, 115–135.

Sabini 2009
M. C. Bettini & A. Nicosia (eds.), *Sabini popolo
d'Italia: Dalla storia al mito.* Roma 2009.

M. Sannibale 2012
The Etruscan Princess of the Regolini Galassi
Tomb, in: N. C. Stampolidis & M. Giannopou-
lou (eds.), *Princesses of the Mediterranean in the
dawn of History* (Exhibition Athens), Athens
2012, 306–321.

M. Sannibale 2015
Levantine and Orientalizing Luxury Goods from
Etruscan Tombs, in: J. Aruz, S. B. Graff & Y.
Rakic (eds.), *Assyria to Iberia at the dawn of the
Classical Age* (Exhibition New York), New York
2015, 313–329.

P. Santoro 2006
Tomba XI di Colle del Forno: Simbologie funera-
rie nella decorazione di una lamina di bronzo, in:
B. Adembri (ed.), *Aeimnestos, miscellanea di Studi
per Mauro Cristofani*, Florence 2006, 267–273.

P. Santoro & A. Emiliozzi 1997
Eretum: i veicoli dalla Tomba XI di Colle del
Forno, in: A. Emiliozzi (ed.), *Carri da Guerra,
Principi Etruschi* (Exhibition Viterbo), Roma
1997, 291–301.

E. Simon 2013
Greek Myth in Etruscan Culture, in: J. M.
Turfa (ed.), *The Etruscan World*, New York 2013,
495–512.

A. Stalinski 2001
Il ritrovamento di "Valle Fuino" presso Cascia: analisi storico-culturale intorno ad un deposito votivo in alta Sabina. Rome 2001.

S. Steingräber 2006
Abundance of Life: Etruscan Wall Painting. Los Angeles 2006.

J. G. Szilágyi 1992
Ceramica Etrusco-Corinzia figurata, I, 630–580 a.C. Firenze 1992.

N. Winter 2009
Symbols of Wealth and Power: Architectural terracotta Decoration in Etruria and Central Italy, 640–510 B.C., Memoirs of the American Academy in Rome, Suppl. Vol. 1., Ann Arbor 2009.

S. Woodford & J. Spier 1992
Kerberos, *LIMC* VI 1992, 24–32.

R. D. Woodward 2006
Indo-European Sacred Space: Vedic and Roman Cult. Chicago 2006.

R. D. Woodward 2013
Myth, Ritual, and the Warrior in Roman and Indo-European Antiquity. Cambridge 2013.

MASKS IN ETRUSCAN TOMBS
A RITUAL READING

J. RASMUS BRANDT

> *… a mask is not primarily what it represents but what it transforms, that is to say, what it chooses* not *to represent. Like a myth, a mask denies as much as it affirms. It is not made solely of what it says or thinks it is saying, but of what it excludes* (Claude Lévi-Strauss: *The Way of the Masks*, Geneva 1975; English translation, Seattle 1982, 144)

What is a mask? What did it look like, and what function did it have? Did the Etruscans use masks? The title of this contribution opens many questions that cannot be answered fully in the brevity of an article, but hopefully answered enough to encourage further studies. The first answer regards the last question: yes, the Etruscans did use masks. And in the following my answers to the three preceding questions shall be presented partly generically and partly in relation to the Etruscan funerary use of them.

In very general and simple terms a mask can be defined as a form of disguise, which, as an object, is "frequently worn over or in front of the face to hide the identity of a person and by its own features to establish another being".[1] It is used in many contexts, covering a wide range of religious, social, funerary, commemorative, therapeutic, festive, theatrical, and other functions in the society.

Etruscan masks, as preserved in images and objects, appear to have been used mainly in funerary and a few religious contexts, some as expressions of local habits. This limits the functions of the masks. In funerary contexts, we find masks depicted in both tomb paintings and in reliefs on sepulchral monuments from, respectively, Tarquinia and Chiusi. They are also found as miniature masks among other grave goods, mainly from Tarquinia; in the shape of large eyes on imported Attic vases; and as stylized human heads on so-called canopic urns. These are the four contexts to be discussed in this article, but it does not exclude that masks could also have been used in other Etruscan contexts.

I have no intention here of making a catalogue of all possible finds of Etruscan masks in the funerary contexts mentioned, but, rather, to discuss the reasons for why masks appeared in these circumstances. Let us start with the relevant painted tombs and sepulchral reliefs at Tarquinia and Chiusi.

Phersu – and correspondent(?) characters

Masks in tomb paintings are few, but they are meaningful. The most significant person to carry a mask is the obscure Etruscan character named Phersu, who, in addition to the black-bearded mask, can be recognized by his pointed hat (**Table 1**).[2] Phersu appears in two situations in the tomb paintings. In the first, he is involved in a scene with some blood running: on a long leash, he holds a dog that is fiercely attacking a man with a covered head who is defending himself with a wooden club (*Tomba degli Auguri*, right wall (**Fig. 1**),[3] and *Tomba delle Olimpiadi*, right wall[4]). The dog has bitten the man in the leg, causing the blood to flow. Flowing blood constituted an important element in Etruscan burial rituals.[5] At death, the blood stops running; flowing blood in a ritual context would thus be a symbol of life. Tertullian's observation that "… earlier, since it was believed

St.no.	Tomb	Place	Date	R	BT	L	ET
42	Tomba degli Auguri	TA	ca. 520	1P		1P	
74	Tomba delle Iscrizioni	TA	ca. 520				2S
59	Tomba con Dionisio e Sileni	TA	520/510		1D+10S		
92	Tomba delle Olimpiadi	TA	ca. 510	1P			
141	Tomba 1999	TA	ca. 510/500	2S		1P?	
104	Tomba del Pulcinella	TA	ca. 500			1P	
67	Tomba della Fustigazione	TA	ca. 490	1s			
24	Tomba della Scimmia	CH	480/70	1P			2s(?)
68	Tomba del Gallo	TA	400–375	1P			

Table 1. – Etruscan tomb paintings containing the figure Phersu (P), satyrs/sileni (S), satyr-/silenus-like persons (s), and Dionysus(? – D), placed on the following walls in the tomb: R = Right lateral wall (as you enter); BT = Back/rear wall tympanum; L = Left lateral wall; ET = Entrance wall tympanum. – St.no = Catalogue number in Steingräber 1986. – TA = Tarquinia; CH = Chiusi.

that the spirits of the dead could be appeased with human blood, they used at funerals to sacrifice prisoners of war or slaves of poor quality...",[6] may be a reflection of this kind of thinking.[7]

Fig. 1 Tarquinia, *Tomba degli Auguri*, right wall. Wrestlers; Phersu orchestrating combat between dog and man. Ca. 530–520 BC. Watercolour by Alessandro Morani (courtesy of The Swedish Institute of Classical Studies in Rome: MOR SK134).

In his other role, Phersu imitates, or perhaps better mimicks the movements of other active participants in the burial ceremonies, as at Tarquinia (*Tomba degli Auguri*, left wall (**Fig. 2**),[8] *Tomba del Pulcinella*,[9] *Tomba 1999*(?),[10] and perhaps *Tomba del Gallo* (**Fig. 3**)[11] and at Chiusi (*Tomba della Scimmia*).[12]

Fig. 2 Tarquinia, *Tomba degli Auguri*, left wall. Phersu to the right, mimicking the boxers in the centre. Ca. 530–520 BC. Watercolour by Alessandro Morani (courtesy of The Swedish Institute of Classical Studies in Rome: MOR SK 132).

Giovannangelo Camporeale saw in Phersu "un uomo mascherato... perciò un attore", drawing the conclusion that masks were by definition connected to theatrical performances, whether that be in the theater or elsewhere.[13] To a certain extent he was right, theatre-like performances made up parts of Etruscan funerary rituals (for those who could afford them),[14]

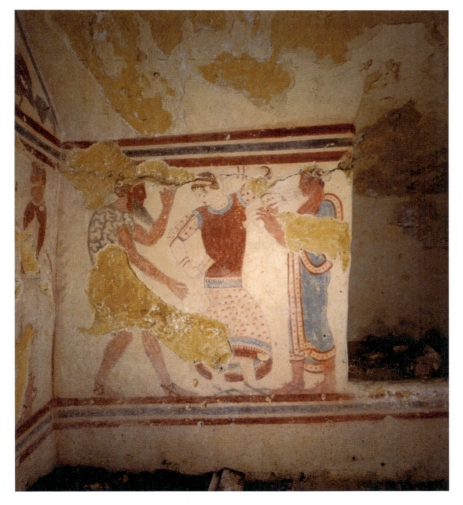

Fig. 3 Tarquinia, *Tomba del Gallo*, detail of left wall. Phersu and woman dancer. Late 5th century BC (© Museo Nazionale Etrusco di Villa Giulia. Archivio fotografico, photo no. 8970D).

but the use of masks was probably not conditioned by an institutionalized theatrical custom but, rather, by Etruscan funerary ideology.

A different kind of mask, carrying facial traits like that of a silenus/ satyr,[15] can be found in *Tomba della Fustigazione* (**Fig. 4**) on the man who, in an erotic scene, whips a woman while he penetrates her from behind.[16] In many a context, masks are used to hide one's own identity and/or to imitate another. In Roman burial rites, the masks of the deceased and his/ her ancestors were worn by the participants in the funerary ceremony.[17] In the Etruscan tomb rituals, the Phersu mask was worn by one of the partici- pants (or a hired professional)[18] to imitate a personality we otherwise have little information about but whose task was obviously partly to perform a specific type of blood ritual, and partly to mimick other participants in the ceremonies, as shown on the lateral walls of *Tomba degli Auguri*. The man with the satyr mask in *Tomba della Fustigazione* has nothing to do with Phersu, and none of them have anything to do with death or ancestor masks; nor do they seem to have anything in common. Or do they?

The answer may be found in some primal ideas in Etruscan eschatology. If we read Etruscan funerary ritual procedures with reference to Arnold van Gennep's three-step *rites de passage* model – separation (the moment of death), transition (between the death and the interment of the deceased) and reintegration (after the interment) – the most critical phase was that of transition.[19] For a given time, in this liminal phase, both the deceased and the participants in the funerary ceremony found themselves betwixt and between in a no man's land. In other words, they were all temporarily sus- pended from normal social life; they were in a border land in which strong, frightful, transcendental or supernatural powers, in the shape of shadowy demons, were released in order to prevent the soul of the deceased from reaching the Underworld and the ancestors. In this phase it was therefore of the utmost importance that the living helped the deceased's soul on its journey; they had to establish contact with the supernatural powers, or demons, to negotiate the safe arrival of the soul. But the soul moved in a space between life and death, a space the living could not reach. How should the living manage this apparently impossible task? They had to find a way in which they could mentally get outside themselves, outside their own body and space. Ecstasy through dance and orgasm in erotic games were two ways of reaching the demons. But in engaging in this, the living ran the risk that the same frightful beings could penetrate their

Fig. 4 Tarquinia, *Tomba della Fustigazione*, right wall. Erotic scene; the man on the left with facial features of a satyr. Early 5th century BC (© Museo Nazionale Etrusco di Villa Giulia. Archivio fotografico, photo no. 117723).

own living space and cause serious harm and disorder. Counter measures had to be taken. One remedial action was to turn the society of the living upside down, creating topsy-turvy situations in order to confuse the demons and rendering them unable to distinguish between what was right and what was wrong, or what was real and what was imaginary. In that way all disruptive attacks on the orderly society would have failed, since

the attacks would have hit a disorderly virtual situation and not a real one. Another counter measure was to create laughter, perhaps because laughter was stimulated by the illogical and unexpected moving between mockery and obscenity. A third counter measure to avert evil spirits, and closely associated with laughter, was scurrilous language (*aischrology*).[20]

What emerges is a funerary ritual with many functions that had to be staged well. We are now talking about opulent burial ceremonies arranged for and by the elite of the society. Less wealthy groups established simpler ways, with presumably some eschatological shortcuts. The larger ceremonies certainly needed a stage manager, who could orchestrate not only the various elements of the funerary ritual but also the emotions of the participating family, friends, colleagues, and society officials.[21] Phersu could have been such a person. In *Tomba degli Auguri* and *Tomba delle Olimpiadi* he conducts the dog, which attacks the blindfolded man in order to secure the running of blood to appease the soul of the deceased. In *Tomba del Gallo* he spurs on the frenzily dancing woman to reach ecstasy and make contact with the frightful demons. In the other tombs in which he is present he mocks the players in the rituals imitating their movements in order to create laughter, which could dissuade vagrant demons to penetrate their space. In this 'touch and go game' Phersu was all the time exposed to attacks from the demons and had to be protected – if he was put out of play, the soul would not reach the Underworld and the society would be at risk. Disguised as a kind of medieval jester (and the jester may well have found in Phersu an ancestral source), an attack on Phersu would be an attack on him as a harmless jester and not as a crucial stage manager. The disguise is even hidden in the name Phersu, perhaps meaning *persona* – that is, "a person", a neutral (if not masked) name that could mean nobody and everybody. Thus, Phersu appears as an Etruscan parallel to Odysseus' "Nobody" in Polyphemus' captivity,[22] the setting and the opponent in the two disguise situations being, of course, completely different.

Phersu's mask (and name) was accordingly used as a protective device. The same may have been the case with the satyr-looking man engaged in erotic play in *Tomba della Fustigazione*. At the moment of orgasm, he exposes himself to the demons in the space beyond that of the living. The purpose was to make contact with the demons, but he also risked being attacked by them. Putting on a satyr disguise, partly human, partly non-human, he could then protect himself from damaging attacks.

On a series of Archaic sepulchral monuments from Chiusi, sileni/satyrs appear engaged in different actions. The most quoted is a sarcophagus in the Louvre composed of three panels: a) a bull sacrifice without sileni (lateral side); b) a symposium with sileni (front face); and c) a rather juicy erotic scene between four sileni and three women: a standing copulation scene where one of the women is carried high in the air, with a fellatio-act and a bed-lying copulation act – all accompanied by the tunes of a double flute (lateral side).[23] Jean-René Jannot, who published the sarcophagus, distinguished between two types of sileni in this and other satyr scenes: one with animal traits like hoof-shaped feet; the other without such traits (like all the sileni in the present sarcophagus). He considered the first type to be *dionysiaque*, the other a disguised person without a *dionysiaque* connection.[24] As such, the disguised silenus-persons here, like the man in *Tomba della Fustigazione*, in the moment of ritual orgasm, protected themselves against attacks from the demons with whom they sought contact. Unfortunately, the sarcophagus is heavily restored, with the few extant fragments hardly identifiable.[25] From what hard sources did the 19th century restorers reconstruct, or even create anew the three scenes? The lateral sides could, from an Etruscan eschatological point of view, pass as possible originals,[26] but not the front face. A banquet in an Etruscan funerary context signalled the happy end of the burial ritual and the reintegration of the participants in the society. In this situation masks were completely out of place, which the modern restorers apparently did not know.

However, masked sileni without a *dionysiaque* connection appear, even if fragmentarily, in other contexts on the Chiusine sepulchral monuments. Four reliefs refer to dancing with or without a female partner,[27] and a fifth one to a silenus attending the deceased.[28] Dancing brought to an ecstatic state was, as mentioned above, a way to get in contact with the demons in the liminal space. Here, as in erotic play the Etruscans may have felt a need to protect themselves against the demons they sought. The fifth relief is a unique presentation: a man, most likely the deceased, carrying a staff with a curved end, a staff of office (a *lituus*?), is attended by a silenus. His disguise may imply that he moves with the deceased in the liminal space.

Satyrs/sileni also appear in the Tarquinian tomb paintings in other roles (see **Table 1**).[29] In *Tomba delle Iscrizioni*, "two heraldic reclining [ityphallic] Silenus figures" occupy the spandrels of the tympanum on the entrance wall; in *Tomba con Dionisio e Sileni*, we find, again in the tympanum but

of the rear wall, a "bearded Dionysos in pale chiton and green cloak (with kantharos?) flanked on each side by five dancing satyrs and sileni";[30] while in *Tomba 1999*, on the right lateral wall are "remains of two naked, bearded sileni dancing towards each other, the one on the right with a wineskin; between them, a small tree with pale leaves".[31] Did they have similar protective roles? In order to answer that, I shall have to make a small detour to Rome.

In the consulship of Quintus Sulpicius Camerinus and Spurius Larcius Flavus (490 BC), a large festival for all the gods was arranged in memory of the Roman victory over the Latins at Lake Regillus six years previously. The festival was opened by a spectacular procession, described in detail by Dionysius of Halicarnassus,[32] who signalled some of its Greek elements (see the text below). However, more likely is that the procession had Etruscan roots.[33] The procession moved from the Capitol Hill through the Forum to Circus Maximus, where games should be celebrated. First came Romans nearing manhood, riding on horseback or on foot; they were followed by charioteers in four- and two-horse chariots or riding unyoked horses; then came the contestants in both light and heavy games; after them numerous bands of Pyrrhic dancers accompanied by flute- and lyre-players and those playing the *barbital*… and…

> 7.72.10. … after the armed dancers others marched in procession impersonating satyrs and portraying the Greek dance called *sicinnis*. Those who represented Sileni were dressed in shaggy tunics, called by some *chortaioi*, and in mantles of flowers of every sort; and those who represented satyrs wore girdles and goatskins, and on their heads manes that stood upright, with other things of like nature. These mocked and mimicked the serious movements of the others, turning them into laughter-provoking performances.

> 11. The triumphal entrances also show that raillery and fun-making in the manner of satyrs were an ancient practice native to the Roman; for the soldiers who take part in the triumphs are allowed to satirise and ridicule the most distinguished men, including even the generals, in the same manner as those who ride in procession in carts at Athens; the soldiers once jested in prose as they clowned, but now they sing improvised verses.

12. And even at the funerals of illustrious persons I have seen, along with the other participants, bands of dancers impersonating satyrs who preceded the bier and imitated in their motions the dance called *sicinnis*, and particularly at the funerals of the rich. This jesting and dancing in the manner of the satyrs, then, was not the invention either of the Ligurians, of the Umbrians, or of any other barbarians who dwelt in Italy, but of the Greeks...

13. After these bands of dancers came a throng of lyre-players and many flute-players, and after them the persons who carried the censers in which perfumes and frankincense were burned along the whole route of the procession, and also the men who bore the show-vessels made of silver and gold, both those that were sacred to the gods and those who belonged to the state. Last of all in the procession came the images of the gods, borne on men's shoulders... These were the images not only of Jupiter, Juno, Minerva, and the rest of whom the Greeks reckon the twelve gods, but also of those still more ancient from whom the legend say the twelve were sprung, namely Saturn, Ops, Themis, Latona, the Parcae, Mnemosyne, and all the rest to whom temples and holy place are dedicated among the Greeks...

The presence of the satyrs and sileni may have been inspired by satyr plays, which saw their beginning in Athens by the end of the 6th century BC. Their function in the procession was to mock and mimic the serious movements of the others, to make people laugh. The dance performed was called *sicinnis*;[34] the same, according to Dionysius, as that which was performed at funerals. Suetonius confirms the information that a dance of that name was also enacted during the funeral procession of emperor Vespasian, and in that procession, too, mockery and mimics played an important part.[35] The purpose of the jesting in both processions was, through laughter, to keep invisible, liminal, frightful demons away. If the demons in any way should manage to disrupt the procession, the society order was at stake.

And what is more, which place did the satyrs and sileni have in the procession? They preceded the musicians who accompanied the holy items and those who carried the censers, or *thymiateria*, and kept them burning along the whole route. The satyrs kept the demons away, the thymiateria with its frankincense was used to purify the road along which the procession went, not at its head but preceding the sacred items and the images of

gods carried as the last items, items and images that could not be at risk of harm or of being polluted.

The satyrs and sileni participated here not as part of a Dionysiac *thiasus*, nor as a bunch of wine-drinking, joyous revellers in a *komos,* but as a group of non-human disguised human beings whose main task was to avert evil. Jars, cups and wine did not make up the paraphernalia of their function. There is therefore nothing Dionysiac about their presence, their disguise as non-human performing dancers was made to protect them from being harmed by possible demons penetrating the space of the living. In addition, they were dressed in a highly unusual, topsy-turvy way: the sileni in shaggy tunics with mantles of flowers, the satyrs in girdles and goatskin with, on their heads, manes which stood upright – all of which were part of the protection strategy. They also, perhaps, uttered foul and obscene words (*aischrology*) as part of the same strategy.

Satyrs and sileni in such a protective function give sense to Etruscan tomb paintings. Returning to **Table 1,** Phersu and satyr-/silenus-like persons all appear on the lateral walls of the painted tombs, the walls reserved for the ritual actions which took place in the liminal transition period of the funerary ceremonies. The use of masks thus belongs to this stage of the ceremonies. Only Dionysus(?) and satyrs can act in the tympana, perhaps the most important pictorial space in the tombs,[36] an area reserved in general for heraldic birds and animal fights. The birds and animals had an apotropaic power and were presumably considered as guardians of the tomb and of the deceased.[37] Dionysus(?) and satyrs should be looked upon likewise, the ityphallic state of the satyrs in *Tomba delle Iscrizioni* underlining their protective powers.

Thus, the presence of satyrs/sileni in the Etruscan tombs does not reveal a Dionysiac message or eschatology in the burial rituals. Their presence should, rather, be looked upon as a kind of metaphor for the living who, disguised as non-humans, tried to contact the demons in the liminal space and in this way protect themselves and the society from evil harms. Or to say it in a different way: the disguised satyrs and sileni, when present in tomb paintings and funerary reliefs, became a paraphrase of the topsy-turvy, liminal environment characteristic of the transition stage in van Gennep's three-stage, *rites de passage* model.

One may ask if the joyous scene presented on the terracotta revetment plaques, type D, from a public(?) house complex (building A) at Acqua-

rossa, belonged to a similar kind of thinking. Presented in this plaque (0.21 × 0.60 m), dated to after the middle of the 6th century BC, is a procession with merry revellers carrying wine skins and drinking vessels; one naked person does a somersault and the person to the right of him dances like a padded dancer on Corinthian 6th-century vases (**Fig. 5**).[38] Padded

Fig. 5 Architectural terracotta with procession, from Acquarossa. Mid-6th century BC. Museo Nazionale Etrusco – Rocca Albornoz, Viterbo (© Museo Nazionale Etrusco di Villa Giulia. Archivio fotografico. Photo Mauro Benedetti, photo no. 1).

dancers may have been padded as a comic addition to their ritual dance;[39] the somersault could be grouped similarly. In that case, the Acquarossa procession should, perhaps, not be regarded simply as an Etruscan copy of a merry Dionysiac *komos*, but rather, through its creation of laughter, as part of a ritual act to keep invisible, liminal, harmful demons away.

In Greece, laughter and the use of foul and obscene language were used in ritual contexts, mainly in celebrations of Demeter and Dionysus.[40] Iambic poetry, containing scornful and taboo words, was a common feature of their festivals. The ritual habit, in the form of such poetry, may well have travelled west with other things Greek, but it may also have had its own Etruscan origin. The Etruscans borrowed much from the Greeks, but not as copies, rather converting the Greek originals into their own social and ritual use.[41] Thus, the iambic poetry could have merged with their own acts of laughter and obscenities (already present, for example, in their erotic funerary rituals),[42] and Greek satyrs and sileni became useful pictorial figures to illustrate the protection strategy against liminal demons. In other words, the Dionysiac figures were put to function not in a Dionysiac ritual implicating rebirth and salvation in Etruscan eschatology[43] but as useful figures in an Etruscan ritual burial strategy. They were present in their Dionysiac forms, but not in their Dionysiac content. The same regards their presence in the procession described in Rome.

The procession in Rome took place in 490 BC. The satyrs and sileni entered the Etruscan tomb paintings around 520 BC and disappeared some 50 years later (as revealed in **Table 1**). The funerary reliefs discussed from Chiusi belonged to the same period, and so did *Tomba dei Giocolieri* at Tarquinia, the only tomb that in its paintings – with the defecating man on the left wall – contained a possible reference to the use of foul words in Etruscan funerary rituals (**Fig. 6**).[44] Could it be that among the Etruscans iambic poetry in this time period rode on a kind of popularity or fashion wave, which gradually died out and was absorbed or substituted by other fashions? For a restricted period, they gave new forms to a basic Etruscan eschatological content.[45] This is also the period in which Phersu, covering a similar role to that of the satyrs and sileni, all masked, was active. Phersu reappeared later, but only once, and then perhaps as a phenomenon of the past, in *Tomba del Gallo* (early 4th century BC)[46] – satyrs and sileni did also, but now in the form of theatrical miniature masks in burials from the Hellenistic period.

Fig. 6 Tarquinia, *Tomba dei Giocolieri*, left wall. Man defecating. Black birds.
Ca. 530–520 BC (© Museo Nazionale Etrusco di Villa Giulia. Archivio fotografico,
photo no. 138600).

Fig. 7 Miniature theatre mask from Tarquinia. Hellenistic. Museo Nazionale Etrusco di Villa Giulia, Rome (© Museo Nazionale Etrusco di Villa Giulia. Archivio fotografico. Photo Mauro Benedetti, photo no. 5080D).

Theatre goes to the tombs

The Etruscan production of the Greek types of theatrical masks, even if only in miniature, in a society which did not build a Greek-looking theatre may seem a paradox. But where lies the paradox? In the lack of a Greek-looking theatrical structure, or in our interpretation of the masks as theatrical?

In the second half of the 19th century many excavation seasons were conducted at Tarquinia in the necropolis of Monterozzi. A large number of theatrical masks were found which were sold and ended up in collections and museums both inside and outside Italy.[47] In 1884, a large collection, containing 280 terracotta masks, was sold by Alessandro Castellani at an auction in Paris.[48] In a stringent and exhaustive article nearly 40 years ago, Grete Stefani collected all the 152 theatrical and satyr masks then known,[49] all presumably produced at Tarquinia (**Figs. 7–8**). Out of these, documentation existed for only 35 masks about their find place: Tarquinia, Vulci, Tuscania, and Viterbo.[50] To these masks can now be added two masks of women (maenads?), one of a satyr, one of a silenus, and one perhaps of Dionysus, all coming from tombs excavated in Fondo Scataglini at Tarquinia and datable between the late 4th and early 2nd centuries BC.[51]

Fig. 8 Miniature mask of satyr from Tarquinia. Hellenistic. Museo Nazionale Etrusco di Villa Giulia, Rome (©Museo Nazionale Etrusco di Villa Giulia. Archivio fotografico. Photo Mauro Benedetti, photo no. 4160D).

In general, the masks are 10–15 cm high; they are mould-made and the larger part of them have two holes at the upper edge, most likely for suspension (in the tombs?). The tombs, in which documented masks have been found, are chamber tombs with more than one burial, often with many burials. It has, therefore, not been possible to connect a mask to a specific burial. Stefani divided the masks into three broad categories:[52]

I. Dionysiac masks: 72 + 5 new ones = 77
II. Theatrical masks: 76
III. Masks of decorated bulls: 4

It seems that the place of production was Tarquinia and that the masks had a rather limited local distribution on the southern, central Etruscan coast and in the immediate hinterland.[53] Miniature masks appear, for example, not to have been recorded at Cerveteri. The appearance of the masks coincides with the spreading of a theatre culture from Greece via Magna Graecia and Sicily to central Italy. By theatre culture, I mean Greek drama and satyr plays. Spectacles of various sorts performed for a public were well known in Etruria from earlier periods, but mainly connected to religious activities, as funerary ceremonies:[54] Phersu, ecstatic dancing, and sexual and other kinds of plays and sports belong to this kind of performances, some of them even transformed and continued in Roman public entertainments.[55] It was from this tradition that the Etruscans, according to Livy (7.2.4–5), introduced theatrical plays to Rome in 364 BC.[56] Mimetic plays accompanied by flutes and "not ungraceful" dancers have nothing to do with the Greek classical theatre tradition.

In Rome, the first Greek-looking theatre in stone was raised by Pompey the Great in 55 BC; before that date all Roman theatres were built in wood and dismantled after the scheduled performances. No traces of such theatres have been found, and we do not know if such buildings for spectacles were put up in Etruria. The only pre-Roman Etruscan structures of a theatrical character registered are, in fact, found in connection with tombs and used for funerary rituals.[57] However, the lack of a proper theatre building may not have hampered the spread of theatrical plays, paraphernalia and gadgets.[58] The Etruscans, as already observed, were quick to pick up Greek models and transform their use into their own societal and ritual world.

Since there is a close connection between the cult of Dionysus and the Greek theatre, it is easy to use the miniature masks to explain a Dionysiac presence in Etruscan funerary rituals,[59] but if we look at the miniature masks with Etruscan eschatological eyes, the answer may not be the same. The period when miniature masks were introduced into the tombs coincides, even if somewhat tardily, with a change in the iconography of Etruscan tomb paintings: the scene shifts from the reality of the living to the reality of the soul on its journey through the liminal world and its arrival in the Underworld of Aita and Phersipnai (Hades and Persephone). But this was not the result of a change in eschatological content, only in eschatological form. It is therefore to be expected that the burial ideology was maintained, and the living still tried to help the soul on its liminal journey with its inherent dangers.[60] When the living tried to arrive in contact with the liminal demons, these demons could still penetrate the world of the living. Masks were still an important tool to protect the persons and society against such harmful attacks. The Greek theatre had only expanded the repertoire of the masks, not changed their function. All the miniature masks found in the Etruscan tombs (both the Dionysiac and the theatrical ones) were thus an expression of protection, not of Dionysiac connections – and they became a local fashion, like the iambic poetry, but only lasting longer.

The paintings in the tombs were not made for the deceased to enjoy passively but to communicate to him/her that the funerary rituals orchestrated to help the soul on the journey to the Underworld and the reunion with the family ancestors were dutifully performed. The message was to ease the deceased's fear and anxieties – to put the wandering soul into a relaxed emotional mood.[61] The presence of masks belongs to the same kind of thinking. This regards also masks of decorated bulls (category III above). Decorated animals were sacrificial animals included in ritual processions; the masks of the bulls mark the concluding sacrifice of the funerary ceremony, an action which brought the soul and the participants in the ceremony out of their liminal situation. The soul entered the Underworld of Aita and Phersipnai, and the participants of the funeral returned to normal social life. The presence of objects like *thymiateria* (found in Stefani's tombs 2, 7 and 14),[62] and vases with figures "in azioni oscene" (tomb 2),[63] are further examples of this kind of thinking.

The presentation of obscene scenes was not uncommon on vases found

in graves, especially at Tarquinia and Vulci,[64] and refer in this context, as the erotic scenes in the tomb paintings, to ritual orgasm.[65] Another recurring theme was pairs of eyes.

For your eyes only

Images of eyes are frequently found on man-made objects of all kinds of uses and sizes, from coins to vases and stamps, to shields and to ships[66] – and not all in a funerary context.[67] From a funerary point of view, an interesting group of vases with eyes are Attic black- and red-figure vases. Eyes decorated cups mainly (**Fig. 9**), but not only – a large variety of other vases like hydriae, kraters, kyathoi, and lekythoi also used this particular motif.[68] They were mainly present on black-figure vases, with one of the first ones being the cup by Exekias showing Dionysus in his boat, a cup that was found at Vulci.[69] In fact, the Etruscans, being one of the major clients of Athenian potters and painters, way well have suggested the theme, which flourished in the last third of the 6th century and gradually disappeared from production early in the following century.[70] More than other Etruscan cities, Vulci seems to have been the main importer of vases with eyes.[71]

Fig. 9 Attic black-figure eye-cup. Between the eyes: Theseus kills the Minotaur. Ca. 530 BC. Metropolitan Museum of Art, New York, inv. 09.221.39 (Rogers Fund) (courtesy of the museum; published as Public Domain under Creative Commons Zero (CC0)).

Fig. 10 Tarquinia, *Tomba dei Leopardi*, right wall. Procession with dancers, musicians, and to the left, a man carrying a large cup for ritual use. Second quarter of the 5th century BC. Watercolour by Alessandro Morani (courtesy of The Swedish Institute of Classical Studies in Rome: MOR SK 027).

Eyes are the most expressive part of the human face. Their exclusive presence on Attic vases may well be a shorthand version of a mask, since in many masks it is the eyes in particular that are accentuated.[72] There are two main explanations as to how they arrived on the cups: as a symposium joke, or as an apotropaic agency.[73] John Boardman once suggested that by drinking from a cup, for the fellow symposiast, the drinker's eyes would disappear and be substituted by the eyes on the cup, and the handles of the cup would take the place of the drinker's ears.[74] This view was adopted by many in a sort of academic anti-magic "campaign", eliminating the apotropaic interpretation of the eye-cups suggested already by George Dennis in his book on Etruria from 1848. Dennis considered the eyes to be "charms against the evil eye".[75] Sheramy Bundrick argues strongly for an apotropaic function of the eyes on the cups and other vases, but in doing so she rightly brings her arguments away from the Attic symposium context to an Etruscan household ritual and funerary context.[76]

Here, we are at the key of the problem. The eyes on vases may have been an Etruscan invention brought to the Athenian painters, who developed

174

Fig. 11 Tarquinia, *Tomba dei Vasi Dipinti*, rear wall. Symposium and courting scene; central man with large cup for ritual use in his hand. End of 6th century BC. Watercolour by L. Schultz (courtesy of Deutsches Archäologisches Institut, Rome, Photo H. Behrens, photo no. 2013.0207).

the design without necessarily having a clear idea of their Etruscan meaning – although the eyes may gradually have acquired an Athenian meaning, too. To the eyes the painters added other motifs from their own mythological and daily life, particularly motifs connected with Dionysus and his world – not surprisingly, since most of the vase-shapes, and especially the cups, were connected with the serving and drinking of wine. The painters' inventiveness did not know many limits. When such vases entered the Etruscan market, the Dionysiac figures may not have been connected to the wine god himself, but rather to the figures protecting the soul of the deceased in her/his liminal death journey, as explained above. The motifs thus fitted very well their use as grave goods!

Many of the eye-cups were extra large – that is, they out-did the standard rim diameter of the drinking cups of up to about 20 cm, with many cups measuring 30–40 cm and the largest even up to 60 cm in diameter.[77] The larger the diameter, the more wine could go into the cup: the Dionysus-cup cited above, with a diameter of 30.4 cm, could contain about 3 litres of wine; a cup measuring 40.2 cm, double that.[78] In both cases, even if not

filled to the rim, this would have been a volume and weight too heavy to handle easily – and too much for one person to drink – at a banquet. Extra large cups are frequently carried by dancers and banqueteers in Etruscan tomb paintings,[79] but the dancers were not part of a *komos*; rather, the size of the cups signalled that they had a ritual function (**Figs. 10–11**). When the deceased had been placed in the tomb, a sacrifice was made to conceal the burial act. The sacrifice began with a wine offering – the large cups carried in the tomb paintings signalled that a sacrifice was part of the burial ritual; the larger the cup, the more wine could be offered and the richer the sacrifice. Such large-size cups, also found in sanctuaries, confirm their use as ritual objects.

The ritual use of the cup also determined the cup's life.[80] It could not be re-used and accordingly was deposited in the tomb. It was left in the tomb to demonstrate for the wandering soul of the deceased that the deceased's family had carried out the funerary rituals according to tradition. Their presence in the tomb was, in addition to the paintings, an element to further calm the soul in its dangerous and hazardous, liminal wandering. Many of these eye-cups, as already suggested, may well have been used in minor private rituals in the house. In that context, the eyes on the vases could certainly have had an apotropaic function. When in the tomb, they maintained this function, but with a twist. If we consider the eyes as an abbreviated version of a mask, the mask may here have had the same function on the ritual vase as it had with the actors seeking contact with the demons in the liminal space. The eye-masks became a protection of the ritual vase – and possibly also of the tomb – against harmful actions by liminal demons. In this context the eyes were for them, the demons.

But from what did this kind of eschatological thinking develop? One possible source could have been canopic urns.

Heads on display

Canopic urns are cinerary vases with a lid shaped as a head (**Fig. 12**). They were exclusively located in the region of Chiusi and were produced roughly from the first quarter of the 7th to the middle of the following century BC. These urns were made in bronze sheet or terracotta, and many were placed in large earthenware containers (*ziri*) in deep pits cut in the rock or soil and covered with a stone slab.[81]

The oldest urns have a lid shaped as a head without facial features; the

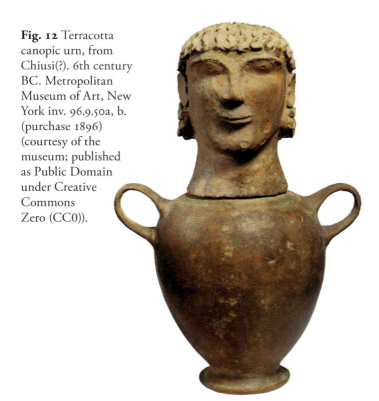

Fig. 12 Terracotta canopic urn, from Chiusi(?). 6th century BC. Metropolitan Museum of Art, New York inv. 96.9.50a, b. (purchase 1896) (courtesy of the museum; published as Public Domain under Creative Commons Zero (CC0)).

features enter gradually, and by the end of their production the heads have strong affinities with a proper portrait. The rather globular vases they cover are, at times, equipped with bodily features such as nipples and arms, as if they were a proper body. In some tombs the vases were put on a throne, with or without a table in front. In this situation they carry similarities to chamber tombs containing thrones and seated figures, all cut out of the rock (cf. *Tomba delle Statue* at Ceri).[82] Alternatively, the thrones are rock-cut with seated figures in terracotta (as in *Tomba delle Cinque Sedie* at Cerveteri).[83] In this context the seated figures are considered ancestors, underlining the importance, also in Etruria, of ancestor cult. The canopic figures are therefore looked upon as a symbolic recreation of the deceased, a substitute for the human body.[84] Or in the words of Otto Brendel: "these vases assimilated to human form, contained the ashes as the body contains the life and soul of a person. They were the last and lasting bodies of the dead."[85] But is this the only explanation, excluding other possibilities?

177

Could the canopic heads by the ancient Etruscans have been considered masks?[86]

A tomb lies in the intersection between the disposal of the dead body for hygienic and/or other practical reasons, the preservation (or not) of the deceased's memory, and the violation afflicted on the dead body and/or the tomb, whether by humans or supernatural forces. Burial modes and funerary rituals grow out of these concerns, each concern weakened or strengthened according to how society, in shifting ways and moments, responded to death.

In the Villanovan period (900–700 BC), the deceased were normally cremated and their ashes put in single-handed biconical urns, which were closed with a single-handed bowl placed upside-down (**Fig. 13**).[87] In a

Fig. 13 Biconical urn with a single-handled bowl as cover, from Tarquinia. Second half of the 9th century BC. Museo Nazionale Etrusco di Villa Giulia, Rome (© Museo Nazionale Etrusco di Villa Giulia. Archivio fotografico, photo no. 9097).

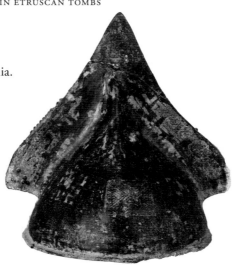

Fig. 14 Helmet in terracotta used as lid for a biconical urn, from Tarquinia. Second half of the 9th century BC. Museo Nazionale Etrusco di Villa Giulia, Rome (© Museo Nazionale Etrusco di Villa Giulia. Archivio fotografico, photo no. 10439).

second phase, some urns were closed by a helmet in bronze or terracotta (**Fig. 14**).[88] These burial modes were used extensively in the Etruscan territories. In the course of the 8th century BC, in most areas the burial practice changed to inhumation, and the ash urn gave way to richer and more varied burial assemblages. However, at Chiusi – and elsewhere in northern Etruria – cremation continued for centuries as the dominating burial rite and triggered a change and a renewal of the traditional ash urn.

An important part of burials were the concluding sacrifices (see pp. 172, 176 above). A sacrifice was initiated with a ritual cleaning of the altar and the sacrificial fire. This was done with wine, or alternatively with water (?) before the introduction of wine culture to Etruria. For this, a bowl would have been used; the bowl thus became a ritualized object with inherent powers, which other grave goods did not acquire. The bowl that covered the biconical urn could have been that ritualized object, which then gave the burnt bones of the deceased a double protection against possible human and supernatural violations: a physical protection as lid, a magic protection as ritualized object. The helmet, made to protect the human head, became, in the next instance, a symbol of the protection of the burnt bones in the urn – perhaps even used and ritualized as a water/wine offering bowl. On a helmet found at Tarquinia, a human face in highly schematic form appears – an early mask, and a missing link between the helmet lid and canopic heads perhaps? [89] And, if so, did the heads on the Chiusine ash

179

urns continue the protective role of the bowls and the helmets, or are they an expression of a ritual change, not only in form but also in content? That is, as described above, the figures were now considered a symbolic recreation of the deceased, a substitute for the human body hidden in the urn.

Seen in isolation, the symbolic recreation theory is interesting, but seen in context with long-term Etruscan burial customs, as I have tried to evidence here and elsewhere,[90] the introduction of the heads was only a change in form, not in content. The heads were introduced not as a substitute for the human body in the urn but as a substitute for the protective bowls and

Fig. 15 Biconical urn with bowl as a lid. The bottom of the bowl (here de uppermost part) is transformed into a human head without facial features, from Vulci. First half of the 8th century BC. Museo Nazionale Etrusco di Villa Giulia, Rome, inv. 8165. (© Museo Nazionale Etrusco di Villa Giulia. Archivio fotografico, photo no. 257080).

helmets. This becomes clearly visible in a biconical urn from Vulci and its cover-bowl: from the bottom of the bowl rises a head without facial features (**Fig. 15**), underlining the direct continuity between the bowls and the canopic heads. The transformed body of the dead in the urn needed to be protected against all kinds of violation. A mask of a human face protects the human being behind it; a human face alone has and gives no protection.[91] Thus, the heads on the urn were masks of the deceased, placed there to confuse the possible violators so that the bodily remains should not be harmed. In the early versions of the canopic heads, the facial traits were very mask-like; later, in the first half of the 6th century BC, they became more and more portrait-like. This was a result of an artistic development and did not change their function; they were still perceived as masks of the dead. The habit of dressing the canopic urns with textiles and jewellery and placing them on thrones fits well into the argument:[92] the ornamentation gave the mask the character of a shrouded corpse, and the throne may have been added as an item to signal social and family position and prestige.

Some of the heads have small holes in the face, holes to fasten an extra mask of a different material, mainly in metal: bronze, or even gold. A total of nine such metal masks are registered.[93] They underline the mask idea behind the heads. One of these bronze masks has an attachment plane not coherent with a face, but rather with a beam's end.[94] It may thus have been attached to a beam or even a ridge pole of a house, to protect the home of the deceased and at the moment of death detached and buried with him/her.[95] The mid-7th century BC use of mould-made human heads as antefixes on buildings at Poggio Civitate (Murlo) may be a correlate to the production of similarly produced heads on funerary urns.[96] A small terracotta model from Capua (4th/3rd century BC) of a house carries a mask-like face on its ridge pole and may confirm that metal masks could have been used in such a manner.[97] The protective function of the mask is transferred from the tomb to the home. This would presumably not have happened if the canopic urn heads were only considered an embodiment of the cremated deceased contained in the urn.

Concluding remarks – a question of ritual reading
I began this article with a generic definition of what is a mask. I shall conclude with another description of a mask, taken from *Brill's New Pauly*: "A mask allows someone to step out of his personality... and by being trans-

formed – possibly into a god or an animal – to attain supernatural pow-
ers, but it also effects a transformation into the ridiculous and aggressively
obscene, or serves to create panic (e.g. initiation rites)."[98]

Both definitions underline that the mask transforms the person carrying
it into a different being, possibly to attain special forces, whether natural
or supernatural. In my presentation, the transformations (if/when present)
are not essential *per se*; the key word is 'protection', protection of both
single persons, and of the society in general, against frightful supernatural
forces. This is also an important function of the mask.

Architecture, objects and images used in a religious context, as a funer-
ary ceremony, must be read in the context of the pertaining rituals. The
basic content of a ritual will normally keep for centuries, but the way it is
displayed, its form, can change with time and place.[99] As underlined a few
times in the text above, I presume that an important part of the Etruscan
death ritual regarded the journey of the deceased's soul in a liminal space
between the world of the living and the world of the dead. The idea of this
dangerous journey belonged to the content – and so did the idea that the
living could help the soul, by coming into contact with the supernatural,
frightful demons that peopled the liminal space. Such contacts could result
in the demons penetrating the space of the living. All measures were taken
to avoid the malice the demons could inflict on the living society, on the
buried bodies and the deceased's soul. One such measure was the use of
masks, which would disorientate the demons and absorb their evil actions
without harming the living and their society. The masks in an Etruscan
burial context can, in this sense, well be considered as apotropaic; they
had a protective function in the way they absorbed and warded off evil,
but they did not petrify the malevolent creatures (animals included) or
supernatural forces, as a Medusa mask would have done. Here lies a small
difference, which it is important to underline.

The Etruscan eschatology gives sense to the use of masks in funerary
contexts. Masks may well have also been used in other Etruscan ritual
contexts, but they were not used as votive offerings; to substantiate a vow
with a mask would have been a contradiction in terms.

NOTES

I am most grateful to the editors for the invitation to participate in the present publication and for their most useful observations on a first version of my manuscript. This gratitude is also extended to the anonymous peer reviewer, who added much valuable information, corrected misunderstandings and asked many questions that were to the point. Any remaining mistakes and omissions are my own.

1 *The New Encyclopædia Britannica* (15th ed.: 1977), *Macropædia* vol. 11, 578.

2 On Phersu, see e.g., de Ruyt 1934; Bomati 1986; Jannot 1993; Emmanuel-Rebuffat 1997; Torelli 1997, 122; Avramidou 2009; Yanko 2015; Brandt 2015, 127, 135; 2020, 51–55. On Phersu on the right wall in *Tomba degli Auguri*, the strings for the mask are even visible. For Phersu scenes outside paintings, see, from Chiusi, two Late Archaic cippus base reliefs: Jannot 1984, 57–59 (C I 27b), fig. 197; Thuillier 1997, 254–255, figs. 1 and 6 (480/470 BC). For small Phersu figurines in bronze, see Szilágyi 1981, 7–8 with further references.

3 Steingräber 1986, 283, colour plates 18, 20–21.

4 Steingräber 1986, 328–329, fig. 243, colour plate 122.

5 See Brandt 2020, 51–52 for examples and references.

6 Tertullian, *De spectaculis* 12; translation by G. H. Rendall (Loeb Classical Library 1946).

7 For a synthesis on human sacrifices in Etruscan contexts, see Di Fazio 2017.

8 Steingräber 1986, 283, fig. 53, colour plates 13, 22; see also Weber-Lehmann 2004, 130 and 132 with belonging illustrations.

9 Steingräber 1986, 337, fig. 276, colour plate 137; see also Moltesen & Weber-Lehmann 1991, 123–124, figs. 104–105.

10 Steingräber 1986, 360.

11 Steingräber 1986, 308, colour plate 76. In Brandt 2020, 53, I gave the Phersu-looking person a different role, but that does not affect the main argument of the article.

12 Steingräber 1986, 273–275, fig. 34 (right wall, left); Moltesen & Weber-Lehmann 1991, 128–132, fig. 114.

13 Camporeale 2015, 186.

14 See, p.171, below.

15 van der Meer 2011, 74–75 (Silenus-mask); Steingräber 1986, 307, is more careful, saying "bearded, with a Silenus-like face".

16 Steingräber 1986, 307, colour plate 75.

17 According to Flower 1996, 2, these masks were not death masks in the proper sense of the word since they were not considered to be worn by the deceased in funerary ceremonies nor in the cult or commemorations of the deceased at the tomb. They were, rather, ancestor masks (*imagines maiorum*), which appear to have been an exclusively Roman custom. On this question, see also Blasi 2010; 2012.

18 See the comments in Brandt 2020, 60–61.

19 van Gennep 1960 (1908), 146.

20 For the eschatological ideas outlined here, see Brandt 2014, and especially 2020, where also laughter is discussed on pp. 53–59. On *aischrology*, see e.g., Burkert 1985, 104–105, with further references, and articles in Dutsch & Suter (eds.) 2015.

21 On emotions, see Brandt 2020.

22 Hom. *Il.* 9.364–465.

23 Jannot 1984, 23.5 (B I 5c), fig. 107, 'peu après 520' p. 302; 2010, sections 108–113 (electronic version).

24 Jannot 1984, 324.

25 Briguet 1972; Jannot 2010, sections 110–113.

26 In disagreement with Jannot 2010, sections 111 and 113.

27 Jannot 1984: (1): 66–67, fig. 221 (type C II 1); (2): 73, fig. 254 (type C II 16); (3): 73–74, fig. 255 (type C II 17); (4): 89–90, fig. 312 (type C III 1). Cf. also Szilágyi 1981, 8, 17, fig. 23.

28 Jannot 1984, 58–59, fig. 198 (type C I 25).

29 All quotes in this paragraph are taken from Steingräber 1986; for his catalogue numbers, see **Table 1**.

30 Steingräber 1986, 302. It should be noticed that the tomb was in bad shape when found; no drawing, only a short description exists. It is, therefore, wise to be hesitant about the interpretation of the figures.

31 Steingräber 1986, 360.

32 Dion. Hal., *Ant. Rom.*, 7.72.

33 Szilágyi 1981, 8–11 with further references.

34 On the dance, see Jannot 1984, 325; Barker 1984, 75 no. 67, 289 no. 194; see also *Ath.*, 20e; Luc. *Salt.*, 22, 26; Gell. *NA*, 20.3.2–3.

35 Suet. *Vesp.*, 19.2.

36 Torelli 1999, 155.

37 Brandt 2015, 123.

38 Strandberg Olofsson 1984, 22 (pl. 4.1), 36–37; their belonging building A: 73–75, 78–80; and suggested functions: 81–82.

39 On padded dancers, see Seeberg 1971; 1995.

40 Gerber 1999, 2–3; see also Burkert 1985, 104–105.

41 On this question, see e.g. Bundrick 2015, 310, and the literature referred to there.

42 For an early erotic presentation on a late 7th century BC Etrusco-Corinthian jug found in a chamber tomb at Tragliatella, inland from Cerveteri, see Helbig 1966, 343–345.1529; Menichetti 1992, 27–29 (*hieròs gámos*); Haynes 2000, 97–99; van der Meer 2011, 71–74; Brandt 2015, 128. Note, furthermore, that on the riding scene in the same frieze an ape (or a person disguised as an ape?) squats on the hind part of the horse. He could, in this case, be there in the role of an acrobat. Acrobats are registered in *Tomba del Guerriero* at Tarquinia (Steingräber 1986, 313, figs. 180–181) and may carry a reference to confusion and laughter, central elements in the Etruscan strategy to protect the funerary participants and society from possible demonic havoc (Brandt 2020, 54–55). See: Caroe and Ahlén in this volume.

43 As suggested by Rafanelli 2013, 579–580.

44 Brandt 2020, 59, note 128. The name of the artist(?), *Aranth Heracanasa*, written across the tree trunk, may not refer to the defecating person, as is generally believed (see e.g. Haynes 2000, 231), but placed here to protect not only the deceased but also the self-conceited(?) artist from aggressive demons. For another interpretation of the scene, see Roncalli 2005, 412–414.

45 On content and form, see Brandt 2015, 152–153.

46 Phersu's late reappearance is a reason why both Steingräber 1986, 308 and myself (Brandt 2020, 53) misinterpreted the dancing person. Do we here have an example of a tomb contractor who, in a period of iconographic changes, harked back to old pictorial customs, recreating an earlier "death myth"? On "death myths", see Oestigaard 2015, 374.

47 Stefani 1979–1980, 243–244.

48 Stefani 1979–1980, 265–269.

49 Stefani 1979–1980, 270.

50 Stefani 1979–1980, 243–244 and catalogue: 244–265.

51 Serra Ridgway 1996, 45, 51–52, 66–67; Linington & Serra Ridgway 1997, 29, 31, 38. The use of the word 'perhaps' in connection with Dionysus is mine. See also Moretti & Sgubini Moretti, 1983, 121–123.

52 Stefani 1979–1980, 270–272.

53 On local Etruscan manifestations, as opposed to viewing the Etruscans as a monolithic cultural entity, see e.g., Bundrick 2015, 333.

54 Camporeale 2010; 2015, 189–191.

55 Brandt 2015, 127 (gladiatorial games); 2020, 50 (sexual plays).

56 Thuillier 2013, 832–833; see also Szilágyi 1981, 2–3, 12–19.

57 Colonna 1993; Thuillier 2013, 831–832; cf. also Haack 2017, 1006–1007; Rathje 2014, 61; Torelli 1999, 122; Brandt 2020, 50. Furthermore, see Camporeale 2015, 377, fig. 151, a theatrical structure and temple found in the sacred area of Castelsecco, near Arezzo, 2nd century BC ("forse il primo e comunque l'unico esempio etrusco sicuro in pietra"). In this setting it has close affinities with theatrical constructions from the Late Republic, as visible in the sanctuary of Juno at Gabii (see e.g., Almagro-Gorbea 1982) and the sanctuary of Hercules Victor at Tivoli (see e.g., Coarelli 2011).

58 For theatrical plays as source for motifs on Hellenistic urns and sarcophagi, see Nielsen 2013, 188; Thuillier 2013, 833–34. Many of the motifs may also have been collected from written "books", which in the Hellenistic period saw an increased circulation.

59 Stefani 1979–1980, 317–319. For a different view, see Thuillier 2013, 833: the masks "may have been deposited among the grave goods as symbols of dramatic spectacles that the families of the deceased could not afford to organize at the time of the funeral"!?

60 Brandt 2015, 152–153.

61 Brandt 2020, 60.

62 Stefani 1979–1980, 243–249 (cat. 2), 254–256 (cat. 7), 263–264 (cat. 14).

63 Stefani 1979–1980, 243–249 (cat. 2). Described as such by the workmen to Wolfgang Helbig, who published the tomb. The vases were sold before he could see them!

64 Lewis 1997; 2003, 189–190; Lynch 2009, 158; until 2009, no erotic scene [i.e. heterosexual intercourse] has been found on Attic pottery during the excavations at the Athenian agora. Note in this context Lynch 2011, 175; according to her "erotic scenes, elaborate mythological scenes, and scenes of the sympotic room [were]… made for the export market".

65 Brandt 2015, 130, 136; 2020, 49–50, 60; and above pp. 162–163.

66 See e.g., Steinhart 1995; Carlson 2009.

67 For an Etruscan funerary context, see Steingräber 1986, 273–275, figs. 34–38, pls. 193–194; in *Tomba della Scimmia* at Chiusi, on the rear wall under a parasol, a red-robed and veiled woman is seated on a diphros with a lion-footed stool, which is decorated with

two eyes. This does not, however, seem to be a singular appearance in tomb paintings.

68 Bundrick 2015, 299.

69 Bundrick 2015, 296, 333–334; 2019, 95.

70 On the theme, see especially Bundrick 2015; on their chronology, see pp. 307–309; 2019, 93–126.

71 Bundrick 2015, 300, Table 1; 2019, 95.

72 See e.g., Braithwaite 2001, 283.

73 Bundrick 2015; 2019, 95 (apotropaion vs. symposion).

74 Boardman 1976; see also Bundrick 2015, 297; 2019, 96–97.

75 Dennis 1848, 434, 438; 1878, 467 (illustration), 471.

76 Bundrick 2015, 334; 2019, 100.

77 Bundrick 2015, 298, 323–324.

78 Bundrick 2015, 296, 298.

79 The numbers in parenthesis refer to Steingräber 1986, catalogue. The tombs are entered in approximate chronological order – 550–500 BC: Tomba delle Iscrizioni(?) (74), Tomba del Topolino (119), Tomba delle Olimpiadi (92: on the ground in the tympanum), Tomba del Morto (89), Tomba dei Baccanti (43), Tomba del Barone (44), Tomba Cardarelli (53), Tomba dei Vasi Dipinti (123); 500–450 BC: Tomba 5591 (164), Tomba della Fustigazione (67), Tomba del Citaredo (57), Tomba dei Leopardi (81), Tomba without name (173); 400–350: Tomba 3713 (149).

80 The biography of such a vase, the Exekias Dionysus-cup referred to above on p. 173, suggested by Bundrick 2015, 334, is an interesting illustration of the possible life-story of one particular vase.

81 For monographs of the canopic urns, see, in particular, Gempeler 1974; and Paolucci 2010; 2015. See also Annette Rathje's contribution in the present publication.

82 Haynes 2000, 74–75, fig. 53 (second quarter of the 7th century BC).

83 Haynes 2000, 92–95, figs. 76–80 (second half of the 7th century BC)

84 See e.g., Gempeler 1974, 250; Torelli 1985/1998, 58, fig. 40; Haynes 2000, 107; Paolucci 2010, 109–110; 2015, 376.

85 Brendel 1978, 106.

86 Camporeale 2015, 129 ('teste a maschera'), 131, but without qualifying why he considered them as masks.

87 Haynes 2000, 11–12, figs. 7–8; in the case of double-handed urns, one of the handles was broken.

88 Haynes 2000, 10–11, fig. 10.

89 Mentioned by Gempeler 1974, 250, without further references. See, however, Rathje, fig 5 in the present publication.

90 Brandt 2014, 2015, 2020.

91 On this, see the interesting observation of Braithwaite 2001, 283: "... the word *mask* of *face mask* does not have to mean a wearable mask, or a terracotta copy of one, with holes cut out for the eyes and mouth. It can also mean the representation of a face, viewed frontally, with eyes, nose, mouth and ears, but without any bust or neck attached..."

92 Paolucci 2015, 368–372.

93 Paolucci 2015, 372.

94 Milani 1885, 204, pl. 8.1; Phillips 1984, 416–417. Paolucci 2015, 369, 372, no. 3.

95 Winter 1974, 157–158; 1977, 23–24.

96 Winter 1977, 23–24.

97 Phillips 1984; 1985; 1986; this last article also refers to an Etrusco-Corinthian aryballos in the British Museum (GR1928.6–14.1) portraying a hoplite with a leather(?)-mask.

98 Bloedhorn 2006, col. 431. Regarding the obscene, a reference is made to Burkert 1985, 104–105.

99 Brandt 2012, 140–142; see also note 90 above.

BIBLIOGRAPHY

M. Almagro-Gorbea 1984
El santuario de Juno en Gabii (Escuela española de historia y arqueologia en Roma. Bibliotheca italica 17). Rome 1984.

A. Avramidou 2009
The Phersu Game revisited, *EtrSt* 12, 2009, 73–87.

A. Barker 1984
Greek Musical Writings: I. The Musician and his Art. Cambridge 1984.

M. Blasi 2010
La "memoria mascherata". I *MIMHTAI* e la rappresentazione del defunto ai funerali gentilizi romani, *Scienze dell'Antichità* 16, 2010, 181–199.

M. Blasi 2012
Strategie funerarie: onori funebri pubblici e lotta politica nella Roma medio e tardorepubblicana (230–27 a.C.) (Studi e ricerche (Sapienza Università Editrice) 1; Studi umanistici, Serie Antichistica: 1). Rome 2012.

H. Bloedhorn 2006
Masks II, in: *Brill's New Pauly*, Leiden-Boston 2006, vol. 8, cols. 431–434.

J. Boardman 1976
A Curious Cup, *AA*, 1976, 281–290.

Y. Bomati 1986
Phersu et le monde dionysiaque, *Latomus* 45, 1986, 21–32.

G. Braithwaite 2001
Masks, Face Pots and Mask Vases, *Rei cretariæ romanæ fautorum Acta* 37, 2001, 283–293.

J. R. Brandt 2012
Content and Form: Some Considerations on Greek Festivals and Archaeology, in: J. R. Brandt & J. W. Iddeng (eds.), *Greek and Roman Festivals. Content, Form, and Practice*, Oxford 2012, 139–198.

J. R. Brandt 2014
Tomba dei Tori at Tarquinia: A Ritual Approach, *Nordlit* 33, 2014, 47–64.

J. R. Brandt 2015
Passage to the Underworld: Continuity or Change in Etruscan Funerary Ideology and Practices (6th–2nd c. BC)?, in: *Death and Changing Rituals*, 2015, 105–183.

J. R. Brandt 2020
Emotions in a Liminal Space: A Look at Etruscan Tomb Paintings, in: H. von Ehrenheim & M. Prusac-Lindhagen (eds.), *Reading Roman Emotions: Visual and Textual Interpretations* (Skrifter utgivna av Svenska institutet i Rom, 4°, 64), 41–67.

O. J. Brendel 1978
Etruscan Art (The Pelican History of Art). Harmondsworth 1978.

M. F. Briguet 1972
La sculpture en pierre fétide, *MEFRA* 84, 1972, 847–877.

S. D. Bundrick 2015
Athenian Eye Cups in Context, *AJA* 119.3, 2015, 295–341.

S. D. Bundrick 2019
Athens, Etruria, and the many Lives of Greek Figured Pottery. Madison 2019.

W. Burkert 1985
Greek Religion, Cambridge MA 1985 (translation of *Griechische Religion der archaischen und klassischen Epoche* [Religionen der Menschheit 15], Stuttgart 1977).

G. Camporeale 2010
Il teatro etrusco secondo le fonti scritte: spettacolo, ritualità, religione, in: L. B. van der Meer (ed.): *Material Aspects of Etruscan Religion. Proceedings of the International Colloquium, Leiden, May 29 and 30, 2008* (BABesch – Annual Papers on Mediterranean Archaeology, suppl. 16), Leuven-Paris-Walpole MA, 155–164.

G. Camporeale 2015
Gli etruschi. Storia e civiltà (fourth edition). Turin 2015.

D. N. Carlson 2009
Seeing the Sea: Ship's Eyes in Classical Greece, *Hesperia* 78, 2009, 347–365.

F. Coarelli 2011
Il santuario di Ercole vincitore a Tivoli. Milan 2011.

G. Colonna 1993
Strutture teatriforme in Etruria, in: J.-P. Thuillier (ed.), *Spectacles sportifs et scéniques dans le monde étrusco-italique. Actes de la table ronde organisée par l'Équipe de recherches étrusco-italiques de l'UMR 126 CNRS, Paris) et l'École française de Rome, Rome, 3–4 mai 1991* (Collection de l'École française de Rome 172), Rome 1993, 321–347.

Death and Changing Rituals 2015
J. R. Brandt, M. Prusac & H. Roland (eds), *Death and Changing Rituals: Function and Meaning in Ancient Funerary Practices*, Oxford 2015.

G. Dennis 1848; 1878
The Cities and Cemeteries of Etruria. London 1848; 1878 (second ed.).

F. de Ruyt 1934
Charun: démon étrusque de la mort (Études de philologie, d'archéologie et d'historie anciennes publiée par l'Institut Historique Belge de Rome 1). Rome 1934.

M. Di Fazio 2017
Nuove riflessioni su sacrifici umani e omicidi religiosi nel mondo etrusco, *Scienze dell'Antichità* 23.3, 2017, 449–464.

D. Dutsch & A. Suter (eds.) 2015
Ancient Obscenities: Their Nature and Use in the Ancient Greek and Roman Worlds. Ann Arbor 2015.

D. Emmanuel-Rebuffat 1997
Hercle aux Enfers, in: F. Gaultier & D. Briquel (eds), *Les Étrusques. Les plus religieux des hommes. État de la recherche sur la religion étrusque* (Actes du colloque inernational. Galeries nationales du Grand Palais 17–18–19 novembre 1992), Paris 1997, 55–67.

Etruscan World 2013
J. M. Turfa (ed.), *The Etruscan World*, London-New York 2013.

H. I. Flower 1996
Ancestor Masks and Aristocratic Power in Roman Culture. Oxford 1996.

R. D. Gempeler 1974
Die etruskischen Kanopen: Herstellung, Typologie, Entwicklungsgeschichte. Einsiedeln 1974.

D. E. Gerber 1999
Introduction, in: *Greek and Iambic Poetry from the Seventh to the Fifth Centuries BC, edited and translated by Douglas E. Gerber* (Loeb Classical Library 259), Cambridge MA-London 1999, 1–12.

M.-L. Haack 2017
Ritual and Cults, 580–450 BCE, in: A. Naso (ed.), *Etruscology*, Berlin 2017, 1001–1011.

S. Haynes 2000
Etruscan Civilization: A Cultural History. London 2000.

W. Helbig 1966
Führer durch die öffentlichen Sammlungen klassischer Altertümer in Rom, H. Speier (ed.), vol. II, Tübingen 1966.

J.-R. Jannot 1984
Les reliefs archaïques de Chiusi (Collection de l'École Française de Rome 71). Rome 1984.

J.-R. Jannot 1993
Phersu, Phersuna, Persona. À propos du masque étrusque, in: *Spectacles sportifs et scéniques dans le monde étrusco-italique. Actes de la table ronde organisée par l'Équipe de recherches étrusco-italiques de l'UMR 126 (CNRS, Paris) et l'École française de Rome, Rome, 3–4 mai 1991* (Collec-

tion de l'École française de Rome 172), Rome, 1993, 281–320.

J.-R. Jannot 2010
Les reliefs de Chiusi: Mise a jour de nos connaissances, *MEFRA* 122, 2010, 51–72 (for the electronic version, see https://doi.org/10.4000/mefra.334).

S. Lewis 1997
Shifting Images: Athenian Women in Etruria, in: T. Cornell & K. Lomas (eds.), *Gender and Ethnicity in Ancient Italy* (Accordia Specialist Studies on Italy 6), London 1997, 141–154.

S. Lewis 2003
Representation and Reception: Athenian Pottery and its Italian Context, in: J. B. Wilkins & E. Herring, *Inhabiting Symbols: Symbol and Image in the Ancient Mediterranean* (Accordia Specialist Studies on Italy 5), London 2003, 175–192.

R. E. Linington & F. R. Serra Ridgway 1997
Lo scavo nel Fondo Scataglini a Tarquinia: scavi della Fondazione Ing. Carlo M. Lerici del Politecnico di Milano per la Soprintendenza Archeologica dell'Etruria Meridionale. Milan 1997.

K. M. Lynch 2009
Erotic Images on Attic Vases: Markets and Meanings, in: J. H. Oakley & O. Palagia (eds.), *Athenian Potters and Painters*, Vol. 2, Oxford 2009, 159–165.

K. M. Lynch 2011
The Symposium in Context: Pottery from a Late Archaic House near the Athenian Agora (*Hesperia* Suppl. 46). Princeton 2011.

M. Menichetti 1992
L'*oinochóe* di Tragliatella e rito tra Grecia ed Etruria, *Ostraka* 1, 1992, 7–30.

L. A. Milani 1885
Monumenti etruschi iconici d'uso cinerario illustrati per servire a una storia del ritratto in Etruria, *Museo Italiano di Antichità classica*, 1, 289–341.

M. Nielsen 2013
The Last Etruscans: Family Tombs in Northern Etruria, in: *Etruscan World* 2013, 180–193.

M. Moltesen & C. Weber-Lehmann 1991
Copies of Etruscan Tomb Paintings in the Ny Carlsberg Glyptotek. Copenhagen 1991.

M. Moretti & A. M. Sgubini Moretti (eds.) 1983
I Curunas di Tuscania. Rome 1983.

T. Oestigaard 2015
Changing Rituals and Reinventing Tradition: The Burnt Viking Ship at Myklebostad, Western Norway, in: *Death and Changing Rituals*, 2015, 359–377.

G. Paolucci 2010
I canopi di Tolle tra restituzione del corpo e memoria del defunto, *Scienze dell'Antichità* 16, 2010, 109–118.

G. Paolucci 2015
Canopi etruschi. Tombe con ossuari antropomorfi dalla necropoli di Tolle (Chianciano Terme). Rome 2015.

K. M. Phillips 1984
Protective Masks from Poggio Civitate and Chiusi, in: *Studi di antichità in onore di Guglielmo Maetzke*, Rome 1984, 413–417.

K. M. Phillips 1985
Italic House Models and Etruscan Architectural Terracottas of the Seventh Century B.C. from Acquarossa and Poggio Civitate, Murlo, in: *ARID* 14, 1985, 7–17

K. M. Phillips 1986
Masks on a Canopic Urn and an Etrusco-Corinthian Perfume Pot, in: *Italian Iron Age Artefacts in The British Museum. Papers of the Sixth British Museum Classical Colloquium, London 10–11 December 1982*, London 1986, 153–157.

S. Rafanelli 2013
Etruscan Religious Rituals: The Archaeological Evidence, in: *Etruscan World* 2013, 566–593.

A. Rathje 2014
Self-Representation and Identity-Creation by an Etruscan Family: The Use of the Past in the François Tomb at Vulci, in: C. Scheffer & B. Alroth (eds.), *Attitudes towards the Past in Antiquity. Creating Identities. Proceedings of an International Conference held at Stockholm University, 15–17 May 2009* (Acta Universitatis Stockholmiensis/ Stockholm Studies in Classical Archaeology 14), Stockholm 2014, 55–65.

F. Roncalli 2005
La Tomba dei Giocolieri di Tarquinia: una proposta di lettura, in: B. Adembri (ed.), *Aeimnestos, Miscellanea di studi per Mauro Cristofani*, 1, Firenze 2005, 407–423.

A. Seeberg 1971
Corinthian Komos Vases (Institute of Classical Studies, Bulletin Suppl. 27). London 1971.

A. Seeberg 1995
From Padded Dancers to Comedy, in: A. Griffiths (ed.), *Stage Directions: Essays in Ancient Drama in Honour of E.W. Handley* (Bulletin of the Institute of Classical Studies, suppl. 66), London 1995, 1–12.

F. R. Serra Ridgway 1996
I corredi del Fondo Scataglini a Tarquinia: scavi della Fondazione Ing. Carlo M. Lerici del Politecnico di Milano per la Soprintendenza archeologica dell'Etruria meridionale. Milan 1996.

G. Stefani 1979–1980
Maschere fittili etrusche di età ellenistica, *Annali della Facoltà di Lettere e Filosofia – Università degli studi di Perugia* 17, 1979–1980, 243–322.

S. Steingräber (ed.) 1986
Etruscan Painting. New York 1986.

M. Steinhart 1995
Das Motiv des Auges in der griechischen Bildkunst. Mainz 1995.

M. Strandberg Olofsson 1984
Acquarossa 5.1: The Head Antefixes and Relief Plaques. Part 1: A Reconstruction of a Terracotta Decoration and its Architectural Setting (Skrifter utgivna av Svenska institutet i Rom, 4°, 38:5.1). Stockholm 1984.

J. G. Szilágyi 1981
'Impletae modis saturae', *Prospettiva* 24, 1981, 2–23.

J.-P. Thuillier 1997
Un relief archaïque inédit de Chiusi, *RA*, 1997, 243–260.

J.-P. Thuillier 2013
Etruscan Spectacles: Theater and Sport, in: *Etruscan World* 2013, 831–840.

M. Torelli 1997
Il rango, il rito e l'immagine. Alle origini della rappresentazione storica romana. Milan 1997.

M. Torelli 1985/1998
L'arte degli Etruschi. Bari 1985/1998.

M. Torelli 1999
Funera tusca: Reality and Representation in

Archaic Tarquinian Painting, in: B. Bergmann &
C. Kondoleon (eds.), *The Art of Ancient Spectacle*
(Studies in the History of Art 56, Center for
Advanced Study in Visual Arts, Symposium
Papers 34), Washington 1999, 147–161.

L. B. van der Meer 2011
Etrusco ritu: *Case studies in Etruscan Ritual
Behaviour* (Monographs of Antiquity, 5).
Louvain-Walpole MA.

A. van Gennep 1960 (1908)
The Rites of Passage. Chicago 1960.

C. Weber-Lehmann 2004
Tomba delle Pantere, in: B. Andreae, A. Hoff-
mann & C. Weber-Lehmann (eds.), *Die Etrusker:
Luxus für das Jenseits – Bilder vom Diesseits –*

Bilder vom Tod (exhibition catalogue: Bucerius
Kunst Forums und des Museums für Kunst und
Gewerbe Hamburg, 13. Februar bis 16. Mai
2004), Munich 2004, 127–128.

N. A. Winter 1974
*Terracotta Representations of Human Heads used
as Architectural Decoration in the Archaic Period.*
PhD-thesis, Ann Arbor 1974.

N. A. Winter 1977
Architectural Terracottas with Human Heads
from Poggio Civitate (Murlo), *Archeologia Clas-
sica* 29, 1977, 17–34.

A. Yanko 2015
Game Phersu: Pro et contra, *Journal of Ancient
History and Archaeology* 2.1, 2015, 7–11.

TAMING THE WILDERNESS
ETRUSCAN IMAGES OF NATURE

INGELA WIMAN

And in the beginning was not a Word, but a Chirrup.
D. H. Lawrence, Etruscan Places 1932.

Is it possible to detect any culturally specific perception of nature in cul-
tures where memories are lost and written evidence scarce? That is a ques-
tion that needs to be posed in all works dealing with the (pre)historic
mind[1] and most relevant for a study on Etruscan attitudes towards their
physical environments. There is ample evidence that intensive studies of
nature's epiphanies were observed in Etruria and priesthoods established
for that purpose from early on. Natural phenomena were studied with the
ambition of predicting and averting disasters but also to explain omens
or heavenly signs.[2] Imagine a world full of magic, every single aspect of
nature filled with meaning: the sky above as a place where the divinities
manifest themselves in the form of mist, rain, thunder, sunrise, sunset
and stars. Soaring birds and their courses were eventful and revealing,
human interference with the natural world was accepted first after neces-
sary rituals had been carried out. Such anthropocentric nature could be
met by a sense of "intimacy and love" but also fear and perplexity at its
unpredictability.[3]

The objective for this study is to trace glimpses of possible symbolic val-
ues attributed to biological singularities by the Etruscans, and is part of a
more exhaustive work collecting and analysing images of the Etruscan bio-
sphere in various respects. This presentation is to be understood as a brief
pilot survey for an evaluation of the fruitfulness of the research idea and
methodology used. The period in antiquity providing more specific infor-
mation on the issue of nature depicted in art, is the Roman late Republic
and early Empire. Paintings of mythical landscapes are preserved from
both Pompeii[4] and Rome and wall paintings of gardens reveal great truth-
fulness in the rendering of species of birds and flowers.[5] Roman frescoes
may therefore be useful as reference as to what kinds of flora and fauna

could be expected in ancient Etruria. It is conceivable, however, that plants and animals were imported and brought from travels like the small monkeys seen, for instance, in Tomba della Scimmia in Chiusi.[6] Pollen analyses and palynological data from excavations are useful both regarding information of climate conditions and species of flora and fauna used for food. Various types of parasites threatening crops and domestic animals may be detected and identified.

Selected material

The cases selected from various media were deemed as representative and therefore chosen. The intention is to establish foundations for a more systematic work. Settings of nature may appear in painted tombs,[7] on painted vases and also on engraved objects like mirrors and *cistae*. Likewise, individual trees, plants and animals may appear in various forms, and decorating objects wide-ranging in size, like fibulae and sculpture used as grave markers. An animal, for instance, a dove, can be preserved as a singular votive gift as well as seen in decoration of various media. The selections of imagery for this brief survey have been chosen for their informative content and illustrative qualities. Mythical beings, like sphinxes or sirens are excluded. The exemplifying images are dated between 650 to around 300 BC, and are chiefly taken from tomb paintings and mirrors. Other objects produced in Etruria are used as *comparanda*.

Methods

In the absence of literature, images are crucial for tracing Etruscan mentality. Interpretations involve an effort to detect a once intended meaning of a piece of art. "Meaning", however, is a controversial term. I agree with Barret in defining meaning as:

> I treat 'meaning' not as an inherent property of objects, but rather, as an emergent phenomenon resulting from the shifting interactions of people and things in temporally and spatially different settings.[8]

The sentence is self-evident enough, but the ever-changing spirit of the concept should be kept in mind as a *caveat* in all strivings of interpretation. Scholars have adopted various ways of dealing with immaterial remnants and acquired techniques for studying the ancient mind.[9] The study of

images, iconography, has developed from being descriptive to establishing hermeneutic explanations of imagery, i.e. iconology.[10] Images had multifunctional purposes and represented conventionalized messages in order to be understood. Examples from fauna and flora are often used as signs clarifying or strengthening the meaning of a whole scene. As such they serve as *metonyms* or *synecdoche,* operational in a way as "untamed thinking" characterizing communication in illiterate cultures.[11] Concepts from information theory have proven useful in determining highly diverse, as opposed to more standardized, simple motifs on Etruscan objects.[12] In various types of imagery, animals and other natural elements may have a clarifying purpose as to the intended meaning of a motif, being the *extra* in a conventional setting. The method used here is, therefore, an analysis of the chosen images in order to trace the role of depicted biological elements and their symbolic value. The receivers of the messages, the contemporary Etruscan audience, have to be kept in mind. Painted tombs have a specific focus for a very limited circle of spectators as opposed to temple decorations visible for a large audience. Therefore, it is very interesting to study pictorial motifs that appear in all these media as indeed do renderings of biological elements. Before, however, trying to apply these methods it may be enlightening to digress a bit to explore the landscape and nature once meeting the eye of an Etruscan beholder.

The Etruscan landscape

The ancient landscape had few similarities with the modern tourist views of extensive, poppy-dotted fields with occasional roads boarded by pines or cypresses leading up to some mansion in the distance. There was of course agriculture but in a small scale. The people of Etruria shaped a landscape organized as a *cultura promiscua*. On the slopes, sweet chestnuts, hazel and oaks grew, sometimes as coppice woods used for fodder and fuel. Further down the hills, the soil had to be kept in place by dry-stone walls forming a network of smaller or larger terraces on which were olive groves and vineyards. These had to be irrigated by rock cut *cuniculi* catching water from rain or from some nearby brook. In the lower land, fields were small parcels of crops and vegetables. In the barns there were pigs, and sheep and goats were grazing on meadows and plains of poorer or waterlogged soils.[13] Vast forests, predominantly formed by oak and beech,[14] like the famous and frightful *Silva Ciminia*, provided game for hunting adventures that

ruling classes of all times hold in high esteem. In the great marsh lands closer to the sea grazed the ancient *bos taurus*, still the preferred breed in the Maremma.

Industrial activities could also be conducted with care of natural resources, to judge from pollen archives. The mines from which the Etruscan wealth emanated required a lot of fuel for the melting processes of copper and iron. Research indicates that melting in Populonian workshops was conducted using coppice wood or *silva cauduae* in processing of the mineral ores.[15] Obviously, they had learnt something from the experience when Elba's resources of trees failed due to deforestation.[16] Still some remote parts of the old Etruria can give an impression of the appeal of the original landscape. These localities are often found close to protected archaeological sites, rich in trees, bushes and small meadows with an affluence of flowers and herbs in springtime.

GLIMPSES OF LANDSCAPES AND GROVES ON SELECTED ITEMS

There is no full-screen natural scenery in Etruscan art, but more snap-shots. A landscape scenery is here defined as containing both floral and faunal components, even in the form of mere signs. The earliest object is a situla, three examples are taken from two painted tombs in Tarquinia and three motifs from engraved mirrors have been selected. Thus, various media are chosen for their motifs which makes a fair selection of the extant "corpus of nature images".

THE PLIKAΣNA SITULA FROM CHIUSI, CA. 650 BC [17]

The bottom frieze of the precious situla shows a herdsman and his dog, flanked by two boars, walking in a "landscape" indicated by stems with whisk-like upper parts shaped by radiating lines on top (**Fig. 1**). The smaller one must indicate a bush, the taller ones, trees. Though simple and stylized, the four stems with their crowns are unmistakably signs of the biotope we call a forest. The image has been interpreted as one of a shepherd herding his flock of pigs. The motif thus serves as an agency (*sensu Gell*) of the aristocratic life of the owner of the vase, as rich in herds as Odysseus himself (*Od.* 14, 5–20.)

Fig. 1 The PLIKAΣNA situla from Chiusi. Museo Archeologico Nazionale, Florence, inv. 2594. Su concessione del Museo Archeologico Nazionale di Firenze (Direzione regionale Musei della Toscana).

TOMBA DELLA CACCIA E DELLA PESCA, TARQUINIA, 520–470,[18]
FIRST CHAMBER

A scenery, similar to the one of the situla but more elaborate is painted above the pediment of the back wall of the first chamber with the entrance to the second chamber (**Fig. 2**). Today the image is badly damaged[19] but a comparison with the scene copied for Carl Jacobsen reveals more details.[20] Two horsemen follow a man striding towards the right. Behind the front horse is a hunting dog and in front of them two more, the first one sniffing the ground. A small hare is hiding behind a plant nearby. Behind the group follow two men, a bigger one carrying two slain animals tied to each side of a long stick. Of these the first could be a carnivore to judge from its paws and head, perhaps a fox, the latter is supposedly a deer, due to the hooves above the rope. Another dog is turning towards a smaller man carrying a stool. Around this group are green plants and trees. To the slanting left side of the pediment a brownish-red stem (stems in this painting are always of that colour while the plant details are bluish green) shows buds and a calyx. The following element is formed by a middle stem with two pairs of tapering, opposed "brushes." At the top of the stem an identical bush-pattern rises. This is a plant element repeated twice, one below the stomach of the brown horse, another one in front of the hare to the right. The latter two have brown cones hanging on either side of the stem. It is tempting to translate them as pine trees, *Pinus pinea* common

196

Fig. 2 Tomba della Caccia e della Pesca, Tarquinia, panel above the entrance to inner chamber. Watercolour by A. Morani. (Courtesy of the Swedish Institute in Rome).

in Tuscany. In the dense forest of ever-green oaks, pines would not live to develop a mighty crown. Single standing trees, however, or pines in a population habitat on sandy soils close to the sea, have branches set wider apart and look more similar to the trees in the painting. Further elements are an ivy with berries below the legs of the front figure, a single laurel-like stem on either side of him. Between the two dogs to the right, is an ornament formed by three long leaves rendered with tight strokes with a middle stem and small strokes lining the edges, looking very much like some kind of bracken – the same type or form appears in the Tomba del Triclinio.[21] Behind the crouching hare, two spiky leaves on a stem are placed in the right corner, the leaves look like the leaves of a holm oak, *Quercus ilex.* The leaves of younger seedlings of this species have sharper spikes than mature specimens. Two more plant elements are visible, one with three leaves, berries and tendrils in front of the game carrier and a flower between the legs of the blue horse. Below the pediment, and flanking the door, two slender trees hung with *taeniae* and a mirror each are flanked by two dancing couples.

TREES

This kind of tree is the most common vegetal element in Etruscan tomb paintings. Predominantly they have elongated, laurel-like leaves set on branches springing from a central stem. The Tomba del Triclinio shows many varied forms of branches and trees executed very realistically in the panels on either side of the "dining" chamber.[22] Here we see ivies with clusters of berries that, very realistically, are approaching the trunks of their "host" tree in order to colonize it. Four conifers and a big-leaved bush or tree, looking like a fig appears on both sides, but the deciduous trees predominate. They generally have the common laurel-like form and sometimes, tinier and more prickly leaves. It could be images of laurels, holm oaks or myrtles. In this tomb, the trees seem to be part of groves hung with taeniae and populated by pigeons and hunting cats and, again a crouching hare and small dogs at the edges. The trees may show thicker, more closely set leaves as have the trees in the Tomba del Barone[23] and also more densely set in the branches. Sometimes the leaves are intermingled with black or red berries and sometimes the leaves are smaller. All these trees may, of course, represent generic trees, but I suggest that laurel, *Laurus nobilis* and myrtle, *Myrtis communis,* sacred trees, are some of the

species depicted in the tombs.[24] Interestingly, trees are also present in the underworld. Tomba dell'Orco shows tiny black figures symbolizing souls climbing them.[25] These trees, however, are barren, without leaves, as would be expected in a landscape of the dead. Sometimes rows of these trees, adorned with ribbons or wreaths are the only representations on the side walls of the chamber for the banqueters to see.[26] This row of trees seems to be such an important symbol that it can appear as the only decoration beside the banquet.[27] It is almost impossible to assume other than these trees represent groves where people are dancing either as guests or as entertainers of the diners in the funeral banquet. Thereby follows the suggestion that, as well as the funeral games, the accompanying banquet was held in sacred areas or groves in the vicinity of the tomb or to some sanctuary along the roads to the necropolis.[28]

TOMBA DELLA CACCIA E DELLA PESCA,
INNER CHAMBER

The inner chamber is concerned with life at sea. Lively scenes of a seascape are painted on all the walls. They all depict birds flying or about to set out to lift. Only one of them is diving into the see in order to feed (back wall). On the right wall are three men in a boat of which one is fishing with a harpoon. On the cliffs in front of the boat a larger man is shooting at the soaring birds with a sling. The left wall shows the birds fleeing from three men in a boat (**Fig. 3**). Birds soar the sky, twenty-three birds appear around the approaching men. The middle man is naked and extending his arms towards the two boys jumping from the cliff. To the left, hidden by the rock, a plump yellow bird is resting on the sea, while two other birds in front of it, one green and one red, are lifting to the sky. The two flying birds are rendered in the same way as the sitting duck thus it is safe to identify all birds in this scene as belonging to the same species, *i.e.* ducks, *Anas platyr-hunchos*. All domesticated species have been evolved from this wild ancestor, but breeding has favoured fatter and white ducks with yellow beaks. The artist of the tomb paintings has captured the specific, heavy, and slow lifting of anserine flyers, whether wild or domesticated. The coloration of them, turquoise, brownish-red, yellow and white gives a dimension of light, sun rays shifting in their feathers as they hurriedly soar to the sky. The dolphins painted in the tomb are painted in a realistic blue-grey colour, one beige and three merely outlined. Their muzzles and bulging heads

identify them as common bottlenose dolphins, *Tursiops truncatus*. Overall, the paintings in this chamber bears evidence of the intimate knowledge of marine wildlife by the painter.

TOMBA DEI TORI, TARQUINIA, 475 BC[29]

Unfamiliar landscapes are also imagined in paintings for deceased ancestors. In the Tomba dei Tori the middle panel of the atrium between the entrances to the two inner rooms is divided into two. The upper panel depicts a motif of an oriental landscape: the Trojan plain where Troilus went to water his horses only to be brutally slain by Achilles ambushing him from behind a fountain **(Fig. 4)**. An amusing detail is that this fountain is built by Etruscan standards, as Edlund-Berry has pointed out.[30] It

Fig. 3 Tomba della Caccia e della Pesca, Tarquinia, inner chamber left wall. Watercolour by A. Morani. (Courtesy of the Swedish Institute in Rome).

was beyond imagination to visualize a Trojan construction and the exotic details were saved for the vegetal parts of the motif.

The lower segment displays a row of trees with ribbons fastened to some of their branches. Such a line of trees is common. This line, however, is slightly different due to the various sizes and tapering forms of their trunks.[31] Three of these trees are rendered with leaves, four without. In the background two shadowy painted, defoliated trees appear. A combination of threes with and without leaves appearing at the same time would perhaps indicate that the painter intended a certain season. However, such a trait can be found in Etruria in both winter, early spring and late autumn. Above this line of trees, Troilos moves in a landscape arranged with exotic vegetation. Central to the motif stands what looks like a huge palm tree,

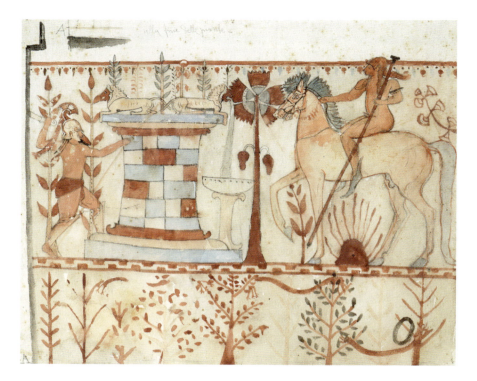

Fig. 4 Tomba dei Tori Tarquinia, the middle panel of the atrium between the entrances. Watercolour by A. Morani. (Courtesy of the Swedish Institute in Rome).

Phoenix dactylifera, with two clusters of dates hanging from either side of the stem. Palm trees originate from the Middle East and North Africa and may here be used as a sign for "oriental land". Italy can only host a small and hardy palm-tree, *Chamaerops humilis*, while the fruit of the date palm was known and traded in the Mediterranean.[32] A vase painter from the early seventh century working in Tarquinia, *Pittore delle Palme*, designed a row of palms around the belly of his name-piece.[33] Etruscan tradesmen doing business with the Levant, certainly brought home both dates and stories of the spectacular tree. It is most interesting to trace the "palm-pattern" in an unfinished late Etruscan sarcophagus from Chiusi, where the large plant (palm?), occupying the centre of the motif, has the same general size and contour but is now converted into a large flower.[34] Again, the pictorial element may signify foreign, or unfamiliar territory.

BIRDS

Birds are common in tomb paintings: ducks, pigeons, partridges and chicken being the most common species, often very naturalistically rendered. Anserine birds are among the earliest artistic expressions of physical creatures and come in many forms. They appear as cast acroteria of bronze hut urns, incised on dress ornaments and painted on architectural plaques.[35] They can appear confronting each other at bridles and helmets used for lids on the biconical burial urns,[36] or in a parade on foot in the Tomba delle Anetre in Veii, dated to the second quarter of the 7th century.[37] The typical form of these early ducks can also be identified as mixed with other animals, e.g. the *cavallo-uccello* decorating pendant discs, for example.[38] Ducks are often seen in combinations with swastika for instance, on two gold pendants from Bologna dated 700–650 in the Louvre.[39] E. Armstrong discusses the Asian origin and possible significance of water-fowl in art.[40] The use of them as "signs" was widely spread by Celtic tribes to the European heartlands and adopted by the (Proto) Villanovan culture in northern Italy.[41] Ducks and geese are probably the first birds to be domesticated since they are easily tamed by humans. Their connections to solar symbols in art, like the swastika, suggest that they were perceived as closely connected to heavenly bodies and were used as signs of immortality, a suggestion supported by their presence in tombs.[42] By the beginning of the sixth century their symbolic value would change and, as in the Tomba della Caccia e della Pesca, considered as pray, or parts of the household as indicated by the mirror found in the Tomba del Triclinio discussed below.

Another bird in early domestic use is the wood pigeon, *Columba palumbus* which seems to have had a great importance. Research in Cavità 254 in Orvieto and studies of bones deposited there shows that chicken were most common closely followed by the wood pigeon.[43] Pigeons have always been an important part of the Mediterranean diet, and are depicted quite early, as exemplified by an Etrusco-Corinthian amphora from Tarquinia showing the bird soaring the sky above a large bull, carrying a ring-shaped object in its beak.[44] Pigeons have been domesticated as long as ducks. In tombs they share the table with their masters and like partridges and chicken collecting crumbs fallen from the dinner table. More intriguing is the presence of this species in the *Tomba François* in Vulci.[45] Below the continuous animal frieze running along the walls, three

pigeons are painted on each of the lintels of room VIII and X.[46] Two are facing each other, and a third is looking towards the atrium. Between the three are painted red four-petalled flowers with a darker red dot in the middle. Above the door to room VIII, over the doves, a hind is mortally attacked by a wolf from the left and a griffin from the right. A cat, *gatto selvatico* is leaving the scene to the right. Above the door to room X a third dove is looking on the two turning right. Above these birds a lion is fighting a bull. It is puzzling to find these docile birds in such a violent ambience.[47] The dove seems to have some specific significance connected to the burial or underworld realms in later Etruscan periods and is found in many tombs, (e.g. Tomba della Scrofa Nera where they pick crumbs from the dining table).[48] A more thorough investigation may shed more light on this issue.

Mirror from Tarquinia, late 6th century BC.
The mirror in question is said to come from Tomba del Triclinio in Tarquinia (**Fig. 5**).[49] Surrounded by an entwined ivy-leaf garland with clusters of berries on top, placed on a base line, a couple – the man to the left, and the woman to the right – stand confronting each other. The woman wears a thin chiton with a himation, which is draped over her shoulders and falling in folds at the front. She is adorned with a diadem, a necklace of pearls and a pendant head (gorgon?) hangs on her upper chest. Her long hair falls from her diadem to her back and shoulders. With her left hand she holds a fold of her mantle while with the right she presents a flower to the man in front of her. They both have pointed shoes. He wears a mantle and his hair is long and hanging over his shoulders. He has a staff in his left hand, the other arm with a bracelet is held behind his back. Behind him is a small tree with a stem and four branches, between the couple a larger winding stem with ivy leaves. Before this ivy stands a pole decorated with rows of leaves tapering towards the top. Behind the woman stands a bed with a cover decorated with dots and crosses and a border of tassels. A piece of cloth is falling in folds from its top. Beneath the bed stands a duck. From the ivy branches hangs a ribbon in the middle. To the left of it hangs a *cista*, and to the right just above the woman's back hangs a large unguent bottle. Under the base line is a wavy line into which four fish are jumping and a bird is swimming. Deeper down are two small shoals of fish and an octopus. Above the lost tang is a palmette pattern.

Fig. 5 Engraved mirror, Antikensammlung Berlin, inv. Fr 32 Misc 3329 (after *CSE, Bundesrepublik Deutschland* 4, 25).

The mirror has many floral and faunal elements, some are difficult to identify like the large, slightly tapering element rising between the couple. A similar tall ornament is seen on the back wall of the Tomba del Barone, also there placed between a woman and a man offering a gift **(Fig. 6)**. Here the man is accompanied by a flute-playing boy. The pole is obviously formed by a row of leaves (?) possibly tied to a wooden shaft. In the mirror motif the pole is thicker and more tightly set but the spoon-shaped elements are clearly visible. Common to the two scenes is the meeting between the couples exchanging gifts and greetings and wearing pointed

Fig. 6 Tomba del Barone. Watercolour by A. Morani. (Courtesy of the Swedish Institute in Rome).

shoes.[50] One gets the impression that the mirror lady is standing in her garden since her beauty-box and a large unguent bottle hang from branches above her head. The four jumping "fishes" beneath the couple are shaped much like dolphins and the two shoals of fish, together with the octopus show that this is deep sea and not an ordinary garden pond. The duck seems to be striding towards the water line in front of him. Perhaps some remnant idea of its connection to the afterlife is still lingering to this bird? It looks as if the scene has been created to give an impression of a garden, some pavilion, where two lovers may meet in private. The pole found both in a tomb painting and on a mirror can perhaps symbolise a covenant binding a couple both in this life and in the one after?

Other images have the same vagueness as the Tarquinia mirror regarding events taking place indoors or outdoors. The Paris Painter shows a similar ambiguity in his works. On a black-figure Pontic vase from around 540 BC[51] the artist has depicted a banquet with dining women with their shoes hanging on the wall. The woman to the right is holding a bird. Behind the couches lie branches, perhaps meant as decorating a floor, but some in the middle seem to grow in the ground. In the Tomba del Vecchio a man

and a younger woman recline on the conventional couch but here, large partridges are looking for crumbles beneath it.[52] Behind a boy/young man attending the couple, laurel branches can be seen. It is not uncommon to display such an ambiguity towards the settings of tomb banquets and it is tempting, again, to assume that groves and gardens were part of the Etruscan culture and used in the context of burial ceremonies.

Other scenery might be even more enigmatic and raises the question of prototypes and cross-cultural influences as, for instance, the motif engraved on another bronze mirror.

Mirror from Orvieto, late 4th century BC.
This mirror, according to Gustav Körte formerly in the A. Castellani collection, comes from Orvieto (**Fig. 7**). [53]

The goddess *Artumes* is identified by an inscription placed alongside her right shoulder. She is riding a stag, both her legs placed to the left of the animal's side and holding on to his left horn. Another stag is running close by to her right. Above her, the sky is indicated by wavy lines and a dotted area inclosing an arching snake with two heads. Placed underneath the uplifted hooves of the stags is a landscape with three trees and a running stream from which a small stag and a hind are drinking. Heart shaped leaves rise from a stem near the head of the hind. Two winding ivy branches spring from a palmette decorating the talon and meet at the top a cluster of berries. The landscape represented here is a rare scene in Etruscan art possibly reflecting oriental motifs of the garden of Paradise.[54] A *bucchero sottile* jug in the Metropolitan Museum of art shows a similar scene.[55] Two confronting stags are drinking water from streams, rock-patterns incised beneath their front legs, and an eagle with outstretched wings seems to intend landing on the head of the right-hand stag's head. Another *oenochoe* from around 725 BC recalls Hittite imagery showing two wild goats flanking a stylized tree.[56] These scenes raise the question of prototypes and cross-cultural influences. Today, as new scientific methods of DNA and strontium isotope analyses have evolved, long range movements of ancient people have been traced and identified.[57] Arranged marriages constituted a well-known way of making alliances and captives from wars, predominantly women,[58] were taken and used as slaves and both phenomena influenced the culture of the new country.[59] Images woven into textiles were immensely valuable to ancient peoples and transported throughout

the Eurasian continent.[60] Trade in the Mediterranean Sea could be practiced all the year round using maritime traffic systems, so called *cabotage,*[61] whereas long distance fares had to be undertaken during the right monsoon winds. It is a fair guess that this kind of motifs, as well as ideas, have travelled along such roads. The idea of stags and antlers found in religious contexts throughout Etruria has been connected to a cult of a goddess, a *Potnia Theron* with aspects of fertility and somehow connected to the underworld.[62] It is interesting in this connection to see *Artumes* holding on to the antler of the stag.[63]

Fig 7. Engraved mirror, Rhode Island School of Design, inv. 25.071 (after *ES* V, pl. 10).

Mirror from Bolsena, 3rd century BC.

Quite another atmosphere is visible in the famous mirror in the British Museum (**Fig. 8**) [64] showing a motif with two men seemingly sneaking up on a centrally placed singer, Cacu with a lyre.[65] All the names of the characters are engraved, *Caile Vipinas* at the border to the left and *Avle*

Fig. 8 Engraved mirror, the British Museum, inv. GR 1873.8-20.105 (courtesy of the Trustees of the British Museum).

Vipinas to the right. A young attendant *Artile* is holding an open diptych in his lap. The landscape is indicated by an undulating line, indicating that both singer and boy are sitting on a rock. The rocky landscape is wild and reflects the grim expressions of the two ambushing men. They are hiding each behind a tree with very little foliage framing a tall cliff behind the main characters. On top of the cliff a satyr-like face looks down to follow the events. Stylized heavenly "atmosphere"[66] is engraved along the edges and the figure-free parts are dotted. A garland of vine with ripe grapes encircles the motif and a little winged boy carrying a knife for pruning the vines is displayed on the exergue.

Many late Etruscan mirrors have backgrounds compatible with Vitruvius' idea of proper settings for dramatic performances of various kinds.[67] The idea that motifs on late Etruscan mirrors can reflect theatrical images has often been discussed.[68] The characters *Caile* and *Aule Vipinas* are heroes in the historical tradition who were active around 500 BC possibly at Vulci.[69] It is not unlikely that a representation of their deeds is presented here. The landscape fits with an idea of a wild and untamed nature and is therefore of utmost interest in this connection.

Concluding remarks

This paper set out to investigate if it is possible to detect an Etruscan sense of nature aided by their visual legacy. So far, the conclusion cannot be affirmative. A thorough autopsy, however, and verbal description of a piece of ancient art may reveal new insights into the "meaning" of pictorial elements or whole scenes. Morgan's idea about a full reference of an element consistent in various media, tombs, mirrors, vase-paintings etc, can demonstrate a context in which it was commonly used, hence a clue to its interpretation.[70] The cases discussed above, however, give an idea of how rich in detail the floral and faunal world could be rendered by an Etruscan artist. In the quest for detecting how the Etruscans perceived wild nature, I believe that a comprehensive analysis of all monuments displaying creatures and images of the natural world could be enlightening. Even if every item described above is made by an individual with his or her own preferences and artistic skill, the individual artist was a part of the *Zeitgeist*. Therefore, it may be possible to detect a particular Etruscan spirit in these works.[71] The total collection of certain animals or environments can give surprising insights and identify overlooked connections.[72] This brief

chronological survey of ducks and pigeons, for instance, has shown that domesticated birds appear in tombs only when painted in connection with banquet scenes. Anserine birds and especially ducks were associated with heaven and, hence, suggestive of a belief in a life after death. This seems to be a conviction in the Geometric and Orientalizing periods but disappears in Archaic time when ducks are shown as game or walking in gardens. It seems that the dove – together with poultry – is the bird of preference in Etruscan art from the Archaic period onwards. Trees are interesting and an almost mandatory part of Tarquinian tomb painting. Only in one case, the Tomba dei Tori, a real wood may have been intended by the painter. Elsewhere, the trees are lined up and in a comfortable human configuration. In this collection only one artist, the engraver of the *Vipinas* brothers' tale, depicts wild, untamed nature. Man, however, even in the "wild" scenes, is the ultimate reason for these motifs, chiefly serving as a background for human or divine actions. What is expressed is a tamed, or else briefly visited, wilderness (*Vipinas* mirror).

NOTES

1 See e.g. Renfrew & Zubrow 1994; Renfrew 2001; Fuglestvedt 2018.
2 The following works have chiefly been consulted in this respect; de Grummond & Simon (eds.) 2006; van der Meer 2004; Turfa 2012; Goldhahn 2019.
3 Fuller 1988, 12.
4 Barrett 2019, *passim*.
5 Ciarallo 2006, pls. 1–17.
6 Perhaps brought from the "ape-island", Pithekoussai, for an image see Moltesen & Weber-Lehmann, 1992, 80–82, fig. 1.82.
7 Nagy 2013, 1017–1025 gives a useful introduction to landscape presentations in Etruscan art; Steingräber's (2006) extensive study of Etruscan tomb paintings has frequently been consulted; Moltesen & Weber-Leman 1991, and their comments on the facsimili of tomb paintings made for the Ny Carlsberg Glyptotek were invaluable for this work. Weber-Lehman, 2017, 55–62 discusses the documentation work on Etruscan tomb paintings, among them Alessandro Morani's sketches. These are used here as basis for both descriptions and illustrations. The correlation between Morani's work and his way

of relating to the originals on the tomb walls are discussed by Wiman 2017, 153–160. A significant and comprehensive study on Tarquinian tombs is provided by Marzullo 2016, with an extensive bibliography for all tombs and a documentation of the various datings of them, including her own suggestions. I generally use her chronology.
8 Barret 2019, 16.
9 Renfrew 2001, 122–140.
10 Beazley 1963 *versus* Morgan 1985, 5 note 2.
11 Sperber 1985 discusses these terms in his essay on understanding the thinking of Lévi-Strauss, 69–76.
12 Wiman 1990, 99; Wiman & Hansson 2017, 186–188.
13 Turfa 2012, 154–180 provides an excellent over-view of biotic material and health and disease in Etruria based on a record of archaeological investigations of settlements and tombs.
14 Today, *Foresta Umbra* in the Gargano Peninsula in Apulia, provides a rare example of a mature Mediterranean forest.
15 Wiman & Ekman 2000–2001, 109–124.
16 Pollen records indicate that no excessive use

of wood took place around the mining centres in the Massetano area before the Roman period, around the end of the first century BC. Wiman 2013, 16–19.

17 Museo Archeologico Nazionale, Florence, Inv. 2594. Turfa 2012, fig. 19, 154; 236.

18 Cf. the chronological list by Marzullo 2016, 77. Her own estimation is 550–520 BC, 78.

19 Cf. Marzullo 2016, 73, for a recent picture.

20 Moltesen & Weber-Lehmann 1991, 46, no. 5 and 1992, 23, 5.2.

21 Moltesen & Weber-Lehmann 1991, 67, no. 31, and 1992, 38, 1.27.

22 Marzullo 2016, 390–4; Moltesen & Weber-Lehmann 1991, 66 nos. 28, 29, 30, 31, and 1992, 37–38, 1.23, 1.24. 1.26. and 1.27.

23 Marzullo 2016, 41–46.

24 Landgren 2004, discusses one single case of a burial garden in Rome from 6 AD, and laurel, 15–18; myrtle, 46–7.

25 Moltesen & Weber Lehmann 1991, 91, no. 65, and 1992, 56 1.47.

26 Cf. Tomba Lerici 5039, Marzullo 2016, 706–7.

27 One exception is Tomba delle Leonesse, cf. Marzullo 2016, 180–183 with an extensive bibliography; an altogether singular tomb regarding its decorations.

28 In the important monography of rural sanctuaries, Edlund discusses various outdoor activities in sacred places, including banquets, 1987, 139–140; Altar and the cult of dead ancestors on top of the tumuli in Cerveteri, suggest that outdoor activities were common in connection to death and burial customs cf. Prayon 2010; possible cult houses on the way to the tombs are discussed by Wiman & Backe-Forsberg 2006–7; Steingräber 2013, 665–6.

29 Cf. Marzullo 2016, 388–389.

30 Edlund-Berry 2014, 284–286.

31 Moltesen & Weber-Lehmann 1991, 114, no. 94, and 1992, 71, 1.68.

32 Pliny writes of Italian palms as "barren" and continues to describe palms of foreign countries in great detail (*NH* XIII. 6. 26 – 9.53).

33 Martelli 1987, Fig. 23, 76.

34 van der Meer 2004, 104, fig. 63.

35 Wikander 1988, fig. 22, 81; Harrison 2013, fig. 60.3, 1095; Drago, 2013, Figs. 18 and 19, 32.

36 For some illustrious examples, all from Monterozzi necropolis, see, for instance, Hencken 1968: "…the cheek-piece is in the form of the central European boat with bird's head at either end with the 'sun-disc' in the middle", 229, pls 55 and 56, and "…with the boat with two birds' carrying the 'sun-disc', 235, pl. 122.

37 Steingräber 2006, 34–38.

38 Weidig 2015, 255–257, figs. 16 and 23.

39 Inv. nos Bj2403; Bj2405; See the Louvre homepage, Collection Louvre.fr/ Département des Antiquités grecques, étrusques et romaines.

40 Armstrong 1959, 33–47.

41 Goldhahn 2019 gives an exhaustive account of these bird-patterns on various bronze objects from northern Europe, 97–152.

42 Goldham 2019, 153–191 discusses bird-bones found in tombs and interpret them as having been used for auspices, however, as Rathje pointed out in personal conversation they could also have provided food for the deceased in the afterlife or, even, been part of the burial ceremonies.

43 George *et al.* 2017, 58–76.

44 Bruni 2019, 172–175.

45 Moretti Sgubini 2004, 44, fig.28.

46 Rathje 2014, 58 fig. 2.

47 Rathje 2014, 60.

48 Marzullo 2016, 333–335.

49 Antikensammlung Berlin, inv. Fr 32 (Misc 3329), *CSE, Bundesrepublik Deutschland* 4, 25.

50 Bonfante 1975, 59–63; 203–4.

51 Metropolitan Museum of Art, New York. Hannestad 1974, 45, no. 10; De Puma 2013, cat. no. 4.102, 122.

52 Moltesen & Weber-Lehmann 1992, 60, 1.52. This unknown artist seems, like the Paris Painter, to have been fond of painting partridges. An amphora in London attributed to the Paris Painter has a series of grave looking partridges facing left parading the belly of the jug and two more stand behind the feet of two confronting warriors, painted on the shoulder of the same vase, Martelli 1987, 150, cat. no. 103.

53 Rhode Island School of Design inv. 25.071, *ES V*, 10; *LIMC* II, *s.v.* Artumes 21, 778 (Krauskopf).

54 A. A.Taghvavaee, M. Ansari & H. M. Nejad 2008, 101–124. Metropolitan Museum of Art New York inv. 21.88.159

55 Inventory number 21.88.159. De Puma, 2013, cat. no. 4.72b, 96.

56 De Puma 2013, 109, comments on the picture "…this is Near Eastern imagery that reached Etruria via Greece…. The piece demonstrates the Etruscan ability to synthesize and seamlessly combine disparate foreign elements with their own traditions".

57 Kristiansen 2007, 149–162; Sjögren *et al.* 2016, 1–33.
58 Perkins 2009, 95–111.
59 Cameron 2016, 133–161.
60 Barber 1999, 131–194.
61 Knapp & Demesticha 2017, 10.
62 Bagnasco Gianni 2013, 594–599; Nielsen & Rathje 2009, 265–66.
63 In a tomb context from Gavorrano in the territory of Vetulonia, for example, the *radius,* some teeth, and the antlers of stags were found inside a tumulus, Cappuccini 2016, 164–5.
64 British Museum inv. GR 1873.8-20.105; de Grummond 1982.

65 Tobin 2013, 845–6.
66 De Grummond 1982.
67 Wiman & Hansson, 2017, 203.
68 Simon 2000; Camporeale 2012, 155–164; Thuillier 2013, 831–840.
69 Haynes 2000, 185–187.
70 Morgan 1985.
71 Scheffer 1984, 229–232, gives a very interesting discussion on Greek and Etruscan ways of painting and gives a detailed argumentation for how the differences were manifested: see also Edlund-Berry 2014, 284–294.
72 Morgan 1985, 5–13.

ACKNOWLEDGEMENTS

Annette Rathje kindly invited me to a very stimulating conference in Copenhagen, for which I am most grateful. Together with her colleague Mette Moltesen, she gave valuable suggestions as to refinements of an earlier version of this paper. Ingrid Edlund-Berry gave references, encouragement and support. Cecilia Sandström discussed ancient trade with me and gave valuable references. Astrid Capoferro and Stefania Renzetti were, as always, helpful in all matters at the Swedish Institute in Rome. Beatrice Warren read and commented on my English in an earlier version of this text and provided stimulating critique. I thank Thorsten and Ingrid Gihls fond, the Fondazione Famiglia Rausing and the Royal Society of Arts and Sciences in Gothenburg for providing funds for studies at the Swedish Institute in Rome.

BIBLIOGRAPHY

E. Armstrong 1958
The Folklore of Birds. London 1958.

G. Bagnasco Gianni 2013
Tarquinia, sacred areas and sanctuaries on the Civita Plateau and on the coast: "Monumental complex", Ara della Regina, Gravisca, in: *Etruscan world* 2013, 594–612.

E. W. Barber 1999
The Mummies of Ürümchi. New York London 1999.

C. E. Barrett 2019
Domesticating Empire. Egyptian Landscapes in Pompeian Gardens. Oxford 2019.

J. D. Beazley 1963
Attic red-figure vase-painters. Oxford 1963.

L. Bonfante 1975
Etruscan Dress. New York 1975

S. Bruni 2019
Ceramiche Corinzie e Etrusco-Corinzie, in A. Cardelli & A. Naso (eds.), *Etruschi Maestri Artigiani. Nuove Prospettive da Cerveteri e Tarquinia,* 2019, 172–76.

C. M. Cameron 2016
Captives. How Stolen People Changed the World. Cambridge 2016.

G. Camporeale 2012
Il teatro etrusco secondo le fonti scritte. Spettacolo, ritualità, religione, in: L. B. van der Meer (ed.), *Material Aspects of Etruscan Religion. Proceedings of the International Colloquium* (Leiden 2008). *BABesch, Annual Papers on Mediterranean Archaeology, suppl* 16, 2010, Leuven 2012, 155–164.

L. Cappuccini 2016
La necropoli etrusca di San Germano (Gavorrano, Gr): Il Tumulo 9. Dinamiche socio-culturali nel territorio di Vetulonia tra VII e II sec. a.C., Firenze 2017.

A. M. Ciarallo 2006
Elementi vegetali nell'iconografia pompeiana.
Roma 2006.

CSE
Corpus Speculorum Etruscorum.

L. Drago 2013
Ricerche sul tema del bestiario fantastico di età
orientalizzante. I precedenti della prima età del
ferro: continuità o discontinuità, in: M. C. Biella,
E. Giovanelli & L.G. Perego (eds.), *Il bestiario
fantastico di età orientalizzante nella penisola itali-
ana (Aristonothos Quaderni 1)*, Trento 2013, 15–33.

I. M. Edlund 1987
*The Gods and the Place. The location and Function
of Sanctuaries in the countryside of Etruria and
Magna Graecia (700–400 BC)., ACTA 4°, XLIII*,
Stockholm 1987.

I. M. Edlund-Berry 2014
La langue de l'architecture dans la céram-
ique étrusque peinte: définition d'une identité
cuturelle, in L. Ambrosini and V. Jolivet
(eds.), *Les potiers d'Étrurie et leur monde, contacts,
échanges, transfert. Hommage à Mario A. Del
Chiaro,* Paris 2014, 284–294.

ES
E. Gerhard, *Etruskische Spiegel*, I-V, Berlin
1840–97.

Etruscan World 2013
J. M. Turfa (ed.), *The Etruscan World,* London and
New York 2013.

I. Fuglestvedt 2018
*Rock art and the wild mind: visual imagery in
Mesolithic Northern Europe.* London and
New York 2018.

P. Fuller 1988
The geography of Mother Nature, in:
D. Cosgrove & S. Daniels (eds.), *The Iconography
of Landscape. Essays on the Symbolic representation,
design and use of past environments* (Cambridge
Studies in Historical Geography 9), Cambridge
1988, 11–31.

A. Gell 1998
Art and Agency: An Anthropological Theory. Oxford
1998.

D. George *et al.* 2017
D. George, C. Bizzarri, P. Bianco, A. Trentacoste,
J. Whitlam and J. Best, Recent Research in Cavità

254 (Orvieto, Italy). *Etruscan Studies* 2017, 20:1,
58–76.

J. Goldhahn 2019
*Birds in the Bronze Age. A Northern European
perspective.* Cambridge 2019.

N. T. de Grummond 1982
Some unusual landscape conventions in
Etruscan art, Antike Kunst 25 1982, 3–14

N. T. de Grummond 2006
Prophets and Priests, in: N. T. de Grummond
& E. Simon (eds.), *The Religion of the Etruscans*,
Austin 2006, 27–44.

L. Hannestad 1974
The Paris Painter – An Etruscan Vase-Painter.
Copenhagen 1974

Y. Hamilakis 2013
Archaeology and the Senses. Cambridge 2013.

A. P. Harrison 2013
Animals in the Etruscan household and
environment, in: *Etruscan World* 2013,
1086–1114.

S. Haynes 2000
Etruscan Civilization. A Cultural History.
Los Angeles 2000.

H. Henken 1968
Tarquinia and Etruscan Origins, London 1968.

B. Knapp & S. Demesticha 2017
*Mediterranean connections: maritime transport
containers and seaborne trade in the Bronze and
early Iron Ages*, New York and London, 2017.

K. Kristiansen 2007
Eurasian transformations: Mobility, ecological
change and the transmission of social institutions
in the third millennium and early second millen-
nium B.C.E., in: A. Hornborg, C. L. Crumley
(eds.), *The World System and the Earth System.
Global socioenvironmental change and sustain-
ability since the Neolithic.* Walnut Creek CA 2007,
149–162.

L. Landgren 2004
*Lauro Myrto et Buxo Frequentata. A study of
the Roman garden through its plants* (diss.).
Lund 2004.

D. H. Lawrence 1932
Etruscan Places. London 1932

LIMC
Lexicon Iconographicum Mythologiae Classicae

M. Martelli 1987
La Ceramica degli Etruschi. La pittura vascolare.
Milano 1987.

M. Marzullo 2016
*Grotte cornetane: Materiali e apparato critico per
lo studio delle tombe dipinte di Tarquinia (Tarchna
supplemento 6).* Milano 2016.

M. Moltesen & C. Weber-Lehmann 1991
*Catalogue of the Copies of Etruscan Tomb Paintings
in the Ny Carlsberg Glyptotek.* Copenhagen 1991.

M. Moltesen & C. Weber-Lehmann 1992
Etruskische Grabmalerei. Faksimiles und Aqua-
relle, *Zaberns Bildbände zur Archäologie. Band 7.*
Mainz am Rhein 1992.

A. M. Moretti Sgubini (ed.)2004
*Eroi etruschi e miti greci: gli affreschi della Tomba
François tornano a Vulci.* Roma 2004.

L. Morgan 1985
Idea, Ideogram and Iconology, *Iconographie
Minoenne (Actes de la Table Ronde d'Athène 1993),
BCH Supplement XI,* 1985, 5–11.

H. Nagy 2013
Landscape and illusionism: Qualities of Etruscan
wall paintings, in: J. Macintosh Turfa (ed.), *The
Etruscan World* 2013, 993–1006.

M. Nielsen & A. Rathje 2009
Artumes in Etruria, in: T. Fischer-Hansen &
Birte Poulsen (eds.), *From Artemis to Diana, Acta
Hyperborea Danish Studies in Classical Archaeology*
12, 2009, 261–301

P. Perkins 2009
DNA and Etruscan Identity, in: J. Swaddling
& P. Perkins (eds.), *Etruscan by Definition: The
Cultural, Regional and Personal Identity of the
Etruscans. Papers in Honor of Sybille Haynes,
MBE,* London 2009, 95–111.

Prayon 2010
The tomb as altar, in: L. Bouke van der Meer
(ed.), *Material Aspects of Etruscan Religion.
Proceedings of the International Colloquium,
Leiden, May 29 and 30, 2008. BaBesch,* supp 16,
Leuven 2010, 75–82.

R. D. De Puma 2013
Etruscan Art in the Metropolitan Museum of Art.
New York 2013.

A. Rathje 2014
Self-representation and identity-creation by an
Etruscan family. The use of the past in the Fran-
çois tomb at Vulci, in: B. Alroth & C. Scheffer
(eds.), *Attitudes towards the Past in Antiquity –
Creating Identities,* Stockholm 2014.

C. Renfrew 2001
Symbol before concept. Material engagement and
the early development of society, in: I. Hodder
(ed.), *Archaeological theory today,* Cambridge
2001, 122–140.

C. Renfrew & E.B.W. Zubrow (eds.) 1994
*The Ancient Mind. Elements of cognitive archaeol-
ogy,* Cambridge 1994.

C. Scheffer 1984
The selective use of Greek motifs in Etruscan
black-figure vase painting, in: H.A. Brijder (ed.),
*Ancient Greek and related pottery (Proceedings of
the International vase symposium Amsterdam 1984),*
Amsterdam 1984, 229–232.

E. Simon 2000
Teatro attico e arte etrusca del V e IV secolo
A.C., *Scienze dell'Antichità* 10, 2000, 511–521.

K.-G. Sjögren, T. D. Price & K. Kristiansen 2016
Diet and Mobility in the Corded Ware of
Central Europe, PLOS ONE DOI: https://doi.
org/10.1371/journal.pone.0155083

D. Sperber 1985
On anthropological knowledge. Three Essays.
Cambridge 1985.

S. Steingräber 2006
An Abundance of Life. Etruscan Wall Painting. Los
Angeles 2006.

S. Steingräber
Worshiping with the dead: new approaches to
Etruscan necropoleis, in: *Etruscan World* 2013,
655–671.

A. A. Taghvavaee, M. Ansari & H. M. Nejad
2008
Cultural Beliefs Regarding Persian Gardens with
the Emphasis on Water and Trees in *African and
Asian Studies,* vol 7, on line publication 2008;
https://doi.org/10.1163/156921008X273097

J.-P. Thuillier 2013
Etruscan spectacles, in: *Etruscan World* 2013, 831–840.

F. Tobin 2013
Music and musical instruments in Etruria, in: *Etruscan World* 2013, 841–854.

J. M. Turfa 2012
Divining the Etruscan World. The Brontoscopic Calendar and Religious Practice. Cambridge – New York 2012.

L. B. van der Meer 2004
Myths and More on Etruscan Stone Sarcophagi (c. 350 – c. 200 B.C.), Lovain-Dudley, MA 2004.

C. Weber-Lehmann 2017
Copiare la pittura etrusca: cenni sulla storia della documentazione, in: A. Capoferro & S. Renzetti, *L'Etruria di Alessandro Morani. Riproduzioni di pitture etrusche dalle collezioni dell'Istituto Svedese di Studi Classici a Roma*, Firenze 2017, 55–62.

J. Weidig 2015
I draghi appenninici. Appunti sulle raffigurazioni degli animali fantastici italici tra Abruzzo, Umbria e Marche in M.C. Biella & E. Giovanelli (eds.), *Nuovi studi sul bestiario fantastico di età orientalizzante nella penisola Italiana, (Aristonothos. Quaderni, n. 5)*, Trento 2015 [2016], 247–272.

C. Wikander 1988
Acquarossa 1. The Painted Architectural Terracottas. Part 1: Catalogue and Architectural Context

(Acta Instituti Regni Sueciae, Series in 4°, XXX-VIII: I, 2), Stockholm 1988.

I. M. B. Wiman 1990
Malstria – Malena. Metals and motifs in Etruscan mirror craft (SIMA 91), Jonsered 1990.

I. M. B. Wiman 2013
Etruscan Environments, in: *Etruscan World* 2013, 11–28.

I. M. B. Wiman 2017,
L'artista e la copia: brevi riflessioni sulla collezione Morani, in: A. Capoferro & S. Renzetti (eds.), *L'Etruria di Alessandro Morani. Riproduzioni di pitture etrusche dalle collezioni dell'Istituto Svedese di Studi Classici a Roma*, Firenze 2017, 153–160.

I. M. B. Wiman & Y. Backe-Forsberg 2006–2007
Surfacing deities in later Etruscan art and the sacellum at San Giovenale, *OpRom*, 31–32, 2006–2007, 17–27.

I. M. B. Wiman & S. Ekman 2000–2001
Man and Nature in Etruria, *OpRom* 25–26, 2000–2001, 109–124.

I. M. B Wiman & U. Hansson 2017
Betwixt Dawn and Dusk. The Etruscan Motif of *Hercle* sailing on an Amphora Raft, in: E. Giovanelli (ed.), *Aristonothos, Scritti per il decimo anniversario di Aristonothos*, Vol. 13.1, Milano 2017, 183–216.

TO THE SOUND OF MUSIC
APPROACHING THE ANCIENT SONIC EXPERIENCE OF ETRUSCAN ART AND ICONOGRAPHY

Introduction: Sound versus silence

So far, archaeology has mainly studied and engaged with direct material evidence in the form of tangible objects, and the five senses are mostly perceived as something, we, as archaeologists, cannot study. This is not surprising, considering that most sensory experiences of the past are lost to us and recreating them tends to be beyond the imagination or our comprehension of ancient space. As a result, it is the surviving visual remains that have always been the focus of attention, and vision has become the dominant sense in the study of ancient art. This situation causes our understanding of Antiquity to be, at present, limited and not embracing of all the multisensory possibilities.[1]

There is no doubt about the power of visual images, partly due to the human ability to create long-lasting representations through sculpture, drawing, painting and other techniques. However, as argued by D. Melcher and M. Zampini: "Certainly, one can tell an art history based on visual representation of visual phenomena, but there is an equally interesting story of the use of visual representation of the other senses."[2] This is not only true for art history, but for archaeology as well.

The ancient Etruscan artefacts are today displayed in museum galleries, where, as much as possible, sound is a factor we seek to limit. Silence among the collections has become a goal in itself, and all kinds of sound are usually avoided. This means that we focus our reception and experience of the artefacts more or less exclusively through using our visual sense. But in this perspective, these objects are about as distantly removed today from their original sound environment as possible, and in complete contrast to the ancient experience. In their original context, they would have been surrounded by sound, which would have greatly influenced the viewer's perception of them: for example, whether in a sanctuary with the sound of

processions, prayers and sacrifices, or in a tomb surrounded by either complete silence or the sounds of burial rituals, the cries of the mourners, and so on. Recent studies have thus engaged with the full sensory spectrum of events such as processions, with their babble of voices, movement, music, colours, smells and visual impressions.[3] Etruscan rituals and other events would not have been solely accompanied by music but probably included a cacophony of different sounds. For example, rituals were likely to have been punctuated with sounds from prophetic voices and the cries of worshippers, and the sounds made by sacrificial animals.[4]

Although it is a difficult and still very elusive topic, my aim in this article is to introduce the significance of sound to our understanding of Etruscan art as well as to explore the ancient experience of some artworks. I will primarily examine the evidence for Etruscan music and consider its significance for our understanding of the ancient experience of the objects displayed in museum collections today.

Sound and art

Before turning to ancient Etruria, it is relevant to briefly address the history of sound and art and the relation between the two fields. 'Sound art' is an artistic discipline that emerged during the late 1970s and early 1980s in which sound is utilised as a primary medium. Like many genres of contemporary art, sound art may be interdisciplinary in nature or used in hybrid forms. The earliest documented use of the term (in the US at least) is from a catalogue for a show called 'Sound/Art' at The Sculpture Center in New York City, curated by William Hellermann in 1983.[5] The show was sponsored by 'The Sound Art Foundation', which was founded in 1982.[6] A European example of the emergence of the art form and its recognition is the now-iconic exhibition *Für Augen und Ohren*, curated by René Block in 1980 at the *Akademie der Künste* in Berlin.[7] The term and concept of sound art is thus – at least from the perspective of Antiquity – a rather late phenomenon, which has been part of the western art scene for about forty years. Another relevant point is that exhibitions of art, and contemporary art, are often curated in a way that focuses on only one or two of the human senses, usually vision and hearing (visual art and/or sound art).

By tradition, the universities tend to separate the visual arts from the sonic arts, as they do the humanities and the sciences. As argued by S.

Shaw-Miller, sophisticated methodologies and historiographies have been developed to provide tools for visual and aural analysis, respectively. But we are only now beginning to forge ways of thinking in the gaps between the disciplines.[8] In a recent article, Melcher and Zampini argue for the breaking down of the artificial barriers between sound and vision, acknowledging the interplay of these two senses, since they find that the theory of 'pure vision' or 'pure sound' is problematic, even in traditionally unisensory art forms such as music or painting.[9]

The fact that sound art and the recognition of sound in art and art history constitute a relatively new phenomenon, and that sound and vision are still separate research fields, is significant for our approach to ancient art, since we still have not entirely merged the many new concepts, theories and approaches with classical art history. Marble sculptures, for example, are still studied and interpreted following a more traditional, exclusively visually-based method. It seems thus that our understanding of art has not been fully brought up to speed with regard to our ancient collections. Just as our contemporary concepts of art, art comprehension and theoretical discussions have moved forward from the ideas of the 18th and 19th century (thus also bringing along the contemporary viewer), our understanding of ancient art should also be reviewed. My point is that we still tend to read the art of Antiquity primarily through an understanding of art introduced in the 19th century.

Sound archaeology and archaeoacoustics

Archaeoacoustics – or the archaeology of sound – is the study of past sounds reconstructing past existence.[10] A new field of research, the formal acceptance and designation of archaeoacoustics as an area of formal study took place at Cambridge during a conference in 2003, and the following proceedings from 2006 formed the first publication to use the title 'Archaeoacoustics'.[11] The first international conference in archaeoacoustics was held on Malta in 2014.[12] It is a highly interdisciplinary field of research and includes a range of disciplines from music, archaeology, acoustics, sound studies, anthropology, ethnomusicology, religious studies, iconography, cosmology, cultural studies, art, drama and film,[13] as well as the natural sciences, engineering, the social sciences, architecture, auditory health[14] and psychology.

The field of archaeoacoustics originally centred on three main areas of

study: 1) modern musical or vocal performance at sites to test their acoustic properties; 2) the use of electronic monitoring equipment to explore and measure the acoustics of monumental sites; and 3) listening to the natural sounds occurring at a site, whether issuing from the structure itself or from environmental factors such as echoes, the local sound of rushing water, wind, rain, etc.[15] Yet, the field of archaeoacoustics has evolved to encompass a wealth of other areas, such as studies of written sources or iconography as testimonies to ancient sounds, the reconstruction of ancient music instruments and music, etc.[16]

Nevertheless, although a broad area of research, archaeoacoustics has so far focused primarily on aspects such as music, and the relationship between architecture and sound through acoustic analyses of, for example, megalithic monuments and rock-art sites.[17] These studies show that the auditory experience greatly shaped social, cultural, political and aesthetic behaviour in past societies. The argument of the present article is that this was also the case with the ancient experience of Etruscan art and iconography.

Approaching ancient sounds

So how do we approach the sounds of Antiquity? The ephemeral and elusive nature of sound obviously makes the study of archaeacoustics a challenging topic. There are certainly a number of reservations or constraints which need to be considered when studying sound, described in an exemplary way by R. Laurence: "Our access to sound is experiential. (...) The link between my experience of a waterfall today and that of a waterfall in Antiquity is not precise: changes in the landscape and built environment mean that we cannot actually know that the volume of the sound was the same, and even if it was, it may have been perceived differently. In consequence, we can only begin to hint at the possibilities of reconstructing Roman sound."[18] Furthermore, we need to be careful not to compare apples with oranges, so to speak. Since auditory perceptions are social phenomena determined by the space-time framework of their production, it is clear that the right understanding of acoustic perceptions of Antiquity can only be affected by taking context into account in the most detailed manner possible.[19]

However, according to A. D'Angour, the ancient musical sounds, for which a range of evidence exists, need not wholly bypass the taste and

musical understanding of modern observers and listeners. It is possible, therefore, that we can understand at least something of the sensations these musical sounds were said to have aroused in their time.[20] D'Angour further argues that even the musical idioms of much earlier periods may have exhibited connections to the way music is still heard and appreciated in contemporary Western contexts.[21] Yet, according to D'Angour, one must remain aware that "ancient music" is a deceptively unitary term. For Greeks of the Classical Age, for example, the term *mousike* embraced song, dance and instrumental music as well as literature. Furthermore, there was a multitude of variegated musical genres and traditions in the ancient world.[22]

Despite these challenges, there is still a wealth of diverse source material that can potentially provide knowledge of sound and ancient art. This includes archaeological artefacts, iconographic depictions, experimental archaeology and written sources. Yet in contrast to ancient Greece and Rome, we do not have Etruscan literary sources informing us about the sounds of ancient Etruria. However, some of the Greek and Latin sources provide glimpses into the musical practices of the Etruscans. Yet, with regard to literary sources, it is imperative to remember to distinguish between a sound and how it is perceived, since there is a fundamental difference between the two. The literary sources only give access to acoustic perception, i.e. the relationship between the emitter of the sound and its sensory perception by the author of the source or their literary persona. Hence, sounds in literary sources only exist insofar as they have been perceived and retranscribed by a subject.[23]

Etruscan music and musical instruments

A good area to focus an investigation of the sounds of ancient Etruria is music, since we are in possession of concrete, comprehensive evidence in the form of three broad categories: archaeological material, such as preserved instruments; iconography, particularly the depictions in tomb paintings and funerary sculpture, on bronze vessels, and in vase paintings;[24] and Greek and Latin texts, which occasionally make a reference to Etruscan musical practices.[25]

The iconographic evidence shows that almost all of the musical instruments that were widespread around the Mediterranean during Antiquity were also used in Etruria on many different occasions,[26] although the instruments that are most commonly represented are not necessarily the

ones that were most common in real life.[27] Yet the compatibility with the remaining Mediterranean area is supported by the written sources.[28] The instruments can be categorised in a number of ways, but belong overall to three groups: wind instruments (aerophones); string instruments (cordophones); and percussion instruments (idiophones and membranophones).[29] These will be discussed in the following. It is important to mention, however, that the names given to these instruments are probably not the Etruscan language's own, but are derived, rather, from Greek, Latin, Medieval, or even modern designations.[30]

Wind instruments (aerophones)

The Etruscans were especially fond of wind instruments, in contrast to the Greeks, who appear to have preferred string instruments.[31] Different types of wind instruments were used, including horns and trumpets such as the *cornu*, the *lituus*, the tuba, and different types of flutes.

The *cornu* was of Etruscan origin. The instrument consisted of a long bronze or brass tube curved to resemble the letter G.[32] Its circumference was typically about 3 metres, and a bar extending across the instrument gave support and served as a grip. It usually had a detachable mouthpiece and often a flared bell.[33] A few preserved examples of this instrument have been recovered in the archaeological record. Two were recovered in the tomb of the Vipinana family in Tuscania; they were probably deposited sometime between the end of the 4th century BC and the mid-2nd century BC.[34] Another *cornu,* the so-called Cornu Castellani, is in the Museo Nazionale Etrusco di Villa Giulia, Rome (**Fig. 1**). According to the museum records, it comes from Tarquinia and has been dated to the 4th century BC.[35] However, it has been suggested that all three instruments have been assembled after excavation.[36] Furthermore, an early version of the *cornu* without cross-bar was recovered in the Tomb of the Chariots (*Tomba dei carri*) in the San Cerbone necropolis at Populonia, dated to the mid-7th to early 6th century BC, where it was found in association with a *currus*, a war chariot, an axe and other artefacts, highlighting the high rank of the deceased.[37] In addition, *cornua* were also constructed in terracotta. The oldest example of a terracotta *cornu* has been dated to the 6th century BC and was recovered in the area of the Faliscan town Civita Castellana but is without exact find context.[38] Another terracotta *cornu,* dated to the 5th to 4th century BC, was recovered during the excavations of the settlement

Fig. 1 The Cornu Castellani. 4th century BC. Museo Nazionale Etrusco di Villa Giulia, Rome, inv. no. 51216. (© MiBAC. Museo Nazionale Etrusco di Villa Giulia. Photo: Mauro Benedetti).

of Montereggi (Capraia-Firenze) in the area of what might be a sanctuary, presenting the possibility that it functioned as a votive offering.[39]

Furthermore, it seems that horns could also be made from other materials. For example, sea conches were used as horns or trumpets from the 8th century BC. Such a "trumpet conch" has been recovered from an elite, male burial in the Poggio dell'Impiccato necropolis in Tarquinia belonging to the 8th century BC.[40]

The *lituus* was a long bronze or brass tube curved at the end to resemble the letter J. It is similar in shape to the ritual staff carried by priests and augurs, which probably explains why it bears the same name.[41] So far, six

Fig. 2 *Lituus*. Museo Archeologico Nazionale di Tarquinia, inv. no. C 176/A/20. (After Bonghi Jovino 1986, fig. 92).

litui (or fragments of *litui*) from Etruria survive. One *lituus*, 1.5 metres long, was discovered in 1927 in a tomb in Vulci and is now in the Museo Gregoriano Etrusco;[42] it has a detachable mouthpiece and could play a natural scale of six notes.[43] A second *lituus* was recovered in Tarquinia in the 1980s in a votive deposit in the Pian di Civita.[44] The deposition can be dated to the 7th century BC. The instrument had been folded up in two parts before being deposited together with a shield and an axe in a pit in front of a sacred building (Building β) (**Fig. 2**).[45] A third *lituus* was recovered near Tumulus II at the Sodo necropolis in Cortona.[46] This instrument was also ritually deposited and like the *lituus* from Tarquinia it was bent before its deposition, which can be dated to the end of the 7th century BC.[47] It has a fragment of a wooden mouthpiece preserved.[48] A fourth *lituus* of unknown date and provenance is in the Staatliche Museen zu Berlin.[49] Furthermore, a fragment of a *lituus* is in the collections of the Badisches Landesmuseum in Karlsruhe. It was recovered in Etruria and dated to the 4th century BC.[50] Finally, a sixth *lituus,* dated to the 5th century BC, was sold at an auction at Sotheby's, London, in 1982.[51]

The tuba was a long, straight, trumpet-like instrument of bronze, brass, or sometimes iron or ivory.[52] It was 1.2 to 1.5 metres in length with a flared

Fig. 3 Musicians playing double pipes and lyre. *Tomba dei Leopardi*, facsimile from 1898. Ny Carlsberg Glyptotek, inv. no. H.I.N. 134 (I.N. 1638). (Photo: Ole Haupt).

bell. The mouthpiece was of horn or ivory. The instrument was known to several ancient peoples but appears to have been especially important to the Etruscans.[53]

The Etruscans appear to have been very fond of flutes, in particular the double pipe, which is the most represented instrument in Etruscan art (**Fig. 3**).[54] The double pipe was known in Greek as the *aulos* and in Latin as the *tibia*. With regard to its Etruscan name, it can be observed that the Latins applied the term *subulo* to the player of the instrument, indicating that the Etruscan word *suplu* refers to the player of this instrument, if not to the instrument itself.[55] The double pipe consisted of a narrow tube with finger holes, and each is joined to a double reed mouthpiece.[56] It was usually made of reed, but also of bone, wood or ivory.[57] It could be played singly, but was more commonly played simultaneously with another pipe as a pair. They varied in length, but were usually around 50 cm.[58]

Other types of flutes included the small transverse flutes and the panpipes, called *syrinx* in Greek. The *syrinx*, or Greek panpipes, consisted of a row of hollow pipes made of cane, wood, clay or bronze. The number of pipes could range from five to thirteen (**Fig. 4**).[59] Due to their perishable materials, only a few flutes have been recovered. A rare example is the

Fig. 4 Depiction of a seated man playing the panpipe on a bronze situla from Certosa, 6th century BC. Museo Civico Archeologico, Bologna, inv. no. 17169. (Museum photo).

eleven or twelve fragments of pipes (ten of boxwood, one of ivory), which have been recovered from the Isola del Giglio shipwreck, which sank in the bay of Campese around 600 BC.[60]

String instruments (cordophones)

The Etruscans also played string instruments such as the lyre. Archaeological remains of lyres have been recovered in Greece and Magna Graecia, but not in Etruria.[61] However, several plectra, attesting to the use of string instruments, and usually made of ivory and with elaborate shapes, have been discovered in burials from various Etruscan sites, including Cerveteri,[62] Tarquinia,[63] and Vulci.[64] They date to the period from the first half of the 7th to the first half of the 6th century BC.[65] Although the archaeological evidence for string instruments is sparse, we are in possession of abundant evidence from Etruscan iconography, particularly the tomb paintings.[66] One of the earliest representations of a string instrument (a lyre) in Etruria is found on an amphora dated to the first half of the 7th century BC, and they appear continuously up until the Roman period.[67]

The string instruments can be divided into four different types of lyres, depicted in Etruscan art: the *chelys* lyre, the barbiton, the cylinder *kithara* and the concert *kithara*,[68] with all having equivalents among the Greek string instruments.[69] The *chelys* lyre has a round body made from tortoise shell, or a wooden structure of similar shape with ox-hide stretched over its concavity. Two wooden arms and a yoke rise from it (**Fig. 3**).[70] The *chelys* lyre was confined to the western part of the Mediterranean. It was probably conceived in the 1st millennium BC and remained popular through the Roman period, where it was depicted in Late Roman mosaics.[71] The barbiton (Latin: *barbitus*) is similar to the lyre, but its arms and strings are longer. The yoke is attached in a distinctive manner.[72]

The *kithara* was an elaborate and more powerful version of the lyre, and one of the most important string instruments of Antiquity. It had seven or more strings of equal length stretched between a yoke attached across two vertical arms that protrude from a wooden soundbox. Different pitches are obtained from various string tensions and thicknesses. The soundbox is either rectangular or rounded.[73] The cylinder *kithara* has a round bottom, a pair of broad arms, and a yoke resting on their upper ends.[74] It first appeared in Ionia around 550 BC, from where it spread to Athens and Etruria where it survived until around 300 BC.[75] The cylinder *kithara*

227

Fig. 5 Man playing the *kithara. Tomba dei Leopardi,* facsimile from 1898. Ny Carlsberg Glyptotek, inv. no. **H.I.N.** 135 (**I.N.** 1640). (Photo: Ole Haupt).

was the most common *kithara* in Etruria, and Lawergren even calls it 'the national instrument' of Etruria.[76] They are often shown in a variety of media and they retained a fixed design for a long time (**Fig. 5**). The concert *kithara* is an elaborate instrument with a flat bottom, which appears to have had a much more modest role in Etruria, since it is only depicted in two tombs.[77]

Percussion instruments (idiophones and membranophones)

Percussion instruments include idiophones and membranophones. The idiophones create sound through the instrument's vibration, while the membranophones produce sound through a vibrating, stretched membrane – namely drums.[78] These instruments are less visible than wind and string instruments in Etruscan iconography. However, they do occur, and some examples have also been recovered in the archaeological record.

The Etruscan idiophones include rattles, bells, *tintinnabula* (sing. tintinnabulum) and *crotala* (sing. *crotalum*). Several rattles of similar shape and size, often decorated, have been discovered at various Etruscan sites, primarily in female burials. They are usually in clay, but some are in bronze. The rattle is among the earliest attested instruments in Etruria, occurring from the middle of the 9th century and the 7th century BC.[79] Bells, *tintinnabula* and other percussion instruments have been found on Etruscan

sites. Among the different kinds that have been recovered are the so-called *phormiskoi*, a type of terracotta vase of a special shape. These have been interpreted as rattles.[80] A unique example of a percussion instrument is a hollow bronze bracelet of unknown provenance that contains small bronze pellets, suggesting its use as an instrument, probably to accompany dancing.[81] Finally, a bucchero cup, recovered from a burial at Veii, dated to the 7th or 6th century BC, contains small inclusions in a hollow cavity in the base/stem which create a rattling sound when shaken or moved.[82] Another, further example are the bronze rattles, the so-called *crepitacula*.[83]

The only type of idiophone that is represented is a type of clapper, similar to modern castanets, and which the Romans called *crotala* (**Fig. 6**).[84] It consists of two hollowed-out pieces of metal, bone or wood, held in the hand and struck together to create a sound. They are always shown being

Fig. 6 Black-figure stamnos, depicting a dancing woman with *crotala*. Possibly from Vulci. Ca. 500–480 BC. Ny Carlsberg Glyptotek, inv. no. **H.I.N.** 524. (Photo: Ole Haupt).

played by dancers. However, there are no known surviving archaeological examples.[85]

The use of drums appears to be harder to define. The hand drum, termed *tympanum* in Latin and *tympanon* in Greek, was well-known in Antiquity. It was a single- or double-sided hand drum with a rim made of metal or wood, about 30 cm in diameter, and typically associated with the cults of Dionysos and Kybele.[86] However, the *tympanum* is the most puzzling and elusive part of the Etruscan musical tradition. There is no evidence of this instrument in the archaeological record: not a single mention is made by Greek and Latin authors regarding its use in Etruria, and there are no surviving depictions in tomb paintings, although it is depicted on red-figure pottery from around 350 BC and onwards (**Fig. 7**).[87] It thus appears that the Etruscans seldom depicted frame drums, or any other kind of drum,[88] indicating that they were possibly not in widespread use in Etruria.

Fig. 7 Red-figure stamnos with a depiction of a seated Nike holding a tympanon. Allegedly found in Falerii. Ca. 350 BC. Ny Carlsberg Glyptotek, inv. no. **H.I.N.** 223. (Photo: Anders Sune Berg).

Reconstructing ancient Etruscan music

Archaeological artefacts, such as the instruments described above, are one source of our knowledge of ancient sounds. Whilst their individual states of conservation are often not optimum, the remains of musical instruments offer the hope that we can recreate the sounds of the past.[89] Although this hope is understandable, it is, as argued by Vincent, also dangerous: just because an instrument physically resembles what is depicted in ancient iconography, or is described in the literary sources, this does not mean it will produce the same sound. Materials and construction techniques are crucial elements in sound production, as are playing conventions and body postures.[90] Thus, the performance capabilities of any instrument are very much a product of the properties of the instrument and the capabilities of the player. In the case of lip-reed instruments, the level of the player's abilities is probably an even more significant factor than with many other instruments, especially with regard to the range over which the instrument might have sounded.[91] Moreover, we obviously do not know any of the ancient melodies. Nevertheless, these testimonies are still invaluable contributions to what ancient music might have sounded like, and we will often be able to project possible scenarios for the sound of ancient musical instruments. In the case of Etruria, we are, moreover, in the fortunate situation of having several relatively well-preserved instruments record. Thus, the earlier scholarly perception that ancient music is wholly lost to us must be recognised as erroneous.[92]

The growing scholarly interest in ancient music has resulted in interdisciplinary initiatives, one of the aims being the reconstruction of ancient music. One such initiative is the European Music Archaeology Project (EMAP).[93] One of the key events of EMAP was the large, travelling exhibition *Archæomusica – The Sounds and Music of Ancient Europe*.[94] The project focused on different aspects of ancient European music, including the musical traditions of Etruria. This included experimental reconstructions of a number of Etruscan musical instruments. Thus, the team made a reconstruction of the *lituus* from the Pian di Civita at Tarquinia, based on a careful archaeological examination of the instrument itself, as well as XRF analyses of its metal composition.[95] Other reconstructions have been made of an Etruscan clay rattle from Vulci, dated to the end of the 7th century BC, and of a bronze rattle from Chiusi, dated to the 6th century BC.[96] A fourth reconstruction was made of a clay horn recovered at Civita

Castellana, dated to 550–500 BC.[97] The sounds of all four reconstructed instruments have been recorded and can be heard on YouTube.[98]

Furthermore, a replica of one of the *cornua* in the British Museum has been constructed in bronze. The replica instrument was played by three individuals, including a regular trumpet player and an occasional euphonium player. According to the outcomes of the experiment, the principal sensation was the lack of centring of the individual notes. Moreover, the shallow mouthpiece contributed with a tone colour of relatively little depth, and the instrument was not nearly as resonant as, for example, a modern euphonium.[99] But perhaps, as argued by Holmes, this might have been a sought-after attribute at the time, and the lack of mellowness associated with deeper brass was perhaps not valued in ancient Etruria. In fact, we know nothing of the sensitivity to tuning and the desire of the makers of the instruments for the players to have the instruments play in tune.[100] However, what the experiment did show was that replicas of ancient instruments, in this case a *cornu*, can be sounded in a manner that yields a performance that we would today term "musical".[101]

So despite the considerable challenges, such experiments involving accurate reconstructions of archaeological musical instruments, as well as music performances, bring the ancient instruments back to life and take us leaps forward in our quest for the soundscapes of Antiquity. It is thus no longer impossible to imagine how Etruscan music might have sounded.

Music in Etruscan society

The Etruscans appear to have played music for many different occasions. This is attested by literary sources, for example, although there are no direct Etruscan sources or any ancient treatises on Etruscan music. However, quite a few Greek and Latin sources mention the topic.[102] Thus, some ancient authors comment on the Etruscan use of musical instruments in very diverse contexts.[103] Yet, as is always the case with such sources, their testimony to the real life of the Etruscans should be taken with some caution. As an example, it is said that the Etruscans flogged their slaves to the sound of the double pipes,[104] which is probably unlikely to be a reflection of Etruscan society as a whole. Nevertheless, they provide important information concerning the significance of music in Etruscan society. Among the authors that mention the topic is Ovid,

who attests to the many diverse occasions when the Etruscans included music:

> On the Ides a temple was dedicated to Unconquered Jupiter. And now I am bidden to tell of the Lesser Quinquatrus. Now favours my undertaking, thou yellow-haired Minerva. "Why does the flute-player (*tibicen*) march at large through the whole city? What mean the masks? What means the long gown?" So did I speak, and thus did Tritonia answer me, when she had laid aside her spear – would that I could report the very words of the learned goddess! "In the times of your ancestors of yore the flute-player (*tibicinis*) was much employed and was always held in great honour. The flute played in temples, it played at games, it played at mournful funerals. The labour was sweetened by its reward; but a time followed which of a sudden broke the practice of the pleasing art.... Moreover, the aedile had ordered that the musicians who accompanied funeral processions should be ten, no more. The flute-players went into exile from the city and retired to Tibur: once upon a time Tibur was a place of exile! The hollow flute was missed in the theatre, missed at the altars; no dirge accompanied the bier on the last march.[105]

A further source for music being played is Athenaeus, according to whom "the Etruscans, as Alcinus records, knead bread, practise boxing, and do their flogging to the accompaniment of the flute".[106] This demonstrates that the Etruscans used music, flute-playing in particular, during religious ceremonies, games, at funerals and in theatres, as well as for more daily activities. Yet sources such as Ovid and Athenaeus are few and rarely provide much detailed information.

Our evidence primarily consists of iconography, such as the depictions in wall paintings, revetment plaques, cippi, urns and situlae, which often depict musicians and dancing men and women. According to Lawergren, musical instruments are unusually common in Etruscan tomb paintings and stone reliefs.[107] According to his study, depictions of at least 129 instruments survive from 52 tombs, dating from 520 to the end of the 3rd century BC. The double-pipe is by far the most commonly represented instrument with 67 examples.[108] A survey of Archaic funerary urns from Chiusi also identified 42 instruments on 38 urns and bases, dating from the 6th to the middle of the 5th century BC. On the urns, too, the double pipe is the

most commonly represented instrument, with 22 examples.[109] The instruments are shown in different scenes in these depictions, which provide us with valuable information as to the occasions for playing music. However, most of the evidence comes from tombs and is therefore closely linked to the funerary sphere, which will be taken into account below when addressing the different occasions for musical performances.

Judging by the iconographical evidence, music was thus performed on many different occasions, including funerals, marriages, banquets, athletic competitions, hunting, sacrifices and other religious events.

Funerals

As Ovid mentioned, the Etruscans played music, particularly flutes, during funerals. This is supported by the iconographic evidence, where many scenes in different media depict musicians accompanying various rituals pertaining to death. In fact, music appears to have been extremely significant in funerary rituals, as the many depictions of musicians and musical instruments in funerary demonstrate.

Direct representations of death are very rare, however, in Etruscan art. Among the few exceptions are some funerary reliefs from Chiusi that depict the prothesis. Music is only indicated in a few cases, and is always played on the double pipe.[110] One such example is a cippus base relief with a prothesis scene from Città della Pieve near Chiusi and dated to ca. 490 BC.[111] The deceased is lying on a bier, surrounded by mourners. By the end of the bier stands a person playing the double pipe (**Fig. 8**). In contrast, the few scenes of prothesis rendered in Tarquinian tombs, or on Etruscan black-figure vases, do not include any musical iconography.[112]

Although clear depictions of death are relatively rare, many representations, which at first sight might appear to be images of daily life, often conceal symbolic references to death. From the last decades of the 5th century BC, Etruscan art often refers to death, and shows, for example, the journey of the deceased to the underworld or scenes from the afterlife.[113] Instruments such as the double pipe and the *kithara* frequently appear, in association with the passage to the underworld in Tarquinian tomb paintings from the late Archaic to the late Classical Period, depicted on either side of the door to the hereafter, or being played near vessels that served in aristocratic banquets and as cinerary urns – such as are represented on the back wall of the *Tomba delle Leonesse* (**Fig. 9**).[114]

Fig. 8 Cippus with depiction of the deceased on *lit de parade*. Ca. 490 BC. Ny Carlsberg Glyptotek, inv. no. **H.I.N.** 81. (Photo: Ole Haupt).

Musicians are often clearly rendered in funerary processions. Generally, processions from Archaic funerary contexts represent either funeral rites – such as the preparation for banquets or games, the presentations of tomb offerings for the deceased and sacrifices to the spirits of the dead – or the journey to the underworld.[115] In the late 5th and early 4th century BC, the traditional funerary scene of the passage to the underworld also began to incorporate the civic and religious iconography of ceremonial processions, where the deceased was portrayed as a magistrate. During the 2nd century BC, the Etruscans continued to develop funerary scenes in which

Fig. 9 *Tomba delle Leonesse*, facsimile from 1898. Ny Carlsberg Glyptotek, inv. no. **H.I.N.** 144 (**I.N.** 1678). (Photo: Ole Haupt).

the journey to the underworld incorporated elements of everyday ritual.[116] Many of these processions include musicians. One example is a sarcophagus from Cerveteri from the 5th century BC with a funerary scene of the journey to the underworld.[117] The procession is led by a person playing the *cornu*, followed by a man carrying a *lituus*, a man playing the *kithara*, and a flautist. Another example showing the journey to the underworld is the sarcophagus from Vulci of Ramtha Visnai from ca. 300 to 280 BC and which demonstrates the importance of music in funerary processions. On the front side of the sarcophagus musicians are depicted playing the *cornu*, *lituus* and *kithara*.[118] A final example, which will be mentioned here, is the *Tomba Bruschi*, which has been dated to the period between the end of the 4th and the beginning of the 2nd century BC. The right wall depicts a pro-

Fig. 10 Tomba Bruschi, Monterozzi necropolis, Tarquinia. The tomb has been dated to the period between the end of the 4th and the beginning of the 2nd century BC. The front wall (upper image) depicts a procession headed towards the right lead by a person playing the *cornu*, followed by one playing the *lituus*, three *togati*, and a fourth man playing the *cornu*. The right wall (below) shows a procession headed by four musicians: two *liticines* and two *cornicines*. (After Mariani 1864).

cession, headed by four musicians: two *liticines* and two *cornicines*, while the front wall depicts a magistrate, who is preceded by a person playing the *cornu*, a person playing the *lituus*, three *togati*, and a second man playing the *cornu* (**Fig. 10**). In other instances, the tomb paintings depict unplayed instruments in tombs, such as the lyre/*kithara* hanging on the wall behind the reclining man in the *Tomba della Caccia e Pesca*, or the lyre hanging on the wall in the *Tomba del Pulcinella*. It thus appears that music involving different instruments, such as the *cornu*, the *kithara* and the double pipes, played a significant role in the funerary rituals of the Etruscans.

Banquets

Banquets are another common theme in Etruscan iconography and are often accompanied by musicians playing instruments like the double pipe, lyre or *kithara*, with male and female dancers occasionally accompanying the music with *crotala*.[119] Banquets attended by musicians are rendered in several tomb paintings: for example, a man playing the double pipe in the *Tomba del Triclinio*; men playing the lyre or *kithara* in the *Tomba della Pulcella* and in the *Tomba Querciola*; and the musicians playing double pipe and *kithara* in the *Tomba Golini*. Musicians are also depicted in banquet scenes in terracotta revetment plaques – those from Velletri and Acquarossa, for example.[120] However, as mentioned above, it can be difficult to ascertain whether these scenes represent elite banquets or perhaps scenes from the afterlife, or whether the action is part of the funerary ritual. That the Etruscans did enjoy music while entertaining at banquets is supported by later literary sources, such as Quintilian, who alludes to ancient, possibly Etruscan musical customs in his discussion of music at banquets: "Even at banquets of our own forefathers it was the custom to introduce the pipe (*tibiae*) and lyre (*fides*), and even the hymn of the Salii has its tune. These practices were instituted by King Numa and clearly prove that not even those whom we regard as rude warriors, neglected the study of music.".[121]

Sports and hunting

Other scenes depict athletic competitions, which appear sometimes to have been accompanied by music. A black-figured amphora, recovered in Vulci and dated to 510–500 BC, offers a scene with two boxers confronting each other. On the right is a nude youth, acting as a 'second' with sponge and aryballos; behind him are two beardless figures, the first playing the double flute, the second holding a long wand. Depicted under one of the handles are four nude male figures, each with *crotala* in either hand.[122] We also see scenes involving sport and music in wall paintings. An example is the *Tomba delle Iscrizioni* in Tarquinia, where the painting on the left wall depicts a scene featuring parts of two boxers, two wrestlers and a flute player (**Fig. 11**).[123]

String instruments do not appear in the context of athletic competitions, only double pipes, *crotala* and the *lituus*.[124] This is supported by Athenaeus, according to whom "the Etruscans accompany their boxing-matches with

Fig. 11 *Tomba delle Iscrizioni* in Tarquinia. Facsimile from 1900. Ny Carlsberg Glyptotek, inv. no. **H.I.N.** 169 (IN 1760). (Photo: Ole Haupt).

the flute (*aulos*)".[125] This might also be the case with hunting, since Aelian records that the Etruscans accompanied their hunts with music.[126]

War

There is also iconographic evidence of the use of music instruments in battle, probably for signalling attack or retreat. An amphora from Tarquinia, dated to ca. 510 BC, depicts a player blowing a *cornu* ahead of warriors holding their shields and ready for battle.[127] A much later example is an urn from Chiusi, dated to ca. 250–225 BC, depicting a battle scene involving a *cornu* player from the *Seven Against Thebes*.[128] A further indication of the association between the *cornu* and battle is the *Tomba dei Rilievi*, where two *cornua* are depicted on either side of the entrance to the tomb, together with armour, greaves and shields.[129] It appears that the Etruscans also used the tuba in battle, as can be seen on a sarcophagus from Viterbo.[130] The straight trumpet (the tuba) is also depicted in a scene of a naval battle on the so-called Aristonothos Krater recovered at Cerveteri.[131] In fact, according to Hesychios, the Etruscans were pirates who sounded the trumpet.[132]

Sacrifices and religious rites

Double pipes appear in scenes of libation and animal sacrifice from the Archaic period through to the Hellenistic age in Etruria. An example is a bronze mirror from the 6th century BC that depicts a sacrificial scene (**Fig. 12**).[133] In the centre of the scene is an altar on which a fire is lit. To the right is a man, attended by a youth, ready to perform a sacrifice or a libation. To the left is a man leading a goat to the sacrifice and a man playing the double pipe. Other iconographic sources confirm the presence of the double pipe, as well as the *kithara* and *lituus*, at rituals.[134] A further indication of their ritual use is the ritual deposition of the two *litui* at Tarquinia and Cortona, respectively.

Latin sources, such as the quotation from Ovid above, also testify to the involvement of music during religious acts and sacrifices in Etruria. It appears that the double pipes as well as lyres were played during the rites performed at the altar, while the tuba announced the arrival of the procession at the place of sacrifice. Interestingly, sacrificial music is not mentioned in the surviving Etruscan texts on rites, the *Liber Linteus* and the *Tabula Capuana*.[135]

Already in Rome, it seems that Etruscan flute players (*tibicines*) performed at sacrifices and public prayers.[136] The music served to drown out every distracting noise, and if it stopped the rite was compromised since the music was indispensable for the communication between the gods and the city.[137] Livy (59 BC–17 AD) attests to this, writing about the disruption of an old religious custom in the year 311 BC where Etruscan *tibicines* participate in religious ceremonies:[138]

> The flute-players, angry at having been forbidden by the last censors to hold their feast, according to old custom, in the temple of Jupiter, went off to Tibur in a body, so that there was no one in the City to pipe at sacrifices. Troubled by the religious aspect of the case, the senate dispatched representatives to the Tiburtines, requesting them to use their best endeavours to restore these men to Rome. The Tiburtines courteously undertook to do so; and sending for the pipers to their senate-house, urged them to return. When they found it impossible to persuade them, they employed a ruse, not ill-adapted to the nature of the men. On a holiday citizens invited parties of the pipers to their houses, on the pretext of celebrating the feast with music. There they plied them with wine, which people of that profession are gener-

ally greedy of, until they got them stupefied. In this condition they threw them, fast asleep, into waggons and carried them away to Rome; nor did the pipers perceive what had taken place until daylight found them — still suffering from the debauch — in the waggons, which had been left standing in the Forum. The people then flocked about them and prevailed with them to remain. They were permitted on three days in every year to roam the City in festal robes, making music and enjoying the licence that is now customary, and to such as should play at sacrifices was given again the privilege of banqueting in the temple.[139]

Fig. 12 Bronze mirror with depiction of a sacrifice by an altar. Next to the altar is a man playing the double pipes. End of 6th century BC. Museo Archeologico Nazionale, Firenze, inv. no. 646. (Museum photo).

As this brief survey clearly illustrates, Etruscan music was of great significance, both in the public and private spheres. Scenes of funerary rituals, religious acts, banquets, athletic competitions, hunting, war and domestic activities illustrate the importance of music in Etruscan culture and society.[140] Etruscan art provides us with a vast selection of musical scenes, and it is thanks to these that we can observe the use of several musical instruments, although the majority of the representations are from funerary contexts.[141] The great importance of music among the Etruscans is corroborated by the literary sources, which mention the different musical occasions. This is further supported by the attribution of the invention of bronze and brass instruments, such as the *cornu, tuba* and *lituus*, to the Etruscans.[142] However, there is wide variation in Etruscan depictions of musical scenes and the literary sources are often brief and do not offer any detailed information, which makes it difficult to draw a consistent picture of music in Etruscan life and society. As Micozzi has stated: "all that we get are glimpses into a few aspects of the rich musical reality of Etruria".[143]

Nevertheless, with regard to the choice of instruments (which might reflect the type of music), some tendencies do become clear from the evidence. Instruments for playing melodic, rhythmic music seem to have been very popular. This is expressed by the frequency of the depictions of the double pipe in particular, as well as the *kithara* and lyre, which were used for almost any occasion, from cheerful music at banquets and games (perhaps accompanied by singing) to mournful music at funerary ceremonies. The *cornu, lituus* and tuba, on the other hand, possibly functioned primarily as signalling instruments rather than for playing melodic music. They are never depicted at banquets, for example, but appear to have been used for state and religious processions, funerals, and probably for signalling attack or retreat on the battlefield, initiating events, as starting signals at games or for summoning people to assembly.[144] According to the representations in iconography, they often accompanied each other.[145] The instruments depicted can thus potentially tell us whether the sounds for the particular occasion were melodic and rhythmic, or a form of signalling or were ambience-creating sounds. We could also speculate that sounds or music played on double pipes and *kithara* would have been able to create higher/lighter tones,[146] while the metal instruments such as the *cornu* or tuba could have created lower tones. Rafanelli describes the sounds of the *cornu* as deep and gloomy, well suited for signalling in battles or hunting.[147]

Music, sounds and ancient experience

Although it might seem obvious, it is important to recognise that the performance of music today is very different from that of ancient times. As Shaw-Miller argues, "recent reproduction technologies have aspired to divorce music more literally from site (and sight), allowing the dislocation of music from its origins in production and performance. Digital technologies have made music's origin and its site of production potentially virtual."[148] Thus, the divorcing of music from accompanying visual information is historically recent. In fact, before Thomas Edison's phonograph was invented, music was never physically removed from the event that produced it.[149] Thus, we must consider that in ancient Etruria, all music was performed live and therefore impossible to fully separate from visual impressions. Furthermore, music is – and always has been, historically – more than simply sound, it is a multisensory experience that centres on sound but is not solely defined by it. This means that music is not 'pure sound', but part of a multisensual, embodied, social and situated activity.[150] This was also the case with musical performances in ancient Etruria, which were social, multisensorial events, involving communication between the performers and listeners, and usually combining sound with vision. In fact, such interactions between hearing and sight increase our ability to localize and understand physical and social events.[151] Music was most likely performed by groups of players accompanied by dancers, as is depicted in Etruscan wall paintings, for example, and not necessarily consumed passively by a stationary audience as in much modern Western culture.[152]

However, in some cases, music, or any other sound, might have been separated from sight. Unlike a static image, sound could pervade space and so reach members of large groups with an equal immediacy. For many ancient events, including religious ceremonies, funerals, and so on, sight must have often been blocked by crowds or lack of light. In such instances, sound would be a way of reaching every individual, rendering them capable of understanding the situation, whether or not they were able to visually observe the actions taking place. Furthermore, loud sounds could work in dialogue with silence to reinforce the experience of disorientation and progression in the performance of mysteries, religious processions and rituals.[153] Since sound could be heard from a distance and be visually detached from its source, it might possibly have been used to intimate the presence of divine or supernatural forces.[154] In fact, some gods were known by their

capacity for noise.[155] It has, thus, been argued that divine presence was felt as sonic.[156]

In this respect, the so-called ventriloquism effect is relevant, since it illustrates how visual information can influence auditory perception and vice versa. The ventriloquism effect is what happens when we watch a ventriloquist's performance and its creation of the illusory perception that the voice we hear is coming from the mouth of the puppet, that we see moving and so it looks as if the puppet is speaking. We know that this art of tricking people by making one's voice emanate from elsewhere was already used in Greek and Roman times by oracles,[157] and possibly also by the Etruscans who might have used sound to evoke the presence of the divine or the deceased. It has also been suggested that music was used as a means of communication between humans and the divine in ancient Etruscan society. During a sacrifice, for example, when ritual silence is imposed, only the sound of the double pipes guarantees contact with the superior being to whom the victim is dedicated.[158]

Many explanations for the ventriloquism effect have assumed that vision dominates sound and somehow captures it. But in other cases, what we hear can change what we see.[159] An example of this phenomenon is the McGurk effect, first reported by H. McGurk and J. MacDonald in 1976. The McGurk effect is a perceptual phenomenon that demonstrates an interaction between hearing and vision in speech perception. The illusion occurs when the auditory component of one sound is paired with the visual component of another, leading to the perception of a third sound. It stems from their observation that on being shown a film of a young woman's talking head, in which repeated utterances of the syllable [ba] had been dubbed on to lip movements for [ga], normal adults reported hearing the new, entirely different [da].[160] This audio-visual effect clearly demonstrated the ability of a combination of visual and auditory inputs to provide a single precept most consistent with both sources of information.[161] Thus, sound and vision have potentially a significant influence on each other. This is relevant in relation to a study of the ancient experience of Etruscan art and iconography, since the presence of certain sounds or a certain kind of music might have been able to change the observer's impression and interpretation of it.

It is a well-known fact that auditory information can have a significant neurological effect, and there is no doubt that sound, and music in par-

ticular, is capable of producing powerful reactions in the listener. Music can evoke feelings of happiness, sadness or nostalgia, or sensations of reverence/solemnity. Cognitive studies have shown that music activates different mechanisms in the brain. Particularly relevant for the present study is *visual imagery*, with the resulting emotions when a listener conjures up visual images while listening to music, and *episodic memory*, which embodies situations where an emotion is induced in a listener because the music evokes a memory of a particular event in the listener's life.[162] These findings indicate that music can potentially affect how we perceive things such as works of art. This is supported by a study from 1998 examining the effect of music on the perception of paintings. This study showed that the participants' aesthetic experience of viewing the paintings was intensified when the paintings were accompanied by music.[163] Such findings are, of course, not directly transferable to ancient Etruria, but they posit the possibility of the potentially huge effect of sound on the ancient experience of Etruscan art, in that sound could be used to structure and shape ritual observance, communication and memory, and induce desired emotional states and possibly even aesthetic responses in the audience. However, it is important to note that sound created such effects in tandem with the other senses, although sound could also operate independently in ways that vision could not, thus leaving unique impressions on social as well as religious experiences.[164] A specific example of the independent effect of sound is its use as location markers: in areas where visibility for various reasons was poor, sound could be used to mark the locations of, for example, funerals or other ceremonies.[165] In this respect, the signalling sound of a *cornu, lituus* or tuba would have been efficient. People who have visited Etruscan necropoleis, such as the Banditaccia at Cerveteri, will have noticed the difficulties in finding one's way around. The sound of a trumpet, for example, could thus have aided people in finding their way to their correct destination.

That sounds, particularly music, could have emotional or even physical effects on the listeners is attested by ancient Greek sources, which describe how music was noted for its ability to express and arouse different emotional states, or even cause madness and frenzy, particularly the sound of the double pipe (*aulos*).[166] According to Plato, musicians (flute-players) had "the power to entrance mankind by means of instruments; a thing still possible today for anyone who can pipe his tunes".[167] Plato further argues

245

that musicians, no matter how well they played, could cause ecstasy in people, leaving them in need of religious purification.[168] Aristotle describes the "power" music could have over people's emotions and behaviour: "(…) under the influence of sacred music we see these people, when they use tunes that violently arouse the soul, being thrown into a state as if they had received medicinal treatment and taken a purge; the same experience then must come also to the compassionate and the timid and the other emotional people generally in such degree as befalls each individual of these classes, and all must undergo a purgation and a pleasant feeling of relief; and similarly also the purgative melodies afford harmless delight to people".[169]

Similar effects of music are attested by the ancient author Longinus (3rd century AD), according to whom music could induce emotions in people and even drive them crazy: "The flute (*aulos*), for instance, induces certain emotions in those who hear it. It seems to carry them away and fill them with divine frenzy. It sets a particular rhythmic movement and forces them to move in rhythm."[170] The ability of music (again, especially the *aulos*) to cause divine frenzy can also, possibly, explain its regular mention in connection with Bacchic, Corybantic, and similar ecstatic cults.[171] Hippocrates tells of a man who, when he heard the sound of double pipes at symposia, was always affected with panic.[172] However, music could also have the opposite effect, of calming the listener, if it was played soberly and sweetly. Thus, based on the written sources, it appears that expert musicians (especially flute players) could provide whatever was wanted: they could appease grief, enhance joy, inflame the lover, or exalt the devout.[173] This was also the case in ancient Etruria, where music played on, for example, the double pipes could enhance the feeling of grief by playing mournful tunes at a funeral, creating joy at a banquet, or at games or for hunting, or even cause religious frenzy or profound devotion by playing in certain ways. These emotional states would obviously have had an effect on how one perceived one's surroundings, whether it was a chamber tomb, a temple, or a private home – as well as the other way round, since the surroundings could obviously also have effect on an individual's emotional state.

There is thus no doubt as to the potential significance of sound to the experience and understanding of Etruscan iconography. As an intellectual experiment, we can imagine a funerary ritual taking place in a chamber tomb in Tarquinia. The tomb would have been dimly lit by torches and

oil lamps, which would have cast shadows and made it difficult to see the wall paintings clearly. The music performed would have contributed to a certain ambience, possibly intended to evoke the presence of the divine or the deceased, and that ambience would have influenced the observer's experience and interpretation of the scenes depicted on the walls.

Conclusions and future perspectives

So why even deal with sound when studying ancient art? Because sound has an immense effect on our emotions and on how we perceive our surroundings. Sound "colours" our world, adding a dimension to our perceptual experience that none of the other four senses ever truly capture.[174] Sound (and rhythm) thus has the potential to form our experience of a situation, as well as of a specific artwork.

As this article has shown, music have played a significant part in Etruscan society. For instance, most of the Etruscan processions, rituals and banquets depicted in iconography appear to have prominently featured musical performances, transforming the spectators into listeners.[175] This implies that the Etruscans would not have viewed the depictions, such as the wall paintings, in silence, but accompanied, rather, by the sound of music.

Although the research into ancient Etruscan art and sound is still relatively new, it is already fruitful to consider its possible dissemination in museums. The way forward in museums is to approach ancient art with an openness that includes the presence of sound, rather than displaying the artefacts in ways that elucidate the auditory complexity of ancient Mediterranean cultures. This would include an assessment and evaluation of the multivalent potential of sound to affect the viewer's experience of the artworks, and the more general acknowledgement of ancient sound as a phenomenon. For instance, it could be interesting to experiment with reproductions of ancient Etruscan music in museum exhibits. It could be particularly interesting, for example, to record music played on reconstructed Etruscan instruments in original locations, such as the chamber tombs in Tarquinia, where musical performances are often depicted, which would add to the acoustic atmosphere in the exhibits. But until this is possible, we must rely on iconography, literary sources, and the preserved archaeological material.

NOTES

1 Laurence 2017, 13.
2 Melcher & Zampini 2011, 284
3 Power 2019, 19.
4 Butler & Nooter 2019, 10.
5 Hellermann & Goddard 1983.
6 https://www.newmusicusa.org/profile/bill-hellermann/
7 Cluett 2014, 114.
8 Shaw-Miller 2011, 252.
9 Melcher & Zampini 2011, 265.
10 Zubrow 2014, 7.
11 Devereux 2018, 7.
12 Eneix 2014.
13 Till 2014, 27.
14 Zubrow 2014, 7.
15 Devereux 2017, 7.
16 For the history of archaeoacoustics and sound archaeology, see Till 2014; Reznikoff 2018.
17 For example, the Hal Saflieni on Malta has been the subject of several archaeoacoustic studies; see Reznikoff 2014; Stroud 2014; 2018; Eneix 2016; 15–31. For other archaeoacoustic studies, see Eneix 2014; Eneix & Ragussa 2018.
18 Laurence 2017, 16.
19 Vincent 2017, 149.
20 D'Angour 2019, 33.
21 D'Angour 2019, 38.
22 D'Angour 2019, 34.
23 Vincent 2017, 149
24 For musical instruments on situlae, see e.g. Bermond Montanari 1999.
25 Powley 1996, 287, 293; Spitzlay 2017, 189.
26 Powley 1996, 293; Tobin 2013, 842; Li Castro 2018, 117.
27 Nor do the instruments in the iconography necessarily look as they did in real life. Tobin 2013, 841.
28 With regard to neighbouring cultures, Greece in particular provides the most comparative material, but several of the nearby cultures have distinct musical profiles, e.g. Lucania (tomb paintings from Paestum), and Magna Graecia (South Italian vases), which both contrast sharply with Etruscan usage: Lawergren 2007, 119.
29 Tobin 2013, 842.
30 Spitzlay 2017, 189.
31 Powley 1996.
32 In iconography, the *cornu* is from the 4th century BC, rendered as large circular instruments with supporting bars that also came to be a feature of the instrument during the Roman era: Micozzi 2018, 68.

33 Powley 1996, 294.
34 British Museum, London, inv. no. 1839, 1109.46.c and 1839,1109.46.d. Castaldo 2012, 23–24; Tobin 2013, 843. According to Holmes (2010), the two *cornua* in the British Museum are part of a group of fragments of U-shaped horns, including one fragmentary instrument, three mouthpiece sections and three separate mouthpieces. The group of fragments, which likely represent six instruments, appear to represent a hoard of some sort and can probably be dated to ca. 500 BC: Holmes 2010, 125–128, 136.
35 Museo Nazionale Etrusco di Villa Giulia, Rome, inv. no. 51216. Tobin 2013, 843. According to Holmes (2010, 130), when found the instrument was very fragmentary and is now heavily restored.
36 Tobin 2013, 843.
37 Museo Archeologico, Florence, inv. no. 152342. Micozzi 2018, 68. For more on the *cornu*, see Holmes 2010, 128–129; Castaldo 2012, 19–20.
38 Castaldo 2012, 23.
39 Museo Archeologico, Montelupo Fiorentino, inv. no. 114918. length: 31–35 cm. Castaldo 2012, 22–23.
40 Castaldo 2012, 20.
41 Powley 1996, 294. The *lituus* is never depicted in northern Etruria. In the rest of the Etruscan territory, the depictions of the *lituus* disappear in the middle of the 5th century but reappear in the 4th century BC in representations of the *processus magistratualis*: Micozzi 2018, 68.
42 Museo Etrusco Gregoriano, Vatican, inv. no. 12329.
43 Powley 1996, 294.
44 Museo Archeologico Nazionale di Tarquinia, inv. no. C 176/A/20.
45 Tobin 2013, 843.
46 Museo dell'Accademia Etrusca e della Città di Cortona, without inv. no.
47 Micozzi 2018, 68; Bernadini 2018, 126.
48 Bagnasco Gianni *et al.* 2017, 59.
49 Bagnasco Gianni *et al.* 2017, 59.
50 Badisches Landesmuseum Karlsruhe, inv. no. F298. Jurgeit 1999, 227–228, no. 367; Bagnasco Gianni *et al.* 2017, 59.
51 Sotheby's 1982, no. 77–78, 244. Its current whereabouts are unknown. Bagnasco Gianni *et al.* 2017, 59.
52 It has been suggested that the tuba can be identified with the *salpinx*, mentioned in numerous ancient written sources. For a

thorough study of the *salpinx*, see Holmes 2008. However, according to Castaldo 2012, 21, the term *salpinx* was generically used to refer to different metal aerophones with a straight tube.

53 Powley 1996, 296. The tuba appears to have been used in state and religious processions and at funerals and also functioned as a military signal instrument.

54 Li Castro 2018, 117.

55 Li Castro 2018, 117. In the *Tomba Golini II* at Orivieto the word "suplu" is written next to the flute player depicted in the wall painting. I thank Marjatta Nielsen for this information.

56 The pipes in *Tomba delle Leonesse* provide a curious exception: they are drawn as long, narrow lines terminating as short perpendicular finials at the far end. Lawergren 2007, 130.

57 According to Pliny the Elder (*NH* 16.60), the Etruscan double pipes played at ritual occasions (sacrifices) were made of boxwood, while the instruments played for entertaining (games) were made of lotus wood, donkey bone or silver.

"At the present day the sacrificial pipes used by the Tuscans are made of box-wood, while those employed at the games are made of the lotus, the bones of the ass, or else silver." (Translation: Bostock 1855).

58 Powley 1996, 296. For the types of double pipes (*auloi*) and the technique of playing the instrument, see Jannot 1974.

59 Powley 1996, 298. Panpipes are depicted, for example, on a situla from Certosa, Museo Civico Archeologico, Bologna, inv. no. 17169, and on the Providence situla in the Museum of Rhode Island School of Design. See Bermond Montanari 1999; Castaldo 2012, 39–43.

60 Three of them are devoid of holes. Jannot 1988, 315.

61 Lawergren 2007, 120–121.

62 Ivory plectrum from the tumulus at Montetosto, Cerveteri (7th century BC). Museo Etrusco di Villa Giulia, Rome, inv. no. 105031. *Principi Etruschi*, 244, no. 285.

63 Two ivory plectra from the tumulus at Poggio Gallinaro, Tarquinia (7th century BC). Museo Nazionale Archeologico, inv. nos. 101237, 101238. *Principi Etruschi*, 244, no. 286–287.

64 From the *Tomba di Iside*: Morandini 2011, 140. Moreover, five Etruscan plectra in bone with elaborate handles are in the Thor-

valdsen's Museum, Copenhagen, inv. nos. H3204, H3205, H3206, H3207, and H3208.

65 Morandini 2011, 139–140; Li Castro 2017, 514; Li Castro 2018, 118. Jannot (1988, 313–314, n.12) also records three ivory plectra from the Giglio shipwreck.

66 The tomb paintings mainly depict the Greek *kithara* and lyre. Powley 1996, 293.

67 Tobin 2013, 845.

68 Lawergren 2007; Tobin 2013.

69 Li Castro 2018, 118.

70 Lawergren 2007, 120.

71 *NGDMM* "Lyre", 423.

72 Lawergren 2007, 121.

73 Powley 1996, 294.

74 Lawergren 2007, 121.

75 *NGDMM* "Lyre", 422. The cylinder *kithara* was previously called the *phorminx* or cradle *kithara*.

76 Lawergren 2007, 122.

77 Lawergren 2007, 127.

78 Li Castro 2017, 516.

79 Bronze rattle, Chiusi (600–500 BC); clay rattle, Cavalupo necropolis, Vulci (ca. 700 BC). Tobin 2013, 847; Li Castro 2018, 118.

80 Morandini 2011, 142–144.

81 Museo Archeologico Nazionale, Chiusi, inv. no. 62782. Morandini 2011, 147.

82 Museo Pigorini, inv. no. 70823.

83 Maggiani 2013; Nielsen 2015, 283, n. 39.

84 Black-figure stamnos, depicting a dancing woman with *crotala*; possibly from the Vulci area and dated to ca. 500–480 BC. Ny Carlsberg Glyptotek, inv. no. H.I.N. 524.

85 Tobin 2013, 847; Li Castro 2018, 118.

86 Powley 1996, 298. Sal. Cat. 63.2.19ff.

87 Examples include three red-figure vases from Falerii, dated to ca. 350 BC: Ny Carlsberg Glyptotek inv. nos. H.I.N. 223 (stamnos), H.I.N. 224 (bell krater), H.I.N. 242 (kylix).

88 Li Castro 2018, 118.

89 Vincent 2017, 150.

90 Vincent 2017, 150–151.

91 Holmes 2010, 136.

92 D'Angour 2019, 32.

93 http://www.emaproject.eu/ The project includes ten institutions from seven countries, including the Comune di Tarquinia, and ran from 2013 to 2018. It was funded by the cultural programme of the European Commission.

94 E.g. at the Parco Regionale dell'Appia Antica, Rome in 2017.

95 http://www.emaproject.eu/events/conferences/47-audio/audio/258-lituus-from-tarquinia.html; for the XRF analysis, see Pelosi *et al.* 2018.

96 http://www.emaproject.eu/content/instruments/various-instruments.html
97 https://youtu.be/m84WJYWM9sE
98 Links in the respective notes above.
99 A brass instrument also known as a "baby-tuba" and very similar to a baritone horn.
100 Holmes 2010, 136–137.
101 Holmes 2010, 39.
102 Tobin 2013, 842.
103 Tobin 2013, 848.
104 Plut. *De cohibenda ira* 11c; Ath. *Deipn.* 12.518b.
105 Ov. *Fast.* 6.649–670. Translation: Frazer 1959.
106 Ath. *Deipn.* 12.518b. Translation: Gulick 1943.
107 Lawergren 2007, 119.
108 Castro 2017, 508.
109 Castro 2017, 508.
110 Micozzi 2018, 123.
111 Ny Carlsberg Glyptotek, inv. no. H.I.N. 81; Christiansen & Petersen 2017, cat. 16.
112 Micozzi 2018, 123.
113 Micozzi 2018, 123.
114 Ny Carlsberg Glyptotek, inv. no. H.I.N. 144 (IN 1678); Moltesen & Weber-Lehmann 1991, cat. 6–9. Bernadini 2018, 126.
115 Holliday 1990,
116 Holliday 1990, 76.
117 Museo Gregoriano Etrusco, inv. no. 14949.
118 Museum of Fine Arts, Boston, inv. no. 1975.799.
119 For dance in Etruscan banquet scenes, see Amann 2000, 155–159.
120 Velletri: Museo Archeologico Nazionale, Naples, inv. no. 21600, ca. 530 BC. Acquarossa: Museo Archeologico Nazionale, Viterbo, inv. no. C1, ca. 560–550 BC. *Principi Etruschi* 2000 162, no. 120.
121 Quint., *Inst.* 1.10.20. Translation: Butler 1920/1953.
122 British Museum, inv. no. 1865,0103.25.
123 Massa-Pairault 1993, 258–262. The scene is quite clear on the facsimile in the NCG, inv. no. H.I.N. 169 (IN 1769). Another example is the *Tomba delle Colle* in Chiusi, where a wall painting depicts a boxer striking his fist during training, accompanied by a youth playing the double pipe. Rafanelli 2013, 30.
124 Tobin 2013, 848.
125 Ath. *Deipn.* 4.154a. Translation: Gulick 1933.
126 Ael. *NA* XII.46.
127 Museo Archeologico Nazionale, Tarquinia, inv. no. RC 1042.
128 Holmes 2010, 133, fig. 35.
129 Castaldo 2012, 29.
130 Holmes 2008, 106, fig. 20.
131 Museo Capitolini, Rome, inv. no. 172. Holmes 2008, 108, fig. 25.
132 Hesychios L 834.
133 Museo Archeologico Nazionale, Florence, inv. no. 646.
134 Bernadini 2018, 126.
135 Bernadini 2018, 126.
136 The musicians were organised in *collegia tibicinum*, well known from inscriptions. E.g. *CIL* VI.3877 = VI.32448 = I.989 from the Esquiline Hill. Funerary inscriptions, dated to 100–50 BC, about members of the guild of the *tibicens* (*collegium tibicinum*) remain.
137 Bernadini 2018, 126.
138 Livy 9.30.5–10.
139 Livy, 9.30.5–10. Translation: Foster 1926.
140 Powley 1996, 293.
141 Micozzi 2018, 122.
142 Pollux 4.85; Ath. *Deipn.* 4.184a; Aesch. *Eum.* 2.567; Soph. *Aj.* 1.17. Powley 1996, 288; Rafanelli 2013, 44–45.
143 Micozzi 2018, 123.
144 Jannot 1988, 315; Powley 1996, 296.
145 The *cornu* is often depicted in use with the *lituus*: Holmes 2010, 138.
146 The later author Pollux (4.72–73) uses the adjectives "strong", "intense", "forceful", "sweet-breathed", "pure-toned", "wailing", "enticing" and "lamenting" for piping. West 1992, 105.
147 Rafanelli 2013, 44.
148 Shaw-Miller 2011, 261.
149 Melcher & Zampini 2011, 278.
150 Shaw-Miller 2011, 252; Melcher & Zampini 2011, 284.
151 Melcher & Zampini 2011, 287.
152 See also Melcher & Zampini 2011, 284.
153 Butler & Nooter 2019, 10.
154 Power 2019, 20.
155 For example, the Greek god Dionysos had the epithet *Bromios*, which personifies the god as rumbling, resonant roaring. And the goddess Artemis had the Homeric epithet *keladeine*, meaning 'resounding': Power 2019, 24.
156 Butler & Nooter 2019, 10.
157 Melcher & Zampini 2011, 267.
158 Morandini 2011, 136.
159 Melcher & Zampini 2011, 267.
160 McGurk & MacDonald 1976.
161 Melcher & Zampini 2011, 266.
162 Hansen 2013, 3.
163 Limbert & Polzella 1998.
164 Power 2019, 20.
165 Bernadini 2018, 126.

166 See e.g. West 1992, 105–106.
167 Pl. *Symp.* 215c. Translation: Lamb 1961.
168 Pl. *Symp.* 215c. West 1992, 105.
169 Arist. *Pol.* 1342a. Translation: Rackham 1944.
170 Longinus, *Subl.* 39.2. Translation: Fyfe 1995.
171 Aesch. Frag. 57; Eur. *Hel.* 1351 ("the goddess smiled, and received in her hand the deep-toned flute, pleased with its loud note"); Eur. *Bacch.* 127 ("the sweet-voiced breath of Phrygian pipes"); Men. *Theophoroumene* 27–30. West 1992, 105.

172 Hippoc. *Epid.* 5.81. West 1992, 105.
173 See e.g. Plut. *Quaest. conv.* 3.8: "as a mournful song and melancholy music at a funeral raises grief at first and forces tears, but as it continues, by little and little it takes away all dismal apprehensions and consumes our sorrows." Translation: Goodwin 1874. West 1992, 106.
174 Arnott & Alain 2014, 85.
175 Power 2019, 19.

ACKNOWLEDGEMENTS

I am very grateful to the Carlsberg Foundation for generously funding the research project *Sensing the Ancient World: The Multiple Dimensions of Ancient Art,* which facilitated this study. I am also indebted to the Ny Carlsberg Glyptotek for hosting the project. My warmest thanks are also due to the Harvard Center for Hellenic Studies for their generous support during my fellowship at the Center. I would also like to thank Nora Petersen for her insightful comments and suggestions on earlier drafts of this article. Finally, I would like to thank Annette Rathje for all her continuous support and encouragement through the years and for her infectious, dedicated passion for Etruscology.

ABBREVIATIONS

NGDMM Sadie, S. (ed.), *New Grove Dictionary of Music and Musicians,* London 1980.

BIBLIOGRAPHY

P. Amann 2000
Die Etruskerin. Geschlechterverhältnis und Stellung der Frau in frühen Etrurien (9.-5. Jh. V. Chr.). Vienna 2000.

S. R. Arnott & C. Alain 2014
A Brain Guide to Sound Galleries, in: N. Levent & A. Pascual-Leone (eds.), *The Multisensory Museum: Cross-disciplinary Perspectives on Touch, Sound, Smell, Memory, and Space,* New York 2014, 85–108.

G. Bagnasco Gianni *et al.* 2017
Tarquinia and the North: Considerations on some Archaeological Evidence of the 9th–3rd Century BC, in: M. Trefný & B. Jennings (eds.), *Inter-regional Contacts During the First Millennium BC in Europe,* Hradec Králove 2017, 46–91.

G. Bermond Montanari 1999
Gli strumenti musicali nell'arte delle situle, in: O. Paoletti (ed.), *Protostoria e storia del 'Venetorum Angulus',* Pisa-Rome 1999, 487–499.

C. Bernadini 2018
Music in Etruscan and Roman Ritual, in: De Angeli *et al.* (eds.) *Music and Sounds in Ancient Europe: Contributions from the European Music Archaeology Project,* 2018, 126–129.

M. Bonghi Jovino (ed.) 1986
Gli Etruschi di Tarquinia, Catalogo della Mostra (Milano 1986). Modena, Panini, 1986.

H. E. Butler 1920/1953
The Instituto Oratoria of Quintilian. Loeb Classical Library. London-New York 1920/1953.

S. Butler & S. Nooter (eds.) 2019
Sound and the Ancient Senses. New York 2019.

D. Castaldo 2012
Musiche dell'Italia antica. Introduzione all'archeologia musicale. Bologna 2012.

S. Cluett 2014
Ephemeral, Immersive, Invasive: Sound as Cura-

torial Theme 1966–2013, in: N. Levent & A. Pascual-Leone (eds.), *The Multisensory Museum: Cross-disciplinary Perspectives on Touch, Sound, Smell, Memory, and Space*, New York 2014, 109–118.

J. Christiansen & N. Petersen 2017
Etruria II: *Catalogue Ny Carlsberg Glyptotek.* Copenhagen 2017.

A. D'Angour 2019
Hearing Ancient Sounds Through Modern Ears, in: S. Butler & S. Nooter (eds.), *Sound and the Ancient Senses*, New York 2019, 31–43.

P. Devereux 2018
When the Ancient World Got a Soundtrack, in: L. C. Eneix (ed.), *Archaeoacoustics* III. *The Archaeology of Sound. Publication of the 2017 Conference in Portugal*, Florida 2018, 7–8.

L. C. Eneix (ed.) 2014
Archaeoacoustics: The Archaeology of Sound. Myakka 2014.

L. C. Eneix 2016
Listening for Ancient Gods: A Study of the First Monument Builders and the Archaeology of Sound. Myakka 2016.

L. C. Eneix & M. Ragussa (eds.) 2018
Archaeoacoustics III. *The Archaeology of Sound.* Myakka 2018.

J. G. Frazer 1959
Ovid's Fasti. Loeb Classical Library. London-Cambridge, Mass. 1959.

W. H. Fyfe 1995
Longinus. On the sublime. Loeb Classical Library. Cambridge, Mass: 1995.

W. W. Goodwin 1874
Plutarch's Morals. Translated from the Greek by Several Hands. Boston 1874.

C. B. Gulick 1933
Athenaeus. The Deipnosophists. Vol. II. Loeb Classical Library. London-New York, 1933.

C. B. Gulick 1943
Athenaeus. The Deipnosophists. Vol. V. Loeb Classical Library. London-New York, 1943.

N. C. Hansen 2013
Cognitive Approaches to Analysis of Emotions in Music Listening, in: M. Zatkalik, D. Collins &

M. Medic (eds.), *Histories and Narratives of Music Analysis*, Cambridge 2013, 597–627.

W. Hellerman & D. Goddard 1983
Catalogue for "Sound/Art" at The Sculpture Center, New York City, May 1–30, 1983 and BACA/DCC Gallery June 1–30, 1983.

P. J. Holliday 1990
Processional Imagery in Late Etruscan Funerary Art, *AJA* 94,1990, 73–93.

P. Holmes 2008
The Greek and Etruscan salpinx, in: A.A. Both, R. Eichmann, E. Hickmann & L.C. Koch (eds.), *Herausforderungen und Ziele der Musikarchäologie = Challenges and Objectives in Music Archaeology. Papers from the 5th Symposium of the International Study Group on Music Archaeology at the Ethnological Museum* (State Museums Berlin, 19–23 September 2006), Rahden 2008, 241–260.

P. Holmes 2010
The Lazio Toscana U-Shaped cornua in the British Museum, in: M. Carrese, E. Li Castro and M. Martinelli (eds.), *La musica in Etruria. Atti del convegno internazionale* (Tarquinia 18–20 Settembre 2009), Tarquinia 2010, 125–154.

J.-R. Jannot 1974
L'aulos étrusque, *L'Antiquité Classique* 53, 1974, 118–142.

J.-R. Jannot 1988
Musiques et musiciens étrusques, CRAI 1988, 311–334.

F. Jurgeit 1999
Die etruskischen und italischen Bronzen sowie Gegenstände aus Eisen, Blei und Leder im Badischen Landesmuseum Karlsruhe. Rome 1999.

W. R. M. Lamb 1961
Plato. Lysis – Symposium – Gorgias. Loeb Classical Library. Cambridge, Mass 1961.

R. Laurence 2017
The Sounds of the City: From Noise to Silence in Ancient Rome, in: E. Betts (ed.), *Senses of the Empire: Multisensory Approaches to Roman Culture*, London 2017, 13–22.

B. Lawergren 2007
Etruscan Musical Instruments and their Wider Context in Greece and Italy, *Etruscan Studies* 10, 2007, 119–138.

E. Li Castro 2017
Musical Instruments, in: A. Naso (ed.), *Etruscology*, Boston-Berlin 2017, 505–522.

E. Li Castro 2018
Crossroads: Musical Instruments in Etruria, in: De Angeli *et al.* (eds). *Music and Sounds in Ancient Europe: Contributions from the European Music Archaeology Project*, 2018, 117–121.

W. M. Limbert & D. J. Polzella 1998
Effects of Music on the Perception of Paintings, *Empirical Studies of the Arts* 16.1, 1998, 33–39.

A. Maggiani 2013
Crepitacula bronzei dall'Etruria, in: G. Graziadio *et al.* (eds.), *Philike synaulia. Studies in Mediterranean Archaeology for Mario Benzi* (BAR Int. Ser. 1460), Oxford 2013, 345–358.

F.-H. Massa-Pairault 1993
Aspects idéologiques des *ludi*, in: J. Thullier (ed.), *Spectacles sportifs et scéniques dans le monde étrusco-italique. Actes de la table ronde organisée par l'Equipe de recherches étrusco-italiques de l'UMR 126 (CNRS, Paris) et l'Ecole française de Rome (Rome, 3–4 mai 1991)*, Rome 1993, 247–279.

D. Melcher & M. Zampini 2011
The Sight and Sound of Music: Audiovisual Interactions in Science and the Arts, in: F. Bacci & D. Melcher (eds.), *Art and the Senses*, Oxford 2011, 265–292.

H. McGurk & J. MacDonald 1976
Hearing Lips and Seeing Voices, *Nature 264* (5588), 1976, 746–748.

M. Micozzi 2018a
Introducing the Authority: Cornua and litui in Etruria, in: De Angeli *et al.* (eds.), *Music and Sounds in Ancient Europe. Contributions from the European Music Archaeology Project*, 2018, 68–71.

M. Micozzi 2018b
Sounds for Life and Death in Etruscan Tombs, in: De Angeli *et al.* (eds.), *Music and Sounds in Ancient Europe. Contributions from the European Music Archaeology Project*, 2018, 122–125.

M. Moltesen & C. Weber-Lehmann 1991
Catalogue of The Copies of Etruscan Tomb Paintings in the Ny Carlsberg Glyptotek. Copenhagen 1991.

F. Morandini 2011
All' origine della comunicazione musicale in

Etruria, in: C. Antonetti, G. Masaro & L. Toniolo (eds.), *Comunicazione e linguaggi, Università Ca' Foscari di Venezia. Contributi della Scuola di Dottorato in Scienze Umanistiche. Indirizzo in Storia antica e Archeologia*, Padua 2011, 135–158.

M. Nielsen 2015
New Times, Old Customs, in: J. Fejfer, M. Moltesen & A. Rathje (eds.), *Tradition: Transmission of culture in the ancient world.* Acta Hyperborea 14, Copenhagen 2015, 269–299.

C. Pelosi *et al.* 2018
In Situ Investigation by X-ray Fluorescence Spectroscopy on Pian di Civita Etruscan lituus from the "monumental complex" of Tarquinia, Italy, *The European Physical Journal Plus* 133, 357.

T. Power 2019
The Sound of the Sacred, in: S. Butler & S. Nooter (eds.), *Sound and the Ancient Senses*, New York 2019, 15–30.

H. Powley 1996
The Musical Legacy of the Etruscans, in: J. F. Hall (ed.), *Etruscan Italy: Etruscan Influences on the Civilizations of Italy from Antiquity to the Modern Era*, Provo, Utah 1996, 287–303.

Principi etruschi 2000
Principi etruschi tra Mediterraneo ed Europa (exhibition catalogue Bologna). Venice 2000.

S. Rafanelli 2013
La musica perduta degli Etruschi: La parola all' archeologia, in: S. Rafanelli & S. C. Cantini (eds.), *La musica perduta degli etruschi*, Grosseto 2013, 15–46.

I. Reznikoff 2014
The Hal Saflieni Hypogeum: A Link Between Paleolithic Painted Caves and Romanesque Chapels? in: L. C. Eneix (ed.), *Archaeoacoustics: The Archaeology of Sound*, Myakka 2014, 45–50.

I. Reznikoff 2018
On Foundations of Archaeoacoustics, in: L. C: Eneix (ed.), *Archaeoacoustics* III. *The Archaeology of Sound. Publication of the 2017 Conference in Portugal*, Florida 2018, 155–166.

S. Shaw-Miller 2011
Sighting Sound: Listening with Eyes Open, in: F. Bacci & D. Melcher (eds.), *Art and the Senses*, Oxford 2011, 251–264.

H. Spitzlay 2017
Tanz und Tibiaklänge, in: *Die Etrusker. Weltkultur im antiken Italien*, Karlsruhe 2017, 189.

K. Stroud 2014
Hal Saflieni Hypogeum – Acoustic Myths and Science, in: L. C. Eneix (ed.), *Archaeoacoustics: The Archaeology of Sound*, Myakka 2014, 37–44.

K. Stroud 2018
Hal Saflieni Hypogeum: An Introduction to the Site and its Acoustics, in: L. C. Eneix & M. Ragussa (eds.), *Archaeoacoustics* III: *The Archaeology of Sound*, Myakka 2018, 191–198.

R. Till 2014
Sound Archaeology: An Interdisciplinary Perspective, in L. C. Eneix (ed.), *Archaeoacoustics: The Archaeology of Sound*, Myakka 2014, 23–32.

F. Tobin 2013
Music and Musical Instruments in Etruria, in: J. MacIntosh Turfa (ed.), *The Etruscan World*, London-New York 2013, 841–854.

A. Vincent 2017
Tuning into the Past: Methodological Perspectives in the Contextualised Study of the Sounds of Roman Antiquity, in: E. Betts (ed.), *Senses of the Empire: Multisensory Approaches to Roman Culture*, London 2017, 147–158.

M. L. West 1992
Ancient Greek Music. Oxford-New York 1992.

E. Zubrow 2014
The silence of sound: a prologue, in: L. C. Eneix (ed.), *Archaeoacoustics. The archaeology of sound. Publication of proceedings from the 2014 conference in Malta*, Myakka 2014, 7–9.

COLLEGARE MONDI
UN PARTICOLARE IMPIEGO DELLO SPAZIO TOMBALE IN PROSPETTIVA ESCATOLOGICA

MATILDE MARZULLO

Sin dai secoli delle prime scoperte, studiosi, artisti, eruditi, collezionisti di antichità, semplici visitatori, nobili personalità in cerca di fortuna, chiunque a vario titolo frequentasse le necropoli d'Etruria, si domandò fra i tanti interrogativi quali fossero le motivazioni che spinsero gli Etruschi a realizzare la famosa pinacoteca sotterranea, definita da M. Pallottino il primo capitolo della storia della pittura italiana.[1] Ancora oggi il tema è di grande attualità, ma si può dire che il dibattito corrente si sia aperto quando la critica ha cominciato ad interrogarsi sull'originalità stessa dell'arte etrusca rispetto a modelli allogeni, greci in particolare, e sul significato dei dipinti nel nuovo ambito culturale, al tempo in via di definizione. Da questo momento le interpretazioni sono state molteplici e spesso molto distanti tra loro: finalità decorativa, pietà familiare, caratteri protettivi, salvifici, religiosi, valore cultuale, mimesi di scene e luoghi reali, valore simbolico.[2]

Se in un primo tempo prevalse la spiegazione ornamentale, legata all'interpretazione della tomba come dimora del defunto, nel corso del tempo si fece sempre più strada l'ipotesi che i monumenti, almeno in età arcaica, potessero rappresentare il luogo dove avveniva il passaggio tra la vita e la morte.[3] Calati in tale contesto, i dipinti assumerebbero valore ideologico, completando lo spazio tombale con numerosi significati allusivi.

Ci si potrebbe dunque domandare in che modo la realtà pittorica fosse permeata di siffatte accezioni: se si possa cioè pensare che tutte le rappresentazioni, indipendentemente dal tema e dalla soglia cronologica, possedessero un significato simbolico, o se sia credibile che alcune di queste abbiano dei fini esclusivamente decorativi. Naturalmente se si vuole procedere in questo tipo di indagine, bisogna tenere conto che si tratta di produzioni specifiche pensate per l'ambiente funerario, create appositamente per tale destinazione, e per questo la loro ragion d'essere non può che andare ricercata all'interno del medesimo contesto e serie testimoniale.[4] Per questo

una via praticabile parrebbe dunque quella di seguire le variazioni delle caratteristiche degli ipogei per cogliere i cambiamenti che interessarono le tradizioni funebri degli Etruschi dal VII al I secolo a.C., e tentare in questo modo di comprenderne usi, costumi e credenze. Spesso, infatti, la particolarità dei soggetti raffigurati non risiede soltanto nell'antichità della comparsa, ma anche nella durata dell'attestazione, che in alcuni casi copre un arco temporale di numerosi secoli.

Per quel che concerne l'atteggiamento della committenza e degli artisti riguardo alle scelte compositive non solo pittoriche ma anche architettoniche, legate al rito della sepoltura, risulta ormai assodato come le diverse città d'Etruria si comportino in maniera differente nel trattamento riservato ai propri defunti, denotando contemporanee, stratificate e distinte ideologie escatologiche: sostanzialmente una per ciascuna di esse.[5] Se infatti si analizza il periodo in cui in Etruria compaiono i primi esempi di pittura parietale funeraria, è possibile osservare come sin da subito il distretto che farà della tomba dipinta il proprio emblema si differenzi in maniera sostanziale dagli altri.[6] Mentre in altre città si sviluppano tumuli di grandi proporzioni che raccolgono al proprio interno numerose tombe a camera a più vani, a Tarquinia si costruiscono camere singole di piccole dimensioni, apparentemente senza articolazioni planimetriche particolari, posizionate al di sotto di una ristretta e singola calotta.[7] Per questo la recente analisi integrale della pittura funeraria, confluita nei due volumi della *collana Tarchna* (*Grotte Cornetane* 2016 e *Spazi Sepolti* 2017), si dedica in maniera sistematica alle caratteristiche del centro che fra gli altri si distinse per il noto fenomeno, indagandone le radici e le specifiche accezioni.

A Tarquinia quasi tutte le tombe dipinte sono camere ipogee scavate a varia profondità nella roccia, oggi identificabili solo in rari casi da un basso accumulo di terreno, residuo dell'originario tumulo sommitale. Il paesaggio odierno è dunque ben diverso da quello che ancora resisteva agli inizi dell'Ottocento, quando dalla superficie del terreno della necropoli si stagliavano più di seicento tumuli anche in buono stato di conservazione.[8] Le ripetute arature succedutesi negli ultimi decenni hanno via via cancellato i resti di questo monumentale paesaggio, da cui prende il nome la necropoli e il moderno toponimo. Le formazioni, una volta spianate, hanno ricondotto nell'oblio molte delle tombe ad esse legate e pertanto oggi non è possibile conoscere esattamente il numero degli ipogei dipinti

scoperti a Tarquinia, né in alcuni casi l'ubicazione di monumenti anche molto noti, pubblicati nel corso del tempo. Attraverso il sistematico esame dei materiali che l'insieme delle indagini pregresse ci ha lasciato e di ciò che è attualmente osservabile nella necropoli, la ricerca edita in *Grotte Cornetane* è arrivata ad identificare circa cinquecento possibili ipogei dipinti,[9] estendendo notevolmente il numero delle attestazioni finora conosciute. Se infatti si tiene presente l'intero campione di tombe inventariate dalla Soprintendenza, il numero degli esempi dipinti passa dal 4% registrato nel 2006, all'8% rilevato nel 2016. Ciò permette di individuare circa 1 committente ogni 12 tombe e fornire interessanti risvolti statistici sulla loro distribuzione nell'evoluzione cronologica.[10]

Lo studio fornisce inoltre gli strumenti critici che permettono di analizzare le tombe dipinte come monumenti, ovvero come strutture complete di tutti gli aspetti compositivi, pittorici, architettonici e di corredo che le contraddistinguono. Sino ad ora, infatti, la pittura parietale è stata studiata sistematicamente soltanto per quanto concerne lo stile delle figurazioni, ma riguardo ai significati alcune posizioni della critica hanno riscontrato come il senso e la resa di molte di esse possa variare a seconda della collocazione all'interno dello spazio.[11] Questa teoria è stata dimostrata per singole tombe e per ristretti nuclei di monumenti, tuttavia finora non era ancora stato avviato uno studio che si proponesse di vagliarla in maniera sistematica per ampi contesti, al fine di testarne l'effettiva validità. Se infatti pittura e architettura fossero parte di un progetto unitario, comprendere i significati legati alle singole partizioni spaziali permetterebbe di gettare luce sul valore di temi ed iconografie lì collocati. Allo tempo stesso pervenire ai concetti legati alle pitture consentirebbe di cogliere eventuali concezioni che potevano governare l'aspetto delle singole partizioni, dando forma agli spazi.

L'analisi sistematica condotta in *Grotte Cornetane* 2016 ha dunque considerato gli aspetti che riguardano il contesto, gli studi pregressi, l'architettura, la pittura, gli elementi distintivi, le possibili osservazioni, i confronti, proponendo una nuova cronologia sulla base di tutti questi dati. Viene inoltre fornita una riproduzione schematica di ciascun ipogeo. Quest'ultima risulta di particolare rilevanza nel permettere il confronto fra elementi diagnostici in tombe dai livelli di conservazione profondamente differenti o note soltanto mediante fotografie scolorite o disegni parziali. Oltre a questo viene fornito un ricco apparato illustrativo attraverso cui vagliare le fonti grafiche sopravvissute, recuperando informazioni concernenti la

storia del monumento, dei restauri e dettagli pittorici o architettonici altrimenti sconosciuti.

L'insieme racchiude anche il patrimonio delle fotografie e degli appunti custoditi negli archivi della Fondazione Ing. C.M. Lerici, che in circa trent'anni di attività ha rilevato con innovativi metodi geofisici più di 6100 tombe nella sola necropoli dei Monterozzi. Purtroppo soltanto un ristretto numero di queste venne effettivamente indagato archeologicamente: la maggior parte delle formazioni sepolte venne documenta attraverso concisi rapporti di ciò che era osservabile tramite un periscopio calato nel vano e attraverso scatti fotografici in bianco e nero presi dalla sua estremità. Finora questo materiale è rimasto sostanzialmente inedito, anche se in molti casi costituisce l'unica fonte di informazione per ipogei dipinti altrimenti del tutto ignoti. Per questo si è scelto di pubblicarlo integralmente, ricostruendo le attribuzioni delle descrizioni alle varie tombe e tutte le sequenze degli scatti fotografici.

Al fine di comprendere le possibili accezioni espresse dal rapporto fra pittura e architettura sono state appositamente studiate specifiche applicazioni multimediali che permettono l'osservazione dinamica degli ambienti ricostruiti virtualmente, risultando particolarmente adatte a vagliare gli effetti percettivi che il monumento completo dei particolari pittorici e architettonici poteva suscitare. La risorsa multimediale, infatti, agevola l'esame di ogni superficie che compone lo spazio, consente di ingrandirne i dettagli e di osservare da prospettive diverse i dipinti all'interno del loro contesto di riferimento. Le applicazioni permettono inoltre di sovrapporre alle fotografie della tomba nell'attuale stato di conservazione le riproduzioni storiche, per poter controllare dettagli e impressioni visive altrimenti difficilmente recuperabili.

Questo insieme di dati e strumenti costituisce la base e il caposaldo per la ricerca dedicata alle scelte e alle motivazioni della formazione e dello sviluppo specifico delle tombe dipinte in questo distretto, edita nel successivo volume della collana Tarchna: *Spazi Sepolti e Dimensioni Dipinte* 2017.

Come si è detto, l'indagine muove dall'ipotesi che se pittura e architettura fossero concepite in combinazione reciproca, identificare i significati dell'una permetterebbe di trasporli anche all'altra. In tale ottica conoscere i valori legati alle partizioni architettoniche consentirebbe di gettare luce sul senso di temi ed iconografie ad esse associati e d'altro canto cogliere il

Tombe dell'Età del Ferro

700-550 700-530 700-550 610-575

630-500 510-425 350-300

Fig. 1 Evoluzione schematica delle architetture funebri tarquiniesi: il momento e la forma architettonica in cui compare la pittura sono posti in evidenza con un rettangolo. (Elaborazione dell'Autrice).

significato delle pitture permetterebbe di comprendere i concetti legati alla progettazione degli spazi.

Si è così deciso di agire dapprincipio in maniera separata e sistematica per le due categorie al fine di osservare le variazioni, anche minime, della pittura e dell'architettura nel corso del tempo. Ciò deriva dalla constatazione che nel momento della comparsa della pittura funeraria a Tarquinia essa si dispone su forme architettoniche già da tempo note e utilizzate (**Fig. 1**), dimostrando che la tomba dipinta non si impone come una novità assoluta in campo funerario nella seconda metà del VII secolo a.C., ma risulta una graduale acquisizione. È dunque verosimile che i valori legati alla forma degli ipogei non abbiano subito particolari variazioni con l'introduzione della pittura e pertanto, nel voler comprendere il significato di quest'ultima,

risulti più vantaggioso partire dalle motivazioni delle forme su cui essa si distribuisce.

Aspetti dell'Architettura

Sintetizzando la situazione tarquiniese partendo dall'epoca protostorica,[12] vediamo per prime le tombe a pozzetto utilizzate per la cremazione, seguite verso la fine dell'VIII secolo a.C. dalle tombe a fossa, legate all'introduzione dell'inumazione. Queste si evolvono in fosse raggiungibili sul lato corto attraverso gradini incavati nella roccia, che talvolta sono provviste di una breve risega, simile ad un ulteriore gradino sul fondo del vano, posizionato dalla parte opposta della scalinata e utilizzato come cuscino per sostenere la testa del defunto. Tali strutture dimostrano come il concetto di tomba a camera ipogea con *dromos* percorribile e letti funebri disposti nel senso della lunghezza del vano possa essere collocato già alla fine dell'VIII secolo a.C., ben lungi dall'apparizione delle prime forme di pittura.

Siffatta configurazione subisce importanti perfezionamenti all'inizio del VII secolo a.C., quando compare la cosiddetta tomba 'a fenditura', specifica dell'ambito tarquiniese e caratterizzante sia le tombe principesche, sia gli esempi non monumentali.[13] Si tratta ancora di una camera solo in parte scavata nella roccia, con una lunga apertura rettangolare sulla sommità del soffitto disposta nel senso della lunghezza: dalla porta d'ingresso alla parete di fondo del vano. Inizialmente l'apertura era lasciata aperta e non doveva essere utilizzata per la deposizione del corpo, data la contemporanea presenza del *dromos* a gradini. Il varco probabilmente veniva chiuso contestualmente alla realizzazione del tumulo, mediante lastre mobili di bianca pietra locale o grigio nenfro.

Si può dunque immaginare che la fenditura, lungi dall'essere un espediente meramente funzionale, esprimesse un valore cultuale legato al collegamento con il superno, in continuità con i precedenti villanoviani e in maniera non dissimile dal ruolo svolto da finestrelle e altre aperture lasciate libere sulla sommità delle urne a capanna, riscontrate anche in questo distretto.[14]

Contemporaneamente alle tombe 'a fenditura' si sviluppano le tombe a camera completamente ipogee, realizzate per una durata più lunga con il soffitto a volta e per un più breve tempo con il doppio spiovente unito centralmente.[15] Queste sono le forme architettoniche su cui si dispone per la prima volta la componente pittorica, composta a questa soglia crono-

logica da linee rettilinee variamente combinate fra loro e di cui si dirà in seguito.

Sullo scorcio del VII secolo viene invece realizzato il *columen* incavato alla sommità del doppio spiovente,[16] caratteristica apparentemente insolita se avvicinata ai contemporanei soffitti degli edifici dei vivi, a quest'epoca costruiti attraverso travature lignee e opere di carpenteria. Tuttavia, come osservato da G. Colonna, se si tiene presente il precedente della tomba 'a fenditura', si può facilmente intendere che attraverso questo espediente si volesse mantenere vivo il contatto della camera ipogea con la superficie del terreno.[17] È dunque possibile che nelle successive tombe a doppio spiovente con *columen* piano, l'idea di contatto con il cielo non sia stata mai definitivamente abbandonata nella progettazione degli spazi. Di conseguenza si può ritenere che anche le tombe con il *columen* a rilievo abbiano mantenuto a lungo il riferimento alla dimensione celeste: decorazioni pittoriche simili al sole e alle stelle, rappresentati al centro dei soffitti di questa tipologia, sembrano infatti supportare tale evenienza.[18]

A Tarquinia il *columen* centrale a rilievo compare alla fine del VI secolo,[19] mostrando ora per la prima volta una correlazione meno dubbia tra ipogeo ed edifici costruibili fuori terra. Ciò dimostra ancora una volta la profonda differenza rispetto ad altre città, dove tale caratteristica è attestata già dalla prima apparizione delle tombe a camera all'inizio del VII secolo a.C., insieme a cassettonati dipinti ed altre opere imitanti la carpenteria lignea dei soffitti.[20] Questo chiaramente rivela come in altri distretti l'architettura funebre sia immediatamente e intrinsecamente legata alle contemporanee case dei vivi, mentre a Tarquinia siffatta relazione non divenga mai così esplicita: come si è visto il *columen* a rilievo viene realizzato soltanto in un momento avanzato dell'età arcaica, mentre il soffitto piano e gli altri elementi che rimandano con maggiore certezza alle abitazioni appariranno soltanto nel periodo ellenistico.[21]

Aspetti della Pittura

All'interno di questo lento processo trovano posto le caratteristiche pittoriche: anch'esse naturalmente possiedono una propria seriazione e possono essere raggruppate in grandi temi iconografici.[22] Fra questi soltanto il caso della decorazione lineare permette di seguirne gli sviluppi in diacronia, per un arco di tempo nettamente superiore a qualsiasi altro: essa infatti è la prima iconografia a comparire nelle tombe orientalizzanti e l'ultima a venire

abbandonata in epoca ellenistica.[23] Spesso ritenuta marginale perché poco significativa dal punto di vista stilistico, tale rappresentazione sembra in realtà la più emblematica nel panorama locale, dovendo la peculiare importanza proprio alla lunga durata, che copre ininterrottamente un arco di vita di circa sette secoli. È dunque verosimile che i significati ad essa affidati fossero intrinsecamente legati alla natura della tomba e che permangano a connotarne le superfici anche quando tutto il resto del programma figurativo doveva essere considerato accessorio.

È stato sin da subito notato che l'insieme delle linee sembra alludere a costruzioni lignee edificate fuori terra, quali ad esempio parti strutturali di capanne per l'epoca orientalizzante, di edifici in pietra, *pisé* e mattoni crudi per i periodi successivi, sino alle grandi aule dei palazzi aristocratici nell'età ellenistica. Tuttavia, se si esaminano tali riproduzioni dal punto di vista strutturale nella combinazione dei vari elementi portanti, si può osservare che a differenza di altri centri etruschi, a Tarquinia esse non danno quasi mai vita a edifici staticamente efficienti.[24] Se si combinano tali considerazioni con quanto appena menzionato riguardo alla tardiva apparizione del *columen* a rilievo e degli altri elementi architettonici che rimandano più da vicino alle architetture dei vivi, risulta chiaro che né per i committenti, né per i progettisti tarquiniesi fosse di primaria necessità l'allusione agli interni delle case o degli altri edifici realizzabili fuori terra.

Il problema cronologico e lo sviluppo dei sistemi compositivi delle tombe dipinte tarquiniesi

Oltre agli aspetti sin qui menzionati, il confronto fra architettura e decorazione pittorica lineare ha permesso di affrontare il problema delle cronologie, da sempre aperto e ancora oggi molto attuale nella storia degli studi. Come è noto, le diverse posizioni della critica stentano a trovare un accordo condiviso, data l'ampiezza dell'intervallo in cui possono essere datati gli ipogei se si considerano gli aspetti stilistici.[25] Comparando invece associazioni ricorrenti di decorazioni pittoriche lineari con le forme architettoniche delle strutture, ci si può svincolare dal problema stilistico e arrivare a definire in maniera più precisa i margini cronologici dei monumenti, compresi i casi privi di figurazioni ma comunque recanti esempi di pitture altrimenti poco diagnostici.[26]

Avendo così definito con sufficiente precisione i termini temporali di circa cinquecento monumenti, si è per la prima volta osservato in manie-

ra integrale lo sviluppo dei sistemi compositivi delle tombe dipinte. Da qui si è potuto procedere nel tentativo di ricostruire l'idea alla base della progettazione degli ambienti, dall'origine fino all'Ellenismo, analizzando i contenuti e gli effetti del messaggio visivo affidato di volta in volta agli elementi che compongono gli spazi. Risulta così che sin dall'inizio lo spazio funerario della tomba era costituito secondo due principali criteri strettamente interconnessi.

Il primo principio è rappresentato dalla traiettoria orizzontale. La forma stessa degli ipogei sembra suggerirne la messa in pratica dagli albori, quando ancora le superfici spoglie delle pareti non mostravano tracce di pittura e il concetto di tomba a camera era ancora in via di definizione. A tal riguardo un primo dato è offerto dalla disposizione dei materiali accessori, dei corredi, delle banchine e successivamente dei loculi in tombe a camera già formate. Sin dal periodo orientalizzante, infatti, la loro sistemazione in tombe "a fenditura" o in fosse con gradini e cuscino, suggerisce che lo spazio utilizzato dai vivi per i riti e le offerte si trovasse presso l'ingresso dell'ambiente, mentre ciò che concerneva più strettamente il defunto, compresa la sua deposizione, si collocasse verso la parte più interna del vano.[27] Anche la frequente conformazione trapezoidale della pianta, con il lato corto verso la porta d'entrata e quello lungo coincidente con la parete di fondo della camera, enfatizza il senso di profondità, indirizzando lo sguardo verso quest'ultima e ampliandone la prospettiva grazie alla consapevole applicazione del punto di fuga.

Con l'introduzione della pittura sul finire del VII secolo a.C. tale ragionata, costante disposizione e dunque presumibilmente anche i significati ad essa associati, non cambiano, vengono semplicemente meglio esplicitati attraverso il nuovo mezzo espressivo, che si dimostra quindi piegato fin da subito agli scopi ideologici e cultuali della sepoltura.

Fra i primi temi iconografici introdotti a decorazione non solo dei frontoni ma anche delle pareti degli ipogei, il caso del banchetto può essere utile per approfondire il ruolo delle pitture nei confronti di questo primo aspetto compositivo.

È stato infatti da tempo notato che la scena viene introdotta nella tomba già sostanzialmente definita e mai in combinazione alla finta porta dipinta, altro soggetto estremamente in voga nella iniziale pittura funeraria tarquiniese.[28] In altre parole tra i contemporanei temi iconografici la scelta

si pone sempre tra banchetto e finta porta. La motivazione è stata chiarita da B. d'Agostino e M. Torelli: il banchetto è creduto svolgersi in un altro luogo e in un altro tempo rispetto al punto e al momento in cui l'anima del defunto varcherà la soglia del regno dei Beati.[29] Nello scenario escatologico estremamente simbolico di età arcaica non si possono dunque rappresentare contestualmente e siffatta interpretazione, scaturita dalla posizione dei dipinti in rapporto all'architettura, permette di scorgere con chiarezza l'idea psicagogica di transizione orizzontale che spetta al defunto nel momento del seppellimento. Se proviamo infatti ad immaginare con tale ottica quali potessero essere le ultime azioni della cerimonia funebre, possiamo figurare che a seguito dei funerali e dei riti in suo onore, il corpo venisse condotto all'interno della camera e così facendo egli abbandonasse, col discendere le scale del *dromos*, il conosciuto, caldo e solare mondo dei vivi, per entrare nelle oscure, fredde e buie profondità della terra. Qui la salma e l'insieme di persone che la trasportavano si trovavano a varcare la soglia della camera tombale, un luogo liminale ed eccezionale, in cui ambiti apparentemente distanti e intoccabili potevano entrare in reciproco contatto.[30] A questo punto infatti le strade si dividevano: i vivi, una volta depositati gli oggetti di corredo e compiuti gli ultimi rituali, sarebbero ritornati al loro mondo attraverso la scalinata; i defunti, invece, grazie agli atti di *pietas* loro rivolti e alla perfetta predisposizione della sepoltura, avrebbero potuto procedere nel viaggio orizzontale, varcando la finta porta e raggiungendo così l'eterno banchetto dei Beati, creduto al di là di essa.

L'analisi sistematica della posizione dei personaggi recumbenti sulle superfici degli ipogei, osservata in diacronia grazie alla riconsiderazione delle cronologie delle tombe, ha permesso di seguire l'evoluzione di tale concezione nel corso del tempo, approfondendo con ulteriori dettagli quanto esposto finora.[31] La definizione delle caratteristiche e dei termini temporali di circa quattrocento ipogei sicuramente dipinti, realizzata in *Grotte Cornetane* 2016 e *Spazi Sepolti* 2017, ha infatti consentito di osservare come la scena si distribuisca all'interno di un quadro più completo di monumenti, nel tempo, nello spazio e in rapporto agli altri soggetti iconografici.

Lo studio ha dimostrato in primo luogo l'insieme di elementi consolidati nella semantica dell'immagine del banchetto nelle tombe dipinte di Tarquinia e il loro significato in associazione.[32] Si sono inoltre rilevati i legami con gli altri temi e con l'architettura, individuando quale sia la partizione

privilegiata per questa scena nei differenti periodi storici e ponendo in evidenza il momento di massima attestazione per ogni singola partizione.[33]

Avendo in questo modo circoscritto il ruolo della riproduzione del banchetto nel panorama locale, è oggi possibile affrontare in maniera sistematica il rapporto con la finta porta per capire in che modo i criteri ad essi legati si trasformino, così come si modifica la loro presenza e disposizione. L'analisi dei dati (**Fig. 2**), conferma che con il passaggio tra l'età arcaica e quella classica l'iconografia della porta viene lentamente abbandonata in favore di una più regolare presenza del banchetto, pressoché esclusiva già dal primo quarto del V secolo a.C. Ciò dimostra come la credenza funeraria alla base di queste rappresentazioni si evolva, finché la seconda finisce per prevalere sulla prima. In termini ideologici si passa dunque dal considerare la tomba da luogo di passaggio tra due mondi distinti, a luogo in cui il regno dei Beati è già raggiunto. Ora infatti la parte interna della porta d'ingresso alla camera funeraria diventa l'altro lato della finta porta dipinta, precedentemente riprodotta sulla parete di fondo della stanza, come ha efficacemente dimostrato G. Colonna per la tomba della Nave.[34] In questo rinnovato scenario escatologico allestito e messo in pratica, quasi come in una performance teatrale nello spazio sepolcrale, defunti e astanti sono così già proiettati nel sereno ed eterno mondo dei Beati.

In linea con siffatta interpretazione i dati proposti (**Fig. 2**) mostrano che la scena di banchetto passa dall'essere prevalentemente riprodotta sulla parete di fondo della camera, come direzione e meta auspicata dell'estremo viaggio, ad occupare anche le pareti laterali, in un pervasivo e rassicurante abbraccio, comprendente sia i defunti, sia gli osservatori.[35]

Dal punto di vista cronologico il tempismo di tali mutamenti non sembra casuale, ma agganciato e di pari passo alle grandi trasformazioni della ceramografia di ambito greco, dove è stato ampiamente dimostrato che la transizione e tra figure nere e figure rosse segni il passaggio da una concezione arcaica personale, specifica, diretta e per così dire monodirezionale, a quella maggiormente partecipativa e socializzante di epoca classica.[36] In questo contesto, infatti, si passa dall'osservare ieratiche figure nere poste generalmente di profilo come isolati attori nel proprio mondo, a vasi dove le figure rosse sono disposte in modo da coinvolgere maggiormente lo spettatore, rendendolo pienamente partecipe delle scene illustrate.[37] Allo stesso modo nelle pitture parietali tarquiniesi si può notare il passaggio da una concezione rettilinea e unidirezionale del viaggio verso l'Aldilà di epoca

265

arcaica, alla rappresentazione pervasiva dello stesso in epoca classica, dove i personaggi raffigurati sulle pareti, i defunti e i convenuti svolgono il medesimo ruolo di interpreti e protagonisti della rappresentazione.

Se in ambito greco ciò è stato spiegato come un riflesso del processo di democratizzazione, in cui l'uomo passa da essere spettatore ad attore del proprio destino, è indubbio che anche in Etruria si cerchi un maggiore coinvolgimento e forse addirittura un maggiore controllo sull'esito dell'estremo viaggio, ponendo lo spazio della tomba e il suo contenuto fisicamente già nel mondo dei Beati. Non si può peraltro escludere che ciò avvenga anche grazie ad una sempre maggiore adesione delle élites locali alle dottrine misteriche, che garantivano ai propri iniziati eterna e certa salvezza nella nuova condizione.[38]

A tal riguardo l'ubicazione delle spoglie e degli arredi mobili e immobili nella tomba contribuisce ad arricchire con ulteriori dati il panorama sin qui delineato. Se si considera infatti la disposizione delle banchine e dei letti funebri ci si accorge che questi passano dalla collocazione lungo le pareti laterali della camera, dalla porta verso la parete di fondo, alla posizione tricliniare con ripartizione anche lungo gli altri setti.[39] Mentre in epoca arcaica gli arredi occupano esclusivamente la metà interna del vano e, in combinazione con i corredi, suggeriscono che la testa del defunto fosse sistematicamente posizionata in direzione dell'agognato Aldilà rappresentato dalla parete di fondo, col trascorrere del tempo tali strutture si dispongono lungo tutte le superfici disponibili e dimostrano che le teste dei defunti sono ora costantemente posizionate secondo una direzione circolare oraria che asseconda sia l'idea dei convenuti a banchetto, sia la ciclicità e l'inalterabilità dell'eterno.[40] Tali trasformazioni giungono all'apice in periodo ellenistico, quando intere genealogie di defunti contenuti in "pseudo-sarcofagi" sono disposti a banchetto in spazi funerari simili a sontuose sale di palazzi aristocratici. In questo rinnovato contesto, l'antica concezione spaziale non viene tuttavia completamente abbandonata, bensì ritirata nella dimensione più privata del sarcofago, che si corredo efficacemente di significati alludenti al transito finale, anche se monumenti impostati secondo il primigenio schema di interpretazione degli spazi non cesseranno mai di essere realizzati.[41]

Il secondo principio rispettato sin dagli albori nella composizione degli interni delle tombe è la traiettoria verticale. A tal proposito si può riscon-

Nome (datazione)	Δ	f/e	s	f	d
Pisciarello 4 (630-620)					
Lerici 2202 (630-580)					
Lerici 3 (630-575)					
Lerici 6188 (620-575)					
Lerici 12 (620-575)					
Marchese 114 (630-550)					
Capanna (600-580)					
Lerici 6120 (600-580)					
Labrouste (575-550)					
Leoni di Giada (575-550)					
Porte e Felini (580-530)					
Topolino (560-530)	Δ	f / e			
Lerici 5039 (550-540)	Δ	f			
Olimpiadi (550-530)	Δ	f / e			
Bartoccini (550-530)	Δ	f			
Coroncine (550-530)	Δ	f			
Lerici 3098 (550-530)				f	d
Auguri (530)					
Caccia e Pesca (530)	Δ	f / e			
Tarantola (attorno 530)	Δ	f			
Lerici 1999 (attorno 530)				f	
Lerici 4780 (attorno 530)	Δ	f			
Leonesse (attorno 530)			s	f	d
Iscrizioni I (530-520)	Δ	/ e			
Lerici 1000 (530-500)			s		
Frontoncino (530-500)	Δ	f / e			
Maestro Olimpiadi (530-500)				f	
Vasi Dipinti (530-500)				f	
Vecchio (530-500)			s	f	d
Biclinio // **Biclinio (530-500)**			s		d
Cardarelli (510-490)					
Fustigazione (510-490)					
Porta di Bronzo (510-500)					
Citaredo (attorno 500)					
Fiorellini (attorno 500)				f	
Lerici 4813 (attorno 500)				f	
Lerici 3988 (attorno 500)	Δ	f	s	f	d
Bighe (500-490)	Δ	f / e		f	
Teschio (510-480)					
Lerici 4255 (510-480)					
Leopardi (480-475)				f	
Letto Funebre (475-460)			s	f	d
Maggi (475-450)				f	
Triclinio (475)	Δ	f		f	
Lerici 4021 (attorno 475)	Δ	/ e			
Lerici 3697 (475-450)				f	
Lerici 4260 (470-450)	Δ	f		f	
Scrofa Nera (460)			s	f	d
Caccia al Cervo (460-450)				f	
Lerici 6071 (460-450)				f	
Querciola I (460-450)				f	d
Lerici 5513 (attorno 450)				f	
Guerriero (attorno 450)				f	
Nave (attorno 450)	Δ	f / e		f	d
Gallo (450-440)					d
Lerici 5517 (450-425)	Δ	f			
Bertazzoni (425-400)				loculi (f, d)	
Demoni Azzurri (430-420)				f	
Pulcella (440-420)			s		d
Lerici 808 (circa 425)			s		
Pigmei (circa 425)				f	
Lerici 1200 (attorno 400)	Δ	f			
Orco I (circa 375)				loculo (f), d	
Scudi (circa 350)				f	d
Orco II-III (350-325)				parete sud	

Fig. 2 Disposizione dei temi iconografici della finta porta dorica e del banchetto nelle pareti delle tombe dipinte di Tarquinia presentate in ordine cronologico: il corsivo indica la finta porta dorica dipinta nella parete frontale, il grassetto gli ipogei in cui il banchetto è rappresentato sulle pareti. Il triangolo nella seconda colonna individua le tombe in cui il banchetto è rappresentato nei frontoni, seguito nella terza colonna dalle lettere che indicano in quale dei due si trova: fondo (f), entrata (e). Nell'ultima colonna invece sono menzionate le pareti su cui si dispongono i personaggi recumbenti o parte della scena di banchetto: sinistra (s), fondo (f), destra (d). (Elaborazione dell'Autrice).

trare come la forma stessa degli spazi suggerisca la precisa intenzione di considerare il monumento come tramite con la superficie del terreno sin dalle prime embrionali attestazioni di tomba a camera, molto prima dell'introduzione delle pitture. Il caso precedentemente affrontato della tomba "a fenditura", ad esempio, pone in evidenza che la parte sommitale della tomba arcaica aveva recepito, assimilandoli, i significati che qualificavano il passaggio verso il superno espressi dalla caratteristica apertura di fase orientalizzante, a sua volta dipendente da precedenti villanoviani.

In questo senso la scena del banchetto può essere ancora una volta utile per approfondirne alcuni aspetti, illustrandone accezioni e valori simbolici. Anche in questo caso l'analisi (**Fig. 2**) conferma quanto già da tempo osservato, ovvero che le prime attestazioni si collocano quasi esclusivamente nello spazio frontonale. Tuttavia l'esame consente ulteriori precisazioni: come è stato spesso notato la scena si trova frequentemente nel frontone frontale, anche se in realtà i dati mostrano che possiede una buona attestazione anche nel frontone d'ingresso. Rispetto a quanto osservato precedentemente riguardo alla disposizione del tema sulle pareti, ciò significa che il suo valore vive indipendentemente dalla collocazione nella parte più interna della tomba e al contempo che i significati di quest'ultima partizione in relazione all'Aldilà possono essere traslati anche alla porzione sommitale degli spazi, rappresentata per l'appunto dai frontoni. Si può dunque credere che tali partizioni, al pari della parete di fondo, proprio per la posizione e il significato del banchetto possano essere considerate come superfici privilegiate per esprimere il felice raggiungimento dell'Aldilà. Tale accezione naturalmente si aggiunge ai riconosciuti valori legati alla sfera del sacro e dell'eroico,[42] specificando con maggiore vigore la forte relazione con la sfera celeste, da sempre connaturata a questi spazi.[43]

Nell'ottica della traiettoria con cui poteva avvenire il viaggio del defunto risultano pertanto estremamente indicative le tombe in cui sono rappresentati contestualmente sia la finta porta dorica sulla parete di fondo, sia il banchetto in uno o entrambi i frontoni (**Fig. 2**). Tali monumenti costituiscono infatti l'esempio più manifesto dell'esistenza delle due direttrici e della loro perfetta, reciproca, indissolubile compenetrazione nell'impianto narrativo, che rende vano poter o dover scegliere fra l'una o l'altra soluzione. Lo spazio appare piegarsi all'applicazione di tali principi e con esso il tempo, dimostrando la contemporanea capacità dell'anima di viaggiare sia in senso orizzontale attraverso la porta, sia in verticale attraverso il ban-

chetto, superando tutte le soglie che separano mondo sensibile da quello ipersensibile. Per questo non è certamente una coincidenza la forma del peculiare sostegno architettonico posto al centro del frontone di numerosi ipogei: esso rimanda direttamente a quella di un altare, la struttura in grado di porre in connessione le profondità della terra, con la superficie e con il cielo.[44]

Tali osservazioni, unite a quanto riscontrato riguardo alla posizione araldica delle figurazioni nei frontoni e alla decorazione policroma di molti dei soffitti delle tombe tarquiniesi,[45] paiono indicare la perfetta immissione del valore di passaggio connaturato alla porzione sommitale delle architetture nel messaggio allusivo globale, integrato e specificato attraverso ulteriori accezioni provenienti dalla pittura, ascrivibili all'ambito sacrale.

Passando così alla composizione della tomba nella sua interezza, si più riscontrare costantemente l'applicazione dei due principi: il primo, in senso orizzontale, collega il mondo dei vivi a quello dei Beati, il secondo, in senso verticale, connette le profondità della terra con il cielo. Esaminandone più nel dettaglio le caratteristiche, grazie alle pitture, alle forme stesse degli ipogei e agli altri elementi d'arredo e corredo, come ad esempio banchine e oggetti appesi alle pareti,[46] è possibile notare che possiedono ciascuno tre suddivisioni interne, che corrispondono alle tappe del viaggio attraverso i diversi piani dell'esistenza per il mondo etrusco: il mondo ctonio, quello terrestre e quello celeste; la separazione, la transizione e la reintegrazione in un rito di passaggio secondo il pensiero antropologico formalizzato da A. van Gennep e V. Turner.[47]

Per quanto riguarda il senso orizzontale, numerosi sono gli elementi che nelle tombe consentono di riconoscere un primo spazio ancora in contatto con il mondo dei vivi, seguito da un livello intermedio che corrisponde all'abbandono da parte del defunto del mondo conosciuto, sino all'ultimo livello identificato dal raggiungimento di una nuova condizione nel mondo dei Beati. F. Roncalli, in un significativo articolo uscito quasi vent'anni fa in questa stessa sede, dedica ampio spazio alla ricostruzione della componente spaziale di tali passaggi, decodificando la sceneggiatura dell'impianto narrativo della tomba dei Demoni Azzurri di Tarquinia, insieme a quella di altri oggetti funerari di diversa tipologia e cronologia, quali sarcofagi e urne, non necessariamente tarquiniesi.[48] Per certi versi essa si dimostra sostanzialmente analoga in numerose serie testimoniali: un viaggio che

procede unidirezionalmente dal noto verso l'ignoto, attraverso una scansione di pause e cesure del testo narrativo che, a partire dalla zona dell'ingresso, valorizzano le nozioni complementari di varco, tragitto, partenza e arrivo.

L'analisi delle costanti compositive delle tombe tarquiniesi permette oggi di dimostrare la lunga durata e la sistematicità di questi intenti[49], aggiungendovi anche la componente verticale. Quest'ultima, oltre che attraverso le caratteristiche più sopra menzionate, è resa particolarmente esplicita dall'ordine prospettico di rappresentazione delle figure, che procede regolarmente dal basso verso l'alto, allontanandosi via via dal punto di vista dell'osservatore.[50] Si può notare anche un'altra costante: i temi iconografici della parte inferiore delle pareti rimandano sempre al mondo ctonio, come ad esempio le onde del mare o la rossa campitura dell'*oinops pontos*;[51] invece ciò che è presente nella partizione mediana si riferisce al mondo sensibile e alla vita sulla terra; infine le iconografie poste in alto sui frontoni richiamano la sfera liminale, i confini del mondo conosciuto, come nel caso di pantere e leoni, o il sereno raggiungimento dell'Aldilà, come le scene di banchetto di cui si è detto.

Chiaramente tali soggetti si caricano anche di significati ulteriori dovuti alle associazioni reciproche, secondo un codice espressivo stratificato, condiviso, consapevole e perfettamente comprensibile dalla comunità. Nell'ottica del viaggio, ad esempio, i feroci felini in posizione araldica al fianco del sostegno-altare, tra le varie componenti rimandano anche al sacrificio senza il quale l'anima del defunto difficilmente avrebbe potuto raggiungere la direzione sperata, il banchetto la visione edonistica del raggiungimento della medesima meta, ottenuta a seguito del periglioso tragitto, simile per la sua alienazione alla condizione dell'ebbro.[52]

Per concludere, la tomba 5513 può essere utile per riprendere gli aspetti sin qui citati, esplicitando con particolare chiarezza le caratteristiche delle due traiettorie (**Fig. 3**). Quella orizzontale è comprovata dalla forma della pianta con il posizionamento degli arredi funebri, in questo caso del loculo pavimentale nella parte interna della tomba, e dall'iconografia del banchetto, anticipato lungo le pareti laterali dalle scene della sua preparazione. La traiettoria verticale è invece attestata dalle onde marine ricorrenti all'interno della fossa nel pavimento, facilmente riconducibili al mondo ctonio-infero, separate mediante una serie di fasce dalla parte centrale, dove sono rappresentate scene di vita tratte dal mondo sensibile. Infine, un'altra serie

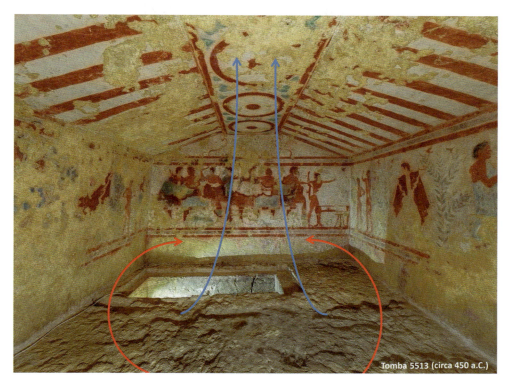

Fig. 3 Tomba Lerici 5513 con indicazione delle due simultanee direttrici di lettura degli spazi, corrispondenti alle possibili e contemporanee direzioni del viaggio verso l'Aldilà. (Elaborazione dell'Autrice).

di fasce divide questa ambientazione dalla sfera celeste, rappresentata dalle foglie di vite e dai simboli solari, significativamente posti al centro del *columen*, nella parte più alta dell'ambiente.

Anche in periodo ellenistico, quando gli ipogei mostreranno con maggiore evidenza i riferimenti alle contemporanee case dei vivi, figure come quella del Charun nella tomba Lerici 5636, continueranno ad enfatizzare la connessione tra cielo e terra, tra il pavimento della tomba e la sommità, grazie al posizionamento sulla superficie del pilastro, l'elemento architettonico che più di ogni altro è destinato ad esprimere tale valore. Allo stesso tempo il supporto consente un particolare effetto visivo, dimostran-

271

do ancora una volta la grande coerenza nella progettazione dell'insieme: sfruttando la superficie prominente dell'architettura, sagomata appositamente per valorizzarne la forma, il demone accompagnatore acquista una notevole plasticità, quasi fisica, e pare così muoversi davvero all'interno della camera funeraria, nel tentativo di condurre i defunti-sarcofagi nel loro ultimo, estremo viaggio.

La ricorrenza di queste attestazioni in ogni tomba dipinta tarquiniese mostra l'accuratezza della progettazione, che procede sempre dalla parete d'ingresso dell'ipogeo verso la parte più interna e contemporaneamente dal basso verso l'alto, attraverso scansioni dello spazio spesso enfatizzate dalla decorazione pittorica lineare. Come si è detto, l'insieme di queste evidenze, avvalorate dalla costante e lunghissima attestazione coincide perfettamente con la concezione dello spazio consacrato, delle sue suddivisioni interne e degli elementi che permettevano di connetterne le varie parti. In quest'ottica è pertanto lecito intravvedere in ogni ipogeo tarquiniese, indipendentemente dalla più o meno ricca decorazione pittorica, un *templum sub terra*, dove il mondo sotterraneo, terreste e celeste entravano in comunicazione, per offrire alle anime dei defunti un sereno passaggio verso l'Aldilà.[53]

La tomba dunque, poiché anzitutto luogo immaginato, può coincidere o meno con la realtà sensibile e di conseguenza gli elementi architettonici e gli altri soggetti evocati tramite pittura possono sì essere giudicati allusivi a elementi concreti, ma devono caricarsi anche di significati confacenti al ruolo che svolgono all'interno dello spazio sacro, assumendo valore ideologico e non soltanto di mimesi. L'insieme delle componenti di pittura e architettura creano così un'unica e singolare condizione pluridimensionale, in cui risulta impossibile distinguere ciò che era ritenuto avvenire nel tempo, da ciò che era creduto accadere nello spazio, proiettando l'intera composizione in una dimensione allusiva globale, perfettamente coerente a livello ontologico.

NOTE

1 Pallottino 1952, 7. Sulla "riscoperta" degli Etruschi v. da ultimo Delpino 2017, con rimandi.

2 Sui diversi aspetti che contraddistinguono la storia degli studi della pittura etrusca, v. *Spazi Sepolti* 2017, 7–27.

3 Numerosi e pionieristici sono i lavori dedicati da B. d'Agostino al significato simbolico dell'iconografia tombale, raccolti oggi per la maggior parte in d'Agostino & Cerchiai 1999. Per altri punti di vista, che in maniera complementare ritorneranno nelle pagine

a seguire, v. Roncalli 1990; Torelli 1997; Roncalli 2001; Torelli 2002, 56–60; Colonna 2003.

4 A lungo si sono cercate spiegazioni attraverso i confronti con altre categorie di oggetti, fra cui solo per citarne alcuni, la pittura vascolare, i cippi chiusini, le lastre architettoniche a matrice, altri monumenti funerari, senza che si potesse agire in maniera sistematica e estrarre modelli interpretativi validi per ampi contesti. Su queste problematiche e per le serie citate v. ad esempio Weber-Lehmann 1985, 19–21, 32; de La Genière 1987, 207–208; Stopponi 1983, 61–62; d'Agostino 1991; Naso 1996a, 425–432. Da ciò deriva la consapevolezza che la spiegazione non può che provenire dal dato in sé, dalla somma delle sue caratteristiche valutate nella loro evoluzione storica e nel proprio contesto di produzione, così come a suo tempo sostenuto da M. Pallottino (Pallottino 1937, 327–329). Su questi temi in rapporto al confronto tra pittura e architettura: *Spazi Sepolti* 2017, 14–31.

5 Data la vastità della materia sarebbe difficile accennare in maniere puntuale alle caratteristiche che differenziano i rituali funebri delle numerose metropoli etrusche, che sin dall'epoca villanoviana hanno dimostrato credenze, rituali, suppellettili e usanze distinte (v. ad esempio quanto osservato da Maggiani 1997, 431). Per il caso dell'architettura funebre, ad esempio, si può richiamare il recente convegno dedicato ai tumuli e alla forma esteriore delle sepolture (*AnnFaina* 2015), che dimostra come ogni distretto elabori forme specifiche a seconda della propria ideologia.

6 Si pensi ad esempio alle differenze fra ipogei dipinti di periodo orientalizzante di differenti centri, quali ad esempio Vaccareccia a Veio, Mengarelli a Cerveteri o Pantere a Tarquinia in termini di scala, planimetria, numero di vani e significato ad essi affidato. Sulle tombe della Vaccareccia e Mengarelli, v. Naso 1996a, 19–21, 29–30. Per la tomba delle Pantere: M. Cataldi, in *Pittura Etrusca a Villa Giulia* 1989, 121–123.

7 Sugli aspetti legati alla progettazione dei tumuli in Etruria, v. in particolare Naso 1996b, 71–85.

8 Westphal 1830, 37; Dennis 1848, 301–303.

9 Grazie all'esito positivo delle ricerche e delle metodologie impiegate per la realizzazione della Carta Archeologica della Civita Tarquinia (v. Marzullo 2018, 18–19) nel quadro del CRC "Progetto Tarquinia" è stata recentemente avviata un'indagine preliminare volta al riposizionamento topografico delle cinquecento tombe dipinte, grazie alle possibilità offerte dai nuovi mezzi di rilievo e di analisi territoriale, impiegati in combinazione a l'analisi storica di materiali bibliografici e d'archivio (su questo v. Marzullo c.s.)

10 Sull'approfondimento di questi temi v. *Spazi Sepolti* 2017, 143–144. È bene ricordare che nel trattare questi dati è necessaria cautela, dato che è impossibile conoscere con esattezza l'intero numero di tombe esistenti, o anche solo di quelle ad oggi scoperte, visti gli innumerevoli scavi più o meno regolamentati che si sono succeduti nel corso dei secoli.

11 V. ad esempio d'Agostino 1991; Torelli 1997; Roncalli 2001; Torelli 2012.

12 Per l'approfondimento delle tipologie che verranno qui di seguito menzionate, v. *Spazi Sepolti* 2017, 80–94 .

13 Per approfondimenti sulla tipologia, v. *Spazi Sepolti* 2017, 61, 81–84.

14 Sulle caratteristiche delle urne a capanna tarquiniesi, v. Bartoloni *et alii* 1987, 57–62, e per il rapporto con le successive tombe a camera *Spazi Sepolti* 2017, 180–181, 191–193; Marzullo c.s.

15 Per approfondimenti sulle tipologie, v. *Spazi Sepolti* 2017, 62–64, 84–86.

16 Sulla tipologia v. *Spazi Sepolti* 2017, 65, 85–86.

17 Colonna 1984, 387.

18 *Spazi Sepolti* 2017, 197–198.

19 Sulla tipologia v. *Spazi Sepolti* 2017, 67–70, 86–88.

20 V. ad esempio Cerveteri, dove sin dagli esempi orientalizzanti, come ad esempio le tombe Campana 1 o del Nuovo Recinto della Banditaccia, è attestata la contemporanea presenza di soffitti evocanti cassettoni, capriate lignee, travi di colmo e travicelli laterali, coperture con l'incannucciata, tetti a padiglione. Per le caratteristiche architettoniche di queste tombe: Naso 1996a, 29–38.

21 Ad esempio le elaborate carpenterie lignee realizzate tramite scultura nelle tombe degli Scudi o dell'Orco I e II, oppure quelle riprodotte tramite pittura nella tomba dei Festoni. Sul rapporto della pittura con la resa dei soffitti v. Harari 2010; *Grotte Cornetane* 2016, 128–129; *Spazi Sepolti* 2017, 91–94, 134–135.

22 *Spazi Sepolti* 2017, 113–131.

23 *Spazi Sepolti* 2017, 131–135.

24 *Spazi Sepolti* 2017, 163–176.

25 I casi emblematici delle tombe tardoclassiche-ellenistiche dimostrano che dal punto di vista dello stile i medesimi ipogei possono

essere datati anche con cento anni di differenza senza che vi siano elementi dirimenti in favore dell'una o dell'altra opzione. M. Torelli ha infatti efficacemente dimostrato che differenti stilemi venivano adottati nella stessa tomba a seconda dei concetti e messaggi espressi dal programma figurativo e non in base alla soglia cronologica (Torelli 2012). Su questi temi: *Spazi Sepolti* 2017, 8–13.

26 *Spazi Sepolti* 2017, 135–139.

27 Per approfondimenti: *Spazi Sepolti* 2017, 158–159.

28 Il tema del banchetto è un argomento estremamente dibattuto nell'ambito della pittura funeraria etrusca. Per gli aspetti qui trattati si vedano in particolare: Stopponi 1983, 42–65; Weber-Lehmann 1985; Roncalli 1990; d'Agostino 1991; Torelli 1997; Roncalli 2001; Weber-Lehmann 2001; Colonna 2003; Fiorini 2007; Cerchiai & Menichetti 2017, 10–11.

29 Su questi aspetti v. in particolare d'Agostino 1983, 10–11; d'Agostino 1991; Torelli 1997. Da questo punto di vista la tomba del Biclinio sembra costituire un *unicum*, in quanto mostra contestualmente la finta porta sulla parete frontale e personaggi sdraiati a banchetto lungo le pareti laterali. Tuttavia, come è risaputo, la tomba è conosciuta soltanto attraverso le riproduzioni di F. Smuglewicz, che non sempre si dimostrano pienamente aderenti al vero (v. ad esempio Dobrowolski 1978; De Marinis 1961, 97; Weber-Lehmann 2001, 31–32). Pertanto, in attesa di ulteriori dati che possano comprovare l'affidabilità delle soluzioni iconografiche rappresentate, al momento l'esempio non sembra costituire un ostacolo a questo tipo di interpretazione.

30 Anche in questo caso i saggi volti ad esplicitare la condizione liminale del corpo appena defunto e della tomba, a metà tra la vita e la morte, sono molteplici. Per una rassegna delle posizioni in rapporto alla questione tarquiniese si rimanda in particolare agli articoli citati alla nota precedente a cui si aggiungono, per i temi qui proposti: Roncalli 2001 e Fiorini 2007.

31 Marzullo 2016.

32 Marzullo 2016, 88–109.

33 Marzullo 2016, in particolare 98–102.

34 Colonna 2003, 71.

35 Su questi aspetti osservati da differenti punti di vista, v. Marzullo 2016, in particolare 103–104 con riferimenti.

36 Su questi temi, legati alla pittura funeraria etrusca v. ad esempio Pallottino 1952, 16–18; Stopponi 1983, 81–94.

37 V. da ultimo in questo senso Osborne 2018, in particolare 116–120, 227 con rimandi.

38 Il tema dei culti misterici leggibile in filigrana attraverso le scelte stilistiche e iconografiche della pittura tarquiniese è da lungo tempo oggetto di approfondimenti. Tra i molti lavori dedicati a questo argomento si vedano in particolare: Cerchiai 1987; Roncalli 1990; Colonna 1991; Colonna 1996; d'Agostino 1999; Massa-Pairault 2001; Pizzirani 2010, 47–52; Harari 2012; Cerchiai 2014.

39 Per maggiori approfondimenti per la base di dati che consente tali valutazioni, v. Marzullo 2016, 103–109.

40 Marzullo 2016, 109.

41 L'allusione al viaggio del defunto intravisibile nella decorazione di sarcofagi e urne funerarie di epoca ellenistica sono state significativamente dimostrate per alcune serie di esempi da F. Roncalli e da G. Bagnasco Gianni (Roncalli 2001, Bagnasco Gianni 2009). Ulteriori aspetti in rapporto all'architettura funebre tarquiniese sono approfonditi in *Spazi Sepolti* 2017, 92–94, 192–193.

42 In particolare sulle tombe tarquiniesi: Cerchiai 1987; Torelli 1997, 63–65.

43 Sulla storia delle interpretazioni e sul ruolo simbolico della partizione del frontone nelle tombe tarquiniesi: *Spazi Sepolti* 2017, 155, 198 con rimandi.

44 Sin da lungo tempo si è discusso della possibilità che questo sostegno rimandi alle forme e alla funzione di un altare, per una rassegna delle differenti posizioni, v. *Spazi Sepolti* 2017, 20–22, 180–181.

45 *Spazi Sepolti* 2017, 170–174, 178–183, 196.

46 Per questi dati cfr. *Spazi Sepolti* 2017, 105–112, 155–163.

47 Van Gennep 1909; Turner 1969.

48 Roncalli 2001, 249–267.

49 *Spazi Sepolti* 2017, 195–202.

50 Per questo aspetto v. in particolare *Spazi Sepolti* 2017, 176–178.

51 Sull'interpretazione del mare come alterità nella percezione arcaica e sul suo rapporto con lo stato indotto dall'eccessivo consumo del vino, v. in particolare d'Agostino 1999, ripreso con ulteriori punti di vista riguardo a questi temi in Pizzirani 2010, 261–262.

52 Come il caso del banchetto, di cui si è già dato conto a nota 29, anche i felini affrontati possiedono una storia delle interpretazioni lunga e articolata secondo molti punti di vista. Per gli aspetti legati al sacrificio v. Roncalli 1990, 234–237; Dobrowolski 1997, 135; Maggiani 1997, 442–444.

53 *Spazi Sepolti* 2017, 195–212.

RIFERIMENTI BIBLIOGRAFICI

AnnFaina 2015
G.M. Dalla Fina (a cura di), La delimitazione
dello spazio funerario in Italia dalla Protostoria
all'età arcaica. Recinti, circoli, tumuli, in: *Annali
della Fondazione per il Museo «Claudio Faina»*
22, 2015.

G. Bagnasco Gianni 2009
Un ossuario fittile a campana del Museo Archeo-
logico di Milano, in: S. Bruni (a cura di), *Etruria
e Italia preromana. Studi in onore di Giovannan-
gelo Camporeale*, Pisa-Roma 2009, 45–54.

Bartoloni *et al.* 1987
G. Bartoloni – F. Buranelli – V. D'Atri – A. De
Santis, *Le urne a capanna rinvenute in Italia*,
Roma. 1987.

L. Cerchiai 1987
Sulle Tombe del Tuffatore e della Caccia e della
Pesca. Proposta di lettura iconologica, *DialArch*
5, 1987, 113–123.

L. Cerchiai 2014
Il dionisismo nell'immaginario funebre degli
Etruschi, in: G. Sassatelli – A. Russo Tagliente
(a cura di), *Il viaggio oltre la vita: gli Etruschi e
l'Aldilà tra capolavori e realtà virtuale*, Catalogo
della Mostra (Bologna, Ottobre 2014 – Febbraio
2015), Bologna 2014, 37–44.

L. Cerchiai & M. Menichetti 2017
La messa in scena della morte nell'immaginario
della pittura tombale tarquiniese di età arcaica,
in: M. Giuman – M.P. Castiglioni – R. Car-
boni (a cura di), *Hagnos, Miasma e Katharsis.
Viaggio tra le categorie del puro e dell'impuro
nell'immaginario del mondo antico*, Atti del
Convegno Internazionale di Studi in onore
di Simonetta Angiolillo (Cagliari, 4–6 mag-
gio 2016), **OTIVM**. Archeologia e Cultura del
Mondo Antico 3, 2017, 1–20.

G. Colonna 1984
Per una cronologia della pittura etrusca di età
ellenistica, *DialArch* III, 2, Atti del Convegno
di Acqua Sparta, 1984.

G. Colonna 1991
Riflessioni sul dionisismo in Etruria. Appendice:
Le tombe tarquiniesi dei Camna, in: F. Berti (a
cura di), *Dionysos mito e mistero*, Atti del Con-
vegno Internazionale (Comacchio 3–5 novembre
1989), Ferrara 1991, 117–151.

G. Colonna 1996
Il dokanon, il culto dei Dioscuri e gli aspetti
ellenizzanti della religione dei morti nell'Etruria
tardo-arcaica, in: L. Bacchielli – M. Bonanno
Aravantinos (a cura di), *Scritti di antichità in
memoria di Sandro Stucchi*, 2. La Tripolitania.
L'Italia e l'Occidente, Roma 1996, 165–184.

G. Colonna 2003
Osservazioni sulla Tomba Tarquiniese della
Nave, in: A. Minetti (a cura di), *Pittura etrusca:
Problemi e Prospettive*, Atti del Convegno (Sarte-
ano, 26–27 ottobre 2001), Sarteano 2003, 63–77.

B. d'Agostino 1983
L'immagine, la pittura e la tomba nell'Etruria
arcaica, *Prospettiva* 32 1983, 37–52.

B. d'Agostino 1991
Dal palazzo alla tomba. Percorsi della imagerie
etrusca arcaica, *ArchCl* 43, 1991, 223–235.

B. d'Agostino 1999
Oinops pontos. Il mare come alterità nella perce-
zione arcaica, *MEFRA* 111(1), 1999, pp. 107–117

B. d'Agostino & L. Cerchiai 1999
*Il mare, la morte, l'amore. Gli Etruschi, i Greci e
l'immagine*. Roma 1999.

J. de La Geniére 1987
Rituali funebri e produzione di vasi, in: M.
Bonghi Jovino – C. Chiaramonte Trerè (a cura
di), *Tarquinia: ricerche, scavi e prospettive*, Atti del
Convegno internazionale di studi La Lombardia
per gli Etruschi, Milano, 24–25 giugno 1986,
Milano, 1987, 203–208.

S. De Marinis 1961
La tipologia del banchetto nell'arte etrusca arcaica,
Studia archeologica 1, Roma, 1961.

F. Delpino 2017
La "riscoperta" degli Etruschi e dei loro monu-
menti in età leonina, in: I. Fiumi Sermattei – R.
Regoli – M.P. Sette (a cura di), *Antico, Conser-
vazione e Restauro a Roma nell'Età di Leone XII*,
Quaderni del Consiglio Regionale delle Marche
235 (2017), 175–191.

G. Dennis 1848
The Cities and Cemeteries of Etruria. London
1848.

W. Dobrowolski 1978
The drawings of etruscan tombs by Smuglewicz and his cooperation with J. Byres, *Bulletin du Musée National de Varsavie* 19, 1978, 97–119.

W. Dobrowolski 1997
La Tomba della Mercareccia e i problemi connessi, *StEtr* 63, 1997, 123–148.

L. Fiorini 2007
Immaginario della tomba, retaggi arcaici e soluzioni ellenistiche nella pittura funeraria di Tarquinia, *Ostraka* 16.1, 2007, 131–147.

Grotte Cornetane 2016
M. Marzullo, *Grotte Cornetane: Materiali e apparato critico per lo studio delle tombe dipinte di Tarquinia*, Tarchna suppl. 6, Milano 2016.

M. Harari 2010
La tomba dei Festoni di Tarquinia e alcuni problemi di pittura greca tardo classica, in: M. Dalla Riva – H. Di Giuseppe (a cura di), *Meetings between Cultures in the Ancient Mediterranean*, XVII International AIAC Congress (Roma 2008), Bollettino di Archeologia Online, 2010, 56–77.

M. Harari 2012
Orco III, in: G. Bagnasco Gianni – C. Chiaramonte Trerè – F. Chiesa (a cura di), *Interpretando l'antico: scritti di archeologia offerti a Maria Bonghi Jovino*, Quaderni di ACME 134, 2012, 287–308.

A. Maggiani 1997
Réflexions sur la religion étrusque "primitive": de d'èpoque villanovienne à l'époque arcaique, in: F. Gaultier – D. Briquel (a cura di), *Les Étrusques, les plus religieux des hommes. Etat de la recherche sur la religion étrusque*, Actes du colloque International (Paris, 17 – 19 novembre 1992), Paris 1997, 431–458.

M. Marzullo 2016
Il bicchiere dell'Addio. Banchetto e spazio funerario a Tarquinia, in: C. Gianni Ardic (a cura di), *Il banchetto simbolico. Feste, simposi e baccanali tra rituali antichi e anacronismi moderni*, Jouvence Filosofia 13, Milano 2016, 81–110.

M. Marzullo 2018
Tarquinia. L'abitato e le sue mura: indagini di topografia storica, Tarchna suppl. 8, Milano, 2018.

M. Marzullo c.s.
Pittura funeraria etrusca: un'indagine tra realtà e rappresentazione, *Atti del XIV Congresso dell'Association Internationale pour la Peinture Murale Antique (AIPMA)* (Napoli 9–13 settembre 2019), c.s.

F.-H. Massa-Pairault 2001
La tombe des Leonnes à Tarquinia. Emporion, cultes et société, *StEtr* 64, 2001, 43–70.

A. Naso 1996a
Architetture dipinte. Decorazioni parietali non figurate nelle tombe a camera dell'Etruria Meridionale (VII-V sec. a. C.), Bibliotheca Archaeologica 18, Roma 1996.

A. Naso 1996b
Osservazioni sull'origine dei tumuli monumentali nell'Italia centrale, *Opuscola Romana* XX, 1996, 69–85.

R. Osborne 2018
The Transformation of Athens: Painted Pottery and the Creation of Classical Greece. Princeton 2018.

M. Pallottino 1937
Tarquinia, *Monumenti antichi pubblicati per cura della R. Accademia Nazionale dei Lincei*, XXXVI, 1937.

M. Pallottino 1952
La peinture étrusque. Genève 1952.

Pittura Etrusca a Villa Giulia 1989
M.A. Rizzo (a cura di), *Pittura etrusca al Museo di Villa Giulia*. Roma 1989.

C. Pizzirani 2010
Identità iconografiche tra Dioniso e Ade in Etruria, *Hesperìa* 26 (2010), 47–69.

F. Roncalli 1990
La definizione pittorica dello spazio tombale nella età della crisi, in: *Crise et transformation des sociétés archaïques de l'Italie antique au Ve siècle av. J.-C.* Actes de la table ronde organisée par l'Ecole française de Rome et l'Unité de recherches étrusco-italiques associée au CNRS (UA1132) (Roma, 19–21 novembre 1987), Roma 1990, 229–243.

F. Roncalli 2001
Spazio reale e luogo simbolico: alcune soluzioni nell'arte funeraria etrusca, *Acta Hyperborea* 8, 2001, 249–272.

Spazi sepolti 2017
M. Marzullo, *Spazi sepolti e dimensioni dipinte nelle tombe etrusche di Tarquinia*, Tarchna suppl. 7, Milano 2017.

S. Stopponi 1983
S. Stopponi, *La Tomba della Scrofa Nera*, Materiali del Museo Archeologico Nazionale di Tarquinia, 8, Roma 1983.

M. Torelli 1997
Limina Averni, realtà e rappresentazione nella pittura tarquiniese arcaica, *Ostraka* 1997, 1, 63–86.

M. Torelli 2002
Ideologia e paesaggi della morte in Etruria tra arcaismo ed età ellenistica, in: I. Colpo – I. Favaretto – F. Ghedini (a cura di), *Iconografia 2001. Studi sull'immagine*, Atti del Convegno (Padova, 30 maggio-1 giugno 2001), Roma 2002, 45–61.

M. Torelli 2012
L'esigenza della chiarezza. La pittura etrusca tardo-classica ed ellenistica e le conquiste pittoriche greche, in: M. Harari – S. Paltinieri (a cura di), *Segni e Colore. Dialoghi sulla pittura tardoclassica ed ellenistica*, Atti del Convegno (Pavia, 9–10 marzo 2012), Roma 2012, 9–26.

V. Turner 1969
The Ritual Process: Structure and Anti-Structure. New York 1969.

A. Van Gennep 1909
I riti di passaggio. Torino 1981 (1 ed. 1909).

C. Weber-Lehmann 1985
Spätarchaische Gelagebilder in Tarquinia, *RM* 92, 1985, 19–44.

C. Weber-Lehmann 2001
Zur Ausstattung etruskischer Klinengelage: Ergebnisse historischer und moderner Dokumentationen der Grabmalerei Tarquinias, in: A. Barbet (ed.), *La peinture funéraire antique, IVe siècle av. J-C. – IVe siècle ap. J-C.*, Actes du VIIe colloque de l'Association internationale pour la peinture murale antique (St-Romain-en-Gal – Vienne, 6–10 octobre 1998), Paris 2001, 29–37.

H. Westphal 1830
Topografia dei contorni di Tarquinia e Vulci, *AnnInst* 1830, 12–41.

LEICHENSPIELE AUF DEM MAGISTRATENSARKOPHAG AUS DER TOMBA DEI SARCOFAGI IN CERVETERI?

LAURA NAZIM

Der Magistratensarkophag, der Mitte des 19. Jhs. zusammen mit drei anderen Sarkophagen aus Travertin in der Tomba dei Sarcofagi in der Banditaccia Nekropole in Cerveteri entdeckt wurde, zählt wohl zu den bekanntesten der so genannten jüngeretruskischen Steinsarkophage.[1] Zum einen, weil in dieser Nekropole ansonsten keine Steinsarkophage dieser Zeitstellung vorkommen. Der Fund gleich mehrerer Exemplare in einem Grab war also keineswegs zu erwarten. Zum anderen, weil die Reliefs und die Figur auf dem Deckel in einem eigenartigen, archaisierenden Stil gearbeitet sind, der bis heute keine Parallelen hat. Dies führt bis in die jüngste Zeit immer wieder zu Kontroversen, Diskussionen um seine Datierung und folglich auch um die Datierung des Grabes, in dem er gefunden wurde.[2]

Dagegen waren Lesung und Interpretation der Reliefs, die sich auf eine Langseite und eine Stirnseite beschränken, nicht umstritten: Es handele sich um die *pompa funebris* eines verstorbenen Magistraten, der von seiner vorverstorbenen Frau ins Jenseits geleitet werde. Der Magistrat, den man mit der Figur auf dem Deckel gleichsetzt, habe vielleicht eine Priesterfunktion innegehabt, wie der *liber linteus* neben seinem Kopfpolster und sein reicher Schmuck wahrscheinlich machten. Die Schmalseite stelle dabei die „Vorhut" mit weiteren Musikern und Tänzern dar, die „das rituelle Ambiente der Prozession definieren".[3] Diese Vorstellung von der Reise eines Beamten in die Unterwelt, die von Tanz und Musik begleitet wird, kann heute wohl als die *communis opinio* bezeichnet werden.[4]

Dennoch dürfte eine genaue Revision der Darstellungen und ihrer Einzelheiten nach der in den 1990er Jahren erfolgten umfassenden Reinigung und Restaurierung des Stückes angebracht sein:[5]

Auf der Langseite des Kastens sieht man neun Figuren, die sich gleich-

mäßig von links nach rechts bewegen. Angeführt wird dieser Zug von einem Paar aus einem Cornu- und einem Lituusbläser, gefolgt von einem Mann mit einem Schlaufenstab, der sich zu den ihm folgenden Figuren umwendet.[6] Diese sind zwei weitere Musikanten, ein Kithara- und ein Aulosspieler, die im Gleichschritt zu gehen scheinen. Ihnen folgt ein Paar aus Mann und Frau, die durch ihre Gesten eng verbunden sind: Die Frau wendet sich zurück und blickt dem Mann in die Augen; sie hat ihre Rechte auf seine Schulter gelegt, mit der Linken zieht sie in dem bekannten Hochzeitsgestus den Mantel zu ihrem Gesicht empor. Der bärtige Mann hält in seiner Rechten einen Stab, die Linke ist in die Hüfte gestützt. Ein Knabe folgt ihm mit einer geschulterten *sella curulis*; die Reihe beschließt eine Biga mit einem Wagenlenker[7] (**Abb. 1**).

Die dem Aufzug vorausgehende Szenerie auf der rechten Schmalseite wird von zwei Männern im Himation gerahmt, der rechte mit Kithara. In der Mitte dazwischen bewegen sich zwei nackte Jünglinge nach rechts. Aufgrund der Beschädigung durch Grabräuber, die den Kasten an der linken oberen Ecke der Schmalseite aufgebrochen haben, sind von der Figur ganz links nur noch der Kopf, der Unterkörper und die Beine zu sehen.[8]

Abb. 1 Beamtenaufzug. Magistratensarkophag aus der Tomba dei Sarcofagi in Cerveteri, 360–325 v. Chr. Vatikan, Museo Gregoriano Etrusco Inv. 14949. (Photo © Governatorato SCV – Direzione dei Musei).

Die Arme sowie der Gegenstand, den der Mann einst gehalten hatte, sind nicht mehr erhalten. Die beiden Jünglinge in der Mitte bewegen sich im Gleichschritt, indem sie mit dem jeweils linken Bein auf dem Boden stehen, das rechte jedoch leicht angewinkelt haben, so dass es nur noch mit den Zehenspitzen den Grund berührt, wie am Beginn eines Tanzschrittes. Dabei hat der linke seine linke Hand auf die Schulter des Vordermannes gelegt (**Abb. 2**). Alle Musiker, das Ehepaar und der Rechte der beiden nackten Jünglinge sind bekränzt, der zweite Jüngling, der Sellaträger, der Bigafahrer und der Mann mit dem Schlaufenstab nicht.

Dass ein Beamtenaufzug und tanzende Jünglinge miteinander nicht wirklich in thematischem Einklang stehen, ist zwar in der Vergangen-

Abb. 2 Musikant(en) und ‚Tänzer'. Magistratensarkophag aus Cerveteri (Schmalseite). (Photo © Governatorato SCV – Direzione dei Musei).

heit schon bemerkt, jedoch nie weiter vertieft worden. Nur Massa-Pairault hat vorgeschlagen, die Darstellung der Schmalseite unabhängig von der Vorderseite zu sehen, und zwar als eine *paideia*, als eine Erziehungsszene, in der die beiden Jünglinge, von denen sie annimmt, dass es sich um die Söhne des Verstorbenen handelt, in Tanz und Musik geschult werden. Dabei verweist sie auf diese aus Sparta überlieferte Sitte der *agoge*, die u.a. der kriegerischen Ertüchtigung dienen sollte.[9] Die Ikonographie des Sarkophages thematisiere also sowohl die herausragende politische Stellung des Verstorbenen in seiner Polis Caere, als auch das erzieherische Ideal dieser Gesellschaft.[10] Massa-Pairault lieferte damit die bis heute einzige abweichende Interpretation für die Schmalseite, die in der Literatur jedoch kaum rezipiert wurde.[11]

Für eine inhaltliche Trennung der Reliefszenen auf Lang- und Schmalseite spricht vor allem die Anordnung der Figuren: So bilden der Kitharaspieler rechts und sein Pendant links gleichsam einen festen äußeren Rahmen für die Tanzszene in der Mitte und grenzen sie damit deutlich von den aufgereihten Figuren des Beamtenzuges ab. Ein inhaltliches Argument kommt hinzu: bei Beamtenaufzügen treten weder auf Sarkophagen noch in anderen Kunstgattungen Tänzer auf.[12]

Zudem sind hier die Tänzer nackt und klein, also zwei Kinder oder Jugendliche. Kinder und Jugendliche, die nicht Dienerfiguren meinen, kommen in der etruskischen Kunst verhältnismäßig häufig bei Abschieds- oder Begrüßungsszenen, etwa auf hellenistischen Urnen, ansonsten aber eher selten vor.[13] Auf Sarkophagen kenne ich nur zwei Beispiele, auf denen mit Sicherheit Kinder gemeint sind. Zu diesen gehören ein heute verschollener Sarkophag, der wahrscheinlich aus Vulci stammte, sowie ein Beispiel aus Volterra.[14] In beiden Fällen sind kleine Kinder dargestellt, während die Jünglinge auf dem Caeretaner Sarkophag schon so groß sind, dass sie unabhängig von einer Bezugsperson wie Mutter, Amme, Vater oder Pädagoge agieren, also sicherlich nicht mehr als „kleine" Kinder anzusprechen sind.[15]

In der Grabmalerei dagegen finden sich Beispiele für Kinder häufiger. Sie kommen bei Aufzügen, Banketten und auch bei Sportwettkämpfen vor. Jedoch ist auch hier keine Darstellung bekannt, in der nackte Jugendliche tanzen.[16]

Vor diesem Hintergrund kommt gerade der Nacktheit der beiden Jugendlichen für die Lesung des Sarkophagbildes besondere Bedeutung zu. Die Interpretation als *paideia* – Szene würde gut dazu passen: Nacktheit kann

in Etrurien offensichtlich dazu dienen, eine kleine Figur als (männliches) Kind zu charakterisieren.[17] In einem Magistratszug hingegen erscheinen unbekleidete Teilnehmer – selbst unbekleidete Kinder – eher befremdlich. Diesen Umstand merkt lediglich van der Meer an, indem er darauf hinweist, dass in der etruskischen Kunst vollkommen nackte Tänzer nicht vorkommen.[18]

Üblich ist die Darstellung nackter männlicher Figuren dagegen bei Sportwettkämpfen oder in Palästraszenen, wie wir sie von zahllosen Denkmälern aller Gattungen in der griechischen und etruskischen Kunst kennen.[19] Natürlich reicht dieser Umstand nicht aus, die beiden Caeretaner Jünglingen lediglich aufgrund ihrer Nacktheit als Sportler zu deuten. Bisher wurde jedoch stets übersehen, dass beide jeweils einen Gegenstand halten, obwohl beide Objekte auf einer von Herbig bereits 1952 publizierten alten Umzeichnung der Schmalseite deutlich zu erkennen sind.[20] Ein Vergleich mit dem Original bestätigt dieses Detail: Der linke Jüngling hält in seiner rechten Hand einen kleinen gekrümmten länglichen Gegenstand, den man ohne Zweifel als Strigilis identifizieren kann, während der rechte – ebenfalls in seiner Rechten – ein kleines Alabastron hält[21]. (**Abb. 3**)

Strigilis und Alabastron sind nun aber mit Sicherheit zwei Objekte, die

Abb. 3 Strigilis und Alabastron in den Händen der Jünglinge auf der Schmalseite des Magistratensarkophags (Detail). (Photo © Governatorato SCV – Direzione dei Musei).

in den Bereich des Gymnasions/der Palästra fallen und somit auch die Nacktheit der beiden Jünglinge erklären. Dazu passt auch die Form des „Kranzes", die bei dem rechten Jüngling gut erhalten ist: Er ist aus drei Schnüren gewickelt, wie die Mittellinien andeuten; es handelt sich also nicht um einen der üblichen Blattkränze, sondern möglicherweise um eine Siegerbinde, wie wir sie aus griechischen Athletendarstellungen kennen.[22] (**Abb. 4**) Beim Kopf des zweiten Jünglings ist zwar die Oberfläche des Steins nicht ganz erhalten; doch sieht es so aus, als ob er gar keine Binde oder Bekränzung trug, weil eben nur einer den Sieg erringen konnte. Alles spricht also dafür, dass es sich bei den beiden Jünglingen nicht um Tänzer, sondern um Athleten handelt, die sich in einer Art Formationstanz zur Musik bewegen.

Jedoch auch in dieser Ausdeutung bleibt die Szene ohne Parallelen auf etruskischen Steinsarkophagen. Anders als in der Grabmalerei, in der Sportwettkämpfe nach dem Gelage das zweithäufigste Thema sind,[23] existiert in der Sarkophagkunst nur ein einziges weiteres Beispiel, ein Stück aus Norchia, auf dem eine Sportszene, genauer ein Boxkampf, dargestellt ist.[24] Da diese Szene isoliert mitten auf der Frontseite des Kastens angebracht ist, sah Herbig darin eine reduzierte Wiedergabe von Leichenspielen.[25]

Abb. 4 Bekränzter Jüngling auf der Schmalseite des Magistratensarkophags (Detail). (Photo © Governatorato SCV – Direzione dei Musei).

Weitere Beispiele von gymnischen Agonen, die als Leichenspiele gedeutet werden können, kommen in der etruskischen Reliefkunst in erster Linie auf den aus Chiusi stammenden archaischen und spätarchaischen Cippi vor. Auf ihnen gehören Gelage, Spiele, Tänze und Prothesis zu den häufigsten Bildthemen, vergleichbar denen in der spätarchaischen und klassischen Grabmalerei.[26] Boxkämpfe -wie in Norchia – sind dabei vergleichsweise selten.[27] Auf den Grabstelen aus Bologna sind sie etwas häufiger; dort sind sie zusammen mit den Ringkämpfen und einem Wagenrennen sowie einem Wettreiten die einzig dargestellten Sportdisziplinen.[28]

Dem Sarkophag aus Caere am ehesten vergleichbar ist ein Cippus in Sarteano.[29] (**Abb. 5**)

Auf diesem tanzen drei nackte Jünglinge mit identischen Bewegungen zur Musik eines Aulosbläsers. Sie sind ebenfalls kleiner dargestellt als der Musiker, also sind auch hier wohl keine Erwachsenen gemeint. Ihre Arme sind erhoben, wobei sie den rechten nach vorne gestreckt und den linken angewinkelt und zurückgezogen haben. Die Hände der linken Arme sind zu Fäusten geballt. Dies ist die typische Haltung von Faustkämpfern in der Anfangsphase des Kampfes vor dem Setzen des ersten Schlages.[30] Der rechte Fuß steht jeweils flach auf dem Boden, während der linke leicht ange-

Abb. 5
Archaischer Cippus in Sarteano. Mimischer Tanz dreier Jünglinge zur Musik eines Aulosspielers während der Bestattungsfeierlichkeiten? Museo Civico Archeologico Sarteano. (Photo Laura Nazim).

winkelt ist und knapp über dem Boden schwebt – ganz ähnlich wie bei den beiden Jünglingen auf dem Caeretaner Sarkophag. Diese Szene wird von Jannot als Darstellung einer *gymnopaideia* verstanden, in der Gesten aus dem Sport übernommen und in einen Tanz integriert werden.[31]

Die *gymnopaideia* ist ein aus Sparta bekanntes, jährliches Fest zu Ehren des Apollon, auf dem Jugendliche ihre körperlichen Fähigkeiten in Wettkämpfen zur Schau stellten.[32] Die anderen drei Seiten des Cippus zeigen jedoch mit der Prothesis, der Totenklage und einem Wettreiten unterschiedliche Momente der Totenfeiern.[33] Man wird daher wohl vermuten dürfen, dass auch die Darstellung auf der vierten Seite, mit den einen Boxkampf tanzenden Jünglingen, in inhaltlichem Zusammenhang mit den Bestattungsfeierlichkeiten steht. Vielleicht handelt es sich um einen mimischen Tanzauftritt von Athleten während der Leichenspiele, der genau wie diese selbst zu Ehren des Verstorbenen veranstaltet wurde.[34]

Auch der Boxer auf der Rückwand der Tomba del Colle in Chiusi, der in kämpferischer Haltung, aber ohne einen Gegner zur Musik eines neben ihm stehend Aulosbläsers zu tanzen scheint, lässt sich wohl kaum durch die Nachlässigkeit des Malers, der den Gegner einfach vergessen hätte, erklären.[35] Viel eher dürfte ein tanzender Athlet gemeint sein, der in einer Reihe mit dem Waffentänzer und der Krotalentänzerin zu sehen ist. (**Abb. 6**). Diese Figuren, die rituelle Tänze aufführen, werden von den Sportlern im engeren Sinne – einem Weitspringer am linken Rand

Abb. 6 Musikalisch und tänzerisch begleitete Sportwettkämpfe in der Tomba del Colle, Rückwand. Chiusi 2. Viertel 5. Jh. v. Chr. Aquarell. ICAR=CHIU67–27. (Datenbank der Etruskischen Zeichnungen der École Francaise, Rom).

und den Ringern am rechten Ende des Bildabschnittes – gleichsam ein-
gerahmt.

Dass tatsächlich die Kampfbewegungen von Boxern als Tanzfiguren
während der Leichenspiele aufgeführt wurden, belegt der tanzende Phersu
in der Tomba degli Auguri in Tarquinia: Neben den beiden korpulenten
Athleten, die sich in der Mitte der linken Seitenwand mit einem großen
Ausfallschritt gegenüber stehen und ihre Arme und Hände für den Beginn
des Kampfes in Position gebracht haben, tritt er als springender Tänzer
auf, der die Haltung der Boxer auf das Genaueste imitiert und durch die
Wiederholung gleichzeitig auch zu parodieren scheint.[36]

Im Rahmen der aufwändigen Bestattungsfeierlichkeiten waren neben
Sportwettkämpfen offenbar auch spielerische und tänzerische Einla-
gen üblich: Immer wieder sehen wir neben oder zwischen Athleten und
Wagenrennen Waffentänzer, Krotalentänzerinnen, ganze Schaustellertrup-
pen und die Figur des Phersu, eines Schauspielers, der mit seiner Maske
parodierend in ganz unterschiedliche Rollen schlüpfen konnte.[37] Tänze,
die die charakteristischen Bewegungsmuster besonders beliebter Sportar-
ten wiederholten und variierten, scheinen in diesen Rahmen gut zu pas-
sen. Durchaus denkbar ist auch, dass derartige Tänze von den Athleten
selbst aufgeführt wurden. Und so könnte es sich bei den drei tanzenden
nackten Männern auf dem Cippus in Sarteano durchaus um jugendliche
Faustkämpfer handeln, die in einer bestimmten Situation des Geschehens –
etwa am Beginn oder am Ende der Kämpfe – eine tänzerische Aufführung
darbieten. Dadurch würde sich auch erklären, dass diese Tänzer nackt dar-
gestellt sind.

Auf einer attisch schwarzfigurigen Pelike in New York bietet sich eine
einzigartige Parallele zu den genannten etruskischen Beispielen, weil hier
ein Kind bzw. Jugendlicher in einen Boxtanz involviert ist. [38] Er tanzt
zusammen mit einem älteren bärtigen Mann zur Musik eines Aulosspie-
lers. Beide bewegen sich mit ausgreifenden Gesten der Arme und Beine in
die gleiche Richtung, wobei der kleinere dem Größeren folgt und offenbar
nicht in der Lage ist, dessen elegante Bewegungen nachzuahmen. Auf-
grund des offensichtlichen Altersunterschiedes zwischen den beiden Tän-
zern und der unbeholfen wirkenden Gesten des Jugendlichen könnte man
in dieser Szene einen Unterricht im Boxkampf vermuten, wobei aber – so
Thuiller – die Anwesenheit des Auleten nicht erklärbar wäre.[39] Der Vor-
schlag von von Bothmer, dass dies eine getanzte Parodie auf den Boxkampf

sei, erscheint auf dem Hintergrund der etruskischen Beispiele jedoch über-
zeugender.[40]

In allen bisher genannten Szenen mit (tanzenden oder tatsächlich kämp-
fenden) Athleten ist der Aulos das Instrument, mit dem die Musik erzeugt
wird.[41] Auf dem Sarkophag aus Caere ist der (erhaltene) Musikant jedoch
ein Kitharist, während man die zerstörte Figur des linken Mannes schon
bald nach der Auffindung zu einem Lituusträger ergänzt hat. Offenbar,
um so eine narrative Verbindung zwischen Lang- und Schmalseite her-
zustellen. Obwohl diese Ergänzung bei den oben erwähnten Restaurie-
rungen rückgängig gemacht worden ist, sehen sie die meisten Beiträge zu
dem Sarkophag noch immer als gegeben an.[42] Unabhängig von der alten
Rekonstruktion geht man nach wie vor davon aus, dass ein weiterer Musi-
kant die Szene komplettiert habe.[43] Für einen Lituusträger sprechen aber
weder die Attribute der fragmentierten Figur, von denen heute nichts mehr
zu erkennen ist, noch der unterstellte Zusammenhang mit dem Beamten-
aufzug.

Abb. 7 Rekonstruierter Aulet auf der Schmalseite des Magistratensarkophags.
(Zeichnung, Laura Nazim).

Stattdessen sprechen die neu entdeckten Attribute Strigilis und Alabastron, aber auch das Musikerpendant auf der anderen Seite des tanzenden Sportlerpaares dafür, den fragmentierten Mann zu einem Aulosspieler zu ergänzen. Wie mein zeichnerischer Versuch einer Rekonstruktion zeigt (**Abb. 7**), passen dazu gut die Haltung des weit angehobenen Oberarms und die freie Fläche, die vor dem Gesicht des Mannes zur Verfügung steht. Ein Aulos ähnlich dem des Musikanten auf der Vorderseite würde dort gut Platz finden und den Raum sinnvoll füllen. Aulos- und Kitharaspieler rahmen also – wenn meine Rekonstruktion das Richtige trifft – die athletische Tanzszene der Jünglinge ein.

Die Wiegenkithara und ein Musikant, der wie der Kitharist auf dem Caeretaner Sarkophag mit leicht geöffnetem Mund zu seiner Musik sogar zu singen scheint (**Abb. 8**), kommen jedoch bei Sportveranstaltungen sonst nie zum Einsatz.[44] Dagegen ist das paarweise Auftreten von Aulet und Kitharist in anderen Zusammenhängen sehr häufig zu beobachten. Auf der

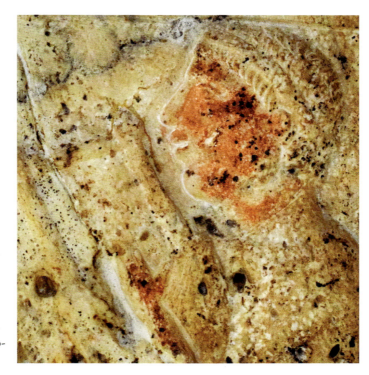

Abb. 8
Singender
Kitharaspieler.
Magistraten-
sarkophag
(Detail).
(Photo ©
Governatorato
SCV – Direzio-
ne dei Musei).

Langseite des Sarkophags der *Ramtha Visnai* in Boston bilden eine Aulos-
und eine Kitharaspielerin den Rahmen für die Begegnung des Ehepaares.[45]
In der Grabmalerei Tarquinias flankiert das Musikantenpaar seit dem aus-
gehenden 6. Jh. zahlreiche Gelage oder es führt einen Zug zum Gelage
an.[46] Besonders hervorgehoben sind die Musikanten, wenn sie neben den
Scheintüren und in den Türgewänden der Grabeingänge auftreten.[47] Dabei
tragen sie je nach dem Zusammenhang eine unterschiedliche Tracht: nur
ein Himation oder ein Lendentuch, wenn sie zum Gelage aufspielen; die
rituelle Tracht aus Chiton und Ependytes oder den Chiton mit Himation,
wobei das Himation auch um die Taille geknotet werden kann, wenn sie
zu Seiten einer realen oder einer Scheintür auftreten.[48]

Diese Beobachtungen zu dem Musikantenpaar aus Aulos- und Kithara-
spieler führen noch einmal zu der oben aufgeworfenen Frage nach dem
Verhältnis der Szenen auf der Lang- und der Schmalseite des Magistra-
tensarkophags zurück. Denn Aulos und Kithara kommen – bei unserer
Rekonstruktion – hier wie dort vor. Wer mit der herrschenden Meinung
davon ausgeht, dass die Szenen zu einem einheitlichen, über die Ecke des
Sarkophags hinweg zusammenhängenden kontinuierlichem Geschehen
gehören, wird wahrscheinlich eher die Parallelität betonen. Wer dagegen
wie ich von zwei unterschiedlichen Bildthemen ausgeht, einem Beamten-
aufzug auf der Langseite und einer Szene aus den Leichenspielen auf der
Schmalseite, die man zu Ehren des Verstorbenen veranstaltet hat, wird eher
nach Unterschieden suchen.

Tatsächlich tragen die Musikantenpaare der Lang- und der Schmalseite
des Caeretaner Sarkophags unterschiedliche Tracht: Die Musikanten der
Langseite sind nur in einen knöchellangen Chiton gekleidet, eine in Etru-
rien eher seltene Tracht, während die der Schmalseite die vollständigere
Variante mit Himation tragen.[49] Auch wenn sich der Grund für diese Dif-
ferenzierung einstweilen nicht sicher bestimmen lässt, wird man sie vor
dem Hintergrund der ganz ähnlichen, sicherlich nicht zufälligen Differen-
zierungen in der Grabmalerei wohl als ein Argument ansehen dürfen, das
ein weiteres Mal für die These spricht, die beiden Seiten des Sarkophags
nicht als fortlaufend zu denken, sondern als in sich abgeschlossene Themen
zu behandeln.

ANMERKUNGEN

1 Museo Gregoriano Etrusco Inv. 14949; Canina 1846–1851, 191–193; Herbig 1952, Kat. 83, 46–47; Roncalli 1978–1980,3–21; Buranelli – Sannibale 1998, 321.

2 Herbig 1952, Kat. 83; Gilotta 1989: immer noch die umfassendste und maßgebliche Gesamtdarstellung zu diesem Problem; Buranelli – Sannibale 1998, 325–326; Papini 2004, 136–138, Abb. 67–69; van der Meer 2004, 68–71, Abb. 35–39; Thiermann – Arnold 2013, 116–117.

3 Thiermann – Arnold 2013, 118.

4 Die Kommission des Vatikans, die das Grab wenige Monate nach seiner Auffindung besuchte und begutachtete, hatte zunächst eine ganz andere Lesung vorgeschlagen „..., che rappresenta per avventura la pompa di un vincitore nella corsa dei carri imperocché evvi l'auriga sul carro tratto da cavalli e preceduto da alcuni suonatori d'instrumenti." Dies wurde in der Forschung allerdings nie aufgegriffen. Vgl. Gilotta 1989, 84, Anm. 83.

5 Buranelli-Sannibale 1998, 321–327.

6 Entgegen der Aussage von Thiermann, 2013, 114 möchte ich an dieser Stelle den Begriff ,Heroldsstab' nicht verwenden, da dieser die Anwesenheit eines Hermes/Turms bzw. einer mythischen Figur implizieren könnte, so z.B. Ahlén 2019, 128. Mangels einer genauen Benennungsmöglichkeit für diese typisch etruskische Insignie im Beamtenzug möchte ich sie neutral als Schlaufenstab bezeichnen. Vergleiche dafür finden sich u. a. bei Magistratsprozessionen in den Gräbern degli Hescanas in Orvieto, del Convegno und del Tifone in Tarquinia (Steingräber 1985, 288, Nr. 34, 309–310, Nr. 58., 355–356, Nr. 118.) sowie auf einem Sarkophag aus der Tomba Giglioli (Steingräber 1985, 317, Nr. 69, Abb. 79) und auf dem Relief eines der Felsgräber in Norchia (Menzel – Naso 2007, 36–37, Abb. 13–15)

7 Gilotta 1989, 70 Abb. 1; Thiermann – Arnold 2013, 113 Abb. 9a-b; für eine Farbaufnahme s. http://www.museivaticani.va/content/museivaticani/it/collezioni/musei/museo-gregoriano-etrusco/sala-iv--pietre--epigrafie-scultura/sarcofago-a-rilievo-policromo.html#&gid=1&pid=1.

8 Buranelli – Sannibale 1998, 325, Abb.170.

9 Massa-Pairault 1996, 151; Quint. Inst. I, 11, 18. Zu Tanz und Musik als kriegerisches Element siehe; Kah 2004; Erker 2018.

10 Massa-Pairault 1996, 151.

11 Massa-Pairaults Interpretation einer Erziehungsszene schließen sich u.a. Ahlén 2019, 129 und van der Meer 2004, 70 an.

12 vgl. Lambrechts 1959; auch in der Grabmalerei kommen bei Magistratsaufzügen nie Tänzer vor: s. die Gräber Bruschi, del Tifone, del Convegno und degli Scudi (Steingräber 1985, 300, Nr. 48, 355, Nr. 118, 309, Nr. 58, 349–351, Nr. 109).

13 Ahlén 2019, 108, Anm. 18–21; die von Ahlén genannten Beispiele aus der Grabmalerei sind allerdings nicht ganz sicher.

14 Herbig 1952, 39, Kat. 70, 86, Kat. 260. Unter Vorbehalt kann der Sarkophag des Laris Pulena mit der Figur einer nackten, am Boden hockenden Gestalt am rechten Bildrand der Schauseite hinzugezählt werden (Herbig 1952, 59, Kat.111). Die Interpretation der Darstellung ist jedoch bislang nicht in allen Details geklärt.

15 Als Beispiel für Kinder, die von einem Pädagogen begleitet werden vgl. Weber-Lehmann 2012, 274 und dies, in: Steingräber 1985, 52–53.

16 Siehe Anm. 12; Ahlén 2019, 108.

17 Ahlén 2019, 107. Ein bestehendes Problem bei der Identifizierung von Kindern und Sklaven ist, dass sich beide durch Nacktheit und ihre geringe Größe auszeichnen können. Das kann mitunter dazu führen, dass nicht eindeutig zu erkennen ist, wer dargestellt wird. Zur Problematik von Kindern und Sklaven vgl. Weber-Lehmann 2018.

18 van der Meer 2004, 70.

19 Zu Sportdarstellungen in der etruskischen Kunst siehe u. a. Sannibale 2012, 123–137. Für eine Palästraszene siehe u. a. einen attisch rotfigurigen Chous in Basel (Neils 2014, 86 Abb. 5.4).

20 Herbig 1952, Taf. 108c; leider gibt Herbig nicht die Quelle für diese Zeichnung an.

21 Mein Dank gilt an dieser Stelle Dr. M. Sannibale, Direktor des Museo Gregoriano Etrusco der Vatikanischen Museen in Rom, der es mir ermöglicht hat den Sarkophag vor Ort ungestört und genaustens betrachten und fotografieren zu können.

22 Der Sieg im Wettkampf wird innerhalb der antiken Ikonographie selten dargestellt. Wenn er vorkommt, dann in Form einer Nike, die den Siegerkranz bringt oder der Wiedergabe eines Siegers mit Kranz oder Binde. Ein Palmenzweig kann ebenfalls als Symbol des Sieges stehen (Neils 2014, 90–91).

23 Weber-Lehmann, in: Steingräber 1985, 51–52.; Deuling 2003, 288.

24 Herbig 1952, 71, Taf. 21c-e, Kat. 188; Thuillier 1989, 158.

25 Herbig 1952, 71. Ähnliche Szenen von isolierten Boxern, die stellvertretend für Leichenspiele stehen, befinden sich in den Gräbern Cardarelli, della Fustigazione, del Teschio und Citaredo (Steingräber 1985, 304–305, Nr. 53, 315, Nr. 67, 354, Nr. 116, 309, Nr. 57; zur Tomba del Citaredo s. auch Andreae 2014, 156–157)

26 Fast 10% der rund 200 bekannten Kammergräber zeigen in ihren Malereien Sportwettkämpfe, die durch den funerären Kontext als Leichenspiele für die Verstorbenen definiert werden (Deuling 2006, 288). Zu den Leichenspielen und den Darstellungen der Agone in der griechischen Kunst siehe: L. Malten 1923–24; L. E. Roller 1981, 107–119.

27 Jannot 1984, 66; Thuillier 1997, 242. Auf einem Beispiel der Sammlung Casuccini in Palermo etwa findet sich ein Boxkampf, der von einem Aulos- und einem Lituusspieler begleitet wird (Jannot 1984, 80, Nr. 8386). Ähnlich eine Szene auf einem weiteren Cippus, ebenfalls in Begleitung eines Aulosbläsers (Thuillier 1997, 252, Abb. 6–7).

28 Sassatelli 1991, 45–67; Govi 2015.

29 Jannot 1984, 28, Nr. 93488, Abb. 114; Thuillier, 1986, 212–213 mit Abb. 1; Cerchiai 2003, 84–85, Abb.6.

30 Bruckner 1954, 23; Vgl. u. a. CVA Kopenhagen III, I c Taf. 126,1; Boxer auf der Rückwand der Tomba delle Bighe in Tarquinia (kleiner Fries) (Steingräber 1985, 297 Nr. 47 Abb. 80); Neils 2014, 85 Abb. 5.2.

31 Jannot 1984, 330; Thuillier 1985, 212; Thuillier 1993, 32.

32 Eine eindeutige *gymnopaideia* – Darstellung befindet sich auf einem spätkorinthischen Aryballos (Dm. 5,2 cm; H. 4,5 cm). Ein Aulet spielt die Musik für eine Reihe von Jünglingen, die paarweise aufgestellt sind. Vor ihnen springt ein einzelner, kleiner Knabe mit erhobenen Armen und angezogenen Beinen in die Luft. Wie aus der Inschrift hervorgeht, ist der Aryballos der Preis für den Sieger des Wettbewerbs (Roebuck – Roebuck 1995, 158, Taf. 63). Dass bereits Kinder und Jugendliche an gymnischen Agonen teilgenommen haben, berichtet u. a. Pausanias an mehreren Stellen (Paus. 5.8.9; 6.2.10). Zur *gymnopaideia* allgemein und Kindern/Jünglingen im Bereich der Palästra s. Pettersson 1992; Kennell 1995; Kah – Scholz

2004; Weiler 2004; Petermandl 2014; Romano 2014.

33 Jannot 1984, Nr. 93488, Abb. 112, 113, 115.

34 Jannot 1985, 73–74; Jolivet 1993, 349–377; zu Spektakeln und Spielen in Etrurien siehe u. a.: Camporeale 2011, 175–184; Thuillier 2011, 184–194.

35 Steingräber 1985, 274–275, Nr. 15; Jannot 1985, 67, 71. Er sieht die isolierten Boxer ohne Gegner, die zu den Klängen des Aulos tanzen und springen, als Nachahmung eines Kampfes an, dessen Zweck wir mangels Quellen nicht kennen (Jannot 1985, 71–72); Cerchiai 2003, 84–85.

36 Steingräber 1985, 291, Nr. 42; Jannot 1993, 281–320; Weber-Lehmann 2004, 132 mit Abb.

37 Weber-Lehmann 2004, 131 mit Kat. II/12.

38 Thuillier 1985, 233, Abb. 31; Cerchiai 2003, 83, Abb. 7.

39 Thuillier 1985, 233.

40 Thuillier 1985, 235. Von Bothmer 1951, 41–42.

41 Für eine Auflistung von Vasen mit Aulosspielern und Sportlern unterschiedlicher Disziplinen siehe: Cerqueira 2016, Anm. 62; Raschke 1985, 197–200. Für etruskische Beispiele siehe u.a.: eine etruskisch-schwarzfigurige Vase in Kalifornien (CVA California (1) Taf. 29.2 a) und eine Bucchero-Oinochoe in Hannover (Gercke 1996, 130 Nr. 85); Dass Auleten als musikalische Begleiter unterschiedlicher Personengruppen vorkommen, lässt sich zudem für die Ikonographie des gesamten Mittelmeerraumes beobachten (Cerqueira 2016, 188).

42 Siehe u. a.: van der Meer 2004; Ahlén 2019.

43 Buranelli – Sannibale 1998, 325.

44 Jannot 1979, 500; Jannot 1988, 315.

45 Herbig 1952, 13, Nr. 5, Taf. 40.

46 Gelage: Gräber 4780, 5513, della Scrofa Nera, della Nave; Zug zum Gelage: Gräber dei Leopardi, dei Demoni. Auch im Komos sind zumeist Paare aus einem Aulosbläser und einem Musikanten mit einem Saiteninstrument zugegen, allerdings wird dann – bis auf eine Ausnahme in der Tomba della Fustigazione – anstelle der Wiegenkithara meist die leichtere Lyra bzw. das Barbiton mitgeführt; siehe: Jannot 1979; Jannot 2004; Weber-Lehamann 2012.

47 Weber-Lehmann 2012, 276 mit Anm. 21.

48 Weber-Lehmann 2012, 276–280.

49 Während lange, ungegürtete Chitone ohne Obergewand bei Musikanten in Etrurien äußerst selten sind, ist die vollständigere Tracht aus Chiton und Mantel sehr

verbreitet, vor allem auf den spätarchaischen Cippen in Chiusi in fast allen Szenen von Tanz, Sport und Spielen, die Variante

mit dem umgegürteten Himation bei der Prothesis.

BIBLIOGRAFIE

B. Andreae 2004
Tomba del Citaredo. Das wiedererstandene Grab des Kitharaspielers aus Tarquinia, in: Spielmann – W. Hornbostel (Hrsg.), *Die Etrusker. Luxus für das Jenseits. Bilder vom Diesseits – Bilder vom Tod* (München 2004), München 2004, 154–161.

A. S. S. Ahlén 2019
Children in Etruscan Funeral Iconography, *Acta Hyperborea* 15, 2019, 105–134.

A. Bruckner 1954
Palästradarstellungen auf frührotfigurigen attischen Vasen. Hannover 1954.

F. Buranelli & M. Sannibale 1998
Reparto antichità etrusco-italiche (1984–1996) 176, *Bollettino Monumenti Musei e Gallerie Pontificie* 18, 1998, 321–327.

G. Camporeale 2011
Camporeale, Spettacoli in Etruria, in: ThesCRA VII, 175–184.

L. Canina 1846–1851
L'Antica Etruria marittima. Rom 1846–1851.

L. Cerchiai 2003
I Pugili ai Lati della Porta, in: A. Minetti (Hrsg.), *Pittura Etrusca. Problemi e Prospettivi Atti del Convegno* (Sarteano-Chiusi 2001), Sarteano 2003, 78–86.

F. V. Cerqueira 2016
To March in Phalanx, to Jump with Weights, to Knead the Bread, to Tread the Grapes. What is the Aulos for?, *Archimède*, 2016, 187–205.

CVA California
H. R. W. Smith, CVA USA 5, University of California 1. Cambridge, Massachusetts 1936.

CVA Kopenhagen
C. Blinkenberg – K. F. Johansen, CVA Danemark 3, Musée National. Paris 1928.

J. K. Deuling 2006
Etruscan Games. Competitive Sports in a Funerary Context, in: *Proceedings of the 16th International Congress of Classical Archaeology* (Boston 2003), Oxford 2006, 288–290.

J. Engels 2004
Das Training im Gymnasium als Teil der Agoge des hellenistischen Sparta, in: D. Kah – P. Scholz (Hrsg.), *Das hellenistische Gymnasion*. Wissenskultur und gesellschaftlicher Wandel 8, Berlin 2007, 97–102.

M. Erker 2018
Musik, Tanz und Krieg – eine antike Kombination?, *MAGW* 148, 2018, 121–135.

W. Gerke 1996
Etruskische Kunst im Kestner-Museum Hannover. Hannover 1996.

F. Gilotta 1989
Il Sarcofago del Magistrato ceretano nel Museo Gregoriano Etrusco, *RIA* (3. Serie) 12, 1989, 69–89.

E. Govi 2015
Studi sulle Stele Etrusche di Bologna tra 5 e 4 sec. A.C. Roma 2015.

R. Herbig 1952
Die Jüngeretruskischen Steinsarkophage, Die Antiken Sarkophagreliefs 7. Berlin 1952.

J.-R. Jannot 1979
La Lyre et la Cithare. Les Instruments à Cordes de la Musique Étrusque, *AntCl* 48 fasc. 2, 1979, 469–507.

J.-R. Jannot 1984
Les Reliefs Archaïques de Chiusi, Collection de l'École Française de Rome 71. Rom 1984.

J.-R. Jannot 1985
De l'Agôn au Geste Rituel. L'Exemple de la Boxe étrusque, *AntCl* 54, 1985, 66–75.

J.-R. Jannot 1988
Musiques et Musiciens Étrusques, *CRAI* 1988, 311–334.

J.-R. Jannot 1993
Phersu, Phersuna, Person. A Propos du Masque Étrsuque, in: *Spectacles Sportifs et Scéniques dans le Monde Étrusco-Italique. Actes de la Table Ronde Organisée par l'Equipe de Recherches Étrusco-Italiques de l'UMR 126 (CNRS, Paris) et l'Ecole*

française de Rome (Rom 1991), Rom 1993, 281–320.

J.-R. Jannot 2004
Musique et Religionn en Etrurie, ThesCRA, Los Angeles 2004, 391–394.

V. Jolivet 1993
Les Jeux Scéniques en Étrurie, in: *Spectacles Sportifs et Scéniques dans le Monde Étrusco Italique. Actes de la Table Ronde Organisée par l'Equipe de Recherches Étrusco-Italiques de l'UMR 126 (CNRS, Paris) et l'Ecole française de Rome* (Rom 1991), Rom 1993, 349–377.

D. Kah 2004
Militärische Ausbildung im hellenistischen Gymnasion, in: D. Kah – P. Scholz (Hrsg.), *Das hellenistische Gymnasion*. Wissenskultur und gesellschaftlicher Wandel 8, Berlin 2007, 47–90.

D. Kah & P. Scholz 2004
Das hellenistische Gymnasion. Wissenskultur und gesellschaftlicher Wandel 8, Berlin 2007.

N. M. Kennell 1995
The Gymnasium of Virtue. Education & Culture in Ancient Sparta. Chapel Hill/ London 1995.

R. Lambrechts 1959
Essai sur les Magistratures des Républiques Étrusques. Etudes de Philologie, d'Archéologie et d'Histoire Anciennes 7. Rome 1959.

L. Malten 1923
Leichenspiele und Totenkult, *RM* 38–39, 1923–24, 300–340.

H. Massa-Pairaults 1996
La Cité des Etrusques. Paris 1996.

M. Menzel & A. Naso 2007
Raffigurazioni di Cortei magistratuali in Etruria. Viaggi nell'Aldilà o Processioni reali?, *Ostraka* 17, 2007, 23–43.

J. Neils 2014
Picturing Victory. Representations of Sport in Greek Art, in: P. Christesen – D. G. Kyle (Hrsg.), *A Companion to Sport and Spectacle in Greek and Roman Antiquity*, Chichester 2014, 81–97.

M. Papini 2004
Antichi Volti della Repubblica. La Ritrattistica in Italia centrale tra IV e II secolo a.C., Roma 2004.

W. Petermandl 2014
Growing Up with Greek Sport. Education and Athletics, in: P. Christesen – D. G. Kyle (Hrsg.), *A Companion to Sport and Spectacle in Greek and Roman Antiquity*, Chichester 2014, 236–245.

M. Pettersson 1992
Cults of Apollo at Sparta. The Hyakinthia, the Gymnopaidiai and the Kameia, ActaAth Ser. 8, 12. Stockholm 1992.

W. Raschke 1985
Aulos and Athlete. The Function of the Flute Player in Greek Athletics, *Arete* 2, 1985, 177–200.

M. C. Roebuck & C. A. Roebuck 1995
A Price Aryballos, *Hesperia* 24, 1995, 158–163.

L. E. Roller 1981
Funeral Games in Greek Art, *AJA* 85, 1981, 107–119.

D. G. Romano 2014
Athletic Festivals in the Northern Peloponnese and Central Greece, in: P. Christesen – D. G. Kyle (Hrsg.), *A Companion to Sport and Spectacle in Greek and Roman Antiquity*, Chichester 2014, 176–191.

F. Roncalli 1978–1980
Osservazioni sui Libri Lintei Etruschi, *RendPontAc. Arch.* 51–52, 1978–1980, 3–21,

M. Sannibale 2012
I Giochi e l'Agonismo in Etruria, in: A. Mandolesi – M. Sannibale (Hrsg.), *L'Ideale Eroico e il Vino Lucente* (Asti 2012), Mailand 2012, 123–137.

G. Sassatelli 1993
Rappresentazioni di Giochi Atletici in Monumenti Funerari di Area Padana, in: *Spectacles Sportifs et Scéniques dans le Monde Étrusco-Italique. Actes de la Table Ronde Organisée par l'Equipe de Recherches Étrusco-Italiques de l'UMR 126 (CNRS, Paris) et l'Ecole française de Rome* (Rom 1991), Rom 1993, 45–67.

S. Steingräber 1985
Etruskische Wandmalerei. Stuttgart 1985.

E. Thiermann & S. Arnold 2013
Die Tomba dei Sarcofagi in Cerveteri. Ein spätklassischer Kontext etruskischer Architektur, Malerei und Sarkophage, *RM* 119, 2013, 99–138.

J.-P. Thuillier 1985
Les Jeux Athlétiques dans la Civilisation Étrusque,
BEFAR 256. Rom 1985.

J.-P. Thuillier 1986
Les Danseurs qui tuent, et les autres Athletes
Étrusques, *Ktema* 11, 1986, S211–219.

J.-P. Thuillier 1993
Les Représentations sportives dans l'Oeuvre du
Peintre de Micali, in: *Spectacles Sportifs et Scé-
niques dans le Monde Étrusco-Italique. Actes de la
Table Ronde Organisée par l'Equipe de Recherches
Étrusco-Italiques de l'UMR 126 (CNRS, Paris) et
l'Ecole française de Rome* (Rom 1991), Rome 1993,
21–44.

J.-P. Thuillier 1997
Un Relief Archaïque Inédit de Chiusi, *RA* 1997,
242–260.

J.-P. Thuiller 2011
Jeux et sports, in: ThesCRA VII, 184–194.

L. B. van der Meer 2004
*Myths and more on Etruscan Stone Sarcophagi
(350–200 B.C.).* Löwen 2004.

C. Weber-Lehmann 2004
Die etruskische Grabmalerei: Bilder zwischen
Tod und ewigem Leben, in: H. Spielmann –
W. Hornbostel (Hrsg.), *Die Etrusker. Luxus für
das Jenseits. Bilder vom Diesseits – Bilder vom Tod*
(München 2004), München 2004, 122–153.

C. Weber-Lehmann 2012
Kultus und Ritus. Taugliche Topoi zur Interpre-
tation der etruskischen Grabmalerei?, in:
P. Amann (Hrsg.), *Kulte – Riten – religiöse Vor-
stellungen bei den Etruskern und ihr Verhältnis zu
Politik und Gesellschaft. Akten der 1. Internationa-
len Tagung der Sektion Wien/Österreich des Istituto
Nazionale di Studi Etruschi ed Italici* (Wien
2008), Wien 2012, 273–286.

C. Weber-Lehmann 2018
Kinder oder Sklaven? Zur Darstellung kleiner
Menschen in der etruskischen Kunst, in: P.
Amann – L. Aigner-Foresti (Hrsg.), *Beiträge zur
Sozialgeschichte der Etrusker. Akten der Internatio-
nalen Tagung* (Wien 2016), Wien 2018, 267–279.

I. Weiler 2007
Gymnastik und Agonistik im hellenistischen
Gymnasion, in: D. Kah – P. Scholz (Hrsg.),
*Das hellenistische Gymnasion. Wissenskultur
und gesellschaftlicher Wandel 8.* Berlin 2007,
25–46.

ARCHAIC ETRUSCAN DEDICATIONS TO A RARELY MENTIONED DIVINITY

HELLE SALSKOV ROBERTS

In 1924 The Ny Carlsberg Glyptotek acquired a large collection of antiquities said to have been found at Orvieto. As part of this collection came a fragmented red-figured skyphos which carried an Etruscan inscription. As the focus at the time was on the figured decoration of Greek vases the inscription did not arouse much interest.[1] The motif on both sides seems to be a woman looking back toward a standing man, from whom she seems to be fleeing. The skyphos is attributed to the Splanchtnopt Painter, a follower of the Penthesilea Painter, and should be dated to the middle of the 5th century BC (**Figs 1–2a-2b**).

The inscription, which is in the south Etruscan sub-archaic alphabet, runs right to left just above the ring-foot. Unfortunately, the inscription is placed where two fragments join and, as a consequence, it is difficult to distinguish between a break-line and an incised line of the inscription. Rix suggested restoring the fourth letter as *u* and read the inscription as *cavuθas · seχis*.[2] However, the facsimile drawing of the recent *CVA* publication does not support this reading, the damaged letter just appearing as a short vertical line parallel to the second letter *a* (**Fig. 2b**). A more correct reading seems to be *cavaθas · seχis*.

Cavaθas seems to be a female name *cavaθa* in the genitive and in agreement with this *seχis* is the genitive of *seχ*, one of the Etruscan words, the meaning of which "daughter" is secured by several funeral inscriptions.[3] The inscription should be interpreted as "belonging to *Cavaθa*, The Daughter", stating that the skyphos is the property of *Cavaθa*, with the epithet *Seχ*. The same combination of these two names in the genitive is found in a longer inscription incised in a similar position just over the ring-foot of a fragmented skyphos with traces of red-figured decoration found at Pyrgi in 2002.[4] (**Fig. 3**)

Fig. 1 Attic red-figured skyphos, Ny Carlsberg Glyptotek I.N. 2718. (Museum photo).

Fig. 2a Detail of skyphos Fig. 1. (Museum Photo)

Fig. 2b Inscription on skyphos Fig. 1. (Facsimile drawing after *CVA Denmark. Ny Carlsberg Glyptotek, fasc. 1,* 2004, 85, fig. 29).

Fig. 3 Line drawing of profile and inscription on Attic skyphos from Pyrgi. (After *StEtr* 69, 2003, 317).

The inscription runs: *[Cav]aθas mi seχis ein men[p]e cape mi nunax*, again stating that the skyphos belongs to Cavaθa Seχ. The latter part of the inscription seems to be a warning against taking away the holy object (*nuna*) from the owner, or "do not touch the untouchable object".[5]

The profile of the skyphos is very similar to that of the Glyptotek skyphos and should also be dated to the middle of the 5th century BC.

This fragmented skyphos was found during the excavations of the Area

Fig. 4 Line drawing of kylix foot with inscription naming *Cavaθa*, diam. of foot 4 cm. (After *StEtr*.2003, 319).

Sud, next to the two major temples A and B, conducted by the University of Rome "La Sapienza" from 1984 to 2002. Here a considerable number of sherds incised with the name *Cavaϑa,* in a more or less complete form, have been found (**Fig. 4**). They originate from objects dedicated at the various altars and small sanctuaries in this sacred area and it is reasonable to assume that *Cavaϑa* is the name of a divinity venerated there. Most of the sherds are from Attic black-glaze vases, some local imitations of that ware and one from impasto pottery shows an example of an inscribed fragment (**Fig. 5**).[6]

Dedications with the name Cavaϑa[7]

The shapes represented are predominantly kylikes and skyphoi. Apart from these, there is one lekythos and one impasto basin.

Kylikes[8]

There are sherds from about ten kylikes, mainly side-sherds, which cannot be precisely dated. However, a few foot-sherds are more helpful. Ps 95(*ET* Cr 3.35) comes from a kylix on low stem, probably from the end of the 6th century BC (**Fig. 5**). Furthermore, the foot-sherds Ps 1+ Ps 25(*ET* Cr 3.36)[9] (**Fig. 6**) and Ps 6(*ET* Cr 3.29)[10] both have the rounded profile of the foot which is not very common, but finds its best parallels in the North Slope cups from about 480–470 BC[11] and in a cup attributed to the Brygos Painter.[12]

Skyphoi, flat-bottomed kotylai, cups [13]

Of these, only the afore-mentioned Ps 93(*ET* Cr 3.33), with traces of red-figure decoration, allows a more precise dating to the middle of the 5th century BC (**Fig. 3**).[14]

Lekythos

Ps 32(*ET* Cr 3.41) thought by F.D. Maras to be from the foot of a lekythos from the end of the 6th century BC or from the first half of the following century.[15]

Basin with thickened rim, impasto

Ps 48 thought by Maras to be dated between the 5th and the 4th century BC, impasto ware being difficult to date precisely.[16]

A few of the dedications that can be dated with reasonable precision are from the end of the 6th century BC, but the majority are from the first decades of the 5th century BC and from about the middle of that century. There is only a single dedication on impasto, probably from the end of the 5th century BC, and after that time there are no certain dedications with the name Cav(a)θa at Pyrgi and there is no trace of the form *Catha at the sacred area, according to Colonna.[17]

Recently D. Moore seems to take it for granted that Caθa mentioned in the long inscription on the sarcophagus of Laris Pulenas from Tarquinia from the 2nd century BC[18], on the Bronze Liver from Piacenza from the 2nd or 1st century BC[19] and on two tile burials from Chiusi from the neo-Etruscan period[20] is identical to Cavaθa venerated at Pyrgi at the end of the 6th century and during the 5th century BC. However, none of these have any obvious relevance for the Cavaθa Seχ at Pyrgi in the archaic period, where there is no evidence for a continuity of a cult of that divinity into the neo-Etruscan period.[21] On the contrary, one can observe two distinct phases divided by a long hiatus of activity in this area.[22]

The epithet Seχ/Śeχ

The long inscription on the skyphos (**Fig. 3**) was presumably put there by the authority of a sanctuary for Cavaθa Seχ trying to protect her property, which would have been used during rituals performed for the goddess.

Fig. 5 Distribution map of sherds found at Area Sud, Pyrgi. (After *StEtr* 69, 2003, fig.1, 308–309).

There are other examples of the authority of a temple marking pottery as the property of the divinity. Most noticeable, perhaps, are the Spurinas cups found at Pyrgi in the fill of the foundation of temple A and in the area of temple B, thus giving a date between 510 and 460 BC. On these cups the name of Uni, sometimes in the genitive, is painted before firing on the interior medallion.[23] The practice of commissioning temple service is also seen at Cerveteri in the case of Genucilia plates with the Greek name Hera from the end of the 4th century BC or the first decades of the 3rd century BC.[24]

An example of an inscription mentioning Śeχ alone is painted on a Spurinas cup in the Vatican.[25] Unfortunately, this cup is without a provenance, but presumably it was commissioned for a sanctuary, maybe in northern Etruria, as the alphabet seems to be sub-archaic North Etruscan (**Fig. 6**).[26]

The skyphos fragments Ps 93 (**Fig. 3**) were found between the quadrants XXIII,3/25; XXII,4/21; XXIII,8/5 and XXIII,9/11, and during the campaign of the year 2000 appeared in quadrant XXIII,9/6-7 a fragment of an Attic black-figured lekythos with part of a Greek inscription [?]κορ[...](Ps 86) (**Fig. 7**).

The inscription [?] κορ[---]may be translated as "young girl" or "daughter", and is especially used for Demeter's daughter Kore/Persephone, to whom the ruler of the Underworld took a serious interest and eventually made his consort.[27] This strongly indicates that a Greek visitor to the sanctuary found it natural to identify Cavaθa Śeχ as the Etruscan equivalent of Kore/Persephone. This has repeatedly been pointed out by G. Colonna[28] followed by Maras.[29]

The chthonic aspect of this female divinity also appears from her name being mentioned in conjunction with Śur/Śuris on a dedication incised on a Greek kylix foot, of which two joining fragments were found during two separate campaigns at Pyrgi, Ps 1 and Ps 25 (**Fig. 8**).[30] The latter was found in the important deposit *xappa* in quadrant XXIII, 9/24, which was undisturbed, in contrast to the first fragment Ps 1 that was found already in 1984 in the quadrant XXIII, 6/3 of the Piazzale Nord, which had undergone a major reorganization, probably in the 4th century BC following the sacking by Dionysios in 384 BC.[31]

The altar lamda *with the deposit* kappa

The deposit *kappa*, where part of the joint dedication to *Cavaθa/Śuris*

Fig. 6 Spurinas cup with painted inscription Śeχ, Museo Gregoriano Etrusco inv. 17633, diam. 16.6 cm. (Photo Musei Vaticani).

Fig. 7 Drawing of fragment of Attic lekythos with Greek inscription, ca. 2 × 3 cm. (After *StEtr.* 69, 2003, 309).

305

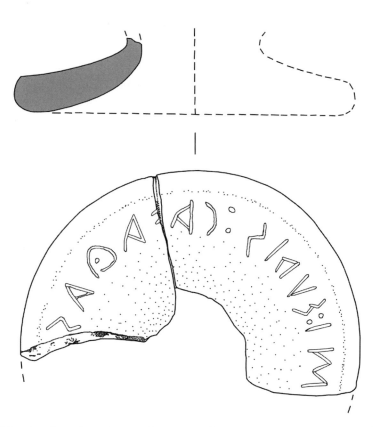

Fig. 8 Line drawing of two joining fragments of Attic kylix with dedication to Śuri and *Cavaθa*, diam. of foot 9 cm. (After *StEtr* 64, 1998, 376 (publ. 2001)).

appeared, belongs to the altar *lambda* in the quadrants XXIII,8 and XXIII,9. This altar is the most conspicuous in the Area Sud, consisting of a cylindrical block, with a diameter of nearly 4 m, to which a long ramp gives access to facilitate the leading of the sacrificial victims to the altar on top.[32] A Caeretan hydria from the last quarter of the 6th century BC may well be rendering such a procession (**Fig. 9**).[33] The superstructure has been totally destroyed, most likely during the afore-mentioned sacking of the sanctuary. Excavation of the remaining part has brought forward important material, especially remarkable are four bars of lead, weighing from 5,229 kg to 6,500 kg and a 5th bar weighing 38 kg.[34] These were thought by

Colonna and B. Belelli Marchesini to be a foundation offering especially intended for Śuri, the male part of the divine couple, to whom the altar *lambda*, as well as the deposit *kappa,* were dedicated.[35]

In the deposit *kappa* the objects were arranged around two rows of stone. A careful analysis of the position of the objects has allowed Maria Paola Baglione[36] and, continuing her work, C. Carlucci and D. Gentili[37] to form

Fig. 9 Caeretan hydria. Danish National Museum, Department of Ancient Cultures of Denmark and The Mediterranean inv. 13.567. H. 40.4 cm. (Museum photo).

an idea of the sequence of the ritual actions connected with the foundation. Between the stones there were remains of burnt offerings of sheep and vegetal seeds and, remarkably, a considerable number of pieces of mainly unworked bronze, weighing nearly 1000 g. Furthermore, there was an

Fig. 10 Painted terracotta panel from the Banditaccia necropolis at Cerveteri. Louvre inv. Cp 6626 H. 1.24 m. (After Roncalli 1965, pl. III).

impasto *olla* standing in a box protected by chips of tufa. It contained *i.a.* four lumps of bronze and a carnelian gem with an incision of a male figure. Next to this were two ox-ribs and an iron knife, as evidence of a sacrifice having taken place. The painted Campana panel in the Louvre shows several elements, *e.g.* the burning fire at the altar and the large metal cauldron, necessary for such a sacrifice (**Fig. 10**).

The presumed value of the offerings of lead and bronze may indicate that some official authority was involved in the inauguration ceremony.[38] The contents of the deposit, as well as those of the altar, point to an inauguration date in the first decades of the 5th century BC.[39]

In the second row of stones was buried another box, containing an alabastron in alabaster, an Attic ceramic alabastron and a packet of about six plaques of iron and bronze. On top was a *phiale* holding an offering of mussels.[40]

There was also a pair of female bust-protomes of Magna Graecian type, evoking associations to the sphere of a cult of Demeter and Kore

Fig. 11 Female bust-protome found in deposit *kappa*. (After *AnnFaina* 19, 2012, 256, fig. 24).

(**Fig. 11**).[41] In this connection it is interesting that recently a new fragment (Ps 122)[42] of a dedication to Demeter, made by a Greek called Eumakhos, has been found in the area in front of the sacello *beta*, which was dedicated to Cavaθa in conjunction with her consort Śur/Śuri.[43]

The presence of alabastra, epinetra, a glass oinochoe and gold jewellery, which all have connotations with the preparations for marriage,[44] under-

Fig. 12 Painted terracotta panel, Boccanera. H. 1.02 m. The British Museum Inv. 89/4-10/2. (After Haynes 2000, fig. 179.

line Cavaθa as Seχ, "the Daughter". Two of the painted terracotta panels from Cerveteri may give an idea of a cult procession, where these objects were used (**Fig. 12**).[45]

Dedications to Śur/Śuri at Pyrgi

Other objects in the deposit *kappa*, like the two colonnette kraters, seem to have Cavaθa's consort Śur/Śuri as the recipient, one having the inscription *mi fuflunusra* incised under the foot and showing a representation of Herakles enjoying a kantharos of Fufluns/Dionysos's gift.[46] The crater is attributed to the Tysckiewicz Painter and should be dated to ca. 470 BC.[47] Also the kantharos, with plastic heads of a satyr and a maenad belonging to the circle of Syriskos, has similar Dionysian connotations.[48]

Śur/Śuri's connection with the wine god is underlined by the inscription on the fragments of an archaic wine amphora [?]Śur[---][49] and also by the dedication *muras.arnth.θufl().śu{u}ris* on a later satyr statuette in the Vatican.[50]

Another joint dedication to Cavaθa and Śur/Śuri is possibly represented by an Attic sherd from Pyrgi [---]*s cav*[---] which Colonna has suggested should be understood as [? *mi Śuri*]*s cav*[*aθas*], and which has been accepted by Maras.[51]

A dedication to Śur/Śuri is incised on a fragment of a black-figured Attic sherd found in the quadrant XXIII, 1/17, *mi śu*[*ris*].[52] On a presumed Etruscan kylix, type C, which was found earlier, also in the quadrant XXIII, 1/17[53] there is the inscription *su* (*ET* Cr 3.58), which is likely to be an abbreviation of the same divine name.

A sanctuary for the joint cult of Cavaθa and Śur/Śuri

In contrast to the sacred area, dominated by the two monumental temples A and B, the Area Sud is characterized by several small and modest buildings. Of these the building *beta* with two cellae in the quadrant XXIII,2 is thought to be shared by the divine couple.[54] From this sanctuary originates a pair of gold earrings, probably[55] a foundation offering,[56] and an olpe of Ionian type usual for libations. A few pieces of the architectural decoration, one in the shape of a bust of the river god Acheloos (**Fig. 13**) suggest a date around 530 BC for the erection of this building, which, however, was badly damaged during the sacking of 384 BC.[57] It was replaced by the building of sacello *alpha* during a great reorganization of the sacred area around

the middle of the 4th century BC.[58] In the fill of a drainage canal under the north corner of the building was found the black-glazed skyphos fragment[59] with the inscription *mi.cavϑas,* a side-sherd of an Attic kylix with part of Cavaθa's name [---]θas[---]was found just outside the west wall[60] and in the pavement layer was found the impasto fragment of a basin Ps 48, also with part of a dedication to Cavaθa.[61]

Dedications to Cavaϑa outside Pyrgi

There are only a few examples of dedication to Cavaθa outside Pyrgi. At S. Feliciano del Lago, *i.e.* Lago Trasimeno, a bronze handle of a rather large patera or shovel has been found.[62] This would indicate a ritual function in a sanctuary, which, however, has not been identified. The upper side of the handle gives the name of the divine owner: a) *eca :kavϑaś : aχuiaś: persie* with the otherwise unknown epithet *aχuia,* while the underside has an incision with the name of a male donor: b) *avle numnaś turke.* This happens to be the only case of a donor having a first name as well as a family name, which in Etruscan society is the sign of high rank.[63] Maybe *persie* is the name of the object itself. The inscription in full view on the upper side is likely to have been pre-consecrated by the staff of the sanctuary, whereas the dedication of the donor is incised on the underside. The alphabet is North Etruscan and the object may be dated to the end of the 5th or the beginning of the 4th century BC.

Another example comes from old excavations at Populonia. There are two inscriptions by different hands on the underside of a well-preserved Attic owl skyphos. One, a) in the centre of the bottom, maybe a pre-consecration giving the name of the divinity *kavϑ/a,* while the second one b) *karmu kavzaś turke* is under the foot-ring, giving the name of the donor, who uses the diminutive of the divine name as a sort of endearment. The name *karmu* seems to be the Etruscan version of the Greek name Κάρμων, which indicates that he could be a slave, a former slave or, maybe, a Greek tradesman. The alphabet is North Etruscan, from the 2nd quarter of the 5th century BC, a date that fits well with that of the owl skyphos.[64]

The name *Cauϑas* initiates a long inscription incised on a lentoid disc made of lead which was found at Magliano in 1882 during agricultural works. The area of Magliano (Provincia di Grosseto) is situated between Northern and Southern Etruria and the alphabet is a South Etruscan version of the 5th century BC. The inscription has recently been studied by R.

Fig. 13 Terracotta acroterion in the shape of Acheloos from the first building *beta*. (After *AnnFaina* 19, 2012, 251, fig. 5).

Massarelli, who, regrettably, has not been able to present a full interpretation, but his analysis clarifies that it seems to give instructions for rituals to be performed at certain times at certain places for several divinities, the first mentioned being *Cauϑa*.[65] However, his analysis does not contribute further in illuminating the character of Cavaθa, apart from confirming that she is a female divinity.[66] Massarelli refers to another recent study of the name by G. Giannecchini, who suggests that Cavaθa simply means "The Girl".[67] Giannecchini suggests the hypothesis that the root **cau* had a more general significance in Etruscan, having to do with the faculty of sight.[68] He then proceeds to establish a link between the "eye" or the "pupil of the eye" and "pupil" meaning a young person or girl, arguing that *cav(aϑ)a* literally corresponds to Greek κόρη.[69] This would, of course, make the gift of the Greek vase inscribed [-?-]κόρ[---] very natural, but would, indeed, make the epithet *Seχ* added on the two Attic skyphoi rather redundant and, therefore, the hypothesis seems unconvincing.

Massarelli also finds support for his idea in the gloss by Dioscorides[70], who mentions a plant which the Romans called "the eye of the Sun", while others called it "millefolium" and the Etruscans named it καυτάμ.[71] A. Maggiani has pointed out the incompatibility of the Latin expression "eye of the Sun" with the concept of the chthonic aspect of Cavaθa, which has repeatedly been underlined by Colonna and Maras and also by Maggiani himself.[72]

Furthermore, it should be noted that καυτάμ is spelt with the letter tau (τ), whereas CavaϑalKauϑa always has theta (θ), the graphic signs of the two letters being quite different, as well as the sounds they represent. They are not interchangeable at will, neither in Greek or Etruscan and, accordingly, the gloss by Dioscorides should be disregarded as irrelevant for the Etruscan name Cavaθa.

Dedications to Apa

A number of dedications to *Apa* or, in a shortened form, *pa* have also been found in the Pyrgi Area Sud.[73] The name means "Father" or "Grandfather" and in 1991 it was suggested by Colonna,[74] followed by Maras[75] that it be an epithet to Śuri.

Recently one more black-glazed cup, with the graffito *pa*, has appeared in the new excavations at Pyrgi. In this case the ritual function for libations is obvious from a circular hole drilled under the rim.[76]

Lately, however, Colonna has drawn attention to finds from Cerveteri, where the example of *apa*[-?-] from località Sant'Antonio clearly is connected with Hercle and so are three more examples from La Vigna Parrocchiale.[77] Accordingly, it seems that *Apa* may be used as an epithet for several divinities.

Dedications to Śur/Śuri, as well as to *Apa,* have appeared at other sanctuaries apart from the Area Sud of Pyrgi.[78] At the large Belvedere temple at Orvieto was a grey bucchero sherd with the incision *Sur*.[79] The alphabet is sub-archaic North Etruscan from the end of the 6th century BC (**Fig. 14**).

There are more dedications mentioning the epithet *Apa* of this divinity, again on sherds from small bowls made of grey bucchero from the same excavations of 1930–1933,[80]clearly referring to the cult of the temple, which Colonna believes was addressed to the same divine couple as those venerated at Pyrgi.[81]

In the recent excavations of Campo della Fiera, at the foot of the Orvieto

Fig. 14 Grey bucchero fragment with dedication to *Sur* from the Belvedere temple, Orvieto. (After *AnnFaina* 19, 2012, 220, fig. 4).

hill, a cup in grey bucchero with the inscription *Apas* was found near an altar (**Fig. 15**).[82] The type of cup, as well as the paleography, suggests a date at the end of the 5th century BC.

Recently M. Torelli has suggested that a small sanctuary with two cellae at Gravisca may have been dedicated to Śuri and Cavaθa, based on the contents of a rich deposit from the 5th century BC.[83]

Possible representations of Śur/Śuri

Also at Campo della Fiera at Orvieto a number of cippi made in a bluish/black volcanic stone, some of them decorated with an arrow in relief, have appeared. They have been interpreted as aniconic symbols of Śur/Śuri.[84] Colonna has also suggested that some antefixes which have recently been found in the city area of Vulci show a representation of Śur/Śuri holding a lightning rod between his teeth.[85]

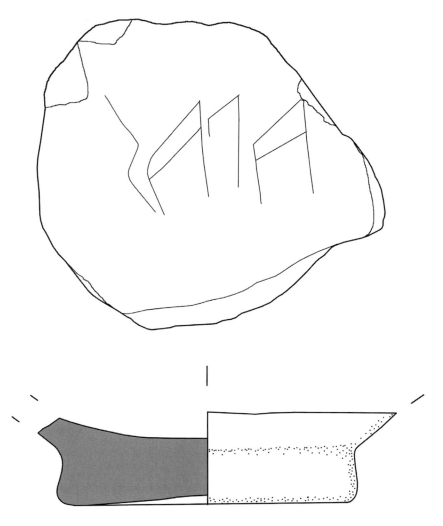

Fig. 15 Grey bucchero fragment inscribed *Apas* from Campo della Fiera, Orvieto. (After *AnnFaina 16*, 2009, 469, fig. 29).

Possible representations of Cavaθa and Śur/Śuri.

There has so far not been found any inscription at Orvieto mentioning Śur/ Śuri's consort Cavaθa, apart from the skyphos in the Ny Carlsberg Glyp- totek, with the provenance given as Orvieto, but we may have a double portrait of the divine couple in some small antefixes of roof tiles.[86] They

Fig. 16 Antefix with a relief of the divine couple Hades and Persephone from the Cannicella sanctuary, Orvieto. (After *StEtr* 75, 2009, pl. I, c).

show a frontal view of the heads of a male and a female in the style of the 2nd half of the 5th century BC (**Fig. 16**). These antefixes are likely to originate from the minor sanctuary of the Cannicella complex, which is located at the foot of the city hill in close proximity to the necropolis. The complex has a most untraditional plan, indubitably conditioned by cult practices that seem dependent on the presence of water.[87] Evidence of this is a well at the entrance to one of the cellae and a multitude of basins, water containers and channels. It is in this building that the remarkable half life-size statue of the naked goddess was found.[88] Apart from the cult statue of the naked goddess that, presumably, belongs to the end of the 6th century BC, there were at least two more statuettes of naked women and the legs of another larger naked woman from the 4th or the 3rd century BC.[89] Furthermore, there was a statuette in a late classical style of a dressed woman[90] hastily moving away and raising her hand in a defensive gesture, not unlike the woman on the Glyptotek skyphos.

The ex-votos, covering a period from the end of the 6th to the beginning of the 3rd century BC, include some statuettes of devotees of both sexes, but mostly they consist of weaving weights, bobbins and spindles, indicating that the frequenters were mainly women.

The emphasis of the Cannicella sanctuary at Orvieto is obviously a concern for fertility and the visits of the women may well have taken place in connection with important events of their lives, *e.g.* marriage and birth.

Conclusion

The excavations at the Area Sud at Pyrgi have brought to light a considerable number of dedications to a female divinity called Cavaθa, in one instance with the epithet Seχ which also appears on the inscription on the Glyptotek skyphos (**Fig. 1a-1b**). The most important of them, including the joint dedication to Cavaθa and her partner Śuri have been found *in situ* in the deposit *kappa* belonging to the large altar *lambda*. Part of a sanctuary with two cellae (sacello *beta*) is likely to be the location where they were originally worshipped.

The structure of the altar *lambda* and the arrangement of the objects in the most important deposit give an idea of the sacrificial ritual performed there. The value of the foundation offerings points to official authorities being involved. It has recently been suggested by Moore that Cavaθa was particularly a divinity of the elite.[91] However, the few instances where the donors are mentioned their names reveal a modest status. Female names: Ps 47, *ra,* short for *ramθa* or *ravnθu*[92]; Ps 6, [...]*uma,* being the ending of *setuma* or *vinuma.*[93] Male names: Ps 4+ Ps 39, *cne[i]ve*;[94] Ps 8, *la,* short for *larθ,*[95] none of these possessing a family name, which in Etruscan society is the indispensable sign of high rank.[96]

At Orvieto there are no documented dedications to Cavaθa, but much evidence for a fertility cult of a female divinity. At Gravisca there may have been a small sanctuary for Cavaθa and her consort.[97]

In northern Etruria there are isolated examples of archaic dedications to Cavaθa at Populonia and S. Feliciano del Lago, but no sanctuaries have been located.

Neither Cavaθa nor her partner Śur/Śuri are known in the theological system elaborated much later and known to us *e.g.* from the Piacenza Liver, dated to the 2nd or 1st century BC. Being indigenous divinities venerated in the archaic period they were only gradually assimilated to Greek gods

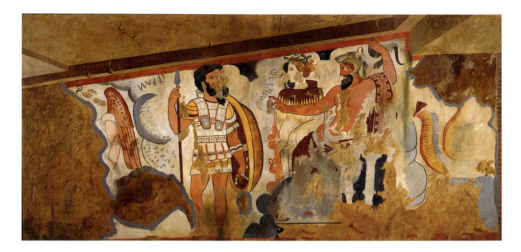

Fig. 17 Facsimile of wall-painting from Tomba dell'Orco II, Tarquinia, 1897. Ny Carlsberg Glyptotek H.I.N.126 (I.N. 1614). (Museum photo).

through the contact between Greek visitors and merchants and Etruscan priests taking place in a harbour town like Caere/Pyrgi. An iconography of these indigenous deities mentioned on the votives was developed only gradually by artists trained in the Greek pictorial tradition. Thus responding to the demands of the donors and the priesthood of sanctuaries with cults introduced about the last quarter of the 6th century BC and the 1st quarter of the following century, as exemplified by the sacello *beta* adorned with Greek inspired architectural decoration about 530 BC, and the altar *lambda* from the first decades of the 5th century BC.

A graphic example of the knowledge of Greek myths, combined with Etruscan religious notions from about the middle of the 4th century BC, can be seen at Tarquinia on the back wall of the Tomba dell Orco II, which shows the three-headed Geryoneus, named in Etruscan *cerun*. He is standing in front of the rulers of the Underworld inscribed *phersipnei* and *aita* corresponding, to Persephone and Hades (**Fig. 17**).[98]

From about the same time, we have the Tomba Golini I at Orvieto, with the divine couple, with their names *eita* and *phersipnei* inscribed, being present at the banquet in the Afterlife (**Fig. 18**).[99] At this time the Greek names, albeit in the Etruscan versions,[100] have completely ousted the

indigenous names for these chthonic powers, as the lack of dedications to Cavaθa after the 4th century BC indicates.

Cavaθa and Śur/Śuri constitute an example of a phase in the process of giving human shape to more amorphous notions of the divinities.[101] An earlier phase is demonstrated by the red-figured skyphos (**Figs. 1–2**), still using the Etruscan name Cavaθa about the middle of the 5th century BC.

Fig. 18 Facsimile of wall-painting from Tomba Golini I, Orvieto, 1899. Ny Carlsberg Glyptotek H.I.N.153 (I.N. 1691). (Museum photo).

The motif of the fleeing woman was hardly chosen at random by the priest-hood of the sanctuary who ordered the inscription of ownership. This was no doubt because it was seen as appropriate at a time, when the interpretation of Cavaθa as Kore, and the myths connected with her and Hades, were beginning to be generally accepted by the Etruscan devotees.[102]

Actually, this is a good example of a phase in the assimilation process.

NOTES

1 Ny Carlsberg Glyptotek IN 2718. H.16,9 cm; diam. of mouth ca. 20,8 cm; diam. of foot 13 cm. I am grateful to the Director of the Ny Carlsberg Glyptotek for allowing me to examine the piece. Bibliography: Bruhn 1938, p. 127 f. *ARV*² 898,139; Beazley Archive record no. 211895; Rix 1989–1990, n. 50, 338–340, pl. 54; Cristofani 1992, 347ff; Colonna 1991–1992, 99; Cristofani 1993, 11; Colonna 1994, 368; T. Fischer-Hansen in: Moltesen 1995, 35, 206–207, no. 111; Maggiani 1997, 23; Steinbauer 1999, 260; Reusser 2002, I, 42; Roncalli 2003, 224; Fischer-Hansen 2004, 84 f. no. 38, pls. 65–66; Colonna 2004, 70; de Grummond 2004, 359; Colonna 2006, 140; Maras 2009, 429 (Vs co. 4); *ET* 2014, 2, 521 (Vs 3.9).

2 Rix 1989–1990, 338–340.

3 TLE² 127, 138, 139, 193, 582.

4 Ps 93 (*ET* Cr 3.33) Maras 2003, 316–318 no. 26.

5 On prohibition, Maras 2009, 99. On *nuna, ibid.*,87 f.

6 Maras 2003, 318 f. no. 28, Ps 95.

7 18 pieces are listed in Maras 2009, 333–367; Maras 2013, notes 31–32.

8 Ps 1+Ps 25 (*ET* Cr 3.36), Ps 4+Ps 39 (*ET* Cr 3.46), Ps 6 (*ET* Cr 3.29), Ps 17, Ps 18, Ps 19+Ps 33 (*ET* Cr 3.40), Ps 45 (*ET* Cr 3.49), Ps 95 (*ET* Cr 3.35), Ps 98 (*ET* Cr 3.45), Ps 108 (*ET* Cr 0.79).

9 Colonna & Maras 1998, 376 no.36.

10 Colonna 1989–1990, 316 no.26.

11 Bloesch 1940, pls. 34,4 and 34,5, 124–126 "Nordabhang-Schalen, die fortschrittliche Richtung."

12 Williams 1993, no. 46, pl. 65 fig. 11c.

13 Ps 5 (*ET* Cr 3.51), Ps 8 (*ET* Cr 3.53), Ps 41 (*ET* Cr 3.47), Ps 42 (*ET* Cr 3.63), Ps 44 (*ET* Cr 3.48), Ps 47 (*ET* Cr 3.56), Ps 93 (*ET* Cr 3.33).

14 Maras 2003, 316–318.

15 Colonna & Maras 1998, 381 no. 42.

16 Colonna & Maras 1998, 393 f. no. 59.

17 Colonna/& Maras1998, 419. *Cathas* appears once as part of a dedication on a bronze weight or small cippus of unknown origin inscribed in a South Etruscan alphabet of the recent period (*ET* OA 2.13).

18 *ET* Ta 1.17.

19 *ET* Pa 4.2

20 *ET* Cl 1.1628 and *ET* Cl 1.2464

21 Moore 2018, 58–77.

22 Maras 2013, 198 f., fig.4. For a possible phonetical development from Cavaθa to Caθ/Caθa in the neo-Etruscan period, see Rix 1989–1990, 340; Colonna 1991–1992, 101; Maras 2013, 204.

23 Maras 2009, 360 f., Py pr. 1, Py pr. 2, Py pr. 3.

24 Colonna 2004, 94 Fig. 13.

25 Museo Gregoriano Etrusco inv. 17633

26 Bernardini 2001,141 no. 78; Maras 2009, p. 319 OI pr. 3 with bibliography.

27 Maras 2003, 308 f. no. 19, = Ps 86.

28 Colonna 2003, 33; *Idem* 2004,70.

29 Maras 2013, 202 f.

30 Ps 1: Colonna 1991; Colonna 1989–1990, 313 no. 21, pl. 58. Ps 25: Colonna &Maras 1998, 376 n. 36; Colonna, 1995 442 fig. 11a; Maras 2009, 340, Py co.17 with bibliography.

31 Baglione 2000, 373f. note 91.

32 Colonna 2006, 138, fig. VIII,11; Stein-gräber & Menichelli 2010, 62 f.

33 Danish National Museum, Coll. of Classical Antiquities inv. 13.567. H. 40,4 cm.; Friis Johansen 1962, 61–81; Hemelrijk 1984 no. 15, 29 f., pl. 9.

34 Colonna 1995, 442, pl. 54a and c; map of area fig. 9.

35 Colonna 1997, 95; Belelli Marchesini *et al.* 2012, 237 f. with note 62.

36 Baglione 2000, 340 ff.

37 Carlucci/Gentili 2012, 233–239.

38 Belelli Marchesini *et al*. 2012, 238.

39 Carlucci/Gentili 2012, 233.

40 Baglione 2000, 344, fig 9.

41 Belelli Marchesini *et al*. 2012, 256 fig.24.

42 Maras 2013, 203.

43 Colonna 2004, 72; 93 figs.
 7–8. *Idem* 1998, 419.

44 Carlucci/Gentili 2012, 254 f., 257, figs 17,
 21, 22, 28, 29, 6cf; Baglione 2000, 380.

45 Roncalli 1965, 67–73, pls. 14–15.

46 Ps 26 (*ET* Cr 3.30) Carlucci/
 Gentili 2012, 256, fig. 25.

47 Baglione 2000, 348 f., fig. 18.

48 Baglione 2000, 347, figs. 14–15.

49 Ps 91 (*ET* Cr 3.30) Maras 2009, 334, Py co.3.

50 (*ET* Vc 3.16) Buranelli 1989,72 ff. n.196;
 Bentz 1992, 210; Sannibale 2007, 133 ff., pl.
 32, a-c, fig.7; Maras 2009, 402 f., Vc do.5.

51 Ps 7 (*ET* Cr 3.52)

52 Ps 2 (*ET* Cr 3.32) Colonna 1989–1990, 314 n.
 22, pl. 58 = Ps 2; Maras 2009, 338, Py co. 13.

53 Colonna, *ibid*. n.23, pl. 59 = Ps 3;
 Maras 2009, 345, Py co. 28.

54 Colonna 2004, 71 with note 14; Bele-
 lli Marchesini *et al*. 2012, 251, fig. 3.

55 Belelli Marchesini *et al*. 2012, 253, fig. 12.

56 Colonna 1995, 445, pl. 52 d-f.

57 Belelli Marchesini *et al*. 2012, 229; 251,
 fig.4: antefix with female head, fig.5:
 acroterion in the shape of Acheloos.

58 Baglione 2000, 373 f. note 91.

59 Ps 47 (*ET* Cr 3.56), Colonna &
 Maras 1998, 392 no. 58.

60 Ps 98 (*ET* Cr 3.45) Maras 2003, 323 no. 31.

61 Colonna 1995, 444 f.

62 (*ET* Pe 3.1) Maras 2009, 327 Pe do.2 with
 bibliography; L. of handle 42,7 cm.

63 Maras 2009, 210.

64 (*ET* Po 3.2+4.2) Maras 2009, 330–332,
 Po do.1, with bibliography. NB new
 reading by Maras, based on autopsy.

65 (*TLE*² 359. *ET* Av 4.1);
 Massarelli 2014, 42 f., 241 ff.

66 The Magliano inscription seemingly also
 mentions Śuris in the group *śuriseisteis*,
 but the interpretation remains uncertain.
 See on the subject Colonna 2009, 9–32.

67 Giannecchini 2008.

68 Giannecchini 2008, 138 f.

69 Giannecchini 2008, 158 f.

70 Dioscorides, who lived in the 1st century
 AD was interested in the pharmacological
 qualities of plants, and his work is transmit-
 ted through the works of the Greek medical
 writer Galen of the 2nd century AD.

71 *TLE*² 823.

72 Maggiani 1997, 45.

73 Ps 10, Maras 2009, p. 339 ff. Py co. 16 (ET
 Cr 2.170): *apa*, from quadrantino XXIII,1.
 Ps 13, *ibid*. Py co. 21: *pa* from
 quadrantino XXIII, 1/16.
 Ps 38, *ibid*. Py co. 20: [---]*apa*[---
] from quadrantino XXIII, 6/7.
 Ps 49, *ibid*. Py co. 29: [-?-]*pa*[-?-]
 from Quadrantino XXIII, 6/18.

74 Colonna 1989–1990, 318.

75 Maras 2009, 150 f, 339.

76 Colonna 2014, 99 pl. 23b.

77 Colonna 2017b, 152.

78 Chiusi: Maras 2009, Cl sa.1, lead sheet
 (defixio?), Archaic. Arezzo: Maras *op.cit*. Ar
 co.3, lead disc = cleromantic sors, 2nd cen-
 tury BC. Tarquinian area: Maras *op. cit*. AT
 co.2, bronze bar=sors, 4th-3rd cent. BC. Tar-
 quinia: Maras, *op.cit*. Ta co.19, nenfro block=
 border stone of temenos, mentioning Śuris
 and *Selvansl*, 4th century BC; Ta do.5, large
 bronze statuette of boy, 3rd century BC, also
 mentioning [śu]ris;selvansl: Perugia, Maras,
 op.cit. Pe co.3, stone block, late Etruscan.Vul-
 ci: Maras *op.cit*. Vc sa.1, stone block, 4th-3rd
 century BC; Maras, *op.cit*. Vc do.5, bronze
 satyr statuette, 3rd cent BC, Maras, *op.cit*.
 Vc co.1, impasto plate, 6th cent. BC. Volt-
 erra: Bonamici 1987–1988, 276 ff. on cult on
 the acropolis before the erection of the two
 Late Hellenistic buildings. See also Colonna
 2007 and 2009 on Śur/Śuri. Outside Etruria
 a Spurinas cup with a pre-painted inscrip-
 tion *apa* has appeared in a closed deposit in
 Southern Gaul, well dated by Attic pottery
 to the third quarter of the 5th century BC.
 Gailledrat *et al*. 2016, 268 ff. This, however,
 should hardly be taken as evidence of a cult
 in that region, but it may be part of looting
 from the sanctuary it belonged to and then
 became mixed with ordinary goods for trade.

79 *CIE* 10537 (*ET* Vs 0.6). Scavi 1930–1933,
 Minto 1934, p. 86 n.8, fig. 13; Ron-
 calli 2003, 223; Maras 2009, 427 f., Vs
 co.1. Colonna 2012, 206, 220 fig. 4.

80 Minto1934, 86, fig. 14; Maras
 2009, 428 Vs co.2 and Vs co.3.

81 Colonna 1991–1992, 74;75; 104.
 Colonna & Maras 1998, 422.

82 Stopponi 2009, 436 with
 note 56, 469, fig. 29.

83 Torelli 2018, 297.

84 Colonna 2012, 207, 221fig. 5.

85 Colonna 2009, 16, pl.3a. Colour in
 de Grummond 2016, 205, fig. 15.

86 Andrén 1967, 64, pl. 27b; Colonna 1987,

14 and 23, fig. 5; Colonna 2006, 150, fig.
VIII, 29; Colonna 2009, 14, pl. I c.

87 Roncalli 1987, pl. 3, fig. 5.

88 Andrén 1967, no. 1, pls. 16 -17. H.:
0,765; Cristofani 1987, pls.1–8.

89 Colonna 1987, pl. 3 fig. 8.

90 Andrén 1967, no. 27, h.: 0,15 m; Col-
onna op.cit., pl. 4, figs.11–12.

91 Moore 2018, 58.

92 Maras 2009, 343 f.

93 Maras 2009, 356.

94 Maras 2009, 357.

95 Colonna & Maras 1998, 417.

96 Torelli 2018, 296.

97 idem, op.cit., 297 suggests that a small
double sanctuary is likely to have been
dedicated to Śuris and Cavaθa, based

on the contents of a rich deposit from
the 5th century BC; Stopponi 2020

98 The most reliable illustration is the facsimile
made in 1897 for The Ny Carlsberg Glyp-
totek, Copenhagen. H.I.N.126 (I.N.1614).
Moltesen & Weber Lehmann 1991, 90–91.

99 This also applies to the facsimile H.I.N. 153
(I.N. 1691) made in 1899. Moltesen & Weber
Lehmann 1991, 134–137. It is worth noticing
that in both tomb paintings the name of the
female goddess starts with a sign looking like
the Greek φ, whereas the p inside the name is
the usual Etruscan p. cf Roncalli 2003, 225.

100 Torelli 2018, 296.

101 cf Cristofani 1993, passim.

102 cf Maggiani 1997, 48–50; Maras 2017, 300 f.

BIBLIOGRAPHY

A. Andrén, 1967
Il santuario della necropoli di Cannicella ad
Orvieto, StEtr 35, 1967, 41–85.

ARV² 1963 = Attic Red-Figure Vase-Painters.
Oxford.

AnnFaina = Annali della Fondazione per il Museo
Claudio Faina.

M. P. Baglione 1989–1990
Considerazioni sui santuari di Pyrgi e di
Veio Portonaccio, Scienze dell'Antichità, 3–4,
1989–1990, 651–668.

M. P. Baglione 2000
I rinvenimenti di ceramic attica dal santuario
Sud, Scienze dell'Antichità 10, 2000, 337–382.

M. P. Baglione 2004
Il santuario Sud di Pyrgi. Beiheft zum Corpus
Vasorum Antiquorum.
Deutschland II, Munich, 2004, 85–106.

J. D. Beazley 1963
Attic Red-Figure Vase-Painters. Oxford.

B. Belelli Marchesini, et al. 2012
Riflessioni sul regime delle offerte nel santuario
di Pyrgi, AnnFaina 2012, 227–263.

M. Bentz 1992
Etruskische Votivbronzen des Hellenismus.
Florence.

C. Bernardini 2001
Il Gruppo Spurinas.Viterbo 2001.

H. Bloesch 1940
Formen attischer Schalen. Bern 1940.

M. Bonamici 1987–1988
Volaterrae. REE / StEtr LV, 1987–1988 [1989],
275–279.

A. Bruhn 1938
From the Collections of the Ny Carlsberg Glyptothek
II. Copenhagen 1938.

F. Buranelli. & M. Sannibale 1989
La Raccolta G. Guglielmi. (Catalogo della
Mostra). Città del Vaticano, 1989.

C. Carlucci & M. D. Gentili 2012
I contesti di carattere rituale nell'Area Sud nel
V sec. A. C., in: Belelli Marchesini, et al. 2012,
233–239.

G. Colonna (ed.) 1985
Santuari d'Etruria. Milan 1985.

G. Colonna 1987
I culti del santuario della Cannicella, AnnFaina
3, 1987, 11–26.

G. Colonna, 1989–1990
Pyrgi, REE/StEtr 56, 1989–1990 [1991], 316–324.

G. Colonna 1991–1992
Altari e sacelli. L'area sud di Pyrgi dopo otto anni
di ricerche, RendPontAcc 64, 1991–1992, 63–115.

G. Colonna 1993
A proposito degli dei del Fegato di Piacenza, *StEtr* 59, 1993, 123–139.

G. Colonna 1994
L'Apollo di Pyrgi, in: *Magna Grecia, Etruschi, Fenici. Atti del XXXIII Convegno di Studi sulla Magna Grecia* (Taranto, 8–13 ottobre 1993), Taranto, 1994, 345–375.

G. Colonna 1995
Scavi e scoperte. Pyrgi, *StEtr.* 61, 1995 [1996] 440–446.

G. Colonna 1997
Divinités peu connues du pantheon étrusque, in: Gaultier & D. Briquel(eds.), *Les Étrusques, les plus religieux des hommes*, (Actes du Colloque international Paris 1992), Paris 1997, 167–84.

G. Colonna 2003
Iscrizioni greche, *REE/StEtr* 69, 2003, 308–312.

G. Colonna 2004
I greci di Caere, *AnnFaina* 11, 2004, 69–94.

G. Colonna 2006
Sacred Architecture and the Religion of the Etruscans, in: N. T. de Grummond & E. Simon, (eds.) *The Religion of the Etruscans,* Austin, 2006, 132–168.

G. Colonna 2007
L'Apollo di Pyrgi, Śur/Śuri ("il Nero") e l'Apollo Sourios', *StEtr* 73, 2007 [2009], 101–134.

G. Colonna 2009
Ancora su Śur/Śuri. 1. L'epiteto *Eista ("il dio"); 2. L'attributo del fulmine,' *StEtr* 75, 2009 [2012], 9–32.

G. Colonna 2012
I santuari comunitari e il culto delle divinità catactonie in Etruria, *AnnFaina* 19, 2012, 203–226.

G. Colonna 2010–2013
Nuovi dati sui porti, sull'abitato e sulle aree sacre della Pyrgi etrusca., *St Etr* 76, 2010–2013 [2014], 81–109.

G. Colonna 2017a
Śuri, non *Śuris, *StEtr* 80, 2017, 149–150.

G. Colonna 2017b
Apa come epiteto di Hercle, *StEtr* 80, 2017, 151–155.

G. Colonna & M. P. Baglione 1997
Appendice I', in: A. Maggiani 1997a, 83–98.

G. Colonna & D. F. Maras 1998
REE Pyrgi, *St Etr.* 64, 1998 [2001], 369–422.

M. Cristofani 1987
La "Venere" Della Cannicella, in: *AnnFaina*, III, 27–39.

M. Cristofani 1992
Celeritas Solis filia, in: *Kotinos* (Festshcrift E. Simon), Mainz a/Rhein 1992, 347–349.

M. Cristofani 1993
Sul processo di antropomorfizzazione nel pantheon Etrusco, in: *Miscellanea etrusco-italica* I, 1993, 9–21.

CVA = Corpus Vasorum Antiquorum

N. T. de Grummond 2004
For the Mother and for the Daughter. Some thoughts on Dedications From Etruria and Praeneste, H*esp.Suppl.* 33, 2004, 351–370.

N. T. de Grummond 2005
Roman Favor and Etruscan Tufl(tha): a note on Propertius 4.2.34, *Ancient West and East*, 4, 2005, 296–317.

N. T. de Grummond. & Erika Simon (eds.) 2006
The Religion of the Etruscans. Austin 2006.

N. T. de Grummond 2008
Moon over Pyrgi: Catha, an Etruscan Lunar Goddess, *AJA* 112, 2008, 419–28.

N. T. de Grummond 2016
Dressing and Undressing the Goddess from the Cannicella Sanctuary, Orvieto, in: A. Ancillotti, A. Calderini, R. Massarelli (eds.), *Forme e strutture della religione nell'Italia mediana antica, Atti del III Convegno di Studi Umbri dell'IRDAU, Istituto di Ricerca e documentazione sugli Antichi Umbri* (Perugia-Gubbio, 2011), Rome 2016, 189–203.

G. M. Della Fina (ed.) 2003. *Storia di Orvieto I Antichità*. Perugia 2003.

ET = Etruskische Texte. Editio minor. 1–2
Etruskische Texte, editio minor. Auf Grund der Erstausgabe von Helmut Rix neu bearbeitet von Gerhard Meiser, in Zusammenarbeit mit V. Belfiore und S. Kluge (Studien zur historisch-

vergleichenden Sprachwissenschaft 4), Hamburg 2014.

Etrstud
Etruscan Studies. Berlin/Boston: De Gruyter.

T. Fischer-Hansen 2004.
CVA Denmark Ny Carlsberg Glyptotek, fasc. I (Denmark 10). Copenhagen 2004.

K. Friis Johansen 1962
Eine neue Caeretaner Hydria, Opuscula Romana 4, 1962, 61–81.

E. Gailledrat et al. 2016
The Etruscans in Southern Gaul during the 5th Century B.C.E.: A Vessel of the "Spurinas" Group discovered at the Settlement of La Monédière in Bessan (Hérault, France), Etrstud 19, 2016, 256–282.

G. Giannechini 2008
Sulla semantica del teonimo Cautha, in: G.M. Facchetti (ed.), Mlax mlakas. Per Luciano Agostiniani, Milan 2008, 135–165.

R. Hägg 1998
Osteology and Greek sacrificial practice, in: R. Hägg (ed.) Ancient Greek cult practice from the archaeological evidence. Proceedings of the fourth international seminar on ancient Greek cult, organized by the Swedish Institute at Athens, 22–24 October, 1993, Athens 1998, 49–56.

S. Haynes 2000
Etruscan civilization. A cultural history. Los Angeles 2000.

J. M. Hemelrijk 1984
Caeretan Hydriae I-II. Mainz a/R 1984.

J. MacIntosh Turfa 2006
Votive Offerings in Etruscan Religion, in: N. T. de Grummond & E.Simon (eds.), The Religion of the Etruscans, 2006, 90–115.

A. Maggiani 1990
Alfabeti etruschi di etá ellenistica, AnnFaina 4, 1990, 177–217.

A. Maggiani 1997
Vasi attici figurati con dediche a divinità etrusche, RdA Suppl. 18, 1997.

D. F. Maras 2003
Iscrizioni etrusche, REE/StEtr 69, 2003, 315–334.

D. F. Maras 2009
Il dono votivo. Pisa/Roma 2009.

D. F. Maras 2013
Area Sud: Ricerche in corso sulla documentazione epigrafica (contesti, supporti, formulari, teonimi), in: M. P. Baglione, M. D. Gentili, D. F. Maras (eds.) Riflessioni su Pyrgi: scavi e ricerche nelle aree del santuario, Roma 2013, 195–206.

D. F. Maras 2016
Fortuna Etrusca, in: A. Ancillotti, A. Calderini, R. Massarelli (eds.), Forme e Strutture della religione nell'Italia mediana antica, (Atti del III Convegno di Studi Umbri dell'IRDAU, Istituto di Ricerca e Documentazione sugli Antichi Umbri Perugia-Gubbio, 2011), Roma 2016, 453–467.

D. F. Maras 2017
Religion, in: A. Naso (ed.), Etruscology, Oxford 2017, 277–316.

D. F. Maras 2018
Kings and Tablemates. The Political Role of Comrade Associations in Archaic Rome and Etruria, in: Beiträge zur Sozialgeschichte der Etrusker (Akten der internazionalen Tagung, Wien, 8.-10.6.2016), Wien 2018, 91–108.

R. Massarelli 2014
I testi etruschi in piombo. Pisa/Roma 2014.

A.Minto 1934
Orvieto. Scavi governativi al Tempio etrusco di Belvedere, NotScav ser.6 10, 1934, 67–99.

M. Moltesen & C. Weber-Lehmann 1991
Catalogue of the Copies of Etruscan Tomb Paintings. Copenhagen 1991.

M. Moltesen 1995
Catalogue. Greece in the Classical Period. Ny Carlsberg Glyptotek. Copenhagen 1995.

D. Moore 2018
The Etruscan Goddess Catha, Etruscan and Italic Studies 21, 2018, 58–77.

A. J. Pfiffig 1969
Die Etruskische Sprache. Graz 1969.

REE = Rivista di Epigrafia Etrusca in Studi Etruschi

C. Reusser 2002
Vasen für Etrurien I-II. Verbreitung und Funktio-

nen attischer Keramik im Etrurien des 6. und 5. Jahrhunderts vor Christus. Zürich 2002.

H. Rix 1989–1990
Rotfiguriger attischer Skyphos in Ny Carlsberg Glyptothek (Inv.Nr. 2718), *REE/StEtr* 56, 1989–1990 [1991], n.50, 338–340.

F. Roncalli 1965
Le lastre dipinte di Cerveteri. Firenze 1965.

F. Roncalli 1987
Le strutture del santuario e le tecniche edilizie, *AnnFaina* 3, 1987, 47–60.

F. Roncalli. 2003
I culti, in: *Storia di Orvieto* I. *Antichità*, Perugia 2003, 217–234.

Sannibale, M. 2007
Tra cielo e terra. Considerazioni su alcuni aspetti della religione a Vulci, *StEtr* 72, 2007, 117–147.

E. Simon 2006
Gods in Harmony: The Etruscan Pantheon, in: N.T. de Grummond & E. Simon (eds.), *The Religion of the Etruscans*, Austin, 2006, 45–65.

Sozialgeschichte 2018
L. Aigner-Foresti & P. Amann (eds.), *Beiträge zur Sozialgeschichte der Etrusker. Akten der internationalen Tagung* (Wien, 8.-10.6.2016), Wien 2018.

D.H. Steinbauer 1999
Neues Handbuch des Etruskischen. St. Katharinen 1999.

D. Steinbauer 2004
Zu Weihinschriften auf attischer Keramik, in: Beiheft zum *CVA Deutschland* II, München 2004, 107–113.

S. Steingräber & S. Menichelli 2010
Etruscan altars in sanctuaries and necropoleis of the orientalizing, archaic and classical periods, in: L. B. Van der Meer (ed.): *Material aspects of Etruscan religion. Proceedings of the international colloquium,* (Leyden May 29–30 2008), Leyden 2010, 51–74.

S. Stopponi 1985
Il santuario del Belvedere a Orvieto. in: Colonna (ed.) Santuari d'Etruria 1985, 80–83.

S. Stopponi 1990
Iscrizioni etrusche su ceramica attica, *AnnFaina* 4, 1990, 81–112.

S. Stopponi 2009
Campo della Fiera di Orvieto: Nuove acquisizioni, *AnnFaina* 16, 2009, 425–478.

TLE ² = *Testimonia Linguae Etruscae.* Florence 1968.

M. Torelli 2018
Intorno ai *servi* d'Etruria, in: Beiträge zur Sozialgeschichte der Etrusker. (*Akten der internazionalen Tagung, Wien, 8.-10.6.2016),* Wien 2018, 295–302.

R. E. Wallace 2008
Zikh Rasna. A Manual of the Etruscan Language and Inscriptions.
Ann Arbor/New York 2008.

D. Williams 1993
CVA The British Museum, fasc. 9 (Great Britain, fasc. 17), London 1993.

BINDING ETRURIA TOGETHER THROUGH MARRIAGE ALLIANCES

LA DONNA È MOBILE

MARJATTA NIELSEN

This contribution will look at the geography of social networking among the Etruscans by examining, through a few case studies, the evidence for marriage alliances between persons living in different Etruscan city-states. In recent years, such expressions of "soft power" have received widespread attention among sholars, also regarding wider geographical areas, as it was realized that not all cultural contacts, which are reflected in material remains, were necessarily due to the business of men – that is, to their mobility as merchants, artisans, warriors, chieftains and the like.

Among the Etruscans there are examples of "uxorilocal" marriages, where the husband settled down in the wife's community, but the norm was the "virilocal" marriage, which implies that it was the bride who moved to the house of her husband.[1] For decades, a wider and systematic mapping of Etruscan women being married elsewhere other than their communities of origin has been recognized as an important field of research. Maristella Pandolfini Angeletti, in connection with the marriage relations of the Curunas family in Tuscania, has suggested that a large-scale study on women's presence in communities other than their origin would give very interesting results.[2] More recently, Luciana Aigner-Foresti has stressed the importance of such studies, giving numerous examples of intermarriage relations from Southern Etruria.[3] And since the mid-1980s, the present author has also touched upon related issues.[4]

One might object to the concept of "marriage" arguing that it is anachronistic. Worldwide social anthropology has taught us about the many possibilities in the field of human relations, and these are, if any, subject to changes. However, the present-day rainbow family constellations in our part of the world appear far more exotic than those that can be documented by the present material. As the author Kjell Westö, my former compatriot, has expressed it: "Everything human is changeable". We have

no Etruscan literature, which would undoubtedly give us a more colour-ful picture of social relations. Greek secondhand gossip about Etruscans rearing all their children and not knowing who the fathers are, does not correspond to the Etruscan "obsession" with genealogies.[5] Likewise, the iconography of Etruscan couples in funerary art, from early on, demon-strates the ideal of close bonds between spouses.[6] The abundant and still growing literature on the institution of marriage in the ancient world, with all its legal, economic and social implications, bears witness to the great potentialities of the topic.[7]

The question of inter-ethnic marriages is the subject of much attention in the global world of today. In contemporary Denmark, this kind of "inter-connectivity" and its impact on society and culture has been felt as a politi-cal problem, to be regulated in detail – especially if, for example, there is a suspicion of arranged marriages involving underage girls.

Documenting Etruscan family relations: the gentilicial name system

What kind of source material do we have at our disposal when studying Etruscan marriage patterns? In this study the key evidence is the onomas-tic material. The art of writing was introduced among the Etruscans as early as the end of the 8th century BC, and most of the preserved inscrip-tions contain names. At the outset, individual names were common, but we can follow the birth of the gentilicial name system, with family names inherited from the father, parallel to the creation of a gentilicial society.[8] Yet, the early epigraphic material is too fragmentary and elusive to allow for a more precise geographical mapping of family names. This also applies to the Etruscan areas in Etruria Padana and in Campania that were more or less lost in the 5th century BC, although Etruscans did not vanish from there altogether.

The best-documented area is "Etruria proper", between the rivers Tib-er and Arno and the Tyrrhenian Sea. During the last four centuries BC, when this area was threatened by the Romans from the south and by the Celts from the north, there was an enormous epigraphic boom, as if the Etruscans wished to leave behind them detailed documentation about their very existence.[9]

Over the course of time, the name inscriptions tend to become more and more elaborate, and they may consist of the following elements:

praenomen: the first name, out of a narrow selection of male and female first
 names; in Southern Etruria, the first name often follows the family
 name;

gentilicium: the family name inherited from the father;

patronymikon: father's first name, often abbreviated;

cognomen: a personal nickname for men; it tended to become hereditary,
 designating different family branches;

matronymikon: the mother's family name;

gamonymikon: the husband's family name, mentioned for women but never
 the other way round.

It is no wonder, then, that all these onomastic elements provide plenty
of material for the study of genealogies and relations between persons
and families, both within and beyond the individual communities. Since
women kept their original *gentilicium* throughout life, and since both men
and women tell their mothers' names, there is much valuable material for
reconstructing marriage alliances. Family names that are ubiquitous, or
which only appear once, are of little use, but most others can be pinned
down on a map (**Fig. 1**). It is important to observe the gender of the per-
sons in question. Women's names may designate the women themselves as
daughters or wives, and the *matronymika* tell who the mothers of both men
and women were.

Since the purpose of this study is to give examples of interstate marriag-
es within Etruria proper, it is possible to utilize disparate source material:
funerary epigraphy; public or private documents from the "world of the liv-
ing", such as votive dedications, inscriptions on boundary stones and legal
documents; and even a few Latin texts regarding contemporary Etruscans.
Here we leave aside the much-exploited stories about legendary figures of
Etruscan origin in the early Roman history. And as to "Etruscan identity",
both the Etruscan speakers themselves and their neighbours understood
them as "Etruscans"; Roman sources call them all *Etrusci*, notwithstanding
their specific city-state.

Single-family tombs give a picture of who was buried with whom. Among
the many possibilities, the most common pattern followed the agnatic lin-
eage: men with a common, hereditary *gentilicium*, and their wives, their
sons and so on, through generations.[10] As we will see, even older tomb
contexts can be reconstructed with the help of inscriptions, since they have

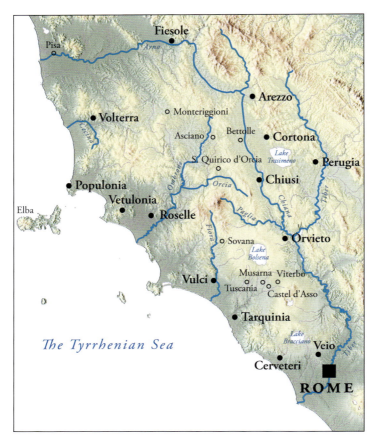

Fig. 1 Map of Etruria. The black dots indicate major Etruscan cities, the circles indicate minor Etruscan sites, most of them mentioned in the text. (Map by Thora Fisker and Janus Bahs Jacquet).

attracted scholarly attention for centuries. The family tombs were situated in the necropoleis of men's home towns, or close to their landed property and economic base. Women were buried in their husbands' family tombs – whether they were near or far away from their original home. We may speak of social endogamy, marriages within the same social class, but especially in elite circles the problem of finding the right match (for the fathers) often led to geographic exogamy.[11]

It is impossible for us to assume that we know the family names of all Etruscans. And yet, new discoveries of texts and tombs do not necessarily bring many new names to our knowledge. For example, of the twenty-seven *gentilicia* listed in the *Tabula Cortonensis*, only a few were new.[12]

Archaic Orvieto/Volsinii – mixing people and classes

An exception from the fragmented picture of the population of early Etruria is Orvieto/Volsinii, which is situated at a nodal crossroads point. In the Crocifisso del Tufo necropolis, the names of the grave "owners" are written loud and clear on the lintels of the tomb doors. The majority of the about 100 names give only male names, with no information about their wives. The inscriptions are all written in the Etruscan language, but many names are transparent and point to Faliscan, Latin, Umbrian and other Italic, as well as to Celtic and Greek origin – that is, to a considerable male mobility and the acceptance of "foreigners".[13]

The picture of Orvieto as an open city is further substantiated by a dedicatory inscription from the end of the 6th century BC which gives a case of a mixed marriage, both socially and geographically. The inscription in question is written on a statue base, discovered in the excavations of Campo della Fiera (**Fig. 2**).[14] Below the slopes of Orvieto, the easily accessible site has been convincingly identified as *Fanum Voltumnae*, the federal sanctuary of the Etruscans. The bronze statue itself is missing, but the sockets for the feet, with rests of iron dowels and lead fixing, indicate a standing statue of about one third human size. The statue was undoubtedly among the 2,000 *signa aerea* brought to Rome by Marcus Fulvius Flaccus following his triumph over Volsinii in 264 BC. Also in this case only the stone podium with a dedicatory inscription has survived in Rome. The reduced size of this statue makes the huge number of bronze statues more credible than the same number of full-sized statues would have been. The inscription tells that the statue was dedicated by a certain Kanuta, defined as a *lautenitha* of the Larecenas family, and Aranth Pinie's wife. *Lauthenitha* is later known in the shorter version, *lautnitha / lautnita*, designating freegiven female slaves, but it is difficult to define the character of her subordinate position in this period.[15] Her own individual name, Kanuta, comparable to the Osco-Campanian Canuties, may provide a hint about her origin.

Kanuta's former patrons, the Larecenas/Laricenas, belonged to the self-conscious Orvietan families; the name is known from the necropoleis of Crocifisso del Tufo and Cannicella.[16] Kanuta's husband's family name, Pinies, was not previously known from Orvieto. The best-known sign of the social status of later Pinies is their chamber tomb at Tarquinia, *Tomba Giglioli*, with late 4th century BC wall paintings and pseudo-sarcophagi directly carved into the rock.[17]

331

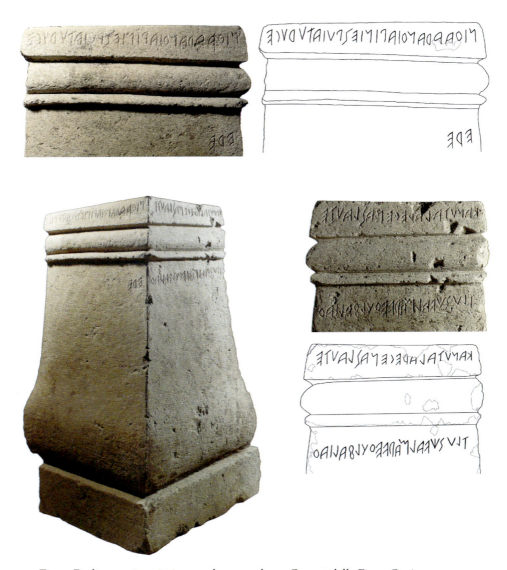

Fig. 2 Dedicatory inscription on the statue base, Campo della Fiera, Orvieto: *kanuta larecenas lauthenitha aranthia pinies puia turuce / tluschval marvethul faliatere*, interpreted as: "Kanuta, *liberta* of the Larecenas family, wife of Aranth Pinies, dedicated / to the deities of Tluschva (and) of Marveth at the Celestial Place". End of 6th century BC. Trachyte. Museo Archeologico Nazionale di Orvieto, inv. 510876. (Photo courtesy of Simonetta Stopponi).

The cultic implications of Kanuta's dedication have called forth some lively discussion, but in the present context it is sufficient to note that her (probably) non-Etruscan origin and subordinate social status did not prevent her from marrying a free man. Simonetta Stopponi has suggested that the dedication of the statue would celebrate her new status as the wife of Aranth Pinie.[18] Perhaps Kanuta had obtained a respected position and wealth in the cults practised in the sanctuary, assisting her in some social climbing.

Arezzo, Bettolle and Tarquinia – the nozze politiche of Cilnei women with Heimnis, Spurinas and Hulchnies

The other examples of interstate marriage alliances presented here belong to the last four centuries BC. A particularly interesting, and often quoted, case involves the Cilnis of Arezzo. The family counts among the maternal ancestors of Augustus's councillor, C. Maecenas, the famous benefactor of Augustan poets.

A few Etruscan inscriptions confirm that some Cilnis did live and die at Arezzo. Furthermore, members of the family have been documented in Arezzo's territory, and their daughters were married far away.[19] At Bettolle, on a hilltop between the Ombrone and Chiana valleys, we encounter a Thankhvil Kilnei, who was buried in the same cinerary urn as her husband, Vel Heimni (**Fig. 3**).[20] The couple are shown half-naked (although with nuptial jewellery), lying side by side in a bed, shaking hands. This is a curious combination of the iconography of the wedding ceremony of *dextrarum iunctio* (for the sake of symmetry, the husband uses his left hand), and the couple's union in *lectus genialis*. Thankhvil Kilnei was married to one of the "lords" of the territory, the Heimnis, who lived on a hilltop with a view – and control – over important communication routes. Her mother's family, the Velasnas, is documented at Fiesole and its territory, again evidence of an inter-territorial link. Other Cilnei women left their names as far as Viterbo and Sovana.[21]

A highly intriguing case regards Larthi Cilnei, whom we know from a Renaissance manuscript recording an inscription copied from a tomb wall. The tomb itself is lost, but these kinds of painted inscriptions appear, with lengthy *elogia*, appears in Tarquinian chamber tombs from the 4th to the 2nd centuries BC. There are some obscure parts in the text, but its main message seems to be as follows (**Fig. 4**):[22] "Larthi Cilnei, daughter to Luv-

chumes Cilni, who left Arezzo in his youth and died here [i.e. at Tarquinia], and the daughter of Felznei, had been the wife of Arnth Spurinas [something about donating the tomb], and was the wife of Luvce Hulchnies for 14 years, died at the age of 83."

Larthi's *elogium* reports her father's life story in some detail, gives the name of her mother (Felznei) and only then, as was customary among the Etruscans, come the names of her two husbands, the length of her second marriage and her remarkably high age. We only lack the number of her children – an item of information that was fairly common in Southern Etruria. Thus, Larthi Cilnei's remarriage means that there was hardly any compelling *univira* ideology among the Etruscans.

Luvchume Cilni has been interpreted as having been exiled in his youth from Arezzo. If the linguistic speculations permit, we might, perhaps, be dealing with an exchange of "elite children" to be educated elsewhere, under the protection of other elite families. The aim of these exchanges

Fig. 3a-b The urn of Thankhvil Kilnei and Vel Heimni, from the tomb of the Heimnis at Bettolle. Sandstone. End of the 4th century BC. The Bible Lands Museum, Jerusalem, inv. 4210. (Fig. 3a museum photo, Fig. 3b from Maggiani 1986).

Fig. 4 A Renaissance copy of a Tarquinian tomb inscription recording Larthi Cilnei, probably from the 3rd century BC. The Vatican Library, ms Vat.lat. 6040. (From Maggiani 1986).

was to knit bonds of hospitality as pacifying measures between the leading families – just as arranged marriages were intended to work. In our times, for example, we have "goodwill programmes" for international student exchanges, which often result in quite voluntary interstate marriages.

If the interpretation of Luvchume Cilni's arrival at Tarquinia (for whatever reason) at a young age and him dying there is correct, we may assume that he married Larthi's mother, Felznei, there. Her *gentilicium* originates from Felzna, the Etruscan name for Volsinii/Orvieto. In fact, one Larth Felzna is known from there, although toponymic names do not make much sense on the site itself. A Felznei woman was married with a Petru at San Quirico d'Orcia and gave birth to several sons (cf. below) This is the very area between the Arretine and Chiusine territories, where the Cilnis played an important role, but this does not prove the family originated from there. Felzna was not the only accepted way of spelling. At San Quirico d'Orcia, it was also spelled as Felśna, and at Tarquinia also, the spelling was open to variations. In Tomb IV at Villa Tarantola, a painted *elogium* records the lifestory of Felsnas La(ris) Lethes, who reached the age of 106 years. He had done and been subject to something (active and passive verb forms of uncertain meanings) at Capua under Hannibal (about 216 BC). With his extraordinary high age in mind, the inscription cannot be earlier

than the 2nd century BC, perhaps even late 2nd century.[23] Whether Larthi Cilnei's mother, Felznei, was brought to Tarquinia from Arezzo's territory, from the Orcia valley, or whether she was of local origin, may remain an open question.

Luvchumes Cilni's and Felznei's daughter Larthi married Arnth Spurinas, who belonged to the principal family at Tarquinia, at least from the late 5th century BC onwards. This is documented in detail in Mario Torelli's recent monograph.[24] Their painted family tombs, the *Tomba dell'Orco* I (from the late 5th century BC) and II (from about 350 to 325 BC) show a remarkable level of genealogical awareness, learning and culture.[25]

In the Julio-Claudian period, the Spurinnae celebrated their glorious family history by erecting three statues of their ancestors in the sanctuary called Ara della Regina, the most prestigious cultic and political centre of the city. The three statues, representing Velthur I and II, and Aulus Spurinna, are, again, missing, but what remains are fragments of the marble revetments of the podium, with the biographies of the three persons carved in Latin. The fragments of these *Elogia Tarquiniensia* give an idea of their deeds from the end of the 5th to the 4th century BC.[26] Among the *res gestae* of the older Velthur Spurinna are recorded military expeditions on land and sea, as far as to Sicily. Of the younger Velthur's deeds only a few fragments remain. The third generation, Aulus Spurinna (if not the second, as the younger Velthur's brother), interfered in political affairs at Cerveteri, Falerii and Latium, and helped Arezzo's leaders (the Cilnis) against servile insurrections in the mid-4th century BC. The problem was not solved even then; again, in 302 BC, Rome was summoned to intervene in the *bellum servile* at Arezzo.[27]

Mario Torelli has reconstructed Larthi Cilnei's biography, in the conviction that her first husband, Arnth Spurinas, was Aulus Spurinna's son, and that her lifecycle had to be fitted into this assumption.[28] In order to get the chronology to work for Aulus Spurinna's expedition to Arezzo in the mid-4th century BC, Torelli proposed that Larthi Cilnei would have entered her first matrimony with Arnth Spurinas at the age of about fifteen; and furthermore, that she had to be still fertile when she married Luvce Hulchnies. There is at least one case of a "child bride" in Etruria, but this was not necessarily the rule;[29] nor can we take it for granted that widows were not eligible for remarriage past their fertile years. Considerable wealth and status might compensate at that point, especially if the groom

himself was a widower and had children of his own. As to the chronology, such a "political wedding" between Arezzo and Tarquinia makes perfect sense in the 4th century BC,[30] but we have to remember that the gaps in our knowledge are too wide to guarantee that we are dealing with precisely the same persons and historical situations.

After Arnth Spurinas' death, Larthi married Luvce Hulchnies – if the interpretation of the somewhat unclear text is correct. Luvce Hulchnies was another member of the Tarquinian elite. Then, after 14 years of marriage, she spent the rest of her long life as a widow. The Hulchnies are amply documented from Tarquinia and its territory, often as eponymous magistrates. Incidentally, the dedicatory inscriptions of the *Tomba dell'Orco I* and the *Tomba degli Scudi* tell that they were founded under the praetorships of two different Hulchnies, Larth and Vel.[31] However, their family tomb is not known – perhaps it was destroyed when Larthi Cilnei's *elogium* was copied in the 16th century.[32]

Curunas, Calisnas, Cursnis: marriage networking between south and north

In the 4th to the 2nd centuries BC, Tarquinia had a circle of elite families who married within their class, within the city and its territory. The leading positions of the male members of these families are testified by inscriptions with *cursus honorum*, lists of their magistracies and priesthoods. Many such families also settled down in the smaller centres in the territory. Notably Tuscania grew in wealth and importance as a networking node, and the funerary inscriptions there show interesting marriage alliances.[33]

The Curunas may serve as an example. The family name itself is known from Tarquinia (also in the Latin version, Corona), but three chamber tombs, packed with sarcophagi, show that Tuscania had become their primary base.[34] The names of the Curunas wives in the tombs at Tuscania show that they came from near and far:[35] an Apunei from Tarquinia (*Tomba Bruschi*); a Phursethnei from Tarquinia or its military colony, Musarna. A Verati, whatever the family's origin, must have belonged to the top of society: a Thanchvil Verati was the wife of Vel Saties in the *Tomba François* in the neighbouring city-state, Vulci. One more wife, Veisi, might perhaps have come from Chiusi, where the name was spelled as Veiza/Veizi.

Here, we place under the magnifying glass one of the Curunas wives, *Thanchvil Calisnei Curunasa*. She was buried in a sarcophagus, decorated

with griffins and floral ornaments, soon to be hidden by later sarcophagi. On the lid she is shown lying flat on two cushions – as was customary around 300 BC – wrapped in a cloak, and lifting her face up; her hairdo resembles that of young brides (**Fig. 5**).[36] In another Tuscanian tomb, that of the Statlanes, was buried a 16-year- old boy, whose mother was likewise a Thanchvil Calisnei; she cannot be identical with "our" Thanchvil, since the boy's sarcophagus, designed for an adult man, is a few generations later.[37]

Male Calisnas appear at Chiusi and Perugia, and as Calisinies at Castel d'Asso, but their "epicentre" is Monteriggioni in the Volterran territory. Calisnei women appear in all these places, as well as at Asciano (another nodal point of marriage alliances), in addition to Tuscania. The Calisnas's large family tomb in the Casone necropolis of Monteriggioni was in use from about 400 to the beginning of the 1st century BC.[38]

Monteriggioni, too, is situated at a strategic junction in the outskirts of Volterran territory, with connections to almost every direction. Nowadays, the road from Siena to Florence passes nearby, and Florentine and Sienese troops have had conflicts at the very spot, called Malacena, which,

Fig. 5 The sarcophagus of Thanchvil Calisnei, wife of Curuna, from The Tomb of the Curunas II, Tuscania. About 300 BC. Nenfro. Museo Archeologico Nazionale di, inv. 86901. (From *Curunas* 1983).

in turn, has given the name to the high quality, black-glaze pottery from the tomb of the Calisna Śepus, but produced at Volterra.[39] The most prestigious urn from the tomb belonged to a married couple (**Fig. 6**).[40] The 'speaking' inscription pays much attention to the husband and very little to the wife, whose figure is placed behind him: *mi capra Calisnaś Larthal Śepuś Arnthalisla Cursnialch* ("I am the urn of Calisna Larth Śepu, son of Arnth, and of Cursnei").

In turn, Larth Calisnas's wife's name, Cursni, points to Fiesole. As an eponymous magistrate, a certain Arnth, son of Larth Cursni, together with Aule Papsinas, were responsible for the erection of the city wall in the 2nd century BC, and the name also appears, abridged, on a boundary stone marking the limits of the city-state.[41] The last four centuries BC were a period of unrest, with enemies threatening from the north and the south,

Fig. 6 The couple Larth Śepu, son of Arnth Calisna, and his wife Cursnei on their urn from Monteriggioni, the tomb of the Calisna Śepus. Alabaster. Mid-3rd century BC. Museo Archeologico Nazionale di Firenze, inv. 80944. (Museum photo).

and huge resources were spent everywhere in Etruria on fortifying the cities themselves and a series of hilltops along their borders. Large-scale quarrying and building enterprises were costly, but they also created possibilities for the making of fortunes.[42]

Property interests in the Tabula Cortonensis

Long lists of names are provided by the *Tabula Cortonensis*, the bronze tablet that turned up at Cortona in 1992 (**Fig. 7**).[43] With its many previously unknown words, the text has been interpreted in various ways. Most schol-

Fig. 7 The *Tabula Cortonensis*, Bronze. 2nd century BC. Cortona, MAEC, inv. 234918. (Photo Soprintendenza Archeologica della Toscana).

ars agree that we are dealing with a legal document recording the transaction regarding landed property in the neighbourhoods of Lake Trasimeno, with vineyards and fields, on hills and in the plain, all accurately measured. Leaving the linguistic discussions aside, we may concentrate on the implications of the text on social networking. On one side of the transaction is the family community of the Cusus, Laris Cusu and his sons, and on the other, the oil merchant/olive farmer Pêtru Scêvas and his wife Arntlei. The Cusus were among Cortona's nobility, previously known for their prestigious tomb monuments from the Hellenistic period. The couple Pêtru Scêvas and Arntlei bear names that are known from all over the countryside of the Chiusine territory, especially towards the Orcia valley. The Pêtru Scêvas had tombs at Belsedere of Trequanda and at San Quirico d'Orcia. The male Arntles were buried at Castelnuovo dell'Abate near Montalcino, while the female members of the family moved in much wider circles.[44] Some inscriptions show that the two parties were not strangers to each other, since some Cusus were married with Petrus; in general, they were socially more equal than what has been supposed.[45]

The sale of landed property to non-citizens must have required heavy bureaucracy. Many further names appear in the document: the highest juridical authority approved the transaction, perhaps in the presence of the whole town council, and still more persons witnessed the copying of the text, destined to be stored in four examples in private houses. This confirms what we have gathered from other sources: landed property and its boundaries were sacrosanct to the Etruscans.

The transaction was almost entirely in the hands of men, but many family bonds are revealed by their mothers' names: the *matronymikon* was used for those with a frequently testified *gentilicium*, while for rare names this was less necessary.[46] The family relationships were not restricted to the area of Cortona and its nearest neighbours, Arezzo and Chiusi, but involved most of inner Etruria, from Perugia to the Siena area, the Orcia valley, and as far as Tarquinia.[47]

Aulus Caecina and Caesennia – Romanized Etruscans from Volterra and Tarquinia

Etruscans living in Rome in the 1st century BC also found each other. Aulus Caecina belonged to the most renowned Volterran family, the Ceicnas. In 69 BC, his old friend, Marcus Tullius Cicero, defended his interests

in a trial.[48] Aulus Caecina had been married to a widow, Caesennia from Tarquinia. Her family, the Ceisinis, are well known there, having a large chamber tomb with their *elogia* painted on the wall.[49] That the family was still thriving in the early Imperial period is also shown by the surviving fragments of "the Monument of the Caesennii" at Tarquinia.[50] Caesennia's first husband had been M. Fulcinius, also from Tarquinia, but who had been a banker in Rome. His *gentilicium* corresponds to the Etruscan Hulchnies, the family we have already met in connection with Larthi Cilnei's second husband.[51] Around 100 BC, one of the members of the previous generation, Luvce Hulchnies, had his name written in an up-to-date medium, the mosaic floor in the baths of Musarna – as the eponymous magistrate, together with Vel Alethnas.[52]

Returning to Caecina's complicated inheritance case, it is sufficient to mention here the following points. With Caesennia's dowry, Fulcinius had bought a farm near Tarquinia, and he bought more land there after his retirement. At Fulcinius's death, the property went to his and Caesennia's common son, but soon after the latter died, too. In the son's will the property was divided between P. Caesennius (an uncle?) and his own wife, but most of it reverted back to his mother. The estates were auctioned in Rome, and with the money Caesennia wished to buy the farm near her own Tarquinian property. She entrusted the transaction to a certain Aebutius, but he carried it out in his own name. Shortly after, Caesennia married Aulus Caecina. Four years after the purchase she died herself, leaving most of her property to her husband, and tiny portions to a freedman and to the cunning Aebutius. In court, the latter claimed that Aulus Caecina had lost his right to inherit since he, as a Volterran, had lost his Roman citizenship as a consequence of Sullan proscriptions. Cicero won the case, making it clear that his friend had not lost his original citizenship nor his civil rights.

So, marrying a wealthy widow was, after all, not a bad idea. The Volterran Ceicnas were quite well off even before and continued to thrive to the end of the 1st century BC, keeping their Etruscan identity alive. In the early Imperial period, two Caecinae gave a generous gift to their home town: a grandiose, stone-built theater with their names carved in the *scenae frons*.[53]

Connecting people: marriage alliances in a wider perspective
Out of many, these few examples of Etruscan interstate marriages demon-

strate that the habit of intermarriage was a common practice in the highest social circles, and involved especially those who lived in strategically important nodes along communication routes: easy connections create connections.

The phenomenon might be projected to wider chronological, geographical and ethnic contexts. In fact, it has become customary to apply terms like marriage alliances as strategic tools for achieving and maintaining wealth, power and elite status, also in the case of preliterate societies and in much wider geographical areas.[54] The present study supports the view that careful marriage strategies are among the ways in which aristocracies distinguished themselves.[55] This kind of social contact and individual mobility are also testified between Etruscans and their neighbours in Campania,[56] and in Northern Italy,[57] where Etruscans had much reason to blend with their non-Etruscan neighbours. When studying preliterate societies, foreign objects – including even humble ones, without market value – in women's tombs may reveal that the women in question had come from afar and were buried with all their exotic paraphernalia.

Summarizing theories of social evolution from family groups to states, Patrice Brun has presented a diagram with concentric circles, placing the spheres of intermarriage relations within the innermost, narrow circle. One might argue that such relations would also be part of the next circle, the sphere of alliance relations, and even of the widest one, the sphere of preferential associations and long-distance exchange.[58] The high-status alliances would be part of the system of gift exchange, a pacifying measure to seal friendship pacts between chieftains.

However, we should keep in mind that several female tombs, both north and south of the Alps, are so richly equipped – even with arms and wagons, normally considered indicators of male status – that we have difficulties in accepting that these women might only have been victims of "trafficking", albeit on an elite level, at the whim of their fathers and husbands. Some of them must have been "princesses/female chieftains" in their own right, with considerable power,[59] like the *Keltenfürstinnen* in Transalpine Europe.[60] In the present contribution, only the localizable names in the inscriptions reveal that the wives in question came from elsewhere, while their burials follow the customs prevailing in their husbands' communities.

Different research disciplines – material culture and archaeology, ono-

mastics and epigraphy, literary records, social anthropology and scientific methods – each give their own contribution to the facets of human, in this case female, mobility, to long-distance social networking, and ultimately, to the dynamics of demographic and historical processes.

NOTES

The title's intentional travesty of Rigoletto's aria has been inspired by the title of Andersson *et al.* 2018, dealing with analogous questions of female mobility.

1 Capdeville 2018, 254–255; for social networking more widely, see e.g. *Archaeological Networks* 2020.

2 Pandolfini Angeletti, in *Curunas* 1983, 171, n. 10: "Sarebbe anzi oltremodo interessante una ricerca statistica su larga scala delle presenze unicamente femminili in località diverse da quella di origine della famiglia."

3 Aigner-Foresti 2018, 230: "Untersuchungen von überschreitenden Heiratsverbindungen sind ein Desiderat der Forschung."

4 Nielsen 1989a–b, 2010, 2018. See also Amann 2006; Bartoloni 1989; Bartoloni & Pitzalis 2011; Benelli 2012, 2014, 2018, 223–224; Capdeville 2018.

5 For discussion on the ancient sources, see Amann 2000, 177–179. For the importance of genealogies for the Etruscans, see Nielsen 2010; Becker 2020, and many earlier studies.

6 Nielsen 1992, 2009a–b, 2010, all with further references (notably to Larissa Bonfante).

7 E.g. *Parenté et strategies familiales* 1990; Fayer 2005; *Ancient Marriage* 2010; *Material Sides of Marriage* 2016, with extensive recent bibliography.

8 Most handbooks on the Etruscans have a chapter on their language and names; e.g. Benelli 2007, 35–38; Bellelli & Benelli 2018, 127–152. For *gens* and gentilicial society, see Smith 2006; *Società gentilizia* 2019; *Ascesa e crisi* 2020, *Etruscan Literacy* 2020. All with extensive further bibliography.

9 All inscriptions collected in *CIE*; yearly additions in *REE*; *ThLE* provides a shortcut to the mapping of single names; *ET* (2nd ed. 2014) is much used as the standard reference work but is less reliable.

10 Nielsen 1989a, 85 (2); Nielsen 1989b, 140 (2).

11 Capdeville 2018, 252–253. On socially or ethnically mixed marriages, see also Marche-

sini 2010; Benelli 2012 & 2014. For Etruscan family terminology, see López Montero 2013.

12 Agostiniani & Nicosia 2000, 68–78 (cf. below). Likewise, several recent tomb finds in the Chiusine and Perusine areas belong to families whom we have long known, such as the tomb of the Pulfna Peris of 2015 (*Città della Pieve* 2019); and the tombs in Perugia, latest *Etruschi* 2019, 298–303 (Cenciaioli), with further references.

13 Benelli 2007, 109–116; van Heems 2009; Marchesini 2010, 74–75; Stopponi, in *Etruschi* 2019, 265, with further references.

14 Stopponi in *REE/StEtr* 74, 2008 [2011], 385–388, no. 140; from the copious literature, see e.g. Stopponi 2009, 445–449, 477–478, figs. 45–47; Stopponi 2013, 637, fig. 31.7; Benelli 2016, 879; Tamburini 2017; Maggiani 2018, 632; *REE/StEtr* 81, 2018 [2019], 376–378, no. 64 (Morandi); *Etruschi* 2019, 270–271, cat. 194 (Stopponi); Stopponi 2020a, 30–32; Stopponi 2020b, 697–698.

15 Cf. Benelli 2013, 450; Benelli 2016. Numerous *lautnis* and *lautnitas* in the Chiusine area derive from the 2nd century BC Roman slave markets in the Eastern Mediterranean; see Maggiani 2018 for latest.

16 For the wider distribution of the variants of the name, see Morandi Tarabella 2004, 272–273, 671.

17 See Massa-Pairault 1988; Nielsen 2002, 99; Morandi Tarabella 2004, 373–379; Torelli 2019, 185–187.

18 Stopponi 2009, 388; *Etruschi* 2019, 271, cat. 194 (Stopponi).

19 Maggiani 1986; Acconcia 2012, 233, 280–281; Benelli 2018, 224.

20 The question of the whereabouts of the double urn has now been solved: it was legally sold and since 1977 has been kept in The Bible Lands Museum in Jerusalem, inv. 4210. Maggiani 1986, 172–174, no. 1, 188, pl. 51–52; Maggiani 2006, 159, pl. 34a; Nielsen 2010, 161; Kunze & Ben-David 2011; Acconcia 2012, 279, cat. 692–693;

Benelli 2018, 223, n. 20; *Etruschi* 2019, 262 (Paolucci); *Tesori dalle terre d'Etruria* 2020, 32–34 (Paolucci), 36–43 (Salvi), 201 (Maggiani); the photo on p. 32 shows the lid with the woman's back turned towards the front of the urn – that is, the lid ought to be turned around.

21 Maggiani 1986, 184–185, 187.

22 The Vatican Library, ms Vat.lat. 6040: Maggiani 1986, 176–177, no. 2, 187–188; Torelli 2019, 113, 119–122, 172, 181–182, with references to previous literature and interpretations.

23 *REE/StEtr* 33, 1965, 473, no. 2, pl. 104a (Torelli); Morandi Tarabella 2004, 171–172, 593–595, 634.

24 Torelli 2019; on the family, especially 10, 169–188.

25 Torelli 2019, 12–14, 125–168.

26 Torelli 1975; for the entire question, see latest Torelli 2019, esp. 10–33, 93–118, 122–124; the proposal for the reconstruction of the statues and their podium, 94; Becker 2020, 160–162, 177 n. 1.

27 Torelli 2019, 113–118.

28 Torelli 2019, 182.

29 An inscription from Tarquinia records the death of a girl who died at 16 when already married: "Safici Sethra, daughter of Vel (Safici) and Plinei, wife of Arnth Puince, years 16" (but the age is somewhat damaged): *REE/StEtr* 33, 1965, 475–477, no. 7, pl. 105b (Torelli); Amann 2006, 11. Persons who died as young adults, in their twenties, were diligently commemorated in Etruscan tombs; cf. Etruscan mortality statistics, which should not be understood as hard demographic facts but as indicators of family obligations: Nielsen 1989a, 73–81; Nielsen 1989b, 130–137.

30 Torelli 2019, 172: "... nozze politiche con membri dell'élite di altre città, mirabile conferma del successo internazionale della famiglia [degli Spurinas]".

31 Torelli 2019, 131; Becker 2020, 163, 165, 176.

32 For the family, see Morandi Tarabella 2004, 243–244; cf Torelli 2019, 122. The *Tomba Gemina* at Piansano, between Tuscania and Lake Bolsena, at the Vulcian borderland, can hardly be qualified as the Hulchnies' family tomb: the dedicatory inscription records the name of A. Hulchnies Prechus, but also two other, unrelated male persons: *REE/StEtr* 73, 2007 [2009], 336–337, no. 72, pl. 56 (A. Morandi); *REE/StEtr* 82, 2019 [2020], 305–312, no. 53, pl. 57 (B. Corradini & D. F. Maras).

33 Morandi Tarabella 2004, 618–647; Aigner-Foresti 2018, 228–235, with many examples of who was marrying whom.

34 *Curunas* 1983; Morandi Tarabella 2004, 58, 104–105, 148–152, and *passim*; Nielsen 2014, 351–352; Aigner-Foresti 2018, 228–229; Torelli 2019, 143, 183.

35 *Curunas* 1983, 171 (Pandolfini Angeletti).

36 *Curunas* 1983, 87–88, tomb II, no. 1 (Moretti).

37 Florence, Museo Archeologico Nazionale, inv. 84274: Benelli 2007, 88–89, no. 17.2. Two more Calisnei women were married at Tuscania; Morandi Tarabella 2004, 104–105, 619, 634.

38 *UV* I, 161–189 (Martelli); Nielsen 1989a, 67, fig. 11; Morandi Tarabella 2004 261 (Kalisina in Archaic Orvieto), 671; Acconcia 2012, 38–39, no. 112; 137, no. 4; 235 n. 79, 275. For Monteriggioni, see also *Monteriggioni prima del Castello* 2018.

39 Martelli, in *UV* I, 1975, p.161.

40 *UV* I, no. 246 (Martelli); Nielsen 1989a, 67, fig. 11; Benelli 2007, 153, 156–158, no. 54; Nielsen 2010, 158–160, fig. 6; Acconcia 2012, 137, no. 4.2; 280–281.

41 Maggiani 2006, 166–167.

42 As stressed by Aigner-Foresti 2018.

43 Agostiniani & Nicosia 2000 (*editio princeps*); on the onomastic material, 69–91; for further discussions, see Maggiani 2001; *Tabula Cortonensis* 2002; Torelli 2005a–b; Giulierini 2006–2007; van der Meer 2010–2013; Acconcia 2012, 282; 242 map of the area; Bellelli & Benelli 2018, 138; 202–203, fig. 5.9; *Etruschi* 2019, 118–119, no. 75 (Salvi), with further references; Becker 2020, 172, 176.

44 Acconcia 2012, *passim* (S. Quirico d'Orcia and Trequanda, Tombe dei Petru).

45 Acconcia 2012, 282, n. 2; Maggiani 2013–2015.

46 Benelli 2002.

47 Agostiniani & Nicosia 2000, 78–79; Giulierini 2006–2007, summarizing the contacts on the coloured maps, pls. 1–2.

48 Cicero *Pro Caec.* 11–12; Harris 1971, 276–284; Hohti 1975; Morandi Tarabella 2004, 244; Nielsen 2014, 353–356; Tweedie 2015.

49 The tomb was discovered and documented in 1735, but then lost: Morandi 1989; Morandi Tarabella 2004, 119–124, 627–628, 641, 643, pls. II–III:1; Torelli 2019, 29, 85–88, with further references.

50 Torelli 2019, 85–87.

51 Morandi Tarabella 2004, 243–244, 629, 643.

52 Broise & Jolivet 2004; Jolivet 2018, 209–210.
53 *Velathri-Volaterrae* 2021.
54 See Bartoloni 2007; Rathje 2007, 27; *Principesse del Mediterraneo* 2012. One might add that arranged, interstate marriages have long continued, and have only recently been abandoned in the Western monarchies.
55 Menichetti & Pellegrino 2020, 107.
56 *Etruschi* 2019, 194–255 (Cerchiai *et al.*), with further references.
57 *Mondo etrusco e il mondo italico* 2016; *Celti d'Italia* 2017; Sassatelli 2018; *Etruschi* 2019,

26–27 (Sassatelli); 355–449 (Govi *et al.*), with further references. At the conference *Gli Etruschi nella valle del Po* 23th–25th June 2022 in Bologna, the session on "Rapporti e interazioni con le culture limitrofe" updated knowledge on the subject.
58 Brun 1999, 32.
59 See *Principesse del Mediterraneo* 2012, *passim*, both local and "international" connections. See also Rathje 2000 and 2007, 28–29.
60 See Verger 2003, 2009; Arnold 2016.

BIBLIOGRAPHY

V. Acconcia 2012
Paesaggi etruschi in terra di Siena. L'agro tra Volterra e Chiusi dall'età del Ferro all'età romana (BAR Int. ser. 2422). Oxford 2012.

L. Agostiniani & F. Nicosia 2000
Tabula Cortonensis. Roma 2000.

L. Aigner-Foresti 2018
Innerstaatliche und zwischenstaatliche Beziehungen etruskischer Eliten ab der Mitte des 4. Jhs. v. Chr., in: *Beiträge zur Sozialgeschichte der Etrusker* 2018, 227–239.

P. Amann 2000
Die Etruskerin. Geschlechterverhältnis und Stellung der Frau im frühen Etrurien (9.–5. Jh. v. Chr.). Wien 2000.

P. Amann 2006
Verwandtschaft, Familie und Heirat in Etrurien, in: P. Amann, M. Pedrazzo & H. Taeuber (eds.), *Italo-Tusco-Romana. Festschrift für Luciana Aigner-Foresti*, Wien 2006, 11–12.

Ancient Marriage 2010
L. Larsson Lovén & A. Strömberg (eds.), *Ancient Marriage in Myth and Reality*. (Rome 2006), Newcastle upon Tyne 2010.

E. Andersson Strand, K. M. Frei, U. Mannering & M.-L. Nosch 2018
La donna è mobile. Biographies of mobile women in ancient European societies, in: M. García Sánchez & M. Gleba (eds.), *Vetus textrinum. Textiles in the ancient world. Studies in honour of Carmen Alfaro Giner* (Instrumenta 59), Barcelona 2018, 225–234.

Archaeological Networks 2020
L. Donnellan (ed.), *Archaeological Networks and*

Social Interaction (Routledge studies in archaeology). London-New York 2020.

B. Arnold 2016
Paramount Elites and Gender Studies in Iron Age Europe, in: D. Krausse *et al.* (eds.), *The Heuneburg and Early Iron Age Princely Seats: First Towns North of the Alps* (Landesamt für Denkmalpflege im Regierungspräsidium Stuttgart), Budapest 2016, 169–171.

Ascesa e crisi 2020
G. M. Della Fina (ed.), *Ascesa e crisi delle aristocrazie arcaiche in Etruria e nell'Italia preromana* (Orvieto 2019), AnnFaina 27, Roma 2020.

G. Bartoloni 1989
Marriage, Sale and Gift, in: A. Rallo (ed.), *Le donne in Etruria*, Roma 1989, 43–49.

G. Bartoloni 2007
La società e i ruoli femminili nell'Italia preromana, in: P. v. Eles (ed.), *Le ore e i giorni delle donne. Dalla quotidianità alla sacralità tra VIII e VI sec. a.C.* (exh. cat. Verucchio 2007–2008), Verucchio 2007, 13–23.

G. Bartoloni & F. Pitzalis 2011
Matrimonio nel mondo etrusco, *ThesCRA* 6, 2011, 95–98.

H. Becker 2020
Evidence for Etruscan Archives: Tracking the Epigraphic Habit in Tombs, the Sacred Sphere, and at Home, in: *Etruscan Literacy* 2020, 159–180.

Beiträge zur Sozialgeschichte der Etrusker 2018
L. Aigner-Foresti & P. Amann (eds.), *Beiträge zur Sozialgeschichte der Etrusker* (Wien 2016). Wien 2018.

V. Bellelli & E. Benelli 2018
Gli Etruschi. La scrittura, la lingua, la società.
Roma 2018.

E. Benelli 2002
Le formule onomastiche della *Tabula Cortonensis*
e il valore del metronimico, in: M. Pandolfini
& A. Maggiani (eds.), *La Tabula Cortonensis e
il suo contesto storico-archeologico* (Roma 2001),
(Quaderni di Archeologia Etrusco-Italica 28),
Roma 2002, 93–100.

E. Benelli 2007
Iscrizioni etrusche: leggerle e capirle. Ancona 2007.

E. Benelli 2012
*Matrimoni misti e identità in cambiamento:
Chiusi da città etrusca a municipio romano,* in:
Matrimoni misti 2012, 103–109.

E. Benelli 2013
Slavery and Manumission, in: *Etruscan World*
2013, 447–456.

E. Benelli 2014
Etruria, terra di migranti, in: S. Marchesini *et al.*
(eds.), *Seconda e terza generazione. Integrazione
e identità dei figli di immigrati e coppie miste,*
Trento 2014, 25–32.

E. Benelli 2016
Female Slaves and Slave-owners in Ancient Etru-
ria, in: S. L. Budin & J. M. Turfa (eds.), *Women
in Antiquity: Real Women Across the Ancient
World,* London-New York 2016, 877–882.

E. Benelli 2018
La società etrusca: il contributo dell'epigrafia, in:
Beiträge zur Sozialgeschichte der Etrusker 2018,
219–226.

H. Broise & V. Jolivet 2004
Musarna 2. Les bains hellénistiques (CEFR 344),
Roma 2004.

P. Brun 1999
La genèse de l'état: les apports de l'archéologie,
in: P. Ruby (ed.), *Les princes de la protohistoire
et l'émergence de l'état* (Rome-Naples 1994),
Naples-Rome 1999, 31–42.

G. Capdeville 2018
Zur Ehepolitik der grossen etruskischen Fami-
lien, in: *Beiträge zur Sozialgeschichte der Etrusker*
2018, 241–266.

Celti d'Italia 2017
P. Piana Agostinetti (ed.), *I Celti d'Italia. I Celti
dell'età di La Tène a sud delle Alpi* (Roma 2010),
(Biblioteca di Studi Etruschi 59), Roma 2017.

CIE
Corpus inscriptionum etruscarum, I. Lipsiae
1893–1902

Città della Pieve 2019
*Città della Pieve e il territorio in età etrusca. Ritro-
vamenti recenti, vecchie scoperte e collezionismo
archeologico* (Città della Pieve 2016), [Perugia]
2019.

Curunas 1983
M. Moretti & A. M. Sgubini Moretti (eds.),
I Curunas di Tuscania. Viterbo 1983.

Etruscan Literacy 2020
R. D. Whitehouse (ed.), *Etruscan Literacy in its
Social Context* (London 2010), (Accordia Special-
ist Series on Italy 18), London 2020.

ET²
*Etruskische Texte, editio minor. Auf Grund der
Erstausgabe von Helmut Rix neu bearbeitet* von
Gerhard Meiser, in Zusammenarbeit mit V.
Belfiore und S. Kluge (Studien zur historisch-
vergleichenden Sprachwissenschaft 4). Hamburg
2014.

Etruscan World 2013
J. M. Turfa (ed.), *The Etruscan World.* London-
New York 2013.

Etruschi 2019
L. Bentini *et al.* (eds.), *Etruschi. Viaggio nelle
terre dei Rasna* (Exh. cat. Bologna 2019–2020).
Milano 2019.

Etruschi fuori d'Etruria 2001
G. Camporeale (ed.), *Gli Etruschi fuori d'Etruria.*
San Giovanni in Lupatoto (VE) 2001.

C. Fayer 2005
*La familia romana, 2. Aspetti giuridici ed anti-
quari. Sponsalia matrimonio dote.* Roma 2005.

P. Giulierini 2006–2007
Famiglie e proprietà a Cortona tra tardo ellen-
ismo e romanizzazione, *Annuario dell'Accademia
Etrusca di Cortona* 32, 2006–2007 [2008],
183–214.

W. V. Harris 1971
Rome in Etruria and Umbria. Oxford 1971.

P. Hohti 1975
Aulus Caecina the Volaterran. Romanization of an Etruscan, in: P. Bruun (ed.), *Studies in the Romanization of Etruria* (Acta Instituti Romani Finlandiae 5), Roma 1975, 405–433.

V. Jolivet 2018
Urbanisme, architecture et société: Musarna hellénistique et romaine, in: *Beiträge zur Sozialgeschichte der Etrusker* 2018, 203–215.

M. Kunze & C. Ben-David 2011
The Classical Court. Highlights from the Borowski Collections. Jerusalem 2011.

R. López Montero 2013
La expreción del parentesco en lengua etrusca. Materiales epigráficos para una reconstrucciòn. Toledo 2013.

A. Maggiani 1986
Cilnium genus. La documentazione epigrafica, *Studi Etruschi* LIV, 1986 [1988], 171–196.

A. Maggiani 2001
Dagli archivi dei Cusu. Considerazioni sulla tavola bronzea di Cortona, *Rivista di Archeologia* 25, 2001, 94–114.

A. Maggiani 2006
I *Papsina* di Figline e altre *gentes* fiesolane in età ellenistica, *Studi Etruschi* 72, 2006 [2007], 149–170.

A. Maggiani 2013–2015
I *Petru* di San Quirico e di Trequanda e i *Cusu* di Cortona, *Annuario dell'Accademia Etrusca di Cortona* 35, 2013–2015 [2016], 369–389.

A. Maggiani 2018
Lautni, in: *Beiträge zur Sozialgeschichte der Etrusker* 2018, 303–319.

S. Marchesini 2010
Costruire l'etnicità nell'Italia antica. Matrimoni misti come veicolo di integrazione nell'Italia preromana, *Rivista Storica dell'Antichità* 40, 2010, 67–83.

F.-H. Massa-Pairault 1988
La tomba Giglioli ou l'espoir déçu de *Vel Pinie.* Un tournant dans la société étrusque, in: M. Torelli & F.-H. Massa-Pairault (eds.), *Studia Tarquiniensia* (Archaeologia Perusina 9 / Archaeologica 83), Roma 1988, 69–100.

Material Sides of Marriage 2016
R. Berg (ed.), *The Material Sides of Marriage: Women and Domestic Economies in Antiquity* (Rome 2013), (Acta Instituti Romani Finlandiae 43), Roma 2016.

Matrimoni misti 2012
S. Marchesini (ed.), *Matrimoni misti: una via per l'integrazione tra popoli* (Verona-Trento 2011). Trento 2012.

M. Menichetti & C. Pellegrino 2020
Le aristocrazie arcaiche: gestione della tradizione e della memoria, in: *Ascesa e crisi* 2020, 103–128.

Mondo etrusco e il mondo italico 2016
E. Govi (ed.), *Il mondo etrusco e il mondo italico di ambito settentrionale prima dell'impatto con Roma (IV–II sec. a.C.),* (Bologna 2013), (Biblioteca di Studi Etruschi 57), Roma 2016.

Monteriggioni prima del Castello 2018
G. Baldini, P. Giroldini & E.-M. Giuffrè (eds.), *Monteriggioni prima del Castello. Una comunità etrusca in Valdelsa* (Exh. cat. Monteriggioni 2018–2019). Ospedaletto (Pisa) 2018.

A. Morandi 1989
La Tomba dei Ceisinies a Tarquinia. Una nuova lettura dell'iscrizione *CIE* 5525, *MDAI(R)* 96, 1989, 285–292.

M. Morandi Tarabella 2004
Prosopographia etrusca. I. Corpus. 1. Etruria meridionale. Roma 2004.

M. Nielsen 1989a
Women and Family in a Changing Society: A Quantitative Approach to Late Etruscan Burials, *Analecta Romana Instituti Danici 17–18, 1989,* 52–98.

M. Nielsen 1989b
La donna e la famiglia nella tarda società etrusca, in: A. Rallo (ed.), *Le donne in Etruria*, Roma 1989, 121–145.

M. Nielsen 1992
Portrait of a Marriage: The Old Etruscan Couple from Volterra, in: T. Fischer-Hansen, J. Lund, M. Nielsen & A. Rathje (eds.), *Ancient Portraiture: Image and Message* ActaHyp 4, 1992, 89–141.

M. Nielsen 2002
"… *stemmate quod tusco ramum millesime ducis…*"
(Persius *Sat* 3.28): family tombs and genealogical
memory among the Etruscans, in: J. Munk Højte
(ed.), *Images of ancestors* (Aarhus 1999), Aarhus
2002, 89–126.

M. Nielsen 2009a
United in Death: The Changing Image of
Etruscan Couples, in: E. Herring & K. Lomas
(eds.) *Gender Identities in the First Millennium
BC* (London 2006), (BAR int.ser. 1983), Oxford
2009, 79–95.

M. Nielsen 2009b
One more Etruscan Couple at the Museum of
Fine Arts, Boston, in: S. Bell & H. Nagy (eds.),
*New Perspectives on Etruria and Early Rome in
Honor of Richard Daniel De Puma*, Madison WI
2009, 171–181.

M. Nielsen 2010
Commemoration of Married Couples in Etruria:
Images and Inscriptions, in: *Ancient Marriage*
2010, 150–169.

M. Nielsen 2014
Roccaforte degli Etruschi. Continuità e tras-
formazione dei costumi funerari nell'Etruria
rupestre negli ultimi secoli a.C., in: S. Steing-
räber *et al.* (eds.), *L'Etruria meridionale rupestre*
(Barbarano Romano-Blera 2010), Roma 2014,
349–358.

M. Nielsen 2018
Sene etruskere i Danmark. Fra museumsgen-
stande til familiehistorier, in: A. S. Schjødt Ahlén
et al. (eds.), *Tæt på etruskerne*, København 2018,
168–197.

Parenté et stratégies familiales 1990
J. Andreau & H. Bruhns (eds.), *Parenté et
stratégies familiales dans l'Antiquité romaine*
(Rome 1986), (CEFR 129), Rome 1990.

Principesse del Mediterraneo 2012
N. C. Stampolidis (ed.), *Principesse del Medi-
terraneo all'alba della storia* (exh. cat. Athens
2012–2013). Atene 2012.

A. Rathje 2000
'Princesses' in Etruria and *Latium Vetus*, in:
D. Ridgway *et al.* (eds.), *Ancient Italy in its
Mediterranean Setting: Studies in Honour of
Ellen Macnamara* (Accordia specialist
Studies 4), London 2000, 295–300.

A. Rathje 2007
Etruscan Women and Power, in: L. Larsson
Lovén & A. Strömberg (eds.), *Public Roles and
Personal Status: Men and Women in Antiquity*
(Copenhagen 2003), (Arachne 3), Sävedalen
2007, 19–34.

REE
Rivista di epigrafia etrusca, published *ad annuum*
in *Studi Etruschi*.

G. Sassatelli 2018
Etruschi e Italici in Italia settentrionale: rapporti
culturali e mobilità individuale, in: *Beiträge zur
Sozialgeschichte der Etrusker* 2018, 355–370.

C. J. Smith 2006
*The Roman Clan: The Gens from Ancient Ideology
to Modern Anthropology.* Cambridge 2006.

Società gentilizia 2019
M. Di Fazio & S. Paltineri (eds.), *La società genti-
lizia nell'Italia antica tra realtà e mito storiografico*
(Biblioteca di Athenaeum 61), Bari 2019.

S. Stopponi 2009
Campo della Fiera di Orvieto: nuove acquisizio-
ni, in G. M. Della Fina (ed.), *Gli Etruschi e Roma.
Fasi monarchica e alto-repubblicana* (Orvieto
2008), *AnnFaina* 16, Roma 2009, 425–478.

S. Stopponi 2013
Orvieto, Campo della Fiera – *Fanum Voltumnae*,
in: *Etruscan World* 2013, 632–654.

S. Stopponi 2020a
*Il luogo celeste. Il santuario federale degli Etruschi a
Orvieto.* Spoleto 2020.

S. Stopponi 2020b
Un santuario e un tiranno, in: *Ascesa e crisi* 2020,
693–712.

Tabula Cortonensis 2002
M. Pandolfini & A. Maggiani (eds.), *La Tabula
Cortonensis e il suo contesto storico-archeologico*
(Roma 2001), (Quaderni di Archeologia Etrusco-
Italica 28), Roma 2002.

P. Tamburini 2017
La scoperta del *fanum Voltumnae*, il santuario
federale della Lega etrusca, in: *Archeologia e storia
a Nepi* 3, 2017, 11–25.

Tesori dalle terre d'Etruria 2020
M. Iozzo & M. R. Luberto (eds.), *Tesori dalle
terre d'Etruria. La collezione dei conti Passerini,*

349

Patrizi di Firenze e Cortona Exh. cat. Firenze 2020–2021. Livorno 2020.

TheLE
E. Benelli (ed.), with M. Pandolfini Angeletti & V. Belfiore, *Thesaurus linguae etruscae 1. Indice lessicale* (2. ed.). Pisa-Roma 2009.

M. Torelli 1975
Elogia Tarquiniensia. Roma 1975.

M. Torelli 2005a
La "Tanella Angori", i Cusu e la *Tabula Cortonensis*, *RendPontAcc* 77, 2005, 163–187.

M. Torelli 2005b
La *Tabula Cortonensis*, in: S. Fortunelli (ed.), *Il Museo della Città Etrusca e Romana di Cortona*, Firenze 2005, 323–332.

M. Torelli 2019
Gli Spurinas. Una famiglia di principes *nella Tarquinia della "rinascita"*. Roma 2019.

F. C. Tweedie 2015
Volaterrae and the *Gens Caecina*, in: S. T. Roselaard (ed.), *Processes of Cultural Change and Integration in the Roman World* (Nottingham 2013), (Mnemosyne Supplements 382), Leiden-Boston 2015, 92–105.

UV 1
M. Cristofani *et al.*, *Urne volterrane, 1. I complessi tombali (Corpus delle urne etrusche di età ellenistica 1)*, Firenze 1975.

L. B. van der Meer 2010–2013
The *tabula cortonensis* and land transactions, *Studi Etruschi* 76, 2010–2013 [2014], 157–182.

G. van Heems 2009
La naissance des traditions épigraphiques funéraires dans l'Étrurie archaïque: le cas de Crocifisso del Tufo, in: M.-L. Haack (ed.), *Écriture, cultures, sociétés dans les nécropoles d'Italie ancienne* (Rome 2007), Pessac 2009, 15–44.

Velathri Volaterrae 2021
M. Bonamici & E. Sorge (eds.), *Velathri Volaterrae. La città etrusca e il municipio romano* (Conf. Volterra 2017). (Bibliotheca di Studi Etruschi 64), Roma 2021.

S. Verger 2003
Qui était la Dame de Vix? Propositions pour une interpretation historique, in: M. Cébeillac-Gervasoni & L. Lamoine (eds.), *Les Élites et leurs facettes. Les élites locales dans le monde hellénistique et romain* (CEFR 309), Rome 2003, 583–622.

S. Verger 2009
La Dame de Vix: une défunte à personnalité multiple, in: J. Guilaine (ed.), *Sépultures et sociétés. Du néolithique à l'histoire* (Séminaire Collège de France), Paris 2009, 285–309.

FACING PROBLEMS OF ETRUSCAN PORTRAITURE
APPROACH, THEORY AND DEFINITION

SOFIE HEIBERG PLOVDRUP

Introduction

Scholarship on Etruscan cinerary urns in Volterra tends to focus on the mythological scenes depicted on the urn box. Even though the scenes are from Greek mythology, they are adapted to Etruscan taste and style.[1] A few studies have examined the lid figures, contributing important findings such as defining chronology, establishing workshop groups and examining the language shift from Etruscan to Latin. Most scholars working with the lid figures define them as types and not portraits, due to the lack of distinctive or physiognomic features. According to Marjatta Nielsen, the more generic the lid figure was, the better – as the generic face made it more readily accessible for a wider range of customers. Several urns for males became urns for females, and vice versa, by changing not the facial features but the hairstyle, drapery and attributes.[2]

Yet the field of Etruscan portraiture is caught in a dichotomy between Greek and Roman portraiture, with the Etruscan viewed either as an unsuccessful adaption of the Greek or as a provincial precursor of the Roman. Scholars have, in the past, tended to view the Classical period of ancient Greece as the peak of artistic achievement,[3] and our understanding today of what makes a portrait has been strongly influenced by the Golden Age of art and literature in Greece. Any sculpture was measured against those of Classical Greece, and found wanting if it did not adhere to the same ideas of beauty and style.

According to the art historian Natalie Boymel Kampen, writing on the history (or, rather, histories) of Roman art: "Roman art was seen as variously imitative, decadent, crude, Greek at its best and bad at its 'worst'."[4] She adds that in the early twentieth century scholars interested in studying Roman art had to defend it as being distinctive from Greek art and constantly had to justify it as a valid academic pursuit. The idea that the

Greeks had achieved the sublime affected subsequent research not only in Roman but also in Etruscan archaeology. Early formal scholarship on Etruscan art found the verism in Etruscan funerary sculpture interesting, as a break with Greek art and as a precursor for the veristic style of the late Republican portraiture of Rome.

However, the role of Etruscan portraiture in its own right, and what defines it, was not part of this scholarly discussion. As Graeco-Roman concepts of portraiture became the criteria for how to define a "real" portrait, this attitude has continued to influence modern scholarship on the Etruscans.[5] Moreover, the Etruscans' status as "other" placed them at the periphery of the Graeco-Roman world,[6] and in many respects this understanding has percolated down through history, casting the Etruscans as either mysterious or strange.[7]

This article argues that Etruscan portraiture needs to be defined according to what it is, instead of what it is not. Defining the portraits on the Etruscans' own terms calls for examining the specific context, function and ideological framework with which it interacted. Hence, I will discuss and engage with recent theory on portraiture and phenomenology in the interest of understanding the social function and use of the Etruscan cinerary urns and lid figures in the family tombs.

The Etruscans: A Place in History

Any investigation of the Etruscans, and more specifically their portraiture, is further complicated by the Etruscan being constructed as "the almost other", neither barbarian nor completely within the Graeco-Roman *koine*.[8] Etruria was located in a geographical position that afforded certain advantages, such as trading with both Mediterranean and Central European cultures from very early on. The influences of several cultures are clearly visible in the art of the Etruscans. For example, on the box of the cinerary urns of Volterra we find scenes from Greek myths with the addition of the Etruscan death demon, Vanth, and the female lid figures simultaneously wear the Celtic torque and Roman coiffures (**Fig. 1**).

The Etruscans were not perceived by the Greeks and Romans as barbarians per se, but certain aspects of their culture were very foreign – such as the status of women, for example, who dined together with their husbands, something deemed vulgar and inappropriate, as the famous and biased description by Theopompus illustrates.[9] The descriptions of the Etruscans

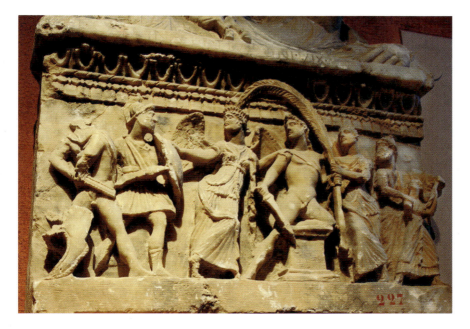

Fig. 1 Vanth figure The winged Etruscan death demon, Vanth, mixed into a scene from the Trojan war, in which the Trojan Prince Paris seeks refuge at the altar of Zeus. Museo Guarnacci inv. 227. (Photo: Sofie Heiberg Plovdrup).

by their Greek and Roman contemporaries seem to revolve around themes that cast them as decadent, with the portrayals of the Etruscan women with their luxurious clothes and jewellery.[10] The Greeks and Romans had a vested interest in portraying the Etruscans in a certain light and, by contrast, highlighting their own morals. However, the problem is not the ancient Greek and Roman view of the Etruscans, but, rather, how that has influenced subsequent modern scholarship.

The Etruscans are often studied in the light of these two paradigmatic cultures of the Mediterranean, the Greeks and the Romans. This attitude towards the Etruscans began very early on, with Winckelmann's description of Etruscan art as one of imitation and exaggeration.[11] This is important to mention, because our modern perception of portraits and the criteria we use to define portraiture by, has been highly influenced by Greek and Roman portraiture. In fields such as art history and archaeology, this understanding has influenced scholarship on the ancient world well

into the twentieth century, with the effect that scholars rarely analyzed or examined the Etruscans on their own terms but usually were comparing and contrasting them to the Greeks and/or Romans.

This effect carried over to our understanding of portraiture; i.e. Roman and Greek portraiture became the formula for how portraiture was used and understood in the ancient world. According to these standards, in which likeness and mimesis were important factors,[12] the Etruscans never made "true" portraits. A serious drawback of the Greek/Roman bias is the fact that the Etruscans may have understood, produced, used and interacted differently with portraits, and the concern is that we will not grasp what the Etruscan portrait was unless we define it on its own terms. I argue that the concept of what portraiture was and what it meant to the Etruscans has been left out of the picture, when in fact their understanding, perception and construction of portraiture should be the point of departure for any study of Etruscan portraits.

A Face or the Face: Definition of a Portrait

All portraiture is created in the tension between two poles, one being ideal/type and the other individual/likeness, with each portrait not being understood as either/or but, rather, somewhere in-between. This introduces the concept of variation – that a portrait could potentially take many different paths while still fulfilling its role and function as a portrait. As Shearer West describes in her book, *Portraiture*, from 2004: "portraits can be placed on a continuum between the specificity of likeness and the generality of type, showing specific and distinctive aspects of the sitter as well as the more generic qualities valued in the sitter's social milieu".[13] This implies that, at times, a portrait is expected to emphasize the unity of the social group it is placed in, and at other times it is in accordance with the expectations and function of the portrait to stand out as an individual. Both these inherent qualities will always be visible in the portrait, but the degree to which they are visible will depend on the times, traditions, function and context. In short, a portrait will always be in a negotiation with the surrounding social norms.

A definition of what a portrait is can be minimal – for example, "a work of art that represents a unique individual".[14] A definition can become more specific, including various criteria and usually encompassing a requirement of likeness. Cynthia Freeland, begins with two primary conditions that

depictions must meet in order to be considered as a portraits: "a portrait is a representation or depiction of a living being as a unique individual possessing (1) a recognizable physical body along with (2) an inner life, i.e. some sort of character and/or psychological or mental states".[15] The version that Freeland proposes as a point of departure for examining portraiture is more narrowly defined and has the advantage, and disadvantage, of limiting what might be perceived as portraiture. Likeness as a criterion sounds logical and quite clear upon first reading, but when trying to pinpoint the exact meaning of likeness, it becomes very elusive. Hans Maes, in his article from 2015, "What is a portrait?", discusses likeness as important in order for a representation to be a portrait.[16] However, likeness in a representation or depiction of a specific person does not necessarily result in a portrait, as Maes demonstrates with the example of an image of a person caught by video surveillance or a paparazzi photographer.[17] The individual person is highly recognizable; there might even be a semblance of "mental state", i.e. an expression of sadness or anger, yet we would not define it as a portrait. What is missing is the element of awareness, which Freeland states as her third condition for a portrait: "For the subject, portraiture involves an act of posing or of self-representation".[18]

Freeland's definition of portraiture touches on the most important and widely debated aspects of portraiture and distills some of its main elements. Any attempt to define such a broad category will run the risk of including or excluding the wrong depictions and representations, and there will invariably be examples of portraits that fall within the a area regardless of which definition of portraiture one chooses to adhere to, and this is also the case for Freelands' definition, as Maes has argued.[19] Some modern works of art will not comply with all the criteria but are still generally regarded as being portraits. One example is Andy Warhol's iconic portrait of Marilyn Monroe, *The Marilyn Diptych* (1962), which does not technically fall within the definition since it does not present us with the inner life of the portrayed person.[20]

This brief overview of the current discussion of the definition of portraiture illustrates that defining portraiture can be a difficult and complex task. I believe that in any considerations of ancient portraiture, the previous discussion is missing an essential component: context. When discussing what constitutes a portrait, the actual function and use of the object should be equally as important as the modern academic response of what

degree of likeness constitutes a portrait, if not more so. Context is essential for understanding the Etruscan lid figures as portraits, due to their place within the specific social frame of the family tomb, and in the following case study the ways they were perceived by the people originally viewing them will be discussed and explored.

For now, it might prove interesting to consider to what extent the lid figures of Volterra abide by the definition of portraiture as laid out by Freeland, in order to elucidate where the modern definition and ancient reality concur or collide. The first condition is that the portrait must be a depiction of a living being as a unique individual with a recognizable body. The lid figures are clearly meant to represent one specific person, often named and within a setting where everyone would know who the deceased person was, but the body is not the focus of the lid figures, which tend to emphasize the head and the hands. Nonetheless, they have recognizable bodies, with different types of dress and adornment befitting the individual's gender, style, taste and status.

The second condition regarding an inner life – character or mental state – is perhaps more difficult to assess; the faces of the lid figures do not show extreme emotions. Yet there is a range of different expressions, from contemplative, stern, alert and often dignified, to the more serene. The facial expressions of the lid figures were enhanced by the addition of colour, especially the painted eyes and eyebrows, lending more vividness and character to the individual face.

The third condition that the subject must pose presents a challenge, due to the fact that the portraits may have been made posthumously or picked out from a workshop. The condition can be met when it is expanded to also encompass an "act of self-representation", a characteristic that the figures could be said to possess. The figures are clearly made to look up at the viewer, and their placement within the tomb would have put them at a height where this was possible. The portrayed persons may have been involved themselves with the process of ordering the lid-figure, and made their own specific demands as to the details, such as attributes, jewellery and the gesturing of the hands or the facial expression. Even if they were not involved in ordering the lid figure, perhaps, as in the case of children or a sudden passing, they would have been aware that an urn would be made for them after their death and placed within the family tomb.

Paolo Spinicci made an amendment to the criteria of posing, because

of the many cases where the portrayed may be already deceased or absent before the creation of the portrait. Therefore, in order for a representation to work as a portrait, and maintain the illusion of the connection between sitter and artist, he added that the "portrayed *persons look as if they have decided to assume a pose*".[21] Spinicci's slight alteration of the third definition seems to allow for more types of portraiture, both ancient and modern. The lid figures look as though they have assumed a specific pose for eternity, and this pose is connected to banqueting and elite modes of being.

The lid figures of the cinerary urns are an attempt to represent a unique individual with a recognizable body, thus fulfilling the first criteria. As for the second, they project different types of inner life within the context; and for the third, with regards to posing, they seem to be posing for the viewer to see them and interact with them. In sum, therefore, the three main conditions of what defines a portrait can be fulfilled by the portraits of deceased family members on the cinerary urns of Volterra.

Historically, these lid figures have been viewed variously as both highly varied individuals and as mere workshop types.[22] In the latest overview of Etruscan portraiture, Alexandra Carpino is still hesitant to label lid figures as portraits, because they "correspond more to types and might better be termed quasi-portraits "...with features and traits that fall within a coded social vocabulary (...)".[23] I argue here that they *should* be perceived as portraits, even if the emphasis is on the more general features and qualities that closely connected them to their social status and family, which is not that strange when thinking of their use within the family tombs. We do not have the privilege of knowing through their own words what the Etruscans thought of portraits; instead, we must look to the material record to see how they engaged with, perceived, and used these portraits.

There were always attempts to personify and represent the deceased within Etruscan culture; it is, as such, not a new idea, but each different period had its own artistic conventions within the societal expectation and traditions. Regardless of the period it is created in, many of the functions of a portrait, such as contact, memory and connectedness, remain vital for the reason behind creating portraiture. The question of why we create portraits is essential as it highlights some important aspects when discussing what a portrait is. The context that the portrait was intended for, and what other objects it interacted with, has a direct bearing on the way portraits were constructed, perceived and understood. Portraiture in Etruria was

357

always made with a specific context in mind, and portraits have so far only been found in either sanctuaries or tombs.[24] The case study of the Ceicna/Caecina family tomb in the next section will illustrate how the portrait and the context acted together to create a setting and an experience that the visitors to the tombs reacted to and interacted with.

Two Portraits in Context: Ceicna/Caecina Tomb II in Volterra

The above discussion attempts to approach a definition of portraiture, while at the same time I acknowledge that any definition will always have the risk of including or excluding the wrong representations. The point I wish to stress is the importance of seeing and accepting more variation within portraiture. I also want to highlight the need to explore the idea of portraiture in the light of the ancient viewer, and for that we must include function, context and agency, on behalf of both viewer and portrait.

The Etruscan funerary sphere was not only a realm of the dead, it was a collection of memories and a visual expression of family and ancestors, as well as a site for rituals where the living relatives gather and visit with the deceased. The family tomb was an active space with ongoing activities that were closely related to identity, status and the Etruscan understanding of the afterlife, and as such the tomb was not a constant.[25] I put forth the argument that, in this light, the tomb is a social frame and in itself an agent working together with both human and non-human agents. The physical surroundings of the tombs, the sensory experience of going down under the earth, where it gets colder, more humid and quieter, was part of creating a palpable change in atmosphere. The lid figures, with their gestures, vivid colours and eyes painted to be more visible, appeared to be merely waiting for the ancient visitor to the grave. It is the portraits within the setting of the family tomb, and the ancient viewers' interaction with them, that will be the focus of my case study.

The two lid figures presented in my case study belong to a large family tomb, the a large family tomb, Caecina tomb II. This tomb, located in the necropolis of Portone outsiside the gates of Volterra, was excavated by Raffaele Pagnini in 1785–1786 (**Fig. 2**).[26] The large tomb was cut into the bedrock and used for four generations by a branch of the Caecina family with the Fetiu cognomen.[27] The tomb had a square chamber with a central pillar; on the back wall there was one doorway, and on either side wall two doorways that led to five small chambers. The tomb had been disturbed

Fig. 2 Plan of Caecina II tomb from the Portone necropolis, Volterra. (After Inghirami 1825).

in Antiquity and forty cinerary urns were found in the central chamber all piled together. The majority of these urns are now missing and only known from the records made at the time of discovery, which included a description of the urns and the Etruscan inscriptions.[28]

359

The two lid figures represent a man and a woman. They are both in the typical format for the Volterran urns, lying as if at a banquet and resting on the left arm on one or more cushions. The female lid figure is dressed in a shortsleaved *chiton* that is gathered under the breast by a girdle with a square pattern and beads at the lower edge; her legs, back and left arm are wrapped in the cloak (**Fig 3**). Her wavy hair is parted in the centre and; the cloak is used as a veil over the hair, and on her head she wears an ornamented diadem. She is wearing a torque necklace and has holes in her earlobes for the insertion of metal earrings.[29] Across the breast she wears a cross-band fastened at the shoulders and gathered in front with a buckle in the shape of a rosette; the cross-band has traces of gilding (**Fig 4**).[30] In her right hand she holds open a rectangular hinged mirror case, with a round mirror in the bottom half. In her left, she holds a common attribute, the pomegranate, and she wears a small ring on the left hand. On the left wrist is a bracelet in the form of a twisted snake, and the arm is resting on two cushions, which are decorated with horizontally incised lines and tas-

Fig. 3 Female lid figure from Museo Guarnacci, inv. 185. (Photo: Sofie Heiberg Plovdrup).

sels at the corners. There are traces of red on the hair, eyes and the incised inscription,[31] as well as of the dark purple which is thought to be a preparation for gilding.

The man is dressed in a short-sleeved *chiton* with his legs, back and left arm wrapped in a cloak, and on his head he wears a plaited wreath of leaves.[32] The cloak covers his head, except the part at the nape that is now missing (**Fig. 5**).[33] His hair is combed forward into small locks on his forehead beneath the wreath and parted in the middle. In his right hand he holds a *phiale mesomphalos*; the left arm rests on two cushions with wavy incised lines and tassels at the corners and holds a horse-head *rhyton*. Traces of colour are found on his pupils and eyebrows, with a black, brownish-red for the wreath,[34] and red for the inscription.[35]

Both lid figures belong to Nielsen's "Idealizing Group" that she defined in 1975, placing the group, ca. 80/60 BC. Later, in 1976, she refined the chronology, dividing the group into two groups: 7.2 and 8.1. The woman based on her type seems to belong to the earlier group 7.2, ca. 100–80

Fig. 4 Detail of the gilding on the female lid figure; faint traces of a dark purple colour is all that remains.

BC, while the man belongs to the later group 8.1, ca. 80/75–50 BC, in which the age at death is introduced in the inscriptions, as we see also on this lid.[36] In regard to portraiture, the group is described by Nielsen as having faces that "seldom have any individual traits".[37] A few men in the group are noted by Nielsen to have more frowning and veristic faces in the style of realistic Roman portraiture.[38] I agree that the Roman influence is visible – for example, in the hairstyles of some of the men, like the lid described above. However, there seems to be an implicit understanding that a face being realistic in a Roman style makes it more of a "true" portrait, juxtaposed with idealized faces being less of a portrait.

As previously described, all portraiture falls somewhere within the continuum where ideal/type and individual/likeness are at opposite ends, but

Fig. 5 Urn with a male lid figure from Museo Guarnacci, inv. 323. (Photo: Sofie Heiberg Plovdrup).

likeness is not a static term, as West phrases it: "What might be considered a 'faithful' reproduction of features relates to aesthetic conventions and social expectations of a particular time and place."[39] I think it is necessary to also look at the lid figures with more idealized faces as a result of a choice. This viewpoint allows for the Etruscans to be active agents who made conscious decisions on the way they wished to have themselves or their family members portrayed. This choice of the manner in which they were portrayed on the cinerary urns would most likely have been shaped by a multitude of different influences, such as ideas on the afterlife, conventions, traditions, and not least the shifting social norms. The portraits we see on the cinerary urns, be they idealized or realistic, are a result of these negotiations, and also a product of a particular workshop that executed them, as well as the opportunities and limits afforded by the material they were made off.

V. Dasen argues in her article from 2010 that for the wax masks, *imagines maiorum*, likeness played on the inherent lifelike qualities of the wax and that the masks were also idealized in their own way. On the concept of likeness, Dasen writes: "Lack of verism should not be interpreted as a lack of skill, but as a choice, and making the choice of excessive likeness was not an obvious one".[40] In some ways it might have been more comfortable for the relatives of the deceased to adhere to a more idealizing type for the funerary portraits, where an accurate likeness might have been too eerie.[41] Idealizing features should, in my view, not be seen as missing a component of realism or an indication of poor craftsmanship, but as a conscious choice of veering towards idealization as a form of convention, preference or style. The option of more realistic-looking portraits might simply not have been the preferred mode of representation for the Etruscans from Volterra.

Within the context of the family tomb, traditions may have imposed restrictions on individuality. The family as a whole might have had a desire to focus more on the portrait's general signs of status and gender, as well as the placing of the individual within the wider family. One might speculate whether the use of more idealizing features alluded to a family resemblance, which would have emphasized family bonds and unity instead of individual likeness. The manner of representation, regardless of which side on the likeness continuum it falls, does not *a priori* decide whether the images are portraits or not. They were portraits because that was the intention at their creation: to serve as a representation of a specific and often named individ-

ual family member, and this was how they were perceived and understood within the context of the family tomb.

The matter of context is pertinent to the discussion, because the portraits on the cinerary urns worked within a specific and concrete setting, together with other urns and objects. In the family tomb, the intended ancient viewer would be a relative, a person who knew the deceased either through meeting them in their lifetime or as an ancestor. The viewer would not have had the modern academic response to categorize into types or to discuss the degree of verism or idealizing features. Rather, they would engage meaningfully with the lid figures as representations of the deceased individuals, as portraits. The names of the deceased would often be inscribed on the edge of the lids, as with the two portraits mentioned above, and the surrounding atmosphere in the tomb, with the rows of ancestors looking back with their painted eyes, would have been quite different from the modern viewers' experience in a well-lit museum.

When discussing the features of portraits in the lid figures we have the advantage, and disadvantage, of doing so in an environment completely different from the tombs. We see the urns in artificial lighting, and usually in museum galleries full of cinerary urns often divided into different rooms by Greek mythological themes on the urn boxes (**Fig. 6**). This allows us to see many different lid figures and study the detail of the individual urns as well as spot common features that lead to the recognition of types and workshops. This could not be further away from the experience of the ancient viewers entering a dark tomb, which would be colder than the ground temperature and have a dampness that could be clearly felt via scent and touch. In the flickering light from a lamp or torch, that would not have allowed for the same degree of detail to be seen, the encounter would be very different, and this does not even begin to account for the emotional component the viewer would be experiencing with their personal connection to the deceased.

The confined space within the tomb would have prompted certain patterns of movement; to see the individual portraits, one would have had to move close up to each face, bringing the viewer within near proximity to the portraits. The light would have reflected in the metals, such as the earring of the female portrait or the wreath of the male, gilded to mimic the effect of real gold, but perhaps also to make use of the dramatic play with light in the tomb. Precisely because of the relative darkness of the

Fig. 6 One of many rooms containing cinerary urns in the Museo Guarnacci. (Photo: Sofie Heiberg Plovdrup).

tombs, the scenes on the boxes would have been brightly painted, as would the portraits themselves as the traces of polychromy on the two portraits demonstrate.

Polychromy is an important component of the lid figures that needs to be investigated further. Previous research often mentions this aspect,[42] but rarely treats it beyond the level of description. The same could be said for the added metals and gilding. There is no question that the polychromy of the cinerary urns on both boxes and lids made for a very different experience for the viewer. The face changes and becomes more lifelike with the addition of colour; the eyes seem to gaze back when the pupils are painted or added in a different material (**Fig. 7**). The painted eyebrows add expression to the face, and we know from observations in neuropsy-

chology that eyebrows are essential for facial recognition.[43] Specific colours could give some semblance of likeness to the portrayed, through hair colour and perhaps the colour of the clothing. The dimension of colour should therefore be factored into the discussion of likeness, because the colour would change the overall appearance. I am not arguing that the aspect of colour completely changes the faces and make them more realistic, but it does render the portraits more lifelike and perhaps added some similarities to the deceased that would have been visible to the relatives visiting the tomb.

The lifelikeness was also enhanced by the characteristics of the very material the portraits were made of, namely alabaster. Alabaster often has a luminescent and somewhat translucent quality to it, depending on the type of alabaster and the quality. It can also look almost wax-like.[44] The specific qualities of alabaster might have been used consciously to mimic

Fig. 7 Two details of eyes, painted on the left and inlaid on the right, which gives the portrait a more lifelike presence. Both portraits are from Museo Guarnacci. The detail on the left is inv. 332 and the one on the right is from inv. 164. (Photo: Sofie Heiberg Plovdrup).

skin and play on the almost lifelike quality of the lid figures. The lid figures seem to be momentarily paused at a banquet or gathering, adorned in their finest garments and jewellery, holding objects that connected them to the elite sphere, to banqueting and the afterlife.

The attributes held by the two lid figures described here are very typical for the "Idealizing group". The female holds a pomegranate and a mirror; the pomegranate is an attribute commonly used throughout the production of cinerary urns at Volterra.[45] It was a symbol of death, birth and the afterlife, perhaps due to its connection to the Persephone myth.[46] The other attribute is the mirror, which is a symbol of adornment,[47] but may also have had more ritual purposes. In Etruria, mirrors, like portraits, are only found in either tombs or sanctuaries and the mirrors used for grave goods are sometimes inscribed on the reflective side with the Etruscan word *suthina*, which can be translated as "for the grave",[48] or "sepulchral gift".[49] Mirrors are almost always found with the reflecting side facing up.[50] The intentional decision to place the reflective surface upwards hints at the duality inherent in the mirrors, being both here and there. In the same way as the portrait, it oscillates between the presence and absence of a person; both the mirror and the portrait capture an essence of the person. Alexandra Carpino suggests that mirrors might have an apotropaic function, or be "imprinted with the image and memory of the deceased, they may have been seen as preserving a very personal part of the deceased for eternity, thus contributing to their immortality".[51] This is further supported by the fact that the word for soul, *hinthial*, in Etruscan can also include the meaning of reflection or an image in a mirror.[52] The idea of immortality, or being able to perhaps travel back and forth, is also present in the portrait, where a very concrete physical presence, the cremated remains of the dead, in the cinerary urns perhaps connects or imbues the portrait with an essence of the deceased.

The male lid figure holds a *phiale* and a horse-head *rhyton*; the *phiale* is a shallow bowl mainly used for and associated with the ritual of pouring libations. The attribute is one of the most common for the male lid figures and is often gilded or painted in a ochre colour and, as such, also an object connected with prestige and socio-economic status.[53]

The *rhyton* is a drinking vessel, which may have many different protomes – of a horse or ox, for example. Drinking vessels are mostly associated with Nielsen's "Idealizing group".[54] The large vessel is very visible

on lid figures, and thus a part of a conspicuous consumption, and the attribute places the lid figure, and by extension the deceased, as part of an elite that participated in banqueting. All of these attributes are known from the material record and most of them play on a duality between elite banqueting and the more ritual character of the objects with connection to the afterlife.

Living with Portraits and Living Portraits

Seneca gives us an insight into what it meant to live with portraits, not as decorative display or merely as works of art, but to interact with and have passionate feeling for portraits. He contrasts two women, Livia and Octavia, as they grieve the deaths of their sons and how in their intense mourning they interact with portraits of the two boys. In Ad Marciam de Consolatione, Seneca writes on the all-consuming sorrow of Octavia, who "remained for the rest of her life what she was at his funeral",[55] and "Octavia did not want to have an *imago* of her dearest son, and no mention of him happened in her presence".[56] Seneca contrasts the behaviour of Octavia, who could not be consoled, with Livia's noble way of grieving: "She did not stop glorifying the name of her son Drusus, setting images of him everywhere, in public and in private, speaking of him or hearing about him very eagerly. She lived with his memory: no one who turns memory into sadness can hold on to and revisit it."[57]

The contrasted pair of mourning mothers, Livia vs. Octavia, are often used to cite mourning and grief, and both cases illustrate the power of portraits and their ability to move us. This example is not meant to transfer Roman culture onto the Etruscans, but rather to give an ancient example of living and interacting with portraits in a more intimate way than we, as modern people, are used to. The example Seneca gives us also touches on the previously discussed subject of likeness, succinctly phrased by Ackers: "This example is indicative of the potentially painful repercussions of the portrait's illusion; too evocative of the subject's presence to allow the bereft release from their memory, but not flesh and blood enough for them to escape within it".[58] With regard to the portraits of the Etruscans, we do not have the benefit of such sensuous descriptions that add feeling and narrative to how they lived with portraits, but through this description we can imagine that emotions and experiences were equally as essential for Etruscan portraiture.

368

When looking at the portraits on the cinerary urns, they seem to have momentarily taken a pause from the banquet,[59] and to look up at the visitor to the grave, holding their attributes, playing with the edge of the cloak or holding a hand more contemplatively up to their cheek. They seem to be posing and merely waiting for the visitor to the tomb to enter and behold the scene of his or her ancestors. Most of the portraits on the cinerary urns of Volterra, indeed all of the portraits in the Ceicna tomb II, are made to look alive, as if in an active mode of participation, as West also argues: "by the very nature of their mimetic function, portraits give the viewer an impression of the inner life".[60]

However, I argue that the portraits are not mere passive objects but, rather, are subjects themselves; they engage the viewer and exert agency in their own right. The theory of agency as presented by Gell in 1998 is an important concept in understanding the relationship between a portrait and a person, whereby we understand both human and non-human agents to be able to exert agency.[61] It is this dialectic relationship with the portraits that compels us to reminisce and provokes strong reactions. The visitor would not passively look at the portraits in the tomb; they would engage with them and be drawn nearer to gaze into their eyes, perhaps touching their cheeks, and this face-to-face encounter would have stirred memories and emotions.

New research in neuro-psychology indicates that when encountering faces that are familiar to us, "their images immediately cue a relatively stable face representation in our memory, creating a perfect correspondence between their appearance and their character. But this relation between appearance and character comes from our prior knowledge of them, not from their appearance."[62] The brain is not only recognizing the face, it is also activating memories and previous experiences with the person.[63] This is important, because the activating of memories projects the deceased's identity or personhood onto the portrait, regardless of the degree of likeness. In considering the effect of memory, Caroline van Eck writes: "vivid images, like vivid words, trigger memories that feed mental images and thus make us relive experiences of living beings while looking at their representations in stone or paint".[64] This is supported by the research in neuro-psychology that can map the human brain and see how the viewing of faces activates face modules that connect to regions of the brain responsible for memory.[65]

The portraits in the family tomb would have *acted* as a kind of placeholder for the deceased, their personhood given permanence in alabaster, stone or terracotta. The portrait was a representation that was made to look lifelike, but not too lifelike, through the qualities of the material (such as the translucency of the alabaster), the gesturing with their hands, the angle of the head, as well as the added colour and gilding. The portrait would have connected the viewers to the deceased, affecting them to relive memories and thus reinforcing the bond between family members past and present.

NOTES

1 Van der Meer 1977/78.
2 Nielsen 1986.
3 Boymel Kampen 2003, 375.
4 Boymel Kampen 2003, 375.
5 Huntsman 2014, 150–151.
6 Turfa 2013, 1.
7 However, recent scholarship seeks to dispel this myth and shed new light on the Etruscans for a wide range of audiences, i.e. Shipley 2017; Smith 2014; Turfa 2013.
8 Bonfante 2011, 235.
9 Theopompus Histories, CLII.
10 Bonfante 2003, 89.
11 Winckelmann 2006.
12 Huntsman 2014, 150.
13 West 2004, 21.
14 West 2004, 21.
15 Freeland 2010, 5.
16 Maes 2015.
17 Maes 2015, 303–304.
18 Freeland 2010, 17.
19 Maes 2015, 305–308.
20 Maes 2015, 305.
21 Spinicci 2009, 48.
22 For a more complete understanding of the ways Etruscan portraiture has been perceived throughout history, see Carpino 2013.
23 Carpino 2013, 1010.
24 Warden 2011.
25 Izzet 2007, 88–89.
26 *UV*I, 36.
27 Capdeville 2002, 189.
28 *UV*I 1975, 36.
29 Nielsen 1975, 306.
30 Nielsen 1975, 315.
31 *CIE* 130.
32 See Nielsen 1975, 304, n. 5.
33 *UV*I 1975, 40.

34 This particular colour is sometimes associated with gilding, see UC I 1975, 118.
35 *CIE* 38.
36 The standard formula is *ril*, which means "at the age of…(years)", see Bonfante and Bonfante 1983, 145. It is "*ril.XL*", see *UV*I 1975, 40 and *CIE* 38.
37 Nielsen 1975, 303.
38 Nielsen 1975, 321.
39 West 2004, 22.
40 Dasen 2010, 145.
41 Dasen describes how the idealizing features might have "represented a comforting compromise", Dasen 2010, 144.
42 The polychromy on both boxes and lids have been described in most of the work on the Volaterran urns, see i.e. *UV*I, where each entry mentions traces of color, but the topic rarely receives attention beyond the purely descriptive.
43 The eyebrows are "critical for both expressions of different emotions and for recognition of people", Todorov 2017, 266.
44 The almost wax-like quality is interesting to note, especially when we think of the Roman death mask and the type of lifelike effect that was achieved through both these media.
45 Nielsen 1975, 287.
46 Haynes 2000, 298.
47 Mirrors have been found in tombs and belong to both males and females, Carpino 2008, 10.
48 Carpino 2003, 4.
49 Bonfante and Bonfante 1983, 145.
50 Carpino 2008, 24.
51 Carpino 2008, 24.
52 Carpino 2008, 24.
53 Nielsen 1975, 311.

54 Nielsen 1975, 311–312.
55 Sen. *Consolation to Marcia* 2.4.
56 Sen. *Consolation to Marcia* 2.5.
57 Sen. *Consolation to Marcia* 3.2.
58 Ackers 2018, 127.
59 See Huntman's discussion of the ritual character of the banquet.

60 West 2004, 37.
61 See Alfred Gell's seminal book *Art and Agency* from 1998.
62 Todorov 2017, 261.
63 Todorov 2017,
64 Van Eck 2015, 67.
65 Todorov 2017, 244.

BIBLIOGRAPHY

H. Ackers 2018
The Face of the Deceased, in: Z. Newby and
R. E. Toulson (ed.), *The Materiality of Morning:
Cross-Disciplinary Perspectives*, London-New York
2018, 121–147.

G. Bonfante & L. Bonfante 1983
The Etruscan Language: An Introduction.
New York 1983.

L. Bonfante 2003
Etruscan Dress (2nd ed.). Baltimore 2003.

L. Bonfante 2011
The Etruscans: Mediators between Northern
Barbarians and Classical Civilization, in:
L. Bonfante (ed.), *The Barbarians of Ancient
Europe*, Cambridge 2011, 233–281.

G. Capdeville 2002
Social Mobility in Etruria, *EtrStud* 9, 177–190.

A. Carpino 2008
Reflections from the Tomb: Mirrors as
Grave Goods in Late Classical and
Hellenistic Tarquinia, *EtrStud* 11, 1–33.

A. Carpino 2013
Portraiture, in: J. M. Turfa ed., *The Etruscan
World*, London 2013, 1007–1016.

V. Dasen 2010
Wax and Plaster Memories, in: V. Dasen &
T. Späth (eds.), *Children, Memory, and Family Identity in Roman Culture*, Oxford 2010,
109–146.

C. Freeland 2010
Portraits and Persons: A Philosophical Inquiry.
Oxford 2010.

A. Gell 1998
Art and Agency: An Anthropological Theory.
Oxford 1998.

S. Haynes 2000
Etruscan Civilization: A Cultural History.
Los Angeles: The J. Paul Getty Museum. 2000.

T. R. Huntsman 2014
*Eternal Personae: Chiusine Cinerary Urns and the
Construction of Etruscan Identity.* Unpublished
dissertation. St. Louis 2014. Available from
ProQuest Dissertations & Theses A&I: ProQuest
Dissertations & Theses Global. (1512415733).
Retrieved from https://search-proquest-com.
ep.fjernadgang.kb.dk/docview/1512415733?acco
untid=13607

F. Inghirami 1825
Monumenti Etruschi o di Etrusco nome IV. Fiesole
1825

V. Izzet 2007
The Archaeology of Etruscan Society. Cambridge
2007.

N. B. Kampen 2003
On Writing Histories of Roman Art, *ArtB* 82, 2,
2003, 371–386.

Hans R. V. Maes 2015
What is a Portrait?, *British Journal of Aesthetics* 55,
2015, 303–322.

M. Nielsen 1975
The Lid Sculpture of Volterran Cinerary Urns, in:
P. Brunn. *et al* (eds.), *Studies in the Romanization
of Etruria. Acta Instituti Romani Finlandiae*, Vol.
V, Rome 1975, 263–404.

M. Nielsen 1986
Fra mand til kvinde eller vice versa: hastværk i
sen etruskisk gravkunst, *MusTusc* 56, Vol. 56–59,
København 1986, 267–288.

J. J. Pollitt 1974
*The Ancient View of Greek Art: Criticism, History,
and Terminology.* New Haven-London 1974.

Seneca
Seneca: *Selected Dialogues and Consolations*,
translated by Peter J. Anderson. Indianapolis
2015.

L. Shipley 2017
The Etruscans: Lost Civilizations. London 2017.

C. Smith 2014
The Etruscans: A Very Short Introduction. Oxford
2014.

P. Spinicci 2009
Portraits: Some Phenomenological Remarks, in:
Proceedings of the European Society for Aesthetics 1,
2009 37–59.

A. Todorov 2017
*Face Value: The Irresistible Influence of First
Impressions*. Princeton-Oxford 2017.

J. M. Turfa 2013
Introduction: Time to Give the Etruscans Their
Due, in: J. M. Turfa (ed.), *The Etruscan World*,
London 2013, 1–7.

L. B. Van der Meer 1977/78
Etruscan Urns from Volterra. Studies on Mytho-
logical Representations, *BABesch* 52/53, 1977/78,
57–131.

C. Van Eck 2015
*Art, Agency and Living Presence: From the
Animated Image to the Excessive Object*.
Leiden 2015.

P. G. Warden 2011
Etruscan Sculpture, in: *Oxford Bibliographies
Online: Classics*, New York: Oxford University
Press. Available at:
https://www.oxfordbibliographies.com.

L. Webb 2017
Gendering the Roman Imago, *EuGeStA* 7, 2017,
140–183.

S. West 2004
Portraiture. Oxford 2004.

J. J. Winckelmann 2006 [1764]
History of the Art of Antiquity. Trans.
H. F. Mallgrave. Los Angeles 2006.

UV I 1975
M. Christofani *et al.* (eds.), *Urne Volterrane* I,
I Complessi tombali (*Corpus delle urne etrusche
di etá ellenistica*, I). Florence 1975.

FORGED AND REPRODUCED ETRUSCAN MIRRORS

A STUDY OF FOUR ETRUSCAN MIRRORS IN THORVALDSEN'S COLLECTION

BJARNE PURUP

Introduction

In the collection of antiquities at the Thorvaldsens Museum in Copenhagen there is a group of 31 Etruscan mirrors. They have only been published once in their entirety in 1847 by Ludvig Müller,[1] the first curator at the museum. However, one mirror has only been described in what is known as "Müller's Blue Book", a blue booklet with handwritten descriptions of a few artefacts kept at the museum.[2]

The Danish sculptor Bertel Thorvaldsen (1770–1844) first arrived in Rome in 1797 on a three-year scholarship. The scholarship was subsequently extended and Thorvaldsen remained in Rome until 1838, and was there again from 1840–1841. He became one of the most celebrated sculptors of his time, and during his years in Rome Thorvaldsen gathered a vast collection of paintings, drawings and etchings by other artists, as well as many antiquities. He was well respected and was truly knowledgeable in the ancient arts. In 1829, he even became co-founder of the Instituto di Corrispondenza Archeologica, today the Deutsches Archäologisches Institut in Rome, where he held talks about Antiquity.

As described by Kristine Bøggild Johansen in this volume, Thorvaldsen had a fine collection of Etruscan antiquities, which were either given to him or that he bought from other, older collections and other collectors.[3] Therefore, it is no surprise to find a rich collection of Etruscan mirrors here. All the mirrors are in bronze and most of them are decorated with engraved patterns and figures on the reverse. Unfortunately, we do not know anything about Thorvaldsen's views on these mirrors. It has always been known that Thorvaldsen did not care for writing letters and he only kept a diary in short periods of his life.[4] Today it is clear that Thorvaldsen

was most likely dyslexic and perhaps therefore has left no testimony to any provenance for his collection. However, we know that his collection of mirrors was bought during the 41 years he lived in Rome. Most likely, he bought them at archaeological excavations in the 1820s and 1830s, either from antiquarians or at the local markets he visited on early Sunday mornings. In the Piazza Montanara, at the foot of the ancient Marcellus Theater, local farmers brought things they had found on their properties and sold them to interested buyers at the market.[5]

In his own art, it is well known that Thorvaldsen was inspired by the motifs of Antiquity, his *Jason with the Golden Fleece* probably being the best example.[6] Here he replicated the pose and overall appearance of ancient classical sculptures such as the Spear Bearer, *doryphorus*, by Polycleitus, and the Apollo Belvedere in The Vatican Collection,[7] creating an entirely new statue. As pointed out by Torben Melander, Etruscan mirrors could also have served as inspiration for the Danish sculptor. A comparison of one of the Lasa mirrors from Thorvaldsen's collection (**Fig. 1**) with Thorvaldsen's first design for the Baptismal Angel in the Church of Our Lady in Copenhagen (**Fig. 2**) reveals several similarities.[8]

In this article I will describe and discuss four of the most interesting mirrors in Thorvaldsen's collection. I intend to show that Thorvaldsen used images from the Etruscan mirrors, both copying them directly and as a source of inspiration. It is also the aim here to exemplify the Etruscomania in the first half of the 19th century. Many of the Etruscan mirrors found without any decoration were given new engravings in order to heighten their price. These forged mirrors are widely recognized today, although some are better forgeries than others.

Previous research and the Danish collectors

Before turning to the mirrors, I will describe the historical studies of Etruscan mirrors and the Etruscomania in the time of Thorvaldsen.

Already in the 16th century, the Etruscan mirrors were known and perceived as mirrors. But in the first half of the 17th century, they began to be looked upon as *paterae*, ceremonial sacrificial libation bowls. However, this general view was rejected by the Italian archaeologist Francesco Inghirami. Inghirami published the first monograph of Etruscan mirrors in the second volume of his Monumenti Etruschi in 1824. He linked the Etruscan mirrors with *cistae* – cylindrical containers, often in bronze – and thought

Fig. 1 Drawing of the reverse of an Etruscan mirror with winged Lasa. 300–100 BC. Thorvaldsens Museum, inv. no. H2151. (Photo: Thorvaldsens Museum).

Fig. 2 Bertel Thorvaldsen, Baptismal Angel Kneeling. Ca. 1827. Pen and ink on paper. Thorvaldsens Museum, inv. no. C270. (Photo: Thorvaldsens Museum).

375

that both *cistae* and mirrors were part of mysterious ceremonies, hence the name *specchi mistici*. It is not impossible that Thorvaldsen bought some of his mirrors under this name. Around the middle of the 19th century, the Etruscan mirrors were once again recognized for what they were, namely mirrors. In the years 1843–67 the German archaeologist, Eduard Gerhard, published his four-volume *Etruskische Spiegel*, in which he collected more than 600 mirrors, including those in his own collection and those of others. The mirrors were divided into groups according to their motifs, yet the chronology of the mirrors was not discussed. Several of Thorvaldsen's mirrors were recorded in the *Etruskische Spiegel*.[9] A fifth volume was published in 1897 by A. Klugmann & G. Körte.

It is interesting that Eduard Gerhard, together with Thorvaldsen, was one of the founders of the Instituto di Corrispondenza Archeologica. A few letters from Gerhard addressed to Thorvaldsen are kept in the Thorvaldsens Museum archive. Here we also find a poem written by Gerhard to Thorvaldsen in which he praises him as an almost divine artist.[10] In Thorvaldsen's personal book collection, currently stored in the library of the Museum, there are several of Gerhard's books with personal dedications to Thorvaldsen. The tribute and dedications suggest that the two gentlemen were confidential, even friends.

In the 20th century, several monographs were published that treated the Etruscan mirrors. The Corpus Speculorum Etruscorum has been an especially ambitious project. In each volume, the mirrors from different European museums have been published, with the Danish collections from the Danish National Museum and the Ny Carlsberg Glyptotek as the first volume, by Helle Salskov Roberts.[11] Ilse Mayer-Prokops's 1967 study of the 55 known Archaic mirrors,[12] and Denise Rebuffat-Emmanuel's thorough study of the Etruscan mirrors from the Cabinet des Médailles from 1973, as well as Nancy Thomson de Grummond's *A Guide to Etruscan Mirrors* from 1982, should also be mentioned. Regarding Thorvaldsen's mirrors, T. Melander has published some of the most interesting, in 1979, 1993 and 2009.[13]

Not only Thorvaldsen but also other Danes bought Etruscan mirrors and other Etruscan artefacts. The Danish archaeologist, and *bon vivant*, P. O. Brøndsted stayed in Rome for several years. Here he became Thorvaldsen's trusted friend (at least until Thorvaldsen lent him a large amount of money that was never paid back).[14] In 1822/23, Brøndsted acquired a

cista, which contained an Etruscan mirror, a strigil and several small vases that could be used in the bath.[15] Both *cista* and mirror are still known as Brøndsted's *cista* and mirror, and are today in the Cabinet des Médailles in Paris.[16] It is not unthinkable that Thorvaldsen and Brøndsted sat together, studying and admiring the details in the decoration of *cista* and mirror.

Likewise, Prince Christian Frederik, the later King Christian VIII, made several large purchases from the Etruscan tombs, especially from Vulci.[17] These include three Etruscan mirrors today in the collection of antiquities at the Danish National Museum.[18]

Four mirrors in Thorvaldsen's collection

The collection in the Thorvaldsens Museum holds 31 Etruscan mirrors. Although none of them are real masterpieces, the collection is, as Melander puts it, a surprisingly representative collection as it holds mirrors from both the Hellenistic and Classical periods, and even three Archaic mirrors, which are more rare.[19] Of the 31 mirrors in the Museum, I have chosen four here that each tell their own story of Thorvaldsen's collection, of the Etruscomania in the first half of the 19th century, and of how Thorvaldsen used the images in his own art.

H2170 – Achilles, Thetis, Athena and Automedon

Fig. 3a–c

The first mirror considered here is one of the best preserved and artistically finest mirrors in Thorvaldsen's collection. The once glossy front of the round mirror is convex and engraved at the rim with a row of small, stylized lotus buds or beads and a floral motif just above the handle. The handle is cast in one piece with the mirror. The end of the handle is shaped like a stylized head of a hind, as was standard for many Etruscan mirrors.[20]

The concave reverse is decorated with a central scene showing a naked youth putting on greaves, resting his right leg on a small rock. He is flanked on the left side by a female warrior with shield and helmet, and on the right by a woman holding a spear and an item of arm or leg armour. On the far right, we see a second naked youth wearing a chlamys around his shoulders. In the background there is a temple pediment, supported by two visible Ionic pillars. Below the scene is a narrow pattern of zigzag lines. The scene has often been interpreted as Achilles putting on the armour made

377

by Hephaestus, known from the Iliad. He is flanked by Athena on the left and his mother Thetis on the right. The second youth is interpreted as Automedon.[21] The temple in the background has been interpreted by Melander as part of the scenery, perhaps the camp of Achilles.[22] Because of the rather large figures placed on a mirror with no circumferential decoration, Sibylle Haynes has placed the mirror in a group that she calls "grossformatiger, grossfiguriger", all dated to the 3rd century BC.[23]

I would like to draw attention to the small field under the scene, just above the handle. Here we see a male bust wearing a chlamys and a winged Phrygian hat, portrayed in a three-quarter frontal view. An almost identical head is found on a mirror at the Cabinet des Médailles in Paris.[24] Rebuffat-Emmanuel has remarked that the motif of a young male head with a winged or Phrygian cap in a corona or a floral pattern is often found on South Italian vases.[25] These vases date to the second half of the 4th century BC,[26] and it is possible to date the mirrors with these

Fig. 3a Drawing of the obverse of an Etruscan mirror. 350–290 BC. Bronze. Thorvaldsens Museum, inv. no. H2170. (Photo: Thorvaldsens Museum).

bust heads accordingly; thus, the Thorvaldsen mirror must be dated to the last quarter of the 4th century or the early part of the 3rd century. As the bust on the Parisian mirror and the Thorvaldsen mirror are almost

Fig. 3b–c Reverse of an Etruscan mirror, with Achilles, Thetis, Athena and Automedon; underneath: a Hermes/Turms bust. 375–290 BC. Bronze. Thorvaldsens Museum, inv. no. H2170. (Photo: Thorvaldsens Museum).

379

Fig. 4 Bertel Thorvaldsen, Tondo: Achilles and Patroclus. 1837. Marble. Thorvaldsens Museum, inv. no. A493. (Photo: Thorvaldsens Museum).

identical, we must assume that they are manufactured by the same crafts-man or workshop.[27]

The young male bust has been interpreted as Turms, the Etruscan Hermes.[28] It is interesting to find Hermes here, where he acts as Hermes Psychopompos, a conductor of souls into the afterlife for the many Trojans that will be killed by Achilles, and eventually for Achilles himself. For the viewer who knew the story of the Iliad, the inclusion of Hermes was a clear hint of what would come. Furthermore, Hermes as guide for the soul reflects the idea of the mirror as a burial item, where he would guide the deceased into the next life.[29]

Why Thorvaldsen bought this mirror, we do not know, but the Iliad scene and the inclusion of Turms as a reference to what will come goes well with Thorvaldsen's own works. Here, we often find small hints to what is going to happen, unknown to the characters displayed but well known to the viewer. In a tondo by Thorvaldsen showing Achilles nursing the

dying Patroclus, (**Fig. 4**), we see the arrow just between the legs of Achilles – an omen of Achilles's doom. By including the arrow, Thorvaldsen tells so much more of the epic poem than what is included in the tondo – it is the death of Patroclus that triggers Achilles' will to fight, which ultimately leads to his own death.

Considering Thorvaldsen's use of props in his own art, it is tempting to argue that he bought this mirror because of this subtle hint to the story. I will return later to Thorvaldsen's use of props in his work, but for now I will turn to the next two mirrors, both of which are forgeries.

Mirror V – Silenus, satyr, and panther
Figs. 5a–d
This second mirror is more distinctive than beautiful and has not yet been published.[30] The presumably once glossy front of the pear-shaped mirror is corroded and bears no decoration, except for the handle which is adorned with dots and a few lines resembling a very simplified animal's head on the rounded tip of the handle. This is an unusual shape, as the ornamented handles of the Etruscan mirrors were normally cast in the shape of either a ram's or a hind's head (as in **Fig. 3b**, for example).[31] Even handles that are too summarily treated to be identified as a ram or hind do bear the overall likeness of an animal's head with a pronounced muzzle and not just a rounded flat tip.[32]

On the reverse, the mirror is decorated by a central scene showing the bearded Silenus sitting on his left knee with his right knee bent upwards. In his right hand he holds a cup. Behind him a satyr holds up a bunch of grapes and vine-leaves behind Silenus' shoulder, squeezing the grapes into the cup. They are both wearing wreaths of vines. They are flanked to the left by a feline animal, presumably a panther, licking the dripping grape juice. The lower part is adorned with a stylized lotus bud. The tip of the handle bears a short, engraved line. The rim of the mirror has been bent up, presumably to protect the motif, as is typical for most of the Etruscan mirrors from the late archaic period and later.[33]

The mirror itself seems to be of genuine Etruscan or Praenestine origin. The pear-shape could indicate that the mirror originated from Praeneste. Praeneste, today Palestrina, lies immediately east of Rome and pear-shaped mirrors were produced there for the Roman market.[34] While the pear shape and the corrosion on the obverse may indicate an ancient origin

for the mirror, the engravings on the reverse are far from antique. The muscles and hairstyle of Silenus and the satyr seem to be too lifelike to fit the style of the Etruscan mirrors, which were simpler – compare the physique of Achilles (**Fig. 3c**) with Silenus' physique. The surface of the reverse has

Fig. 5a–b Obverse of an Etruscan (Praenestine) mirror. Bronze. Thorvaldsens Museum. Müller V. (Photo: Bjarne Purup).

been thoroughly cleaned and the engravings seem to be deep and crude and executed with such force by the burin that the mirror has cracked at the lotus bud.[35] Also the composition seems to be non-antique. The way the satyr is positioned partly behind Silenus has no similarities in other

known Etruscan mirrors.[36] The action of the satyr squeezing juice from behind the shoulder of Silenus and into his cup just seems too complex for an Etruscan craftsman.

Therefore, I will conclude that the mirror itself might be authentic, but the engravings are likely to be more recent and produced in the first

Fig. 5c–d Reverse of the mirror in Fig. 3a-b with a later engraving of Silenus, satyr and panther. Bronze. Thorvaldsens Museum. Müller V. (Photo: Bjarne Purup).

decades of the 19th century. In fact, several of the known forged Etrus-
can mirrors are authentic bronze mirrors but embellished with a modern
engraving. These mirrors were found in excavations without any decora-
tion and were then embellished with an engraving of some likeness to the
Etruscan style and motifs, presumably to sell better and at a higher price

385

in the local antiquities market. As de Grummond has stated, a great number of these forged mirrors are pear-shaped, and thus likely to originate from Praeneste.[37] The source of inspiration for the forged engravings were other known mirrors,[38] ancient statues,[39] vase paintings,[40] or just scenes with an Etruscan touch to them.[41] The source of inspiration for the Thorvaldsen mirror, however, is not obvious. As stated above, the scene does not seem antique, but some of the details might be inspired by ancient models. To start with the way Silenus is sitting: it does seem to be an unnatural and forced way to sit, with the legs in an almost *Knielauf* position. Although not with the exact same pose, coins of the Greek city state Thasos bear on the obverse a satyr in the so-called *Knielauf* position (**Fig. 6**). Here we see, although mirrored, a trihemiobol (half drachm), with the satyr holding a cantharus. Compared to the mirror, the satyr on the coin shows almost the same physique as Silenus – not an athlete's body, but with a clear musculature. Also, the tail of the mirror satyr and the coin satyr have some similarities. A coin like this may very well have been the source of inspiration.

Fig. 6 Trihemiobol of Thasos. Obverse: Satyr in *Knielauf*, right, holding cantharus. Reverse: Amphora, legend: ΘΑ(Σ) / (I)Ω(N). 400–350 BC. Silver. The Royal Collection of Coins and Medals, inv. no. KP. 833.4. Sylloge Nummorum Greacorum, no. 1031. (Photo: Rasmus Holst Nielsen, The National Museum of Denmark).

Fig. 7 Peter Paul Rubens, Drunken Silenus. 1609–1610. Oil on panel. Villa Durazzo Pallavicini. (Photo: Wikimedia Commons).

For the composition of the satyr squeezing grapes from behind Silenus' shoulder, the closest likeness is actually found in an early 17th century painting by Peter Paul Rubens, now in the Villa Durazzo Pallavicini in Genova (**Fig. 7**).[42] Here we see the grapes of the drunk Silenus' wreath being squeezed from behind by a relatively short-haired male with a goat skin across his shoulder – we might suspect him to be a satyr. Although not a perfect likeness, the way the satyr squeezes the grapes from behind the shoulder of Silenus shows that this, or a similar scene, must have been the inspiration for the Etruscan mirror.

Concerning the panther on the left side, the model can perhaps be found in Etruscan metalwork or in a wall painting. Nevertheless, the multifaceted scene shows that the engravings are a forgery. A tempting thought would be that Thorvaldsen himself was the actual forger of this mirror. Thorvaldsen did use both silens/bacchantes and satyrs, as well as panthers, in his art. Amongst his drawings we find two scenes with a satyr and a

Fig. 8 Bertel Thorvaldsen, Satyr Offers a Panther to Drink. 1805. Pen and grey ink with grey wash on paper. Inscription in pen. Thorvaldsens Museum, inv. no. C834. (Photo: Thorvaldsens Museum).

Fig. 9 Bertel Thorvaldsen, Bacchant – (A Young Satyr) Offers a Panther a Drink. 1806. Pencil, pen and ink on paper. Thorvaldsens Museum, inv no. C31r. (Photo: Thorvaldsens Museum).

388

panther (**Figs. 8–9**). In both these scenes, the satyr is lying up against the panther, offering it something to drink. But where the first scene is calm and peaceful, the other is bacchantic and wild and more in style with the mirror scene. But when we look at the details it becomes obvious that there are differences in the way they have been executed: the tail of the panther, especially, in Thorvaldsen's drawings does not have any similarities with the tail of the panther on the mirror.[43]

Mirror H2175 – Making of the Trojan horse
Figs. 10a–c
The third mirror is also a well-known, partial forgery. The convex front of the mirror is engraved with a stylized floral motif just above the handle. The handle is cast in one piece with the mirror and formed as a tang to fit into a handle of a different material, so therefore it bears no decoration.[44] The edge of the mirror is decorated with a tongue pattern.

The rim of the reverse is bent up. The centre is decorated with an engraved motif of two men, one of them holding an axe or a hammer, and a horse. Above the men are two words in Etruscan lettering, "ANTVL" and "VSLIBN", presumably indicating their respective names. To the right, is a third word in a rectangular square: "HELINSAL". The first two words are utter nonsense and cannot be related to any known Etruscan or Greek gods or heroes. The third word, however, appears to be a rewriting of the Greek word HELENES, meaning Greeks. This implies that the two men are Greeks and are manufacturing the Trojan horse.

At first glance, the mirror, with its engravings, seems authentic. But the surface of the reverse demonstrates that the old patina has merely been removed from the centre before the engravings were carried out.[45] The mirror itself is from the 5th century BC,[46] but the backside engraving must have been applied in the late 18th or the first part of the 19th century. This was known already to Müller in 1847, and he states in the museum catalogue that the graffiti is probably a recent copy of an original, as the lines, contrary to other Etruscan mirrors, are engraved with a triangular instrument and appear also to cut through the oxidized parts of the metal, and that the lines are nowhere covered by oxidization.[47] Müller also points out that the inscribed words indicate a forgery. In fact, Thorvaldsen's mirror must be a copy of a late Etruscan mirror with the exact same scene, now in the Cabinet des Médailles in Paris (**Fig. 11**).[48] Here the scene is shown

Fig. 10a
Drawing of the
obverse of an
Etruscan mirror.
5th century
BC. Bronze.
Thorvaldsens
Museum, inv.
no. H2175.
(Thorvaldsens
Museum).

Fig. 10b–c Reverse of an Etruscan mirror with scene of the construction of the Trojan horse and "Etruscan" inscriptions. 5th century BC. Bronze. Thorvaldsens Museum, inv. no. H2175. (Photo: Thorvaldsens Museum).

with the addition of an encircling wreath and other inscriptions: SETH-LANS (Etruscan Hephaestus), PECSE (probably Pegasus, meaning horse), ETULE (Etruscan Aitolos, brother of Epios, who built the Trojan horse) and HELINS (Helenes). It is strange to find Sethlans/Hephaestus in this scene, but we must assume that it is an example of the Etruscan ability to mix the Greek myths.

So why are the Selinus and Trojan horse mirrors in the Thorvaldsen collection? Both mirrors may, in themselves, be originals, but the engravings are forgeries and are not hard to distinguish as such.[49] Since we know so little about how Thorvaldsen acquired his ancient artefacts, or where he bought the individual piece and what he as collector thought about them, the question invites several possible answers:

1. He did not know.
2. He knew they were forgeries but loved the images.
3. He knew, but also wanted to support the local dealer.
4. He bought them in a lot with some (or all?) of the other mirrors.

Fig. 11 Drawing of the reverse of an Etruscan mirror, with original scene of the construction of the Trojan horse and Etruscan inscriptions. 3rd century BC. Bronze. Cabinet des Médailles, Paris, inv. no. 1333. (After Gerhard, II, pl. CCXXXV).

Whatever the answer might be, it emphasizes the Etruscomania that raged through the Western world in the first half of the 19th century. It was possible to sell almost anything if it had some Etruscan feel to it. But perhaps the next mirror will help to broaden our understanding of why Thorvaldsen bought the mirrors and how he used them.

Mirror H2156 – Iris fetching water
Figs. 12a–c

The fourth and final mirror is, to me, one of the most interesting in Thorvaldsen's collection. It is both an artistically fine mirror, and in my opinion it was deliberately used in Thorvaldsen's own art. The once glossy front of the mirror is adorned with a flower ornament at the bottom and along the edge with a pearl border. On the outer edge of the mirror is a tongue pattern. The slightly concave reverse is adorned with an ivy wreath. Because of

Fig. 12a
Drawing of the obverse of an Etruscan mirror. Ca. 480 BC. Bronze. Thorvaldsens Museum, inv. no. H2156. (Thorvaldsens Museum).

Fig. 12b–c
Reverse of an
Etruscan mirror,
with Iris fetching
water. Ca. 480 BC.
Bronze. Thorvald-
sens Museum, inv.
no. H2156. (Photo:
Thorvaldsens
Museum).

the execution of the ivy wreath, it has been suggested that the mirror might have been produced at Vulci.[50] In the centre of the mirror a winged female figure is holding a container, a *stamnos* or *hydria*,[51] under a waterspout shaped like a lion's head. Below her is a snake with a bearded head, which could indicate that the scene takes place in the underworld.[52] The style of the mirror sets the dating just between the archaic and the classical periods. Where the head of the winged female figure points the date towards classical times, the dovetailed dress and stiff folds point to the archaic period. This mix of different styles places the mirror at or just after 480 BC, when the Etruscan mirrors underwent a gradual change towards the more severe style.[53] The folds of the dress, especially, have parallels in both Etruscan and Greek art. The skirt's lower fold has a similarity to the folds of one of the dancing women from the *Tomba del Triclinio* in Tarquinia,[54] especially the soft folds in the lower edge of the dress. Likewise, Mayer-Prokop has pointed out that a similarity in the draping of the winged female figure's himation can be seen on a bell crater from Boston by the Pan Painter.[55] Here, Artemis killing Actaion is reproduced with almost exactly the same dovetailed himation. There is yet another similar scene that I have found on an oinochoe by the Pan Painter, who operated in the decades after 480 BC.[56] The oinochoe is from the end of this period and shows on the belly a scene with Oreithyia fleeing Boreas. To the left of Oreithyia we see a nymph fleeing as well, with her himation waving behind her. The sharp folds of her himation resemble the himation of the mirror goddess, although it is pointing in the opposite direction. This oinochoe was found in Vulci[57] – which is interesting, as the mirror's ivy wreath decoration points to this location as the place of origin.[58] Therefore it is not unrealistic that the motif in the mirror in Thorvaldsen's collection is inspired by an Attic vase painter such as the Pan Painter, active in the first decades after 480 BC.

Both Gerhard and Müller have argued that the winged female figure could represent Iris fetching water from the river Styx in a jug of gold,[59] in reference to the Theogony by Hesiod.[60] Here, it is told that Iris, in a dispute among the Olympic gods, was sent out to fetch water from the river Styx in the underworld. Considering the bearded snake below the winged female figure, this interpretation seems to be a good option.[61]

However, Mayer-Prokop, in her monograph of the archaic Etruscan mirrors, has argued that the goddess figure more likely represents Nike fetching water for the ritual funeral cleansing of a deceased, the so-called *Totenbad*.[62]

She points out that on several *lekythoi* of the Bowdoin painter, a woman is filling a hydria with water from a fountain or waterspout.[63] It has been suggested by E. Diehl that this water was intended for the *Totenbad*.[64] On other *lekythoi*, Nike has taken the woman's place in the process of filling the *hydria* with water.[65] Mayer-Prokop has argued that there could be a close connection between Nike and the rituals concerning the death cult. She has therefore suggested that we must assume that it is Nike on the Thorvaldsen mirror and not Iris. But on a white ground *lekythos* of the Bowdoin painter, we see a winged goddess who pours a liquid on a sacrificial altar (**Fig. 13**). This winged figure can be identified as Iris because of the *kerykeion* she holds in her left hand. I would therefore argue that Iris can also be seen in connection with libation sacrifices, thereby challenging Mayer-Prokops' hypothesis, or at least pointing out that we cannot rule out that it is either one goddess or the other.

But something that might be of more interest in relation to Thorvaldsen's own work is what this mirror tells about his use of antique motifs. As mentioned above, Thorvaldsen was heavily inspired by the classical arts and borrowed stances from both Greek and Roman sculptures. One of the more interesting works by Thorvaldsen is a relief showing King Priam pleading with Achilles for the corpse of his son Hector (**Fig. 14**). We see Priam portrayed wearing a Phrygian cap, on his

Fig. 13 Attic white-ground lekythos by the Bowdoin Painter. Iris pouring a libation onto a blood-stained mound altar. Ca. 470–460 BC. Terracotta. J. Paul Getty Museum, object no. 86.AE.249. (Photo courtesy of the Getty Open Content Program).

Fig. 14 Bertel Thorvaldsen, Relief: Priam Pleading with Achilles for Hector's Body. Executed by Georg Christian Freund under the supervision of C. C. Peters after Thorvaldsen's original plaster model from 1815. 1868–1870. Marble. Thorvaldsens Museum, inv. no. A775. (Photo: Thorvaldsens Museum).

knees in front of the proud Greek. This scene shows strong associations with the Roman silver cups found at Hoby on the Danish island of Lolland.[66] On one of those cups we see the exact same scene. But where Thorvaldsen's relief was cut in 1815,[67] the Hoby cups were first unearthed in 1920.[68] This means that the Hoby cup could not have been Thorvaldsen's source of inspiration. But the motif seems to have been a well-known miniature motif that flourished in Antiquity.[69] It is therefore no surprise that in Thorvaldsen's own collection we find a gem with a part of the same scene, showing Priam on his knees with only the legs of Achilles preserved (**Fig. 15**). Whether Thorvaldsen was inspired by this, or whether he bought it because it confirmed him in his own reproduction of the antique motifs is uncertain.

In the Priam relief, there is a hidden detail that might derive from the Etruscan mirror. In the hands of the second person from the left, identified as one of the Trojans because of his Phrygian cap, is a large amphora.

Fig. 15 Priam Pleading with Achilles for Hector's Body. Imprint from gem. Plaster. Thorvaldsens Museum, inv. no. 1888. (Photo: Bjarne Purup).

The faint relief on the amphora indicates a beaten work in metal.[70] In the mid-section of the vessel is a winged figure turned to the left, hovering over a collapsed figure.[71] The hovering figure has slight similarities with the winged goddess of the Etruscan mirror. While the figure in the marble relief is too vague to distinguish it clearly, the original plaster model gives a much better impression of the winged figure and its surroundings (**Fig. 16**). Here the details are much clearer. If we compare this original plaster with the slightly tilted mirror, the body and the arm seem to be in the same positions, highlighted in blue (**Fig. 17**). Even the curvature of the mirror is preserved in the plaster model, marked in yellow. This detail has so far been overlooked in the otherwise well-studied relief. Only the wings in the relief seem to be in the more severe classical style, while the wings in the mirror seem Archaic.[72]

Despite the different execution of the wings, it is possible to conclude that Thorvaldsen was most likely inspired by the goddess mirror. In the relief, the scene with the kneeling figure serves to remind the viewer of the deathly outcome of war and might even be a reference to the dead body of Hector. In that case, the hovering figure could represent Apollo, who protected the lifeless body of Hector from harm.[73] As a drawing by Thorvaldsen shows, this theme was familiar to him (**Fig. 18**). Here, Hector's body is dragged behind Achilles's chariot. Achilles, enraged by the death of his friend Patroclus, who was killed by Hector, sought to deface Hector's dead

397

Fig. 17 Mirror H2156 and segment of amphora. Body and arms of the winged god-
dess highlighted in blue, and the curvature of the mirror highlighted in yellow.

body. But as the drawing shows, the body was safeguarded by Apollo as a yet again hovering figure above Hector's corps.

Conclusion

As these four mirrors show, it is quite possible that Thorvaldsen did use the Etruscan mirrors as inspiration in his own work, if not always from a specific motif (as seen in the Priam-Achilles relief) then as a source of inspiration for putting a scene together in a small field – or, as Melander has pointed out, as the basic outline of a sculpture, like the Baptismal Angel in the Church of our Lady (**Fig. 2**). Another example is the Achilles mirror (**Fig. 3b–c**) where Achilles's right leg is resting on a small rock, reflected in

Fig. 18 Bertel Thorvaldsen, Achilles Trails Hector's Body after his Chariot; Fainting Woman Being Steadied. Date unknown. Pencil on paper. Thorvaldsens Museum, inv. no. C1067r. (Thorvaldsens Museum).

Thorvaldsen's own tondo of Achilles and Patroclus (**Fig. 4**).[74] We see Achilles bending slightly forward, nursing the wounded Patroclus. The bend seems necessary to fit Achilles naturally into the round disc. Here the rock (also supporting Patroclus) works as Thorvaldsen's "prop" to make it seem natural. In both the Baptismal Angel and the Achilles-Patroclus examples, it is interesting to see Thorvaldsen using the flat, two-dimensional bronze mirrors as the source of inspiration for his three-dimensional art. This further emphasizes the fact that Thorvaldsen's ancient collection was a tool of inspiration as well as a historical collection.

The Etruscan mirrors also demonstrate the Etruscomania in the first half of the 19th century. Anything could be sold if it had an Etruscan feel to it. Mirrors with no engravings were given a makeover and sold at a better price. Was this forgery? Both yes and no. As we know from Thorvaldsen's own work, he restored ancient sculptures, giving them new life with new limbs otherwise lost in time – most notably the sculptures from the Aphaia temple on Aigina now in the Glyptothek in Munich.[75] Although the general academic circles in the late 18th century wanted to preserve the antiquities as they had been unearthed, it was still a common practice to enhance otherwise broken statues. Even Thorvaldsen had his doubts about the restoration work. He claimed that it was an unthankful task to restore the ancient statues. If, on the one hand, the work was poorly done, it was not worth doing at all; on the other hand, if it was well done, no one would notice all the effort.[76] Therefore it is possible to conclude that restauration or enhancement of the mirrors was a practice accepted in the time of Thorvaldsen, but a forgery nonetheless. As bronze oxidises quite easily, and the forgers sought to hide the unauthenticity of the new engravings, it was hard to tell the real from the fake. But whether this mattered to Thorvaldsen or not is unknown. If he sought out antiquities as inspiration for his work, then even a mirror with a copied motif would serve his needs.

As shown in this short study of four Etruscan mirrors from the Thorvaldsens Museum, there is still much to be learnt from Thorvaldsen's collection regarding Thorvaldsen's use of the mirrors in his own works as well as an obligation to having them treated in an academic and professional manner. It is therefore my hope that we will see the mirrors published in their entirety.

NOTES

I would like to thank the Thorvaldsens Museum for permission to study the mirrors and curator Kristine Bøggild Johannsen for her enthusiasm and support. Similarly, I thank the editors of Acta Hyperborea for their patience and goodwill.

1 Müller 1847, 162–170.
2 Müller's Blue Book, v.
3 It is unknown exactly when Thorvaldsen started his collections. In his early years in Rome (1797–1803) he was quite poor and depended on the goodwill of patrons such as the Danish diplomat Herman Schubart and on small jobs, such as assistant to the English landscape painter, George Augustus Wallis, for whom he painted minor figures in the artist's landscapes (see Kofoed 2015). But eventually Thorvaldsen became rich and was able to lend money to friends and princes (see Frederiksen 2014).
4 See Stampe 1912, 235, where Baroness Christine Stampe explains about Thorvaldsen's writing skills and how he always had a dread of people not being able to read his letters.
5 Melander 2009, 9.
6 Thorvaldsens Museum inv. no. A822. See *Meddelelser fra Thorvaldsens Museum/Thorvaldsens Museum Bulletin* 2003. København, 2004.
7 von Einem 1974; Hartmann & Parlasca 1979, 49–50, 31–34; Johansen 2004; Melander 2004, 81.
8 Melander 1979, 165.
9 Gerhard, I, pl. XXXII,2; XLI; XXXVII,4; LXXXIV; LXXXV; Gerhard, II, pl. CXLVIII; CCXXVIII; CCXXX.
10 Item m32, nr. 94 in the Thorvaldsen's Museum archive.
11 Salskov Roberts 1981.
12 The Archaic mirrors known in 1967.
13 Melander 1979; 1993, 122–123, pls. 78–78; 2009, 98–115.
14 Purup (forthcoming).
15 Brøndsted 1847.
16 Gerhard, I, 18–20, Tables III–V; Rebuffat-Emmanuel 1973, 10, 11 n.3, 23.
17 Salskov Roberts 1981, 1; Rasmussen 1999.
18 Salskov Roberts 1981, cat. nos. 1–3.
19 Melander 2009, 114–115.
20 de Grummond 1982, 11 with fig. c; Rebuffat-Emmanuel 1973, 362.
21 See Melander 2009, 98–99, fig. 74; Melander 1979, 163, n. 39 for further notes.
22 Melander 1979, 163 with further notes and discussion on the appearance of Athena and Automedon.

23 Haynes 1953, 30. For dating, see pp. 36–37 with n. 68.
24 Inv. no. 1348. See Rebuffat-Emmanuel 1973, cat. no. 66, 317–320 (426–427, 440, 480–482, pls. 66, 81, 84); or Gerhard, I, 94 n. 153, pl. XXV,9.
25 Rebuffat-Emmanuel 1973, 426–427.
26 Rebuffat-Emmanuel 1973, 427. Rebuffat-Emmanuel further draws attention to an Apulian crater with a bust head of young male with a winged Phrygian hat from the last third of the 4th century or the very start of the 3rd century, which is very similar to the Parisian mirror (Rebuffat-Emmanuel 1973, 440).
27 For mirrors with busts, but not identical to the Thorvaldsen or Parisian mirror, see Gerhard, II, pl. CLXX (included in Haynes's *grossformatiger, grossfiguriger*); Gerhard, IV, pl. CCCXXIII.
28 Melander 2009, 98–99, fig. 74.
29 For Hermes Psychopompos on another Etruscan mirror in Thorvaldsen's Museum, see Melander 1979, 162 with n. 25 for further reading.
30 It has only been described in Müller's Blue Book (Mirror V).
31 de Grummond 1982, 11; Rebuffat-Emmanuel 1973, 360–363.
32 E.g. de Grummond 1982, 11, fig. 48.
33 de Grummond 1982, 8–9; Mayer-Prokop 1967, 115; Melander 2009, 107.
34 Melander 2009, 102–103. But as Melander points out, the Etruscan mirrors, perhaps under the influence of the Praenestine mirrors, are also sometimes pear-shaped.
35 This kind of damage is not unheard of. Rebuffat-Emmanuel has noted in her work on the mirrors at the Cabinet des Médailles that one of the mirrors (no. 1311) has been re-engraved with such force that the mirror has cracked.
36 The closest example is on a mirror from Museo Civico in Bologna showing the birth of Minerva/Menrva. Jupiter/Tinia is sitting on a rock and Minerva/Menrva comes out of his head. To the left, Thalna (the Etruscan divine figure of unknown ancestry) is holding her arms around Jupiter/Tinas's abdomen, almost indicating that she is standing behind him, but her entire body is visible and not, as on the Thorvaldsen mirror, hidden partly behind the other person. For photos, see Sassatelli 1981, cat. no. 13; de Grummond 1982, fig. 96.

37 de Grummond 1982, 62 (with further references). De Grummond also points out that Praeneste has gradually become notorious for its forgeries, as not only mirrors but also *fibulae* and *cistae* from Praeneste have been reworked in recent times (de Grummond 1982, 67–68).

38 Fischer-Graf 1980, 84ff; de Grummond 1982, 64–65, figs. 72–79, 96; Rebuffat-Emmanuel 1973, 418–420.

39 de Grummond 1982, 63, figs. 66–67; Rebuffat-Emmanuel 1973, 416–417.

40 *CVA Deutschland* 21, pl. 49; de Grummond 1982, 63–64, figs. 68–69.

41 The forgers themselves are almost unknown; see de Grummond 1982, 67–68 (with further references).

42 I would like to thank Lejla Mrgan (Ph.D. candidate at the University of Copnehagen and the Thorvaldsens Museum) for inputs concerning Peter Paul Rubens and the authenticity of the painting. Private conversation.

43 Also, the hairstyles of the Thorvaldsen satyrs and the mirror satyr do not match.

44 See de Grummond 1982, 11 for a description of tanged mirror grips.

45 Melander 1979, 162; Müller 1847, 170, Cat. No. 175 & n. 1.

46 Melander 1979, 162.

47 "Men denne Graffito er sandsynligt en i den nyere Tid udförte Copi efter [original], idet Stregerne, tvertimod den ved de etruskiske Speile brugte Fremgangsmaade, ere indgraverede med et trekantet Instrument, meget ujevnt og paa nogle Steder dobbelt, og vise sig, idet Overfladen kun tildeels er blevet afsleben, ogsaa at være skaarne igiennem de oxyderede Dele af Metallet, hvor dette har skudt ud i större forhöininger, uden nogetsteds at være bedækkede af disse. Indskrifternes Beskaffenhed tyder ligeledes paa en Forfalskning" (Müller 1847, 170, Cat. No. 175 & n. 1).

48 Gerhard, II, pl. 235, 2; 1863, 219–220; Melander 1979, 162; Rebuffat-Emmanuel 1973, Cat. 51, 252–258, with additional references. Formerly found in the Cabinet de l'Abbaye de Sainte-Geneviève, and after 1797 in the Cabinet de Médailles in Paris.

49 One of them has never been published and the other was defined already as bearing a forged engraving by 1847.

50 Melander 2009, 102, fig. 76.

51 Melander states that it is a *stamnos* (Melander 2009, 102, fig. 76), while Müller (Müller

1847, 165) and Mayer-Prokop (Mayer-Prokop 1967, 20 Kat. S15, 68–70) identify it as a *hydria*.

52 Mayer-Prokop 1967, 69; Müller 1847, 165, Kat. nr. 156.

53 de Grummond 1982, 143 (ca. 480 BC); Mayer-Prokop 1967, 68 (480–70 BC); Melander 2009, 102, fig. 76 (ca. 480 BC).

54 Mayer-Prokop 1967, 68; Melander 2009, 102, fig. 76.

55 Mayer-Prokop 1967, 68. For an illustration, see Boardman 1988, fig. 335.2.

56 See Boardman 1988, 193, fig. 341; Beazley 1974, fig. 5.2.

57 Beazley 1974, 15, cat. no. 75 (62).

58 Melander 2009, 102, fig. 76 text.

59 Gerhard, I, Pl. XLI; III, 26; Müller 1847, 165, Kat. nr. 156.

60 Hesiod, Theog. V. 782 f.

61 Mansuelli has argued for "Lasa alata" as the identity of the goddess, Mansuelli 1946/77, 12. See Mayer-Prokop 1967, 68, n. 210 for counterarguments.

62 Mayer-Prokop 1967, 68–69.

63 For illustrations, see Beazley 1963, 473, No. 79; 476, No 161; Orsi 1906, 363f, fig. 266; Riezler 1914, 53, fig. 29.

64 Diehl 1964, 136.

65 For illustrations, see Orlandini 1956, 370, fig. 17; Orsi 1932, 140, fig. 4; Thomsen 2011, 173, fig. 72.

66 Friis Johansen 1923.

67 Hartmann-Parlasca 1979, 140, (pls. 89–93).

68 Jensen 2006, 313; Friis Johansen 1923, 119ff.

69 See Hartmann-Parlasca 1979, 141–142; and esp. Johansen 1923, 132 n. 1 with further examples.

70 As indicated in the Iliad, where Achilles's men carry in the golden vessels from King Priam's wagon, which the king brings to appease Achilles (Iliad, XXIV, 571–586). In the Thorvaldsen relief, however, the men are indicated as Trojans.

71 See Melander 2009, 188, fig. 188.

72 For an Etruscan mirror with severe classical wings, see e.g. Salskov Roberts 1981, 103–105, figs. 22a–b.

73 In the ancient mythology, the *kerykeion* once belonged to Apollo but was given to Hermes as a sign of friendship and peace – thereby making the *kerykeion* the attribute of Apollo and not Iris.

74 Thorvaldsen Museum, inv. no. A493.

75 Diliberto 2009.

76 Friborg 2014, with citation.

BIBLIOGRAPHY

J. D. Beazley 1963
Attic Red-Figure Vase-Painters. Oxford 1963.

J. D. Beazley 1974
The Pan Painter. Mainz 1974.

J. Boardman 1988
Athenian Red Figure Vases the Archaic Period.
London 1988.

B. Bundgaard Rasmussen 2000
A Danish Prince in Naples, in: B. Bundgaard
Rasmussen *et al* (eds.), *Christian VIII & The
National Museum,* Copenhagen 2000, 11–43.

P. O. Brøndsted 1847
Den Ficoroniske Cista. København 1847.

CVA Deutschland 21.
Corpus vasorum antiquorum Deuthschland 21,
Berlin, *Antiquarium* vol. 2. Berlin 1962.

E. Diehl 1964
Die Hydria. Mainz am Reihn 1964.

M. Diliberto 2009
*Decouverte et restauration des fronton du temple
d'Athena Aphaia a Egine.* Paris 2009.

H. von Einem 1974
Thorvaldsens »Jason«. Versuch einer historischen
Würdigung, in: *Bayerische Akademie der Wisssen-
schaften. Sitzungsberichte 1974,* Heft 3, München
1974.

U. Fischer-Graf 1980
Spiegelwerkstätten in Vulci. Berlin 1980.

N. K. Frederiksen 2014
Christian 8.'s Loan From Thorvaldsen (transla-
tion by David Possen), from:
www.arkivet.thorvaldsensmuseum.dk

F. Friborg 2014
Prometheus at Slotsholmen, from:
www.arkivet.thorvaldsensmuseum.dk

E. Gerhard, I–IV
Etruskische Spiegel. I–IV. Berlin, 1843–67 (for the
fifth vol. see A. Klugmann & G. Körte 1897).

N. T. de Grummond 1982
A Guide to Etruscan Mirrors. Tallahassee FL 1982.

J. B. Hartmann & K. Parlasca 1976
Antike Motive bei Thorvaldsen. Tübingen 1976.

S. Haynes 1953
Ein neuer etruskischer Spiegel, in: *Mitteilungen
des Deutschen Archäologischen Institut,* band 6,
1953, 21–45.

F. Inghirami 1824
Monumenti etruschi, II, book 1 and 2. Fiesole,
1824.

J. Jensen 2006
*Danmarks Oldtid – Ældre Jernalder, 500 f.Kr.–400
e.Kr.* København, 2006 (2. udgave).

F. Johansen 2004
Den antikke mandskrop – og så Jasons, in: *Med-
delelser fra Thorvaldsens Museum/Thorvaldsens
Museum Bulletin* 2003, København 2004, 35–41.

K. Friis Johansen 1923
Hoby-Fundet, *Nordiske Fortidsminder* II,3
(119–164). København 1923.

A. Klugmann & G. Körte 1884–97
Etruskische Spiegel. V. Berlin 1884–97.

K. Kofoed 2015
Thorvaldsen's Collection of Paintings – a
Collection with a Significant Lack, from:
www.arkivet.thorvaldsensmuseum.dk

G.A. Mansueli 1946/1977
*Gli specchi figurati etruschi. Studi sugli specchi
etruschi.* Firenze 1977 (January 1, 1946).

I. Mayer-Prokop 1967
*Die gravierten etruskischen Griffspiegel archaischen
Stils.* Heidelberg 1967.

Thorvaldsens Museum Bulletin 2003. Copenhagen
2004.

T. Melander 1979
Some Late Etruscan Mirrors in the Thorvaldsen
Museum, in: *Bronzes hellénistiques et romains.
Tradition et renouveau.* Actes du Ve colloque
international sur les bronzes antiques, Lausanne,
8–13 mai 1978, Lausanne 1979, 161–167.

T. Melander 1993
Thorvaldsens Antikker. København 1993.

T. Melander 2004
Et antikt Jason forbillede? Og Kampen om Det
gyldne Skind, in: *Meddelelser fra Thorvaldsens
Museum/Thorvaldsens Museum Bulletin* 2003,
København, 2004, 81–89.

T. Melander 2009
Thorvaldsens antikke bronzer. København 2009.

L. Müller 1847
Thorvaldsens Museum. Tredje afdeling. *Oldsager*.
København 1847.

Müller's Blue Book. No year.
A blue handwritten booklet at Thorvaldsens
Museum.

P. Orlandini 1956
XVII. – Gela. – Ritrovamenti vari, *Notizie degli
Scavi di Antiochita* Serie 8, vol. 10, Roma 1956,
203–401.

P. Orsi 1906
Le Necropoli del Secolo V, *Monumenti Antichi*
17, Milano 1906, 269–536.

P. Orsi 1932
XVII. – Gela – Esplorazione di una necropoli
in contrada Spina santa, *Notizie degli Scavi di
Antichita* Serie 6, vol 8,1–3, Roma 1932, 137–149.

B. B. Purup 2017/2021
Ludvig Müller og møntsamlingen på Thorvald-
sens Museum – Lånet, Testamentet og Bytte-
handelen, in: *Aarbøger for Nordisk Oldkyndighed
og Historie* 2017 (with English summary), Køben-
havn 2021, 127–153.

D. Rebuffat-Emmanuel 1973
*Le miroir étrusque d'après la collection de Cabinet
des Médailles*. Rome 1973.

W. Riezler 1914
Weissgrundige attische Lekythen. München 1914.

H. Salskov Roberts 1981
*Corpus Speculorum Etruscorum, Denmark, 1,
Copenhagen, The Danish National Museum & The
Ny Carlsberg Glyptothek*. Copenhagen 1981.

G. Sassatelli 1981
*Corpus Speculorum Etruscorum, Italia 1, Bologna,
Museo Civico 1*. Roma 1981.

C. Stampe 1912
Baronesse Stampes Erindringer om Thorvaldsen.
Udgivet af Rigmor Stampe. København 1912.

A. Thomsen 2011
Die Wirkung der Götter. Berlin-Boston 2011.

BERTEL THORVALDSEN AND THE STUDY OF ANCIENT ETRURIA

KRISTINE BØGGILD JOHANNSEN

The opinion which I hold about the important collection of antiquities belong-
ing to Herr Hofrat Dorow is so high and fixed that I have no misgivings about
writing it down and signing it, and I can do this so much the better, as I have
seen all of the items in this extensive collection arriving here from the locations,
where they have been excavated and discovered, so their full authenticity is most
strictly guaranteed. An advantage, which the art objects acquired by means of
the art dealers, does not have to the same degree.[1]

On 30 March 1828 the Danish neoclassical sculptor Bertel Thorvaldsen
(1770–1844) witnessed a great number of Etruscan vases, bronzes and oth-
er artefacts arriving in Rome (**Fig. 1**).[2] The objects had been discovered by
his acquaintance, the German archaeologist Wilhelm Dorow (1790–1846),
and were allegedly excavated at the Etruscan sites of Corneto (Tarquinia),
Ponte dell'Abadia at Vulci (Ponte Badia) and Chiusi.[3] In the passage quoted
above, deriving from a written statement dated six months later and only
known in its published version, Thorvaldsen approves of the provenance
and authenticity of the objects, as he has seen all of the items arriving in
Rome. It may, however, be argued that it would have been impossible for
him to confirm the provenance of the objects once they had been brought
to Rome, and that he would have to rely solely on the information given by
Dorow.[4] Indeed, other sources point to a more complex picture of the situ-
ation and suggest that a substantial number of the items came from illegal
excavations in the area and only subsequently were sold off to Dorow, who
took the honour of having excavated them himself.[5] In spite of this, Thor-
valdsen's statement is highly remarkable. Not only is it one of the very few
known examples of Thorvaldsen directly expressing his view on ancient
art (and art in general). Noteworthy is also the importance that he places
on the completeness of the collection which – according to him – allows
new insights about Etruscan art, mythology and perhaps even language
that could encourage new research and understandings of ancient Etruria.[6]

With Thorvaldsen's report on Dorow's collection as the point of departure this article seeks to explore and give a brief introduction to Thorvaldsen's role in the rediscovery of ancient Etruria in the first half of the nineteenth century, which hopefully may serve as a building block to a more comprehensive picture of Thorvaldsen's important and lifelong involvement in the study of Antiquity.

The Archives

Bertel Thorvaldsen was notoriously known for his reluctance towards writing, and today it is generally accepted that he suffered from dyslexia.[7] Consequently, he only kept a diary in a short period of his life.[8] Similarly, he did not keep systematic lists or inventories of how and where he acquired the antiquities in his collection. If we are to understand his interest in ancient Etruria, we must therefore take another path. His rich collections of books, drawings, engravings and – of course – his collection of antiquities hold important pieces of evidence. But perhaps even more important is the inescapable goldmine of information to be found in the numerous letters, receipts and notes kept in the Thorvaldsens Museum Archives, since 2008 presented online.[9]

The Thorvaldsens Museum Archives presents more than 10,000 documents of various character – from contracts to love letters by, to, about or in other ways relating to Bertel Thorvaldsen. A substantial amount of these documents deals with subjects related to archaeology and the study of ancient art and culture. The documents, which in many cases still are uncommented, often hold important information which allow us to create a still more detailed picture of Thorvaldsen's network and role in the archaeological circles in Rome.

Thorvaldsen's interest in Etruscan art and culture seems to have been awoken quite early in life.[10] A survey of the archival material reveals that the earliest reference is a diary-entry dated 7 February 1797, only a week after he first set foot on the Italian mainland. In the diary which he kept around the time of his arrival, he mentions having admired "Etruscan" vases during a visit to Capodimonte, while staying in Naples as he awaited permission to continue his journey to Rome.[11] It is, nevertheless, obvious that Thorvaldsen must have been referring to Greek painted vases, which according to the general understanding at the time were thought to be Etruscan. This corresponds well with the survey of the archival materi-

Fig. 1 Johann Christian Lotsch, *Caricature of the archeologist Wilhelm Dorow and the Swedish Count Nils Gustav Palin(?)*, c. 1828. Pencil, pen, ink and watercolour on paper. 316 × 235 mm. Thorvaldsens Museum, inv. no. D1005. (Photo: Thorvaldsens Museum, Helle Nanny Brendstrup).

al, which documents that until the early 1820s the terms "Etruria" and "Etruscan" were mostly used as references to the modern Kingdom of Etruria (1801–1807)[12] or to Greek painted vases.[13] However, from this time onwards the number of accounts of visits to the Etruscan sites north of Rome, descriptions of Etruscan artefacts and summons to witness newly excavated finds increase remarkably. This mirrors well the increasing interest in ancient Etruria as a result of the discovery of the painted tombs at Tarquinia in 1827 by the Baltic-German baronet Otto Magnus von Stackelberg (1787–1837), the German diplomat August Kestner (1777–1853) and the German architect Joseph Thürmer (1789–1830) and the rich excavations carried out at Tarquinia, Vulci and Chiusi the following years by Dorow, the Italian archaeologist Vincenzo Campanari (1772–1840), the brothers Candelori and above all by the Prince of Canino, Lucien Bonaparte (1775–1840).[14] All of which, as we shall see below, were part of Thorvaldsen's network in Rome. Two groups of documents, however, stand out and provide us with important insight in Thorvaldsen's role in the archaeological milieu.

The first important group is formed by the more than 80 letters related to Thorvaldsen's longstanding membership (1816–1838) of the influential Papal art commission, *Commissione Generale Consultiva di Belle Arti*.[15] Most of the preserved documents are short notices with invitations to witness newly excavated finds brought to Rome or occasionally to visit actual excavations.[16] The documents, mostly signed by the secretaries of the commission, the Italian archaeologists Filippo Aurelio Visconti (1754–1831) and Luigi Grifi (1799–1880), enable us to draw a rough picture of Thorvaldsen's engagement, which – in view of the sheer number of documents – must have taken up a considerable amount of his time. As we have seen in Thorvaldsen's statement about the Dorow collection, it appears to have been a common procedure that the commission inspected newly excavated finds when they had been brought to Rome. Although it is evident that the members also made excursions to ongoing excavations, these trips seem to have been less frequent. While the assignments of the commission seem to have been diverse in the period 1816–1827, inspections of finds from Etruria appear to have taken a more prominent place from 1828, which corresponds well with the increasing number of excavations. One of these events took place in the evening of 10 June 1829 at the Palazzo Imperiale in Rome, where the commission members were gathered to examine the Etruscan

vases recently excavated by the Prince of Canino.[17] By the means of sessions like the mentioned, Thorvaldsen gained first-hand access to the newly excavated finds, expanded his knowledge about Etruscan art and consolidated his already extensive network in the archaeological milieu in Rome. As member of the commission Thorvaldsen, however, not only acted as an advisor on matters regarding art and archaeology. He also participated actively in the establishing of the Museo Gregoriano Etrusco (1836) and is explicitly praised for his role in explaining and curating the *oggetti tutti Etruschi* (**Fig. 2 a–b**).[18] Thorvaldsen also undertook various restoration assignments for the Vatican Museums. Most important in this connection

Fig. 2 a–b One of the silver medals awarded to Thorvaldsen in connection with his role in the establishment of Museo Gregoriano Etrusco in 1836/1837. Silver. 51 mm diameter. Thorvaldsens Museum, inv. no. F82 (Photo: Thorvaldsens Museum, Jakob Faurvig).

is the restoration of the bronze figure of the so-called Mars from Todi, a small town in Umbria. It was discovered in 1835 and incorporated in the Vatican collections in 1836. (**Fig. 3**).[19]

Another group of documents in the Archives holds valuable information about Thorvaldsen's membership of other archaeological societies, most importantly his role in the establishment of the *Instituto di Corrispondenza Archaeologica*.[20] The idea to form an institution with the main purpose to publish results of recent excavations and archaeological discoveries was first articulated by a circle of German archaeologists based in Rome in the mid-1820ies, also known as *Die römische Hyperboreer*.[21] Among the leading figures we find the archaeologists Eduard Gerhard (1795–1867), Theodor Panofka (1800–1858), Christian Karl Josias von Bunsen (1791–1860) along with the abovementioned Kestner and Stackelberg. On Winckelmann's birthday 9 December 1828 Bunsen invited Thorvaldsen and the Italian archaeologist Carlo Fea (1753–1836) to join Gerhard, Kestner and himself for a meeting in Palazzo Caffarelli in Rome (the later seat of the institute) to discuss the organisation of the new institute. The main reason for inviting Thorvaldsen and Fea to join the board of the institute was naturally their comprehensive knowledge about ancient art, but perhaps just as much their close ties to the papal administration – both being members of the *Commissione Generale* and Thorvaldsen at the time furthermore president of the papal art academy *Accademia di San Luca*. As member of the board Thorvaldsen served as expert in various matters about art, most importantly in connection with the large-scale publication project *Impronte Gemmarie* where he together with Gerhard and Kestner was responsible for the selection of objects for publication. It is hardly surprising that items from Thorvaldsen's collection feature prominently in the publications. Similarly, there are several references in the journals published by the institute, *Bullettino del Instituto* and *Annali del Instituto*, which often hold important information about the provenance of the items. The letters preserved in the Archives add further to this image and give us additional information about Thorvaldsen's role in the administration and how he gave access to his collection and library for scholars and board members.[22]

In addition to the abovementioned groups of documents, it is worth drawing attention to the letters where Thorvaldsen specifically is asked for his expertise about Etruscan art or to act as intermediary and acquire

Fig. 3 Sculpture of a warrior, the so-called Mars from Todi, without and with Thorvaldsen's restorations. Etruscan, late fifth century BC. Bronze. 141 cm. Musei Vaticani, inv. no. 13886. (Photos: Left, Jean-Pol Grandmont, Wikimedia Commons, CC-BY-SA 3.0. Right, Wikimedia Commons).

objects from excavations in Etruria via his extensive network.[23] In a letter to Thorvaldsen dated 26 February 1833 the Danish prince Christian Frederik (the later Christian VIII) thus writes to Thorvaldsen:

> For enlargement of my vase collection I could wish to possess an excellent vase from Vulci, one of those excavated by Lucien Buonaparte. Several of these have been sold in England possibly some are for sale in Rome. One of this kind chosen by you and returned on this occasion would be very pleasant to me; I expect that the price would be 20 to 30 Louisd'ors which Chiaveri if so would pay out.[24]

In his answer Thorvaldsen agrees to purchase an "excellent ancient vase" for the prince.[25] However, the venture was repeatedly postponed and it is uncertain if the purchase was ever realized.

The Collections

As suggested by the diary entry mentioned above, the seed for Thorvaldsen's interest in ancient Etruria must have been planted well before the "etruscomania" of the 1820s. His extensive collections of books, prints and drawings point in the same direction. It has recently been documented that Thorvaldsen received – either by testamentary disposition or simply took over – a substantial number of drawings and prints with Egyptian motifs after the death of his mentor, the Danish archaeologist and philologist Georg Zoëga (1755–1809). Similarly, several engravings and prints with Etruscan motifs came into his possession on this occasion (**Fig. 4**). Some of the pieces, which were long considered lost, are specifically mentioned in Zoëga's rich correspondence with fellow scholars, collectors and patrons, today preserved in the Danish Royal Library.[26] The provenance of others is less clear, but most likely came from Zoëga's estate too.[27] This may e.g. be the case with publications such as *Musaei Kircheriani aerea notis illustrata* (1763) by Contuccio Contucci and *Gli antichi sepolcri ovvero mausolei romani ed etruschi* (1768) by *P. Santi Bartoli,* which is one of the eleven publications on pre-roman Italy preserved in Thorvaldsen's personal library today.[28] Originally the collection contained additional titles, which would have been interesting for this study too. They were, however, sold off in 1849 at one of the public auctions over objects from Thorvaldsen's estate, which the museum board decided not to include in the new museum –

Fig. 4 Engraving with items from an Etruscan tomb discovered in 1696. The engraving is reprinted or copied by Antonio Giuseppe Barbazza and part of a series of engravings published as illustrations in Francesco Bianchini's *La Istoria Universale Provata con Monumenti, e figurata con simboli degli Antichi* (1747). Thorvaldsens Museum, inv. no. E1432. The engraving is among the drawings and engravings which Thorvaldsen may have taken over from his mentor, the Danish archaeologist Georg Zoëga. (Photo: Thorvaldsens Museum, Helle Nanny Brendstrup).

either because they were doublets or for other reasons not considered relevant.[29] Among these titles we find doublets of the mentioned publication by Bartoli, *Voyage archéologique dans l'ancienne Etrurie* (1829) by Dorow and *Storia degli antichi popoli italiani* (1832) by the Italian archaeologist Giuseppe Micali. In addition to the latter Thorvaldsen owned three other titles by Micali, namely *L'Italia avanti il domino dei Romani* (1810), the accompanying *Antichi monumenti per servire all'opera intitolata l'Italia avanti il dominio dei Romani* (1810) and *Monumenti per servire alla Storia degli antichi populi italiani* (1832). Correspondence preserved in the Archives reveals that Micali was based in Rome in the spring of 1830 with the purpose of preparing a revised version of his *L'Italia*.[30] Here he learned that Thorvaldsen owned a copy of the 1810 edition, only rarely accessible at the time. He therefore contacted Thorvaldsen with the purpose to consult the publication, but also to draw a bronze statuette of Silenus in Thorvaldsen's collection for the book. The Silenus is indeed included in the new edition (**Fig. 5**).[31] Yet, other artefacts from the collection are presented in the publication too.[32] It is, however, remarkable that several of these items are indicated as belonging to the Prince of Canino, not to Thorvaldsen.[33] Although it is hardly surprising that Thorvaldsen would own objects from the Canino excavations, as we have seen above, the provenance of the objects in question has hitherto not been known. The example thus not only gives us important insight into the origin of these specific items, but also of the growth of the collection. Around the time when Micali was working on the revised second version of his publication, Thorvaldsen's collection had reached a considerable size and was recognized as one of most important private collections of Etruscan artefacts in Rome. In a notice dated 12 June 1832 the editors of the well esteemed German journal *Kunst-Blatt für gebildete Stände* writes:

> *In Rome has the collection of Volcentic vases and bronzes of Mr. Candelori been brought to another room and hereby made difficultly accessible; the collections of the Prince of Canino are still closed; only the Feoli Collection is open for inquisitive connoisseurs. The cabinet of Baron von Beugnot has been enriched through rich and exquisite additions of vases, bronzes and terracottas from Etruria; multiplied was also the collections of Mr. Kestner, Lord Nordhampton, Dr. Nott, Comm. Thorwaldsen and Gerhard.*[34]

Although, Thorvaldsen in 1817 may have been directly involved in excavations at Palestrina together with his friend, the Italian painter and art dealer Vincenzo Camuccini (1771–1844), there can be little doubt that most of the Etruscan items in the collection were acquired in the late 1820s.[35] From a rough inventory of the collection done in 1830 by the Danish-German painter H.D.C. Martens in connection with a decoration assignment it appears that the groups described amounted to 60 vases, 200 cups, 200–300 terracottas, 100 marble fragments, two cupboards filled with bronzes, a coin collection and other precious items. [36] Disregarding approximately 50 vases, which would be added to the collection, this number roughly corresponds to the number of items shipped back to Copenhagen in 1838. Today, Thorvaldsen's collection holds around 307 Etruscan objects.[37] A substantial number to which could be added several of the Greek black and red figure vases in his collection, many of which presumably were excavated at Etruscan sites.

Thorvaldsen and Ancient Etruria

The rich archival material combined with sheer numbers of Etruscan artefacts and engravings and books on Etruscan topics in Thorvaldsen's collection speak their own language. There can be no doubt about Thorvaldsen's deep and profound interest in Etruscan art and culture – and in ancient art in general. Yet, what was Thorvaldsen's own view on the items in his collection? Among the items published in Micali's *Storia* we find a bronze statuette, today in Thorvaldsen's collection (**Fig. 6**).[38] It is a winged female figure with the one hand raised, which according to Micali's information was discovered at Chiusi. The location of the statuette is, however, not mentioned. A rare notice in the *Bullettino del Instituto* dated two years later describes how Thorvaldsen at a meeting presented an Etruscan bronze figurine in his collection depicting *with wings and with a radiate crown the frequent figure of Venus in the guise of the Roman Hope*. There can be no doubt that this statuette is identical with the one published by Micali. It is thus fair to assume that Thorvaldsen acquired the piece between 1830 and 1832.

The brief passage complements our understanding of Thorvaldsen's approach to the study and interpretation of ancient artworks. The abovementioned Kestner provides additional information in his memoirs *Römische Studien* (1850). Here he in a nuanced way describes how Thorvaldsen

Fig. 5 Statuette of Silenus in Thorvald-sen's collection with plate from Micali's *Monumenti*. Etruscan, 500–475 BC. Bronze. 6.5 cm. Thorvaldsens Museum, inv. no. H2008. (Photo: Thorvaldsens Museum, Jakob Faurvig).

on the one hand may not have engaged in lengthy scholarly discussions, but on the other hand always expressed opinions and judgements about ancient artworks that were interesting, factual and to the point. Furthermore, he draws a vivid picture of how Thorvaldsen when introduced to newly discovered ancient objects was completely absorbed and tended to forget the world around him:

> *If occasionally at amiable societies, after dinner or at evening punch, works of art were presented, excavated, found or newly discovered, nothing else was observed by him, before he had studied everything closely, acknowledged the skillful, observed the less good in silence, discussed the doubtful. Then there was never an artist, who more than he with his entire self, in these moments so fully had achieved the meaning of his life*[39]

Fig. 6 Statuette of winged goddess in Thorvaldsen's collection with plate from Micali's *Monumenti*. Etruscan, 530–500 BC. Bronze. 10.3 cm. Thorvaldsens Museum, inv. no. H2002. (Photo: Thorvaldsens Museum, Jakob Faurvig).

Adding to the extensive archival material, the engravings and literature on ancient Etruria in addition to the numerous Etruscan artefacts in his collection of antiquities, a picture gradually emerges of Thorvaldsen – not only as an artist and collector – but also as an expert in the field with thought-provoking and remarkably modern views on subjects such as the significance of archaeological context as expressed in the final paragraph of his statement on the Dorow collection.

> *About the collection as a whole I should like to mention that if an individual or a government should like to acquire individual pieces from this museum, and the owner should grant it, the division of the artefacts would be an offence against the history, science, art and art history of the so important Etruscan people. The way in which the collection is at present it appears as a large entity, a local collection of the most important Etruscan artworks, which no country, no state, neither in Italy or elsewhere, could present until now.*[40]

Although Dorow would have had personal reasons for emphasizing the importance of Thorvaldsen's statement, I will argue that he was not fully in the wrong, when he stated that *A writing of this character belongs to Art History and should not be kept from the world.* [41] Perhaps not the way he intended, but as an absolutely central document to understand Bertel Thorvaldsen's role in the study of ancient Etruria.

NOTES

I am very grateful to the editors Annette Rathje and Mette Moltesen for their precious encouragement and patience with this article. Also, I am deeply indebted to former curator Torben Melander, who pioneered the research on Thorvaldsen's collection of antiquities with his numerous seminal publications on this subject, see e.g. Melander 1989; Melander 1993; Melander 1999/2000; Melander 2009. The current article will consequently to a large extent be based on – and occasionally further develop – the conclusions first presented by Melander.

1 *Die Meinung, welche ich von der bedeutenden Sammlung von Alterthümern des Herrn Hofrath Dorow habe, ist so groß und bestimmt, daß ich kein Bedenken trage, sie niederzuschreiben und zu unterzeichnen, und ich kann dieß um so mehr thun, da ich sämmtliche Gegenstände dieser zahlreichen Sammlung von dem Orte, wo sie ausgegraben und gefunden worden, jetzt hier habe ankommen sehen, so daß deren gänzliche Ächtheit aufs strengste zu verbürgen ist. Ein Vorzug, dessen sich diejenigen Kunstgegenstände, welche mittelst des Kunsthandels erworben werden, nicht in dem Grade zu erfreuen haben.* Excerpt (translated from German by the author) from the written statement by Bertel Thorvaldsen on the nature and quality of the collection of Etruscan artefacts excavated (?) by the German archaeologist Wilhelm Dorow, dated 29 September 1828. The statement repeats the view on the collection that Thorvaldsen expressed orally 30 March 1828. The state-

ment is published in a booklet on the collection, *Etrurien und der Orient nebst Albert Thorwaldsen's Darstellung der 1828 entdeckten Etrurischen Alterthümer*, published by Dorow the following year (Dorow 1829, 27–31). The statement can be read in its full extent in the Thorvaldsens Museum Archives, https://arkivet.thorvaldsensmuseum.dk/ documents/ea4928. See also Melander 1993, 95–97.

2　Thorvaldsen mentions this date in his written statement, cf. n. 1. A letter from the British archaeologist and numismatist James Millingen, dated April 15 1828, confirms that Thorvaldsen must have written to him about Dorow's findings immediately after having seen them in Rome, cf. https://arkivet.thorvaldsensmuseum.dk/ documents/m131828,nr.41.

3　Thorvaldsen specifically mentions the sites in his statement, cf. n. 1. See also Urlichs 1877.

4　On the history of the Dorow collection, see also Furtwängler 1885, XI, XVI, XVII.

5　Nørskov (2009, 66) mentions that many of the vases in Dorow's collection in fact derived from illegal excavations and subsequently were sold to Dorow, who brought them to Rome as his own discoveries. See also Melander 1993, 95–97; Melander 2009, 13–14.

6　See below, p. 421, n. 40.

7　Kofoed 2009.

8　https://arkivet.thorvaldsensmuseum.dk/ documents/ea8136. See also Thiele1851, 91–98.

9　Kofoed 2008. For the Thorvaldsens Museum Archives in general, see http://arkivet.thorvaldsensmuseum.dk/en.

10　For Thorvaldsen's Etruscan collection, see also Melander 1993, 94–125; Melander 2009, 12–14, 40–115.

11　See n. 9.

12　The Kingdom of Etruria was a short-lived Italian kingdom, founded in 1801 after the Treaty of Aranjuez and dissolved in 1807 by Napoleon and integrated in the French Empire. The kingdom was created from the Grand Duchy of Etruria and made up by a large part of modern Tuscany with Florence as the capital.

13　Among the references to Greek vases, we also have two freight bills dated 3 April 1811 documenting the Thorvaldsen's purchase of *"Una cassa contenente Vasi Etruschi"* from the Naples area, cf. https://arkivet.thorvaldsensmuseum.dk/ documents/gmIII,nr.38;

https://arkivet.thorvaldsensmuseum.dk/ documents/gmII,nr.3. See also Melander 1999/2000, 11.

14　For history of the discovery of the painted tombs at Tarquinia, cf. Siebert 2010. For Campanari's excavations, cf. Buranelli 1991.

15　The archive holds 42 letters to Thorvaldsen from the commission and 40 additional letters from Filippo Aurelio Visconti, but there may be further documents of relevance. The majority of these are letters summoning Thorvaldsen to inspect newly excavated finds or other artworks, but there are also examples of invitations to witness actual excavations. See e.g. https://arkivet.thorvaldsensmuseum.dk/documents/gmV,nr.80. See also Melander 1993, 95.

16　https://arkivet.thorvaldsensmuseum.dk/ documents/gmV,nr.80

17　https://arkivet.thorvaldsensmuseum.dk/ dokumenter/m141829,nr.80

18　In a letter dated 30 January 1837 the Camerlengo A. Fieschi thanks Thorvaldsen warmly for his role in establishing the museum and awards him two silver medals and a gilded bronze medal for his achievements, https://arkivet.thorvaldsensmuseum.dk/ dokumenter/m29II,nr.62. For Thorvaldsen's involvement in the establishment of the museum, see also Buranelli 1991, 25; Christensen & Johannsen 2015, 16–17, n. 87.

19　https://arkivet.thorvaldsensmuseum.dk/ documents/ea9900; Melander 1989.

20　https://arkivet.thorvaldsensmuseum.dk/ dokumenter/Smaatryk1829,Institutoarcheo logica; https://arkivet.thorvaldsensmuseum. dk/dokumenter/ea9738; https://arkivet. thorvaldsensmuseum.dk/dokumenter/ea9738

21　On the purpose of the institute see e.g. Michaelis 1879, 31.

22　https://arkivet.thorvaldsensmuseum.dk/ dokumenter/C351v; https://arkivet.thorvaldsensmuseum.dk/ dokumenter/m141829,nr.91; https://arkivet.thorvaldsensmuseum.dk/ dokumenter/m141829,nr.114; https:// arkivet.thorvaldsensmuseum.dk/ dokumenter/m151830,nr.28; https://arkivet. thorvaldsensmuseum.dk/dokumenter/ m161831,nr.18; https://arkivet.thorvaldsensmuseum.dk/ dokumenter/m231840,nr.25

23　It is well-documented that Thorvaldsen on several occasions was asked for his expertise

in matters about the purchase of ancient
sculptures, see e.g. Johannsen 2021, 196–197.

24 *Til forøgelse af min Vase Samling kunde
jeg nok ønske at besidde en udmærket Vase
fra Vulci, en af de ved Lucien Buonaparte
udgravede. Der ere solgte endeel af dem i
Engeland muelige at nogle ere til Salg i Rom.
En saadan udvalgt ved Dem og hiemsendt
ved denne Lejlighed vilde være mig saare
behageligt; jeg formoder at Prisen vilde være 20
til 30 Louisd'ors som Chiaveri i saafald vilde
kunne udbetale"* (translated from Danish
by the author). For letter in its full length,
cf. https://arkivet.thorvaldsensmuseum.dk/
dokumenter/m181833,nr.23

25 The letter from Thorvaldsen to Prince
Christian Frederik,
https://arkivet.thorvaldsensmuseum.dk/
documents/ea4808. See also Melander 1993,
97–98; Melander 1999/2000, 12.

26 Thorvaldsens Museum, inv. nos. E1401-
E1415, E1432, E1434. See also Johannsen
2015 and online catalogue
(https://arkivet.thorvaldsensmuseum.dk/
artikler/relics-of-a-friendship) for references
to inventory numbers, letters and literature.

27 Thorvaldsens Museum, inv. nos.
E1429-E1431, E1468-E1469, E1496,

28 The following publications are listed in
Ludvig Müller's catalogue of the collection
(Müller 1850, 10): *Musei Kirkeriani aerea,
notis illustrata* (inv. no. M77), G. Micali:
L'Italia avanti il dominio dei Romani, 1810
(inv. no. M78), G. Micali, *Antichi monumenti
per servire all'opera initolata L'Italia avanti
il dominio dei Romani*, 1810 (inv. no. M79),
G. Micali, *Storia degli antichi popoli italiani*,
1832 (inv. no. M80), G. Micali, *Monumenti
per servire alla Storia degli antichi popoli
italiani*, 1832 (inv. no. M81), F. Inghirami,
Monumenti Etruschi, 1821–26 (inv. no.
M82), W. Dorow, *Voyage archéologique
dans l'ancienne Étrurie*, 1829 (dedicated to
Thorvaldsen) (inv. no. M83), *Notizie intorno
alcuni vasi etruschi del dott. Dorow, Pesaro
1828* (inv. no. M84), N. G. Palin and B.
Quaranta, *Zwei Sendschreiben vom Ritter
v. Palin in Rom und Bernardo Quaranta in
Neapel an den Dr. Dorow, über Ausgrabungen
im alten Etrurien, während der Jahre 1827 bis
1829*, 1832 (inv. no. M85), L. Grifi, *Monu-
menti di Cere antica*, 1841 (inv. no. M86).

29 https://arkivet.thorvaldsensmuseum.dk/
documents/Smaatryk1849,THMsbestyrelse2

30 https://arkivet.thorvaldsensmuseum.dk/
documents/m151830,nr.49; https://arkivet.
thorvaldsensmuseum.dk/documents/ea4760.

31 Micali 1832a, III, 64 no. 6–7; Micali 1832b,
Tav. XLI, no. 6–7.

32 In addition to Silenus, Micali refers to sev-
eral scarabs in Thorvaldsen's collection (inv.
nos. I22; I2; I28; Micali 1832a, III, 217 nos.
13, 18, 22; Micali 1832b, Tav. CXVI nos. 13,
18, 22).

33 A red-figured cup painted by Onésimos
rendering a youth balancing a yoke with two
baskets (inv. no. H605, Micali 1832a, III, 172
no. 3; Micali 1832b, Tav. XCVII, no. 2), a
red-figured amphora attributed to the Geras
Painter rendering Acteon being attacked by
Artemis' dogs (a) and two ithyphallic silenoi
playing blind man's buff (inv. no. H599;
Micali 1832a, III, 179–180 no. 1; Micali
1832b, Tav. C, no. 1).

34 *In Rom ist die Sammlung von volcentischen
Vasen und Bronzen der Herren Candelori in
ein andres Lokal gebracht und dadurch schwer-
er zugänglich geworden; die Sammlungen
des Fürsten von Canino blieben fortwährend
geschlossen; nur die Sammlung Feoli blieb der
Wißbegierde der Liebhaber offen. Das Cabinet
des Baron von Beugnot wurde durch reichen
und auserlesenen Zuwachs in Vasen, Bronzen
und Terracotten aus Etrurien bereichert;
vermehrt wurden auch die Sammlungen des
Herrn Leg. R. Kestner, Lord Nordhampton,
Dr. Nott, Comm. Thorwaldsen und Gerhard.*
Passage translated from German by the
author. https://arkivet.thorvaldsensmuseum.
dk/documents/ea9963.

35 On the possible excavation at Palestrina, cf.
https://arkivet.thorvaldsensmuseum.
dk/documents/ea6007; https://arkivet.
thorvaldsensmuseum.dk/documents/
m51817,nr.30; https://arkivet.
thorvaldsensmuseum.dk/documents/
m51817,nr.38.
See also Melander 1993, 94; Melander 2009.
Among the earlier acquisitions of artefacts
from Etruscan contexts, we find an Attic
black figure neck amphora (inv. no. H538),
which derives from a tomb discovered
before 1817 at Castel d'Asso by Viterbo and
published by Campanari in 1825 (Campanari
1825). See also Melander 1993, 94–99, 110.

36 Martens presents the inventory in a letter
to the Danish prince Christian Frederik, cf.
Glarboe 1944. See also Melander 1993, 18;
Melander 1999/2000, 12; Christensen &
Johannsen 2015, 18.

37 For further discussion of the Etruscan
objects in Thorvaldsen's collection, cf.
Melander 1993, 94–125; Melander 2009,
50–115; Christensen & Johannsen 2015,
83–103.

38 Thorvaldsens Museum, inv. no. H2002. Melander 2009, 62–63, fig. 43–44, cat. no. 23; Johannsen 2021, 203, Abb. 7.6.

39 *Kamen alsdann zuweilen bei gesellingen Vereinen, etwa nach Tische, oder beim Abendpunsch, Werke bildender Kunst zum Vorschein, Aufgefundenes, Entdecktes oder neu Erscheinenes, so ward nichts Anderes mehrvon ihm beachtet, bevor er nicht Alles dies genau durchgesehen, das Tüchtige gewürdigt, das minder Gute mit Stille beseitigt, das Zweifelhafte besprochen hatte. Denn keinen Künstler hat es jemals gegeben, der mehr wie er, mit dem ganzen Umfange seines Selbest, so ganz seine Bestimmung in jedem Augenblicke seines Lebens erfüllt hätte.* (Passage translated from German by the author), Kestner 1850, 67–68.

40 *Doch über die Sammlung als ein Ganzes will ich noch bemerken, daß wenn Einzelne oder auch ein Gouvernement Einzelnes aus diesem Museum zu acquiriren wünschen, und der Eigenthümer dieses zugestehen sollte, dieses Trennen der Gegenstände eine Versündigung an Alterthum, Wissenschaft, Kunst und Kunstgeschichte des so wichtigen etrurischen Volkes seyn würde. So wie die Sammlung jetzt besteht, erscheint sie als ein großes Ganze, als eine Lokalsammlung der wichtigsten etrurischen Kunstwerke, wie kein Land, kein Staat, weder in Italien noch sonst wo, sie bis jetzt aufzuweisen hat.* (Passage translated by the author) from the written statement by Bertel Thorvaldsen on Dorow collection, cf. above n. 2.

41 *Eine Schrift dieser Art gehört der Kunstgeschichte an und darf der Mitwelt nicht vorenthalten werden … .* (Passage translated by the author) from the written statement by Bertel Thorvaldsen on Dorow collection, cf. above n. 2.

BIBLIOGRAPHY

F. Buranelli 1991
Gli Scavi a Vulci della Società Vincenzo Campanari – Governo Pontificio (1835–1837). Roma 1991.

W. Dorow 1828
Notizie intorno alcuni vasi etruschi del dott. Dorow, Pesaro 1828

W. Dorow 1829a
Etrurien und der Orient nebst Albert Thorvaldsen's Darstellung der 1828 entdeckten Etrurischen Alterthümer. Heidelberg 1829

W. Dorow 1829b
Voyage archéologique dans l'ancienne Étrurie. Paris 1829 (dedicated to Thorvaldsen)

V. Campanari 1825
Illustrazioni di due vasi di terra cotta, *Memorie Romane di antiquità e belle arti* 2, 1825, 155–160. Roma 1825

J. L. Christensen & K. B. Johannsen 2015
Thorvaldsen's Ancient Terracottas. A Catalogue of the Ancient Greek, Etruscan and Roman Terracottas in Thorvaldsens Museum. Copenhagen 2015.

C. Contucci
Musei Kirkeriani aerea, notis illustrata. Roma 1763–65.

A. Furtwängler 1885
Beschreibung der Vasensammlung im Antiquarium, I. Berlin 1885.

H. Glarbo 1944
"Martens og Thorvaldsen", in: *Meddelelser fra Thorvaldsens Museum,* 1944, 53–62.

L. Grifi 1841
Monumenti di Cere antica spiegati colle osservanze del culto di Mitra. Roma 1841

F. Inghirami 1821–26
Monumenti etruschi o di etrusco nome. Fiesole 1821–26

K. B. Johannsen 2015
"Relics of a Friendship. Objects from Georg Zoëga's Estate in Thorvaldsens Museum, Copenhagen", in: K. Ascani, P. Buzi & D. Picchi (eds.), *The Forgotten Scholar. Georg Zoëga and the Dawn of Egyptology and Coptic Studies,* Leiden 2015, 25–35.

K. B. Johannsen 2021
"Bertel Thorvaldsen – der Antikensammler", in: F. Knauss (ed.), *Bertel Thorvaldsen und Ludwig I. Der dänische Bildhauer in bayerischem Auftrag,* München 2021, 195–205.

A. Kestner 1850
Römische Studien. Berlin 1850.

K. Kofoed 2008
"History of the Archives", https://arkivet.
thorvaldsensmuseum.dk/articles/history-of-the-
archives

K. Kofoed 2009
"Thorvaldsen's Spoken and Written Language",
http://arkivet.thorvaldsensmuseum.dk/articles/
thorvaldsens-spoken-and-written-language

T. Melander 1989
"Oldtidens bronzeværker, noget af det ypper-
ste", *Meddelelser fra Thorvaldsens Museum* 1989,
167–177.

T. Melander 1993
*Thorvaldsens Antikker. En temmelig udvalgt sam-
ling*. København 1993.

T. Melander 1999/2000
*Corpus Vasorum Antiquorum, Danemark, Thor-
valdsens Museum*, I. Copenhague 1999/2000.

T. Melander 2009
Thorvaldsens antikke bronzer. Copenhagen 2009.

G. Micali 1810a
L'Italia avanti il dominio dei Romani. Firenze
1810.

G. Micali 1810b
*Antichi monumenti per servire all'opera initolata
L'Italia avanti il dominio dei Romani*. Firenze
1810

G. Micali 1832a
Storia degli antichi popoli italiani. Firenze 1832.

G. Micali 1832b
*Monumenti per servire alla Storia degli antichi
popoli italiani*. Firenze 1832.

A. Michaelis 1879
*Geschichte des Deutschen Archäologischen Instituts,
1829–1879*. Berlin 1879.

L. Müller 1850
*Fortegnelse over Bögerne og Kobberværkerne i
Thorvaldsens Museum*. København 1850.

V. Nørskov, 2009
"The Affairs of Lucien Bonaparte and the
Impact on the Study of Greek Vases", in:
V. Nørskov, L. Hannestad, C. Isler-Kerenyi
& S. Lewis (eds.), *The World of Greek Vases*
(ARID Suppl. XLI) 2009, 63–75.

N. G. Palin & B. Quaranta 1832
*Zwei Sendschreiben vom Ritter v. Palin in
Rom und Bernardo Quaranta in Neapel an den
Dr. Dorow, über Ausgrabungen im alten Etrurien,
während der Jahre 1827 bis 1829*. Berlin 1832.

A. V. Siebert 2010
August Kestner, Etrurien und die Etruskologie.
Hannover 2010.

J. M. Thiele 1851
Thorvaldsens Ungdomshistorie. 1770–1804.
København 1851.

K. L. Urlichs, 1877
"Dorow, Wilhelm", in: *Allgemeine Deutsche
Biographie* Bd. 5, 359–360.

CONTRIBUTORS

ANNA SOFIE S. AHLÉN obtained her MA in classical archaeology at the University of Copenhagen. Her primary area of research lies in the field of Etruscology, especially Etruscan religion and beliefs concerning the afterlife as represented on wall paintings from chamber tombs, primarily from Tarquinia. She was involved in creating the exhibition 'Etruskerne, Rejsen til Dødsriget' (The Etruscans, the journey to the hereafter), which opened at Antikmuseet, University of Aarhus, in 2014. Ahlén has been a lecturer in Roman archaeology and Etruscology at the University of Copenhagen, and since 2016 has been teaching Greek and Roman culture and literature at high school level.

J. RASMUS BRANDT is Professor Emeritus in Classical Archaeology at the University of Oslo. He graduated with a DPhil from Oxford University in 1975 and was assistant director (1975–1983) and director of the Norwegian Institute in Rome (1996–2002). He has directed two research projects financed by the Norwegian Research Council: *Theatrum Roma: The Christianization of the Imperial capital* (1997–2001) and *Thanatos: Dead bodies – Live data, A study of funerary material from the Hellenistic-Roman-Byzantine town Hierapolis in Phrygia, Turkey* (2010–2015). He has a wide experience of excavations in Norway, Cyprus, Italy and Turkey. His interest in Etruscology is of a recent date.

CECILIE BRØNS is curator, senior researcher at the Ny Carlsberg Glyptotek in Copenhagen, where she is the head of an interdisciplinary research project on the polychromy of ancient art and architecture, entitled 'Sensing the Ancient World: The invisible dimensions of ancient art', financed by the Carlsberg Foundation. She received her PhD in Classical Archaeology in 2015 from The National Museum of Denmark and The Danish National Research Foundation's Centre for Textile Research (CTR) at the University of Copenhagen. Her research concentrates on ancient polychromy and textiles, particularly in relation to ancient sculpture, as well as on the importance and effect of the senses for the perception and understanding of ancient Mediterranean art.

LIV CARØE obtained her MA in Classical Archaeology from the University of Copenhagen. She is currently employed as a lecturer in Greek and Roman archaeology and Etruscology at the University of Copenhagen. Her research interests lie in the study of Roman sculpture in private villas and studies of collecting, as well as various aspects of Etruscan culture. She has participated in field projects in Greece (The Ancient Sikyon Project) and in Turkey, at Neoklaudiopolis, with the project 'Where East meets West', and also in Italian excavations at Francavilla, Tarquinia and Veii.

INGRID EDLUND-BERRY is Professor Emerita in the Department of Classics, the University of Texas at Austin. She received her fil. lic. degree at the University of Lund and PhD at Bryn Mawr College, Pennsylvania, and has taught at the University of Georgia, University of Minnesota, the Intercollegiate Center in Rome, and the University of Texas, Austin. Her excavation experience includes Poggio Civitate (Murlo), S. Angelo Vecchio (Metaponto), and Morgantina in Sicily.

KRISTINE BØGGILD JOHANNSEN is a curator of the collection of antiquities at the Thorvaldsens Museum, Copenhagen. She obtained her MA in Classical Archaeology from the University of Copenhagen in 2006. Her primary area of research is the reception of Antiquity in the late 18th and early 19th century. Other interests include Roman architectural terracottas and portraiture from Antiquity to the present day. She is currently co-directing (with Dr. Jane Fejfer, University of Copenhagen) the interdisciplinary research and dissemination project 'Powerful Presences: The Sculptural Portrait between Presence and Absence, Individual and Group'. As part of this project, she recently curated the acclaimed exhibition 'Face to Face: Thorvaldsen and Portraiture' (March–December 2020) at the Thorvaldsens Museum. She has participated in several field projects, primarily in Italy but also in Cyprus and Germany.

LARS KARLSSON is Professor of Classical Archaeology in the Department of Archaeology and Ancient History, Uppsala University. He has a BA and a PhD from the University of Gothenburg and an MA from the University of Virginia. He has published material related to the American excavations at Morgantina in Sicily, and has directed excavations at Etruscan San Giovenale and at the Carian sanctuary of Zeus Labraundos in Labraunda, Turkey.

During his years as a Research Assistant at the Swedish Institute in Rome (1993–1999), he completed the publication of Arne Furumark's important excavations of Area F East at Etruscan San Giovenale, 2006.

MATILDE MARZULLO is a graduate in classics and archaeology, and obtained a PhD in Etruscology with a project dedicated to the analysis of painted tombs. She is currently assistant researcher for the Etruscology and Italic Antiquities course at the University of Milan. Her scientific contributions concern iconography, and in particular the relationship between painting and architecture, the three-dimensional drawing and restitution of archaeological structures and the methods of non-destructive archaeological investigations. Since 2009 she has participated in the 'Project Tarquinia', directed by G. Bagnasco Gianni. She is responsible for the excavation of the *complesso monumentale* at Tarquinia, where she is in charge of specific areas of research. She is the author of publications related to these aspects and has published a corpus of the Tarquinian funerary paintings, as well as an Archaeological Map of the Civita di Tarquinia.

LAURA NAZIM graduated in Classical Archaeology at the Ruhr-Universität Bochum. She has taken part in several archaeological excavations, and was a research assistant in the university museum in the department of ancient art. Currently, Laura Nazim is writing her PhD about the Etruscan stone sarcophagi of the Hellenistic period. Her research focuses on Etruscan art and culture with a specialization in grave contexts, burials and sarcophagi.

MARJATTA NIELSEN has studied archaeology, art history, anthropology and Roman literature at the University of Helsinki, and has been a member of research teams studying the last centuries of Etruscan civilization (Rome-Helsinki, 1967–1971; Lund, 2001–2003). She has participated in excavations in Italy and in exhibition projects and publications at Volterra (1985 and 2007) and Helsinki (2003). She has also been co-editor of *Acta Hyperborea*, and has given lectures on the Etruscans in European countries and worldwide. Her research comprises late Etruscan funerary sculpture, social issues such as family relations, women, couples and children, as well as research history and the reception of Antiquity. She is a foreign member of the *Istituto Nazionale di Studi Etruschi ed Italici*.

NORA PETERSEN received her MA in Classical Archaeology from the University of Copenhagen. Her primary area of research is Etruria during the Orientalizing period. Her main focuses within this period are graves and funerary rites, elite customs, banquets and food. Besides Etruscology, Nora Petersen has conducted research into the Bronze Age and Early Iron Age periods, particularly the burials from the sites of Caesar's Forum and Latium Vetus. Recently, she has branched into podcasting, using her passion for archaeology to teach the next generation about Antiquity.

SOFIE HEIBERG PLOVDRUP holds a BA in Prehistoric Archaeology as well as a BA and MA in Classical Archaeology from the University of Copenhagen. She is currently a PhD student with the Saxo Institute, University of Copenhagen. The topic of her PhD dissertation is changing identity and portrait strategy as reflected in cinerary urns from Volterra during the last centuries of the Etruscan civilization. Her main research area lies in the field of Etruscology, with a focus on portraiture, theories engaging with phenomenology, materiality, and the connection between elite status people across cultures and boundaries. She has participated in fieldwork in Italy and Denmark.

BJARNE B. PURUP obtained his MA in Classical Archaeology from the University of Copenhagen. He is currently working as a field archaeologist at the Museum Southeast Denmark. His research revolves around mummy portraits, numismatic studies and the collection of antiquities created by the Danish neoclassical sculptor Bertel Thorvaldsen. He has previously worked on a full registration of Thorvaldsen's coin collection for a digital publication.

BODIL BUNDGAARD RASMUSSEN has been with the National Museum since 1981. From 1989–2013 curator and from 1995 keeper at the department of Classical and Near Eastern Antiquities. She is now Emerita Head of Collections and Research of the department of Ancient Cultures of Denmark and the Mediterranean. During 1981–1982 she was engaged in the exhibition *The World of the Etruscans – Life and Death* staged in the National Museum as a joint project of Thorvaldsens Museum, the Ny Carlsberg Glyptotek and the National Museum. Her work has mainly been centred on material in the

department, i.e., idols from the Early Cycladic Bronze Age, Greek pottery, Greek and Etruscan jewellery, and Baltic amber found in Italy. Another area of interest is the history of museums, especially the history of the department of Classical and Near Eastern Antiquities.

ANNETTE RATHJE is Associate Professor Emerita of Classical Archaeology at the Saxo Institute, University of Copenhagen. A foreign member of the *Istituto Nazionale di Studi Etruschi ed Italici*, she has taught Etruscan archaeology among other subjects. Her main subject is *encounter archaeology* and much of her work treats the interaction, networks and connectivity of the Mediterranean Area in the 8th–6th centuries BC. She has been involved in fieldwork in Etruria and Latium Vetus, and is engaged in publishing the pre-Republican habitation layers above the *Sepulcretum* in the Forum Romanum. Her current research includes early Etruscan imagery and visual narrative seen from an archaeological point of view.

HELLE SALSKOV ROBERTS was a curator at the National Museum of Denmark in the Department of Classical and Near Eastern Antiquities 1959–1970. She is a Lecturer Emerita at the Saxo Institute, University of Copenhagen. Her interests have concentrated on Etruscology, especially bronzes of the archaic period. She has enjoyed long periods of study at the Danish Academy in Rome and has travelled intensively in Italy, visiting a vast range of provincial museums. In 2021 she published *Catalogue of the Sardinian, Etruscan and Italic bronze statuettes in The Danish National Museum,* Gösta Enbom Monographs vol. 7. Copenhagen-Aarhus 2021.

INGELA M. B. WIMAN completed her PhD in 1990 in the field of Etruscology, employing an interdisciplinary approach combining metal analytical data and iconographical information. She has been engaged in environmental history studies at the department of Environmental and Energy Systems Studies at Lund University, Sweden. She is now Associate Professor Emerita in the Department of Historical Studies at Gothenburg University. She has published several papers on the ecological aspects of ancient civilizations, including cultural perceptions of the relationship with nature, chiefly dealing with the Etruscan cultural sphere.

427